SOLED

OUT

SNEAKER
FREAKER

THE GOLDEN AGE OF
SNEAKER ADVERTISING

SOLED
OUT

CONTENTS

POWER OF PRINT

From the sublime to the ridunkulous, there are nearly 900 vintage sneaker advertisements in this book. Viewed collectively, this is the 20th-century sports industry expressed in its own grandiose prose and muscular image. It also represents several decades of human evolution through exercise, but it works equally well as an almanac of graphic design, trick-shot photography, pro-sports mythology and razor-sharp copy writing. The free-flowing creativity on every page is mind-boggling.

At this point it's worth acknowledging how this book came about. A decade ago I figured vintage sneaker advertising would make a killer *Sneaker Freaker* feature, so I set about acquiring the raw materials. As the collection grew close to four-figure territory, the focus narrowed. Skateboarding was out, along with football and baseball. Nike All Conditions Gear (ACG) ads don't technically fit that brief, but they're way too cool not to allow them a mulligan. A strict millennial curfew also seemed appropriate – advertising from the 2000s onwards is simply too modern and too knowingly sophisticated for sentimental reflection.

Speaking of which, as a magazine proprietor for close to two decades, researching and assembling this project has been a fairly bittersweet process. For every brilliant piece of content we uncovered, sober reflection took hold. What happens when there are no more magazines? How will Nike promote their new enfant terrible tennis prodigy and how will we remember their Wimbledon-winning sneakers 30 years from now?

Perhaps that's a tad melodramatic. But as I processed my own professional obsolescence, it dawned on me that it's the advertising that is often more memorable than the products it promotes. The unrequited teenage desire I had for Andre Agassi's Air Tech Challenge tennis shoes still burns bright decades later, but it's Wieden+Kennedy's brilliant 'Rock n' Roll Tennis' ads for Nike that are forever etched into my mental database. The fact that they appeared

in magazines I obsessed over seems crucial to the process of nostalgic alchemy. Still, I wonder…was it the actual shoes I craved so badly I'd have happily sold my left kidney to raise the cash, or was it Andre's peroxided mullet in the pages of *Rolling Stone* that gave me feels for life?

In the 'digital-native' era we all live in today, memories are archived very differently to the way they were last century. Gen-Ys and Millennials have curated Spotify playlists and iPhones full of images, not to mention social feeds that document their daily shoenanigans. As a Gen-Xer, I embrace technology, but it's the books, vinyl records and ephemera I've acquired over the years – along with my crates of dusty magazines – that are the font of my cultural capital. What and where would I be without the eclectic knowledge drawn from this bowerbird booty? Hmmmnh…All I know is that every time I've moved house I've had plenty of reasons to doubt my sanity and question my philosophical commitment to the cause. IRL is both a blessing and a curse.

Ten years from now, aside from the pages of *Sneaker Freaker* magazine of course, you have to wonder how sneaker culture will be remembered other than in random blog posts accessed via darkweb search bots. Magazine titles may come and go, as they have since the 1950s, but when they no longer exist as a viable commercial platform, way more will be lost than just the intoxicating smell of ink on paper. Allow me to answer my own rhetorical question. Ten years from now, at least you'll still have this epic book!

Keep your laces loose.

Woody

Sneaker Freaker
Editor-in-Chief

THERE IS NO FINISH LINE.

Sooner or later the serious runner goes through a special, very personal experience that is unknown to most people.

Some call it euphoria. Others say it's a new kind of mystical experience that propels you into an elevated state of consciousness.

A flash of joy. A sense of floating as you run.

The experience is unique to each of us, but when it happens you break through a barrier that separates you from casual runners. Forever.

And from that point on, there is no finish line.

You run for your life. You begin to be addicted to what running gives you.

We at Nike understand that feeling. There is no finish line for us either. We will never stop trying to excel, to produce running shoes that are better and better every year.

Beating the competition is relatively easy.

But beating yourself is a never ending commitment.

NIKE

World Headquarters
8285 SW Nimbus Ave., Suite 115
Beaverton, Oregon 97005.

Also available in Canada through Pacific Athletic Supplies Ltd., 2433 Beta Avenue. B.C. Canada V5C 5N1 (604) 294-5307

1979: Nike

THERE IS NO FINISH LINE

With 24-hour-a-day blog coverage and social media up the wazoo, the Sneaker Game™ is so integrated into our digital lives these days it's easy to forget that the industry is already well over 100 years old. New Balance, Brooks, Saucony and Converse date back to the early 1900s, while adidas, PUMA and Onitsuka Tiger all emerged from the ashes of the late 1940s. By the time the hairy-chested 1970s rolled around and super-tight silky shorts started appearing on running tracks all over North America, Nike, Reebok and Pony rode into town to revolutionise the way sneaker business – especially the marketing of athletes – was done.

Over the next few decades, the industry expanded exponentially. Aggressive sales tactics drove the business forward at a rapid clip. Product lines diversified to capitalise on flimsy exercise trends, while new frontiers in footwear manufacturing opened up China and Korea to the outside world. Athletes swapped their amateur status for exaggerated personas that feasted on their genetic and psychological attributes. The stakes were high and climbing fast.

While competitive marathons may have been around since the late 1800s, the spectacle of tens of thousands of runners in London, Boston and New York [p.86] was a tangible sign that jogging 26.2 masochistic miles (42.2 kilometres) was officially part of the zeitgeist. The arrival of televised sport in technicolour played a dramatic role as well, illustrated perfectly by Rod Dixon's last-gasp win in the 1983 New York City Marathon [pp.704–5]. Generating primetime coverage and front-page fame, Dixon was Saucony's first superstar athlete, motivating the brand to release a signature range of DXN runners for both men and women.

The timing of the modern sporting goods renaissance synced perfectly with the hardcore running scene's pubescent growth spurt. Specialist magazines such as *Runner's World*, which went monthly in 1973 – right about the time Phil Knight pulled the plug on Blue Ribbon Sports and started Nike in retaliation for Onitsuka Tiger scuttling his US distribution deal – are key to understanding how the industry became a billion-dollar bonanza.

JUST DO IT.

1988: Nike

Rod Dixon wasn't satisfied until we put a mattress, a window and a trampoline in these shoes.

Before Rod Dixon let us put his name on these trainers, he took them for a run. And another. And another. And he came back with a few suggestions.

First, he said, how about an EVA midsole wedge with tiny holes drilled in it. For extra cushioning on impact. We suggested the name Dixon Mattress. He said that would be just fine.

Then, Rod said, how about a feature in the backtab that would relieve nagging tension on your Achilles tendon over long runs.

We designed a collapsible backtab, suggested the name Dixon Window, and Rod said that would be just fine.

Then, he said, it sure would be nice to build in a trampoline effect that adds spring during the toeing-off phase. Perhaps, he went on, a supersoft protective insert under the metatarsal head coupled with a flatter outsole.

We agreed that would be just fine.

Now, Rod Dixon is a world class runner. A New York Marathon winner. And a tough customer to satisfy.

So when he said our Dixon Trainers were good enough to wear his name—that was good enough for us.

Just one question remains: Are they good enough for you?

Saucony
Division of Hyde Athletic Industries.
432 Columbia Street, Cambridge, Mass. 02141

1985: Saucony, Dixon Trainer, ft. Rod Dixon

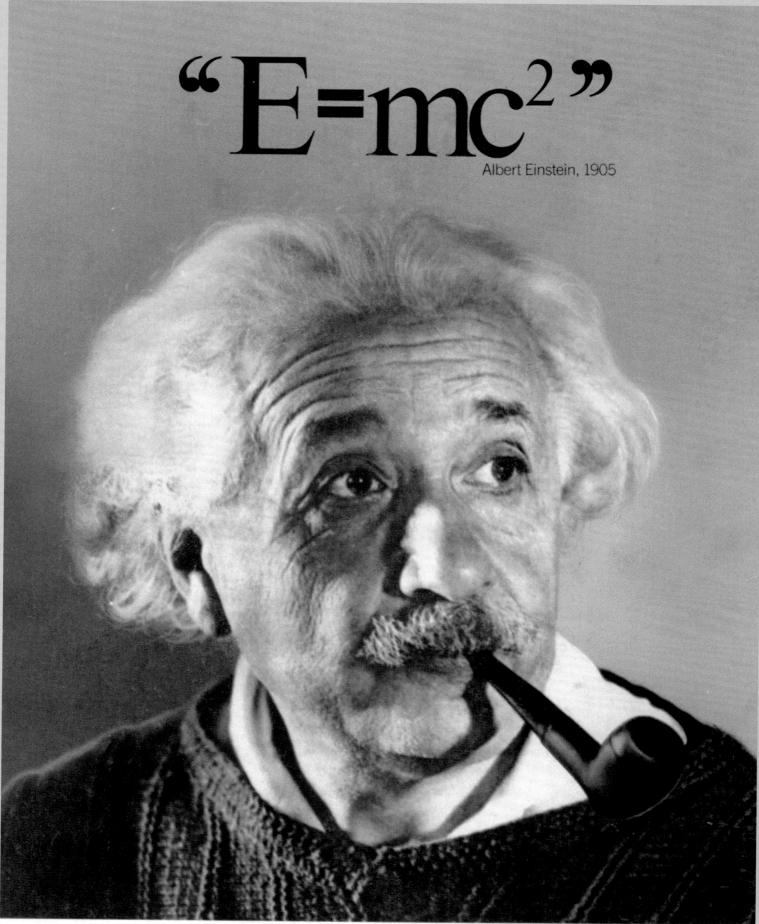

Not bad. But we've got the formula for comfort.

1980: Brooks, ft. Albert Einstein

TECHNOLOGY HYPERBOLE

Competition for the running dollar was fierce, with brands using sports scientists [p.586], psychiatrists, podiatrists [p.697] and even Hulk Hogan to advance their claims to technical superiority. Consumers may have demanded the best sneakers money could buy, but the slick sci-fi terminology used to justify the price tag was utterly bamboozling. New-fashioned buzzwords like stability [p.472], motion control [pp.672–3], shock-absorption [p.143] and pronation [p.133] elevated sneakers into highly evolved concept vehicles that categorically promised to make us all run faster, jump higher and look cooler.

Cutting-edge hyperbole weaponised the adverts. Mysterious acronyms and chronic exaggeration made for some irresistible – and highly dubious – marketing-driven cocktails. Stable Air, Visible Air, Air-Flex, Compression Plugs, Duratech, Dellinger webbing, Dynamic Cradles, Dura-Trac, D-rings, Dynacoil, Omnicoil, ENCAP, Energy Return, Flextended Saddles, Hexalite, Hytrel Tubes, Hy-Elvaloy, ghillie lacing, GEL, GRID, Morflex, Motion Control Devices, Ree-Action, Recap, Radial Decelerators, Quadra-Lacing, Propulsion Tech, Texon, VISA mesh…the list of these apparently 'revolutionary' concepts was endless.

Smoking and fitness aren't bedfellows in many marketing campaigns, but this didn't faze Brooks when they used a portrait of Albert Einstein chugging on a pipe for their 'E=mc^2' ad. PUMA also joined the sneaker space race when they released the RS Computer Shoe, along with a series of ads that extolled their virtues as 'The Intelligent Way to Run' [p.578]. Plugged into hi-tech Commodore 64 computers, the primitive software tracked the performance of runners and even measured calorie intake. The concept was decades ahead of the competition – *Nike+ from 2006, anyone?* – but the integration into the shoes was clunky and the 8-bit punching power couldn't quite deliver on their potential. Regardless, the ambitious project was indicative of the sneaker industry's relentless obsession with innovation and one-upping rivals.

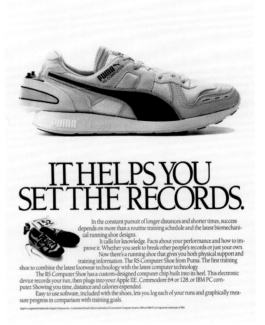

IT HELPS YOU SET THE RECORDS.

In the constant pursuit of longer distances and shorter times, success depends on more than a routine training schedule and the latest biomechanical running shoe designs.

It calls for knowledge. Facts about your performance and how to improve it. Whether you seek to break other people's records or just your own. Now there's a running shoe that gives you both physical support and training information. The RS Computer Shoe from Puma. The first training shoe to combine the latest footwear technology with the latest computer technology.

The RS Computer Shoe has a custom-designed computer chip built into its heel. This electronic device records your run, then plugs into your Apple IIE, Commodore 64 or 128, or IBM PC computer. Showing you time, distance and calories expended.

Easy to use software, included with the shoes, lets you log each of your runs and graphically measure progress in comparison with training goals.

1986: PUMA, RS Computer Shoe

IT ALSO HELPS YOU KEEP THEM.

The RS Computer Shoe is a technological breakthrough even without its computer. It incorporates numerous biomechanical innovations including Puma's unique Multiplex IV Midsole. A new four-part wedge combines lightweight polyurethane with rigid foam stabilizers and an EVA Impact Sector. Collectively reducing the weight of the shoe while achieving durability and shock attenuation far superior to conventional midsole technology.

The RS Computer Shoe from Puma. When it comes to running shoe technology, it holds the record.

PUMA
OUR WORD FOR QUALITY

The Computer Shoe comes with easy-to-use software that plots time, distance and calories expended, plus makes graphic comparisons to past performances and training goals.

1986: PUMA, RS Computer Shoe

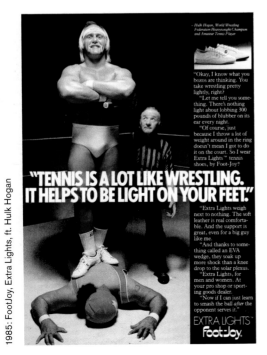

– Hulk Hogan, World Wrestling Federation Heavyweight Champion and Amateur Tennis Player

"TENNIS IS A LOT LIKE WRESTLING. IT HELPS TO BE LIGHT ON YOUR FEET."

"Okay, I know what you bozos are thinking. You take wrestling pretty lightly, right?

"Let me tell you something. There's nothing light about lobbing 300 pounds of blubber on its ear every night.

"Of course, just because I throw a lot of weight around in the ring doesn't mean I got to do it on the court. So I wear Extra Lights" tennis shoes, from Foot-Joy.

"Extra Lights weigh next to nothing. The soft leather is real comfortable. And the support is great, even for a big guy like me.

"And thanks to something called an EVA wedge, they soak up more shock than a knee drop to the solar plexus.

"Extra Lights, for men and women. At your pro shop or sporting goods dealer.

"Now if I can just learn to smash the ball *after* the opponent serves it."

EXTRA LIGHTS"
footJoy.

1985: FootJoy, Extra Lights, ft. Hulk Hogan

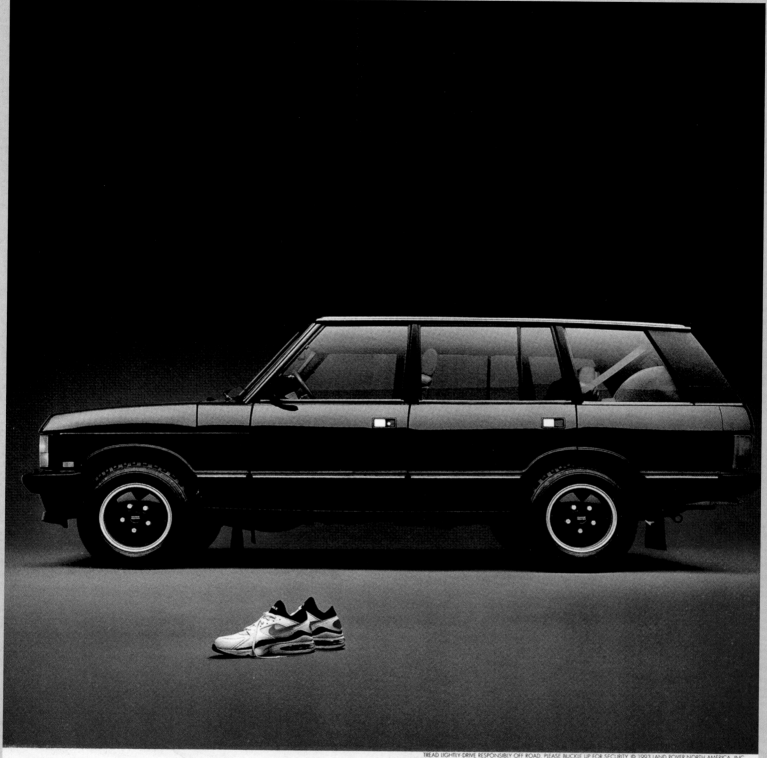

Now there's an air suspension system for every size budget.

The very technology that created a revolution in running shoes is now creating one in Range Rovers.

It's called air suspension.

And beneath the rugged chassis and opulent interior of the 1993 Range Rover County LWB, you'll find it doing things coil spring suspensions just can't do.

Like monitoring the vehicle's height 100 times per second. Muting road and cabin noise to substantially lower levels. Providing a smoother ride on a variety of surfaces. As well as five different height settings to suit a variety of conditions. It can even be lowered enough to make getting in and out easier.

Of course there are also over 80 additional improvements to speak of.

Like a new 4.2 liter V-8 engine. Electronic traction control. And a 108" wheelbase that makes this the roomiest Range Rover ever built.

Why not try one on for size by calling 1-800-FINE 4WD for the nearest dealer?

Granted, these new County LWBs are hardly inexpensive.

But considering how sturdy and comfortable they are, we think you'll end up wanting a pair.

RANGE ROVER

1993: Nike, Air Max 93

AUTO-EROTIC

American muscle cars and exotic European supercars – just like athletic sneakers – are intuitively designed to look speedy even when they're standing still, so it's no surprise the link was made explicit in several memorable campaigns. From Magic Johnson's enormous black Cadillac to Dan Marino's cocaine-hued Testarossa [p.536], high-performance vehicles and powerful athletes were an irresistible club sandwich often served up with a tasty side order of testosterone.

As detailed on the previous pages, the footwear industry has long perfected the art of lionising sneakers as miraculous mechanical objects loaded with advanced 'technology'. Cushioning concepts like Nike Shox [p.505] and L.A. Gear's 'airbags' [p.250] were directly car related, while materials sourced from the auto industry such as Kevlar and carbon fibre [p.242] added pseudo-science credence to tech sheets.

That nexus reached an unlikely advertising apogee in 1993 when Range Rover incorporated Nike's new Air Max runner into the promotion of their top-of-the-line County LWB model. The copy could have come straight from the new Apple Mac Performas whizzing away at Nike's advertising agency Wieden+Kennedy, though it did lack a touch of their trademark pizzazz. 'The very technology that created a revolution in running shoes is now creating one in Range Rovers. It's called air suspension,' reads the first line of the ad. Phil Knight must have been chuffed with the comparison between his $75 sneakers and the luxurious English off-roader.

Eagle-eyed fans of the *Last Dance* documentary may have noticed Michael Jordan driving an identical blacked-out Range Rover – along with a coven of Corvettes, S-Class Mercedes and a white slant-nose Porsche 911 Turbo – to Bulls practice in the 1990s. MJ was also famous for his beloved Ferrari 550 Maranello, which provided the inspiration for Tinker Hatfield's Air Jordan 14 sketch in 1998. Vehicular design references were no guarantee of footwear gold, however, as Kobe Bryant found out when he signed with adidas in the late 1990s. His signature model based on the curvaceous silver Audi TT [p.52] was so downright fugly and unloved he decided to switch lanes and join Nike soon afterwards. But that's a whole other story!

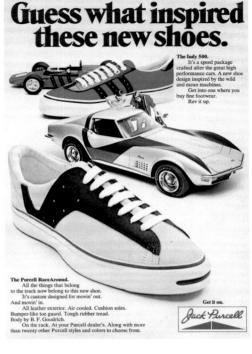

1974: Converse, Purcell RaceAround and Indy 500

1990: Converse, ft. Magic Johnson

MAN VS MACHINE.

1979: Nike

Serious Runners Don't Put On Airs.

They put on ASICS. And count on ASICS' GEL for serious shock absorption.

Want proof?

Run down to a local 10K race or marathon, and take a look at the crowd. Chances are you're going to find an abundance of ASICS running shoes, from the new GT-Xpress to the GEL-110. Worn by runners who rack up the miles. And depend on ASICS' GEL for excellent protection against injury.

If you're not convinced by the sheer number of

Encapsulated ASICS' GEL effectively disperses vertical energy into a horizontal plane. These special pads provide excellent shock absorption and make for a more comfortable stride.

runners wearing ASICS, talk to some of them. You'll hear more than you ever need to know about orthotic sock liners, torsional rigidity, compression molded EVA midsoles, and of course the unique properties of GEL.

We're sure that after you've picked their brain, you'll pick their brand.

GT-Xpress

Women's GEL-110 Men's GEL-110 Women's GEL-Runner 90 Men's GEL-Runner 90

For the ASICS dealer nearest you, call 1-800-866-ASICS.

asics.
Don't Just Do It. Do It Better.

1990: ASICS, GT-Xpress, GEL-110 and GEL-Runner 90

Why our thick gel is better than their thin air.
Introducing Tiger's new GT II™ with ASICS' GEL™.

When we looked at what many are calling state-of-the-art running shoes, what we found was a lot of thin air.

Air, we're told, is an excellent shock absorber. Yet our research tells us an alarming 25% of all running-related injuries still stem from insufficient shock absorption. So we figured you're aching for an idea that is brighter than air. An advancement with real substance.

We call it ASICS' GEL™—developed from a new class of engineering compounds pioneered by Geltec, Ltd. This viscous, silicone-based gel has impressive energy-absorption properties. Our biomechanical tests show the new GT II™ with ASICS' GEL dispels up to 28% more impact than the Nike Air® Epic. In a 10K run,

Anatomically located at fore and rearfoot reflex points, ASICS Gel pads allow our new GT II to absorb significantly more impact than the leading "air" shoe.

that could spare your body 1.2 million pounds of punishing force.

The GT II also gives you a longer run for your money. Unlike air chambers, our gel pads rest above the EVA midsole where they help delay midsole deterioration. Generous Ecsaine reinforcements

give the upper a longer life. And the tri-density outsole with black carbon rubber also extends wear.

And so you won't sacrifice stability for comfort or wear, the GT II delivers great strides in motion control. Our integrated heel pillar, sculpted orthotic insole, extended heel counter and stabilizing upper straps successfully reduce damaging overpronation.

Tiger's new GT II with ASICS' GEL. Revolutionary technology for runners who are beyond putting on airs. To find the Tiger Dealer nearest you call 1-800-447-4700.

Nike Air® is a registered trademark of Nike, Inc.

asics TIGER.

1986: ASICS, GT II

THE NEW 620

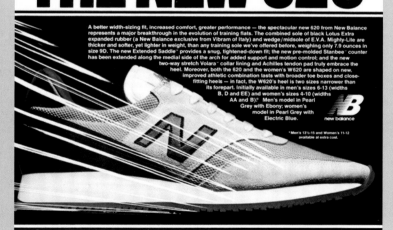

A better width-sizing fit, increased comfort, greater performance — the spectacular new 620 from New Balance represents a major breakthrough in the evolution of training flats. The combined sole of black Lotus Extra expanded rubber (a New Balance exclusive from Vibram of Italy) and wedge/midsole of E.V.A. Mighty-Lite are thicker and softer, yet lighter in weight, than any training sole we've offered before, weighing only 7.9 ounces in size 9D. The new Extended Saddle™ provides a snug, tightened-down fit; the new pre-molded Stanbee™ counter has been extended along the medial side of the arch for added support and motion control; and the new two-way stretch Volara™ collar lining and Achilles tendon pad truly embrace the heel. Moreover, both the 620 and the women's W620 are shaped on new, improved athletic combination lasts with broader toe boxes and close-fitting heels — in fact, the W620's heel is two sizes narrower than its forepart. Initially available in men's sizes 6-13 (widths B, D and EE) and women's sizes 4-10 (widths AA and B).* Men's model in Pearl Grey with Ebony; women's model in Pearl Grey with Electric Blue.

NB new balance

Men's 13's-15 and Women's 11-12 available at extra cost.

LIGHTER THAN AIR*

New Balance Athletic Shoe, Inc., 38 Everett Street, Boston, Massachusetts 02134 *lighter than competitors' shoes using the air bag or air inner soles

1979: New Balance, 620

Don't Just Do It. Duet Better.

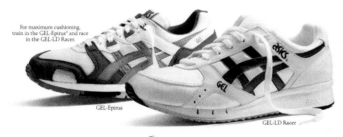

For maximum cushioning, train in the GEL-Epirus™ and race in the GEL-LD Racer.™

GEL-Epirus

GEL-LD Racer

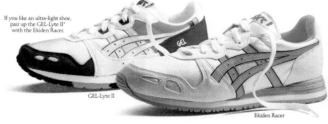

If you like an ultra-light shoe, pair up the GEL-Lyte II™ with the Ekiden Racer.™

GEL-Lyte II

Ekiden Racer

Some days, it's training. Solid, steady, long hauls. Race days, it's crank and burn. Faster pace, going for a personal best.

That's why ASICS has shoes tuned to maximize your performance and protection in each.

With the incredible shock absorption of ASICS' GEL! And designs adjusted to bring

state of the art cushioning, support, stability and flexibility to both training and racing.

So instead of one pair for everything, each pair can do what it does best.

Because when you're training and racing in shoes with technology this advanced, you won't just do it.

You'll duet better.

Encapsulated ASICS' GEL effectively absorbs shock by dispersing vertical energy into a horizontal plane.

asics.
Don't Just Do It. Do It Better.

Official footwear and apparel supplier to the New York City Marathon.
*Available in women's models. ¹Available in most models. For information please write ASICS Tiger Corp., Dept. R, P.O. Box 15352, Santa Ana, CA 92705.

1989: ASICS, GEL Epirus, GEL-LD Racer, GEL Lyte II and Ekiden Racer

AIR APPARENT

As new exercise and fashion trends arrived, brands were forced to change strategy to stay one step ahead of the competition. One particular moment of innovation disrupted the industry like no other. Nike may have launched M Frank Rudy's cushioning concept in the soles of the Tailwind in 1978, but once Tinker Hatfield made the inflatable Air bags visible in his first Air Max design [pp.302–3], Nike's fortunes changed overnight.

The futuristic future franchise was championed by a suitably slick advertising campaign. Licensing 'Revolution' by the Beatles as the TV commercial's backing track was a controversial move that made headlines [p.308], but it's the print ads that really established the mythology of Air. 'Shock Treatment for the Road', 'Air Max. Air Even More Max' [p.322] and 'It's a Revolution' [p.304] are all classics in the oeuvre. Another highlight is the esoteric Air 180 campaign [pp.318–21] that featured the work of Ralph Steadman, an illustrator previously known for his affiliation with the hell-raising author Hunter S Thompson.

It's surprising – and unintentionally hilarious today – to witness brands going toe-to-toe in this bygone era, taunting each other with schoolyard smack talk. ASICS hit back hard at Nike with

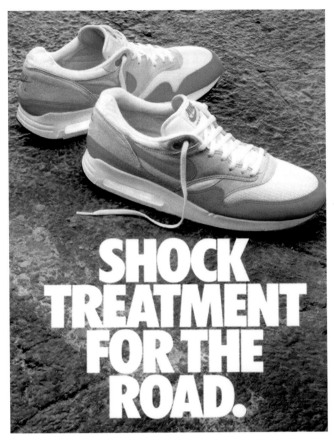

SHOCK TREATMENT FOR THE ROAD.

1987: Nike, Air Max

the reactionary 'Serious Runners Don't Put on Airs'. The brand's academic manifesto that explained 'Why Our Thick Gel is Better Than Their Thin Air' was a longwinded contribution to the canon. Continuing the battle theme, ASICS announced their new GEL-Trainer with the slogan 'Just Doing It Doesn't Do It' [pp.122–3], turning attempted positivity into double-negative territory. 'Don't Just Do It. Duet Better' also championed the GEL series.

New Balance also chimed in on the Air-bashing action, top-billing their 620 model as 'Lighter Than Air'. Another campaign trumpeted the fact that New Balance's product development costs were 'Six Times Greater Than a Sales and Marketing Budget' [p.291], a cheeky jibe at Nike's reputation for glossy style over scientific substance.

The 'Air Vs. Air Conditioning' slogan was yet another in a long line of uppercuts, but featuring the Nike Windrunner above the ASICS GT-COOL model is definitely one of the most jarring revelations in these pages [p.149]. Known as 'comparative advertising', the practice is not considered illegal these days, though the use of trademarks such as the Swoosh is definitely problematic. Regardless, this type of 'knocking copy' does illuminate the cut-throat nature of the industry at that time. As the ASICS text signed off, 'Pretty cool huh?'

1997: Reebok, DMX Run, ft. J Spencer White

TEST THE SHOE THAT BEAT NIKE AIR MAX!

© 1997 Reebok International Ltd. All Rights Reserved. REEBOK and the Vector Logo (⟫) are registered trademarks and DMX is a trademark of Reebok International.

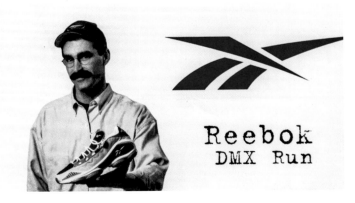

Reebok
DMX Run

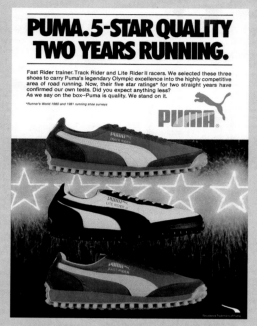

1980: PUMA, Track Rider, Lite Rider II and Fast Rider

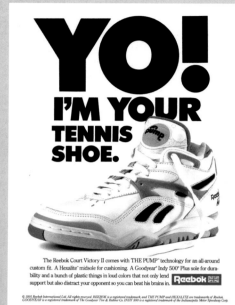

1991: Reebok, Pump Court Victory II

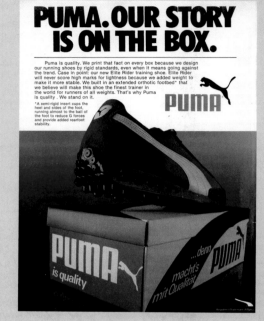

1980: PUMA, Elite Rider

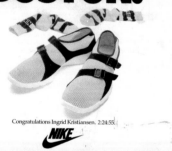
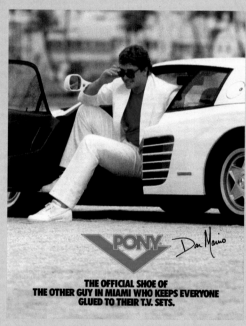

1985: Nike, Sock Racer

1987: PONY, ft. Dan Marino

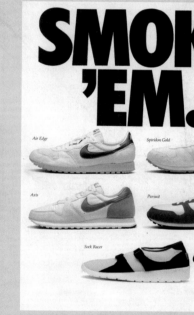

1986: Nike, Air Edge, Spiridon Gold, Axis, Pursuit and Sock Racer

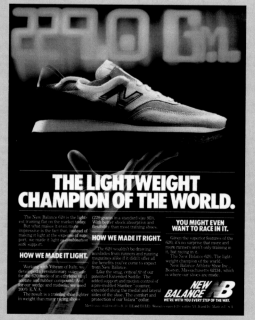
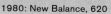

1980: New Balance, 620

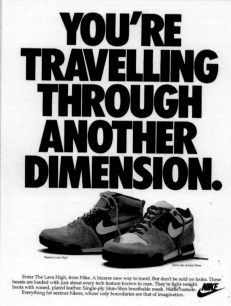

1988: Nike, Lava High and Son of Lava Dome

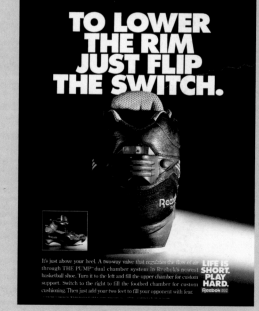

1991: Reebok, Pump

BACK TO THE FUTURA

1989: Nike, Air Pressure

Designed by Paul Renner and released in 1927, the sans-serif Futura typeface was inspired by the teachings of the Bauhaus, an art, architecture and design school founded in Germany by Walter Gropius in 1919. A condensed version of the font arrived a few years later and there are now dozens of different weights and cuts available. The Futura name was no accident. Renner rejected traditional serif typography and conceived his font design as a modern, clean, direct and uncomplicated communication tool.

In July 1969, the Apollo 11 space mission – the first to land a man on the moon – planted a commemorative plaque. As a sign of the times, NASA designers chose Futura for the 'We came in peace for all mankind' lettering. That might help explain why the font was marketed in North America as 'the typeface of today and tomorrow'. Another fun fact: Futura was also Stanley Kubrick's favourite!

Futura is still instantly recognisable 50 years later thanks to myriad corporate logos. The cockpit controls in Boeing planes and Mercedes-Benz instrument panels both use Futura. The oblique cut was used by conceptual artist Barbara Kruger in her feminist critiques of consumer culture, which was in turn referenced by Supreme, the New York skate company.

Futura in all its forms was ubiquitous in sneaker advertising throughout the 1980s and 90s, with PONY, PRO-Keds, Reebok, PUMA and nearly every brand (except adidas) using the font to get their message across. It's unclear which brand used it first, but based on appearances in these pages alone, we're prepared to anoint Nike as Futura's moral custodian. From the earliest sighting of 'Just Do It' in 1988 to taglines such as 'No Ph.D. Required' and 'Smoke 'Em', Futura Bold Condensed is synonymous with the Swoosh and is still widely utilised by Nike across apparel design, social media communication and advertising. If there's such a thing as a sneaker font, it's gotta be Futura!

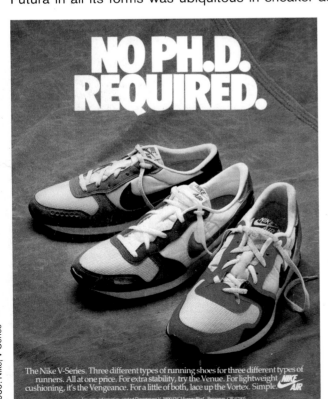

NO PH.D. REQUIRED.

The Nike V-Series. Three different types of running shoes for three different types of runners. All at one price. For extra stability, try the Venue. For lightweight cushioning, it's the Vengeance. For a little of both, lace up the Vortex. Simple. NIKE AIR

For more information, contact Department V, 3900 SW Murray Blvd., Beaverton, OR 97005.

1985: Nike, V-Series

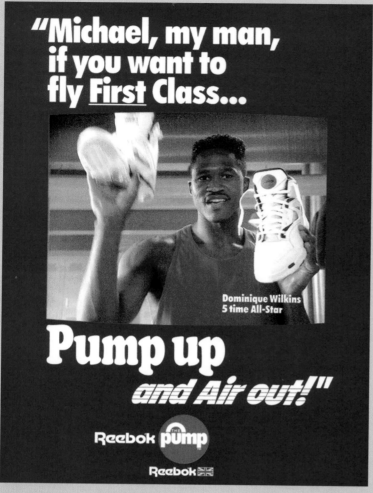

1991: Reebok, Pump, ft. Dominique Wilkins

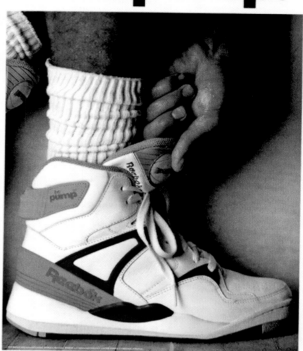

1989: Reebok, Pump

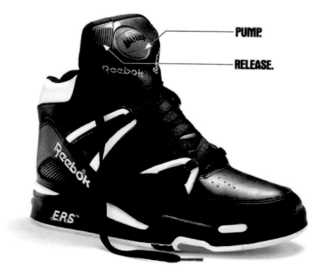

1990: Reebok, Omni Zone

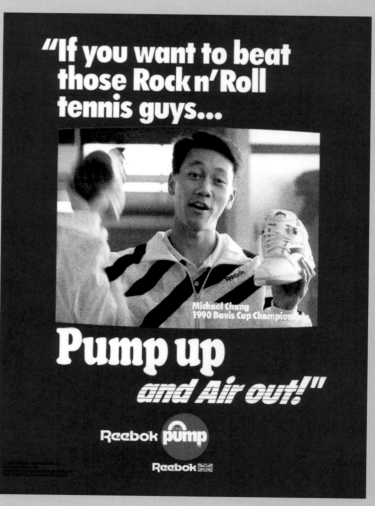

1991: Reebok, Court Victory

Pump it up here.

Reebok Basketball

PUMP IT UP

With a feisty attitude financed by their domination of the aerobics and fitness market, the launch of Reebok's Pump technology in 1989 inflated their bottom line to epic proportions. Kids just couldn't get enough of the squishy orange balls on the tongues of their basketball sneakers.

The custom-fit concept was perfect for Reebok's pro athletes who clearly enjoyed delivering trash-talk. Dominique Wilkins goaded the GOAT with 'Michael, My Man, if You Want to Fly First Class… Pump Up and Air Out!'. A few years later, Shaquille O'Neal's 'Shaq Attaq' pro model [pp.660–1] was launched using the flattened face of an opponent, crushed by '300 pounds of rim-wrecking force'. Aussie golfer Greg 'The Great White Shark' Norman also had his own signature pair of Pump-infused spikes. Reebok's tennis team was also acutely aware of Nike's sloganeering power, picturing their metronomic hero Michael Chang under an Agassi-baiting caption. 'If You Want to Beat Those Rock n' Roll Tennis Guys… Pump Up and Air Out!'. The kick-ass attitude must have been inspirational for the sales team on the frontline. As Reebok promised in another of their memorable taglines, 'Life is Short. Play Hard' [p.644]. They did.

One curio from this golden era is *Drac's Night Out*, a NES video game from 1991 [pp.20–1]. Rocking huge Reebok Twilight Zones on his feet, the Count used his powers of hypnotism to nullify mobs of angry villagers before sucking their blood dry and turning into a bat. Reebok's 'subtle' sponsorship was reinforced by the insertion of Pump 'power-ups' in the game, which when gobbled up gave our titular vampire a useful shot of 'blood-pumping' turbo power. Although *Drac's Night Out* was never officially released, the original CD-ROM has been bootlegged and is easily found online today, where it remains a cult Nintendo classic. This surely must rank as one of the earliest marketing cross-overs between gaming and sneakers.

The Pump.™
A mother of
an invention.

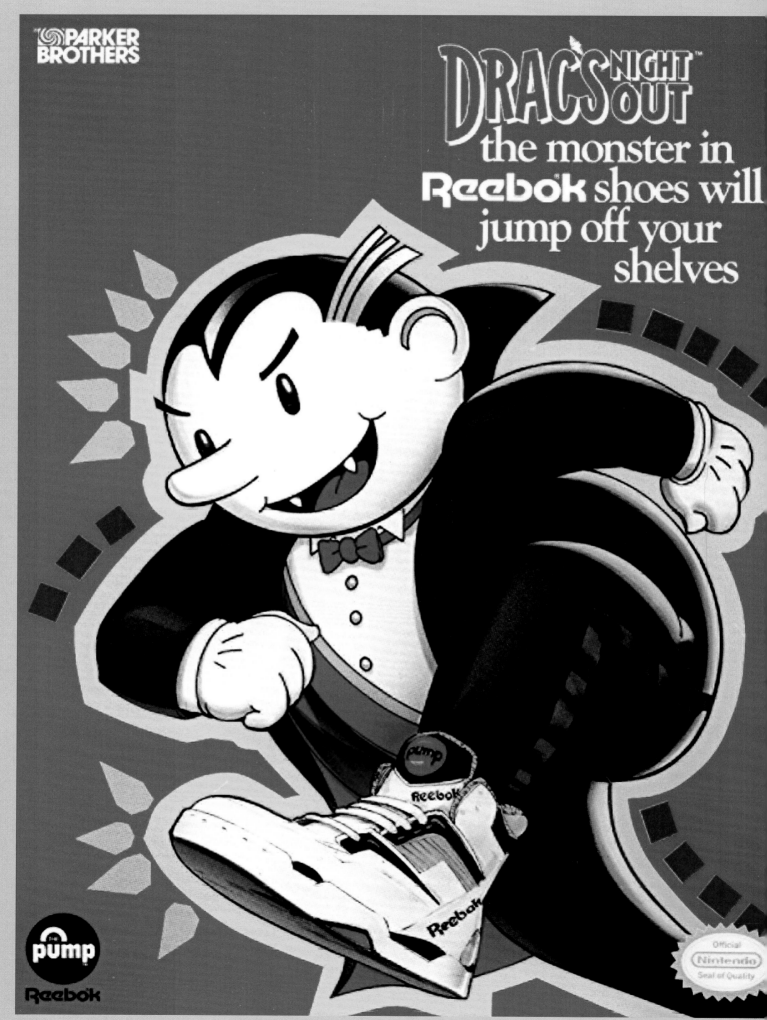

1991: Reebok, Twilight Zone Pump

DRAC'S NIGHT OUT,™ the blood-pumping game with the Reebok® connection!

The DRAC'S NIGHT OUT™ game is packed with sales power! It's the first Nintendo Entertainment System® video game to feature a licensed product (THE PUMP™ athletic shoes by Reebok®) as part of gameplay. Packed with excitement as our teenage Drac must capture lovely Maiden Mina and suck her blood before sunrise.

Video gameplay so clever it's scary!

Innovative Gameplay: You play as blood-thirsty Drac, trapping victims with unique chain-reaction contraptions.

256-screen, 3-D Village: Drac must find lovely Mina–and suck her blood!

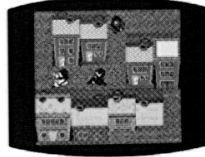

Action/Adventure: Drac must use strategy and deductive reasoning, find the clues he needs–and avoid being zapped by mobs.

The Parker Brothers power pack!

Powerful theme:
- Dracula theme provides instant recognition; several new movies in 1991 will feature Dracula
- Drac wears hot athletic shoes, THE PUMP™ by Reebok®, that give him special powers

Powerful gameplay:
- Unique chain-reaction gameplay reminiscent of Rube Goldberg
- THE PUMP™ athletic shoes pump up Drac to make him jump higher, run faster, spin and even squash people
- Action and adventure combined to make your excitement soar and your blood run cold

Powerful promotion:
- Major joint promotion with Reebok including:
- $5 rebate for THE PUMP™ by Reebok®
- Cross-media tagging/promotions
- Major POP promotion through athletic shoe store channels
- High-impact packaging
- A monster media program aimed at the heart of the NES market

PACKING SPECS: No. 4016 UPC 0-73000-0416-1 • Item: 7 x 5 x 1, 6.4 ozs. • Pack: 24 • Master Carton: 13 1/2 x 12 x 9, .84 cu. ft., 12.5 lbs. • Shippable Inner Carton: 7 1/2 x 6 1/2 x 5 1/2 • Pack: 6, 3 lbs.

DRAC'S NIGHT OUT and THE GAME THAT PUMPS YOU UP are Parker Brothers' trademarks for its Count Dracula video game equipment. NINTENDO and NINTENDO ENTERTAINMENT SYSTEM are trademarks of Nintendo of America Inc. REEBOK is a registered trademark and THE PUMP is a trademark of Reebok International. This game is licensed by Nintendo ® for play on the Nintendo Entertainment System ®. Please note that indicated advertising and promotion represent current planning. These plans may be changed at Parker Brothers' discretion as business requirements dictate. © 1991 Parker Brothers, Division of Tonka Corporation, Beverly, MA 01915. Telephone: Customer Service, 1-800-344-4050. Printed in U.S.A.

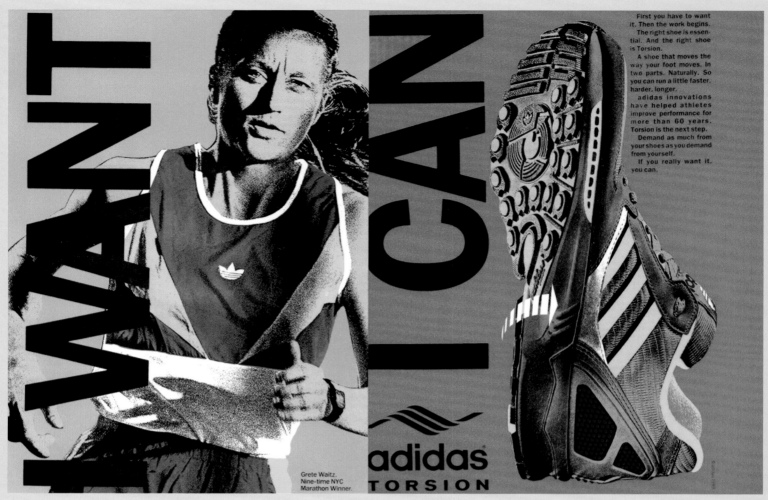

1989: adidas, Torsion, ft. Grete Waitz

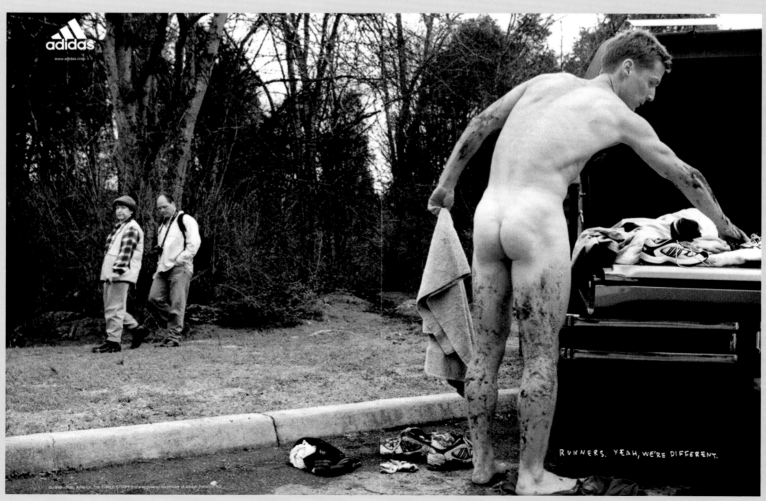

1999: adidas

THE BEST OF ADIDAS

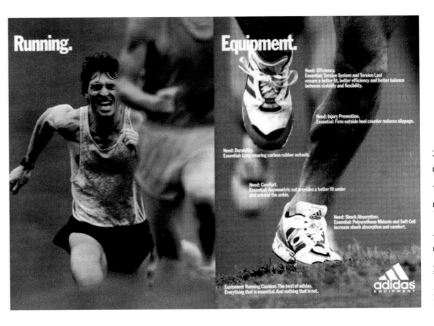

1991: adidas, Equipment Running Cushion

While adidas may have been the biggest sports brand in the world throughout the 1950s, 60s and 70s, they don't seem to have invested as heavily in print advertising as their American adversaries. The ads they did release were much more reserved and less prone to chronic exaggeration and bullshit.

In 1985, adidas acknowledged their innate sobriety with the 'We're Running Serious' [pp.96–97] series that promoted the ZX500 and Helsinki models. The revered Equipment range [pp.54–69] from the early 1990s was also presented within a very matter-of-fact context. 'The best of adidas' [p.64] was emotionally as dry as toast, but it was forthright and the takeaway communication was simple and effective. The phenomenal photography of runners slugging it out in the rain drove the EQT message home.

Perhaps it's a reflection of their conservative German heritage – or their advertising agency's lack of chutzpah – but humour was pretty much non-existent at adidas until the late 1990s when the 'Runners. Yeah, We're Different' [pp.100–5] campaign arrived. With muddy asses and snotty joggers cocking a snook at running's staid image, this still-stylish series would make for killer viral video content today.

The tightest visual moment for adidas is undoubtedly the 'I Want. I Can' series [pp.110–15], which used marathon legend Grete Waitz along with anonymous tennis, squash and basketball athletes to hype the Torsion range. With a nod to Andy Warhol, the pop colours still cut a particularly dashing image three decades later. Curiously, the fine print included a sign-off that was polite and a little downbeat; 'If you really want it, you can' [p.111] was a somewhat limp riposte to Nike's world-famous 'Just Do It' [p.463].

The experimental 'Feet You Wear' [pp.70–81] era in the mid-1990s inspired a campaign that emphasised laid-back cool over right-up-in-your-grille sporting credentials. Monotone athlete images were superimposed over ankles and heels, while the photocopier texture and scribbly text were both hallmarks of David Carson's trailblazing deconstruction-style art direction in *Ray Gun* magazine.

1985: adidas, Starlite and Web, the Web System

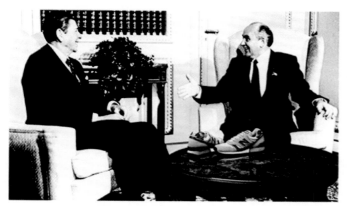

IN THE INTEREST OF A MORE STABLE WORLD, NEW BALANCE HAS BROUGHT SOMETHING SPECIAL TO THE TABLE.

Once again, New Balance is displaying its S.D.I. No, that doesn't stand for Strategic Defense Initiative. It stands for Stability Development Instincts.

We've never demonstrated them more convincingly.

Presenting the New Balance 675.

Of the many features that make it one of the world's more stable running shoes, the most noteworthy is a remarkable new midsole made in our exclusive V-Channel design. The medial and lateral sides of the rearfoot of the midsole are made of a firmer C-Cap® compression-molded EVA to limit overpronation and oversupination. At the same time, the softer C-Cap EVA in the center of the heel provides added cushioning.

The 675 also boasts a newly designed insert unlike any we've ever offered. Double-density EVA/polyethylene foam in the forefoot provides superior cushioning and memory.

But the big news is the 675's firmer EVA polyethylene horseshoe in the rearfoot, which provides improved stability during heel strike.

To reduce excessive pronation and supination, the 675 employs a thermoplastic urethane stability device that wraps around the heel. And the 675's highly durable, high-grade carbon rubber outsole provides excellent traction and exceptional stability from heel strike through toe-off.

Achieving stability in the world may be out of your hands. Fortunately, achieving stability when you run is well within the grasp of your feet.

Like most New Balance running shoes, the 675 comes in a variety of widths—B, D, EE, EEEE—for a more perfect fit.

new balance®

1987: New Balance, 675, ft. Ronald Reagan and Mikhail Gorbachev

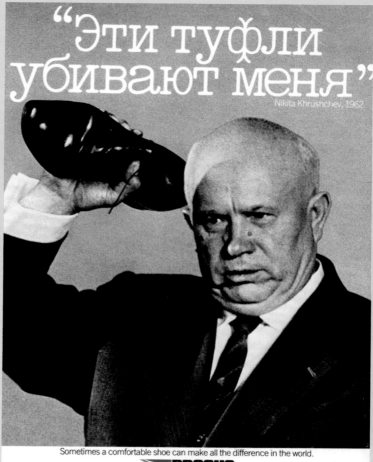

"Эти туфли убивают меня"
Nikita Khrushchev, 1962

Sometimes a comfortable shoe can make all the difference in the world.

BROOKS

1980: Brooks, ft. Nikita Khrushchev

NIKE

HE CAN'T RUN IN '88. BUT YOU CAN.

The Constitution prevents the President from running again.

But nothing's keeping you from running. Because this year, there are more road races to choose from than ever before.

At Nike, we should know. We sponsor hundreds of races every year, including many of Runner's World's top-ranked events. Everything from the Cascade Run Off to the Freeze Yer Buns Run in Twisp, Washington. Seriously.

For a list of the races we sponsor, just drop us a line: Nike Road Racing Dept., 9000 Nimbus Dr., Beaverton, OR 97005.

So if you're looking for a little competition, we're looking for a few runners.

And guess what? You're nominated.

1988: Nike, ft. Ronald Reagan

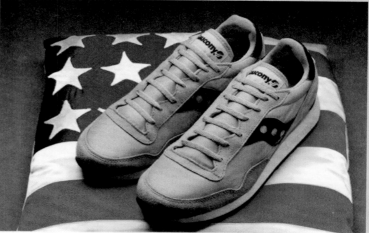

America the Comfortable.

From dawn's early light to the twilight's last gleaming, these are the most comfortable shoes you can run in.

We call them America.

And we build them to be worthy of the name. In a country full of roads that weren't created equal.

To soak up shock on the cobblestones of Boston, we refined a piece of Saucony ingenuity known as the Dutchman.

It's a pad of soft Hytrel plastic which combines with our MEVA midsole to give you a supersoft running system that's exceptionally stable.

For all-terrain traction, from the sands of Santa Barbara to the canyons of Manhattan, we designed a durable, studded outsole of carbon rubber.

And to beat the steamy heat of the muggy Midwest, we let the lightweight uppers breathe, through a tough new mesh.

We, the people who make Saucony shoes, believe we have created a more perfect union of high technology and good old-fashioned comfort.

One more thing.

You don't have to be rich to live in these Americas.

Saucony

1985: Saucony, America

POLITICAL PEDANTRY

As the old saying goes, 'When you're on a good thing stick to it!' and New Balance's trademark combo of a punchy heading above an acre of chatty copy was a winning formula that served them well for several decades. As a result, they have a surprisingly solid catalogue and a consistently maverick point of view that is noticeably less conservative than the family-owned and -operated company itself. Classic ads such as 'Why There's No Such Thing as the Perfect Running Shoe' [pp.264–5] were infused with healthy inner confidence. 'On a Scale of 1000, This Shoe is a 990' [pp.272–3] and 'Mortgage the House' [p.282] also come to mind, with the latter explaining that the 1300 model 'costs more because it offers more', while 'Some Guys Eat Sneakers' [p.283] was another inventive approach to the art of selling sneakers.

Oddly, politicians also feature several times in New Balance ads from the 1980s, with Ronald Reagan and Mikhail Gorbachev promoting 'stability' in a somewhat oblique reference to the 675 runner. Only Brooks dared fight the Cold War in the trenches alongside New Balance, with Nikita Khrushchev featuring in a bizarre ad from 1980. Beneath Russian script, which translates as 'These Shoes Will Kill Me!', the image references Khrushchev's speech at the United Nations in 1960 when he infamously pounded the lectern with his shoe to make a point.

Given New Balance's ongoing commitment to manufacturing footwear in Lawrence, Massachusetts, the patriotic intent no doubt reflected the brand's 'Made in the USA' ethos. Saucony was another brand that embraced homegrown pride as a fundamental principle. While 'America the Comfortable' referenced their blue-collar running shoe by the same name, it could have also applied to their factory in Bangor, Maine, where they made shoes right up until the late 1990s. Following a consumer complaint in the mid-1990s, the Federal Trade Commission cracked down on the definitions of 'Made in America' and 'Assembled in America'. As a result of the high-stakes legal dramas that ensued, Saucony acquiesced, closing their last remaining factory and shifting sneaker production to Asia. More than 300 American workers lost their jobs, a bitter by-product of political pedantry. Today, New Balance is the only brand that still 'makes or assembles' footwear in the US, with five facilities across Maine and Massachusetts producing more than four million pairs of shoes each year.

If we can make great athletic shoes in America, why can't our competition?

1992: New Balance, 997

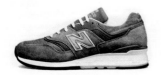

1992: New Balance, 997

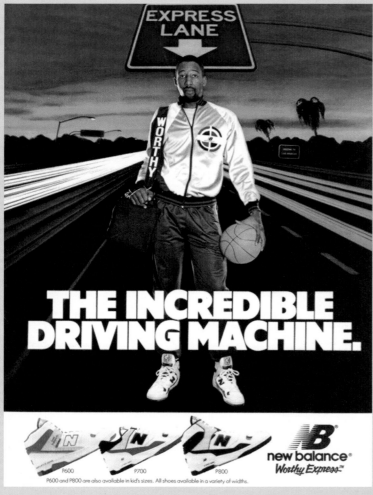

THE INCREDIBLE DRIVING MACHINE.

new balance®
Worthy Express™

P600 P700 P800

P600 and P800 are also available in kid's sizes. All shoes available in a variety of widths.

1987: New Balance, Worthy Express P600, P700 and P800, ft. James Worthy

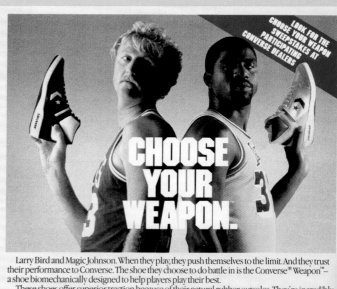

CHOOSE YOUR WEAPON.

LOOK FOR THE
CHOOSE YOUR WEAPON
SWEEPSTAKES AT
PARTICIPATING
CONVERSE DEALERS

Larry Bird and Magic Johnson. When they play, they push themselves to the limit. And they trust their performance to Converse. The shoe they choose to do battle in is the Converse® Weapon™ – a shoe biomechanically designed to help players play their best.

These shoes offer superior traction because of their natural rubber outsoles. They're incredibly cushioned as well, due to the Center of Pressure outsole and a shock absorbing EVA midsole. And for the strong ankle support that Bird, Magic and every other ballplayer needs, there's the unique Y-Bar Ankle Support System.

Besides all these features, the Converse Weapon has a comfortable, removable insole and an extra padded collar that combines with the Y-Bar System for enhanced ankle support and comfort.

Bird and Magic have chosen their weapons. Now choose yours.

THE CONVERSE® WEAPONS™

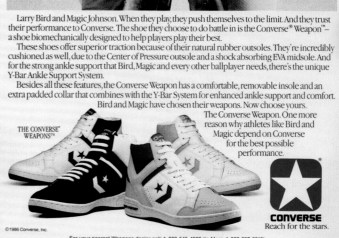

The Converse Weapon. One more reason why athletes like Bird and Magic depend on Converse for the best possible performance.

CONVERSE
Reach for the stars.

©1986 Converse, Inc.

For your nearest Weapons dealer call: 1-800-545-4323 (in Mass. 1-800-637-5215)

1986: Converse, Weapon, ft. Larry Bird and Magic Johnson

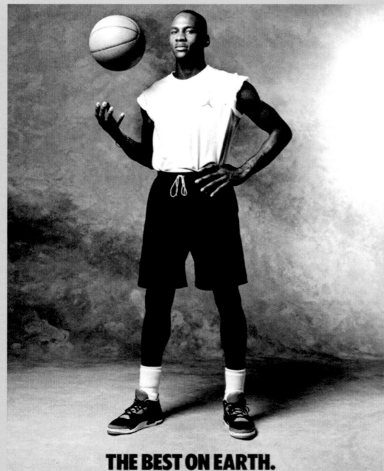

THE BEST ON EARTH.
Air Jordan from Nike.

1988: Nike, Air Jordan III, ft. Michael Jordan and Mars Blackmon

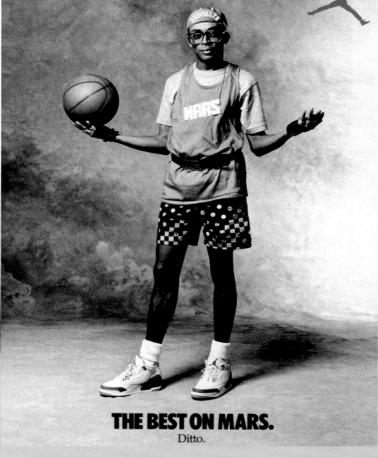

THE BEST ON MARS.
Ditto.

BALLERS

Basketball is the perfect showcase for power athletes and their telegenic high-top sneakers. As the NBA surged in popularity in the 1970s, Walt 'Clyde' Frazier [p.562] and Julius 'Dr J' Erving [p.177] wowed crowds and TV viewers with their showmanship and charismatic personas. Over at Converse, the 1980s and 90s were fertile periods for the basketball division. Magic Johnson was their alpha baller, as evidenced by the 'Chillin'' and 'Thrillin'' ads [pp.186–7], the former of which shows MJ (the other one!) stooping on the trunk of his Cadillac. Isiah Thomas, Kevin McHale and Larry Bird rounded out a serious-minded squad that united under the 'Weapon' banner [p.181].

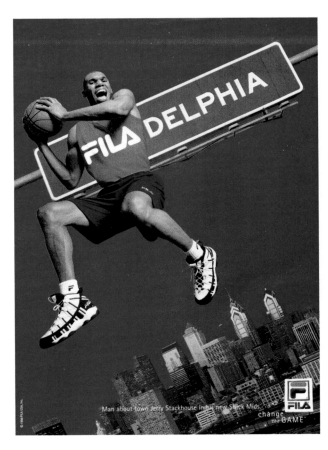

1996: FILA, Stack Mid, ft. Jerry Stackhouse

Nike Basketball is built on the spirit of 'Force' [pp.356–7], which was exemplified by 'Sir Charles' Barkley's snarly toughness [p.374]. However, it's impossible to overlook Michael Jordan in any basketball discussion. Spike Lee's 'Mars Blackmon' character was the perfect idiosyncratic foil to MJ's GOAT status, as displayed in the serene 'Best on Mars' double pager. 'A Death-Defying High-Flying 360 Slam Dunk' [pp.232–3] is another masterpiece of 1990s graphic design.

A few notables that might escape initial attention are also worth discussion. Given New Balance's philosophical 'Endorsed by No One' approach to (not) paying athletes huge endorsement fees, their ads with basketballer James 'The Incredible Driving Machine' Worthy stand out. New Balance has since rescinded the policy but the historical legacy explains why all-star names are lacking in their advertising roster throughout the decades.

Under a 'We Will Rock You!' tagline swiped from Freddie Mercury, L.A. Gear flaunted their endorsements with ace quarterback Joe Montana [p.251] and basketballers Hakeem Olajuwon and Kareem Abdul-Jabbar [p.248–9]. The blank 'blue-steel' model poses were as comical as the text was bombastic. 'A phenomenon of light and warmth – a source of inspiration – the flicker of creation that sparked the basketball sneakers of the future'. L.A. Gear's blatant knock-off of Reebok's Pump concept under the Regulator name [p.250] is another low blow documented for posterity.

One of my personal all-time favourites is the 'Filadelphia' image that captured an elegant Jerry Stackhouse flying across the Philly skyline in his 'Spaghetti' joints. The succinct wordplay and rapturous expression on Stackhouse's face are an economical symphony that belied FILA's lackadaisical commitment to the sport.

1989: L.A. Gear, ft. Joe Montana, Hakeem Olajuwon and Kareem Abdul-Jabbar

IF BO JACKSON TAKES UP ANY MORE HOBBIES, WE'RE READY.

Who says Bo has to decide between baseball and football? We encourage him to take up the Nike Air Trainer SC. A cross-training shoe with plenty of cushioning and support everything from basketball to cycling. And to train for them all in for a number of sports. Or should we say, a number of hobbies?

Air Trainer SC

For information on starting your own cross-training program, write: Nike Fitness, 9000 S.W. Nimbus Dr., Beaverton, OR 97005 or phone 1-800-344-NIKE.

1989: Nike, Air Trainer SC, ft. Bo Jackson

Introducing the Cross-Training System by Reebok.
Three shoes designed for any kind of workout, starting with what you do best.

Before.

After.

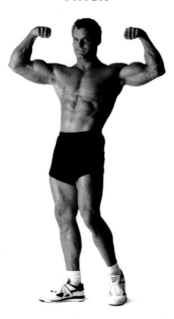

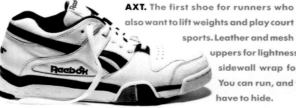

AXT. The first shoe for runners who also want to lift weights and play court sports. Leather and mesh uppers for lightness. Forefoot sidewall wrap for stability. You can run, and you won't have to hide.

$$speed \quad V = \frac{2\pi R \; N}{C}$$

$$power \quad P = \frac{W}{t}$$

SXT. The first shoe for weight lifters who also want to run and play court sports. Midfoot and ankle straps for maximum support. Wide base ensures maximum stability for you, and total insecurity for everyone around you.

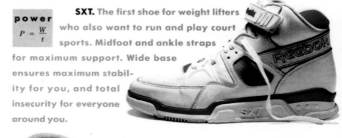

CXT. The first shoe for court players who also want to run and lift weights. Midfoot strap for medial support. Midfoot sidewall for lateral support. Good for adjusting the attitude of that poor geek who beat you in tennis last week.

$$force \quad F = ma$$

The physics behind the physiques.™ Reebok

1989: Reebok, AXT, SXT and CXT

FIVE SHOES IN ONE

In response to the aerobics boom, the sneaker industry set out to invent an all-new aesthetic for wannabe buff-chested blokes. Designed for the track, gym and tennis court, white leather cross-trainers were the hottest ticket in town in the late 1980s. Reebok's Workout model [p.606] from 1986 is arguably the first of its kind, but Tinker Hatfield once again seized the day with his Air Trainer 1 design [pp.378–9].

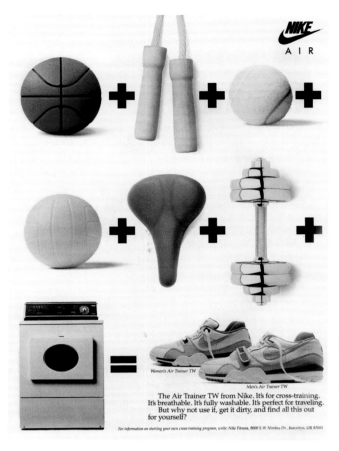

The Air Trainer TW from Nike. It's for cross-training. It's breathable. It's fully washable. It's perfect for traveling. But why not use it, get it dirty, and find all this out for yourself?

For information on starting your own cross-training program, write: Nike Fitness, 9000 S.W. Nimbus Dr., Beaverton, OR 97005.

1988: Nike, Air Trainer TW

With his dual role as pro-baseballer and all-star American football player, Bo Jackson was the perfect bod for the job. Nike parlayed their über-alpha athlete into a series of quintessential ads that, more than 30 years later, are as timeless and brilliant as the day they were composed. 'The Jackson 5' [pp.382–3] and 'Can Anyone Fill Bo's Shoes?' [pp.392–3] showcased Bo's virtuoso superiority at anything he put his mind to, yet it was the relatively sombre black-and-white vision of him in shoulder pads with a baseball bat that effortlessly personified the cross-trainer attitude. When John 'The Queen of England' McEnroe [pp.514–15] started repping Bo's exotic Air Trainer 1 model on the tennis court, later switching over to the Air Tech Challenge range, the entire sporting planet suddenly seemed obsessed with forefoot Velcro straps.

PUMA and ASICS tried to muscle in on the action, but the cross-trainer category was a tough gig for brands without a multi-skilled athlete on their books. Reebok did produce a few gems during this time, notably 'If It's Not One Thing, It's Another' [p.610] and 'The Physics Behind the Physiques'.

Cross training shoes for your feet.
And everything they stand for.

XTG from Puma. For aerobics, court sports, light running, and anything else you do with your feet to make your body look good.

PUMA
Anything but tame.

1988: PUMA, XTG

ROCK N' ROLL TENNIS is not allowed at places where it is needed most. Rock n' Roll tennis is rugby with a racket. Rock n' Roll tennis is not the tennis your parents had in mind. Rock n' Roll tennis is hitting the ball as loud as you can. Rock n' Roll tennis is rated NC-17. Rock n' Roll tennis plays fair, but not by the rules. Rock n' Roll tennis doesn't have polite applause. Rock n' Roll tennis doesn't play on AM radio. Rock n' Roll tennis is a no-no in Britain. Rock n' Roll tennis doesn't send flowers.

If you want rock n' roll tennis, you want the Nike Air Tech Challenge 3/4.
If you want Nike-Air® cushioning, you want the Nike Air Tech Challenge 3/4. If you want a Durathane™ toe piece for extra wear, you want the Nike Air Tech Challenge 3/4.
If you want flowers, you want another shoe.

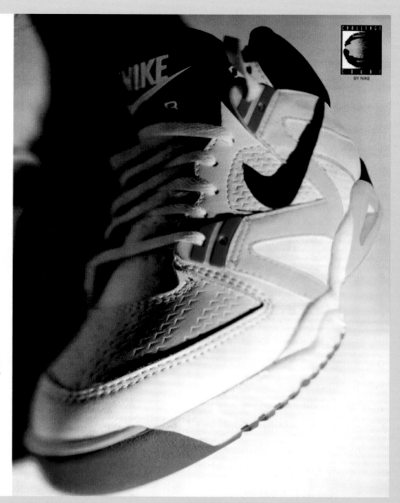

1991: Nike, Air Tech Challenge 3/4

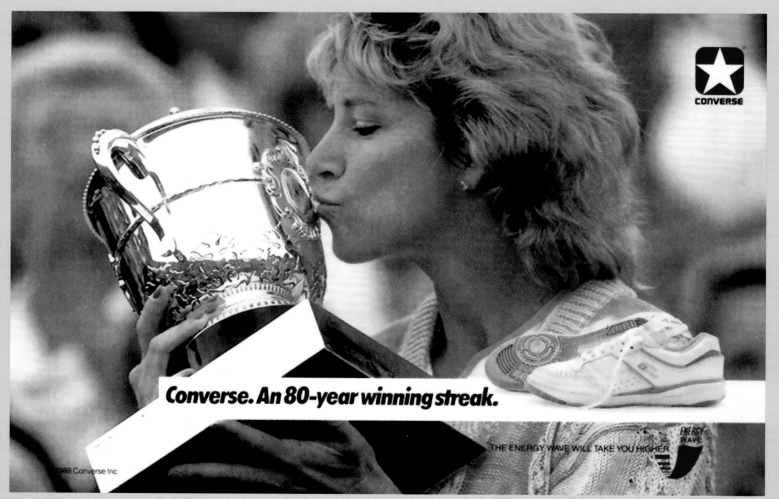

Converse. An 80-year winning streak.

THE ENERGY WAVE WILL TAKE YOU HIGHER

1988: Converse, Energy Wave, ft. Chris Evert

TENNIS ANYONE?

We also have to pay our respects to Andre Agassi, the magnificently charismatic tennis prodigy from Las Vegas. Nike's 'Rock n' Roll Tennis' and 'Hit the Ball as Loud as You Can' ads made Agassi a household name. His flamboyant persona, coupled with his signature neon spandex and acid-wash denim range, was a formidable ensemble. What made this partnership so powerful was the obvious affinity between Agassi and Nike. Brash, in-your-face and determined to win at all costs are three characteristics that come straight from the Phil Knight playbook [p.426].

Over at adidas, the contrast was obvious. The supernaturally dour Ivan Lendl and his ice-cold Swedish counterpart Stefan Edberg [p.107], held court in their Three Stripe apparel and pro-model sneakers. The psychological profile comparison between Agassi–McEnroe and Lendl–Edberg says a lot about the image both brands wanted to project. Nike were loud, anti-authority and egotistical, while adidas were calm, thoughtful and introverted. The boundary between the brands was clear.

PUMA and Converse lobbed somewhere in between those baselines. With Guillermo Vilas [p.588], Boris 'Boom Boom' Becker [p.590] and Martina Navratilova [p.589] on the squad at different stages, PUMA certainly had the raw talent at their disposal. The Converse campaign with Jimmy Connors and Chris Evert as the 'Winningest Pair in Tennis' [p.218] is their standout moment. It also represents one of the few – *and possibly only?* – times a sneaker brand dared to picture top-ranking male and female athletes together in an advertising campaign.

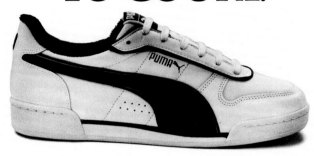

WE'RE TAKING BORIS BECKER AND MARTINA NAVRATILOVA TO COURT.

If you want evidence of why Boris and Martina depend on Puma to help them prosecute their court opponents, just visit your athletic shoe dealer.
There you'll find the Becker Ace, as well as our full line of tennis shoes, clothes and rackets.
Puma. Judged by Boris and Martina as the best way to make a court appearance.

PUMA
OUR WORD FOR QUALITY

1986: PUMA, Becker Ace

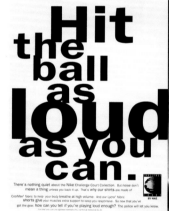

Hit the ball as loud as you can.

There's nothing quiet about the Nike Challenge Court Collection. But noise don't mean a thing unless you back it up. That's why our shirts are made of CoolMax fabric to help your body breathe at high volume. And our Lycra® fabric shorts give your muscles extra support to keep you responsive. So now that you've got the gear, how can you tell if you're playing loud enough? The police will let you know.

1991: Nike, Challenge Court Collection, ft. Andre Agassi

dominate the court.

PERSONALITY: Ivan Lendl No. 1 world ranked
PRODUCTS: Shoe—Lendl Supreme, part of the Lendl Collection Rackets-GTX Pro, T-shirt, pullover, vest, shorts, jacket, warm-up suit
DESIGN: Dominant
COLORS: White-oats-sky-silver, white-navy-china blue-red-black, white-navy-sea blue-black
WHERE: Pro shops, sporting goods stores, and fine department stores
MANUFACTURER: adidas

1986: adidas, Lendl Supreme, ft. Ivan Lendl

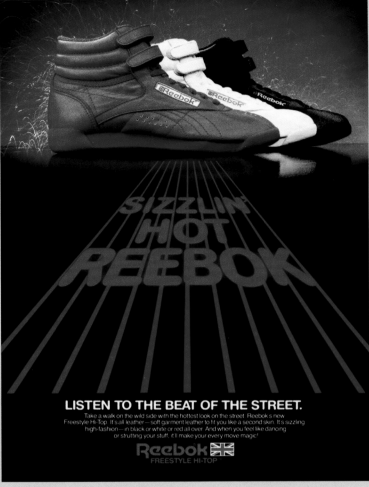

1985: Reebok, Freestyle Hi-Top

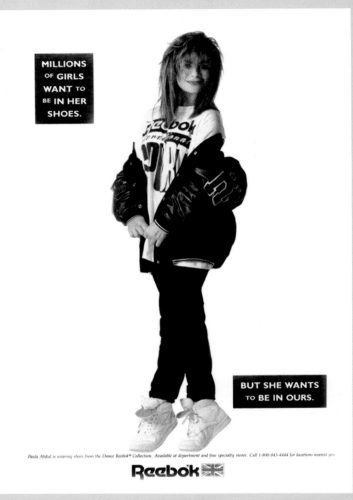

1989: Reebok, Dance Reebok Collection, ft. Paula Abdul

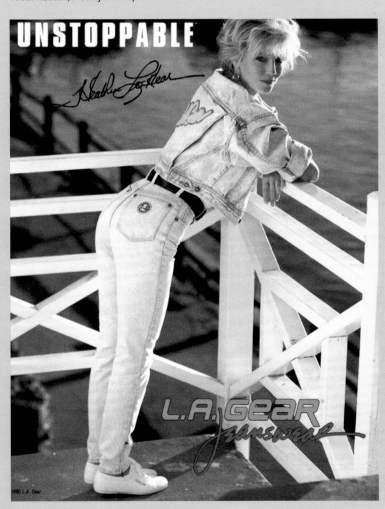

1990: L.A. Gear, ft. Heather Locklear

1985: Reebok, Freestyle Hi-Top

FOR THE LADIES

There are some glaringly obvious omissions. The lack of professional female athletes is a poor but accurate reflection of the industry's hyper-masculine focus in the 1980s and 90s. Grete Waitz, Ingrid Kristiansen and Jackie Joyner-Kersee are just a handful who were deemed worthy of their own campaigns. Basketball was a total bust, with only a frocked-up Larry Johnson as 'Grandmama' repping (ironic) XX chromosomes. On the tennis tip, at least Chris Evert and Martina Navratilova had solid endorsement deals in their day.

In running circles, Saucony's sales split was 60/40 in favour of women, a unique distinction in the sportswear business. Capitalising on their inherent 'sex' appeal, Saucony introduced female-specific models such as the Lady Dixon and Lady Jazz [p.697]. New Balance's unique selling point is making their shoes in multiple sizes and widths, with the W320 model [p.261] specifically targeting female runners with odd-shaped feet.

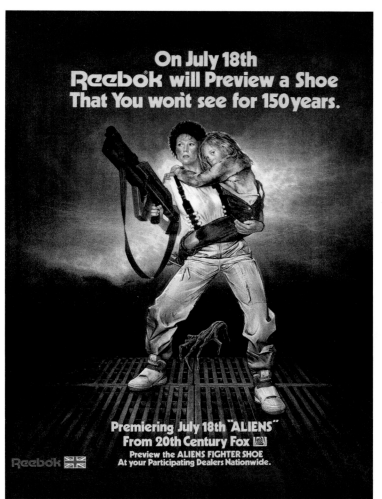

1986: Reebok, Aliens Fighter Shoe, ft. Sigourney Weaver

The fact that women were not allowed to run Olympic marathons as recently as the 1980s seems absurd today, but this historical travesty is illuminated in one of Nike's most polemic ads [p.35]. Playing hardball, Nike berated the IOC and IAAF for their discriminatory stance and encouraged readers to send letters of complaint to their Beaverton campus. The hard-fought campaign was successful and the ban was finally lifted in 1984. In the inaugural Olympic marathon for women, Joan Benoit Samuelson won gold from Grete Waitz.

The Reebok Freestyle is without doubt the highest-selling female-specific sneaker of all time. Made from supple 'garment' leather, the aerobicised high-top was available in dozens of 'Sizzlin' Hot Neon' colours, though it was never featured heavily in magazine advertising. With sales in the bazillions and beyond, perhaps it just didn't need any extra juice to rocket off the shelves. As Reebok proudly pointed out in their Paula Abdul ad from 1989, 'Millions of Girls Want to Be in Her Shoes. But She Wants to Be in Ours'. The brand also celebrated their product placement on the toughest cinematic heroine of all time, with Sigourney Weaver's 'Ripley' character rocking the Bok's 'Alien Stomper' high-tops in the *Aliens* sequel.

The chapter on L.A. Gear may seem an unlikely inclusion in this book, but with their conga line of co-signs [p.252] from the likes of Priscilla Presley, Heather Locklear and Belinda Carlisle, they were a heavy early adopter of celebrity fashion and the only brand that really endeavoured to satisfy female desire for casual sporting attire.

1991: Converse, Aero-Glide, ft. Larry Johnson

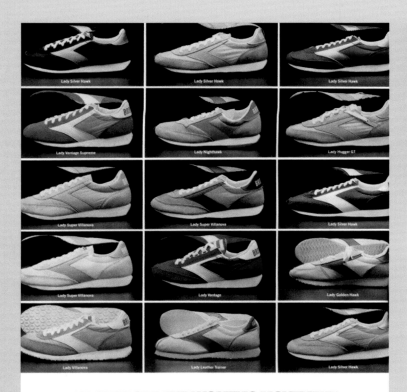

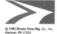

WE SUPPORT THE WOMEN'S MOVEMENT.

It is not mere coincidence that some of the swiftest women in the world wear Brooks shoes.

The fact is, no other running shoes have as much cushioning as our Lady Vantage and Lady Hugger GT. And no other shoe company has the Varus™ Wedge to control pronation and help prevent running injuries.

So, whether you're a woman who's setting records or just setting out on your first mile, we want you to know one thing. We support your efforts completely.

© 1981 Brooks Shoe Mfg. Co., Inc.
Hanover, PA 17331

BROOKS
Feel the difference.

1981: Brooks

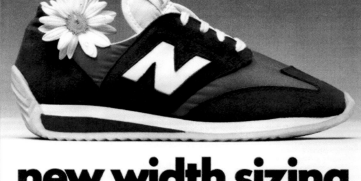

new width sizing for women the W320

Yes, New Balance's top-rated road trainer, the 320, now comes in a special model for women runners. Called the W320, it's designed on a woman's athletic combination last with a heel two sizes narrower for a snugger fit throughout the heel and Achilles tendon area. Otherwise, it's the same great trainer—with full width sizing, soft one-piece upper, unique arch-support saddle, and durable, protective sole/wedge/midsole combination. Women's sizes 4-10; widths AA, A, B, C and D (sizes 11 and 12 available at additional cost), in Royal Blue and White with distinctive Red logo. New Balance's W320—the first running shoe truly fit for women.

new balance
New Balance Athletic Shoe, Inc.
38 Everett Street, Boston, Massachusetts 02134

1979: New Balance, W320

Ramona

PONY

THE OFFICIAL SHOE OF THE GIRL WHO'S TURNED THE WORLD OF FITNESS UPSIDE DOWN.

© 1987 Pony International, Inc.

1987: PONY, Ramona, ft. Ramona Melvin

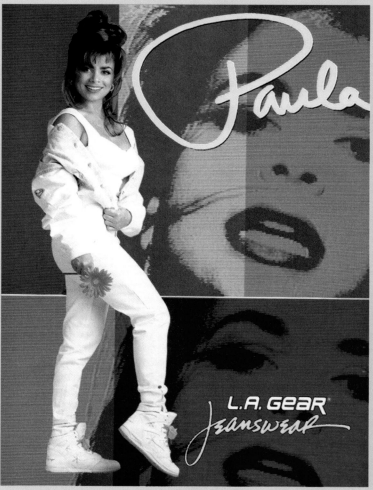

Paula

L.A. GEAR
Jeanswear

1991: L.A. Gear, Sunblossom, ft. Paula Abdul

WE THINK IT'S TIME THE IOC STOPPED RUNNING AWAY FROM WOMEN RUNNERS.

For some archaic reasons, the International Olympic Committee refuses to allow women runners to compete at any distance longer than 1500 meters.

They say that running a marathon isn't feminine. Women aren't strong enough.

Or that not enough countries are interested. Right. The IOC recognizes things like roque and team epee as Olympic events.

We say the members of the IOC have their heads in the sand.

We'd like to take a stand here for women runners. We've joined the crusade to convince the IOC to allow women to run the distance races just like men do.

And world-class women runners need your help, too. If you agree that women should get equal treatment from the IOC, say so in a letter to us at the address below.

We'll collect all the letters in one giant pouch and dump them on the IOC and the IAAF.

Your letter might make all the difference in getting women in Olympic distance races.

And in getting the IOC off their brains.

NIKE.
World Headquarters
8285 SW Nimbus Avenue, Suite 115
Beaverton, Oregon 97005

Send your letter to the attention of Patsy Mest.

1982: Nike

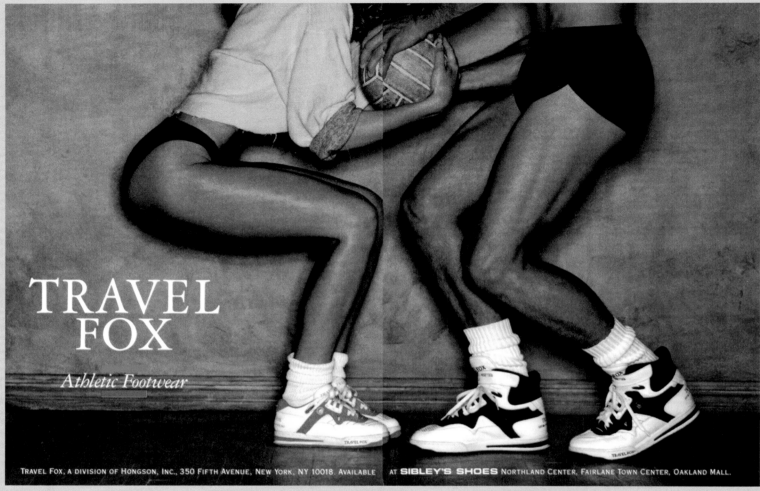

1988: Travel Fox

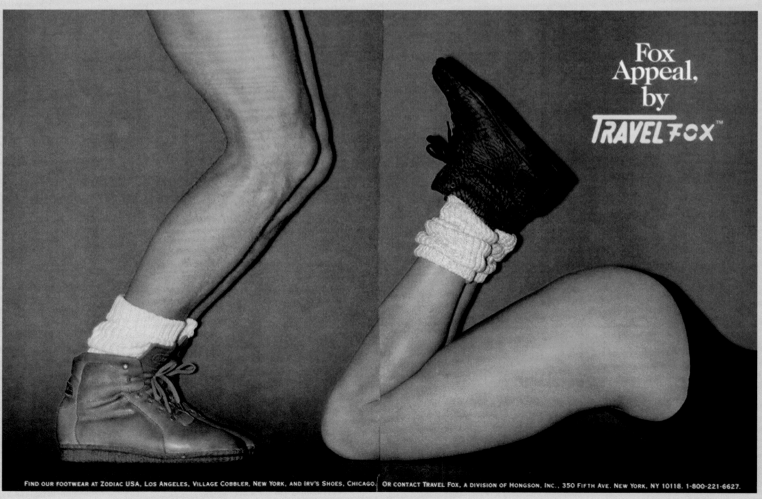

1988: Travel Fox

1976: PUMA, Joe Namath, ft. Joe Namath

FOX APPEAL

Aficionados of obscure delights will enjoy some of the random discoveries hidden within these pages. Who knew that Arnie Schwarzenegger starred in a Nike ad back in 1987 [p.385], or that Vans once purpose-built a performance sneaker for the ancient Olympic sport of breakdancing [pp.40–1]? Sadly, brogued-out boxing boots didn't turn out to be popular with lockers, poppers and b-boys, but at least we have evidence these crazy clown shoes existed.

On a non-sporting tip, the sneaker industry's embrace of musicians is minor but noteworthy. British Knights employed MC Hammer to deliver on his 'U Can't Touch This!' catchphrase [p.38], while L.A. Gear signed Michael Jackson to endorse an 'Unstoppable' range [pp.254–5] that ultimately did grind to a halt in a $10 million lawsuit. Avia's 'Wimps, Slugs and Couch Potatoes' ad with Brian Bosworth's bizarre flat-top quiff [p.39] is another macho spectacle worthy of a reprint. And check out the orgasmic expression on the sexagenarian Etonic race winner from 1982 below. Charming naivety is what makes these images so funny and radically unsophisticated so many years later.

Hall of Fame quarterback 'Broadway Joe' Namath, whose heroics at Super Bowl III made his white boots the talk of the town, was a notorious playboy, which more than explains his PUMA campaign from 1976. Pictured with a lady friend nestled into his million-dollar right arm, the sex-positive slogan 'Joe Namath Scores in Pumas' is one we're unlikely to see repeated today. Lifestyle brand Travel Fox also rejoiced in double entendres. Their saucy sequence of 'Fox Appeal' ads with male and female legs akimbo definitely wouldn't survive the scrutiny of neo-Puritanical fun-police. Speaking of which, the 'Air is What Makes It Good' campaign [p.499], which pairs an inflatable XXX doll with the Air Tuned Max runner is another punchline that seems shockingly out of touch with modern mores. The Air Huarache Light single pager claiming that 'the average person has a sexual thought every fifteen seconds' [p.484] would also do more than raise horny eyebrows today. For better – and for worse – they sure don't make 'em like they used to!

1982: Etonic, Etonic Courier

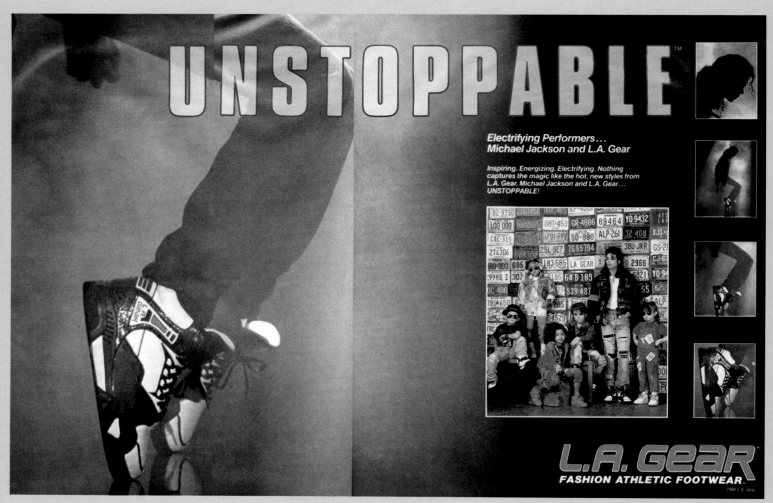

1990: L.A. Gear, ft. Michael Jackson

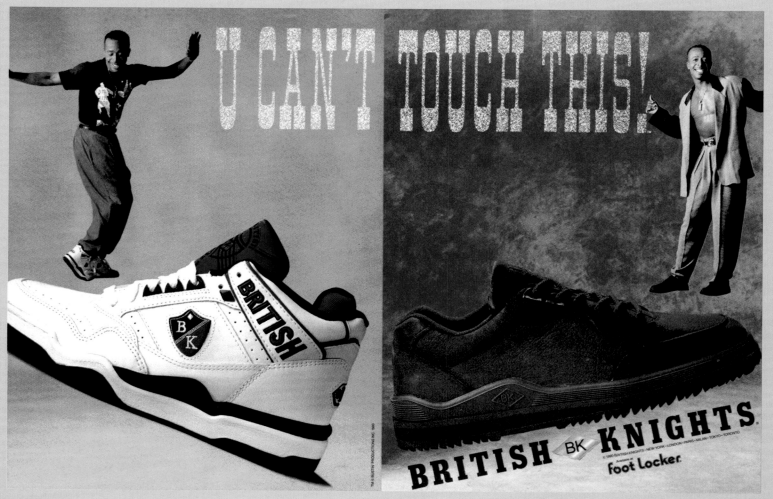

1990: British Knights, ft. MC Hammer

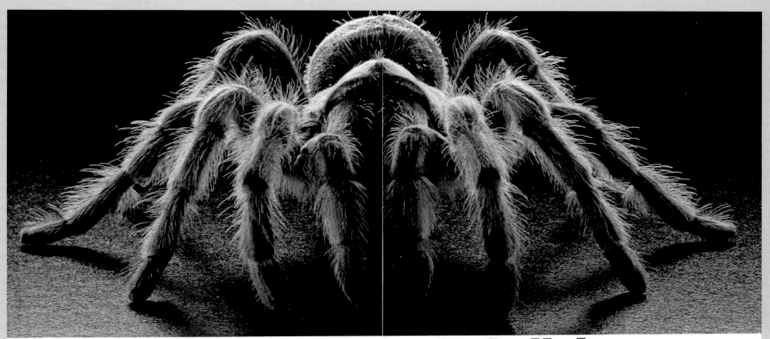

Some of our new basketball shoes come with a rather surprising feature inside.

It has multiple legs for stability. It's low and wide but built for jumping. It can soak up a million hard landings and still bounce back for more. Any wonder we decided to name it after the fellow above? You'll find SpiderArc™ only in our 890 and 875 models. Built right into the midsole, it's a unique flexible platform that fits over, and works with, our patented Cantilever® sole. And, does it ever work.

To cushion your jolts and stabilize your quickest lateral moves. Without breaking down, without wearing out. Of course, all this performance doesn't come cheap. So if basketball is just a passing interest to you, try someone else's shoes. But watch out. If you're not playing with Spiders, better hope you never play against them.

AVIA
FOR ATHLETIC USE ONLY™

1989: Avia, 890 and 875

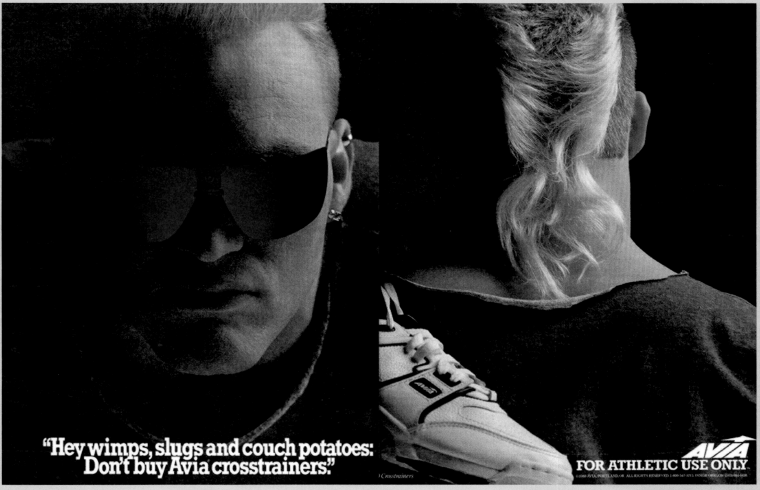

"Hey wimps, slugs and couch potatoes: Don't buy Avia crosstrainers."

AVIA
FOR ATHLETIC USE ONLY

1989: Avia, ft. Brian Bosworth

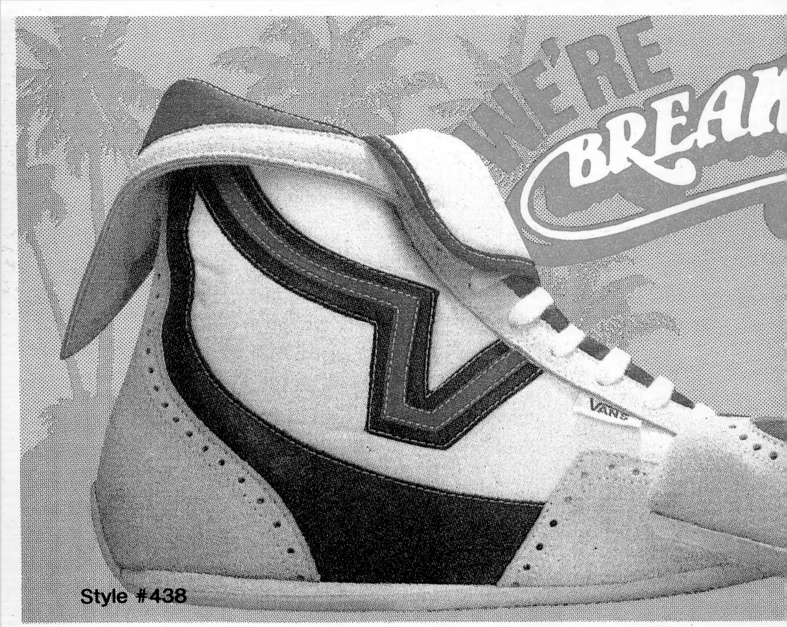

Style #438

from C O A S T

1984: Vans, Breakers

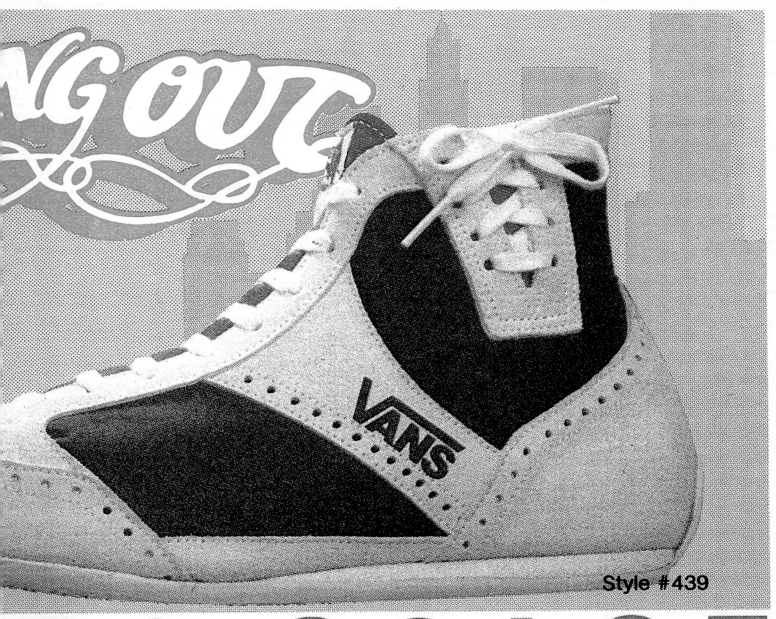

Style #439

NG OUT

TO COAST

41

OUR SHOES ARE BETTER THAN YOUR SHOES.

The midsole is the heart of any running shoe. It helps protect you from injuries and it absorbs most of the shock. And of all the running shoes, only one comes with a midsole guarantee. The Pro-Keds Conquest.™

WE DON'T CLAIM OUR MIDSOLES LAST THE LIFE OF THE SHOE. WE GUARANTEE IT.

Unlike the common EVA midsole that loses up to 75% of its resiliency after 300 miles, the Conquest's EVA/Polyisoprene midsole retains most of its shock

3M SCOTCHLITE®
REFLECTIVE TRIM

FULLY MOLDED HEEL
COUNTER FOR ADDED
STABILITY

EVA/POLYISOPRENE
MIDSOLE

HEEL CRADLE
STABILIZER CUSHIONS
IMPACT AND PROVIDES
MAXIMUM REARFOOT
CONTROL

CARBON RUBBER INDY
500® HEEL PLUG FOR
INCREASED DURABILITY

BEVELED HEEL

SPONGE RUBBER OUTSOLE

absorbent properties for the life of the shoe. And should it ever go dead before the outsole wears out, we'll do something unheard of. We'll give you a brand new pair of Conquests with no questions asked.

And this revolutionary midsole isn't the only feature that sets the Conquest apart from all the competition.

The Conquest also has an incredibly tough Indy 500® heel plug for heavy heel strikers. It has a fully molded heel counter that reduces excessive foot motion so there's less strain on the lower back, knees and Achilles tendons. And it even has a 3M ScotchLite® reflective trim that reflects car headlights up to 200 yards away.

The new Pro-Keds Conquest. It's a better running shoe than the shoe you're using now. And isn't that reason enough to switch?

PRO-Keds®

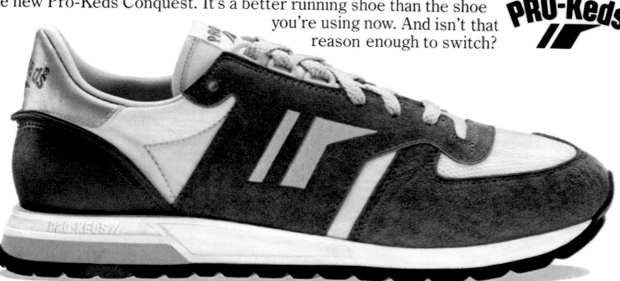

PRO KEDS. WE COME TO PLAY.

© 1983 Keds Corp., Div. of Stride Rite Corp., 5 Cambridge Ctr., Cambridge, MA 02142 (800-428-6575).

1983: PRO-Keds, Conquest

JOIE DE VIVRE

If there's one image in these pages that encapsulates the entire book, it has to be the PRO-Keds ad for their Conquest runner. Though they were never the coolest or the biggest in their heyday, that didn't stop PRO-Keds from loudly proclaiming that their runners were not only the best, but that they would guarantee a replacement pair 'no questions asked' should the soles lose their shock-absorbent properties. The tech-talk and conversational banter are regulation fare,

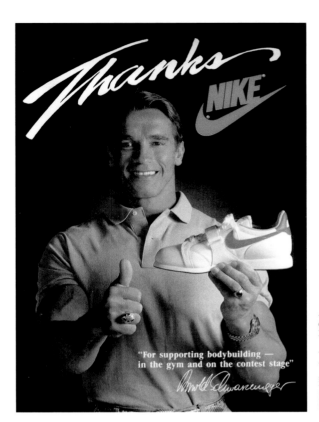

1987: Nike, ft. Arnold Schwarzenegger

but it's the punchline that said it all. 'Our Shoes Are Better Than Your Shoes' is the most succinct synopsis imaginable.

Enjoy the spectacular scenery ahead as we take you on a rowdy look back at the athletic sneaker industry as told through (close to) 900 glorious advertisements. This is a modern library of pop culture, a ridiculous retrospective of sporting achievements and a colossal collection of virtuoso artistic endeavour all packaged up in 720 lovingly assembled pages.

Whether it's the sublime skills of pre-Apple computer graphic designers or the insane trick-shot photographs developed way before digital retouching was invented, the creativity evident on every page is infectious. Shout-outs also to the army of unknown copywriters whose ambitious imaginations and outta-the-park home puns inspired and fired the intersection of product design and sport. As we survey their collective work in all its genre-spanning glory, it's the sheer joie de vivre that lingers longest and defines the freewheeling attitude of the 20th-century sneaker industry.

It may have taken more than 10 years for *Sneaker Freaker* to acquire the raw ingredients displayed here, but we know there are hundreds more entertaining ads out there that deserve recognition. Send us an email via hello@sneakerfreaker.com with your hot tips and, if Phaidon will have us back again, we'll curate a second volume. Finally, to paraphrase the immortal wisdom of Philip Hampson Knight… just read it!

●

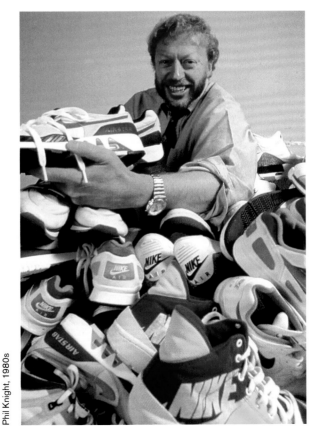

Phil Knight, 1980s

SELECTION

With close to 900 sneaker ads to categorise, some rigorous decision-making was required. One early draft had footwear from all brands mixed together by category, but that was quickly ditched in favour of a brand-first organisation, followed by sporting purpose. In terms of team games, basketball was in while baseball and football were out – this book is all about sneakers, not cleats! While cross-training was never a sport, Nike treated it like one, although some firms favoured 'fitness' as a more unisex solution. As the ads kept piling up, genre anomalies and oddball discoveries kept us entertained and puzzled. L.A. Gear, for example, had ace quarterback Joe Montana running in their basketball sneakers. The original Converse All Star ads are logically located under basketball, while the fashion-focused ads from the 1980s are not. Jack Purcell is similarly placed in badminton. We also broke things down by sub-labels. Nike ACG and Air Max, and Reebok Pump, totally deserve their own codification, while adidas Equipment, Feet You Wear and Torsion are also grouped together individually in honour of their multi-sport application. Lastly, if you look closely, you might even find a few pages where we took the odd chronological liberty – all in the name of achieving harmonic balance of course. Enjoy!

●

ADIDAS

Following a hot-headed dispute with his brother Rudolf, Adolf 'Adi' Dassler walked away from the family firm to start adidas in 1949. Sadly, the pair never reconciled and the stories of their mutual hostility are legendary. Adi's status as the forefather of the industry cannot be overstated; however, it was his enigmatic son Horst who really turned adidas into a global business, propelling both the Olympics and international football into mega-money professionalism.

Some long-forgotten relics from the adidas archive are shown here. The oddball Cangoran range featured synthetic leather and was mysteriously sold as 'One Less Worry for 20 Million Kangaroos'. Tennis is one sport adidas excelled in over the years, with Ivan Lendl and Stefan Edberg leading the charge in the late 1980s. Feet You Wear, Torsion and the high-end Equipment franchise are other sub-labels worthy of celebration.

Here's an odd piece of trivia straight from Wikipedia. 'The acronym All Day I Dream About Sport, although sometimes erroneously considered the origin of the adidas name, was applied retroactively, which makes it a backronym.'

●

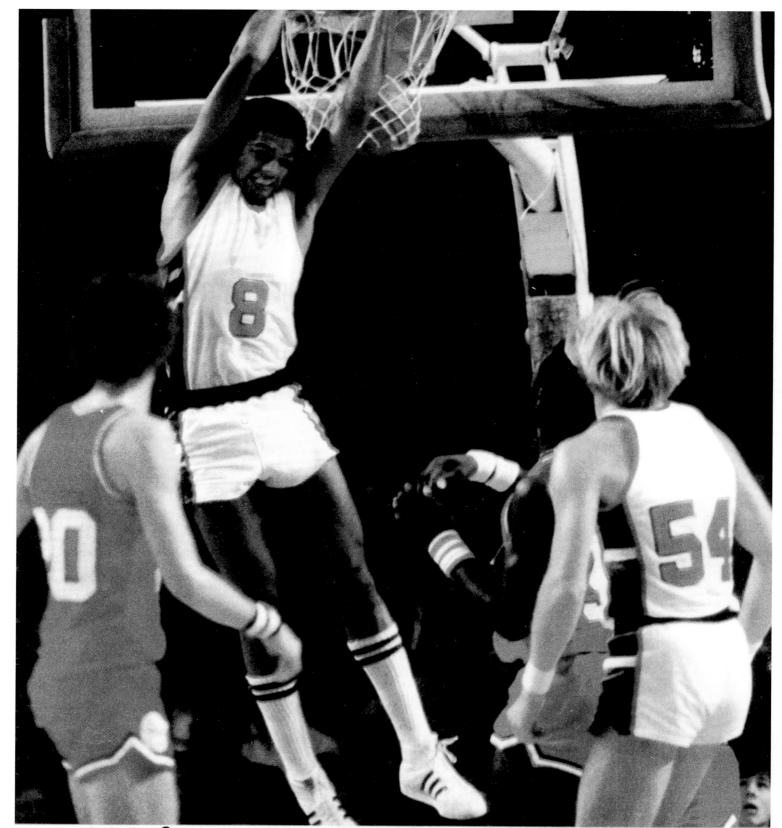

We've got a feeling for winning.

Top Ten High
adidas' top
basketball shoe.

The incomparable Marques Johnson is one of the many top basketball
players who depend on adidas.
Whether you play in the neighborhood playground,
or on national television, adidas has the right shoe for you.

1980: Top Ten High, 'We've Got a Feeling for Winning', ft. Marques Johnson

Rick Barry, Inventor.

When Rick Barry helped us create the adidas Top Ten basketball shoe, he knew it would have the severest critics of all: the U.S. "Top Ten" players.

Rick pressed for every advantage. He insisted we develop the upper with a special Foreflex™ cut that lets the foot flex easily and in the correct position. And had us add an Ankle Saver™ support system for increased protection.

He had us remove a semi-circle from the heel-counter to prevent heel irritation.

He watched as we perforated the toe area to ensure proper ventilation.

And he demanded we build the deep herring-bone sole with a turning disc and a serrated edge for softness, traction and flex.

Then Rick tested our adidas Top Ten on the "Top Ten". They all gave it their seal of approval. Now all we need is yours.

The adidas Top Ten is worn by "Top Ten" players Doug Collins, Marques Johnson, Kermit Washington, Adrian Dantley, Bob Lanier, Bobby Jones, Billy Knight, Sidney Wicks, Mitch Kupchak and Kevin Grevey.

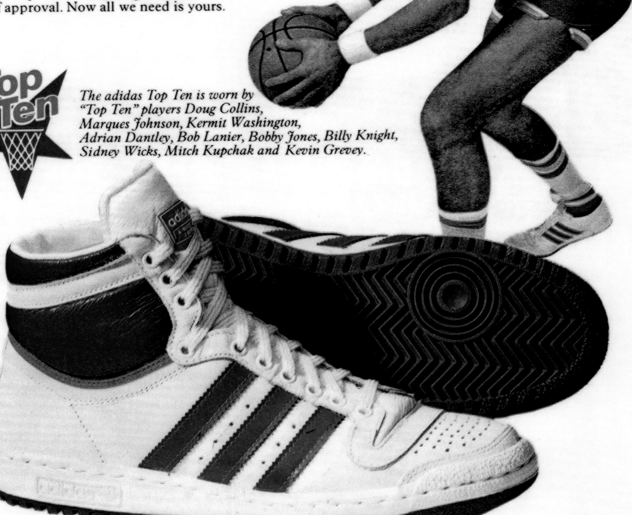

adidas®
The science of sport

1979: Top Ten High, 'Rick Barry, Inventor', ft. Rick Barry

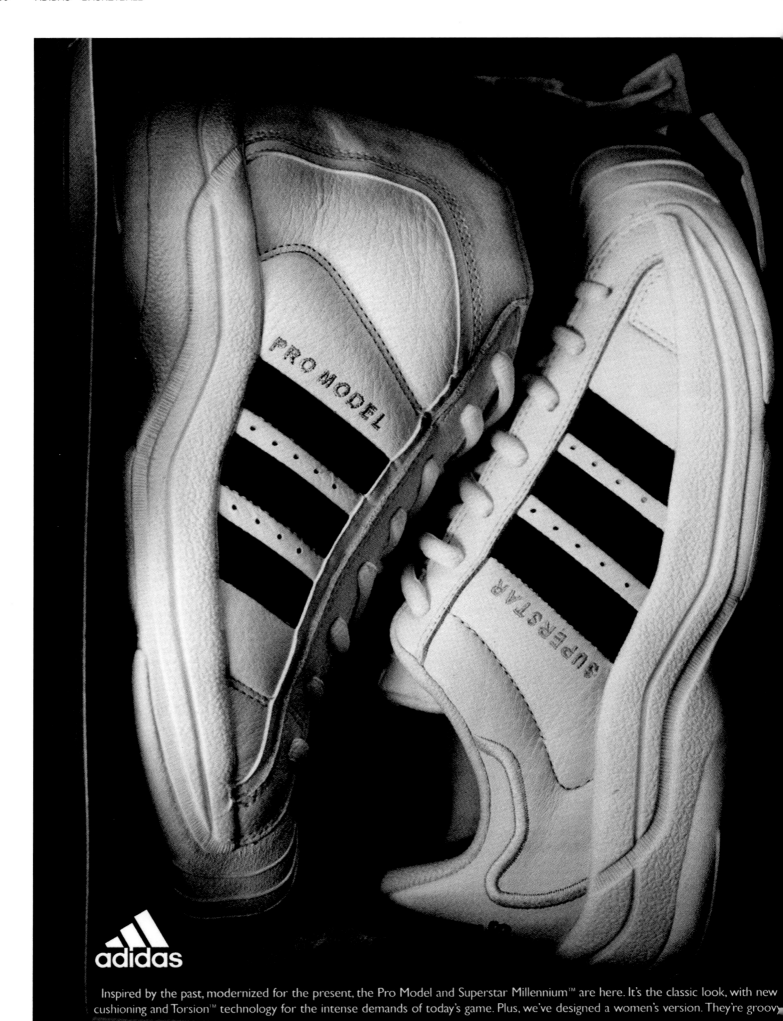

Inspired by the past, modernized for the present, the Pro Model and Superstar Millennium™ are here. It's the classic look, with new cushioning and Torsion™ technology for the intense demands of today's game. Plus, we've designed a women's version. They're groovy

1998: Pro Model and Superstar Millennium, 'Worn by Legends'

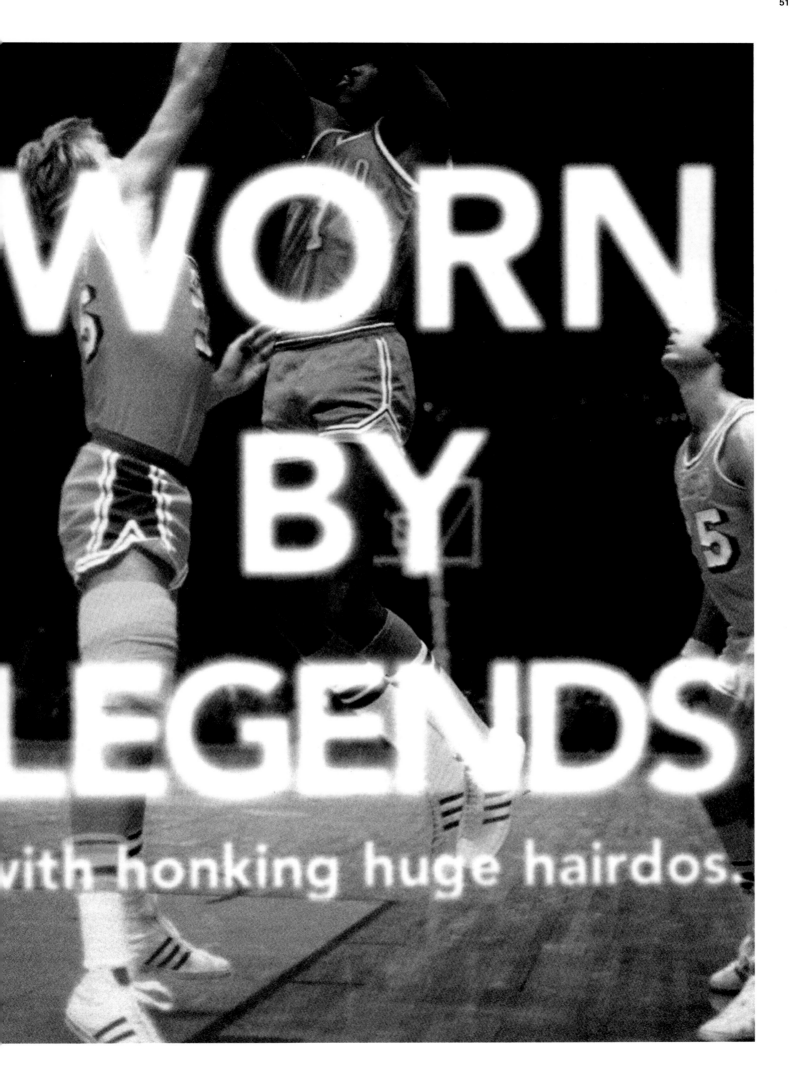

WORN BY LEGENDS

with honking huge hairdos.

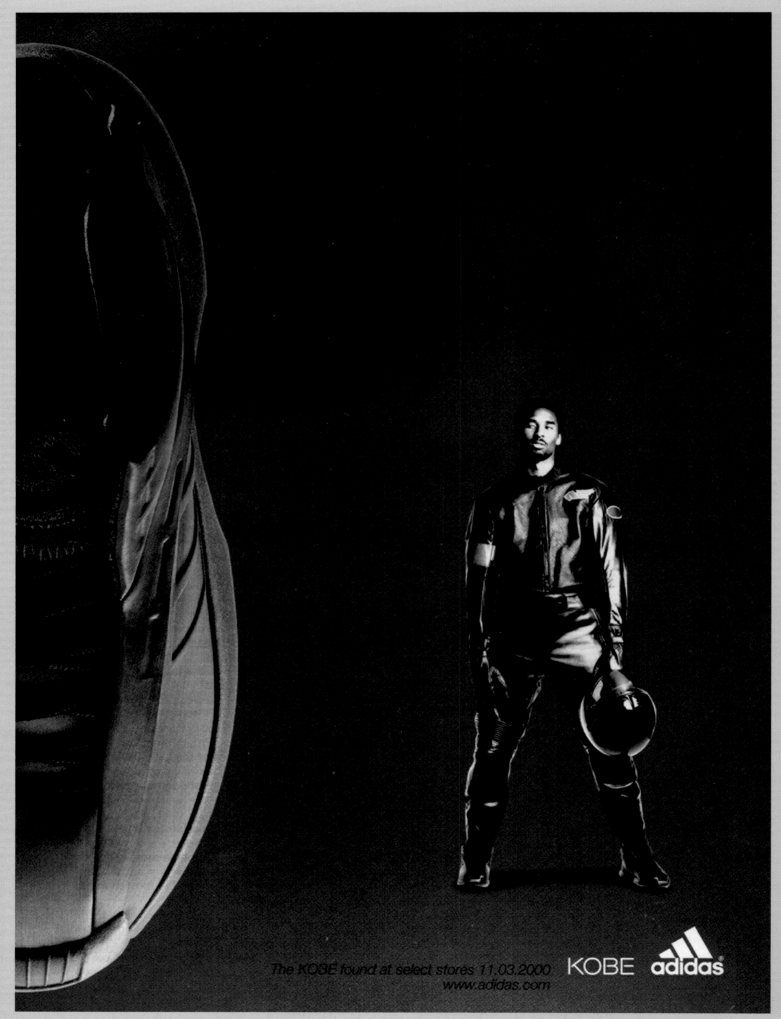

The KOBE found at select stores 11.03.2000
www.adidas.com KOBE adidas

2000: The Kobe, ft. Kobe Bryant

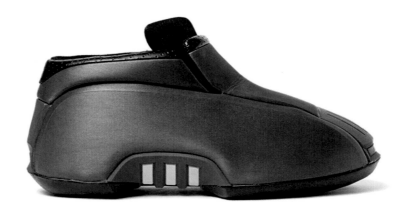

" People just weren't ready for such a radical design. I remember my friends calling them 'moon boots'. The Kobe was inspired by the Audi TT, so it's really no different to the Air Jordan 14, which took design cues from MJ's Ferrari 550M. When it comes to design, Kobe usually thought about performance first and looks last. I thought the Kobe Two was interesting, but I must confess I never bought a pair back in the day. People would just look at you so weird for wearing them. I know adidas was hard at work on the Kobe Three before he jumped ship to Nike. "

Darryl Glover
'King Kobe'
Sneaker Freaker, issue 35 (2016)

Running.

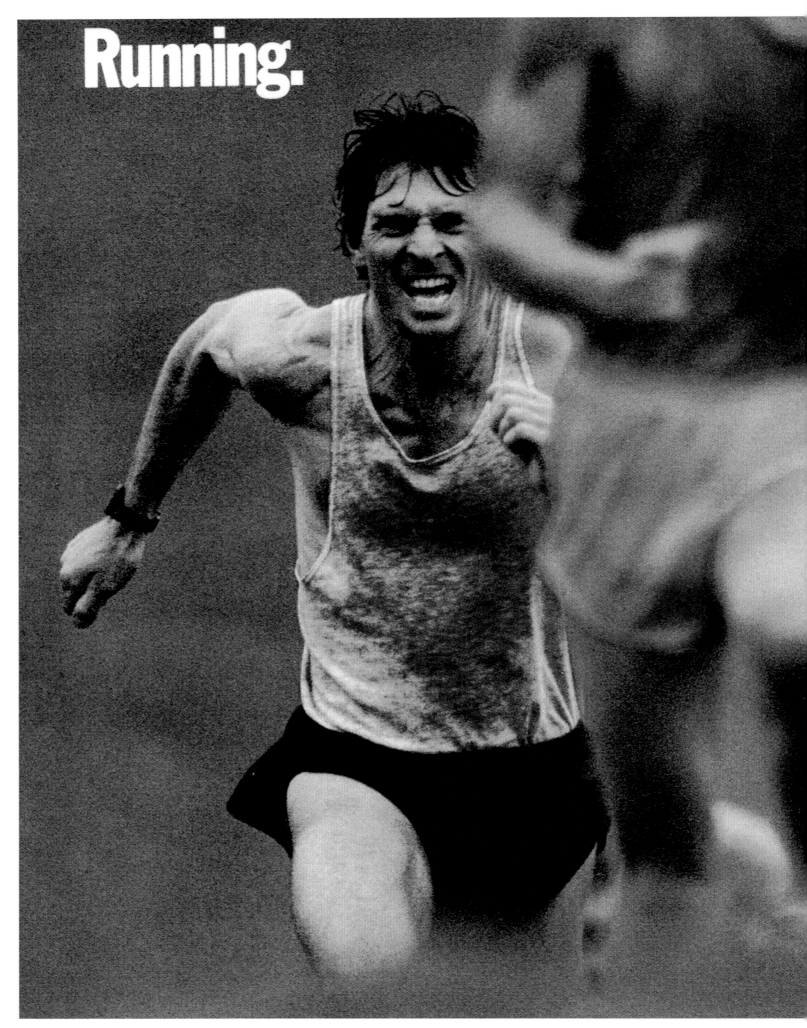

1991: Equipment Running Cushion, 'Running. Equipment'

Equipment.

Need: Efficiency.
Essential: Torsion System and Torsion Last
ensure a better fit, better efficiency and better balance
between stability and flexibility.

Need: Injury Prevention.
Essential: Firm outside heel counter reduces slippage.

Need: Durability.
Essential: Long wearing carbon rubber outsole.

Need: Comfort.
Essential: Asymmetric cut provides a better fit under
and around the ankle.

Need: Shock Absorption.
Essential: Polyurethane Midsole and Soft Cell
increase shock absorption and comfort.

Equipment Running Cushion. The best of adidas.
Everything that is essential. And nothing that is not.

adidas
EQUIPMENT

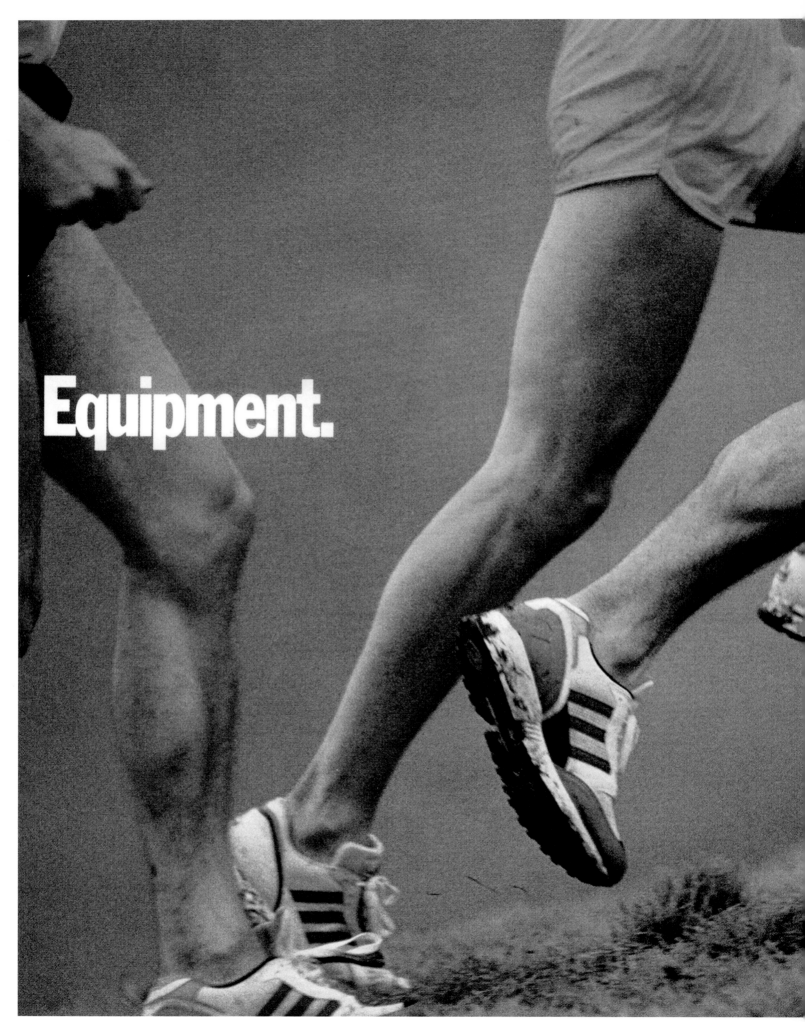

1991: Equipment, 'Equipment'

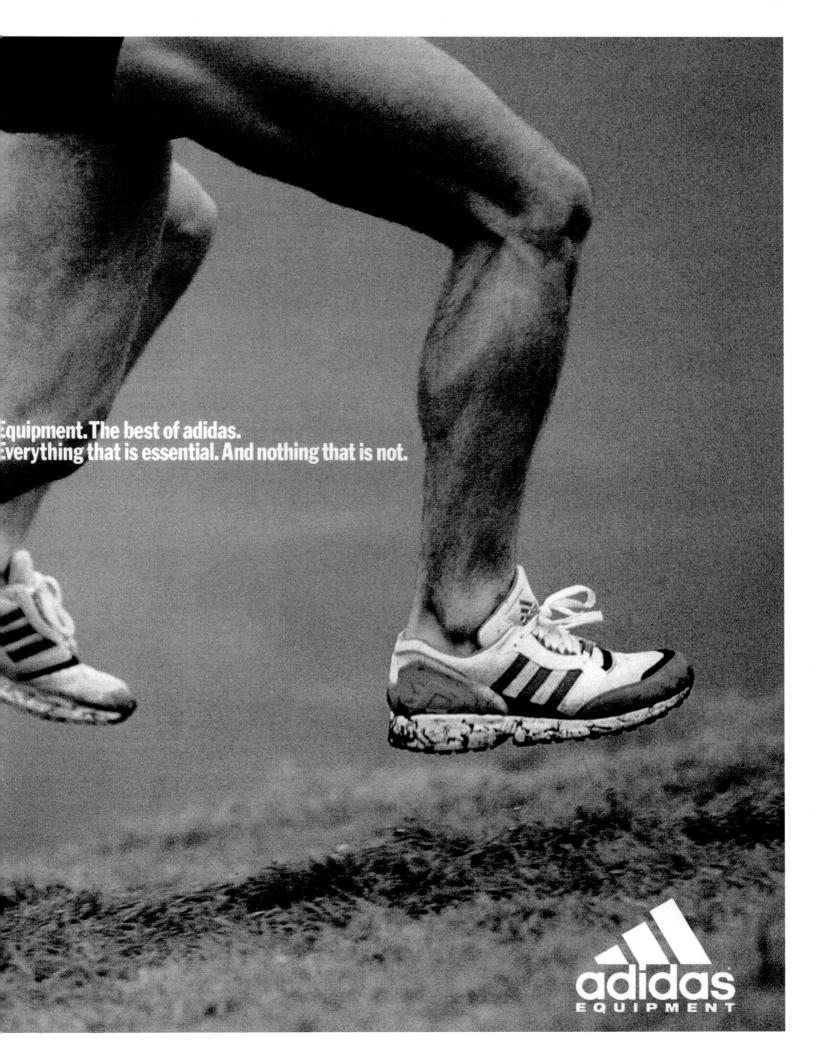

Equipment. The best of adidas.
Everything that is essential. And nothing that is not.

Tennis.

1991: Equipment, 'Tennis. Equipment'

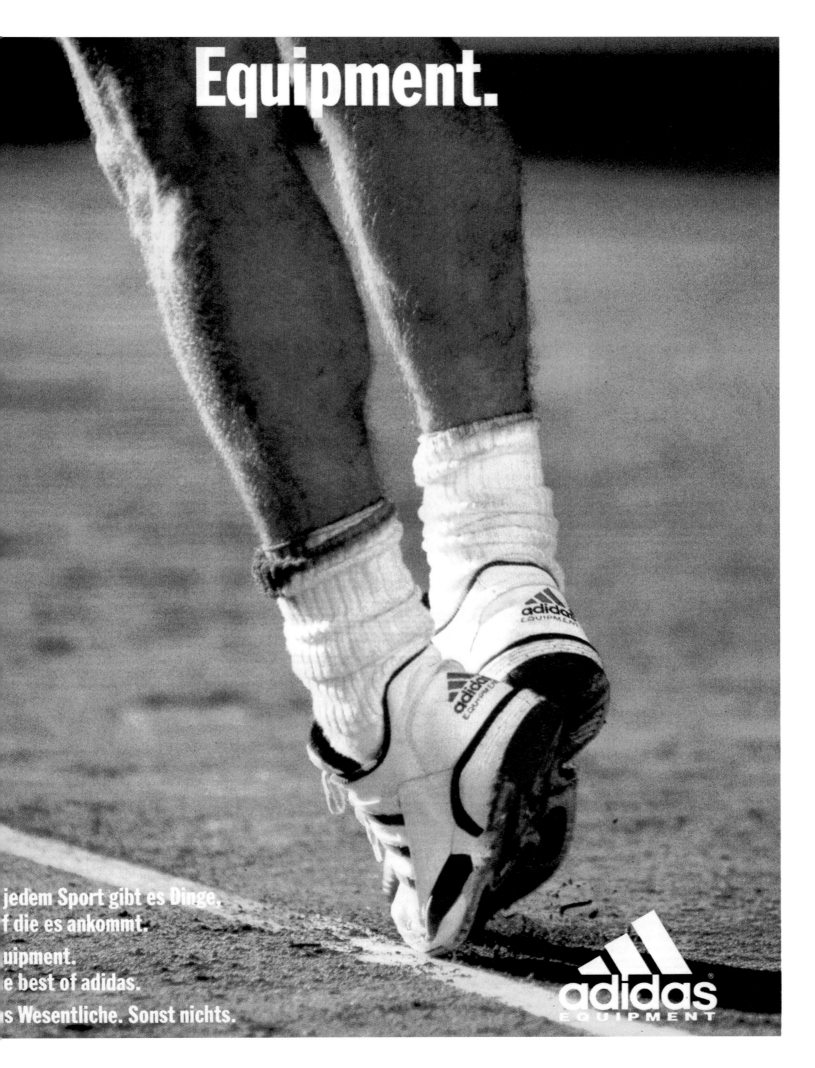

Equipment.

jedem Sport gibt es Dinge,
f die es ankommt.
uipment.
e best of adidas.
s Wesentliche. Sonst nichts.

adidas
EQUIPMENT

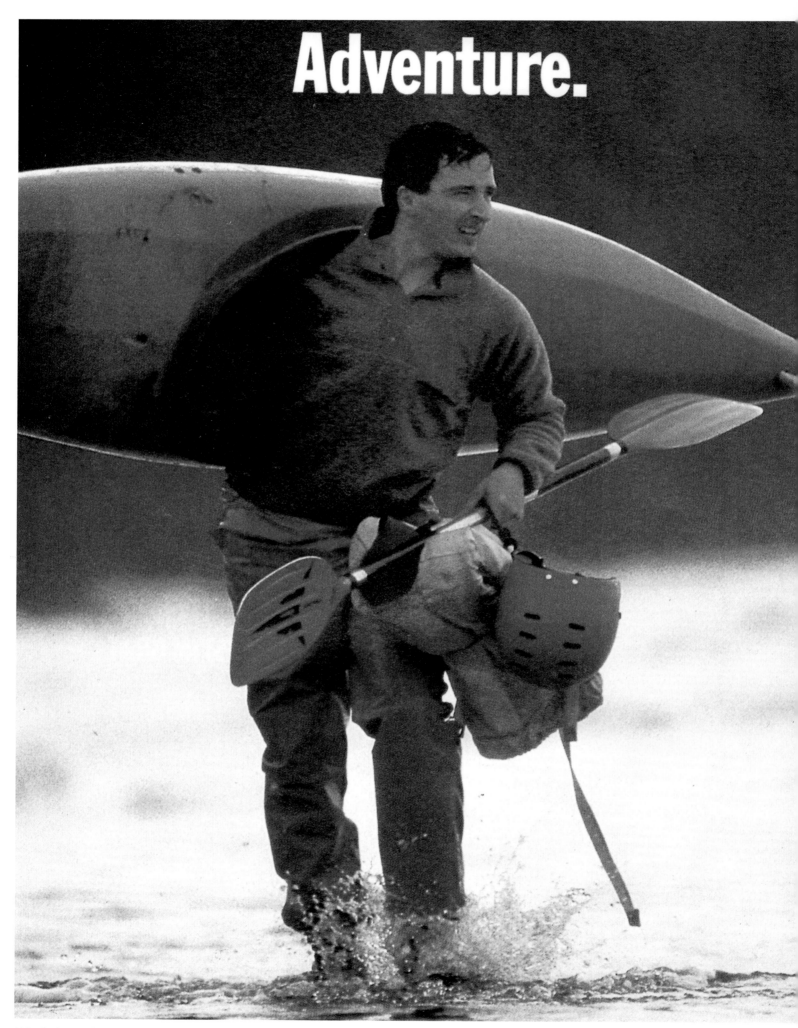

Adventure.

1991: Equipment, 'Adventure. Equipment'

Equipment.

Jedem Sport gibt es Dinge,
auf die es ankommt.
Equipment.
The best of adidas.
Das Wesentliche. Sonst nichts.

adidas
EQUIPMENT

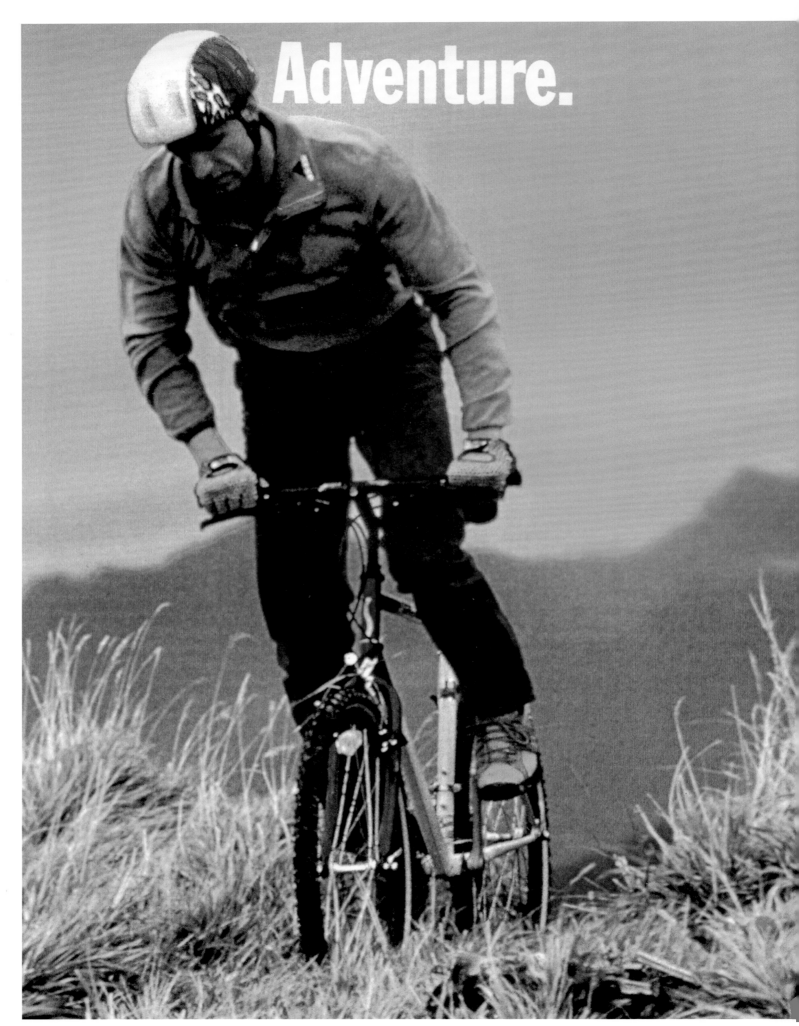

1991: Equipment, 'Adventure. Equipment'

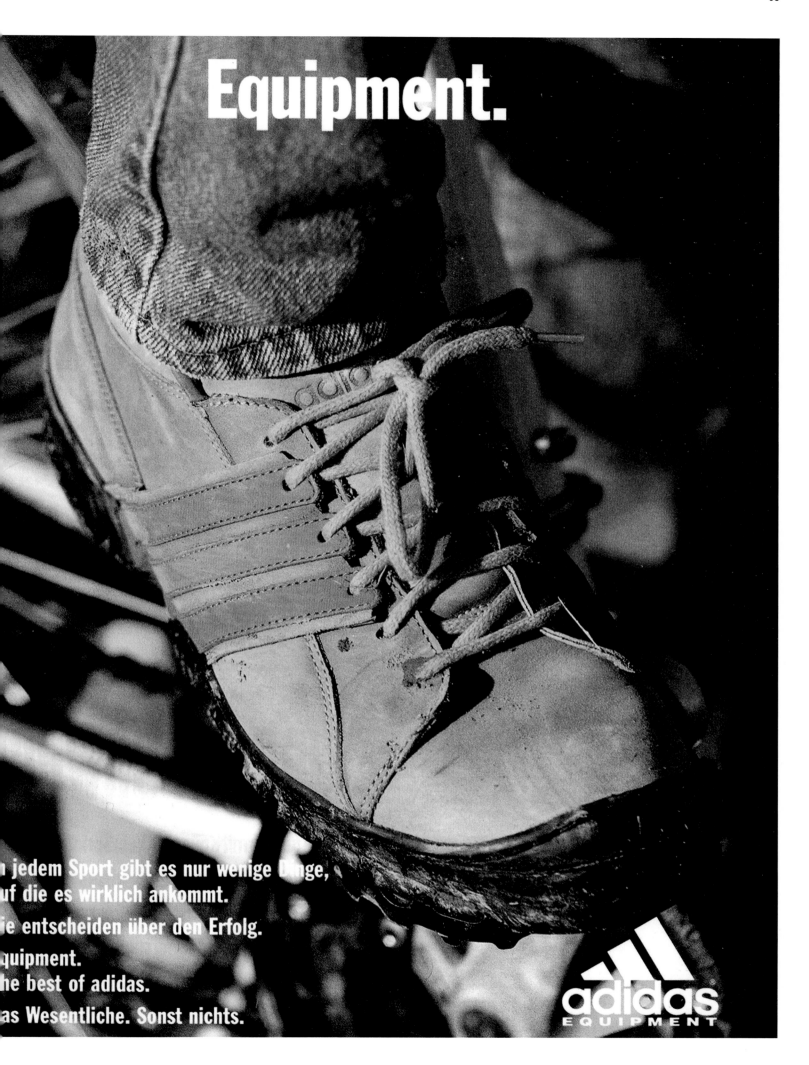

Equipment.

n jedem Sport gibt es nur wenige Dinge,
uf die es wirklich ankommt.
ie entscheiden über den Erfolg.
quipment.
he best of adidas.
as Wesentliche. Sonst nichts.

adidas
EQUIPMENT

Tennis Equipment.

Equipment. The best of adidas.
Everything that is essential. And nothing that is not.

1991: Equipment, 'Tennis Equipment'

" EQT is a revered series of runners, tennis shoes and accessories that existed within the adidas line-up in the early 1990s. EQT stood for Equipment and, like a Lamborghini Countach, the shoes were designed to deliver the ultimate in uncompromising performance. By combining manufacturing excellence with definitive colourways and high-spec material combinations, EQT was found in the exclusive end of the sports store. They weren't cheap in the 1990s and they're certainly not cheap now, with vintage prices for EQT runners well in excess of 1000 euros. And up! The slogan said it all. 'The best of adidas'. **"**

Paul Kampfmann
'Mr EQT'
Sneaker Freaker, issue 22 (2011)

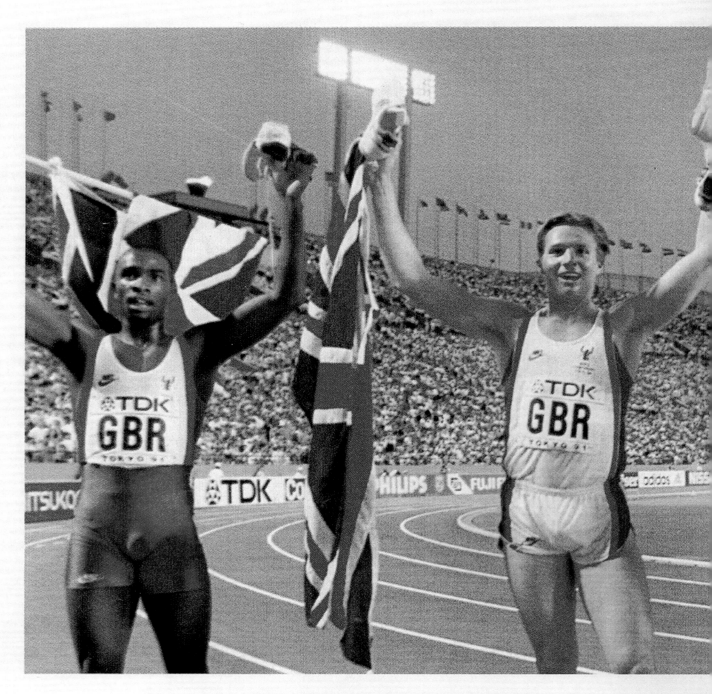

Not bad, considering one of

1991: 'Not Bad, Considering One of Them Wasn't Even Wearing adidas', ft. Derek Redmond, John Regis, Roger Black and Kriss Akabusi

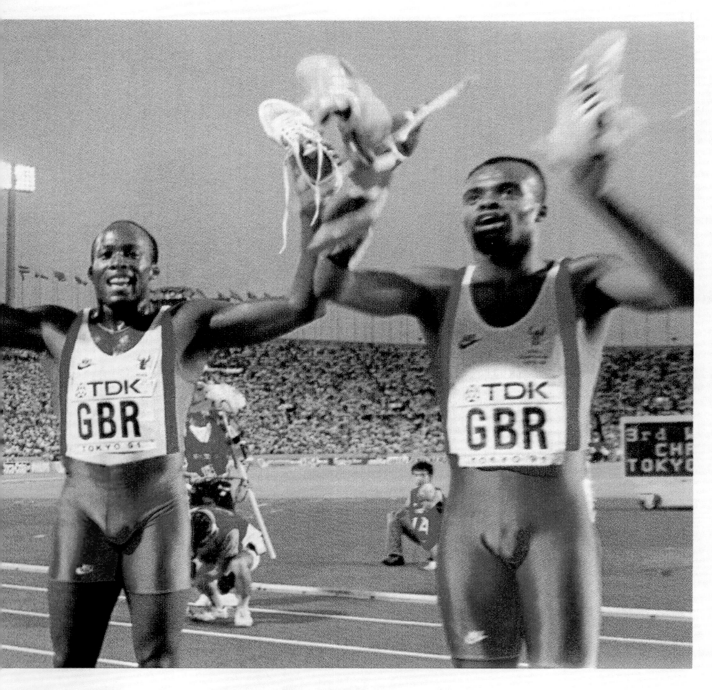

wasn't even wearing adidas.

They kinda spring off the pavement, but they feel sort of
 squishy? Maybe like new shoes every time you put them o
I don't know...

 ...but I've never felt anything like this befo

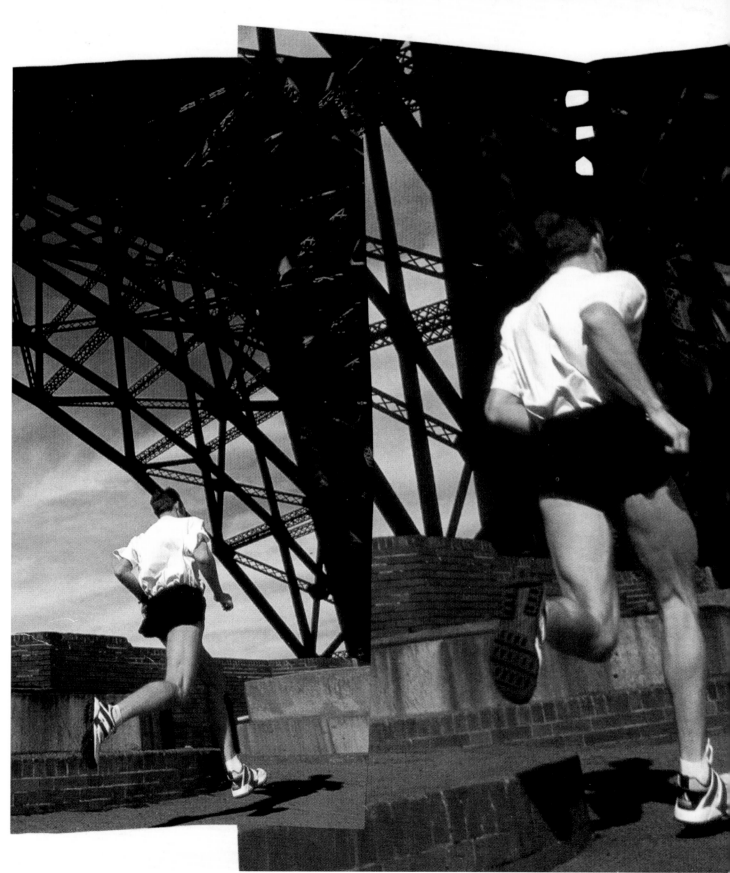

1995: Equipment Cushion 2

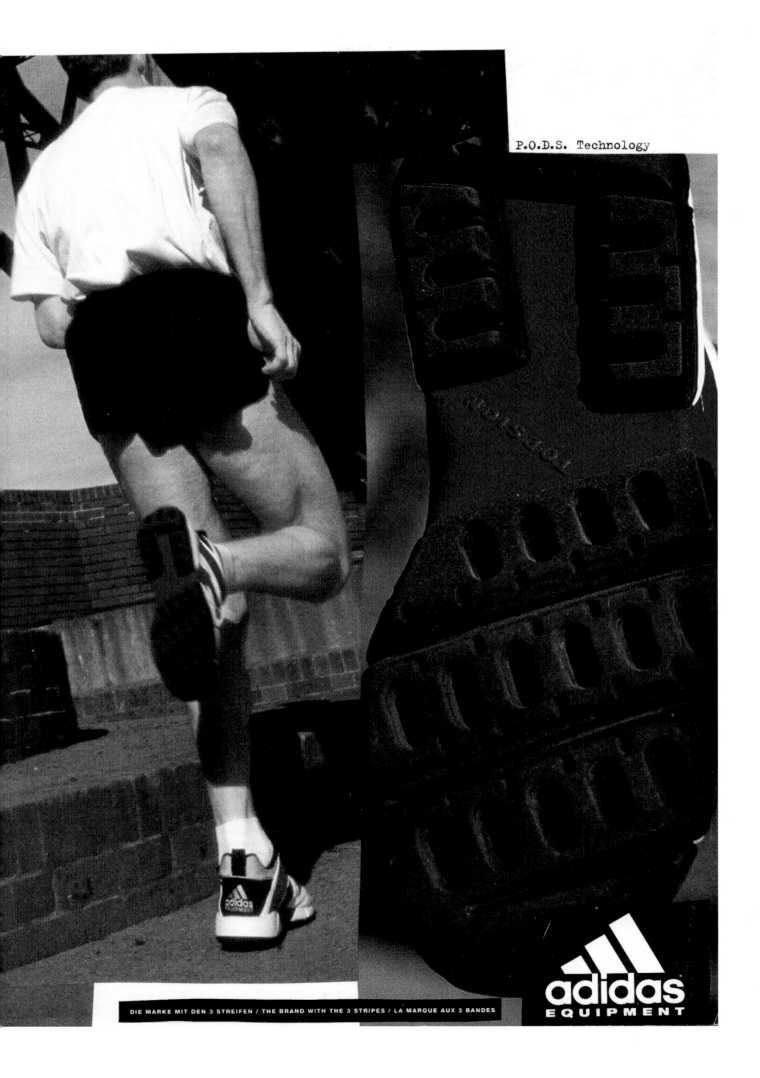

P.O.D.S. Technology

DIE MARKE MIT DEN 3 STREIFEN / THE BRAND WITH THE 3 STRIPES / LA MARQUE AUX 3 BANDES

adidas
EQUIPMENT

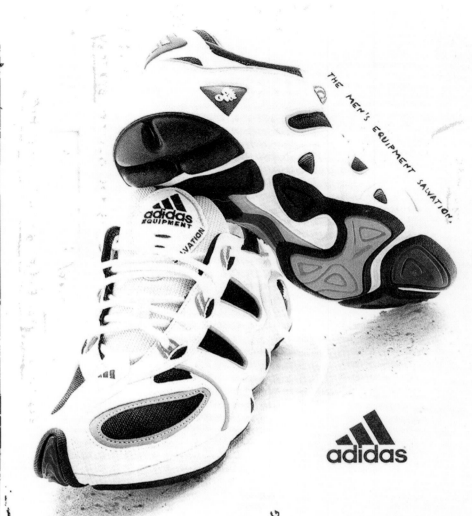

TODD WILLIAMS, U.S. 10,000 METER CHAMPION, WEARS THE EQUIPMENT SALVATION RUNNING SHOE.

TODD'S FEET WORK. WE COPIED THEM.

THE MEN'S EQUIPMENT SALVATION.

FEET YOU WEAR™ SHOES ARE BASED ON THE GREATEST PIECE OF SPORTS EQUIPMENT EVER. THE FOOT.

THE ROUNDED EDGES IMPROVE STABILITY AND SURFACE FEEL. THE TORSION™ SYSTEM INCREASES MIDFOOT SUPPORT WHILE ALLOWING FLEXIBILITY. THE POINT OF DEFLECTION™ SYSTEM ENHANCES HEEL CUSHIONING AT THE POINT OF IMPACT.

BUT WILL THEY IMPROVE YOUR PERFORMANCE? JUST ASK TODD — IF YOU CAN CATCH HIM.

FEET YOU WEAR™

adidas

www.adidas.com
IS A TRADEMARK AND COPYRIGHTED WORK OF adidas AG.

1997: Equipment Salvation, 'Todd's Feet Work. We Copied Them', ft. Todd Williams

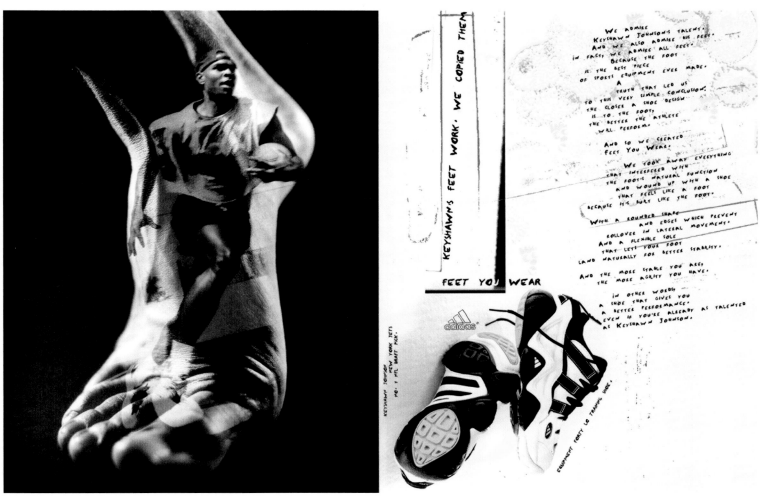

1996: Equipment Forty Lo, 'Keyshawn's Feet Work. We Copied Them', ft. Keyshawn Johnson

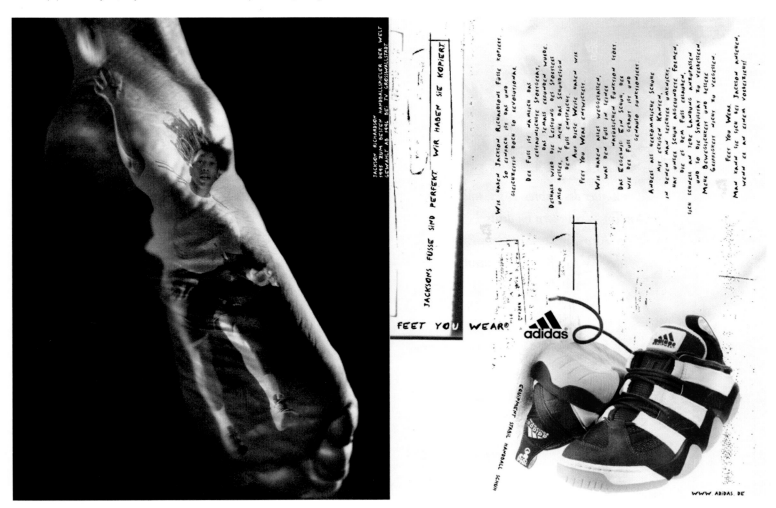

1997: Equipment Stabil Handball, 'Jackson's Feet Work. We Copied Them', ft. Jackson Richardson

KEYSHAWN JOHNSON, NEW YORK JETS, WEARS THE EQUIPMENT KEY TRAINER TRAINING SHOE.

KEYSHAWN'S FEET WORK. WE COPIED THEM.

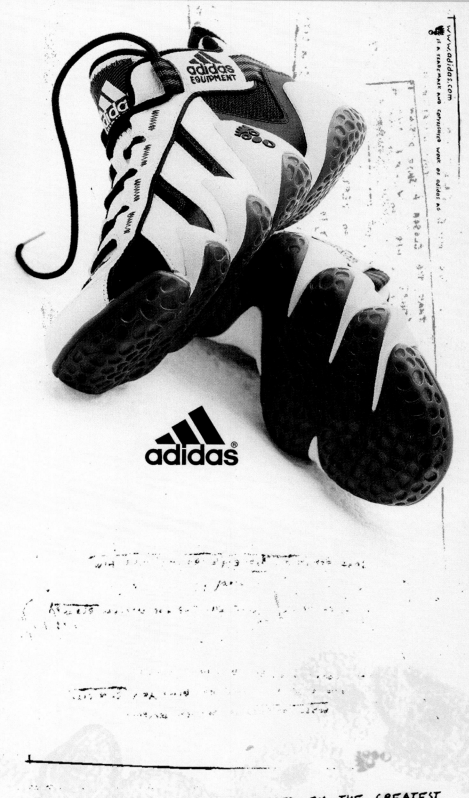

FEET YOU WEAR SHOES ARE BASED ON THE GREATEST

PIECE OF SPORTS EQUIPMENT EVER. THE FOOT.
THEY'VE GOT ROUNDED EDGES AND A WRAPAROUND MIDSOLE.

SO YOU GET BETTER STABILITY. IMPORTANT WHEN YOU CUT
AND MOVE LIKE KEYSHAWN JOHNSON.
 (YOU WISH).

FEET YOU WEAR™

1996: Equipment Key Trainer, 'Keyshawn's Feet Work. We Copied Them', ft. Keyshawn Johnson

1997: Equipment Key Trainer

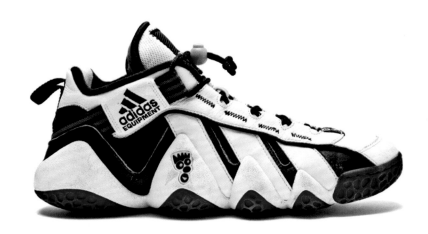

" Identified by exotic ergonomics and bulbous midsole pods that mimicked the human foot, the adidas Feet You Wear range debuted in 1996. An all-star roster of athletes including Kobe Bryant and Steffi Graf projected multi-sport ambitions, though it was Keyshawn Johnson's basketball pro-model with key-shaped hangtags and pink lacelocks that came closest to becoming a bona fide sales phenom. Licensing issues between adidas and inventor Frampton Ellis resulted in Feet You Wear's abrupt conclusion in 2001, though the franchise was subsequently rebooted in the late 2010s via adidas Consortium retros and collaborations with KITH and Yohji Yamamoto. BTW… Feet You Wear's comical Fido Dido-esque logo drawn in the shape of a human foot was known as Freddy. "

Minh Vuong
'Feet You Wear is Back in Town'
Sneakerfreaker.com (2019)

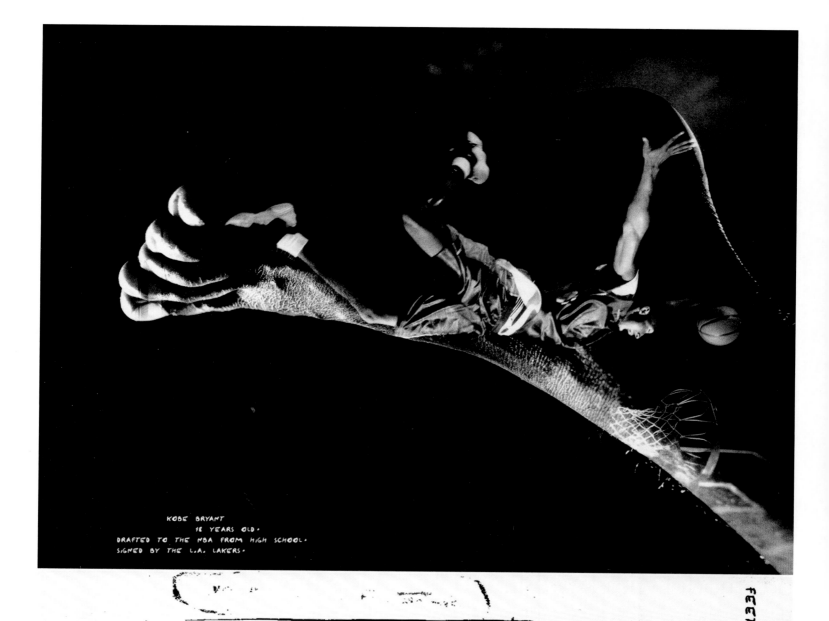

KOBE BRYANT
18 YEARS OLD.
DRAFTED TO THE NBA FROM HIGH SCHOOL.
SIGNED BY THE L.A. LAKERS.

KOBE'S FEET WORK. WE COPIED THEM.

FEET YOU WEAR

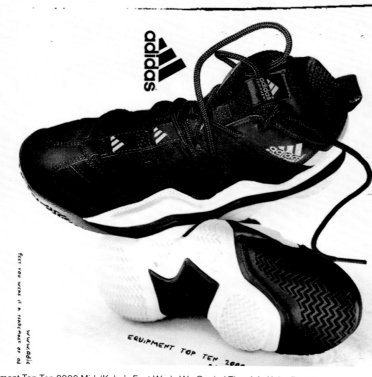

WE CAN'T GIVE YOU KOBE'S TALENT,
BUT WE CAN GIVE YOU HIS FEET.
SORT OF.

WHEN DESIGNING KOBE'S SHOE,
WE LOOKED AT HIS FEET.
AND CAME TO
THIS REALIZATION:
THE FOOT IS THE BEST
PIECE OF SPORTS EQUIPMENT EVER MADE.
WHICH LED TO A VERY SIMPLE TRUTH:
THE CLOSER A SHOE DESIGN IS TO THE FOOT,
THE BETTER THE ATHLETE WILL PERFORM.

AND SO WE CREATED FEET YOU WEAR. A
SHOE THAT IS BUILT LIKE YOUR FOOT,
TO WORK LIKE YOUR FOOT.

WHEN YOU JUMP, THE ROUNDED
SHAPE AND EDGES ALLOW
YOUR FOOT TO RECOVER STABILITY
WHEN IT LANDS.
AND THE FOOT-LIKE SOLE ACTS
LIKE YOUR FOOT TO LET YOU CUT FASTER.

BETTER STABILITY,
BETTER AGILITY,
BETTER FEEL.
WHICH MEANS YOU PERFORM BETTER.
AND,

1996: Equipment Top Ten 2000 Mid, 'Kobe's Feet Work. We Copied Them', ft. Kobe Bryant

ADAMS FÜSSE SIND PERFEKT. WIR HABEN SIE KOPIERT.

ADAM HEANEY
TEILNEHMER BEIM
"SURVIVAL OF THE FITTEST".

FEET YOU WEAR

ADAM HEANEY HAT EINZIGARTIGE FÜSSE. UND EIGENTLICH IST DER FUSS DAS BESTE SPORTGERÄT, DAS JEMALS ERFUNDEN WURDE. EINE TATSACHE, DIE UNS ZU DEM EINFACHEN SCHLUSS BRACHTE, DASS DIE LEISTUNG EINES SPORTLERS UMSO BESSER WIRD, JE MEHR DAS SCHUHDESIGN DEM FUSS ENTSPRICHT.

UND DAS FÜHRTE UNS ZU FEET YOU WEAR.

EIN SCHUH, DER WIE DER FUSS GEBAUT IST UND GENAUSO FUNKTIONIERT. ER IST RUND, INNEN WIE AUSSEN. DADURCH KANN ER SICH BESONDERS GUT AN UNEBENES GELÄNDE ANPASSEN. UND SEINE FLEXIBLE SOHLE GIBT EINEM SELBST DANN STABILITÄT, WENN MAN GERADE EINEN ABHANG HINUNTER RENNT.

MIT ANDEREN WORTEN EIN SCHUH, DER DIE LEISTUNGSFÄHIGKEIT VERBESSERT. MAN BRAUCHT NUR ADAM HEANEY ZU FRAGEN. WENN MAN IHN ERWISCHT.

EQUIPMENT XTR ADVENTURE SCHUH

adidas

1996: Equipment XTR Adventure, 'Adam's Feet Work. We Copied Them', ft. Adam Heaney

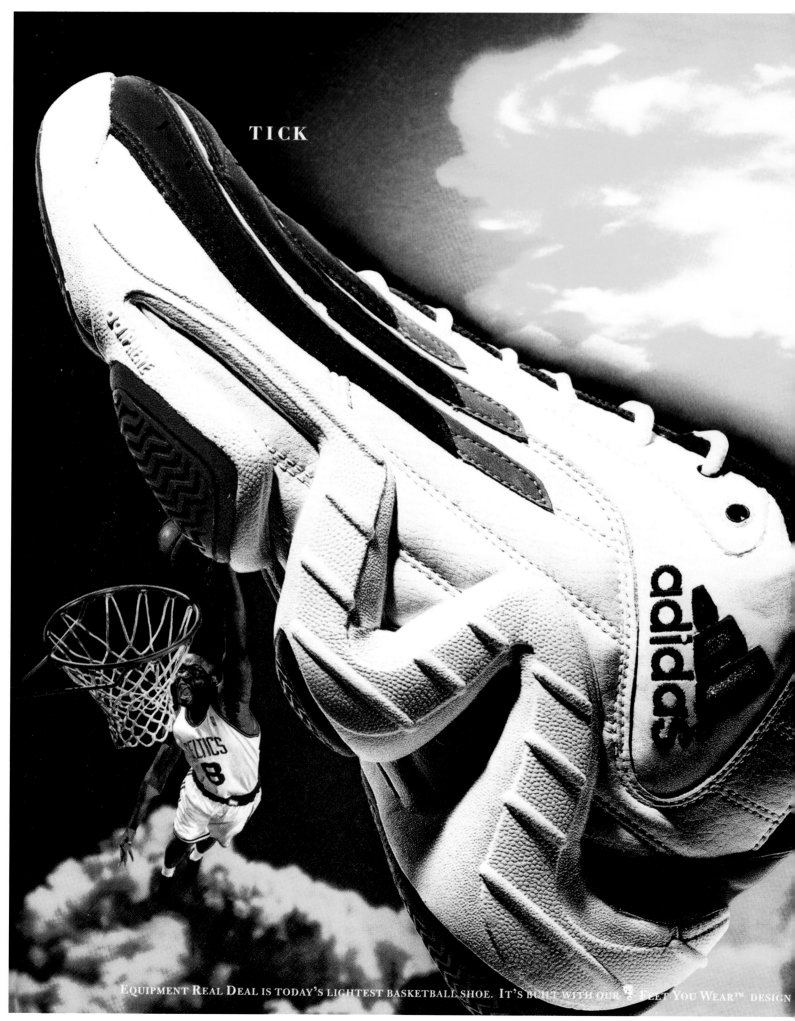

TICK

EQUIPMENT REAL DEAL IS TODAY'S LIGHTEST BASKETBALL SHOE. IT'S BUILT WITH OUR FEET YOU WEAR™ DESIGN

1997: Equipment Real Deal, 'Tick Tick', ft. Antoine Walker

TICK

TICK

www.adidas.com

adidas

RMS LIKE THE PLAYER'S NATURAL FOOT. THE RESULT IS A SHOE THAT GIVES YOU A FASTER EDGE. DON'T HURT SOMEBODY.

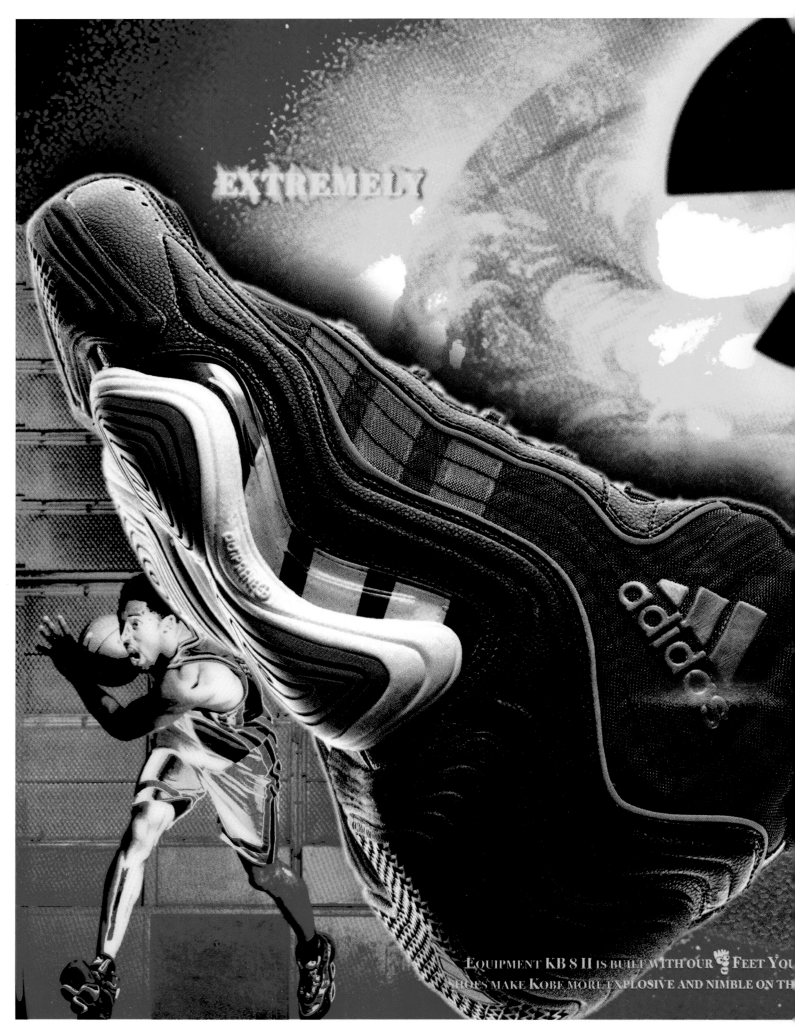

1998: Equipment KB 8 II, 'Extremely Reactive', ft. Kobe Bryant

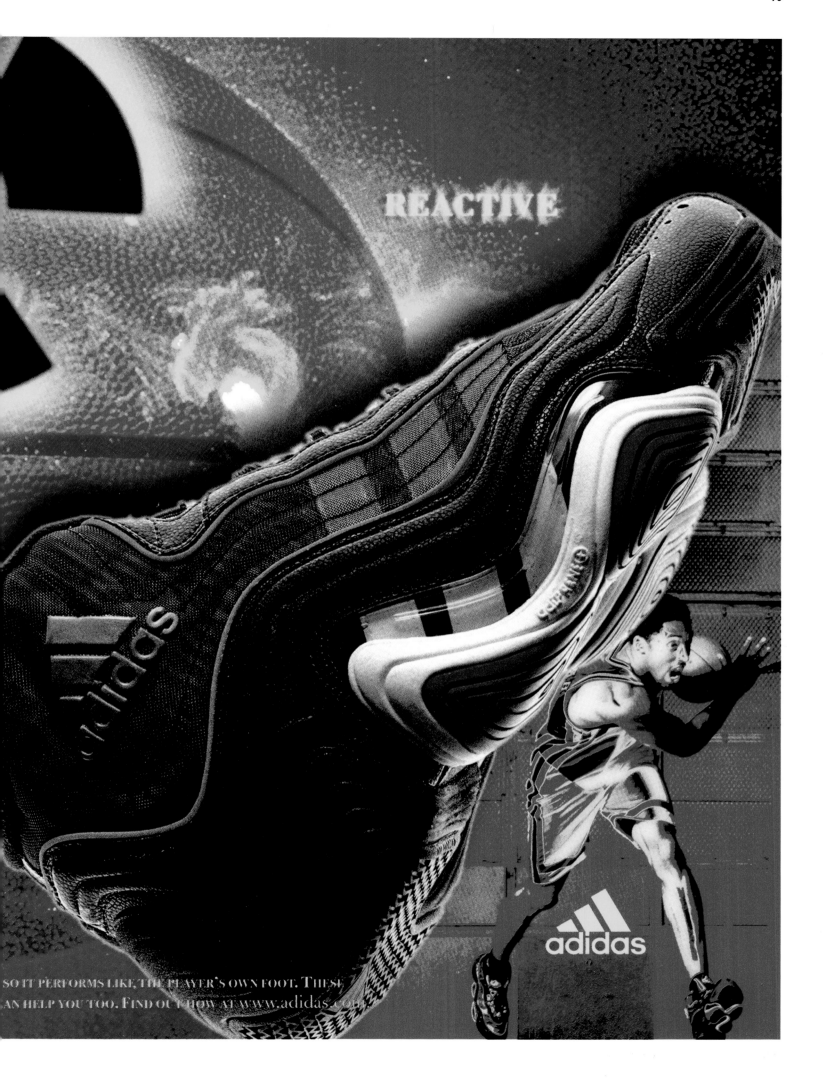

1998: Equipment Badlander, 'Go Where You Feel Most Alive'

KAUKASUS

HIMALAJA

PYRENÄEN

FEEL MOST ALIVE.

www.adidas.de

adidas®

DVENTURESCHUH BASIERT AUF UNSERER ♂ FEET YOU WEAR® TECHNOLOGIE. DER BERG RUFT. ANTWORTE.

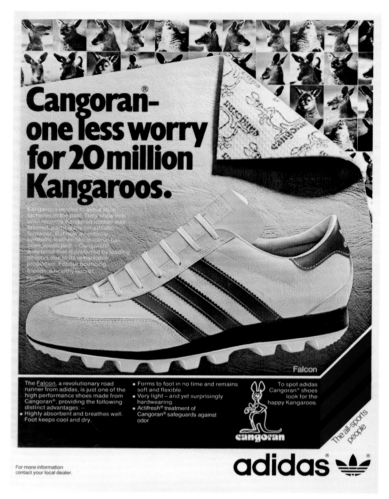

1977: Falcon, 'Cangoran – One Less Worry for 20 Million Kangaroos'

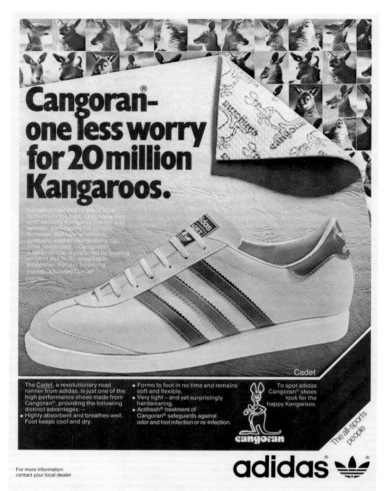

1977: Cadet, 'Cangoran – One Less Worry for 20 Million Kangaroos'

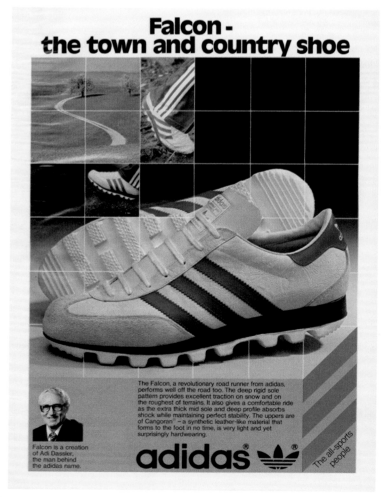

1978: Falcon, 'Falcon – The Town and Country Shoe'

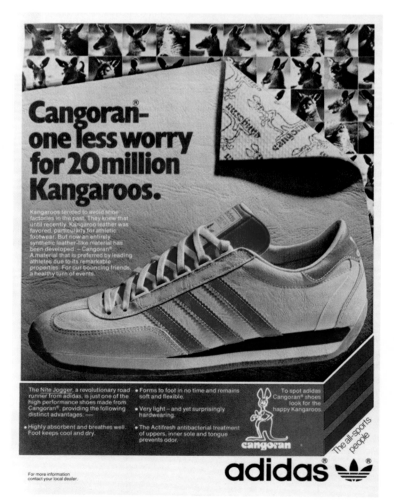

1977: Nite Jogger, 'Cangoran – One Less Worry for 20 Million Kangaroos'

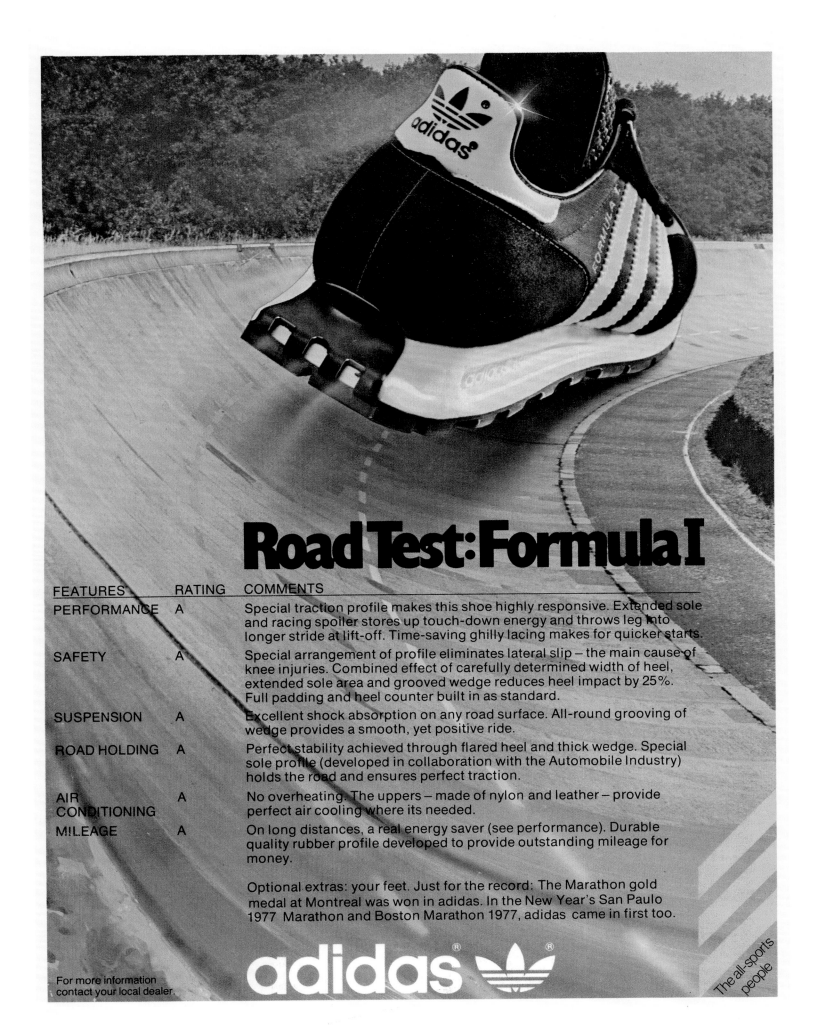

Road Test: Formula I

FEATURES	RATING	COMMENTS
PERFORMANCE	A	Special traction profile makes this shoe highly responsive. Extended sole and racing spoiler stores up touch-down energy and throws leg into longer stride at lift-off. Time-saving ghilly lacing makes for quicker starts.
SAFETY	A	Special arrangement of profile eliminates lateral slip – the main cause of knee injuries. Combined effect of carefully determined width of heel, extended sole area and grooved wedge reduces heel impact by 25%. Full padding and heel counter built in as standard.
SUSPENSION	A	Excellent shock absorption on any road surface. All-round grooving of wedge provides a smooth, yet positive ride.
ROAD HOLDING	A	Perfect stability achieved through flared heel and thick wedge. Special sole profile (developed in collaboration with the Automobile Industry) holds the road and ensures perfect traction.
AIR CONDITIONING	A	No overheating. The uppers – made of nylon and leather – provide perfect air cooling where its needed.
M!LEAGE	A	On long distances, a real energy saver (see performance). Durable quality rubber profile developed to provide outstanding mileage for money.

Optional extras: your feet. Just for the record: The Marathon gold medal at Montreal was won in adidas. In the New Year's San Paulo 1977 Marathon and Boston Marathon 1977, adidas came in first too.

For more information contact your local dealer.

adidas ®

The all-sports people

1977: Formula 1, 'Road Test: Formula I'

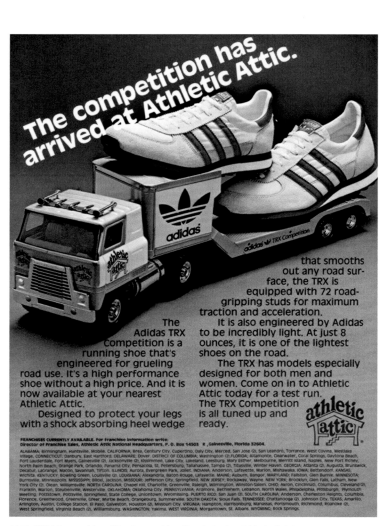

that smooths out any road surface, the TRX is equipped with 72 road-gripping studs for maximum traction and acceleration.

It is also engineered by Adidas to be incredibly light. At just 8 ounces, it is one of the lightest shoes on the road.

The Adidas TRX Competition is a running shoe that's engineered for grueling road use. It's a high performance shoe without a high price. And it is now available at your nearest Athletic Attic.

Designed to protect your legs with a shock absorbing heel wedge

The TRX has models especially designed for both men and women. Come on in to Athletic Attic today for a test run. The TRX Competition is all tuned up and ready.

1978: TRX Competition, 'The Competition Has Arrived at Athletic Attic'

Our research staff

At adidas we know it takes a special kind of research to develop a shoe that fits a runner's psyche as comfortably as it fits his feet.

That's why we asked active runners to help us design the new adidas SL80 with everything it needs to be as easy on the spirit as it is on the body.

It's why we shaped the SL80's two material sole with a unique adidas tread core for flexibility and durability.

Why we constructed it with a special lacing system that flexes to conform to the size and shape of the foot.

And why we built-in a wide toe box to alleviate pressure.

The new adidas SL80. It takes running a step further.

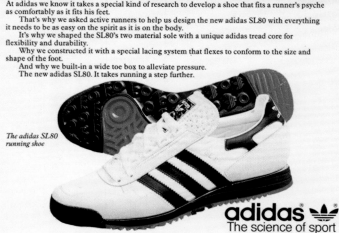

The adidas SL80 running shoe

adidas
The science of sport

1979: SL80, 'Our Research Staff'

Our road test.

To develop the new adidas TRX Competition required the most trained scientists in the field: America's runners.

They insisted the TRX Competition be incredibly light. At just 8 ounces*, it is.

They required it to provide the foot with maximum stability. The kind of stability only our proven adidas heel counter could ensure.

And they demanded its sole be responsive. So we created it of 72 gripping road studs that deliver sure traction in any weather, even on curved or banked surfaces.

Then they put the adidas TRX Competition through their ultimate test: they ran it on the road.

Our scientists are back with their results. The adidas TRX Competition out-ran their expectations. Now let it run for you.

*Men's size 8½.

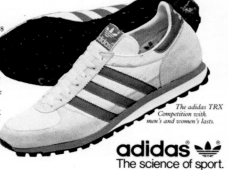

The adidas TRX Competition with men's and women's lasts.

adidas
The science of sport.

1979: TRX Competition, 'Our Road Test'

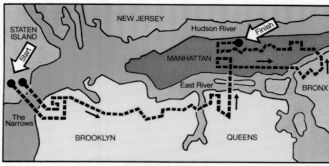

Our test track.

We put everything science could offer into our new adidas Marathon 80. Then we put our Marathon 80 to the ultimate test. The New York City Marathon.

To prove that adidas' lightest running shoe (a mere 6.3 ounces*) can make the difference of a ton less to lift over 26 miles.

To prove that the adidas Marathon 80's divided heel spoiler helps absorb maximum shock, even on the most uneven road surfaces.

To prove that the Marathon 80's incredibly sleek silhouette sole of 72 trefoil studs act as glide and stop supports for sure traction. In any weather.

The results are in from the lab. One example: in the 1978 New York City Marathon, the adidas Marathon 80 was worn by the runner who set the sensational new world record for women.

*Men's size 8½.

The Marathon 80. adidas' lightest running shoe.

adidas
The science of sport.

1979: Marathon 80, 'Our Test Track'

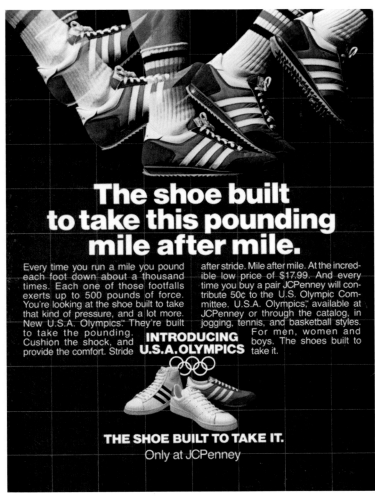

The shoe built to take this pounding mile after mile.

Every time you run a mile you pound each foot down about a thousand times. Each one of those footfalls exerts up to 500 pounds of force. You're looking at the shoe built to take that kind of pressure, and a lot more. New U.S.A. Olympics.™ They're built to take the pounding. Cushion the shock, and provide the comfort. Stride

after stride. Mile after mile. At the incredible low price of $17.99. And every time you buy a pair JCPenney will contribute 50¢ to the U.S. Olympic Committee. U.S.A. Olympics,™ available at JCPenney or through the catalog, in jogging, tennis, and basketball styles. For men, women and boys. The shoes built to take it.

INTRODUCING U.S.A. OLYMPICS

THE SHOE BUILT TO TAKE IT.

Only at JCPenney

1979: U.S.A. Olympics, 'The Shoe Built to Take This Pounding Mile After Mile'

Introducing the adidas Galaxy. It passed every test we could give it.

In creating the adidas Galaxy we were determined to design a racing flat as advanced as the people who'd wear it.
So we fashioned one of the lightest most durable racing shoes the world has ever seen.
And gave it a unique set of scientific advantages that tested out for superior performance.
The adidas Galaxy passed every test we could give it.
Now it is ready to be tested by you.

adidas
The science of sport

1979: Galaxy, 'Introducing the adidas Galaxy. It Passed Every Test We Could Give It'

TRX – a revolution in Traction Dynamics

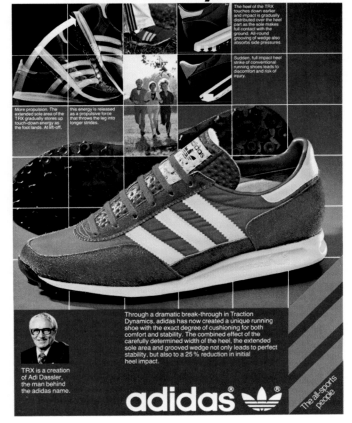

Through a dramatic break-through in Traction Dynamics, adidas has now created a unique running shoe with the exact degree of cushioning for both comfort and stability. The combined effect of the carefully determined width of the heel, the extended sole area and grooved wedge not only leads to perfect stability, but also to a 25% reduction in initial heel impact.

TRX is a creation of Adi Dassler, the man behind the adidas name.

adidas

1979: TRX, 'TRX – A Revolution in Traction Dynamics'

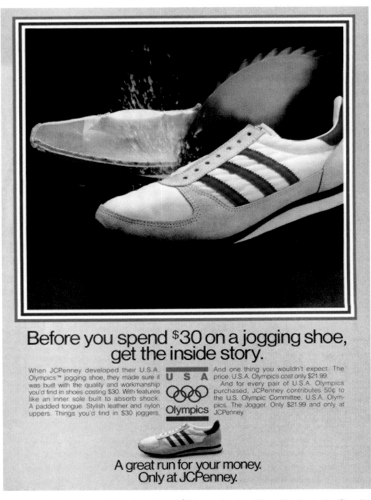

Before you spend $30 on a jogging shoe, get the inside story.

When JCPenney developed their U.S.A. Olympics™ jogging shoe, they made sure it was built with the quality and workmanship you'd find in shoes costing $30. With features like an inner sole built to absorb shock. A padded tongue. Stylish leather and nylon uppers. Things you'd find in $30 joggers.

And one thing you wouldn't expect. The price. U.S.A. Olympics cost only $21.99. And for every pair of U.S.A. Olympics purchased, JCPenney contributes 50¢ to the U.S. Olympic Committee. U.S.A. Olympics. The Jogger. Only $21.99 and only at JCPenney.

U S A Olympics

A great run for your money.
Only at JCPenney.

1980: U.S.A. Olympics, 'Before You Spend $30 on a Jogging Shoe, Get the Inside Story'

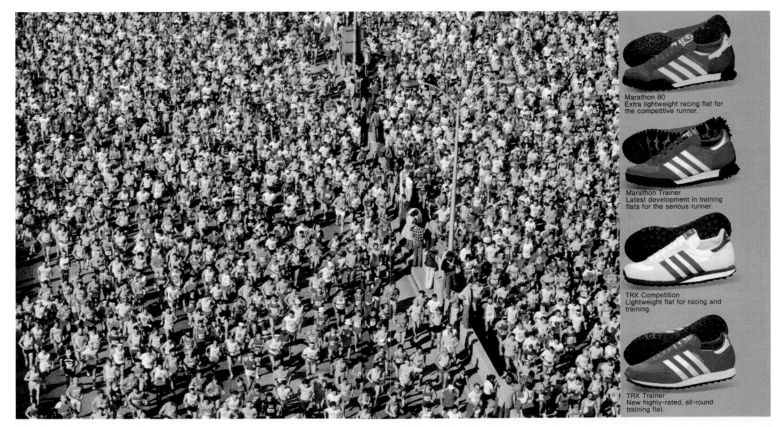

We've got a feeling for winning.

"Whether your goal is to run in Two Hours and Ten or Ten Hours and Two, adidas is there to help with the most winning gear in the World."

1980: Marathon 80, Marathon Trainer, TRX Competition and TRX Trainer, 'We've Got a Feeling for Winning'

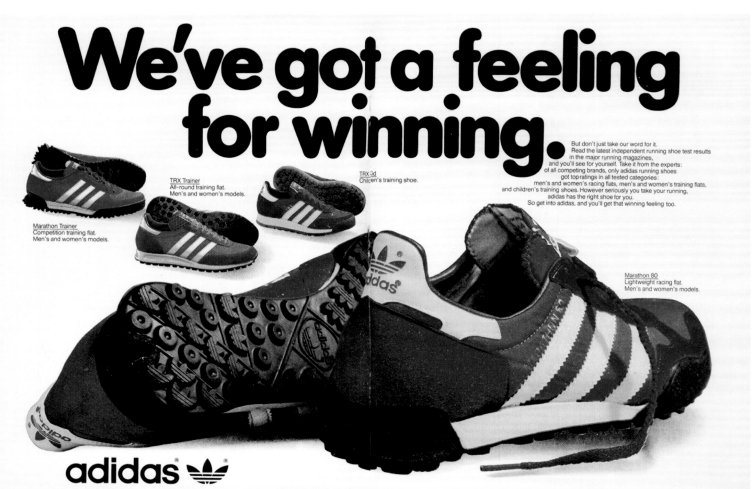

1980: Marathon Trainer, TRX Trainer, TRX Kid and Marathon 80, 'We've Got a Feeling for Winning'

Long distance runners shouldn't wear short distance shoes.

Lightweight, breathing nylon uppers, reinforced with velour leather at points of most wear.

Midsole wedge of shock-absorbing Elasto-air material. Rubber outer sole with 72 road-gripping studs.

Our TRX trainers are designed to keep a runner running: they have a special studded sole, a special polyurethane heel wedge and special padding. The way we see it, long distance running is supposed to give you peace of mind. So your shoes should cope with the weather, the hills, the valleys and the grinding asphalt, and, afford you maximum protection and durability. The TRX Trainer. All the way.

adidas
We've got a feeling for winning.

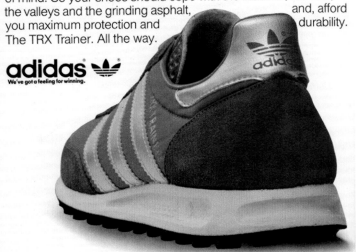

At last! The shoe that fits more than your foot.

Breathing nylon mesh uppers with velour leather reinforcement, and ankle and heel padding.

Shock absorbing rubber sole with slanted multi-studs.

A 150 pound man who runs on the road should not buy the same pair of shoes as a 200 pound man who runs in the park, right? Wrong. Wrong, that is, if they both buy adidas' new Los Angeles Trainer. The adidas Los Angeles Trainer comes with a set of adjustable shock-absorbing rods which allow a runner to fine tune his shoes according to his weight and the surface he runs on. Remarkable, you say? No, just adidas.

adidas Los Angeles Trainer.

adidas
We've got a feeling for winning.

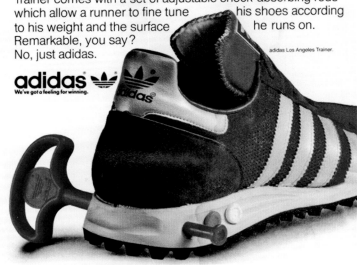

1981: TRX Trainer, 'Long Distance Runners Shouldn't Wear Short Distance Shoes'

1981: Los Angeles Trainer, 'At Last! The Shoe That Fits More Than Your Foot'

adidas reports:

Bill Dellinger has discovered a new use for Newton's Third Law of Motion.

As most of you know, Bill Dellinger is the University of Oregon's running coach; and he will be doing the same honors for the United States Olympic Team in 1984. He has become world-renowned for getting the most out of some of the finest runners around. But now, he's about to become equally famous for getting extra performance from a gentleman who had his peak many years ago. Because he and adidas have developed a way to harness Sir Issac's fundamental law that will make a fundamental difference to runners.

Close-up of The Web.

shock. Up to ten percent of the shock, in fact. Ten percent that the runner doesn't ever feel. Which means that the runner has ten percent more energy to devote to running instead of shock absorption. As if that weren't enough, there's even another advantage to The Web. The heel impact puts The Web in a state of tension, with some areas compressed and others stretched. As the runner rolls forward into the next stride, The Web springs back, giving a trampoline effect. And all of this is accomplished without sacrificing stability, and with no gain in thickness or bulk.

Dellinger's Law:
"You pay for the whole shoe, why not use it?"

As we've explained, most running shoes only use part of the sole most of the time, an inefficiency your whole body pays for directly. But now with The Web, you can have a shoe that does part of the work you've been used to doing. The adidas-developed Web is currently available in the Atlanta, Oregon, and Lady Oregon. Only from adidas, the company that can bring the laws of physics to heel.

normal shoe

adidas

Distribution of impact shock.

The Dellinger Web: For runners, it's a loophole in the Third Law of Motion.

Newton's dictum states that for every action, there must be an equal and opposite reaction. Until now, for runners, this has meant that what goes down (in terms of initial heel shock), must go up (as an equal shock transmitted straight up the leg). But The Web disperses part of the heel shock throughout the entire sole of the shoe, where it is not felt by the leg. So in effect, what goes down goes sideways as well as up.

The Web: What it is and how it works.

The Web is a unique polyamide netting that covers the midsole from heel to toe. To a runner, this simply means a type of construction that can significantly reduce leg fatigue.

When a runner's heel strikes the ground, it compresses the netting in the heel area. This compressed netting in turn pulls in on the rest of the netting throughout the entire sole of the shoe. The resistance of the netting and sole acts much like a torsion bar to absorb part of the impact

© adidas U.S.A. 1982

Atlanta

Oregon

Lady Oregon

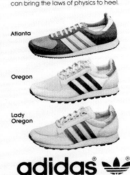

adidas

1982: Atlanta, Oregon and Lady Oregon, 'Bill Dellinger Has Discovered a New Use for Newton's Third Law of Motion', ft. Bill Dellinger

GOLD AHEAD L.A. '84

adidas reports:

In Rome, Tokyo, Mexico City, Munich, Montreal, and Moscow, athletes wearing adidas won three times as many medals as all other shoes.

Combined.

Right now, top athletes all over the world are training for the '84 Olympics. And soon the best will gather, records will fall, and the world will once again marvel at the triumph of pride over possibility.

If past history is any guide, most of the medals will go to those who go with adidas. Because we've been outfitting winners since before Jesse Owens astonished the world in our 1936 model.

Our success is no coincidence. We don't just design our shoes from the ground up. We also design them from the specific event involved, and the unique demands each makes on both the athlete and the shoe. Each shoe is an original, representing a fresh set of solutions to the problems inherent in that event only. It's specialization taken to the logical extreme. So, logically, track and field specialists come to us when it comes to their feet.

We're honored to have such an important place in the Olympic picture, and we'd like to wish everyone the best of luck. See you in L.A.

adidas ®

1983: 'Gold Ahead L.A. '84'

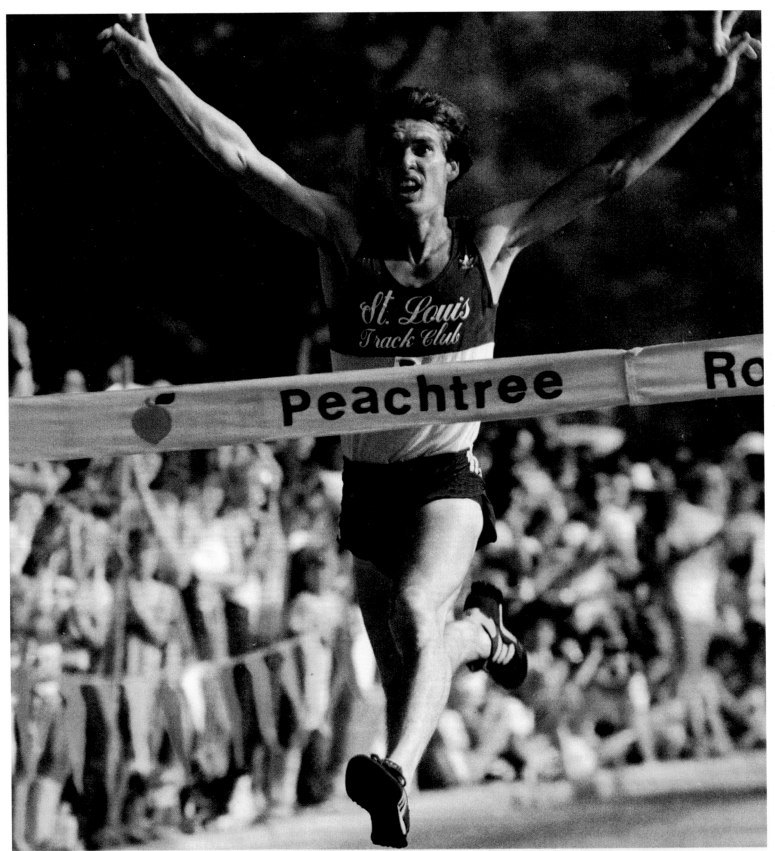

We've got a feeling for winning.

Victory is sweet whether you're racing the clock or fighting yourself to get around the park before breakfast. And adidas is there to help with the most winning gear in the world .

Marathon 80
Lightweight
racing flat

1980: Marathon 80 Lightweight, 'We've Got a Feeling for Winning', ft. Craig Virgin

Wherever you live, run in New York.

adidas reports:

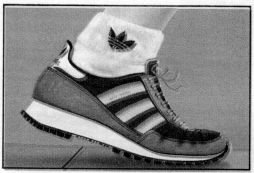

We put some great support and shock absorption features into this shoe. And we did it all without adding any weight or bulk. In fact, the New York is just about the lightest, most flexible training shoe on the market today.

We're sure you'll be impressed with the look, the comfort, the durability of this remarkable shoe. So no matter where you live, come run in New York.

Whether you live in Chicago, Los Angeles, in Montana or Maine, adidas has a suggestion for you: why don't you run in New York?

Our New York. The latest in a line of outstanding running shoes from adidas. Give it a workout. And discover how really special New York is.

For starters, it has an extended heel counter and a new solid carbon rubber outsole, with a concave profile, to help lead your foot and insure proper follow through on every stride. Why is leading the foot so important? Because correct placement and follow through reduce pronation, thereby helping to prevent stress and lessening your chance of injury.

The New York is incredibly comfortable, too, thanks to our unique adi-air midsole. A midsole that cushions your foot every step of the way. What's more, we've also placed an EVA heel stabilizer at the heel strike position. That means you'll get the rear foot control every runner needs.

EVA heel stabilizer.

Extended heel counter.

The New York
adidas ® ⬩

1983: New York, 'Wherever You Live, Run in New York'

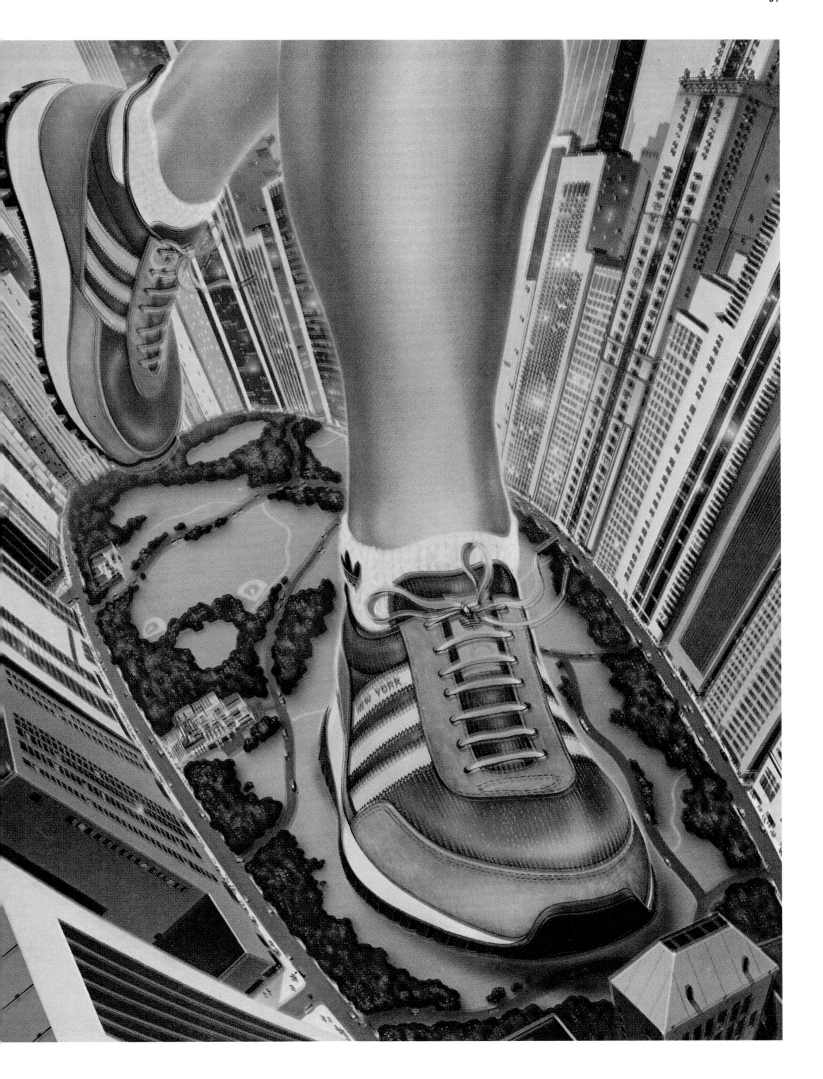

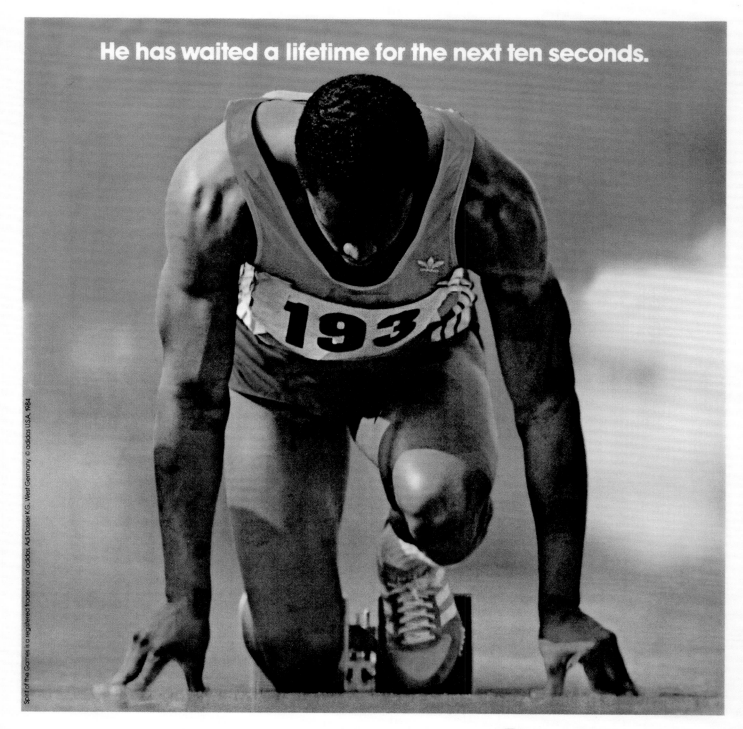

When she flies, our hearts soar.

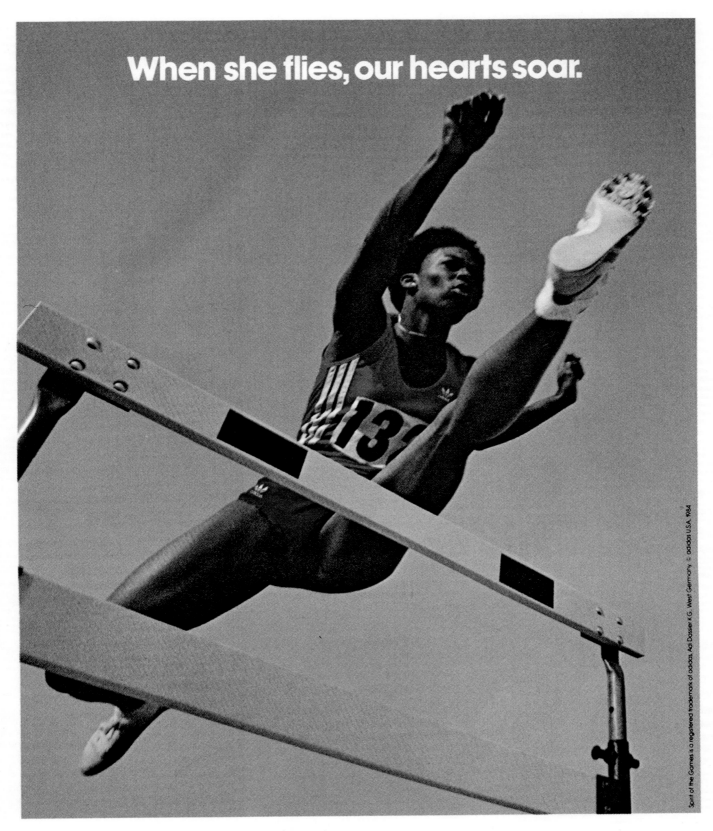

We dream of excellence. She shows us what it looks like. Now, after years of struggle and dedication, her moment is here. Win or lose, she has done something remarkable. And when she flies our hearts and our dreams and pride go with her.

That's the Spirit of the Games. adidas.

1984: Spirit of the Games, 'When She Flies, Our Hearts Soar'

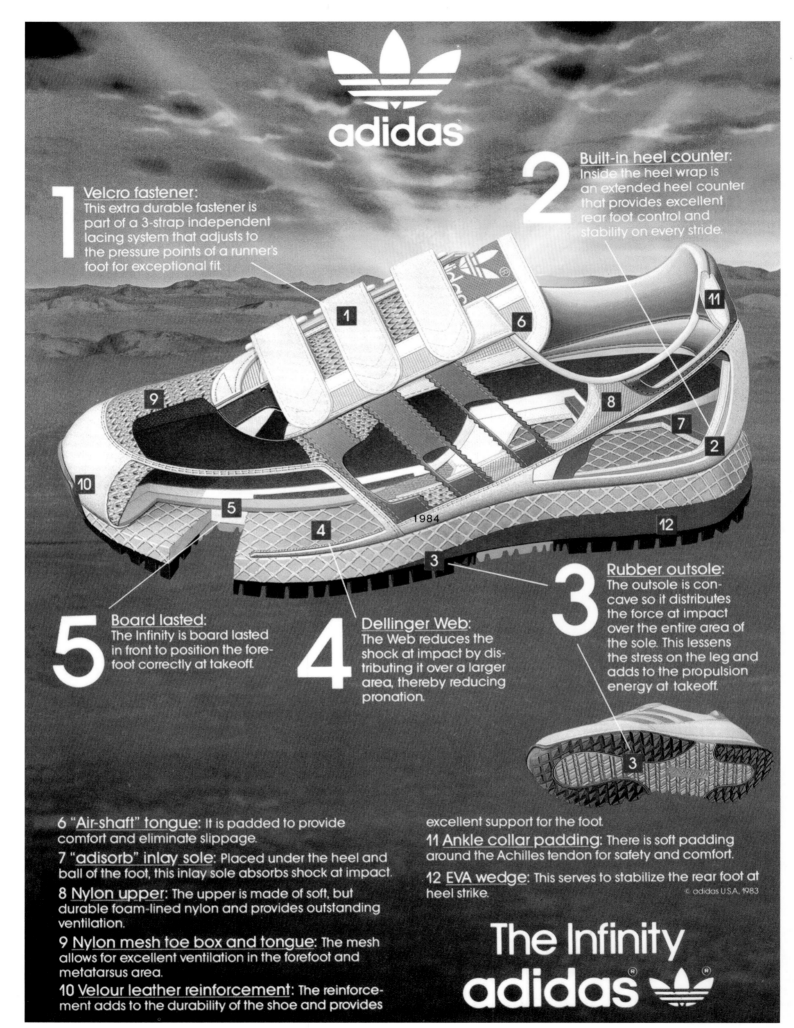

adidas

1 Velcro fastener: This extra durable fastener is part of a 3-strap independent lacing system that adjusts to the pressure points of a runner's foot for exceptional fit.

2 Built-in heel counter: Inside the heel wrap is an extended heel counter that provides excellent rear foot control and stability on every stride.

1984

5 Board lasted: The Infinity is board lasted in front to position the forefoot correctly at takeoff.

4 Dellinger Web: The Web reduces the shock at impact by distributing it over a larger area, thereby reducing pronation.

3 Rubber outsole: The outsole is concave so it distributes the force at impact over the entire area of the sole. This lessens the stress on the leg and adds to the propulsion energy at takeoff.

6 "Air-shaft" tongue: It is padded to provide comfort and eliminate slippage.

7 "adisorb" inlay sole: Placed under the heel and ball of the foot, this inlay sole absorbs shock at impact.

8 Nylon upper: The upper is made of soft, but durable foam-lined nylon and provides outstanding ventilation.

9 Nylon mesh toe box and tongue: The mesh allows for excellent ventilation in the forefoot and metatarsus area.

10 Velour leather reinforcement: The reinforcement adds to the durability of the shoe and provides

excellent support for the foot.

11 Ankle collar padding: There is soft padding around the Achilles tendon for safety and comfort.

12 EVA wedge: This serves to stabilize the rear foot at heel strike.

© adidas U.S.A. 1983

The Infinity
adidas ®

1983: Infinity

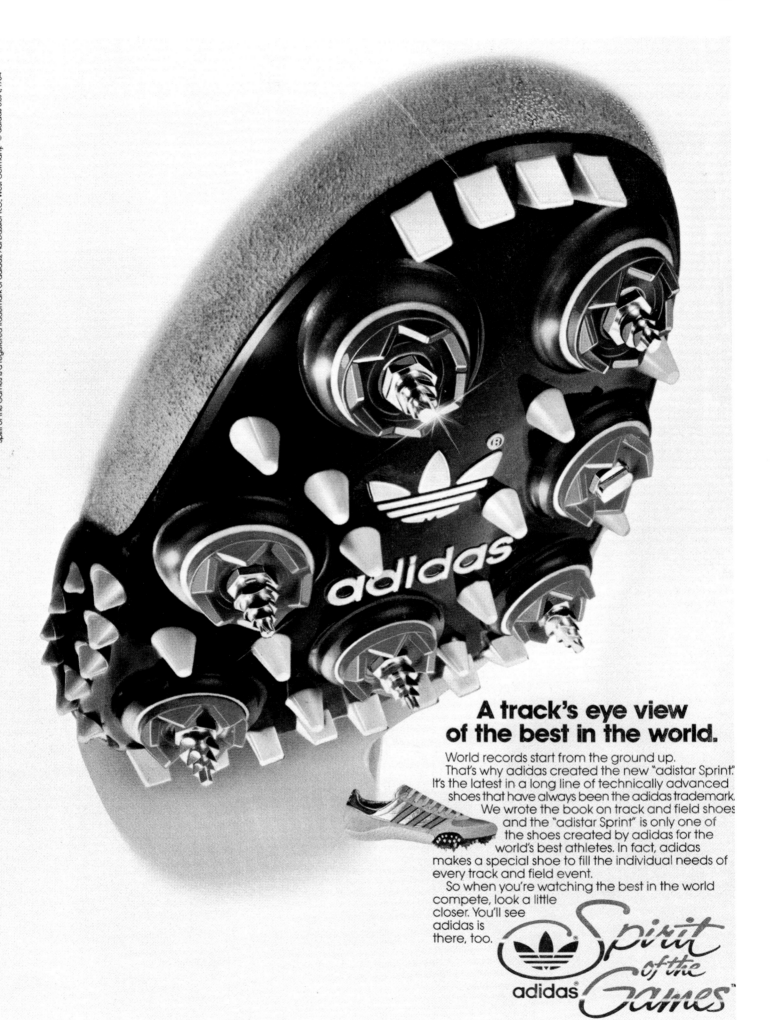

A track's eye view of the best in the world.

World records start from the ground up.
That's why adidas created the new "adistar Sprint."
It's the latest in a long line of technically advanced
shoes that have always been the adidas trademark.
We wrote the book on track and field shoes
and the "adistar Sprint" is only one of
the shoes created by adidas for the
world's best athletes. In fact, adidas
makes a special shoe to fill the individual needs of
every track and field event.
So when you're watching the best in the world
compete, look a little
closer. You'll see
adidas is
there, too.

adidas Spirit of the Games

1984: adistar Sprint, 'A Track's Eye View of the Best in the World'

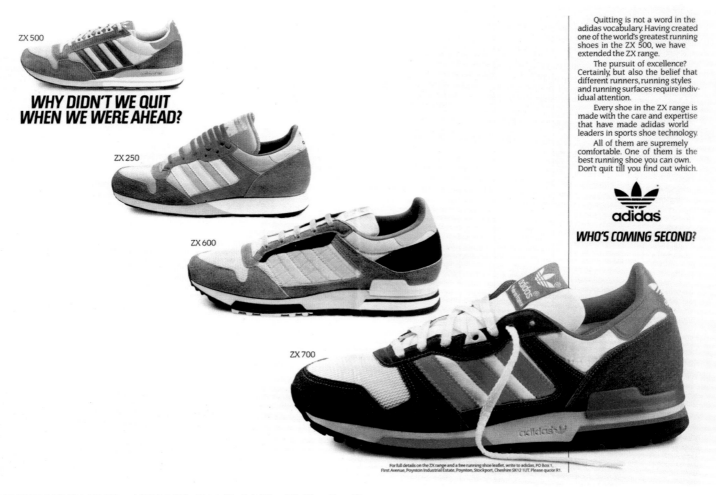

ZX 500

WHY DIDN'T WE QUIT WHEN WE WERE AHEAD?

ZX 250

ZX 600

ZX 700

Quitting is not a word in the adidas vocabulary. Having created one of the world's greatest running shoes in the ZX 500, we have extended the ZX range.

The pursuit of excellence? Certainly, but also the belief that different runners, running styles and running surfaces require individual attention.

Every shoe in the ZX range is made with the care and expertise that have made adidas world leaders in sports shoe technology.

All of them are supremely comfortable. One of them is the best running shoe you can own. Don't quit till you find out which.

WHO'S COMING SECOND?

For full details on the ZX range and a free running shoe leaflet, write to adidas, PO Box 1, First Avenue, Poynton Industrial Estate, Poynton, Stockport, Cheshire SK12 1UT. Please quote IR1.

1985: ZX 500, ZX 250, ZX 600 and ZX 700, 'Why Didn't We Quit When We Were Ahead?'

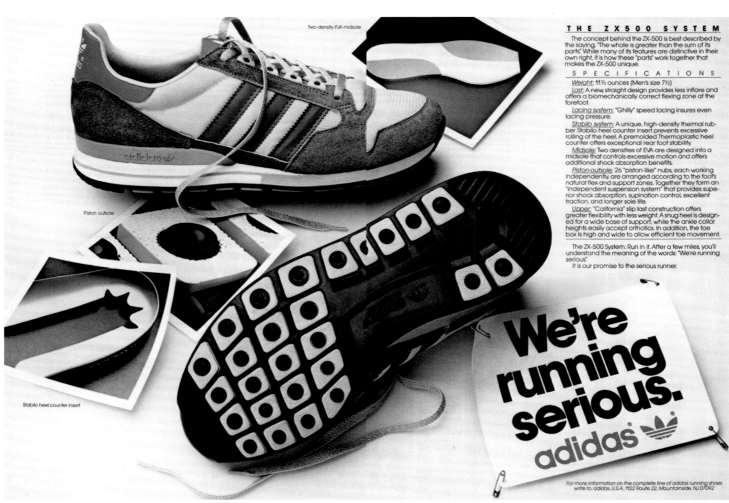

Two-density EVA midsole

Piston outsole

Stabilo heel counter insert

THE ZX 500 SYSTEM

The concept behind the ZX-500 is best described by the saying, "The whole is greater than the sum of its parts." While many of its features are distinctive in their own right, it is how these "parts" work together that makes the ZX-500 unique.

SPECIFICATIONS

Weight: 11½ ounces (Men's size 7½)

Last: A new straight design provides less inflare and offers a biomechanically correct flexing zone at the forefoot.

Lacing system: "Ghilly" speed lacing insures even lacing pressure.

Stabilo system: A unique, high-density thermal rubber Stabilo heel counter insert prevents excessive rolling of the heel. A premolded Thermoplastic heel counter offers exceptional rear foot stability.

Midsole: Two densities of EVA are designed into a midsole that controls excessive motion and offers additional shock absorption benefits.

Piston-outsole: 26 "piston-like" nubs, each working independently, are arranged according to the foot's natural flex and support zones. Together they form an "independent suspension system" that provides superior shock absorption, supination control, excellent traction, and longer sole life.

Upper: "California" slip last construction offers greater flexibility with less weight. A snug heel is designed for a wide base of support, while the ankle collar heights easily accept orthotics. In addition, the toe box is high and wide to allow efficient toe movement.

The ZX-500 System. Run in it. After a few miles, you'll understand the meaning of the words: "We're running serious."

It is our promise to the serious runner.

We're running serious.

adidas

For more information on the complete line of adidas running shoes write to: adidas, U.S.A. 1122 Route 22, Mountainside, NJ 07092

1985: ZX 500 System, 'We're Running Serious'

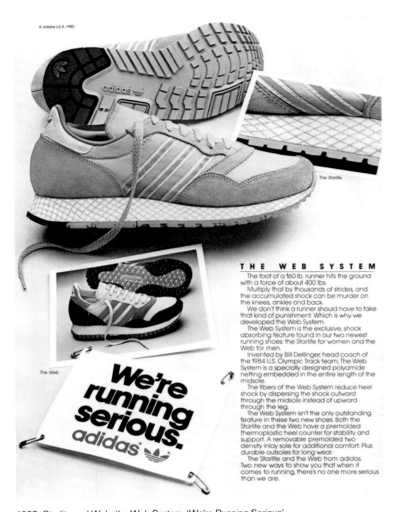

THE WEB SYSTEM

The foot of a 160 lb. runner hits the ground with a force of about 400 lbs.

Multiply that by thousands of strides, and the accumulated shock can be murder on the knees, ankles and back.

We don't think a runner should have to take that kind of punishment. Which is why we developed the Web System.

The Web System is the exclusive, shock absorbing feature found in our two newest running shoes: the Starlite for women and the Web for men.

Invented by Bill Dellinger, head coach of the 1984 U.S. Olympic Track team, The Web System is a specially designed polyamide netting embedded in the entire length of the midsole.

The fibers of the Web System reduce heel shock by dispersing the shock outward through the midsole instead of upward through the leg.

The Web System isn't the only outstanding feature in these two new shoes. Both the Starlite and the Web have a premolded thermoplastic heel counter for stability and support. A removable premolded two density inlay sole for additional comfort. Plus durable outsoles for long wear.

The Starlite and the Web from adidas. Two new ways to show you that when it comes to running, there's no one more serious than we are.

We're running serious. adidas

1985: Starlite and Web, the Web System, 'We're Running Serious'

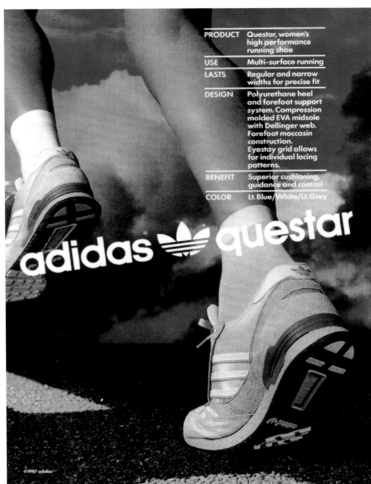

PRODUCT	Questar, women's high performance running shoe
USE	Multi-surface running
LASTS	Regular and narrow widths for precise fit
DESIGN	Polyurethane heel and forefoot support system. Compression molded EVA midsole with Dellinger web. Forefoot moccasin construction. Eyestay grid allows for individual lacing patterns.
BENEFIT	Superior cushioning, guidance and control
COLOR	Lt. Blue/White/Lt. Grey

adidas questar

1987: Questar

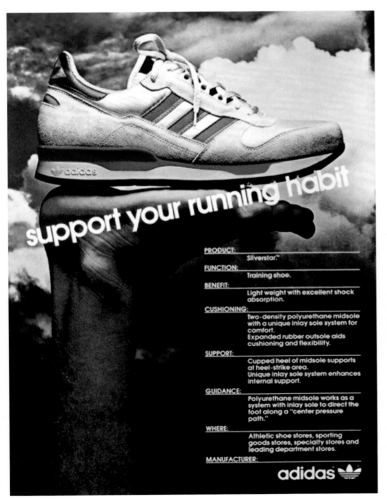

support your running habit

PRODUCT:	Silverstar.™
FUNCTION:	Training shoe.
BENEFIT:	Light weight with excellent shock absorption.
CUSHIONING:	Two-density polyurethane midsole with a unique inlay sole system for comfort. Expanded rubber outsole aids cushioning and flexibility.
SUPPORT:	Cupped heel of midsole supports at heel-strike area. Unique inlay sole system enhances internal support.
GUIDANCE:	Polyurethane midsole works as a system with inlay sole to direct the foot along a "center pressure path."
WHERE:	Athletic shoe stores, sporting goods stores, specialty stores and leading department stores.
MANUFACTURER:	adidas

1986: Silverstar, 'Support Your Running Habit'

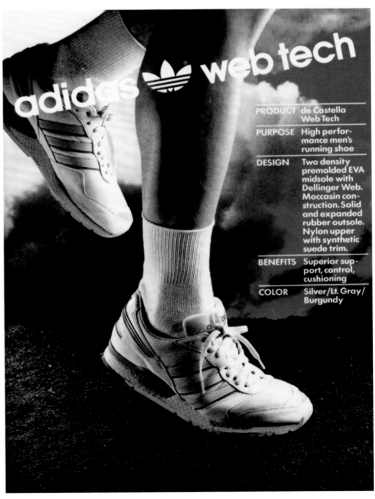

adidas web tech

PRODUCT	de Castella Web Tech
PURPOSE	High performance men's running shoe
DESIGN	Two density premolded EVA midsole with Dellinger Web. Moccasin construction. Solid and expanded rubber outsole. Nylon upper with synthetic suede trim.
BENEFITS	Superior support, control, cushioning
COLOR	Silver/Lt. Gray/Burgundy

1987: de Castella Web Tech

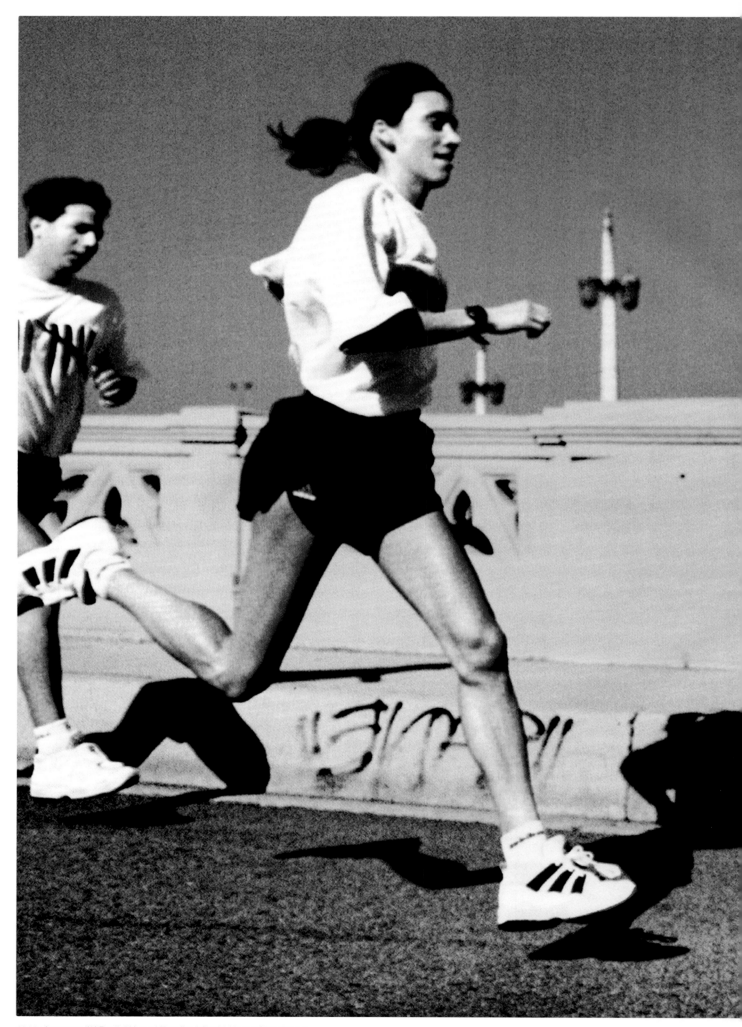

1996: Argonaut, 'If I Really Wanted Equality, I Could Always Slow Down'

IF I REALLY WANTED EQUALITY, I COULD ALWAYS SLOW DOWN.

adidas

The Argonaut running shoe by adidas. Also available in men's sizes.

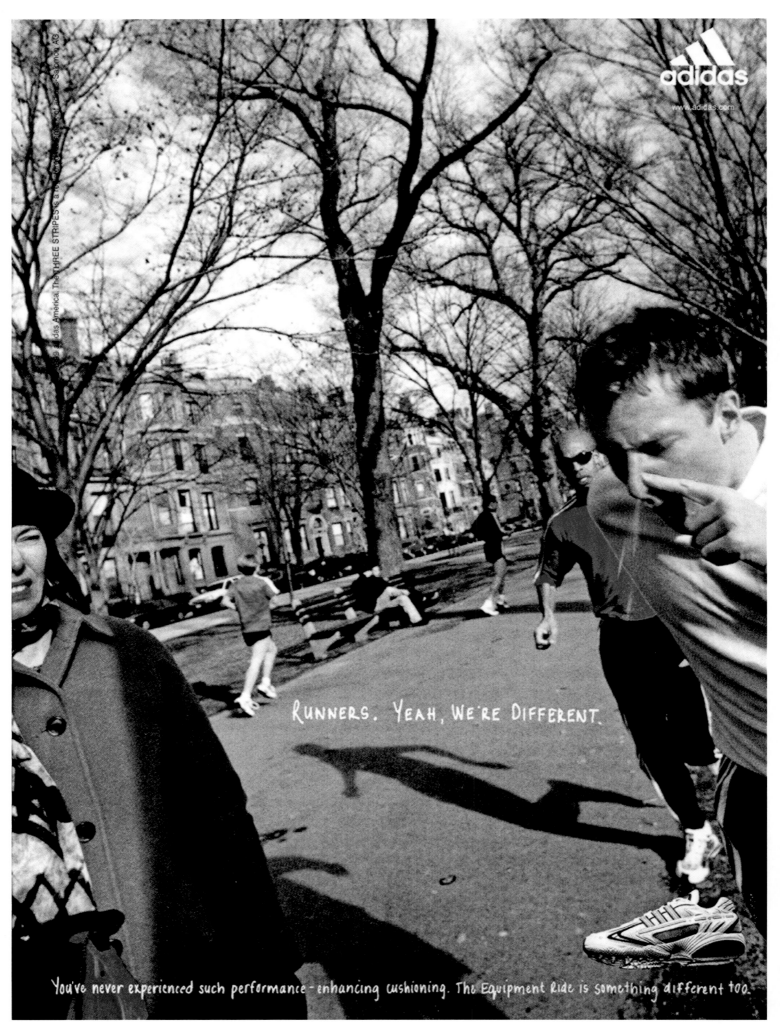

1999: Equipment Ride, 'Runners. Yeah, We're Different'

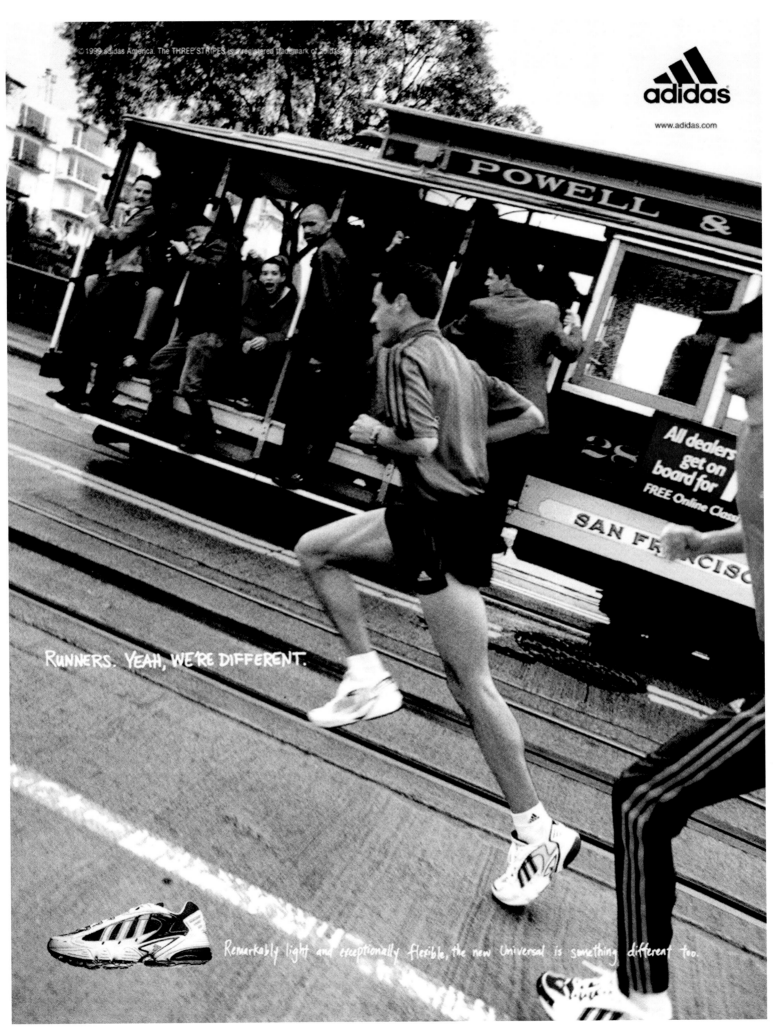

1999: Universal, 'Runners. Yeah, We're Different'

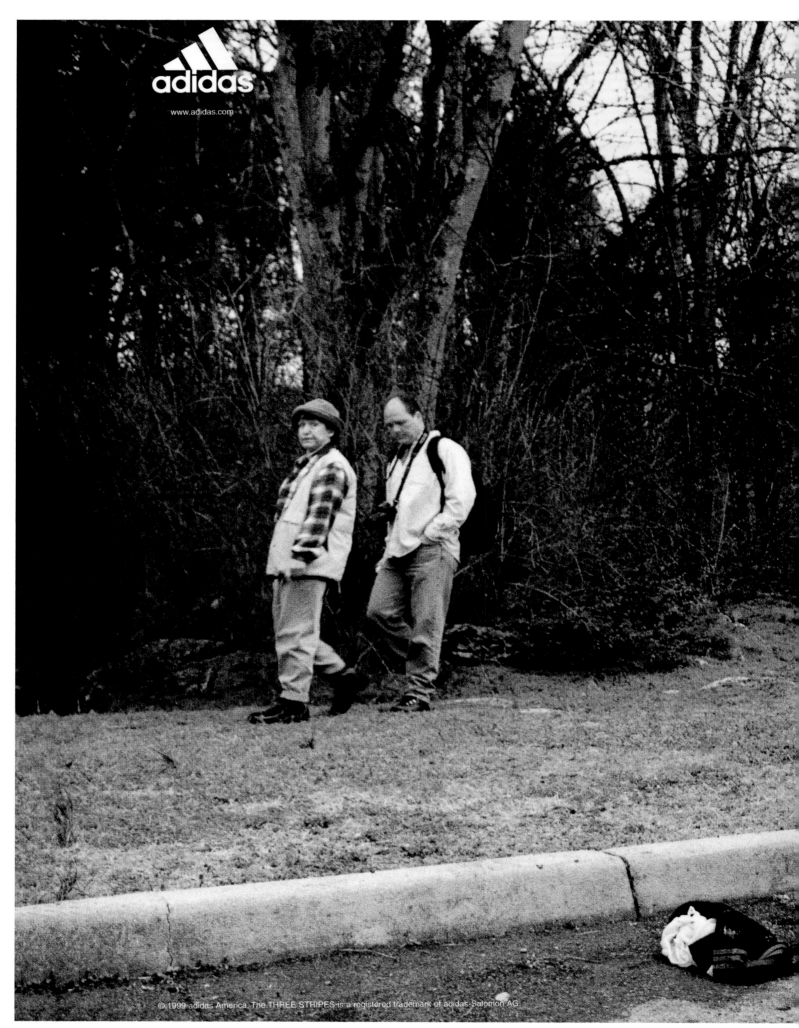

1999: 'Runners. Yeah, We're Different.'

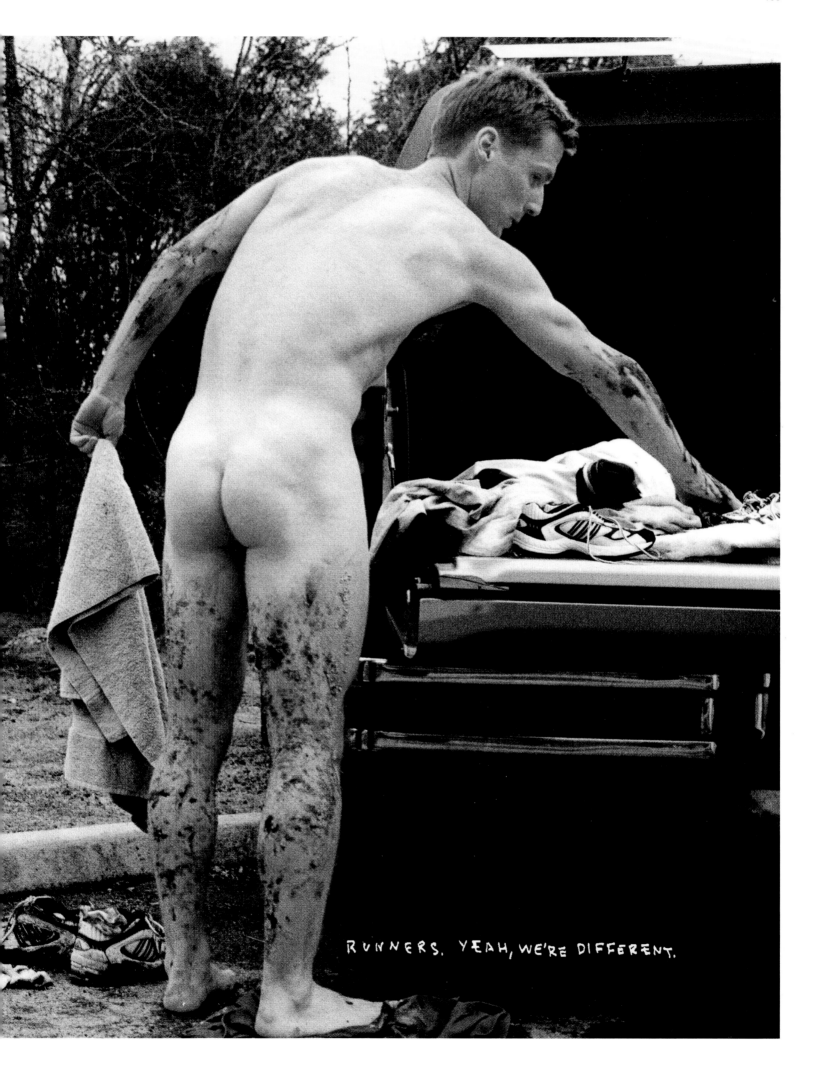

RUNNERS. YEAH, WE'RE DIFFERENT.

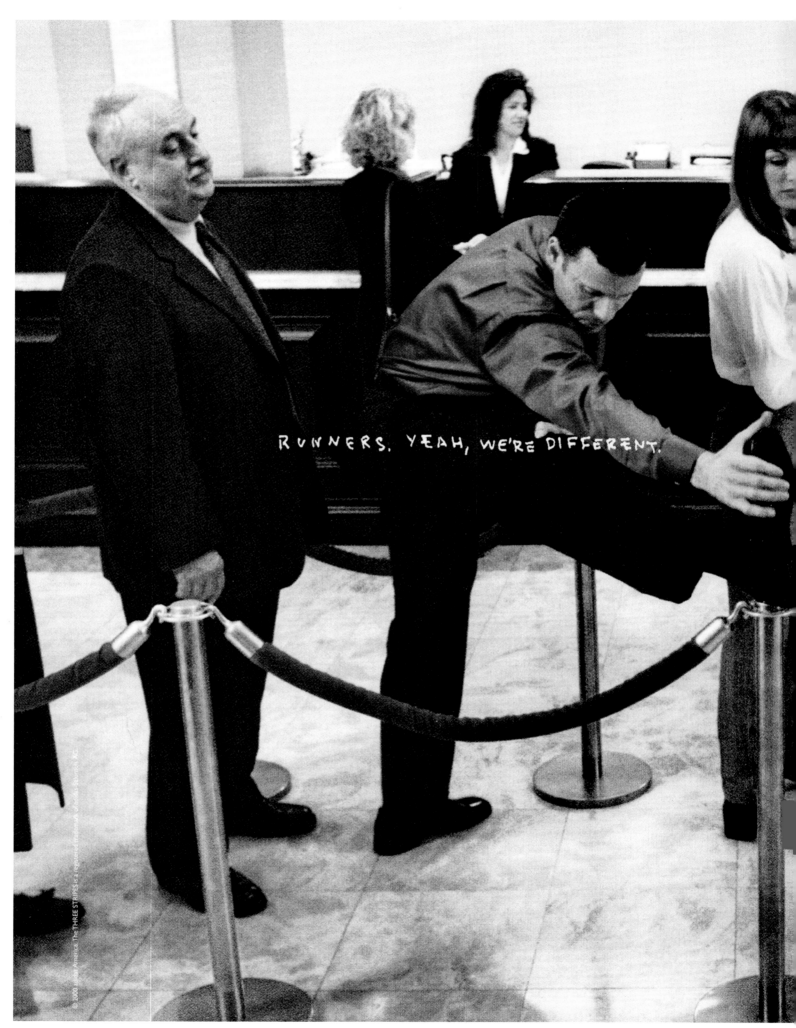

1999: Harmony, 'Runners. Yeah, We're Different.'

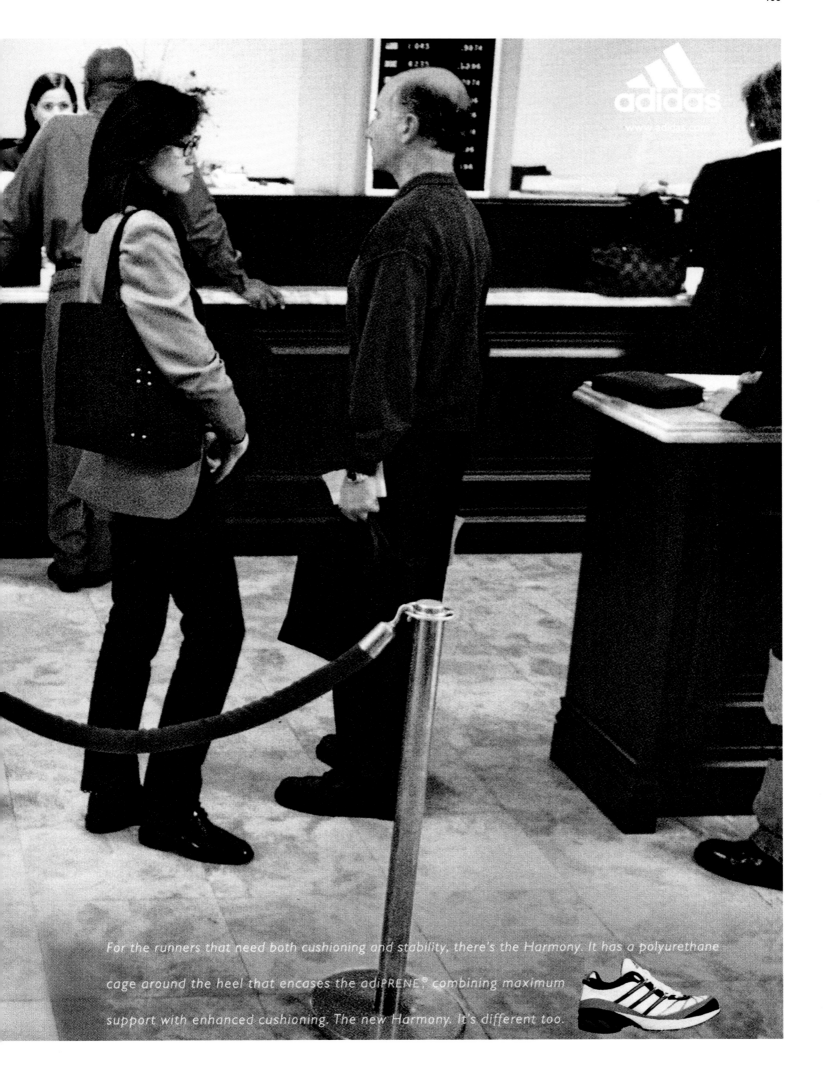

For the runners that need both cushioning and stability, there's the Harmony. It has a polyurethane cage around the heel that encases the adiPRENE® combining maximum support with enhanced cushioning. The new Harmony. It's different too.

Our proving grounds.

Proving that the Forest Hills is adidas' lightest and most advanced tennis shoe required a unique series of scientific experiments: championship tennis matches. Matches which helped verify that its 8.7 ounce* weight made it easier to keep going...even after three gruelling hours.

Matches that aided in demonstrating the sophisticated adjustable sole ventilation system could keep inside temperatures 20% lower.

Matches that assisted in proving the specially developed Polaire sole to be five times more durable than ordinary soles.

The adidas Forest Hills. It took everything science knew about tennis and turned it to your advantage.

*Men's size 8½.

*The Forest Hills
adidas' lightest tennis shoe*

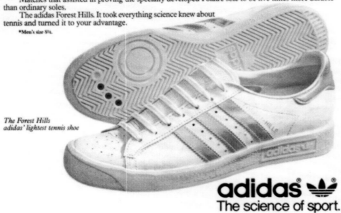

adidas 🔱
The science of sport.

1978: Forest Hills, 'Our Proving Grounds'

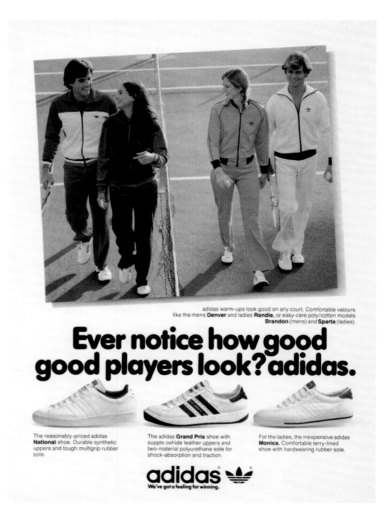

adidas warm-ups look good on any court. Comfortable velours like the mens **Denver** and ladies **Randie**, or easy-care poly/cotton models **Brandon** (mens) and **Sparta** (ladies).

Ever notice how good good players look? adidas.

The reasonably-priced adidas **National** shoe. Durable synthetic uppers and tough multigrip rubber sole.

The adidas **Grand Prix** shoe with supple oxhide leather uppers and two-material polyurethane sole for shock-absorption and traction.

For the ladies, the inexpensive adidas **Monica**. Comfortable terry-lined shoe with hardwearing rubber sole.

adidas 🔱
We've got a feeling for winning.

1981: National, Grand Prix and Monica, 'Ever Notice How Good Good Players Look? adidas'

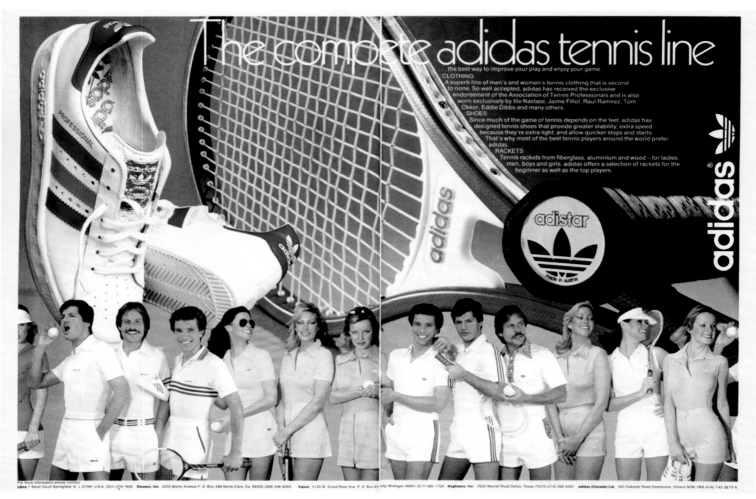

1976: 'The Complete adidas Tennis Line'

1982: Grand Prix, The Smith, Biscayne and Lisa, 'Love Your Body. Flash adidas'

1987: Stefan Edberg shoe and apparel line, ft. Stefan Edberg

1985: Player GS and Quest, 'Improve Your Style of Play'

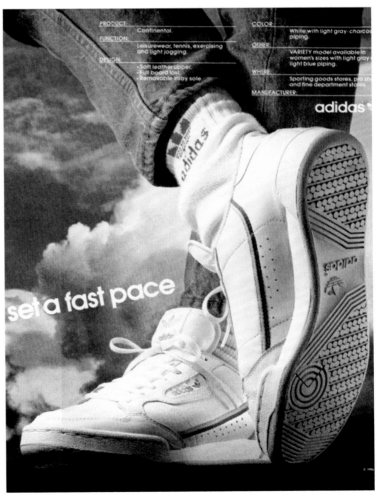

1986: Continental, 'Set a Fast Pace'

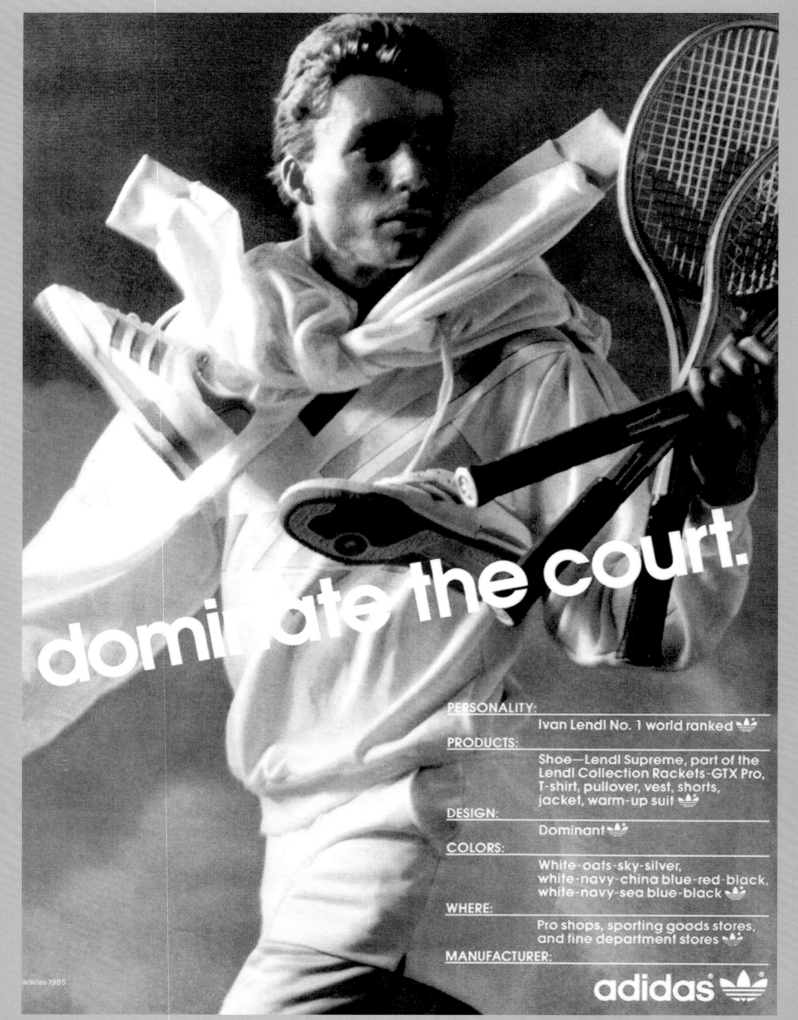

dominate the court.

PERSONALITY:

Ivan Lendl No. 1 world ranked

PRODUCTS:

Shoe—Lendl Supreme, part of the
Lendl Collection Rackets-GTX Pro,
T-shirt, pullover, vest, shorts,
jacket, warm-up suit

DESIGN:

Dominant

COLORS:

White-oats-sky-silver,
white-navy-china blue-red-black,
white-navy-sea blue-black

WHERE:

Pro shops, sporting goods stores,
and fine department stores

MANUFACTURER:

adidas

adidas 1985

1985: Lendl Supreme, 'Dominate the Court', ft. Ivan Lendl

 John McEnroe and Ilie Nastase were the original tennis bad boys and the perfect foils to Bjorn Borg's Nordic coolness. Jimmy Connors was another brash brawler with major attitude, while adidas signed Ivan Lendl and another ice-cool Swede, Stefan Edberg. The dashing Argentinian Guillermo Vilas and his Lithuanian sidekick Vitas Gerulaitis were avowed nightclub playboys as much as tennis pros. Sampras was famously boring but as a player he was close to the best of all time. Throw in Michael Chang as your 5-foot-9 counter puncher and Boris 'Boom Boom' Becker as a teenage prodigy and you have a formidable list of alpha personalities throughout the 1980s and into the 90s. Is it any wonder today's bland crop of grain-fed tennis players are struggling to assert themselves as ambassadors of style?

Nick Santora
'Anyone for Tennis?'
Sneaker Freaker, issue 23 (2011)

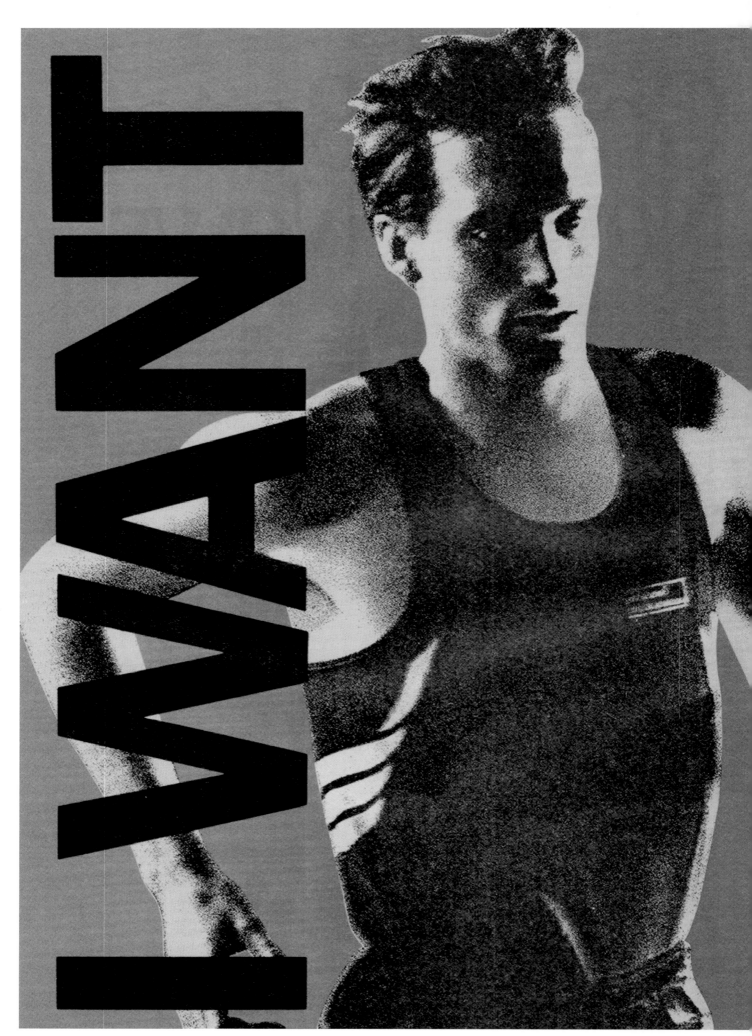

1989: ZX 9000 C, 'I Want. I Can'

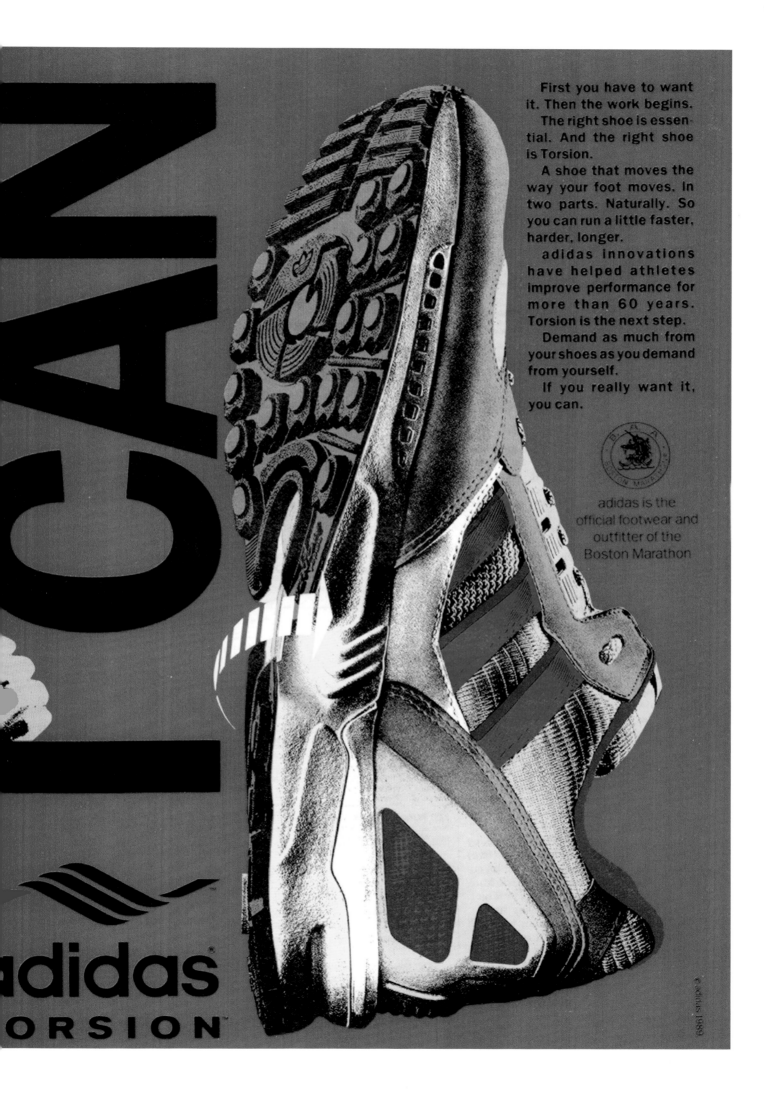

First you have to want it. Then the work begins. The right shoe is essential. And the right shoe is Torsion.

A shoe that moves the way your foot moves. In two parts. Naturally. So you can run a little faster, harder, longer.

adidas innovations have helped athletes improve performance for more than 60 years. Torsion is the next step.

Demand as much from your shoes as you demand from yourself.

If you really want it, you can.

adidas is the official footwear and outfitter of the Boston Marathon

adidas
TORSION

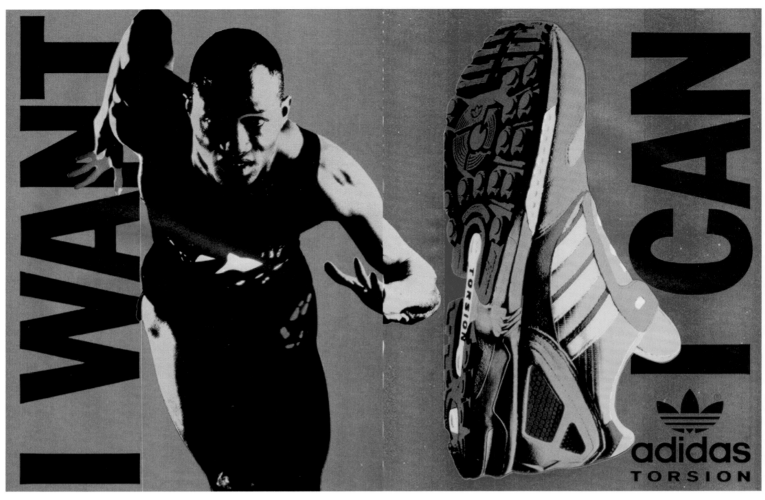

1989: ZX 8000, 'I Want. I Can'

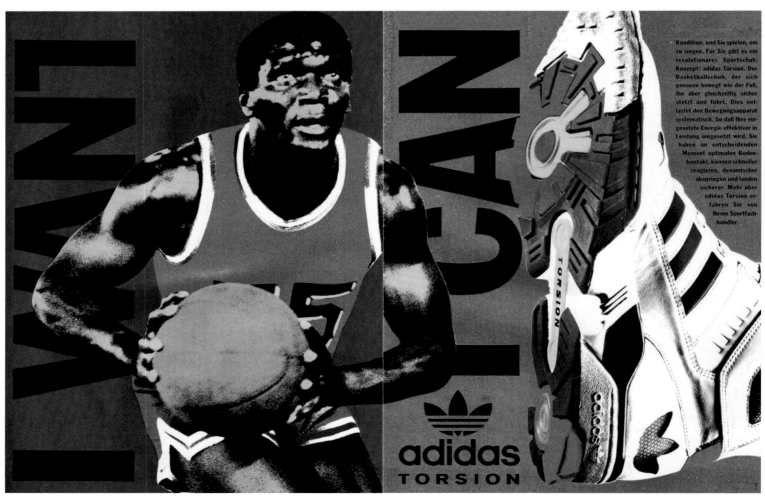

1989: Artillery, 'I Want. I Can'

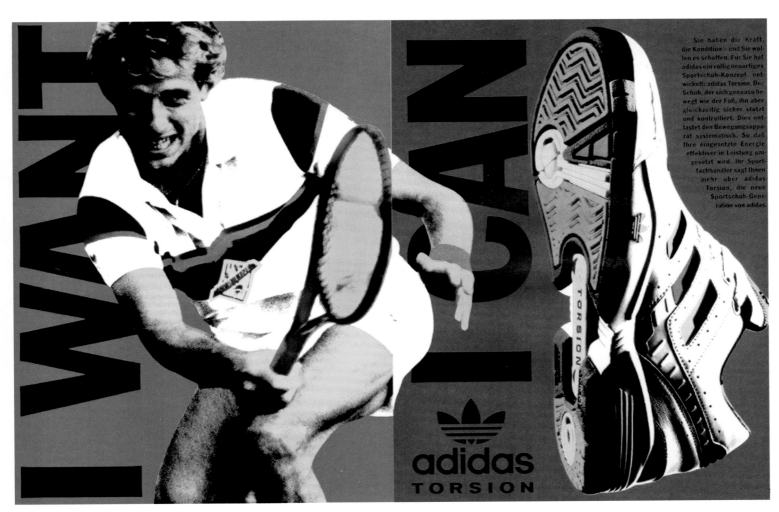

Sie haben die Kraft, die Kondition – und Sie wollen es schaffen. Für Sie hat adidas ein völlig neuartiges Sportschuh-Konzept entwickelt: adidas Torsion. Der Schuh, der sich genauso bewegt wie der Fuß, ihn aber gleichzeitig sicher stützt und kontrolliert. Dies entlastet den Bewegungsapparat systematisch. So daß Ihre eingesetzte Energie effektiver in Leistung umgesetzt wird. Ihr Sportfachhändler sagt Ihnen mehr über adidas Torsion, die neue Sportschuh-Generation von adidas.

1989: Comp, 'I Want. I Can'

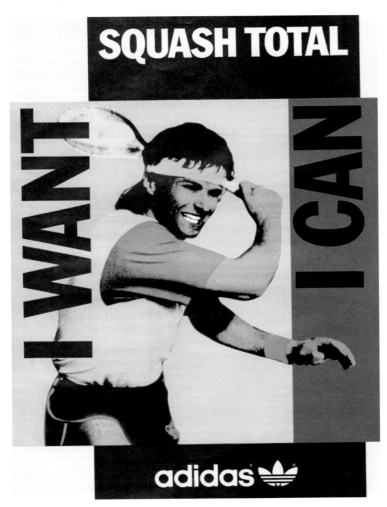

1989: Squash Total, 'I Want. I Can'

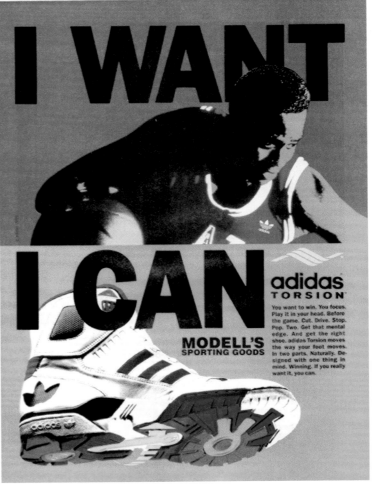

You want to win. You focus. Play it in your head. Before the game. Cut. Drive. Stop. Pop. Two. Get that mental edge. And get the right shoe. adidas Torsion moves the way your foot moves. In two parts. Naturally. Designed with one thing in mind. Winning. If you really want it, you can.

MODELL'S SPORTING GOODS

1989: Artillery, 'I Want. I Can'

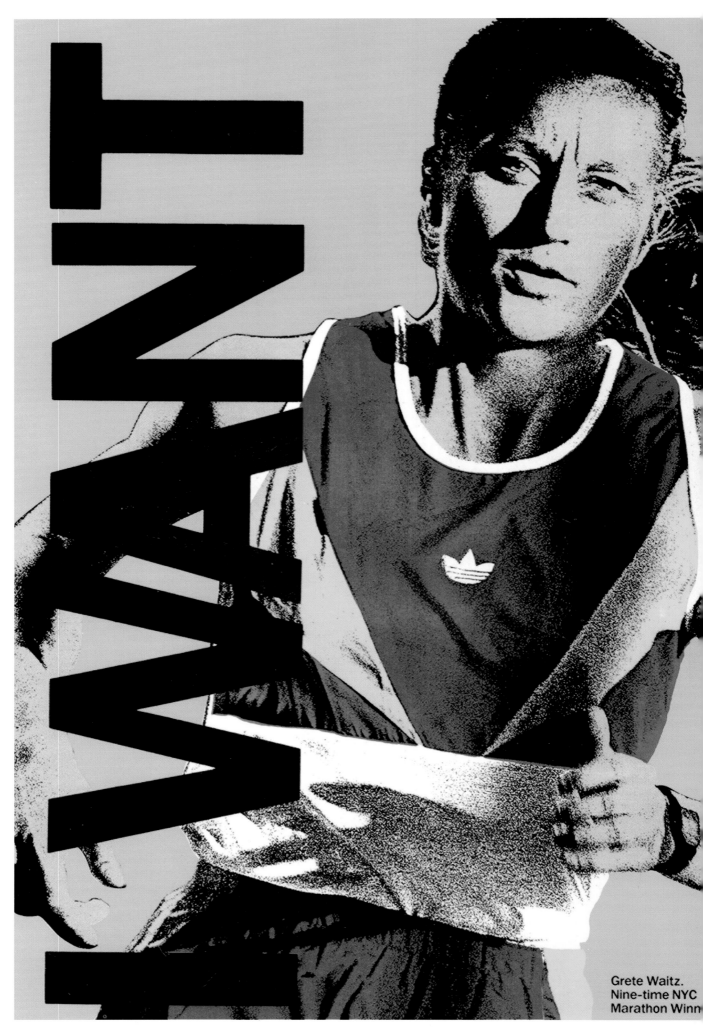

Grete Waitz.
Nine-time NYC
Marathon Winn

1989: ZX 8000, 'I Want. I Can', ft. Grete Waitz

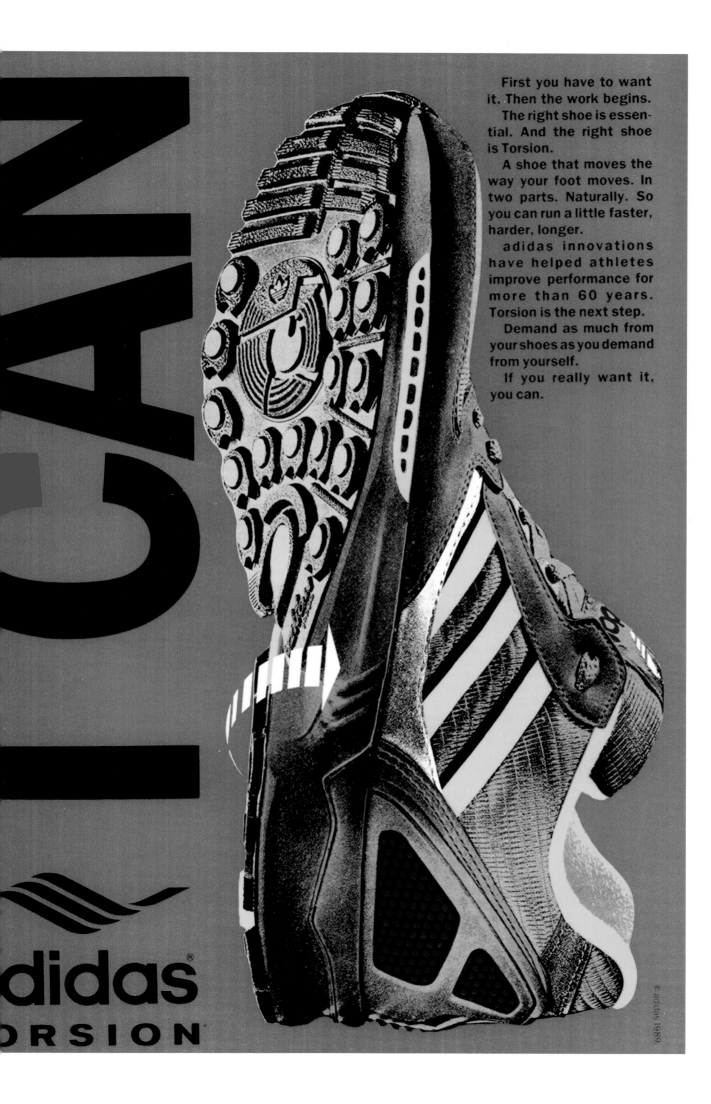

First you have to want it. Then the work begins. The right shoe is essential. And the right shoe is Torsion.

A shoe that moves the way your foot moves. In two parts. Naturally. So you can run a little faster, harder, longer.

adidas innovations have helped athletes improve performance for more than 60 years. Torsion is the next step.

Demand as much from your shoes as you demand from yourself.

If you really want it, you can.

CAN

adidas
ORSION

ASICS

Mr Kihachiro Onitsuka was motivated to start making footwear in 1949 by the plight of post-war Japanese youth. Aiming to build mental and physical resilience through athletic prowess, Mr Onitsuka began with a basic basketball boot before branching out to cater to high-mileage runners. As the product range expanded to suit the specific needs of Olympians, ASICS began making shoes for football, martial arts, basketball, volleyball, weightlifting, wrestling, fencing and tennis.

Originally known as Onitsuka Co., the company name was changed to ASICS in 1977 following an amalgamation. ASICS is an acronym of the Latin phrase *anima sana in corpore sano*, which translates as 'healthy soul in a healthy body'. Confusingly, Onitsuka Tiger and ASICS are still both in simultaneous use today. The Mexico model from 1966 is considered pure Onitsuka Tiger, while the GEL series of performance runners from the 1990s lives under the ASICS umbrella, even though both share the distinctive 'Tiger Stripe' logo. From tongueless runners to trainer outsoles modelled on octopus suction cups, ASICS' ongoing commitment to manufacturing excellence and innovation is widely respected.

●

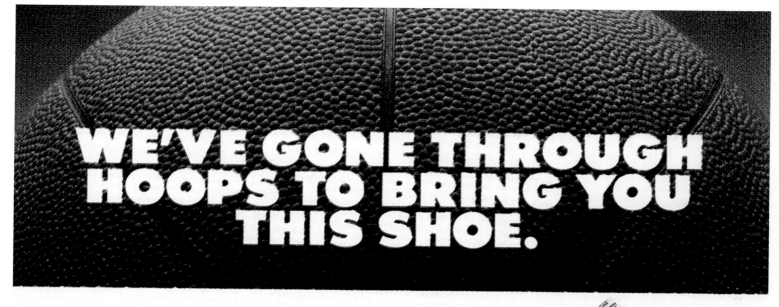

WE'VE GONE THROUGH HOOPS TO BRING YOU THIS SHOE.

THE MERIDIAN

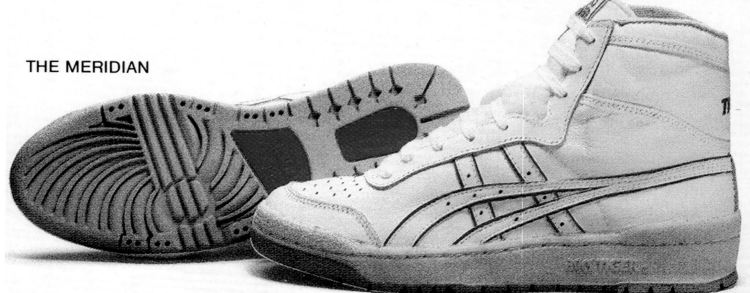

We slipped. We slid. We came up with a molded heel cup for stability. Then we got a real jump on the competition with a one piece EVA midsole. All to bring you durability and comfort that stands up in court.

BORN TO PERFORM.

For more information write: ASICS TIGER CORP., 3030 S. Susan Street, Santa Ana, CA 92704

1986: The Meridian, 'We've Gone Through Hoops to Bring You This Shoe'

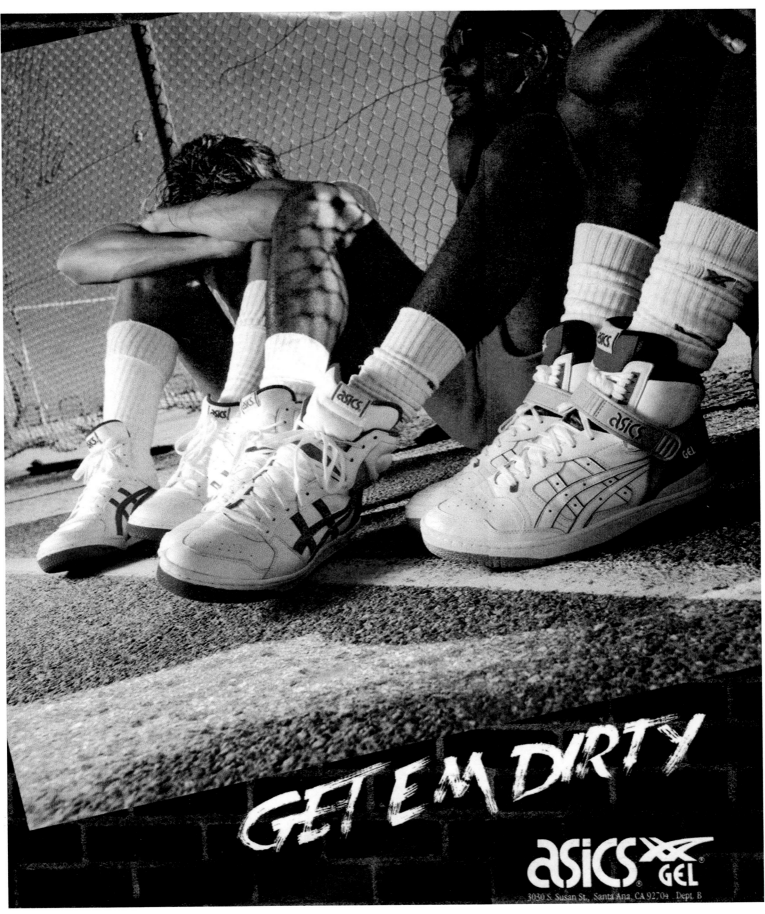

1988: GEL, 'Get Em Dirty'

Isiah Thomas' working shoes.

ASICS GEL-Spotlyte, the lightweight performance basketball shoe.

Isiah Thomas' playing shoes.

ASICS GT-Intensity II, crosstrainers, with shock absorbing ASICS GEL.

GEL

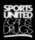

Both models available in a variety of colors. For more information call 1-800-766-ASICS.

1991: GEL Spotlyte and GT-Intensity II, 'Isiah Thomas' Working Shoes. Isiah Thomas' Playing Shoes'

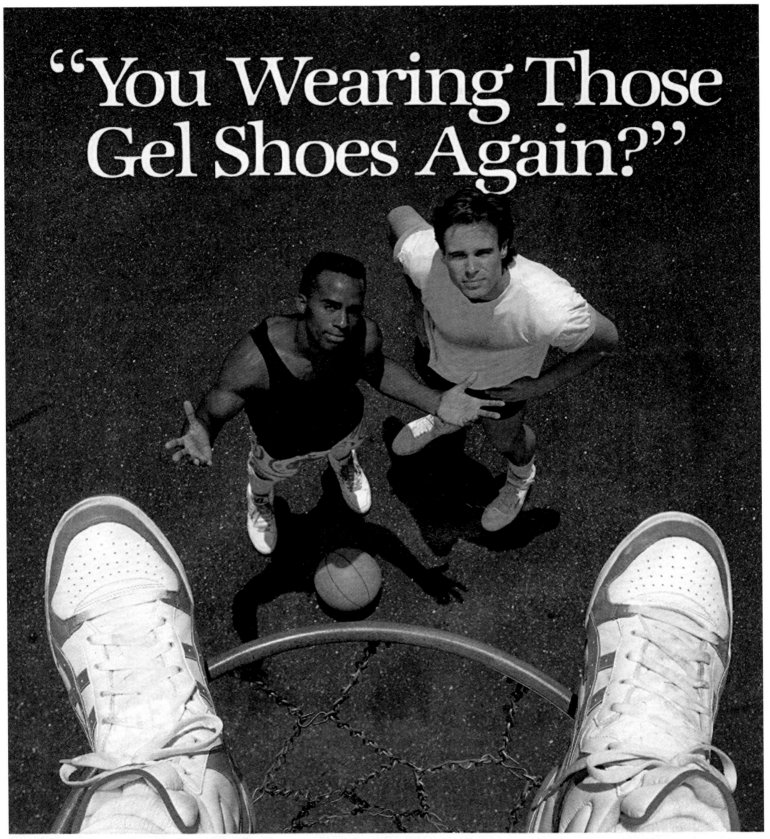

"You Wearing Those Gel Shoes Again?"

Our gel hightops are the only basketball shoes on earth with a layer of shock absorbing gel inside. Wear them and you're ready to break rules that haven't even been made yet.

How outrageous can you get? Find out by calling 1-800-447-4700 for the Asics Tiger Dealer near you.

asics®

THE CHOICE OF FANATICS

1985: GEL Hightops, '"You Wearing Those Gel Shoes Again?"'

Just Doing It Doesn't Do It.

Introducing The ASICS' GEL-Trainer. No matter which sport you're training for or which surface you're training on, you can now do it better.

With the incredible shock absorption of ASICS' GEL.

Because now, the heart and sole of our running shoes is available in our new GEL-Trainer.

The difference: space age silicon GEL permanently encapsulated in pads at points of maximum biomechanical impact.

Encapsulated ASICS' GEL effectively absorbs shock by dispersing vertical energy into a horizontal plane.

Which not only reduces workout fatigue, but offers you outstanding injury protection and stability.

So try on a pair of our low or mid-top GEL-Trainers.

The all-terrain vehicles for people who *don't* just do it.

asics ✖
Don't Just Do It. Do It Better.

1989: GEL-Trainer, 'Just Doing It Doesn't Do It'

Just doing it doesn't do it.

1989: 'Just Doing It Doesn't Do It'

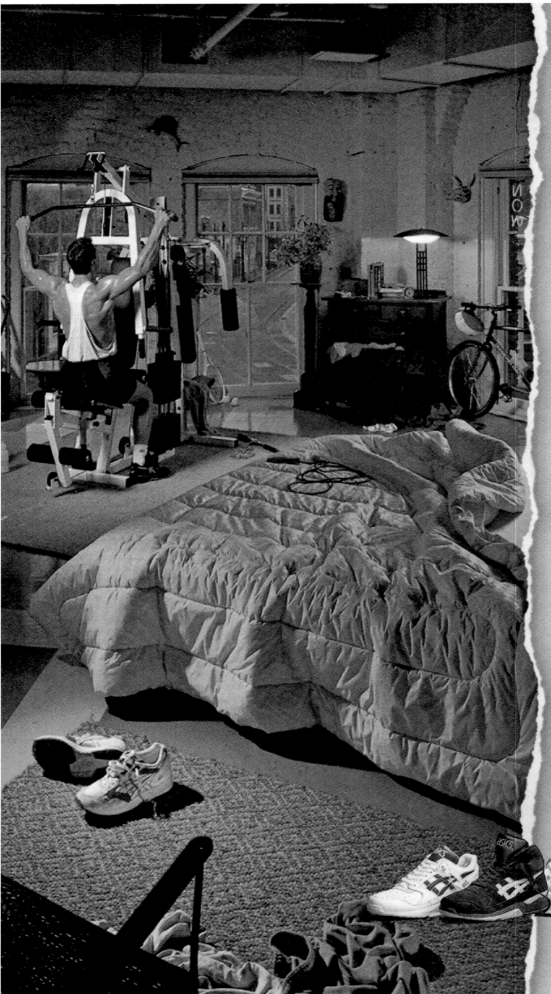

Anyone can push the snooze button.

You're having that dream again. The one that takes place in a world where body fat and receding hairlines do not exist. Where you dominate every sport you play. Where you're faster. Stronger. Smarter. Suddenly, your alarm clock goes off.

GT-Quick GEL-Saga

ASICS GEL™ cushioning system featured in the forefoot of the GT-Quick and the rearfoot of the GEL-Saga.

Sleeping in is not an option. So you run. The world records are safe, but a few miles a day could lead to something. That's why you choose the ASICS® GEL-Saga™ with its unique GEL™ cushioning system.

Then you lift. This is where the ASICS GT-Quick™ is the stuff dreams are made of. Its GEL cushioning system and lightweight construction beg for more sets.

Wake up. It's time to get some ASICS and do something much tougher than pushing a snooze button. It's time to push yourself.

asics. GEL
The Next Level.™

GT-Quick, GT-Quick MT, GEL-Saga
All available in a variety of colors.
For the dealer nearest you call Mon.–Fri.
7 a.m. to 4 p.m. PST. 1-800-766-ASICS

1991: GT-Quick, GT-Quick MT and GEL-Saga, 'Anyone Can Push the Snooze Button'

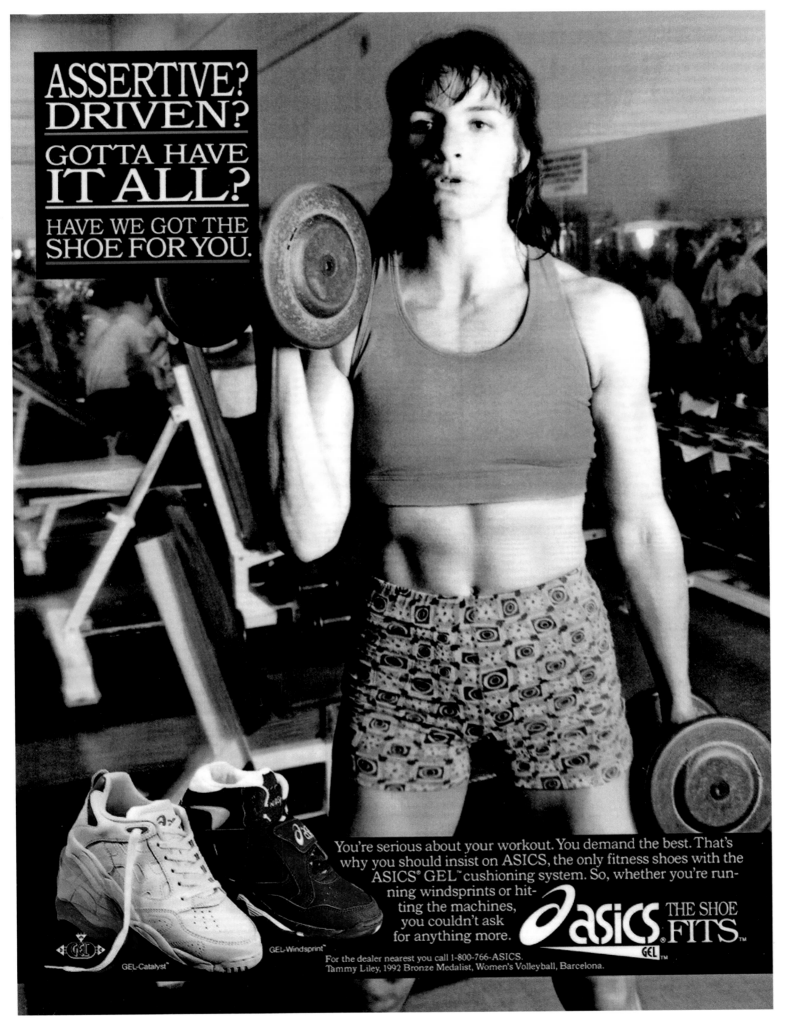

1994: GEL-Catalyst and GEL-Windsprint, 'Assertive? Driven? Gotta Have It All? Have We Got the Shoe for You'

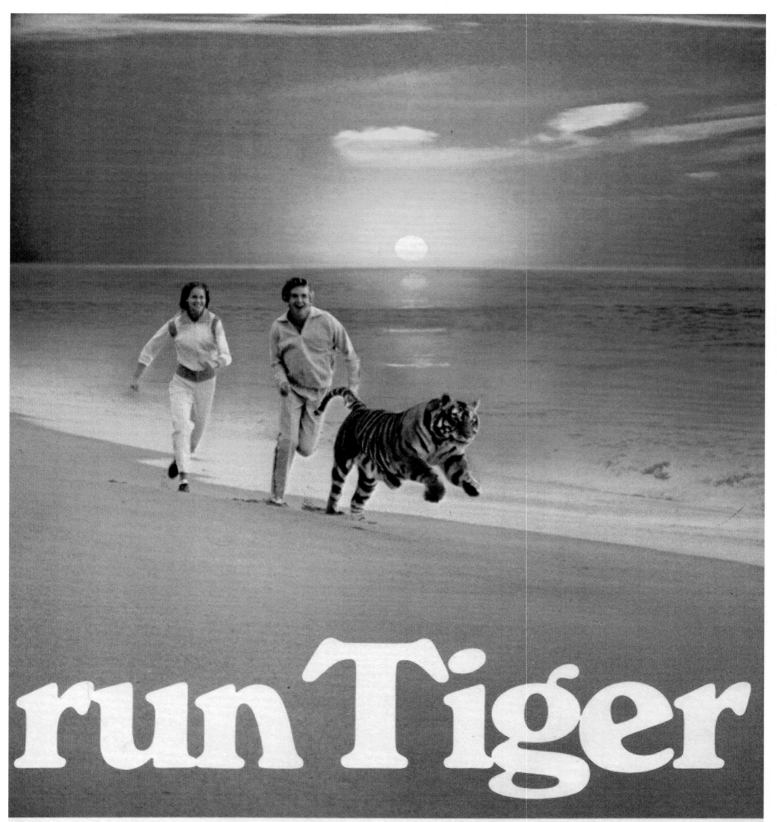

run Tiger

Quality attracts quality, and that's why so many world class runners choose to "Run Tiger."

The spirit of distance running is caught by our new "Run Tiger" full color poster. This striking 22" x 29" poster suitable for framing duplicates the exciting shot you see above.

To get a Tiger poster, visit your local Tiger Running Center and see the complete line of Tiger shoes and other quality ASICS Sports Products.

You can tell by the stripes

Onitsuka Tiger

asics

ASICS SPORTS OF AMERICA INC.
2052 Alton Avenue
Irvine, Ca 92714

TG-880 12/78

1978: 'Run Tiger'

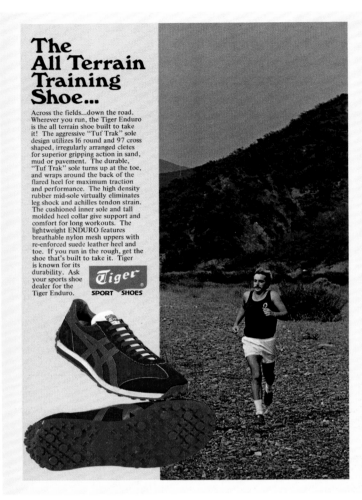

1977: Tiger Enduro, 'The All Terrain Training Shoe'

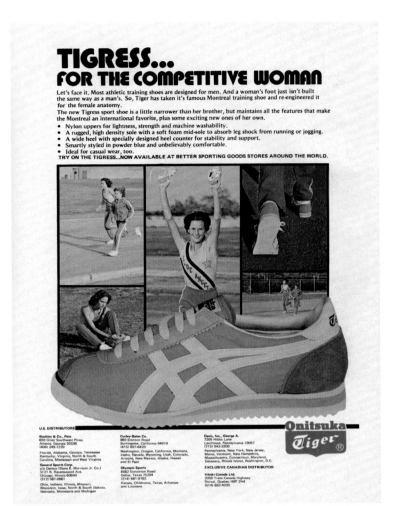

1977: Tigress, 'Tigress...for the Competitive Woman'

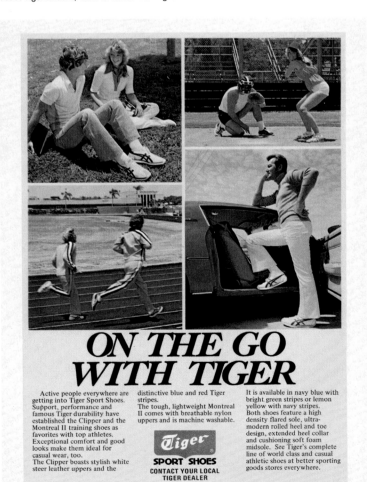

1977: Clipper and Montreal II, 'On the Go With Tiger'

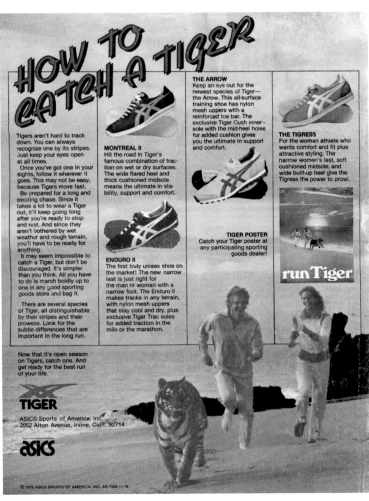

1978: Montreal II, Enduro II, Arrow and Tigress, 'How to Catch a Tiger'

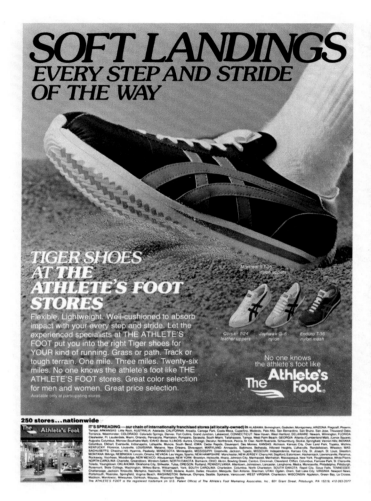

SOFT LANDINGS
EVERY STEP AND STRIDE OF THE WAY

TIGER SHOES AT THE ATHLETE'S FOOT STORES

Flexible. Lightweight. Well-cushioned to absorb impact with your every step and stride. Let the experienced specialists at THE ATHLETE'S FOOT put you into the right Tiger shoes for YOUR kind of running. Grass or path. Track or tough terrain. One mile. Three miles. Twenty-six miles. No one knows the athlete's foot like THE ATHLETE'S FOOT stores. Great color selection for men and women. Great price selection.

Available only at participating stores.

No one knows the athlete's foot like

The **Athlete's Foot**

1979: Montreal II T-35, Corsair T-24, Jayhawk G-5 and Enduro T-36, 'Soft Landings Every Step and Stride of the Way'

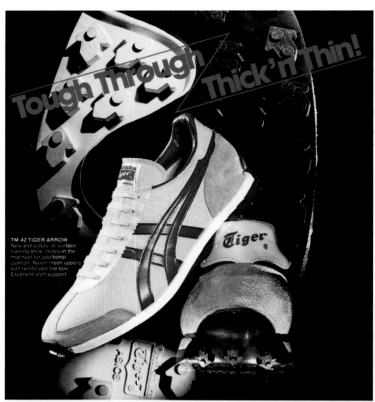

TM-42 TIGER ARROW
New extra-duty all surface training shoe. Holes in the mid-heel for additional cushion. Nylon mesh uppers with reinforced toe box. Excellent arch support.

Asics Tiger Shoes—For the knowledgeable runner

Top athletes of the world know how good Asics Tiger shoes are, so they wear them in training, in competition and in record-breaking attempts. They put their trust in Asics Tiger, because they have learned through experience that Asics Tiger is trustworthy. Whether for track and field, volleyball, soccer, jogging, or any other sport, Asics Tiger is the name you can trust.

★Worn by winners of '79 Boston and New York marathons!

asics TIGER
SPORTS SHOES

ASICS Sports of America Inc.
Head Office: 2052 Alton Avenue, Irvine, California 92714, U.S.A.
Phone: (714) 751-0451, 0452 Telex: 230-685533

1979: TM-42 Tiger Arrow, 'Tough Through Thick 'n Thin!'

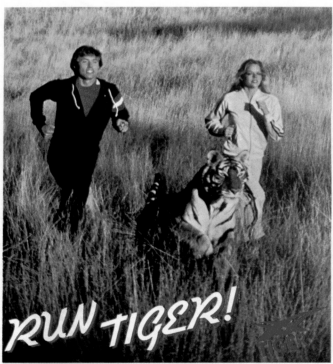

TIGERSPIRIT TM36

Spirit. The tough, lightweight trainer from Tiger. With rugged Tiger Trac sole for all-terrain running. And light, nylon mesh uppers for all-weather comfort.

Tiger Spirit. Part of the full line of sports shoes from Tiger. Catch the Spirit at your local Tiger dealer. (And get into the Tiger Spirit with our 'Run Tiger' poster/ training chart—also available at your Tiger dealer.)

Sport, the universal language

asics ASICS Sports of America, Inc.
2052 Alton Avenue
Irvine, California 92714

1979: Tiger Spirit, 'Run Tiger!'

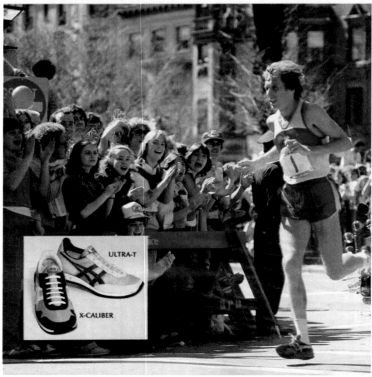

The Best Run With TIGER

From New York to Boston...marathons across the country are won in TIGERS. Such as the 1976, 1977, 1978 and 1979 New York Marathons and the Boston Marathons of 1978, 1979 and 1980. TIGER—a complete line of shoes for the serious runner.

asics TIGER.
ASICS Sports of America, Inc.

ULTRA-T

X-CALIBER

1980: Ultra-T and X-Caliber, 'The Best Run With Tiger'

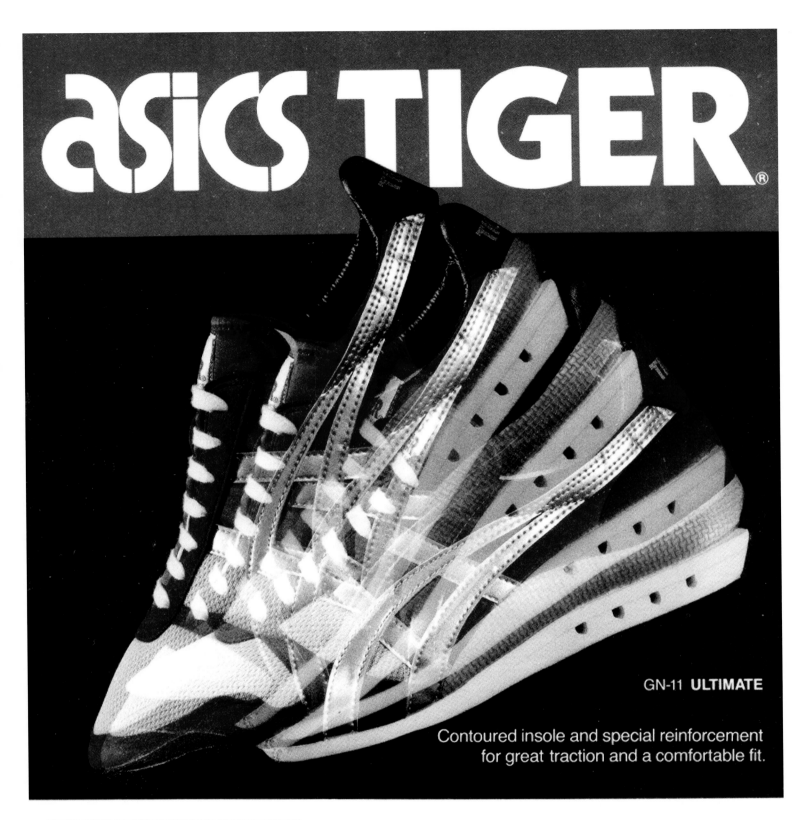

asics TIGER®

GN-11 ULTIMATE

Contoured insole and special reinforcement
for great traction and a comfortable fit.

TM-13 **X-CALIBER**

The X-Caliber, our top trainer with the look and feel of today
at under 200 grams. Special EVA midsole for superior
shock absorbency. The upper is made from nylon mesh
and suede for strength and cool comfort on long runs.

ASICS Sports of America, Inc.

1980: GN-11 Ultimate and TM-13 X-Caliber

TIGER. ISN'T OUT TO BE MORE POPULAR THAN NIKE.

JUST MORE COMFORTABLE.

Alliance ™

We try harder at things like cushioning, flexibility, and motion control.

You and your feet can feel the results.

So compare, and judge for yourself. We think you'll decide on Tiger.

TIGER. BORN TO PERFORM. ASICS TIGER ®

ASICS TIGER CORP. 3030 South Susan Street, Santa Ana, CA 92704.

1984: Alliance, 'Tiger Isn't Out to Be More Popular Than Nike. Just More Comfortable'

Why our thick gel is better than their thin air.

Introducing Tiger's new GT II™ with ASICS' GEL™.

When we looked at what many are calling state-of-the-art running shoes, what we found was a lot of thin air.

Air, we're told, is an excellent shock absorber. Yet our research tells us an alarming 25% of all running-related injuries still stem from insufficient shock absorption. So we figured you're aching for an idea that is brighter than air. An advancement with real substance.

We call it ASICS' GEL™— developed from a new class of engineering compounds pioneered by Geltec, Ltd. This viscous, silicone-based gel has impressive energy-absorption properties. Our biomechanical tests show the new GT II™ with ASICS' GEL dispels up to 28% more impact than the Nike Air® Epic. In a 10K run,

Anatomically located at fore and rearfoot reflex points, ASICS Gel pads allow our new GT II to absorb significantly more impact than the leading "air" shoe.

that could spare your body 1.2 million pounds of punishing force.

The GT II also gives you a longer run for your money. Unlike air chambers, our gel pads rest above the EVA midsole where they help delay midsole deterioration. Generous Ecsaine reinforcements

give the upper a longer life. And the tri-density outsole with black carbon rubber also extends wear.

And so you won't sacrifice stability for comfort or wear, the GT II delivers great strides in motion control. Our integrated heel pillar, sculpted orthotic insole, extended heel counter and stabilizing upper straps successfully reduce damaging over-pronation.

Tiger's new GT II with ASICS' GEL. Revolutionary technology for runners who are beyond putting on airs. To find the Tiger Dealer nearest you call **1-800-447-4700.**

Nike Air® is a registered trademark of Nike, Inc.

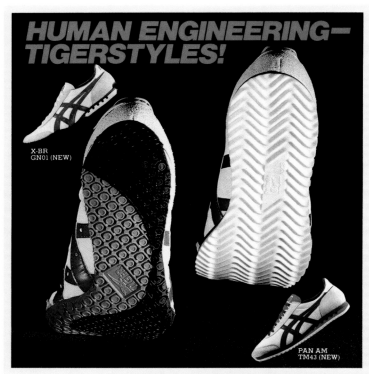

X-BR, worn by the winner at the last two Boston and New York marathons. The ultimate marathon shoe from its carbonized suction soles to ventilated lightweight uppers.

Pan Am, designed for the Pan Am games. The best in training shoes, combining comfortable durability with stylistic freshness.

Tiger is quality. Tiger is innovation. That's human engineering – Tigerstyle.

asics TIGER.
SPORT SHOES

ASICS Sports of America Inc.
2052 ALTON AVENUE,
IRVINE, CALIFORNIA 92714, U.S.A.

1980: X-BR and Pan Am, 'Human Engineering – Tigerstyles!'

Nobody knows the athlete's foot like The Athlete's Foot.® We know that when you want protection and comfort, you can count on the shoe that's earned its stripes internationally. Tiger. Known the world over for winning performance.

Looking for a superior distance shoe? Try the Tiger Explorer with famous super-cushion midsole that virtually eliminates leg shock.

For ultra light weight and comfort, check the X-Caliber GT Tiger's top-of-the-line training and racing flat.

Training and casual wear? The Corsair in men's and ladies' models gives you Tiger quality at a comfortable price.

Run with Tiger. The world beater. At The Athlete's Foot store near you.

Tiger makes it.
We have it.

Nobody knows the athlete's foot like

The Athlete's Foot.®

More than 400 stores worldwide.

Corsair, Explorer, Lady Explorer, X-Caliber GT

asics TIGER.

1982: Corsair, Explorer, Lady Explorer and X-Caliber GT,
'The Shoe That Runs Around the World'

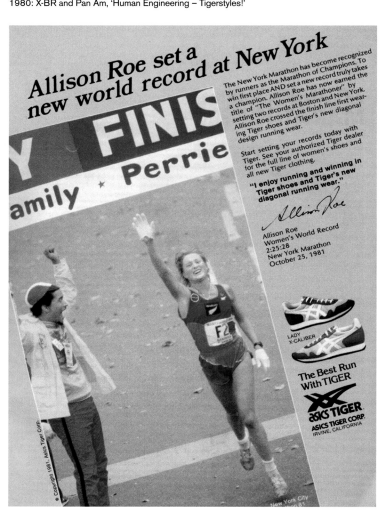

1982: Lady X-Caliber, 'Allison Roe Set a New World Record at New York', ft. Allison Roe

HOW TO IMPROVE YOUR MILEAGE.

Introduce yourself to the Extender.

A remarkable new training shoe designed to take all the wear and tear high-mileage runners can give it. It offers a long wearing, solid gum carbon rubber sole with bi-level tread for cushioning, stability and traction.

The midsole is a lightweight, compaction resistant EVA formula that features air canals at the forefoot, anti-overpronation DUOMAX™ and triducts at the heel.

The heel counter is a laminated rigid fiber with double extended Duo-Stay rubber for extreme rear foot motion control.

And the innovations go on and on.

The Extender.

Try it.

And watch your mileage go up and up.

Tiger. Born to perform.

1983: Extender, 'How to Improve Your Mileage'

Comfort runs in the family.

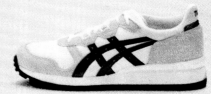

EPIRUS
The state-of-the-art running shoe.

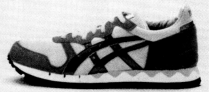

ALLIANCE
Tops for stability and control.

X-CALIBER GT
The high caliber shoe for overpronation.

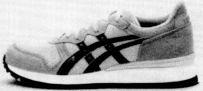

ULTRA 1000
Ultra shock absorption. Ultra comfort.

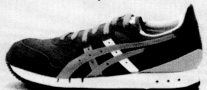

STRIKER ST
Stability for heavy heel strikers.

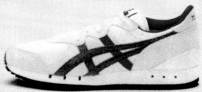

EXTENDER
Extended wear in wide and narrow widths.

ASICS TIGER
Born to perform.

For technical information about Tiger's complete line of shoes, write to ASICS Tiger Corp., 3030 South Susan St., Santa Ana, CA 92704.

1985: Epirus, Alliance, X-Caliber GT, Ultra 100, Striker ST and Extender, 'Comfort Runs in the Family'

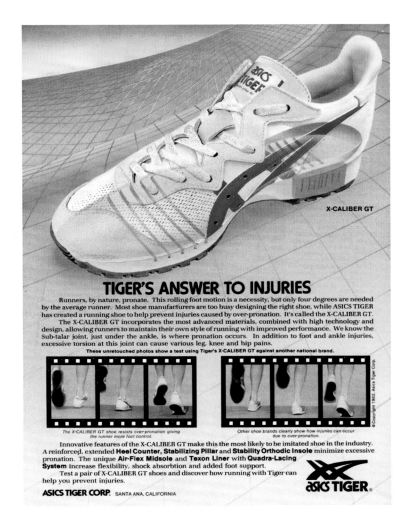

X-CALIBER GT

TIGER'S ANSWER TO INJURIES

Runners, by nature, pronate. This rolling foot motion is a necessity, but only four degrees are needed by the average runner. Most shoe manufacturers are too busy designing the right shoe, while ASICS TIGER has created a running shoe to help prevent injuries caused by over-pronation. It's called the X-CALIBER GT.

The X-CALIBER GT incorporates the most advanced materials, combined with high technology and design, allowing runners to maintain their own style of running with improved performance. We know the Sub-talar joint, just under the ankle, is where pronation occurs. In addition to foot and ankle injuries, excessive torsion at this joint can cause various leg, knee and hip pains.

These unretouched photos show a test using Tiger's X-CALIBER GT against another national brand.

The X-CALIBER GT shoe resists over-pronation giving the runner more foot control.

Other shoe brands clearly show how injuries can occur due to over-pronation.

Innovative features of the X-CALIBER GT make this the most likely to be imitated shoe in the industry. A reinforced, extended **Heel Counter, Stabilizing Pillar** and **Stability Orthodic Insole** minimize excessive pronation. The unique **Air-Flex Midsole** and **Texon Liner** with **Quadra-Lacing System** increase flexibility, shock absorbtion and added foot support.

Test a pair of X-CALIBER GT shoes and discover how running with Tiger can help you prevent injuries.

ASICS TIGER CORP. SANTA ANA, CALIFORNIA

ASICS TIGER

1982: X-Caliber GT, 'Tiger's Answer to Injuries'

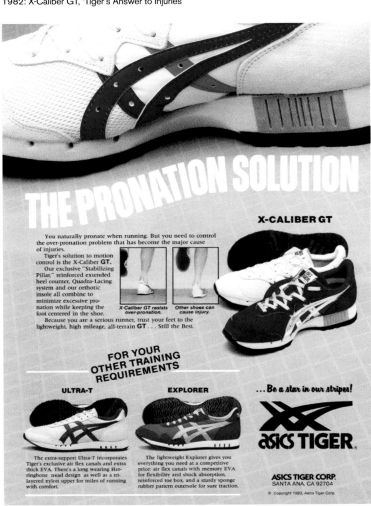

THE PRONATION SOLUTION

X-CALIBER GT

You naturally pronate when running. But you need to control the over-pronation problem that has become the major cause of injuries.

Tiger's solution to motion control is the X-Caliber GT. Our exclusive "Stabilizing Pillar," reinforced extended heel counter, Quadra-Lacing system and our orthotic insole all combine to minimize excessive pronation while keeping the foot centered in the shoe.

Because you are a serious runner, trust your feet to the lightweight, high mileage, all-terrain GT . . . Still the Best.

X-Caliber GT resists over-pronation.

Other shoes can cause injury.

FOR YOUR OTHER TRAINING REQUIREMENTS

ULTRA-T
The extra-support Ultra-T incorporates Tiger's exclusive air flex canals and extra thick EVA. There's a long wearing Herringbone tread design as well as a tri-layered nylon upper for miles of running with comfort.

EXPLORER
The lightweight Explorer gives you everything you need at a competitive price: air flex canals with memory EVA for flexibility and shock absorption, reinforced toe box, and a sturdy sponge rubber pattern outersole for sure traction.

...Be a star in our stripes!

ASICS TIGER

ASICS TIGER CORP.
SANTA ANA, CA 92704

1983: X-Caliber GT, Ultra-T and Explorer, 'The Pronation Solution'

Comfort is the name of the game.

No matter what sport you're into, get into Tiger for the utmost in comfort and quality.

BASKETBALL

DISCOVERY: The top gun in ankle support and stability.

MERIDIAN: Fast break comfort.

FITNESS

AMADEUS HI: Added support, added stability, added comfort.

AMADEUS LOW: Work out in classic comfort.

TENNIS

PIVOT II: Affordable comfort, set after set.

ASICS TIGER
Born to perform.

For technical information about Tiger's complete line of shoes, write to ASICS Tiger Corp., 3030 South Susan St., Santa Ana, CA 92704.

asics
THE CHOICE OF FANATICS

Our gel makes even the latest advancements seem a bit flat.

Reducing impact-related running injuries has been an important goal of shoe manufacturers for years. And when the "airsole" appeared, it was the breakthrough researchers and runners could call state-of-the-art.

Until ASICS' GEL.

This revolutionary silicone formulation disperses vertical impact with unmatched effectiveness and durability. Encapsulated into pads cradled in an EVA midsole, ASICS' GEL is the reason our GT II, Gel 100 and Miramar models deliver the best shock absorption available. Along with other advanced features that add up to a safer, stronger run for your money.

Try a pair of Tigers and run with the technological leader. You'll find there's nothing inflated about our promise of superior shock absorption. Call 1-800-447-4700 for the ASICS Tiger Dealer nearest you.

GT II

Gel 100

Miramar

Lady Miramar

Lady Gel 100

Gel amount and location varies by shoe model— there's a gel shoe for every kind of runner.

ASICS TIGER CORP.

1985: Discovery, Meridian, Amadeus Hi, Amadeus Low and Pivot II, 'Comfort is the Name of the Game'

1987: GT II, Gel 100, Miramar, Lady Miramar and Lady Gel 100, 'Our Gel Makes Even the Latest Advancements Seem a Bit Flat'

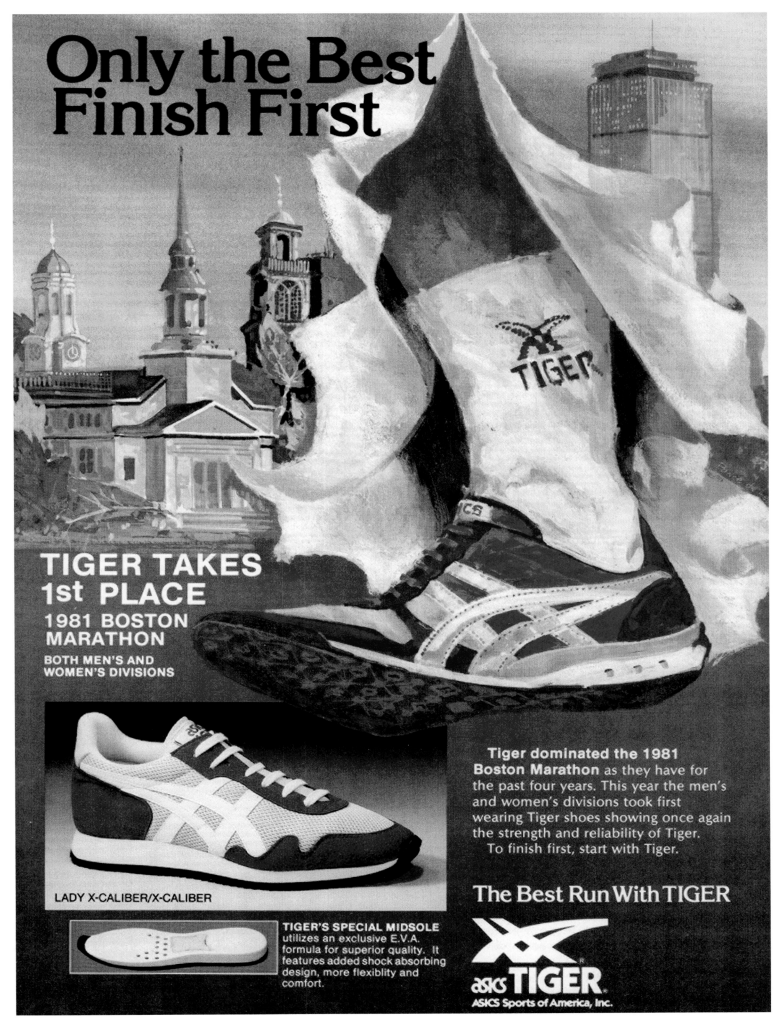

1982: X-Caliber and Lady X-Caliber, 'Only the Best Finish First'

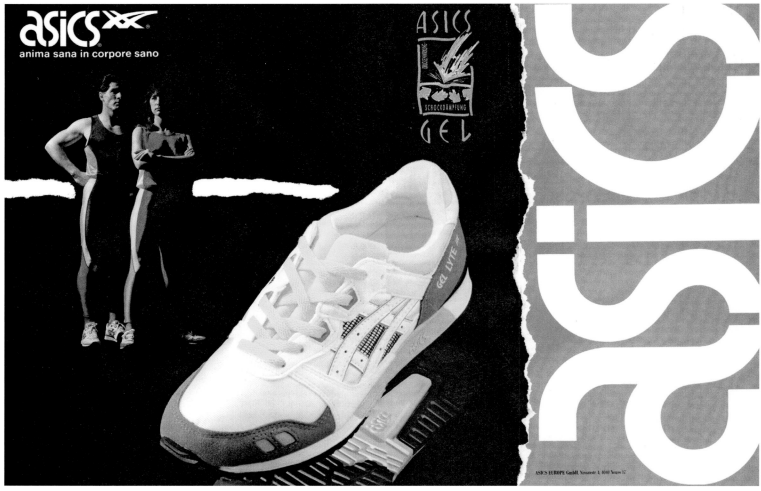

1981: GEL-Lyte III

Heel Strikers. There's a lot of you out there. That's why Tiger designed the Striker ST.™ A shoe that absorbs a great deal more shock than most training shoes, thanks to the Wingfoot XL™ heel insert.*

For serious runners, the term "pounding the pavement" takes on a whole new meaning when you run regularly. But the Striker ST can take the pounding better than your average training shoe.

The Striker ST. Just because you run hard doesn't mean you should suffer for it.

TIGER. BORN TO PERFORM.

*Wingfoot XL™ is a trademark of Goodyear Tire and Rubber Company.

1984: Striker ST, 'Striking Difference'

Don't Just Do It. Duet Better.

For maximum cushioning, train in the GEL-Epirus* and race in the GEL-LD Racer.

GEL-Epirus

GEL-LD Racer

If you like an ultra-light shoe, pair up the GEL-Lyte II* with the Ekiden Racer.

GEL-Lyte II

Ekiden Racer

Encapsulated ASICS' GEL effectively absorbs shock by dispersing vertical energy into a horizontal plane.

Some days, it's training. Solid, steady, long hauls. Race days, it's crank and burn. Faster pace, going for a personal best.

That's why ASICS has shoes tuned to maximize your performance and protection in each.

With the incredible shock absorption of ASICS' GEL† And designs adjusted to bring state of the art cushioning, support, stability and flexibility to both training and racing.

So instead of one pair for everything, each pair can do what it does best.

Because when you're training and racing in shoes with technology this advanced, you won't just do it.

You'll duet better.

asics

Don't Just Do It. Do It Better.

Official footwear and apparel supplier to the New York City Marathon.®

*Available in women's models. †Available in most models. For information please write ASICS Tiger Corp., Dept. R, P.O. Box 15352, Santa Ana, CA 92705.

1989: GEL Epirus, GEL-LD Racer, GEL Lyte II and Ekiden Racer, 'Don't Just Do It. Duet Better'

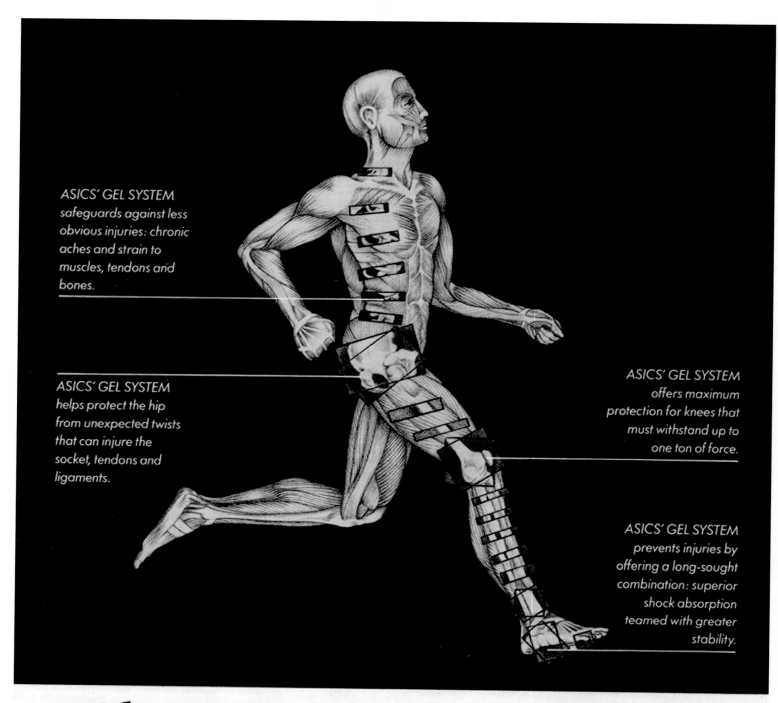

ASICS' GEL SYSTEM safeguards against less obvious injuries: chronic aches and strain to muscles, tendons and bones.

ASICS' GEL SYSTEM helps protect the hip from unexpected twists that can injure the socket, tendons and ligaments.

ASICS' GEL SYSTEM offers maximum protection for knees that must withstand up to one ton of force.

ASICS' GEL SYSTEM prevents injuries by offering a long-sought combination: superior shock absorption teamed with greater stability.

With Asics' Gel, you won't be shocked by your shoe's performance.

Each year, thousands of athletes suffer painful, preventable injuries caused by shoes that fail to provide adequate shock absorption and stability. If you've ever suffered because of athletic shoes, here's a test result worth remembering: our ASICS' GEL ranked #1 in *both* shock absorption and overall stability in tests conducted by Dr. Barry Bates of the University of Oregon Sports Medicine Laboratory. Whether your passion is for running, court sports or aerobics, you can find the right ASICS' GEL shoe by seeing your Asics Dealer or writing Asics Tiger Corp., 3030 S. Susan St., Dept. G, Santa Ana, CA 92704.

Basketball VHP

Aerobic Fanatic

Volleyball Pacific Gel

Tennis Echelon

Running GT-II

THE CHOICE OF FANATICS

1988: VHP, Fanatic, Pacific Gel, Echelon and GT-II, 'With ASICS' Gel, You Won't Be Shocked by Your Shoe's Performance'

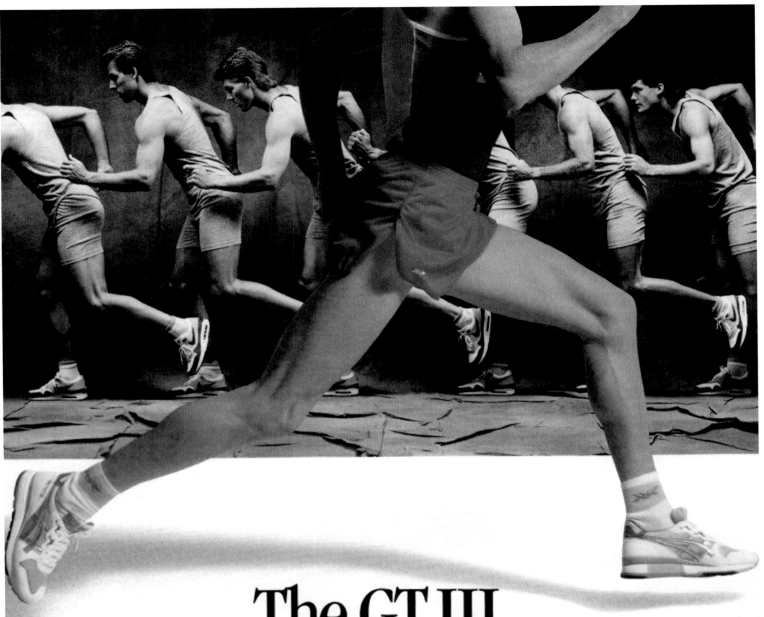

The GT III.
Not for the masses.

Some manufacturers promise a running shoe revolution, but end up catering to a herd of conformists. Asics' new GT III is for the runner on the road less traveled: the path of a leader.

While fad followers and bargain hunters head the other way, serious runners will give the GT III a serious workout. And discover that Asics' safest gel shoe protects their running future like nothing else.

Only the GT III incorporates the advanced Asics' Gel² System—added gel protection for the most complete shock absorption ever. An extended heel collar and stabilizing pillar improve motion control, further reducing the risk of injury.

Move out from the pack. Try the GT III gel shoe at your local Asics dealer.

1988: GT III, 'The GT III. Not for the Masses'

Our new GTII's are for runners who are tired of short-term relationships.

Searching for the right running shoe can be a pretty sad affair. Just because it starts with love at first sight doesn't mean it's going to last. One shoe leaves you blistered. Another leaves you injured. The next one wears out before you've thrown the box away.

The GTII's Asics' Gel configuration represents our most advanced shock absorption system.

If you're tired of starting over, it's time you paired up with Asics' new GTII. It's stable, protective, enduring—everything you want from the perfect running partner.

Its dual pads of Asics' Gel protect you against impact injuries. Other shoe makers are still racing to catch up with our original silicone formula shock

absorber that works better and lasts longer than traditional cushioning systems.

Asics' Gel also allows the GTII to maintain its superior stability—biomechanical tests indicate the GTII is 21% more stable than the top-of-the-line "air" shoe. And the integrated heel pillar and heel counter comfortably control motion.

Built to last, the GTII's Ecsaine upper and improved carbon rubber heel outsole ruggedly withstand miles of trials and tribulations.

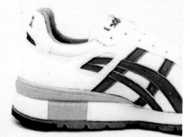

A high-density midsole pillar delivers great strides in motion control.

You're going to give your next pair of running shoes some of the best miles of your life. We've made the GTII worthy of such devotion. See what we mean by calling 1-800-447-4700 today for the name of the Asics Tiger dealer nearest you.

asics®

THE CHOICE OF FANATICS

The GTII's new outsole has been thickened from 4mm to 6mm and reformulated with a more durable rubber compound that lasts longer, even under the heaviest heel strikes.

1988: GTII, 'Our New GTII's Are for Runners Who Are Tired of Short-Term Relationships'

At last. A shoe that keeps you on the level.

If your heels say "tilt," this is your shoe.

It's the GEL-Striker. A new high-performance shoe designed to provide additional stability for overpronators and runners over 150 pounds.

To begin with, it has ASICS' advanced GEL system for superior rearfoot shock absorption. Which helps prevent nagging problems like shin splints, knee injuries, stress fractures and lower back pain.

Only this shoe goes even further.

By ingeniously adjusting for the most common biomechanical problem in running: overpronation.

Exclusive molded EVA external arch support.

External PVC midsole collar stops "over-roll" on landing.

ASICS' GEL system and compression molded EVA provide cushioning and midsole durability.

Internal nylon shank provides excellent torsional rigidity.

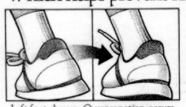

Left foot shown. Overpronation occurs when the back of the heel rolls inward relative to the lower leg at groundstrike.

With technical features like our external PVC midsole collar and exclusive external arch support.

Working in combination, they provide you with optimal rearfoot motion control.

And our new internal nylon shank provides extra torsional rigidity that overpronators and heavier runners require.

So if you're ready to straighten up and fly right, get the new GEL-Striker from ASICS. And keep your heel on a more even keel. **asics** ✕

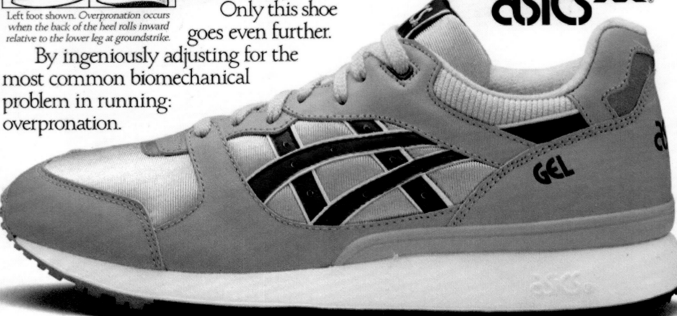

For more information please write ASICS Tiger Corp., Dept R, 10540 Talbert Ave., West Building, Fountain Valley, CA 92708.

1988: GEL-Striker, 'At Last. A Shoe That Keeps You on the Level'

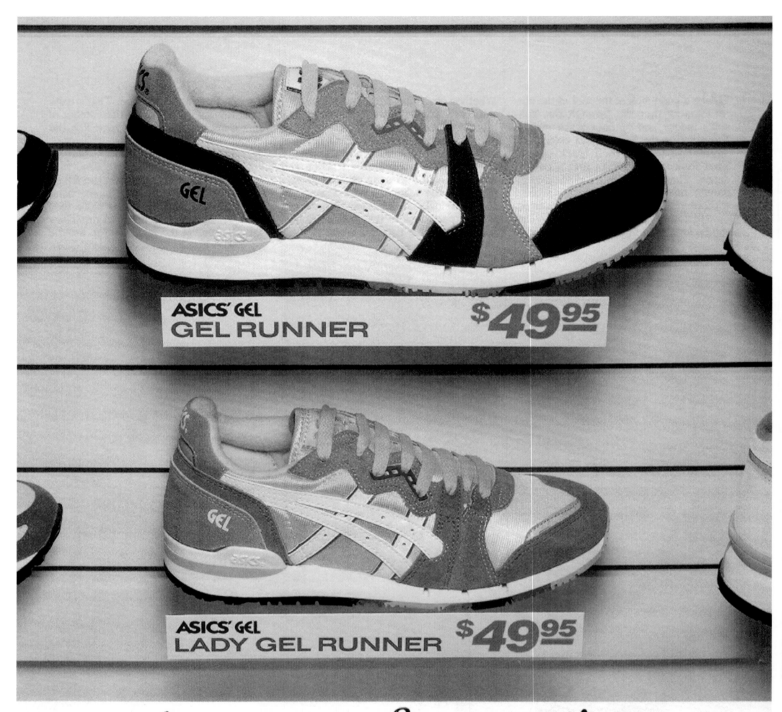

An ounce of prevention shouldn't cost a fortune.

No one can afford to run with injuries. But now everyone can afford a shoe designed to prevent them—the Gel Runner by Asics. Both men's and women's models protect you from damaging impact forces with the ASICS' GEL system, an encapsulated silicone shock absorber cradled within an EVA midsole. ASICS' GEL also enhances the stability created by our thermoplastic heel counter. We've even added reflective tabs for safer running at night. All of which proves the right running shoe can be defensive without being expensive. See the Gel Runner at your Asics Tiger Dealer or write Asics Tiger Corp., Dept. R, 3030 S. Susan St., Santa Ana, CA 92704.

*Asics'
Gel Pad*

THE CHOICE OF FANATICS

1988: GEL Runner and Lady GEL Runner, 'An Ounce of Prevention Shouldn't Cost a Fortune'

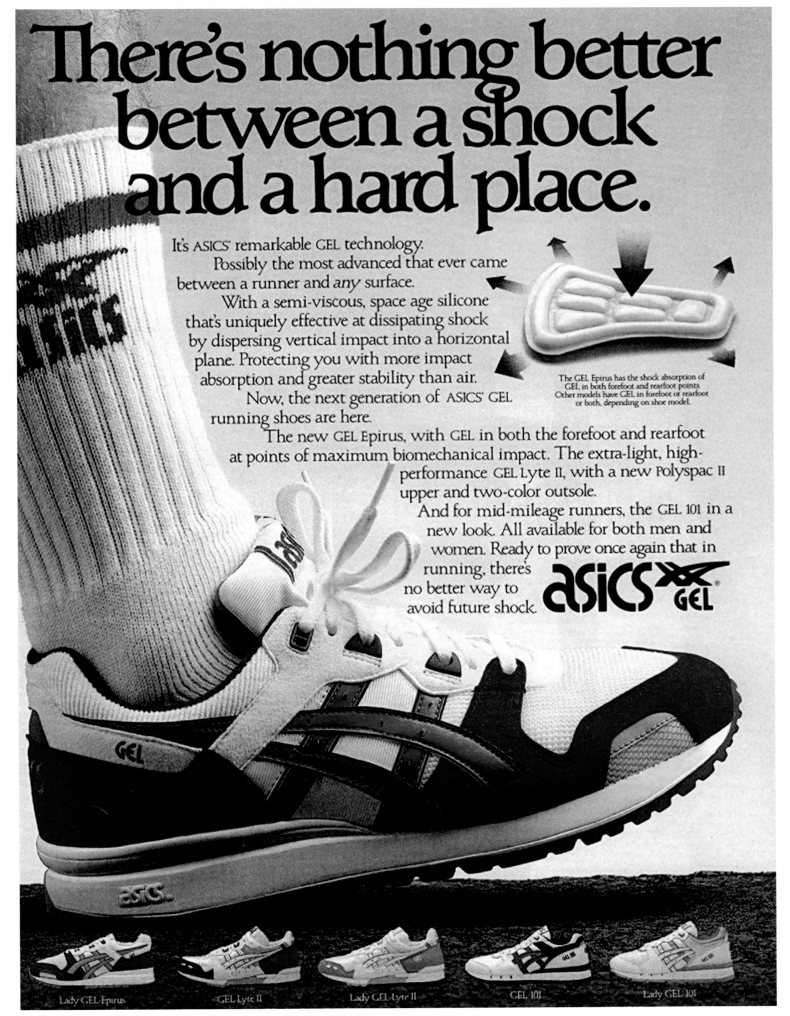

There's nothing better between a shock and a hard place.

It's ASICS' remarkable GEL technology. Possibly the most advanced that ever came between a runner and *any* surface.

With a semi-viscous, space age silicone that's uniquely effective at dissipating shock by dispersing vertical impact into a horizontal plane. Protecting you with more impact absorption and greater stability than air.

Now, the next generation of ASICS' GEL running shoes are here.

The GEL Epirus has the shock absorption of GEL in both forefoot and rearfoot points. Other models have GEL in forefoot or rearfoot or both, depending on shoe model.

The new GEL Epirus, with GEL in both the forefoot and rearfoot at points of maximum biomechanical impact. The extra-light, high-performance GEL Lyte II, with a new Polyspac II upper and two-color outsole.

And for mid-mileage runners, the GEL 101 in a new look. All available for both men and women. Ready to prove once again that in running, there's no better way to avoid future shock.

asics GEL

Lady GEL-Epirus GEL Lyte II Lady GEL-Lyte II GEL 101 Lady GEL 101

1989: Lady GEL-Epirus, GEL-Lyte II, Lady GEL-Lyte II, GEL 101 and Lady GEL 101, 'There's Nothing Better Between a Shock and a Hard Place'

The ASICS Perform
Who Start Running Mond

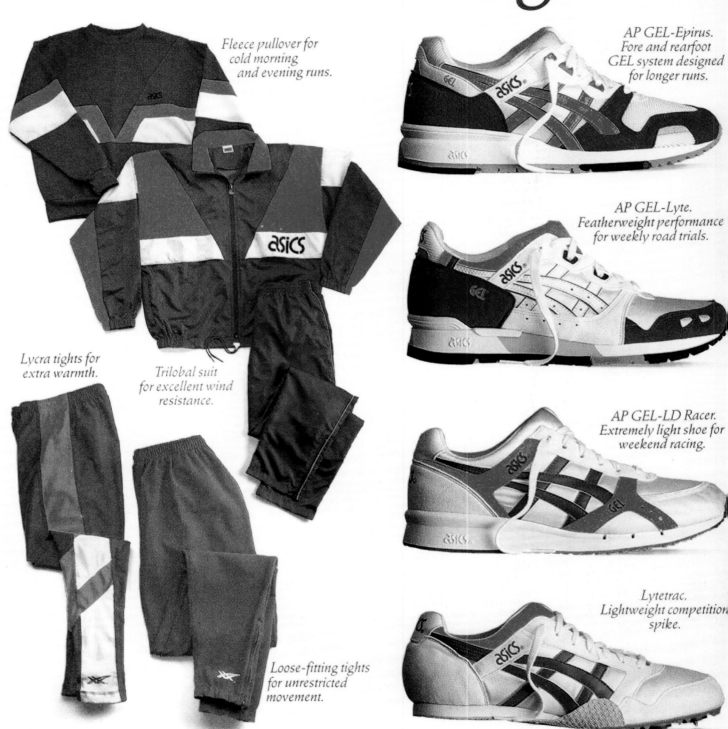

Fleece pullover for cold morning and evening runs.

AP GEL-Epirus. Fore and rearfoot GEL system designed for longer runs.

AP GEL-Lyte. Featherweight performance for weekly road trials.

Lycra tights for extra warmth.

Trilobal suit for excellent wind resistance.

AP GEL-LD Racer. Extremely light shoe for weekend racing.

Lytetrac. Lightweight competition spike.

Loose-fitting tights for unrestricted movement.

Presenting the first athletic gear tailored to fit your body, your feet and your schedule. Particularly i you cover as many miles and as much varying terrain as Steve Scott or Ingrid Kristiansen. The ASIC Performance Package lets you do it better all the time. With 4 pairs of specific-function footwear,

1990: 'The ASICS Performance Package. For People Who Start Running Monday and Don't Stop til Sunday', ft. Steve Scott and Ingrid Kristiansen

e Package. For People And Don't Stop Til Sunday.

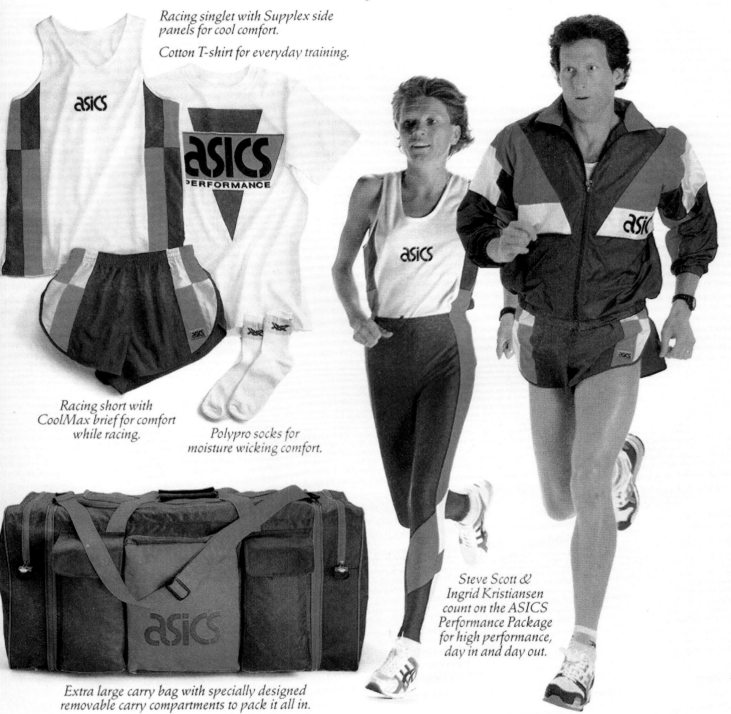

Racing singlet with Supplex side panels for cool comfort.

Cotton T-shirt for everyday training.

Racing short with CoolMax brief for comfort while racing.

Polypro socks for moisture wicking comfort.

Steve Scott & Ingrid Kristiansen count on the ASICS Performance Package for high performance, day in and day out.

Extra large carry bag with specially designed removable carry compartments to pack it all in.

featuring our innovative split tongue™ design, a complete collection of apparel and all the necessary accessories to get you through the toughest distance of all: the work-out week. See the ASICS Performance Package today, especially if you train like there's no tomorrow.

To find out where to buy the ASICS Performance Package, call (800) 243-1003.

asics

Don't Just Do It. Do It Better.

This magazine probably weighs more than the ASICS GEL-Lyte III.

If you'd like to take issue with this, get out your scale. You'll find that the new ASICS GEL-Lyte III reads a mere 10 ounces, one of the lightest shoes you can train in.

However, there's more to this shoe than less weight. There's history. ASICS introduced the classic light training shoe, the GEL-Lyte, back in 1987.

There's high performance. ASICS incorporates technology that other light shoes simply

Encapsulated ASICS GEL effectively absorbs shock by dispersing vertical energy into a horizontal plane.

don't have. Like the innovative split-tongue™ for an incredibly comfortable fit. And the super durable AHAR rubber heel plug.

And there's GEL. The unique shock absorption system that has more people running to ASICS every year.

Of course there's more to tell you about our feather weight shoes. As well as our full line of running shoes. But please see your local ASICS retailer. In the interest of living up to our claim, we're trying to keep this reading material light.

asics⨯⨯ GEL
Do it Better.

Women's GEL-Lyte III Men's GEL-Exult Women's GEL-Exult Men's GEL-MC

For the ASICS dealer nearest you call 1-800-766-ASICS

1990: GEL-Lyte III, GEL-Exult and GEL-MC, 'This Magazine Probably Weighs More Than the ASICS GEL-Lyte III'

" The GEL-Lyte III's split-tongue design was intended for performance purposes as it keeps a better fit for the shoe. The second reason is that with a normal tongue, you have to use your hands, but the split-tongue allows hands-free fitting. I thought sneaker colours were really bland at that time. For the GEL-Lyte III, consumers wanted something different so I looked for the right Pantones. I made a hundred ideas and sent them to the factory. Using a little bit of dark green plus yellow, it made the 'Citrus' combination. Younger consumers still love this design. Maybe it's because there are many amazing collaborations based on the GEL-Lyte III. "

Shigeyuki Mitsui (ASICS designer)
'30 Years of the ASICS GEL-Lyte III'
Sneakerfreaker.com (2019)

Serious Runners Don't Put On Airs.

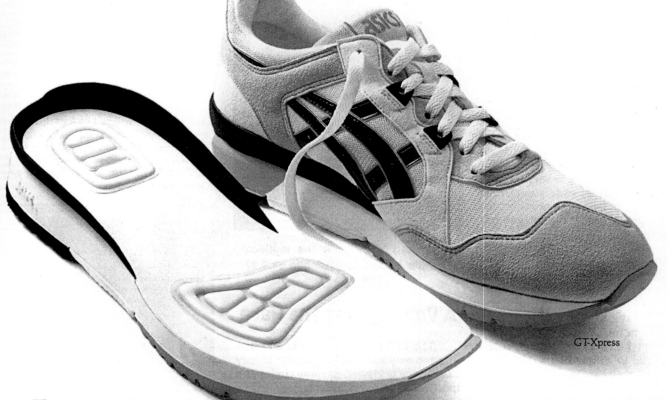

GT-Xpress

They put on ASICS. And count on ASICS' GEL for serious shock absorption.

Want proof?

Run down to a local 10K race or marathon, and take a look at the crowd. Chances are you're going to find an abundance of ASICS running shoes, from the new GT-Xpress to the GEL-110. Worn by runners who rack up the miles. And depend on ASICS' GEL for excellent protection against injury.

If you're not convinced by the sheer number of

Encapsulated ASICS' GEL effectively disperses vertical energy into a horizontal plane. These special pads provide excellent shock absorption and make for a more comfortable stride.

runners wearing ASICS, talk to some of them. You'll hear more than you ever need to know about orthotic sock liners, torsional rigidity, compression molded EVA midsoles, and of course the unique properties of GEL.

We're sure that after you've picked their brain, you'll pick their brand.

asics ✕

Don't Just Do It. Do It Better.

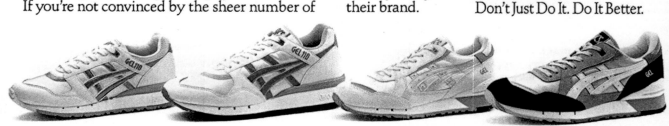

Women's GEL-110 Men's GEL-110 Women's GEL-Runner 90 Men's GEL-Runner 90

For the ASICS dealer nearest you, call 1-800-866-ASICS.

1990: GT-Xpress, GEL-110 and GEL-Runner 90, 'Serious Runners Don't Put on Airs'

AIR

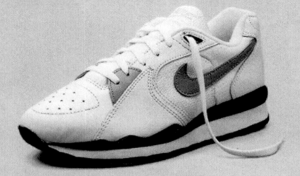

VS.

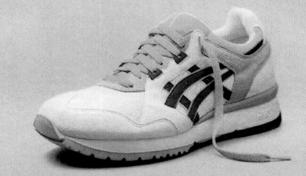

AIR CONDITIONING

Introducing GT-COOL, the first running shoe featuring Coolmax,* the legendary fabric that enhances your body's cooling mechanism.

When combined with the pair of Coolmax socks included with your purchase, a unique system is formed. A system which uses Coolmax's ability to dry much faster than nylon, the material traditionally found in running shoe uppers.

Combine that with all the features that have already made ASICS a

recognized leader in running shoes, including shock absorbing GEL, and you have one of the most significant technological running shoe breakthroughs in years.

So cool your heels. Try on a pair of GT-COOLs at your dealer today. And when you buy them, we'll even throw in a portable cooler with a Coolmax singlet, a water bottle and other fun things.** Pretty cool huh?

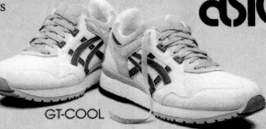

GT-COOL

aSICS GEL

For more information call 1-800-766-ASICS. 7 a.m.-5 p.m. Pacific Standard Time.
*Coolmax is a DuPont certification mark for fabrics of high performance polyester meeting its quality standards. **$3.95 for postage and handling charge.

1991: GT-COOL, 'Air Vs. Air Conditioning'

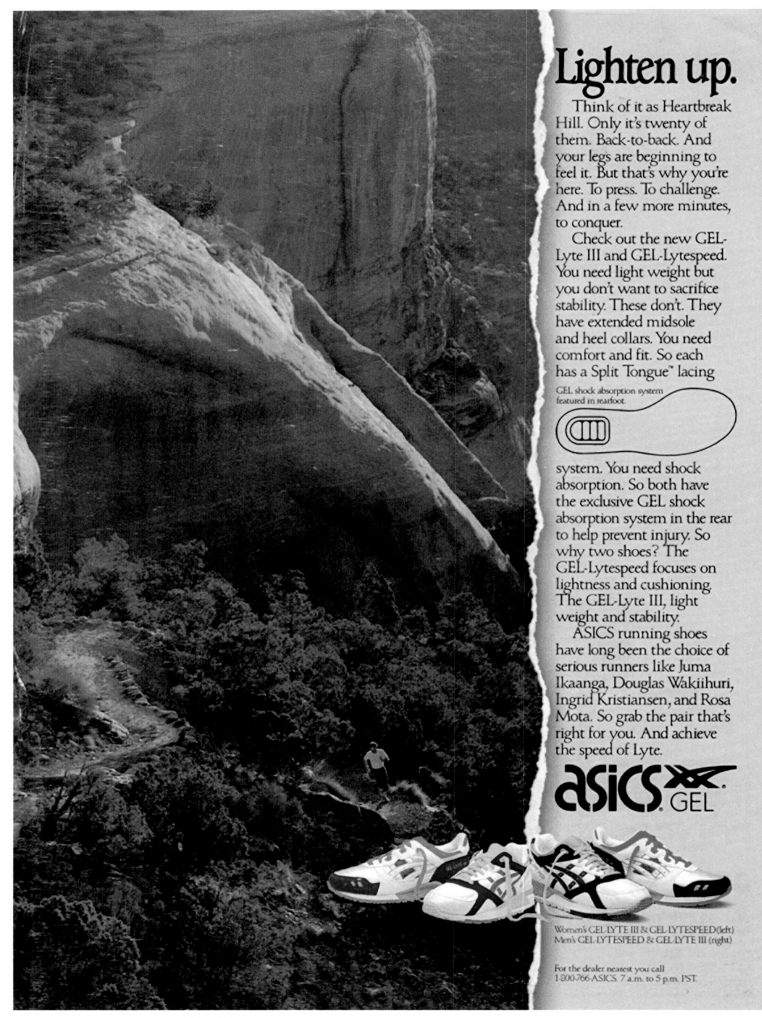

Lighten up.

Think of it as Heartbreak Hill. Only it's twenty of them. Back-to-back. And your legs are beginning to feel it. But that's why you're here. To press. To challenge. And in a few more minutes, to conquer.

Check out the new GEL-Lyte III and GEL-Lytespeed. You need light weight but you don't want to sacrifice stability. These don't. They have extended midsole and heel collars. You need comfort and fit. So each has a Split Tongue™ lacing

GEL shock absorption system featured in rearfoot.

system. You need shock absorption. So both have the exclusive GEL shock absorption system in the rear to help prevent injury. So why two shoes? The GEL-Lytespeed focuses on lightness and cushioning. The GEL-Lyte III, light weight and stability.

ASICS running shoes have long been the choice of serious runners like Juma Ikaanga, Douglas Wakiihuri, Ingrid Kristiansen, and Rosa Mota. So grab the pair that's right for you. And achieve the speed of Lyte.

asics GEL

Women's GEL-LYTE III & GEL-LYTESPEED (left)
Men's GEL-LYTESPEED & GEL-LYTE III (right)

For the dealer nearest you call
1-800-766-ASICS. 7 a.m. to 5 p.m. PST.

1991: GEL-Lyte III and GEL-Lytespeed, 'Lighten Up'

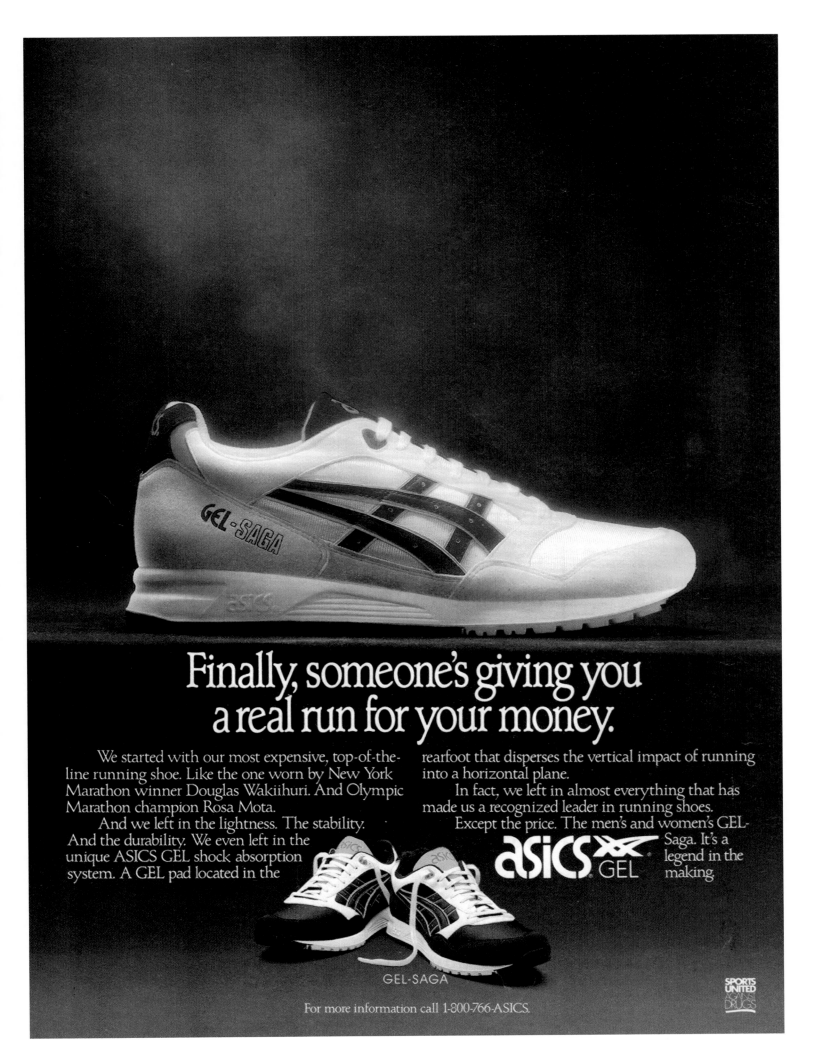

Finally, someone's giving you a real run for your money.

We started with our most expensive, top-of-the-line running shoe. Like the one worn by New York Marathon winner Douglas Wakiihuri. And Olympic Marathon champion Rosa Mota.

And we left in the lightness. The stability. And the durability. We even left in the unique ASICS GEL shock absorption system. A GEL pad located in the rearfoot that disperses the vertical impact of running into a horizontal plane.

In fact, we left in almost everything that has made us a recognized leader in running shoes.

Except the price. The men's and women's GEL-Saga. It's a legend in the making.

asics GEL

GEL-SAGA

For more information call 1-800-766-ASICS.

1991: GEL-Saga, 'Finally, Someone's Giving You a Real Run for Your Money'

BROOKS

Founded in 1914 by John Goldenberg, Brooks started making ballet slippers before diversifying into cleats and roller skates. Goldenberg's homespun enterprise later rode the running boom to become one of the top three brands in the US by the mid-1970s. *Runner's World* magazine named the Vantage as its shoe of the year in 1977 – lofty praise from the publication that did more to make distance running a weekly part of American life than any other. By the early 1980s, however, Brooks was beset with difficulties and the company was forced into Chapter 11 bankruptcy.

With ads ranging from freaked-out illustrations that likened Brooks to flying and dancing, to hard-nosed pitches that pulled no punches ('Put Nike, adidas, Etonic and New Balance together and you still won't have the Brooks Hugger GT'), Brooks was more than a contender. To this day, no other sneaker brand has quoted a gun-toting Bonnie Parker, the notorious gangster moll of 'Bonnie and Clyde' fame, in their advertising. As the headline threatened, 'Life on the run ain't no fun.' Unless, of course, you were wearing Brooks sneakers on your feet.

●

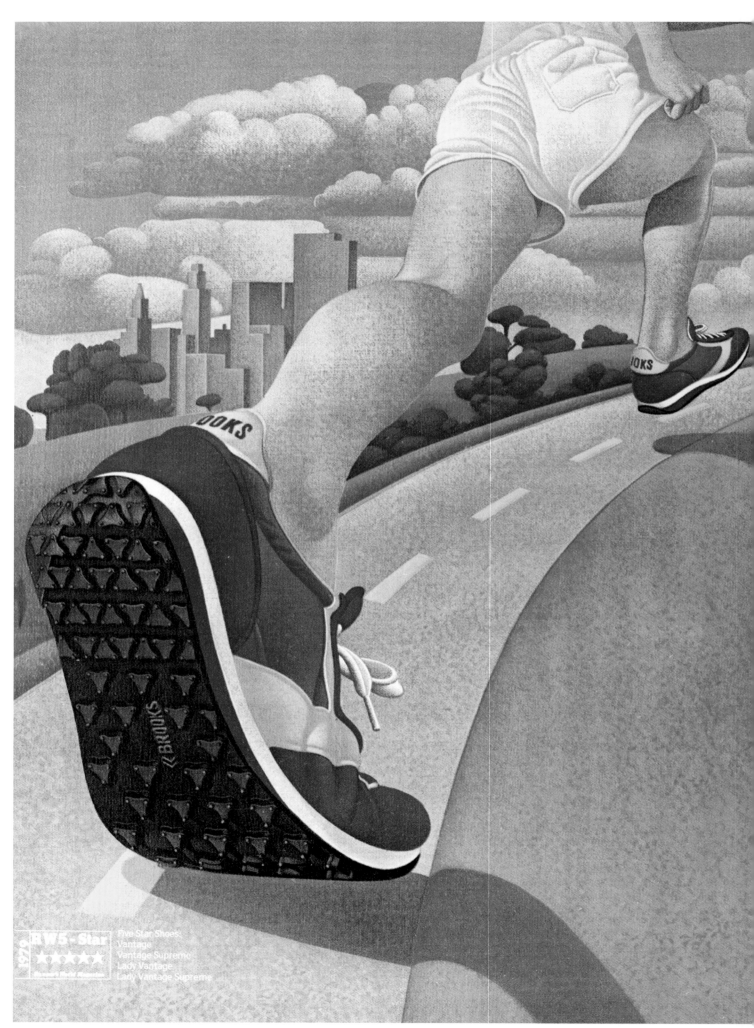

1979: Sensation, 'It's Like Flying'

It's like flying.

It's like flying. Like skimming the earth. Barely touching down.

It's like soaring. With a fresh breeze at your back and the whole world in front of you.

It's the sweet taste of cool air in your lungs. The crunch of country gravel. The swishing sound of hot concrete as it melts away under your feet.

It's a shoe so light you barely know it's on. A shoe that hugs your heel and cushions every footfall. A shoe that meets the earth squarely and evenly as it propels you steadily along.

It's the Brooks feeling. The Brooks Sensation. Sensational.

1. Perforated Midsole*. Scientifically designed perforation pattern flexes naturally with your foot and protects delicate metatarsals.

2. Custom Contour Insole. Molds to your foot as you run for custom fit at heel and arch.

3. Varus Wedge™*. 4° midsole wedge reduces twisting of the foot and lessens heel strike impact to help prevent foot, ankle, knee, and back problems.

4. Reinforced Racing Sole. Cushions every footfall and dissipates road shock. Reinforced heel strike zone extends sole life.

*Patents Pending

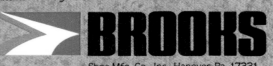

Shoe Mfg. Co., Inc., Hanover, Pa. 17331

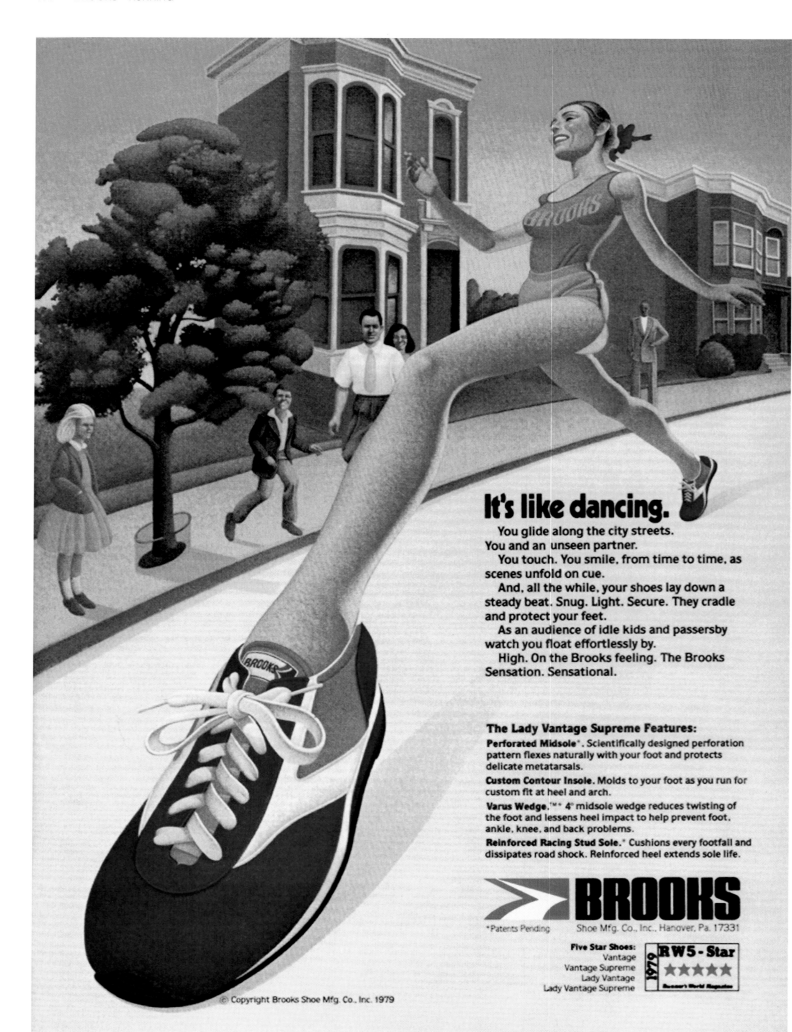

It's like dancing.

You glide along the city streets.
You and an unseen partner.

You touch. You smile, from time to time, as scenes unfold on cue.

And, all the while, your shoes lay down a steady beat. Snug. Light. Secure. They cradle and protect your feet.

As an audience of idle kids and passersby watch you float effortlessly by.

High. On the Brooks feeling. The Brooks Sensation. Sensational.

The Lady Vantage Supreme Features:

Perforated Midsole*. Scientifically designed perforation pattern flexes naturally with your foot and protects delicate metatarsals.

Custom Contour Insole. Molds to your foot as you run for custom fit at heel and arch.

Varus Wedge.™* 4° midsole wedge reduces twisting of the foot and lessens heel impact to help prevent foot, ankle, knee, and back problems.

Reinforced Racing Stud Sole.* Cushions every footfall and dissipates road shock. Reinforced heel extends sole life.

BROOKS

*Patents Pending Shoe Mfg. Co., Inc., Hanover, Pa. 17331

Five Star Shoes:
Vantage
Vantage Supreme
Lady Vantage
Lady Vantage Supreme

RW 5 - Star
★★★★★
Runner's World Magazine

© Copyright Brooks Shoe Mfg. Co., Inc. 1979

1979: Lady Vantage Supreme, 'It's Like Dancing'

PUT NIKE, ADIDAS, ETONIC AND NEW BALANCE TOGETHER AND YOU STILL WON'T HAVE THE BROOKS HUGGER GT.

There are plenty of fine running shoes. And they all have one or two outstanding features.

But no other shoe has all five of the distance-building features the new Brooks Hugger GT has.

OUR UPPER.

The Hugger GT is the only shoe in the world made with Gore-Tex® fabric and Aqua Shed™ treated suede. Gore-Tex is waterproof and breathable. Aqua Shed suede resists water 300% better than conventional suede and dries 9 times faster. So your feet stay drier when it's wet and breathe beautifully when it's hot.

OUR HEEL HUGGER STRAP.

Other shoes have a stabilizing lace, but it's not our Heel Hugger Side Strap.

Our Side Strap holds the entire heel counter snug against your heel which, in turn, makes the Hugger GT and your foot a more biomechanically efficient (and less injury prone) structure. It also makes the Hugger more comfortable for runners with narrow heels.

RIGHT FOOT

OUR VARUS WEDGE.

Some shoes have a midsole wedge, but it's not the Varus Wedge.

We slant the sole of our new Hugger GT 3° to compensate for the fact that most runners run on the outside edge of their heels and pronate inward. As a result, you'll notice considerably less heel shock in the Hugger GT and much less twisting of the foot and ankle during pronation, too.

OUR CUSTOM CONTOUR INSOLE.

Most shoes have a soft insole, but it's not the Custom Contour Insole.

The Custom Contour Insole in the Hugger GT actually forms to your foot as you run and stays that way. It's like having your Hugger GT's custom-made just for you.

OUR SOLE.

Some shoes have a racing sole, but it's not our Racing Stud Sole.

We triple-reinforce the outside edge of the Hugger GT Sole at the critical heel strike point. The result: our soles wear longer, which means you don't have to resole or buy new shoes

RW5-STAR
★ ★ ★ ★ ★
Runner's World

as often. We also drill a scientifically alig pattern of holes in our midsole, which helps the Hugger GT flex more naturally with your foot as you run and makes the shoe lighter.

OUR PRICE. EXPENSIVE, BUT WORTH IT.

This new Brooks Hugger GT isn't for everyone. But think about it this way. You could buy four other shoes and still not get all five distance-building features the Hugger GT has.

It's truly a sensational shoe.

The new Hugger GT. About 9 oz. in size 9.

BROOKS

©1980 Brooks Shoe Mfg. Co., Inc. Hanover, PA 17331

1980: Hugger GT, 'Put Nike, adidas, Etonic and New Balance Together and You Still Won't Have the Brooks Hugger GT'

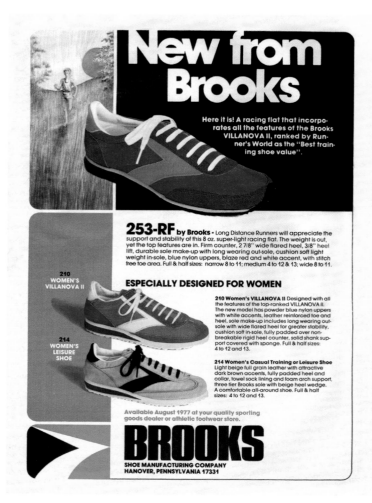

1977: 253-RF, Villanova II and Leisure Shoe, 'Especially Designed for Women'

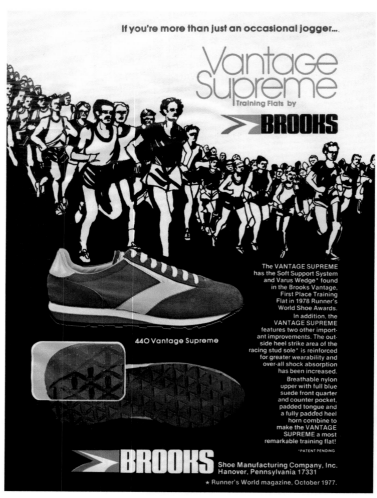

1977: 440 Vantage Supreme, 'If You're More Than Just an Occasional Jogger...'

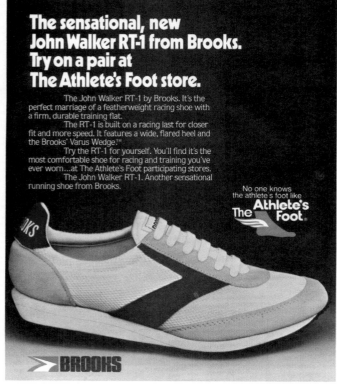

1979: John Walker RT-1

1981: 'We Support the Women's Movement'

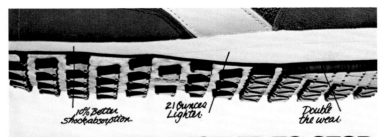

WHY WE'VE DECIDED TO STOP MAKING SIX OF OUR MOST POPULAR RUNNING SHOES.

There's an old racing strategy that says: Don't look over your shoulder when you're in the lead.

Well, we've taken that maxim to heart. And now that we've improved six of our most popular shoes, it just doesn't make sense to sell the originals any more.

DOUBLE THE WEAR.
We've changed the rubber in our Racing Stud Sole to a new compound called Brooks B-22, and increased the stud length. In tests at a leading independent laboratory, our new B-22 Sole outperformed our original sole by 100%, which means you should get twice as many miles from our new and improved Vantage, Vantage Supreme and Super Villanova.

2.1 OUNCES LIGHTER.
The midsole material is new, too. It's called My/T/Lite®Foam. And in our Vantage, for example, it shaves off more than two ounces of weight. That's almost 20% less to carry. So whether you're racing or just out for your daily training run, the net weight savings is phenomenal. (More than 2½ tons for the marathon, for instance.)

10% BETTER SHOCK ABSORPTION.
Our new midsole also increased shock absorption an amazing 10%. No mean feat when you consider that

these shoes are already rated among the best in the world in absorbing road shock.

WHAT WE DIDN'T CHANGE.
You'll be pleased to know that we haven't changed the Brooks Sensation, that tremendously satisfying feeling you get from running in Brooks shoes. Or any of our sensa-

tional Brooks features. The Varus Wedge* to control pronation. The Custom Contour Insole* for custom fit. The triple-reinforced heel strike area for longer sole wear.

We haven't changed the Brooks Sensation.

We've just made it more sensational.

THE NEW VANTAGE SUPREME.

THE NEW LADY VANTAGE SUPREME.

THE NEW VANTAGE.

THE NEW LADY VANTAGE.

THE NEW SUPER VILLANOVA.

THE NEW LADY SUPER VILLANOVA.

BROOKS

*Not in Super Villanova ©1979 Shoe Mfg. Co., Inc., Hanover, PA 17331

1979: Vantage Supreme, Vantage and Super Villanova, 'Why We've Decided to Stop Making Six of Our Most Popular Running Shoes'

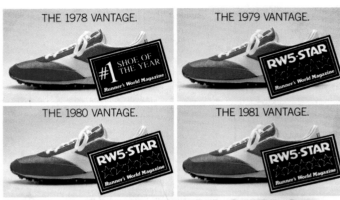
THE 1978 VANTAGE. THE 1979 VANTAGE.
THE 1980 VANTAGE. THE 1981 VANTAGE.

THE MORE THINGS CHANGE THE MORE THEY STAY THE SAME.

The Brooks Vantage has set another record. A record no other running shoe can claim.

In open competition against the best shoes Germany and Japan have to offer, the Vantage captured the coveted 5 Star rating from Runner's World magazine again this year (that's *three* years in a row). And before there was a 5 Star Award, the Vantage was named Shoe of the Year.

The reason? We're always improving the Vantage. This year, for example, we've continued to reduce the weight of the Vantage. Last year we discovered a

way to make the Vantage absorb shock 15% better. And in 1979 we reinforced the heel strike area to make the sole of the Vantage last twice as long.

But you don't have to take our word for what a fine shoe the Vantage is. Try this little test.

Put a Vantage on your right foot and any other running shoe on your left. You'll feel the difference right away. And if you're

like a lot of runners, it'll make you change your brand of running shoes.

Which, as nice as awards are, is the reason we keep changing ours.

THE 1981 VANTAGE.

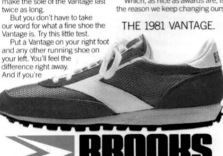

BROOKS
Feel the difference.

© 1980 Brooks Shoe Mfg. Co., Inc., Hanover, PA 17331

1981: Vantage, 'The More Things Change, the More They Stay the Same'

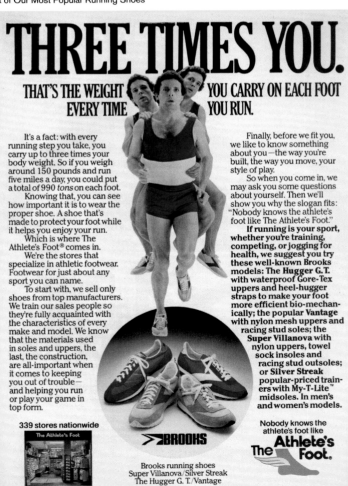

THREE TIMES YOU.
THAT'S THE WEIGHT YOU CARRY ON EACH FOOT EVERY TIME YOU RUN.

It's a fact: with every running step you take, you carry up to three times your body weight. So if you weigh around 150 pounds and run five miles a day, you could put a total of 990 *tons* on each foot.

Knowing that, you can see how important it is to wear the proper shoe. A shoe that's made to protect your foot while it helps you enjoy your run.

Which is where The Athlete's Foot® comes in.

We're the stores that specialize in athletic footwear. Footwear for just about any sport you can name.

To start with, we sell only shoes from top manufacturers. We train our sales people so they're fully acquainted with the characteristics of every make and model. We know that the materials used in soles and uppers, the last, the construction, are all-important when it comes to keeping you out of trouble— and helping you run or play your game in top form.

Finally, before we fit you, we like to know something about you—the way you're built, the way you move, your style of play.

So when you come in, we may ask you some questions about yourself. Then we'll show you why the slogan fits: "Nobody knows the athlete's foot like The Athlete's Foot."

If running is your sport, whether you're training, competing, or jogging for health, we suggest you try these well-known Brooks models: The Hugger G. T. with waterproof Gore-Tex uppers and heel-hugger straps to make your foot more efficient bio-mechanically; the popular Vantage with nylon mesh uppers and racing stud soles; the **Super Villanova** with nylon uppers, towel sock insoles and racing stud outsoles; or Silver Streak popular-priced trainers with My-T-Lite™ midsoles. In men's and women's models.

Nobody knows the athlete's foot like The **Athlete's Foot.**

339 stores nationwide
The Athlete's Foot

BROOKS

Brooks running shoes
Super Villanova/Silver Streak
The Hugger G. T./Vantage

1980: Super Villanova, Silver Streak, Hugger G. T. and Vantage, 'Three Times You'

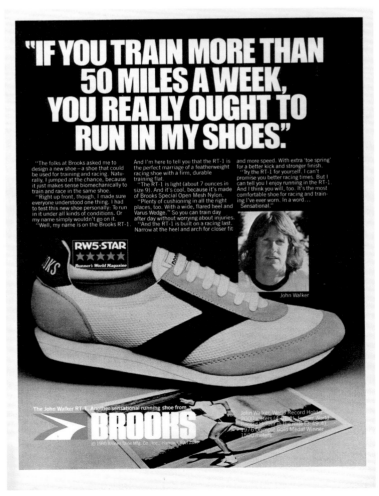

"IF YOU TRAIN MORE THAN 50 MILES A WEEK, YOU REALLY OUGHT TO RUN IN MY SHOES."

"The folks at Brooks asked me to design a new shoe–a shoe that could be used for training and racing. Naturally, I jumped at the chance, because it just makes sense biomechanically to train and race in the same shoe.

"The RT-1 is light (about 7 ounces in size 9). And it's cool, because it's made of Brooks Special Open Mesh Nylon.

"Plenty of cushioning in all the right places, too. With a wide, flared heel and Varus Wedge." So you can train day after day without worrying about injuries.

"And the RT-1 is built on a racing last. Narrow at the heel and arch for closer fit

And I'm here to tell you that the RT-1 is the perfect marriage of a featherweight racing shoe with a firm, durable training flat.

"Right up front, though, I made sure everyone understood one thing. I had to test this new shoe personally. To run in it under all kinds of conditions. Or my name simply wouldn't go on it.

"Well, my name is on the Brooks RT-1.

and more speed. With extra 'toe spring' for a better kick and stronger finish.

"Try the RT-1 for yourself. I can't promise you better racing times. But I can tell you I enjoy running in the RT-1. And I think you will, too. It's the most comfortable shoe for racing and training I've ever worn. In a word... Sensational."

RW5·STAR
Runner's World Magazine

John Walker

The John Walker RT-1. Another sensational running shoe from

BROOKS

© 1980 Brooks Shoe Mfg. Co., Inc., Hanover, PA 17331

1980: John Walker RT-1, '"If You Train More Than 50 Miles a Week, You Really Ought to Run in My Shoes"', ft. John Walker

"Life on the run ain't no fun."

Bonnie Parker, 1936

It is if you're in our shoes.

1980: 'Life on the Run Ain't No Fun', ft. Bonnie Parker

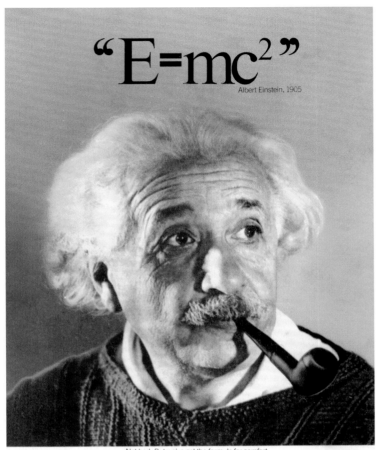

Not bad. But we've got the formula for comfort.

1980: 'E=mc²', ft. Albert Einstein

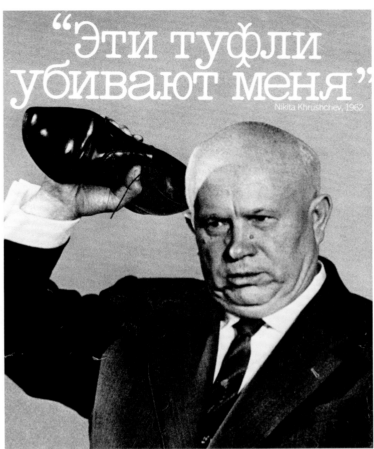

Sometimes a comfortable shoe can make all the difference in the world.

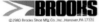

1980: 'These Shoes Will Kill Me!', ft. Nikita Khrushchev

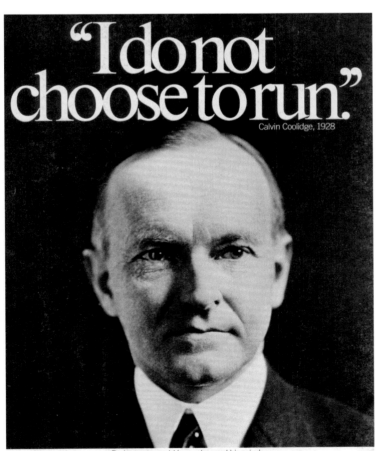

Perhaps we could have changed his mind.

1980: 'I Do Not Choose to Run', ft. Calvin Coolidge

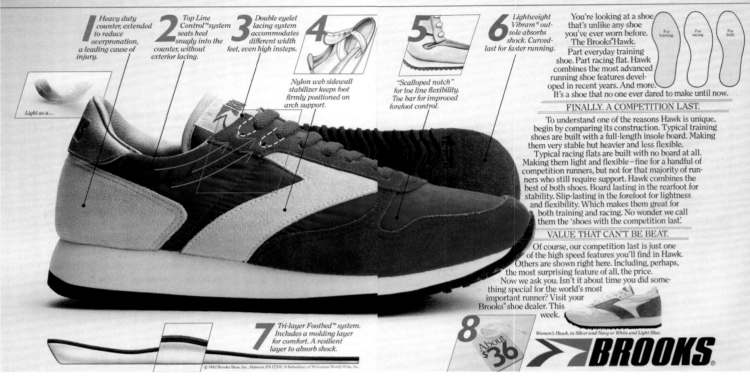

NOW YOU CAN BEAT THE MOST IMPORTANT RUNNER IN THE WORLD. YOURSELF.

Introducing the Brooks Hawk. Easily the most advanced blend of high speed features ever found in a training shoe.

1 Heavy duty counter, extended to reduce overpronation, a leading cause of injury.

2 Top Line Control™ system seats heel snugly into the counter, without exterior lacing.

3 Double eyelet lacing system accommodates different width feet, even high insteps.

4 Nylon web sidewall stabilizer keeps foot firmly positioned on arch support.

5 "Scalloped notch" for toe line flexibility. Toe bar for improved forefoot control.

6 Lightweight Vibram® outsole absorbs shock. Curved-last for faster running.

Light as a...

You're looking at a shoe that's unlike any shoe you've ever worn before. The Brooks® Hawk. Part everyday training shoe. Part racing flat. Hawk combines the most advanced running shoe features developed in recent years. And more. It's a shoe that no one ever dared to make until now.

FINALLY, A COMPETITION LAST.

To understand one of the reasons Hawk is unique, begin by comparing its construction. Typical training shoes are built with a full-length insole board. Making them very stable but heavier and less flexible.

Typical racing flats are built with no board at all. Making them light and flexible – fine for a handful of competition runners, but not for that majority of runners who still require support. Hawk combines the best of both shoes. Board lasting in the rearfoot for stability. Slip-lasting in the forefoot for lightness and flexibility. Which makes them great for both training and racing. No wonder we call them the 'shoes with the competition last.'

VALUE THAT CAN'T BE BEAT.

Of course, our competition last is just one of the high speed features you'll find in Hawk. Others are shown right here. Including, perhaps, the most surprising feature of all, the price. Now we ask you. Isn't it about time you did something special for the world's most important runner? Visit your Brooks® shoe dealer. This week.

Women's Hawk, in Silver and Navy or White and Light Blue.

7 Tri-layer Footbed™ system. Includes a molding layer for comfort. A resilient layer to absorb shock.

8 About $36

© 1982 Brooks Shoe, Inc., Hanover, PA 17331. A Subsidiary of Wolverine World Wide, Inc.

BROOKS®

1982: Hawk, 'Now You Can Beat the Most Important Runner in the World. Yourself'

THE NIGHTHAWK. COMPARED TO ANY OTHER SHOE THE DIFFERENCE IS LIKE NIGHT AND DAY.

This new lightweight running shoe is different from any shoe you've ever worn.

This new shoe is called Nighthawk.

SHOULD LIGHTNESS BE AN END IN ITSELF?

Even though the Nighthawk™ weighs in at a scant 216 grams*, there's nothing you should find extraordinary about that fact alone. What's so extraordinary about the Nighthawk is that it protects the body from shock so well, wears so well, and still weighs only 216 grams.

Actually, it took a team of Brooks chemists almost a year to select a rubber compound that struck the delicate balance between shock absorption, sole wear and weight the Nighthawk has.

They wear-tested, weighed and analyzed dozens of formulations. And they rejected all but one: a remarkable new sole compound we call Brooks B-17—a compound that is, at once, extremely light, tremendously shock absorbent and very long wearing.

In fact, our tests show B-17 absorbs shock as well as the sole compound in our 5 Star Vantage Supreme, but weighs less.

ANOTHER BROOKS FIRST: REFLEXITE™

Who would wear a shoe this light? The answer is obvious: High-mileage runners, who often do one workout in the morning and another one at night.

So, for their safety, we made the heel tab of the Nighthawk from an ultra-high visibility material called

The Nighthawk weighs 216.6 grams, but that, in itself, isn't important.*

Reflexite—a material that contains 47,000 light-dispersing little prisms, called microprisms, per square inch.

Unlike most other reflective materials, Reflexite has the amazing ability to retain its reflective properties in the rain. And, unlike other shoes, only the Nighthawk has it.

A NEW LACING SYSTEM.

The Nighthawk has another feature no other Brooks shoe has. It's called Reflexlacing™. And when we tell you how it works, you'll be surprised someone didn't think of it years ago.

We cut a diamond shape opening in the top facing of the Nighthawk at the flex point, so the shoe works in a reflex action with your foot. As your foot flexes, the lacing system opens up, which means the Nighthawk doesn't bind the girth of your foot during toe-off.

A small design change? Yes. But it makes the Nighthawk infinitely more comfortable than ordinary shoes.

Our new Reflexlacing system.

ALL THE OLD BROOKS FEATURES BUT ONE.

For extra long wear, we've reinforced the Nighthawk at the critical heel

The Reflexite heel tab.

strike zone with a special heel plug of Brooks B-22 Sole Compound. And we added our Custom Contour Insole, which forms to your foot as you run for custom fit at your heel and arch. But, alas, for all you runners who swear by the Varus Wedge™, the Nighthawk doesn't have one. It's a Neutral Plane Shoe. (Our Vantage, Vantage Supreme, and Hugger GT still have the Varus Wedge, of course.)

Reinforced heel strike zone for extra long wear.

FEEL THE DIFFERENCE IN THIS SHOE.

All of which brings us to the final point we'd like to make.

With the exception of our Reflexite heel tab, you can't really see the difference between The Nighthawk and any other lightweight shoe. You have to feel the difference.

And we suggest you do. Put a Nighthawk on your right foot and any of the "new" lightweight shoes on your left foot, and compare the two.

You'll feel the difference right away. It's as plain as the shoe on your foot.

© 1980 Brooks Shoe Mfg. Co., Inc., Hanover, PA 17331. *In size 9.

BROOKS
Feel the difference.

1980: Nighthawk, 'Compared to Any Other Shoe the Difference is Like Night and Day'

LESS SHOE FOR YOUR MONEY.

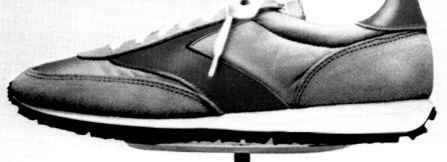

The suggested list price of our new Super Villanova lightweight trainer is only $29.95.

Now, a lot of training shoes sell for roughly that price. But the Super Villanova weighs in at a mere 270.3 grams in size 9. Which is pretty amazing, when you compare it with these other training shoes:

Shoe	Weight	Suggested Retail Price
Brooks Super Villanova	270.3g	$29.95
Nike Daybreak	306.1g	$42.95
Adidas Marathon Trainer	289.2g	$39.90
Etonic Stabilizer	326.4g	$39.95
Osaga KT-26	327.7g	$39.95

Source October 1979, *Runner's World*

But just because the new Super Villanova is light, doesn't mean it's less comfortable.

There's a mildly flared heel and a My/T/Lite™ midsole, which help to make the new Super Villanova comfortable and 10% more shock absorbent than it was before. The sole wears twice as long, too. That's because it's made of a new

rubber compound called Brooks B-10, and it's triple reinforced at the critical heel strike point. (No wonder the Super Villanova earned a 5-Star Rating for 1980.)

So if you're looking for a durable, lightweight training shoe at a reasonable price, try on the Brooks Super Villanova.

It's a lot less shoe for the money.

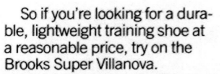
WOMEN'S SUPER VILLANOVA

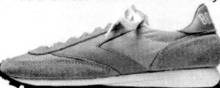
WOMEN'S SUPER VILLANOVA

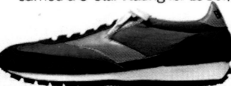
MEN'S/WOMEN'S SUPER VILLANOVA

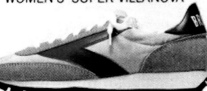
WOMEN'S SUPER VILLANOVA

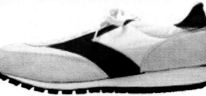
MEN'S SUPER VILLANOVA

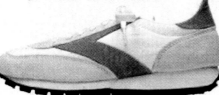
WOMEN'S SUPER VILLANOVA

RW5-STAR ★★★★★ *Runner's World Magazine*

BROOKS

© 1980 Brooks Shoe Mfg.Co.,Inc.,Hanover,PA 17331

1980: Super Villanova, 'Less Shoe for Your Money'

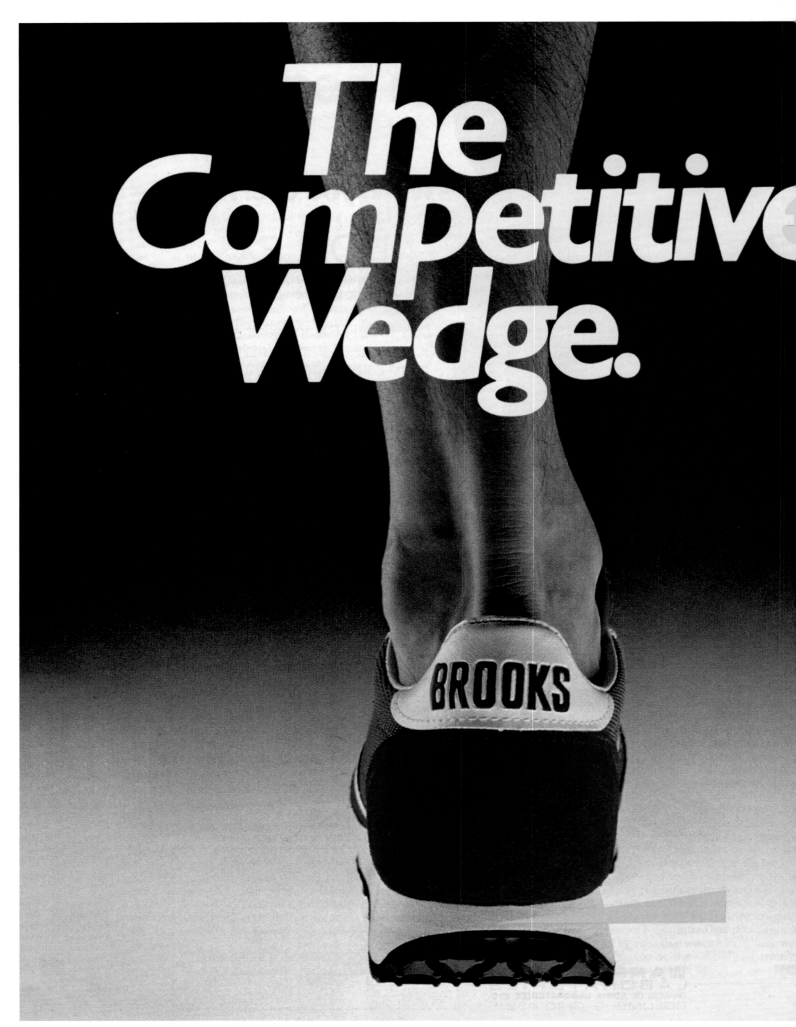

1982: Vantage, 'The Competitive Wedge'

Presenting a shoe that's designed to give you what you really want from running: More performance.

It's amazing.

The shoe you're wearing could actually be preventing you from running as far, or as fast as you can.

Surprised?

Here are the facts:

Most running shoe padding is flat at the heel. Which is fine as long as you're standing.

But when you run, your heel strikes the ground at an angle (check your shoes and you'll probably see extra wear on the outer edge of the heel).

What happens next as you run is that your foot immediately begins to roll inward. Which, as most runners know, is called pronation.

What a lot of runners still don't know is that a majority of them actually *overpronate.* Their feet roll inward too much. And when they push off from this overpronated position, they lose efficiency.

THE VARUS WEDGE SOLUTION

The Brooks Vantage is the one shoe designed to correct this problem. It's got a patented, V-shaped midsole called the Varus Wedge*, 3-4° of thicker padding at the inner edge of the heel. So body weight is distributed over a much larger area. And pronation is controlled.

Which is the secret to why the Brooks Vantage, with the Varus Wedge, helps you run farther, and faster.

A MORE EFFICIENT LEVER

By limiting pronation, the Varus Wedge keeps the foot in a flatter position. So that when you push off, the lever action of your leg and toes is far more efficient. Your foot is now a stronger, more biomechanically efficient structure.

And as every runner knows, when you run more efficiently, you can easily increase distance and speed.

MORE INJURY-FREE MILES

Obviously, a shoe that gives you this extra performance is worth owning. But Vantage gives you still another important advantage: Less chance of injury.

By controlling pronation, Vantage also controls one of the leading causes of running injuries. You run with less twisting...which means more miles, injury-free.

What it gets down to is the fact that just one shoe is designed to give you what you really want from running.

The Brooks Vantage. Think of it as the shoe with the Competitive Wedge.

BROOKS®

CONVERSE

The Converse Rubber Shoe Company was founded in 1908. A decade later, the fledgling firm released a simple canvas and rubber model that would go on to become the highest-selling sneaker in the history of the universe. The All Star was highly coveted by pro-ballers right through to the late 1960s, when it gracefully retired from the hardwood to become the definitive punk-rock-rebel-teenager-slacker sneaker of choice.

Thanks to the 'Choose Your Weapon' print campaign that featured NBA titans Larry Bird and Magic Johnson, Converse steadily built their roster through the 1980s. The 'It's What's Inside That Counts' series with Larry Johnson is a memorable moment of cross-dressing zaniness. Converse also flourished on the tennis court, with Jimmy Connors and Chris Evert representing the brand with panache as 'The Winningest Pair'.

Today, Converse are a subsidiary of Nike Inc. Though they are no longer strictly a performance powerhouse, Converse's affiliation with musicians, artists and skateboarders has maintained the brand's ineffable coolness.

●

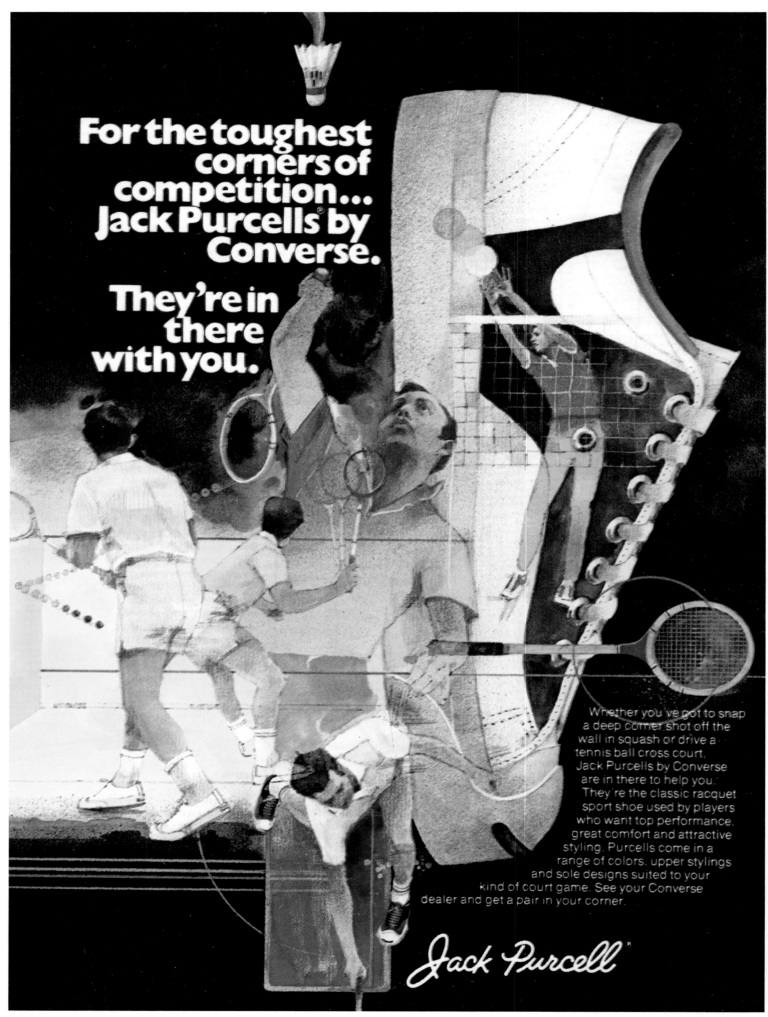

For the toughest corners of competition... Jack Purcells® by Converse.

They're in there with you.

Whether you've got to snap a deep corner shot off the wall in squash or drive a tennis ball cross court, Jack Purcells by Converse are in there to help you. They're the classic racquet sport shoe used by players who want top performance, great comfort and attractive styling. Purcells come in a range of colors, upper stylings and sole designs suited to your kind of court game. See your Converse dealer and get a pair in your corner.

Jack Purcell®

1974: Jack Purcell, 'For the Toughest Corners of Competitions…Jack Purcells by Converse'

Guess what inspired these new shoes.

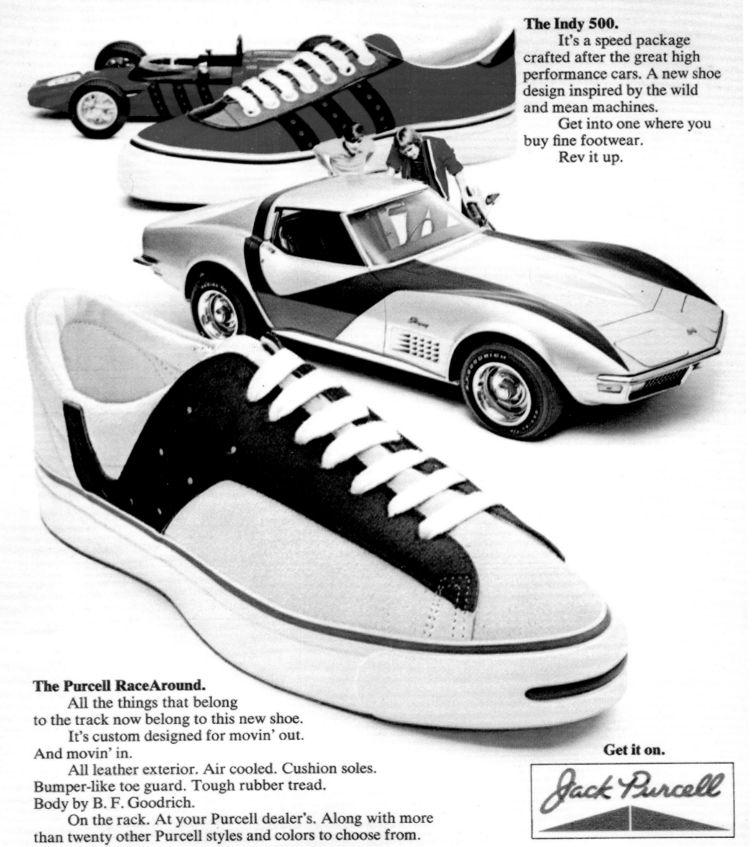

The Indy 500.

It's a speed package crafted after the great high performance cars. A new shoe design inspired by the wild and mean machines.

Get into one where you buy fine footwear.

Rev it up.

The Purcell RaceAround.

All the things that belong to the track now belong to this new shoe.

It's custom designed for movin' out. And movin' in.

All leather exterior. Air cooled. Cushion soles. Bumper-like toe guard. Tough rubber tread. Body by B. F. Goodrich.

On the rack. At your Purcell dealer's. Along with more than twenty other Purcell styles and colors to choose from.

Get it on.

Jack Purcell

1974: Indy 500 and Purcell RaceAround, 'Guess What Inspired These New Shoes'

1930: All Star, 'The Sole That Helps You Win Basketball Games'

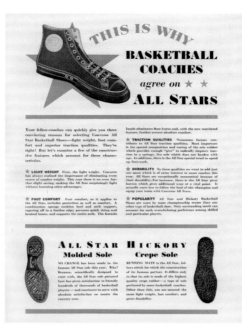

1931: All Star, 'Equip Your Team With…All Stars'

1933: All Star, 'This is Why Basketball Coaches Agree on All Stars'

1934: All Star, '"They Breathe With Every Step You Take!"'

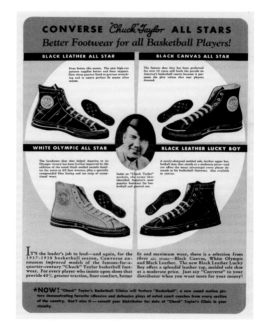

1937: All Star, 'Better Footwear for All Basketball Players!'

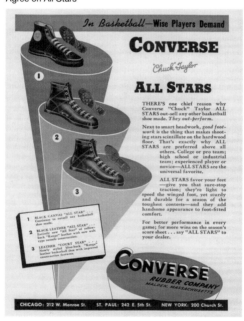

1939: All Star, 'In Basketball – Wise Players Demand Converse All Stars'

1947: All Star, 'Built for Basketball!'

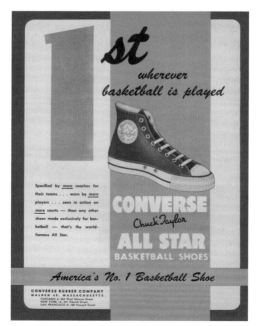

1949: All Star, '1st Wherever Basketball is Played'

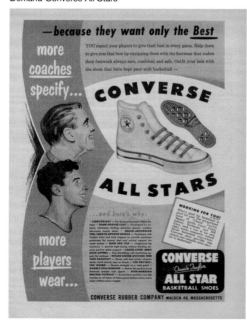

1953: All Star, 'More Coaches Specify…More Players Wear… Converse All Stars – Because They Want Only The Best'

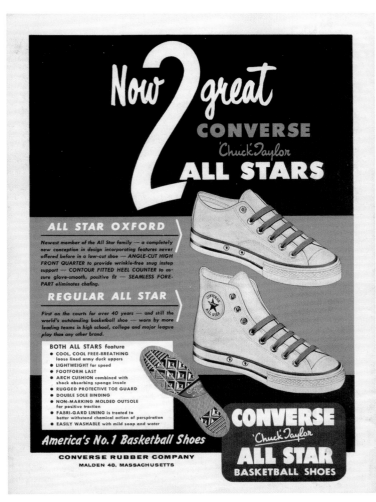

1957: All Star, 'Now 2 Great Converse All Stars'

1963: All Star, 'We Go Right on Winning Players, Coaches, Games, Titles'

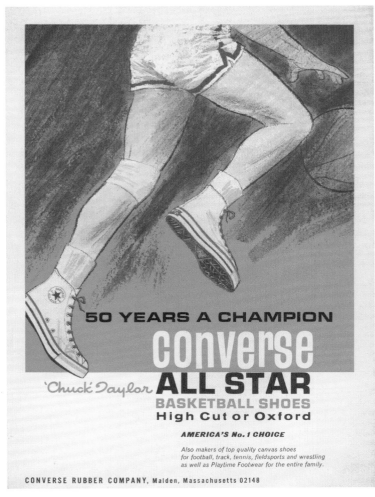

1964: All Star, '50 Years a Champion'

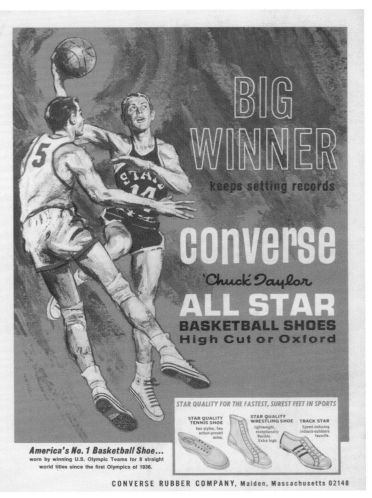

1965: All Star, 'Big Winner Keeps Setting Records'

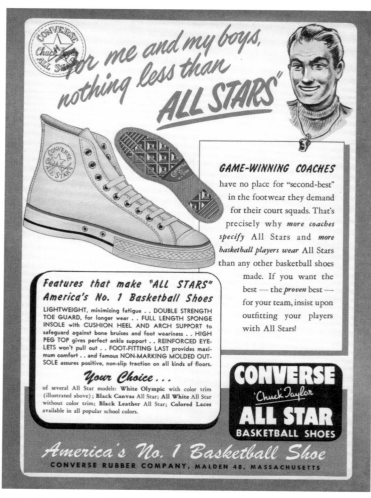

1950: All Star, 'For Me and My Boys, Nothing Less Than All Stars'

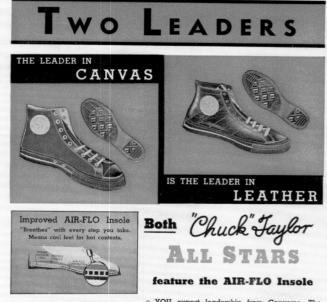

1953: All Star Canvas and Leather, 'The Leader in Canvas is the Leader in Leather'

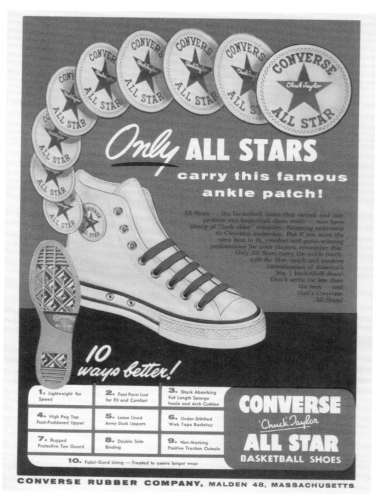

1956: All Star, 'Only All Stars Carry This Famous Ankle Patch!'

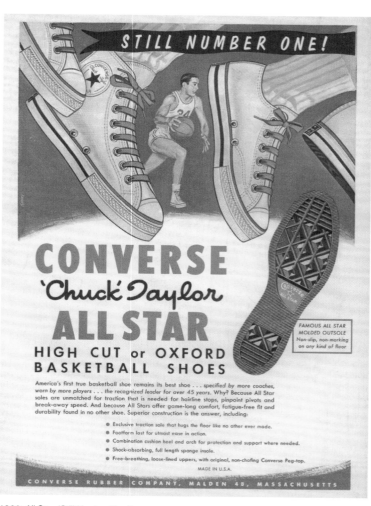

1960: All Star, 'Still Number One!'

In basketball there is only one All Star.®

★ **converse** When you're out to beat the world

Converse Rubber Company, Malden, Mass. 02148

1968: All Star, 'In Basketball There is Only One All Star'

There is only one All Star.® Only Converse makes it. Only sporting goods dealers sell it.

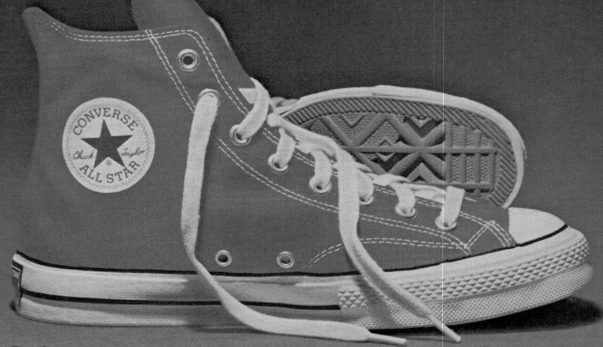

The Converse All Star is basketball's shoe. This year 8 out of 10 players in every major college and junior college tournament wore Converse All Stars. Converse All Stars have been worn by every U.S. Olympic Team since 1936, and All Stars have been selected again by the U.S. Olympic Committee for the 1976 Olympics. They are available in 10 team colors, 5 action styles in suede, leather and canvas.

an **Eltra** company

★ **converse**

1973: All Star, 'There is Only One All Star. Only Converse Makes It. Only Sporting Goods Dealers Sell It'

❝ When the Converse Rubber Shoe Company started manufacturing athletic goods in 1910, Dr James Naismith's ideas for a recreational pastime tentatively called 'Basket Ball' were still at a primitive stage. In 1917, Converse responded to demand from basketball players with the Non-Skid, a high-top named after its grippy diamond-patterned outsole. Three years later, the model was retitled as the All Star, then changed again to the Chuck Taylor All Star in 1934. As the game exploded in the US, the shoe remained the number one choice for professional players for decades. In 1962, Wilt Chamberlain played his historic 100-point game wearing a pair of Chucks. The final NBA appearance was on the feet of Wayne 'Tree' Rollins in the 1979–80 season. It's a big statement, but without Converse and the All Star, basketball might never have become the sport it is today. **❞**

'American All Star'
Sneaker Freaker, issue 36 (2016)

There is only one All Star.®
Converse makes it.
Only sporting goods dealers sell it.

The Converse All Star is basketball's shoe. Last year 8 out of 10 players in every major college and junior college basketball tournament wore All Stars. They've been worn by every U.S. Olympic Basketball Team since 1936, and have been selected again by the U.S. Olympic Committee for the 1976 Olympics. Converse All Stars are available in 10 team colors, 5 action styles in suede, leather and canvas.

an **Eltra** company

★ converse

1975: All Star One Star, 'There is Only One All Star. Only Converse Makes It. Only Sporting Goods Dealers Sell It'

"THANKSCOACH."

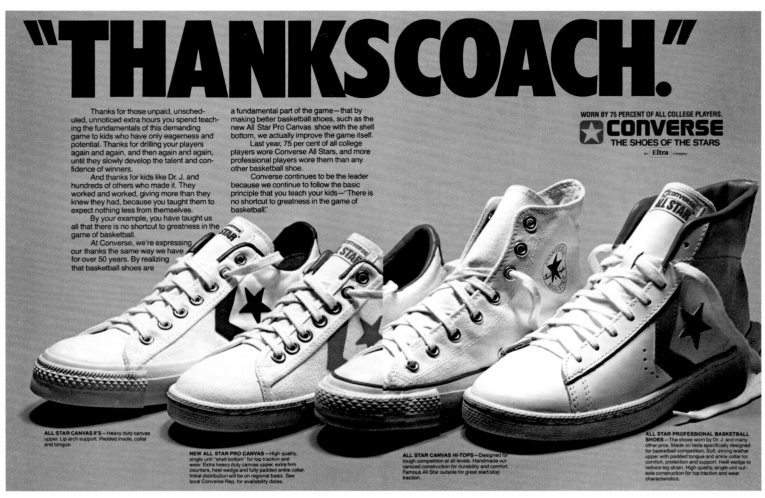

Thanks for those unpaid, unscheduled, unnoticed extra hours you spend teaching the fundamentals of this demanding game to kids who have only eagerness and potential. Thanks for drilling your players again and again, and then again and again, until they slowly develop the talent and confidence of winners.

And thanks for kids like Dr. J. and hundreds of others who made it. They worked and worked, giving more than they knew they had, because you taught them to expect nothing less from themselves.

By your example, you have taught us all that there is no shortcut to greatness in the game of basketball.

At Converse, we're expressing our thanks the same way we have for over 50 years. By realizing that basketball shoes are a fundamental part of the game—that by making better basketball shoes, such as the new All Star Pro Canvas shoe with the shell bottom, we actually improve the game itself.

Last year, 75 per cent of all college players wore Converse All Stars, and more professional players wore them than any other basketball shoe.

Converse continues to be the leader because we continue to follow the basic principle that you teach your kids—"There is no shortcut to greatness in the game of basketball."

WORN BY 75 PERCENT OF ALL COLLEGE PLAYERS.

⭐ **CONVERSE**
THE SHOES OF THE STARS
an Eltra company

ALL STAR CANVAS II'S—Heavy duty canvas upper. Lip arch support. Padded insole, collar and tongue.

NEW ALL STAR PRO CANVAS—High quality, single unit "shell bottom" for top traction and wear. Extra heavy duty canvas upper, extra firm counters, heel wedge and fully padded ankle collar. Initial distribution will be on regional basis. See local Converse Rep. for availability dates.

ALL STAR CANVAS HI-TOPS—Designed for tough competition at all levels. Handmade vulcanized construction for durability and comfort. Famous All Star outsole for great start/stop traction.

ALL STAR PROFESSIONAL BASKETBALL SHOES—The shoes worn by Dr. J. and many other pros. Made on lasts specifically designed for basketball competition. Soft, strong leather upper with padded tongue and ankle collar for comfort, protection and support. Heel wedge to reduce leg strain. High quality, single unit outsole construction for top traction and wear characteristics.

1978: All Star Canvas, All Star Pro Canvas, All Star Canvas Hi-Tops and All Star Professional Basketball Shoes, '"Thanks Coach"'

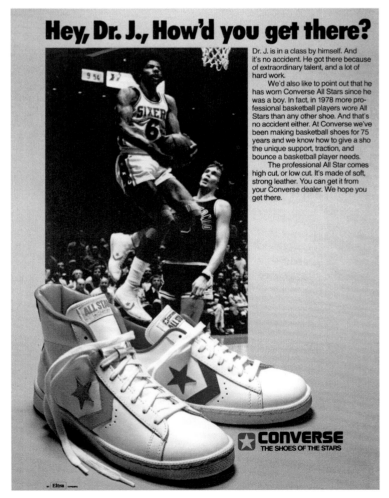

Hey, Dr. J., How'd you get there?

Dr. J. is in a class by himself. And it's no accident. He got there because of extraordinary talent, and a lot of hard work.

We'd also like to point out that he has worn Converse All Stars since he was a boy. In fact, in 1978 more professional basketball players wore All Stars than any other shoe. And that's no accident either. At Converse we've been making basketball shoes for 75 years and we know how to give a sho the unique support, traction, and bounce a basketball player needs.

The professional All Star comes high cut, or low cut. It's made of soft, strong leather. You can get it from your Converse dealer. We hope you get there.

⭐ **CONVERSE**
THE SHOES OF THE STARS

Eltra company

1977: All Star Pro Leather, 'Hey, Dr. J., How'd You Get There?', ft. Dr. J

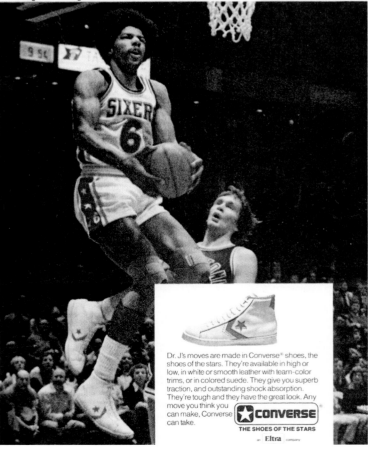

HEY, DR. J, WHERE'D YOU GET THOSE MOVES?

Dr. J's moves are made in Converse® shoes, the shoes of the stars. They're available in high or low, in white or smooth leather with team-color trims, or in colored suede. They give you superb traction, and outstanding shock absorption. They're tough and they have the great look. Any move you think you can make, Converse can take.

⭐ **CONVERSE**
THE SHOES OF THE STARS
an Eltra company

1977: All Star Pro Leather, 'Hey, Dr. J., Where'd You Get Those Moves?', ft. Dr. J

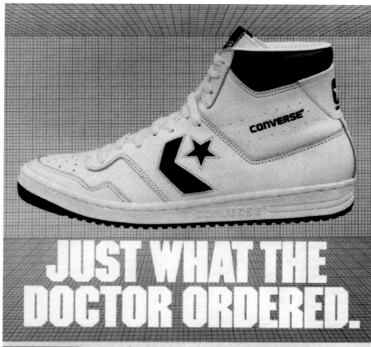

JUST WHAT THE DOCTOR ORDERED.

The new Converse StarTech.™ It's biomechanically designed to have what one of the hardest-playing pros needs most – unyielding protection and long-lasting construction.

Converse's uni-saddle design has extra lateral support for safer side-to-side moves and ankle-twisting pivots. The advanced shell sole and All Step insole have super shock absorption for jumping on rebounds and going up for high-flying slam dunks.

The Converse Star Tech mid-cut

Plus, it's designed the way we design all our athletic shoes. By working with top athletes and coming up with improved biomechanical designs to satisfy their needs.

That's why Dr. J wouldn't even think of taking the court before taking two Converse StarTechs™ for his feet.

© 1984 Converse Inc.

Reach for the stars. Reach for Converse.
The Official Athletic Shoe of the 1984 Olympic Games.

1984: StarTech Mid-Cut, 'Just What the Doctor Ordered', ft. Dr. J

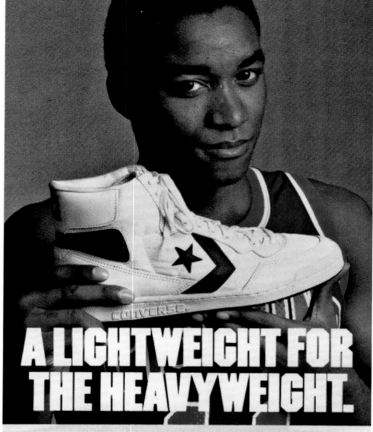

A LIGHTWEIGHT FOR THE HEAVYWEIGHT.

The Converse Fastbreak.™ It's easy to see why top pros like Isiah Thomas wear it. It's designed with a super lightweight nylon/leather upper that has the kind of support you'll find in full leather uppers. But it weighs a lot less.

Plus, we designed the Converse Fastbreak the way we design all our athletic shoes. By working with top athletes and coming up with improved biomechanical designs to satisfy their needs. Which is the reason a shoe as light as the Converse Fastbreak carries so much weight with the pros.

© 1984 Converse Inc.

Reach for the stars. Reach for Converse.
The Official Athletic Shoe of the 1984 Olympic Games.

1984: Fastbreak, 'A Lightweight for the Heavyweight', ft. Isiah Thomas

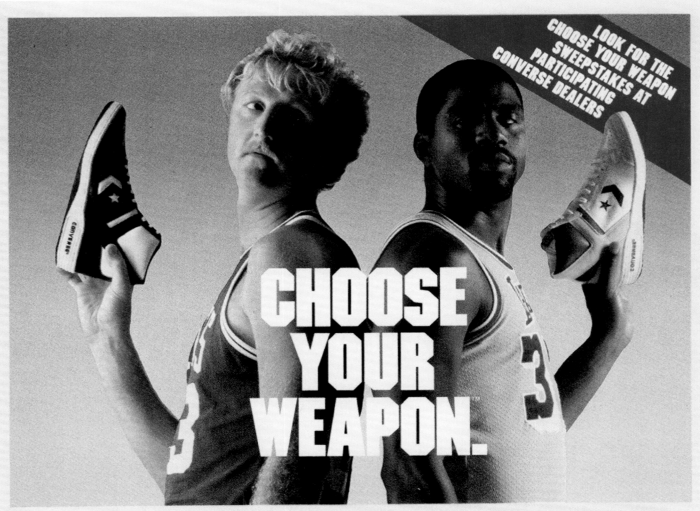

CHOOSE YOUR WEAPON.

Larry Bird and Magic Johnson. When they play, they push themselves to the limit. And they trust their performance to Converse. The shoe they choose to do battle in is the Converse® Weapon™ – a shoe biomechanically designed to help players play their best.

These shoes offer superior traction because of their natural rubber outsoles. They're incredibly cushioned as well, due to the Center of Pressure outsole and a shock absorbing EVA midsole. And for the strong ankle support that Bird, Magic and every other ballplayer needs, there's the unique Y-Bar Ankle Support System.

Besides all these features, the Converse Weapon has a comfortable, removable insole and an extra padded collar that combines with the Y-Bar System for enhanced ankle support and comfort. Bird and Magic have chosen their weapons. Now choose yours.

THE CONVERSE® WEAPONS™

The Converse Weapon. One more reason why athletes like Bird and Magic depend on Converse for the best possible performance.

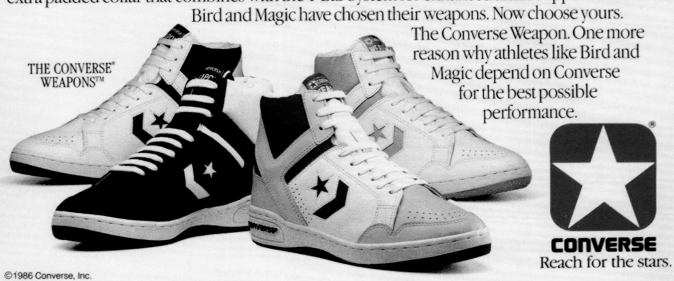

CONVERSE
Reach for the stars.

©1986 Converse, Inc.

For your nearest Weapons dealer call: 1-800-545-4323 (in Mass. 1-800-637-5215)

1986: Weapon, 'Choose Your Weapon', ft. Larry Bird and Magic Johnson

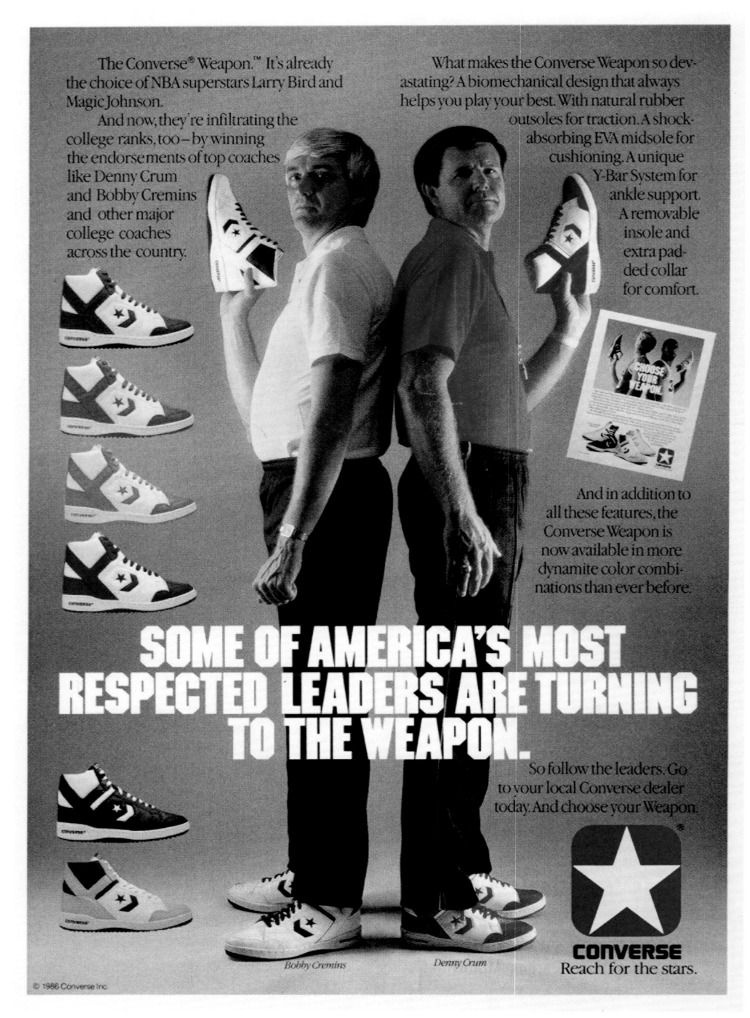

The Converse® Weapon.™ It's already the choice of NBA superstars Larry Bird and Magic Johnson.

And now, they're infiltrating the college ranks, too – by winning the endorsements of top coaches like Denny Crum and Bobby Cremins and other major college coaches across the country.

What makes the Converse Weapon so devastating? A biomechanical design that always helps you play your best. With natural rubber outsoles for traction. A shock-absorbing EVA midsole for cushioning. A unique Y-Bar System for ankle support. A removable insole and extra padded collar for comfort.

And in addition to all these features, the Converse Weapon is now available in more dynamite color combinations than ever before.

SOME OF AMERICA'S MOST RESPECTED LEADERS ARE TURNING TO THE WEAPON.

So follow the leaders. Go to your local Converse dealer today. And choose your Weapon.

Bobby Cremins *Denny Crum*

CONVERSE
Reach for the stars.

© 1986 Converse Inc.

1986: Weapon, 'Some of America's Most Respected Leaders Are Turning to the Weapon', ft. Bobby Cremins and Denny Crum

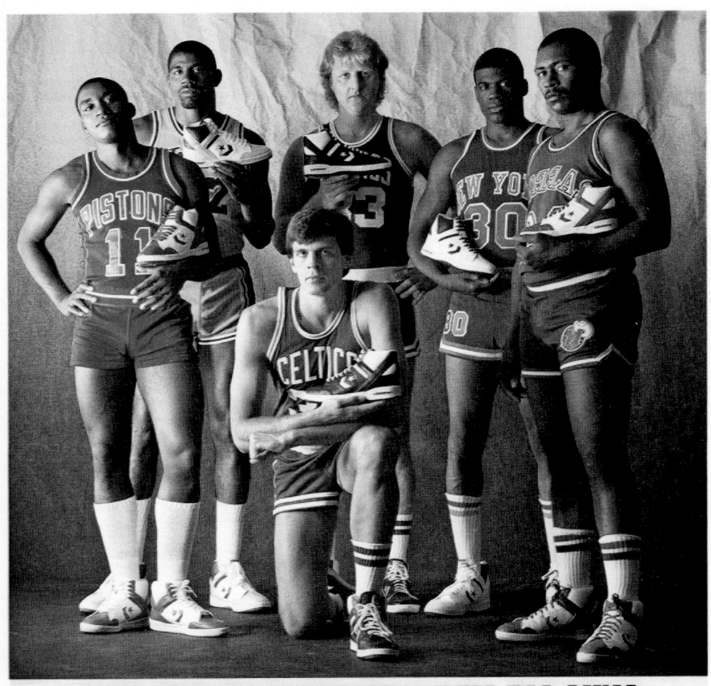

MORE AND MORE OF THE NBA'S BIG GUNS ARE WIELDING A NEW WEAPON.

The Converse® Weapon.™ Last year, it helped Larry Bird and Magic Johnson lead their teams to division championships. Well, the word is spreading. Because this year, it's also the choice of NBA superstars Isiah Thomas, Kevin McHale, Bernard King and Mark Aguirre. What makes the Converse Weapon so devastating? A biomechanical design that always helps you play your best. With natural rubber outsoles for traction. A shock-absorbing EVA midsole for cushioning. A unique Y-Bar System for ankle support. A removable insole and extra padded collar for comfort. And this year, the Converse Weapon is available in some dynamite new color combinations. So follow the leaders. Go to your local Converse dealer today. And choose your Weapon.

 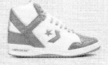 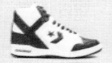 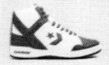 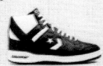

CONVERSE

© 1987 Converse Inc.

1987: Weapon, 'More and More of the NBA's Big Guns Are Wielding a New Weapon', ft. Isiah Thomas, Magic Johnson, Larry Bird, Bernard King, Mark Aguirre and (front) Kevin McHale

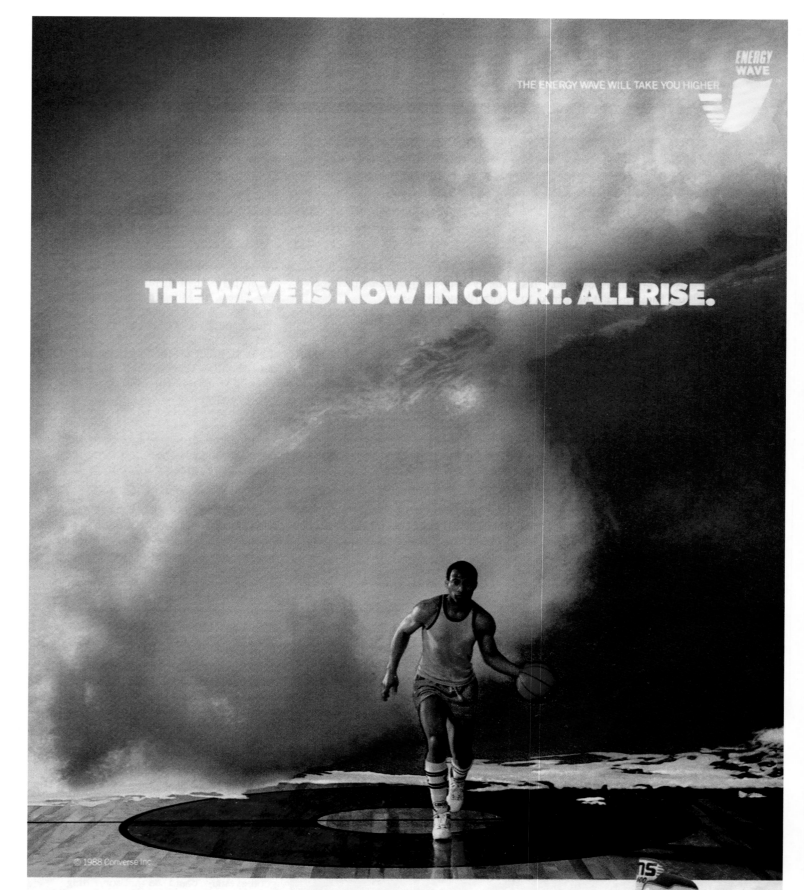

THE ENERGY WAVE WILL TAKE YOU HIGHER

ENERGY WAVE

THE WAVE IS NOW IN COURT. ALL RISE.

© 1988 Converse Inc.

Introducing the Converse Energy Wave.™ And our new Cons™ Series. With 77% better energy return than Nike Air. Cushioning that lasts longer than EVA. And Wave shoes are cooler for maximum comfort. All so you can jump higher and play longer. Repeat, jump higher. Play longer.

CONVERSE

Results are based on direct material tests of the Converse Energy Wave, Nike Air, and EVA.

Look for the blue-on-blue Energy Wave.

1988: Energy Wave, 'The Wave is Now in Court. All Rise'

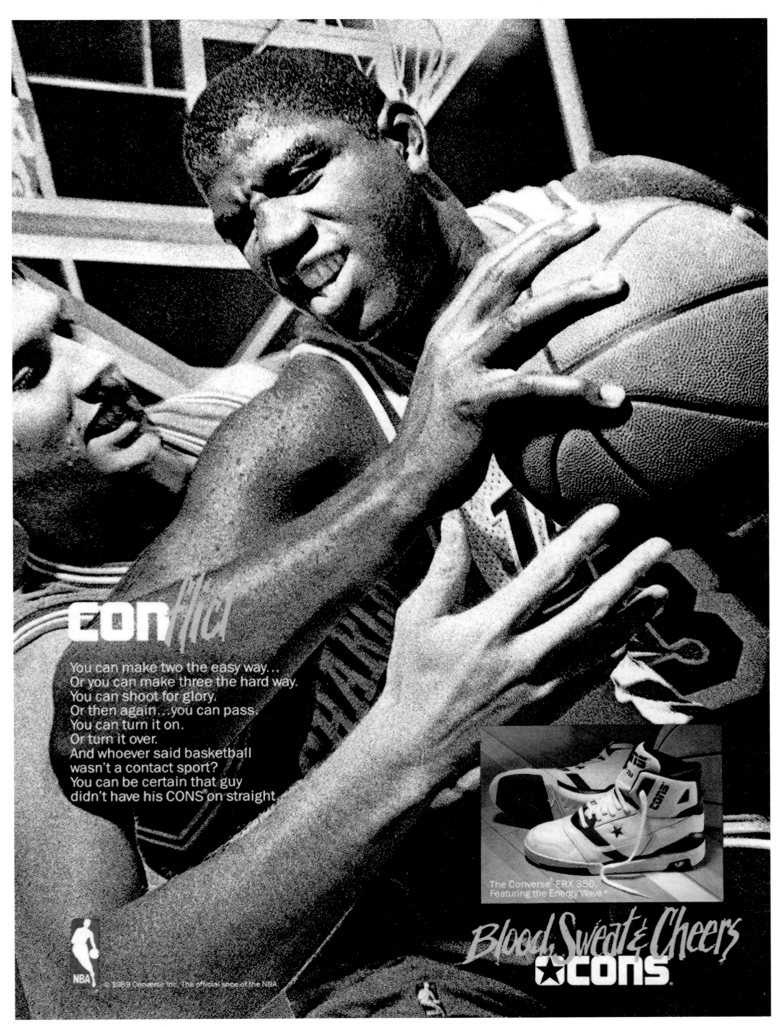

conflict

You can make two the easy way...
Or you can make three the hard way.
You can shoot for glory.
Or then again...you can pass.
You can turn it on.
Or turn it over.
And whoever said basketball
wasn't a contact sport?
You can be certain that guy
didn't have his CONS on straight.

The Converse ERX 350.
Featuring the Energy Wave

Blood, Sweat & Cheers
★CONS

© 1989 Converse Inc. The official shoe of the NBA

1989: ERX 350, 'Conflict', ft. Magic Johnson

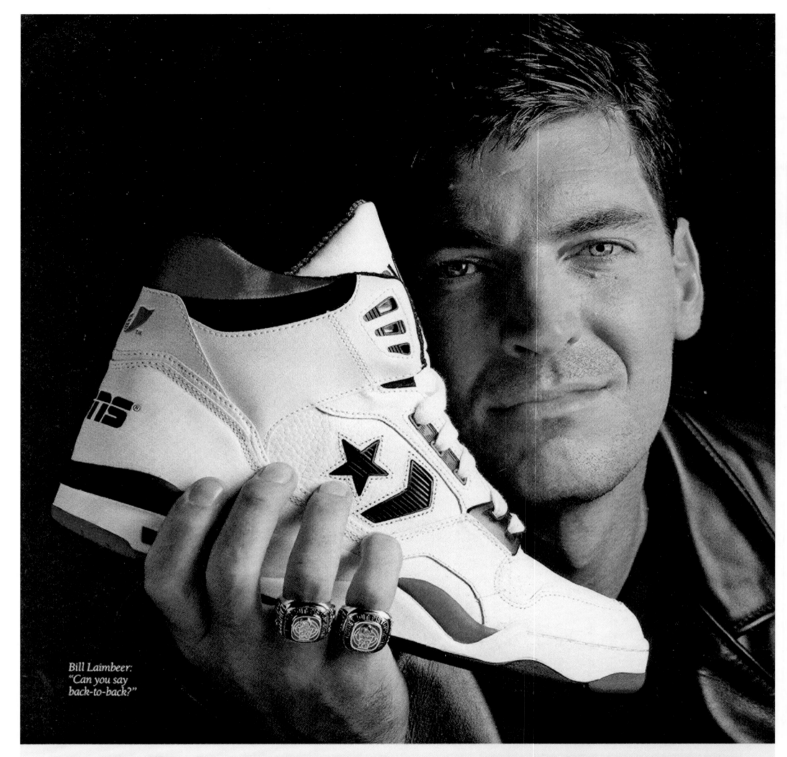

Bill Laimbeer:
"Can you say
back-to-back?"

WHAT SEPARATES THE RINGBEARERS FROM THE BRIDESMAIDS.

See that pair of NBA championship rings? Bill won both of them in a pair of Cons.® Which kind of makes you wonder what the guys who went home empty-handed were wearing.

NBA The Official Shoe Of The NBA.

The sleek, light Converse® Wave Conquest.™

CONVERSE

© 1990 Converse Inc. NBA and the NBA logo are registered trademarks of the National Basketball Association.

1990: Wave Conquest, 'What Separates the Ringbearers From the Bridesmaids', ft. Bill Lambeer

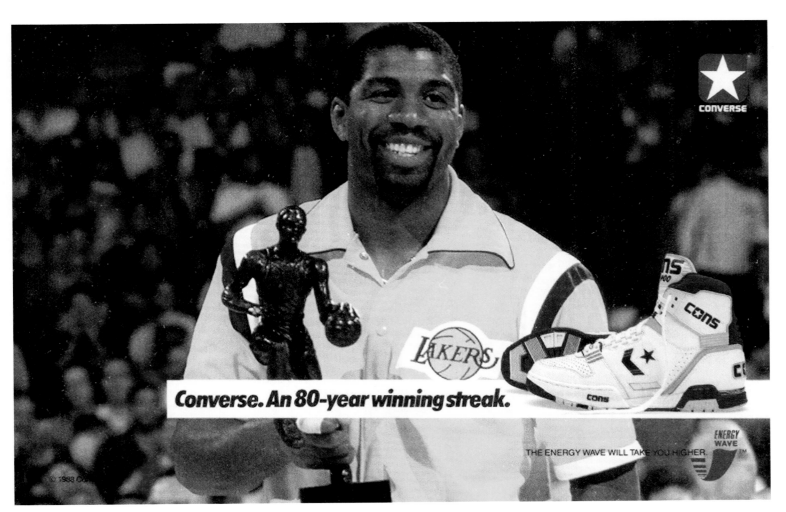

1988: Energy Wave, 'Converse. An 80-Year Winning Streak', ft. Magic Johnson

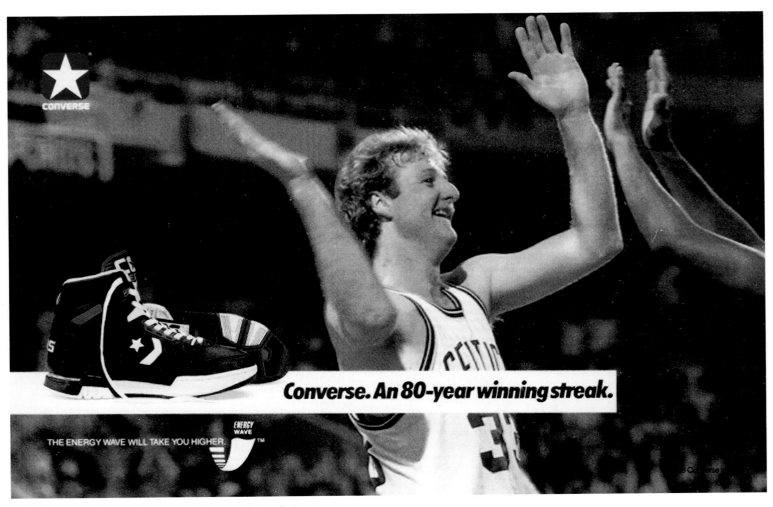

1988: Energy Wave, 'Converse. An 80-Year Winning Streak', ft. Larry Bird

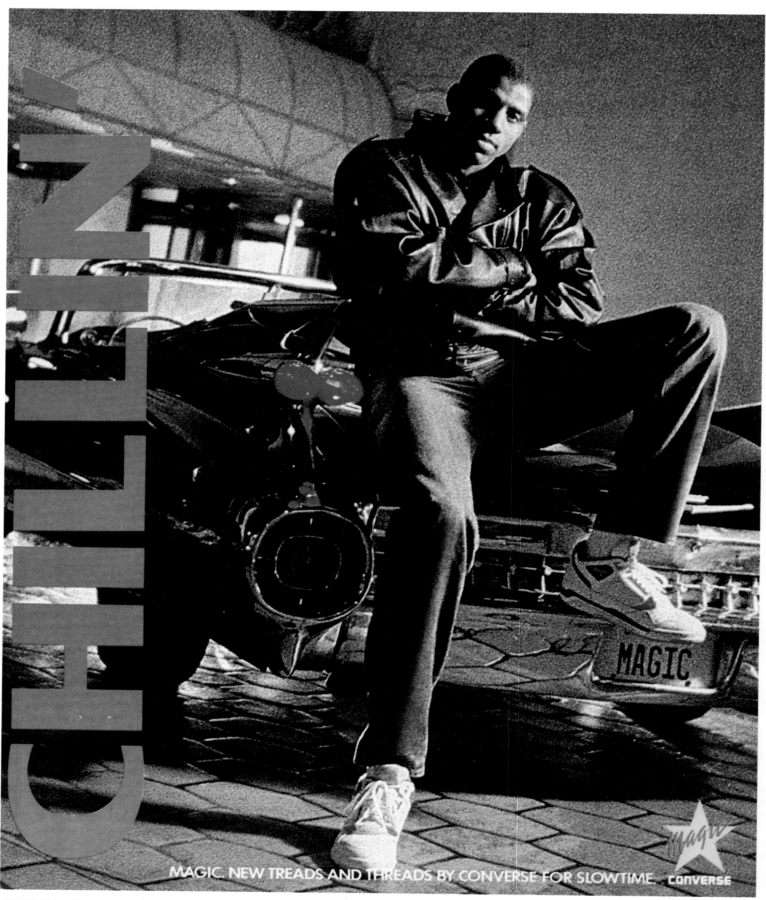

1990: 'Chillin'', ft. Magic Johnson

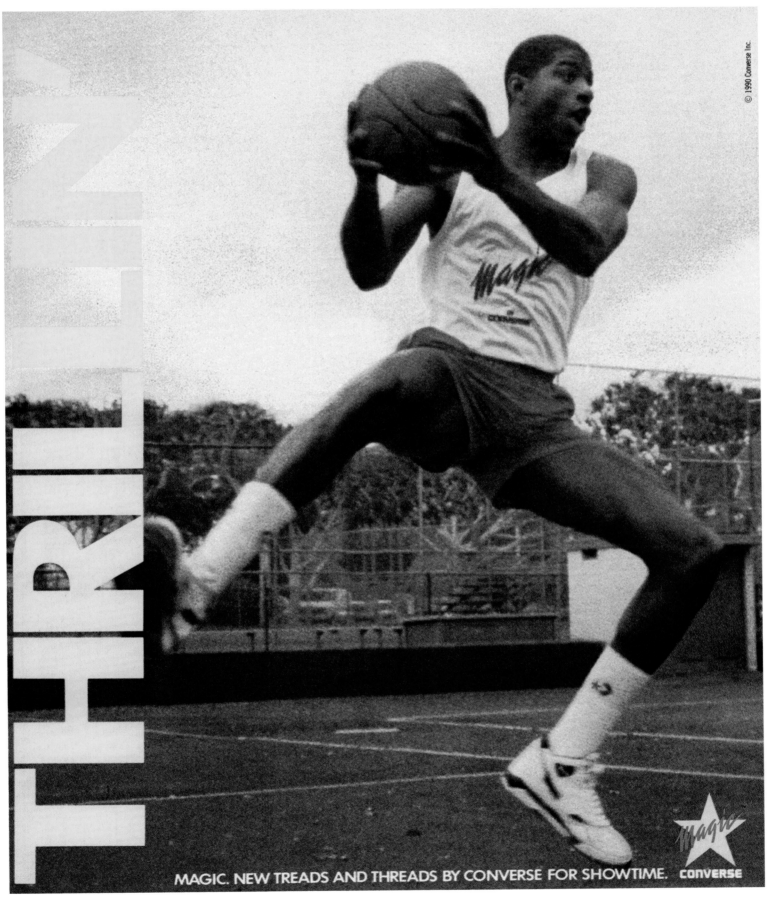

MAGIC. NEW TREADS AND THREADS BY CONVERSE FOR SHOWTIME.

1990: 'Thrillin'', ft. Magic Johnson

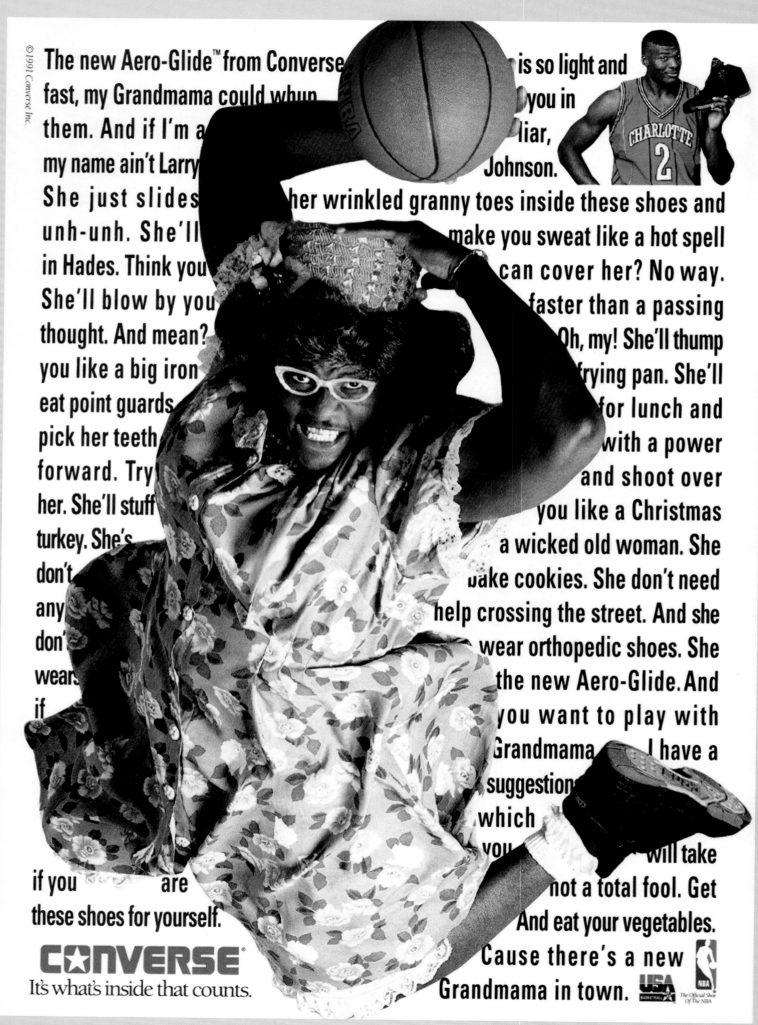

The new Aero-Glide™ from Converse is so light and fast, my Grandmama could whup you in them. And if I'm a liar, my name ain't Larry Johnson. She just slides her wrinkled granny toes inside these shoes and unh-unh. She'll make you sweat like a hot spell in Hades. Think you can cover her? No way. She'll blow by you faster than a passing thought. And mean? Oh, my! She'll thump you like a big iron frying pan. She'll eat point guards for lunch and pick her teeth with a power forward. Try her. She'll stuff you like a Christmas turkey. She's a wicked old woman. She don't bake cookies. She don't need any help crossing the street. And she don't wear orthopedic shoes. She wears the new Aero-Glide. And if you want to play with Grandmama, I have a suggestion, which you will take if you are not a total fool. Get these shoes for yourself. And eat your vegetables. Cause there's a new Grandmama in town.

CONVERSE
It's what's inside that counts.

1991: Aero-Glide, 'It's What's Inside That Counts' ft. Larry Johnson

1993: Aero-Jam

" Larry Johnson was selected first overall by the Charlotte Hornets in the 1991 NBA draft. With Bird and Johnson already on the team, the Converse rack was stacked in the early 90s, but Johnson quickly became the brand's top-billing baller. His appearance in the sitcom *Family Matters* as the 'Grandmama' character was parlayed into a subversive series of TV spots and print ads as part of the 'It's What's Inside That Counts' campaign. Displaying deadly proficiency at hair-salon trash-talk and the posterisation of Kevin Johnson, Grandmama's barnstorming antics were perfect for the Aero-Glide and Aero-Jam. Hiding inside Grandmama's shoes was ankle-swirling React Juice cushioning. And inside Grandmama was a 6-foot 7-inch, 250lb power forward with a gold front tooth and a 5XL dress. "

Minh Vuong
'Grandmama is Back!'
Sneakerfreaker.com (2014)

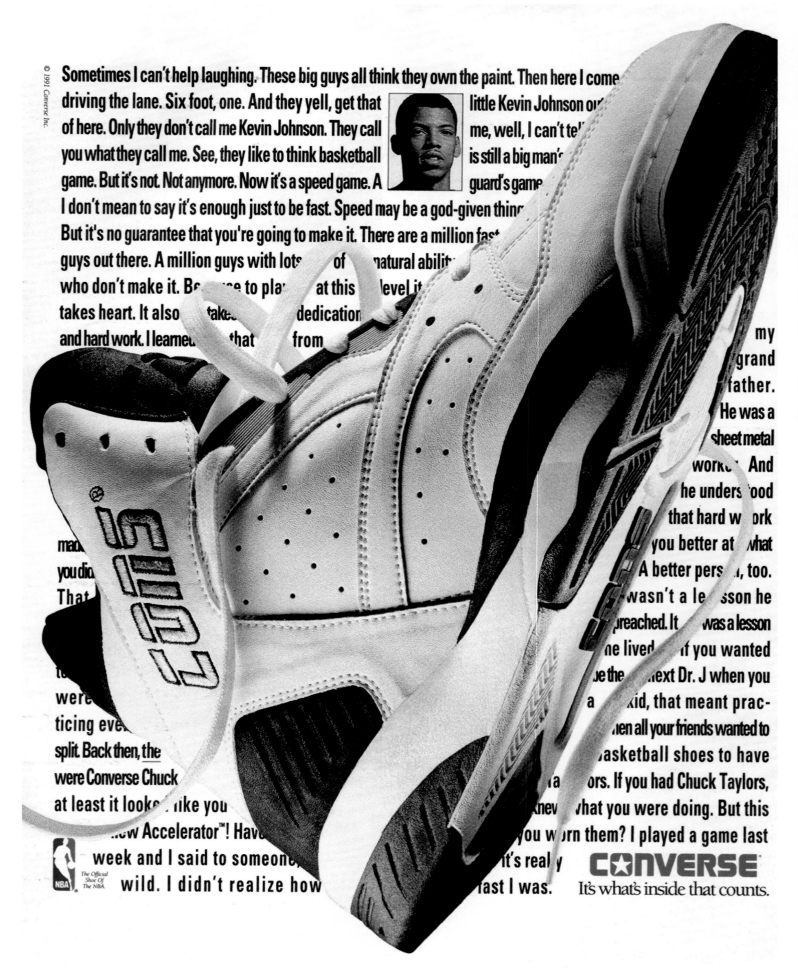

Sometimes I can't help laughing. These big guys all think they own the paint. Then here I come driving the lane. Six foot, one. And they yell, get that little Kevin Johnson out of here. Only they don't call me Kevin Johnson. They call me, well, I can't tell you what they call me. See, they like to think basketball is still a big man's game. But it's not. Not anymore. Now it's a speed game. A guard's game. I don't mean to say it's enough just to be fast. Speed may be a god-given thing. But it's no guarantee that you're going to make it. There are a million fast guys out there. A million guys with lots of natural ability who don't make it. Because to play at this level it takes heart. It also takes dedication and hard work. I learned that from my grandfather. He was a sheet metal worker. And he understood that hard work made you better at what you did. A better person, too. That wasn't a lesson he preached. It was a lesson he lived. If you wanted to be the next Dr. J when you were a kid, that meant practicing even when all your friends wanted to split. Back then, the basketball shoes to have were Converse Chuck Taylors. If you had Chuck Taylors, at least it looked like you knew what you were doing. But this new Accelerator™! Have you worn them? I played a game last week and I said to someone it's really wild. I didn't realize how fast I was.

CONVERSE
It's what's inside that counts.

The Official Shoe Of The NBA.

1991: Accelerator, 'It's What's Inside That Counts', ft. Kevin Johnson

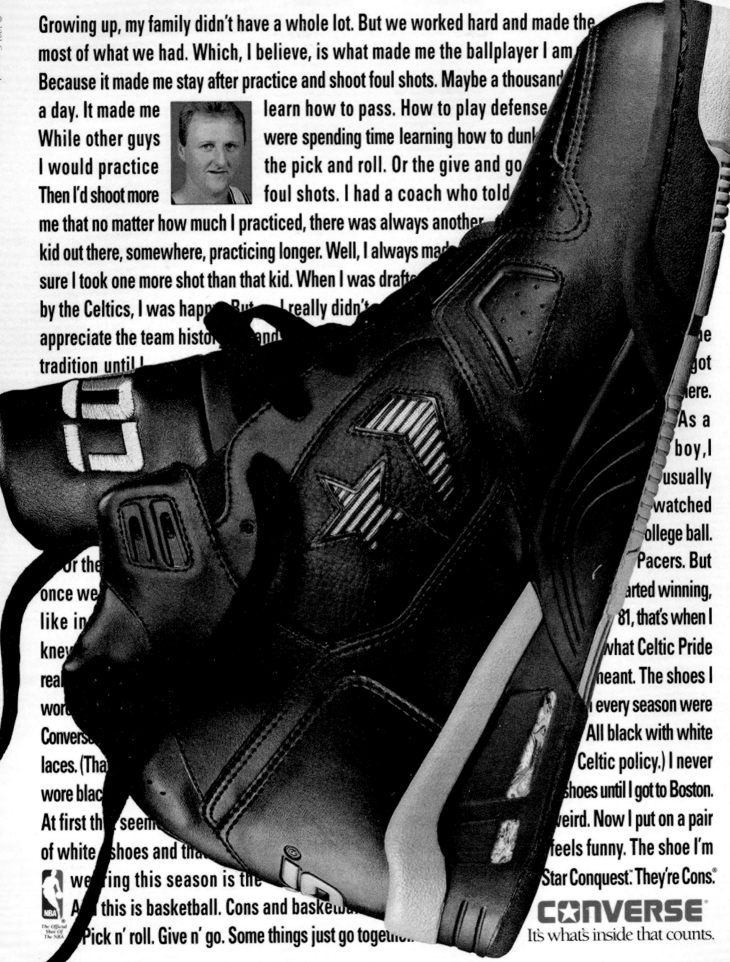

© 1991 Converse Inc.

Growing up, my family didn't have a whole lot. But we worked hard and made the most of what we had. Which, I believe, is what made me the ballplayer I am. Because it made me stay after practice and shoot foul shots. Maybe a thousand a day. It made me learn how to pass. How to play defense. While other guys were spending time learning how to dunk, I would practice the pick and roll. Or the give and go. Then I'd shoot more foul shots. I had a coach who told me that no matter how much I practiced, there was always another kid out there, somewhere, practicing longer. Well, I always made sure I took one more shot than that kid. When I was drafted by the Celtics, I was happy. But I really didn't appreciate the team history and tradition until I got here. As a boy, I usually watched college ball. Pacers. But once we started winning, like in '81, that's when I knew what Celtic Pride really meant. The shoes I wore every season were Converse. All black with white laces. (That's Celtic policy.) I never wore black shoes until I got to Boston. At first they seemed weird. Now I put on a pair of white shoes and that feels funny. The shoe I'm wearing this season is the Star Conquest. They're Cons. And this is basketball. Cons and basketball. Pick n' roll. Give n' go. Some things just go together.

CONVERSE
It's what's inside that counts.

1991: Star Conquest, 'It's What's Inside That Counts', ft. Larry Bird

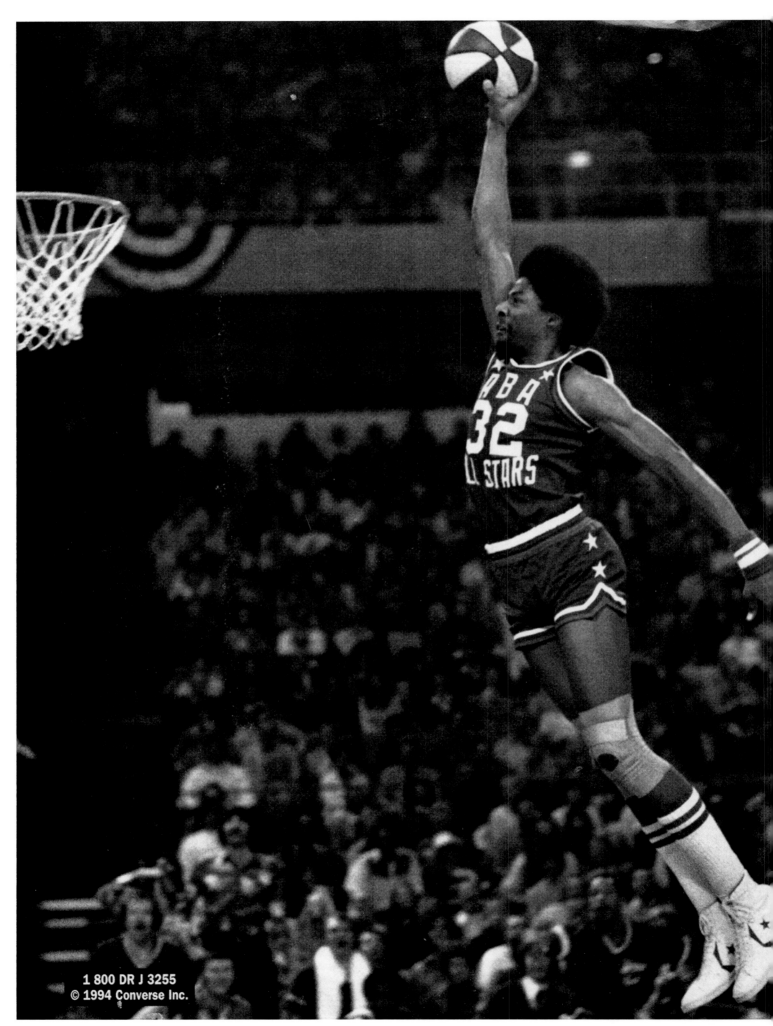

1 800 DR J 3255
© 1994 Converse Inc.

1994: Dr. J's, 'Make a Fist Like the One on Your Afro Pick and Come Ten-Fold Strong With the Bomb', ft. Dr. J

**Make a fist like the one on your afro pick
and come ten-fold strong with the bomb.**

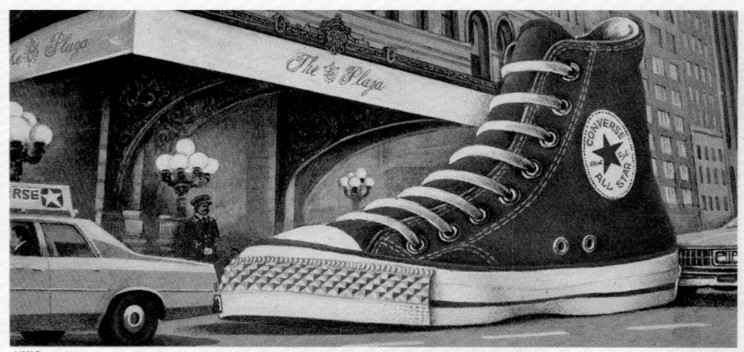

LIMOUSINES FOR YOUR FEET.

Converse All Stars.® The original canvas high tops and oxfords in eighteen fun and flashy colors and prints for people who want to go places in style.

©1985 Converse Inc.

CONVERSE
Reach for the stars.

1985: Chuck Taylor All Stars, 'Limousines for Your Feet'

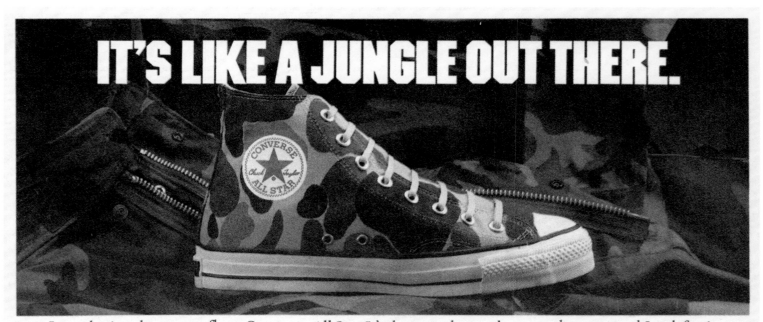

IT'S LIKE A JUNGLE OUT THERE.

Introducing the camouflage Converse All Star. It's the most hunted canvas shoe around. Look for it in all the other great All Star colors, too. You can track them down everywhere.

©1984 Converse Inc.

CONVERSE
Reach for the stars. Reach for Converse.
The Official Athletic Shoe of the 1984 Olympic Games

1984: Chuck Taylor All Stars, 'It's Like a Jungle out There'

195

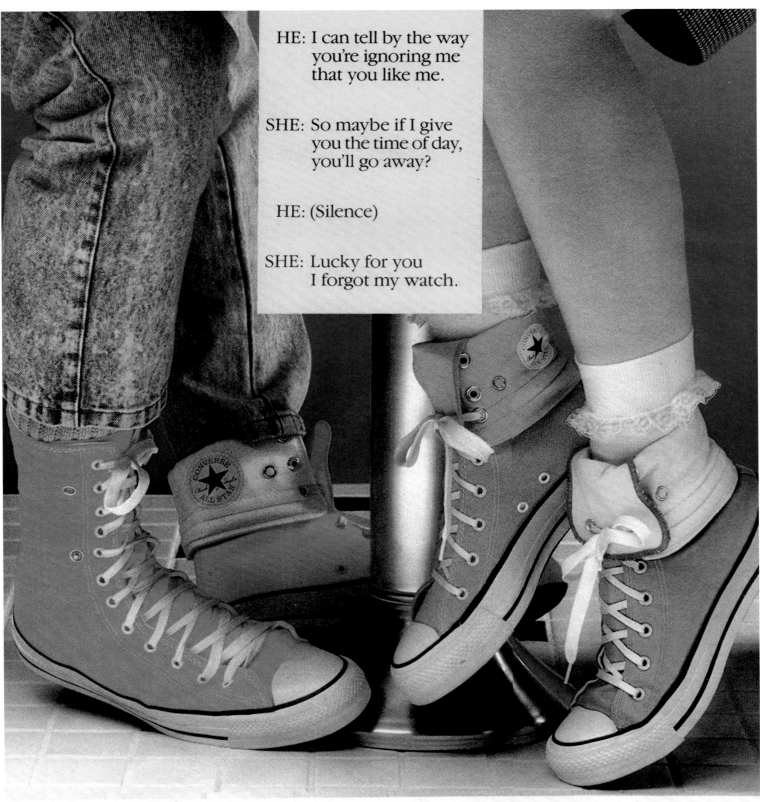

Neehi™ All Stars® from Converse® Somewhere between !!!! and ????

© 1987 Converse Inc.

1987: Neehi All Stars, 'Somewhere between !!!! and ????'

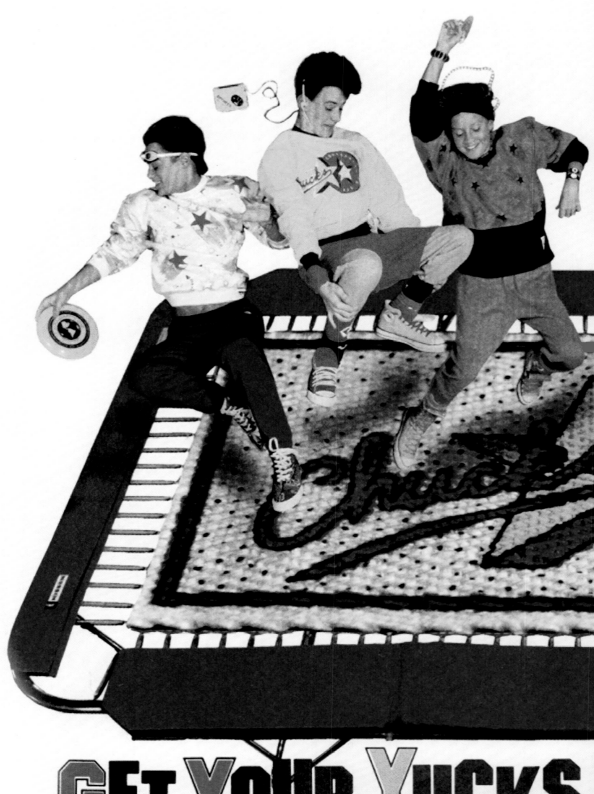

GET YOUR YUCKS

ATL5

You already know the shoes—the legendary "Chuck Taylor" All-Stars® from Cor
Well, now there's a line of activewear to go with them. The name is Chucks.™ The

1987: Chuck Taylor All Stars, 'Get Your Yucks in Chucks'

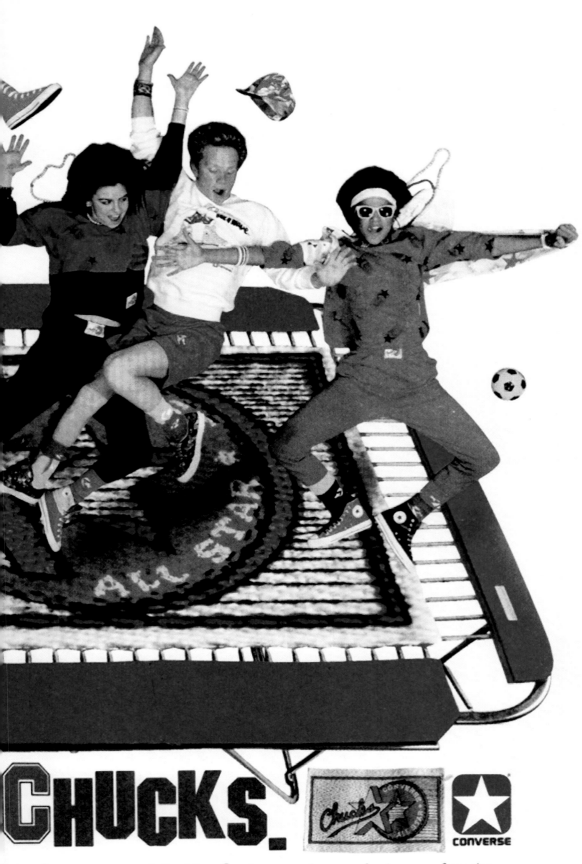

CHUCKS.

CONVERSE

now. And the look is full of fun. So the next time you're in your favorite sporting goods or department store, check out the Chucks. From Converse.

1989: Jack Purcell, 'Jack Purcells and Friend, 1955', ft. James Dean

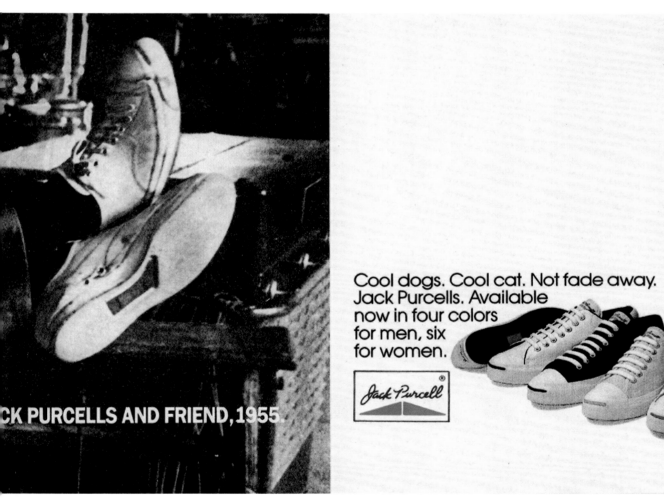

CK PURCELLS AND FRIEND, 1955.

Cool dogs. Cool cat. Not fade away.
Jack Purcells. Available
now in four colors
for men, six
for women.

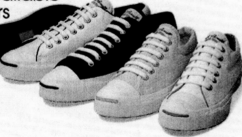

When Your Heart Longs For The Hills And Your Feet Live In The City.

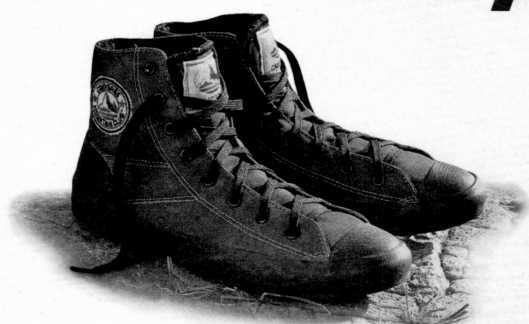

Finally, a shoe that lets you be in two places at one time. Follow your heart to the Converse® Mountain Club.™ Five high-styled canvas colors that live for the city. And long for the great outdoors.

© 1988 Converse Inc.

1988: Mountain Club, 'When Your Heart Longs for the Hills and Your Feet Live in the City'

CONVERSE REINTRODUCES WINGTIPS.

They're back. Batman™ and his arch enemy, the Joker.™ From Converse. At select stores for a limited time only. Call 1-800-545-4323 for the store nearest you.

CONVERSE

1989: Batman and Joker, 'Converse Reintroduces Wingtips'

I'm Dickie Barrett, the lead singer of the Mighty Mighty Bosstones. Actually, the way I sing, I'd prefer the term lead vocalist. We've been together now for about five years. But for three years, we were broken up. The reason we enjoy playing together is because we're all friends. All nine of us. We'd probably make a pretty good baseball team. But most baseball teams don't need a horn section. Even if we weren't a band, we'd still hang around together. We always wear plaid. Plaid shirts. Plaid hats. Plaid sox. Because plaid is all colors and patterns mixed up. Fat lines and skinny lines. It's a lot like our music. Sometimes metal, sometimes ska. We're even working on a big band sound. We want our music to mean different things to different people. When you come to one of our show, wherever we play, never you can care who you might from. Just as long as you happen to be, or what have fun. It's even you look fun when we go on like the road. We rent a van and pile in. Boston to Montreal. Boston to Manhattan. Boston to Parts Unknown. Then back again. We always travel in Converse Chuck Taylor All-Stars. Mainly because they're comfortable. And fun. Since they come in a bunch of cool colors, they match everything. Even plaid. I've worn Chuck Taylors ever since I was a little kid. Me and Chuck, we go way back. We even went to school together. Come to think of it, he still owes me some money.

CONVERSE
It's what's inside that counts.

1991: Chuck Taylor All Star, 'It's What's Inside That Counts', ft. Dickie Barrett

1950s: Chuck Taylor All Star

" The All Star is a punk rock style staple. The third edition of *Punk* magazine features a John Holmstrom illustration of Joey Ramone wearing Chucks, though the band truthfully mostly rocked Keds, which were the next best thing. Sid Vicious was famously spotted in them at the Chelsea Hotel and both Viv Albertine from the Slits and Joe Strummer from The Clash embraced the All Star's iconoclast vibes. By the 1980s, the arrival of hardcore advocated a more utilitarian view of fashion, which suited the All Star just fine. Finding a shoe perfect for the mosh was always the most important thing. As Henry Rollins said, 'The more time you spend worrying about clothes, the less time you have to grab life by the balls!' "

Gabe Filippa
'Sneakers That Defined England's Punk Scene'
Sneakerfreaker.com (2018)

CONVERSE WORLD CLASS. THE NEW STAR OF RUNNING SHOES.

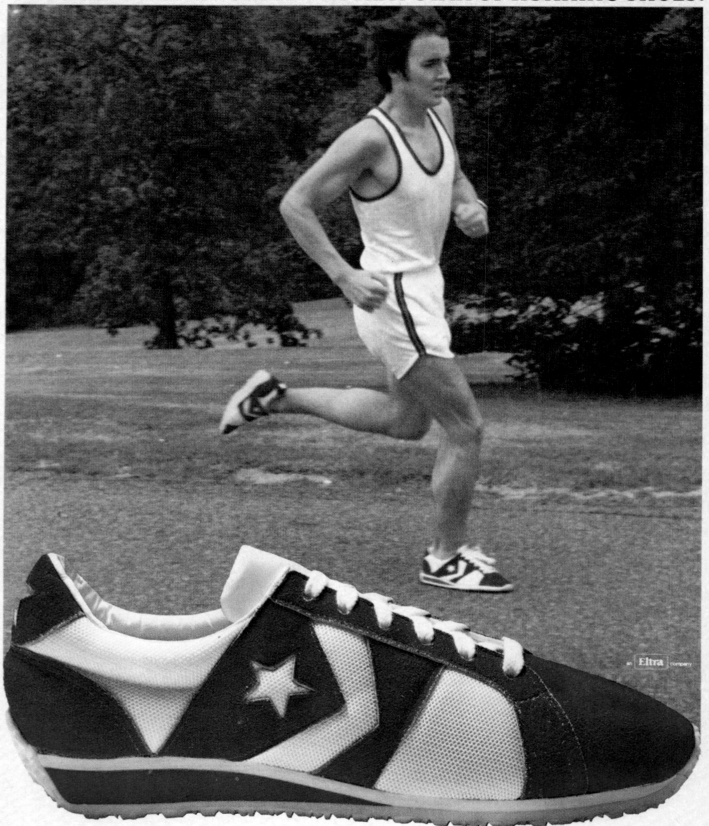

Converse World Class™ Marathoners and Trainers are unique. Because they're built with the advice of 736 serious runners.* Their "lace-to-toe" design lets you adjust the fit of the shoe to the ball of your foot. And they're incredibly light. The Marathoner weighs just 7¼ oz. per shoe (size #9) and the trainer 9¾ oz. per shoe (size 9). And they offer protection, flexibility and durability. Look for the distinctive star and chevron design. You'll be looking at what could be the finest running shoes in the world. *Survey conducted by Northeast Research (1977)

CONVERSE®
THE SHOES OF THE STARS

1977: World Class, 'Converse World Class. The New Star of Running Shoes'

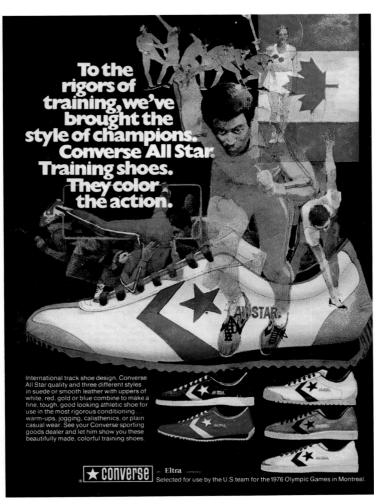

1978: All Star Training, 'Converse All Star Training Shoes. They Color the Action'

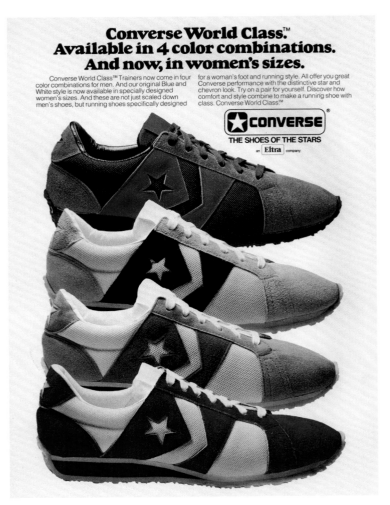

1979: World Class, 'The Shoes of the Stars'

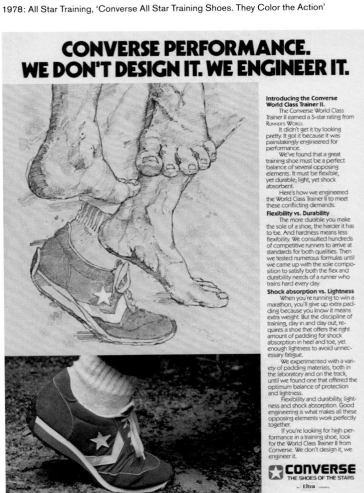

1979: World Class Trainer II, 'Converse Performance. We Don't Design It. We Engineer It'

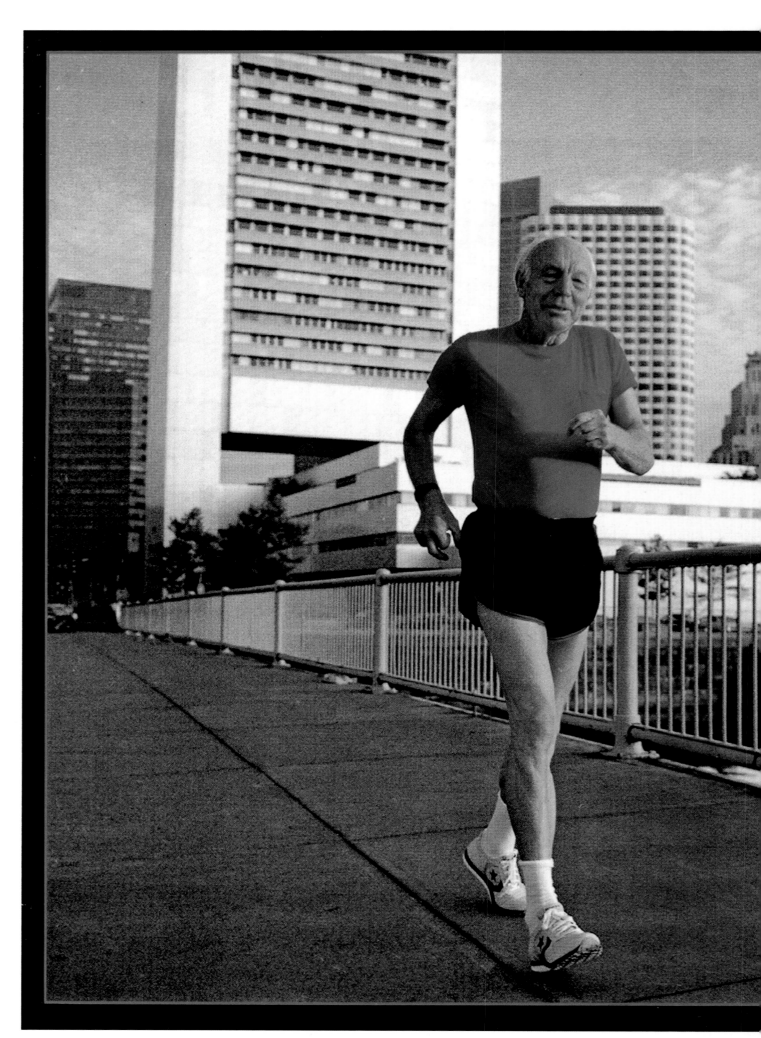

1980: Arizona 84 and World Class 84 Trainer, 'Run for 50 Years Without Stopping'

Run for 50 years without stopping.

The most magnificent marathon of all is the run that lasts a lifetime.

It's a tough course, with obstacles all along the way – hamstring pulls, twisted ankles, sore knees, muscle spasms. If you don't manage your running program well, they'll retire you early.

That's why Converse believes a training shoe should help you keep running by doing everything possible to minimize soreness and injuries.

For example, our training shoe for advanced runners, the new Arizona 84,™ uses high technology to reduce strain over long distances, while providing good support. A combination slip last forefoot and machine lasted heel provide optimal forefoot flexibility and rear foot stability.

And our new World Class 84™ Trainer compensates for the form and fatigue problems of intermediate runners by providing extra support and control. A full Texon board, a state-of-the-art EVA midsole and a plastic heel counter provide the extra stability that less experienced runners need.

Converse training shoes also offer you comfort, lightness, and style. Nice extras that we want you to have, but not the main point, in our view.

The main point is protection. And if you're ever tempted to sacrifice protection for a flashy style, consider this:

Who's got more style than a 73-year-old who's still running?

Converse keeps America running.

Converse training shoes are loaded with protection features to help keep you running for life.

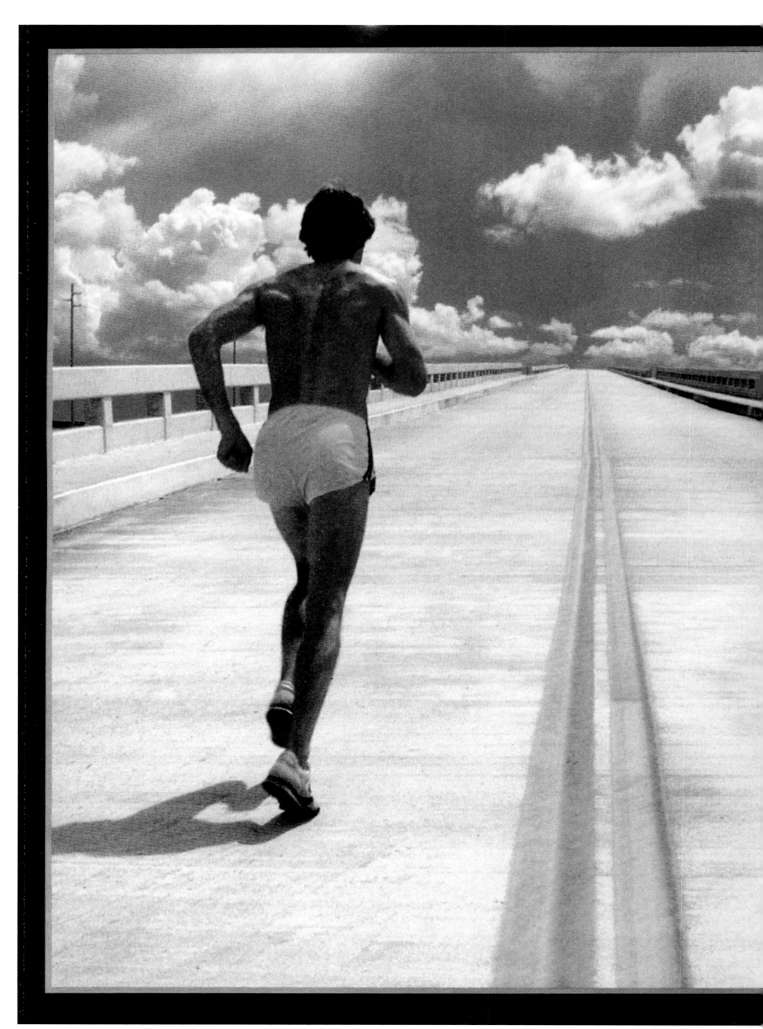

1980: Arizona 84 and World Class 84 Trainer, 'Avoid Breakdowns on the Road'

Avoid breakdowns on the road.

Long-distance running is not a dependable form of transportation. This year, 1 runner in 3 will be stopped, at least temporarily, by soreness or injury.

That's why Converse builds breakdown prevention into every shoe we make, to keep you running mile after mile.

For example, our training shoe for advanced runners, the new Converse Arizona 84™, uses high technology to reduce strain over long distances. A combination slip last forefoot and machine lasted heel provide optimal forefoot flexibility and rear foot stability.

Our new World Class 84™ Trainer compensates for the form and fatigue problems of intermediate runners by providing maximum support and control for the life of the shoe.

With many shoes, support and protection wear thin long before the shoe wears out. Rear-foot support deteriorates. Heels wear down dangerously. Foam compacts, robbing the foot of shock protection. Converse designs shoes for durability and uses state-of-the-art polymers that resist wear so you continue to get good support and protection down the road.

Plus, Converse training shoes are lightweight, comfortable, and good looking.

Yet good looks aren't the main point. After all, there are plenty of shoes to buy if you just want a flashy shoe that'll stop traffic on the road.

But these are the shoes to buy if you want to keep the road from stopping you.
Converse keeps America running.

Converse running shoes have extra protection features to help keep you running mile after mile, day after day.

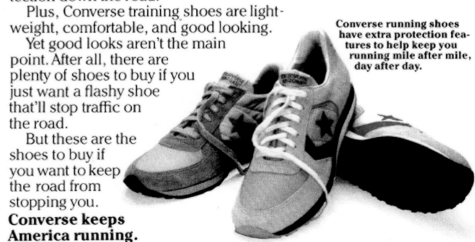

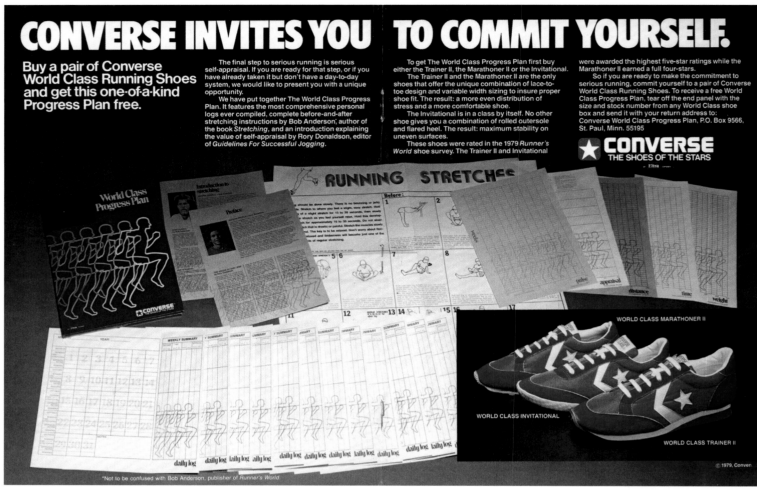

CONVERSE INVITES YOU TO COMMIT YOURSELF.

Buy a pair of Converse World Class Running Shoes and get this one-of-a-kind Progress Plan free.

The final step to serious running is serious self-appraisal. If you are ready for that step, or if you have already taken it but don't have a day-to-day system, we would like to present you with a unique opportunity.

We have put together The World Class Progress Plan. The most comprehensive personal logs ever compiled, complete before-and-after stretching instructions by Bob Anderson*, author of the book *Stretching*, and an introduction explaining the value of self-appraisal by Rory Donaldson, editor of *Guidelines For Successful Jogging*.

To get The World Class Progress Plan first buy either the Trainer II, the Marathoner II or the Invitational.

The Trainer II and the Marathoner II are the only shoes that offer the unique combination of lace-to-toe design and variable width sizing to insure proper shoe fit. The result: a more even distribution of stress and a more comfortable shoe.

The Invitational is in a class by itself. No other shoe gives you a combination of rolled outersole and flared heel. The result: maximum stability on uneven surfaces.

These shoes were rated in the 1979 *Runner's World* shoe survey. The Trainer II and Invitational were awarded the highest five-star ratings while the Marathoner II earned a full four-stars.

So if you are ready to make the commitment to serious running, commit yourself to a pair of Converse World Class Running Shoes. To receive a free World Class Progress Plan, tear off the end panel with the size and stock number from any World Class shoe box and send it with your return address to: Converse World Class Progress Plan, P.O. Box 9566, St. Paul, Minn. 55195

★ CONVERSE
THE SHOES OF THE STARS
Eltra

WORLD CLASS MARATHONER II
WORLD CLASS INVITATIONAL
WORLD CLASS TRAINER II

© 1979, Conver

*Not to be confused with Bob Anderson, publisher of *Runner's World*.

1979: World Class Marathoner II, World Class Invitational and World Class Trainer II, 'Converse Invites You to Commit Yourself'

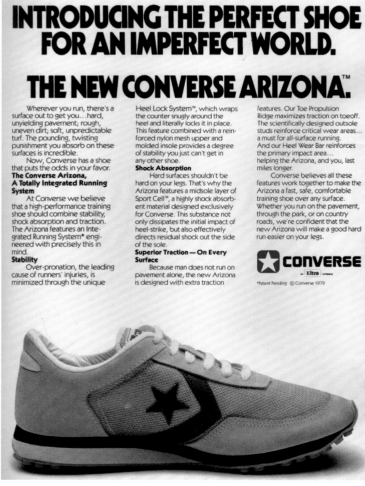

INTRODUCING THE PERFECT SHOE FOR AN IMPERFECT WORLD.

THE NEW CONVERSE ARIZONA.™

Wherever you run, there's a surface out to get you...hard, unyielding pavement; rough, uneven dirt; soft, unpredictable turf. The pounding, twisting punishment you absorb on these surfaces is incredible.

Now, Converse has a shoe that puts the odds in your favor.

The Converse Arizona, A Totally Integrated Running System

At Converse we believe that a high-performance training shoe should combine stability, shock absorption and traction. The Arizona features an Integrated Running System* engineered with precisely this in mind.

Stability

Over-pronation, the leading cause of runners' injuries, is minimized through the unique Heel Lock System™, which wraps the counter snugly around the heel and literally locks it in place. This feature combined with a reinforced nylon mesh upper and molded insole provides a degree of stability you just can't get in any other shoe.

Shock Absorption

Hard surfaces shouldn't be hard on your legs. That's why the Arizona features a midsole layer of Sport Cell™, a highly shock absorbent material designed exclusively for Converse. This substance not only dissipates the initial impact of heel-strike, but also effectively directs residual shock out the side of the sole.

Superior Traction — On Every Surface

Because man does not run on pavement alone, the new Arizona is designed with extra traction features. Our Toe Propulsion Ridge maximizes traction on toeoff. The scientifically designed outsole studs reinforce critical wear areas... a must for all-surface running. And our Heel Wear Bar reinforces the primary impact area... helping the Arizona, and you, last miles longer.

Converse believes all these features work together to make the Arizona a fast, safe, comfortable training shoe over any surface. Whether you run on the pavement, through the park, or on country roads, we're confident that the new Arizona will make a good hard run easier on your legs.

★ CONVERSE
Eltra company

*Patent Pending © Converse 1979

1979: Arizona, 'Introducing the Perfect Shoe for an Imperfect World'

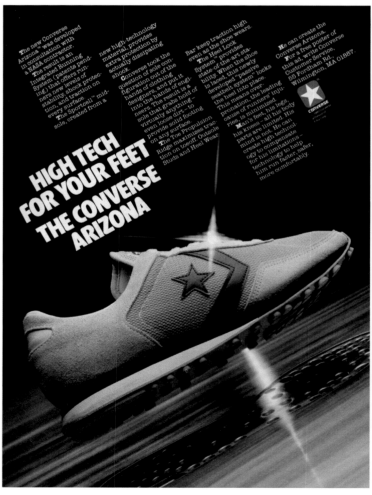

HIGH TECH FOR YOUR FEET THE CONVERSE ARIZONA

The new Converse Arizona™ was developed in consultation with a NASA contractor. The result is an Integrated Running System (patents pending) that offers runners new levels of stability, shock protection, and traction on every surface.

The Sportcell™ midsole, created from a new high-technology material, provides extra protection by actually dissipating shock.

Converse took the question of sole configuration out of the hands of clothing designers, and put it into the hands of engineers. The result is a sole that virtually anything—even loose dirt—to provide solid footing on any surface.

The Toe Propulsion Ridge maximizes traction on toeoff. Outside Studs and Heel Wear Bar keep traction high even as the shoe wears.

The Heel Lock System provides state-of-the-art stability. When the shoe is laced, this newly developed "passive snafbelt system" locks the heel into place. This means over-pronation, the leading cause of runners' injuries, is minimized.

Man's feet, his legs, his knees—all his body parts are limited. His mind is not. He can create high technology to compensate for his limitations, technology to help him run faster, safer, more comfortably.

He can create the Converse Arizona.

For a free poster of this ad, write Converse Customer Service, 55 Fordham Rd., Wilmington, MA 01887.

CONVERSE

1980: Arizona, 'High Tech for Your Feet. The Converse Arizona'

THE LONGEST ROAD FOR ANY RUNNER IS THE ONE TO RECOVERY.

One of the most difficult things any runner has to endure is being sidelined by a running injury. And the most common forms of running injury are knee injuries

New Men's Force-5

New Laser (for men & women)

Phaeton for men, Selena for women.

New Tribune (for men & women)

caused by pronation and supination, the side-to-side motion your foot makes when you run.

So at Converse, we've engineered a line of 4 hi-tech running shoes with built-in stabilizers designed specifically to help reduce pronation and supination.

All of them have their own unique injury prevention features to fit different running styles. Like the Force-5's™ dual medial support and extra dense midsole. The Phaeton's™ and Selena's™ heel stabilizer. The Laser's™ midfoot and rearfoot support. And the Tribune's™ lateral stability.

Converse. When it comes to helping prevent running injuries we're with you every step of the way. Because we know how important it is for you to stay off the road to recovery if you're going to stay on the road to success.

©1983 Converse Inc.

CONVERSE

The Official Athletic Shoe of the 1984 Olympic Games.

1983: Force-5, Laser, Phaeton and New Tribune, 'The Longest Road for Any Runner is the One to Recovery'

The heel counter stabilizer keeps your foot remarkably stable throughout your stride.

NO, IT'S NOT A FACTORY SECOND. IT'S AN INDUSTRY FIRST.

At first glance, the lacing on this shoe might strike you as a manufacturing error, or a blatant attempt at gimmickry. But make no mistake. The new Converse Odessa™ is the most technologically advanced shoe a dedicated runner can wear.

The Dual Density removable insole gives you outstanding shock absorption.

Why the side lacing? Simple. Through biomechanical research, we proved it gives you more stability throughout the shoe. But the lacing is just one reason Odessa is an industry first.

It's got three features that, *together*, give you an unprecedented combination of motion control and cushioning. In fact, the Odessa provides 15% more stability and 13% more cushioning than any other running shoe.

The side lacing system works to keep your foot stable.

The extended heel counter keeps your foot remarkably stable throughout your stride. The dual density midsole and urethane wedge work to cushion your foot better than any shoe in its class. And finally, our center-of-pressure outsole provides cushioning and stability, and centers your foot during your stride. But while it's heavy on features, this shoe is incredibly light on your feet.

The Dual Density Center-of-Pressure outsole is made of Vibram Infinity® for long-lasting durability. The outsole helps center your foot during your stride, without sacrificing cushioning.

The cushioned Dual Density Midsole provides cushioning, stability and flexibility where you need it most.

So if you're a dedicated runner who thinks of Converse strictly as a great basketball shoe company, see the Odessa at your Converse dealer.

You'll immediately think of us as a great running shoe company.

CONVERSE
Reach for the stars.

© 1985 Converse Inc.

1985: Odessa, 'No, It's Not a Factory Second. It's an Industry First'

Give us your tired, your sore.

Every year runner's knees, injured Achilles tendons, shin splints, heel spurs and the like keep 1 runner in 3 grounded, at least temporarily.

So we design support and protection into our shoes to minimize your risks.

Take the new Converse World Class® 84 training shoe. It compensates for the form and fatigue problems of intermediate runners by providing extra support and control.

The new Converse Arizona 84™ for advanced runners uses high technology to reduce strain over long distances and to give you forefoot flexibility with rearfoot stability.

Converse training shoes are good-looking and lightweight too. But the best thing is they'll help keep you running, all over the land of opportunity. **Converse keeps America running.**

★ **CONVERSE**®

© Converse 1981, an Allied Chemical Company.

1981: Arizona 84 and World Class 84 Trainer, 'Give Us Your Tired, Your Sore'

Avoid breakdowns on the road.

This year, 1 runner in 3 will be stopped by soreness or injury. That's why Converse builds breakdown protection into every shoe we make.

Our training shoe for advanced runners, the new Converse Arizona 84™ uses high technology to reduce strain over long distances.

Our new Converse World Class® 84 Trainer compensates for form and fatigue problems of intermediate runners by providing maximum support and control.

Converse training shoes are lightweight, comfortable, good looking. And they're durable to last longer. But the best thing is, when you're running in Converse training shoes, you'll probably last longer too.

★ **CONVERSE**®

Converse keeps America running. © Converse 1981, an Allied Chemical Company.

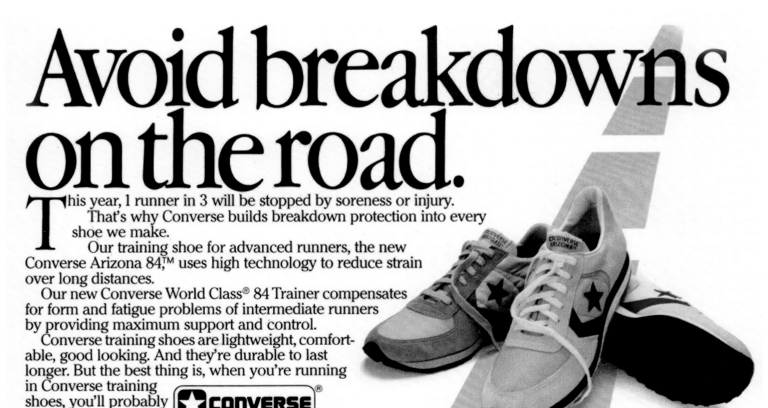

1981: Arizona 84 and World Class 84 Trainer, 'Avoid Breakdowns on the Road'

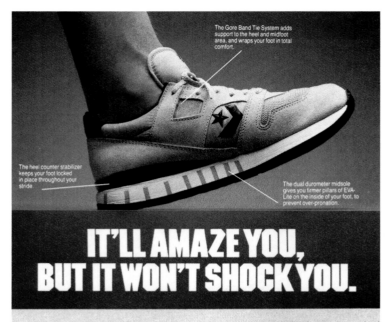

IT'LL AMAZE YOU, BUT IT WON'T SHOCK YOU.

The new Revenge™ from Converse will amaze you for a lot of reasons. But there's one good reason it won't shock you—our

EVA-Lite Domino Midsole. It's biomechanically designed to give you soft cushioning on the outside of your foot. And the pillars of firmer EVA-Lite along the inside of your foot give you extra support and prevent your foot

Where your foot strikes, the EVA-Lite midsole is soft to give you great cushioning. As your foot rolls to the inside, the firmer pillars prevent over-pronation and add support.

from rolling too far inward during your stride.

Now, let's talk about the amazing features. First, the heel-stabilizer counter keeps your foot completely stable throughout your stride. Then there's our unique Gore Band Tie System that helps support your heel and midfoot area, and wrap your foot in total comfort.

What's more amazing about the Revenge? The price. No other shoe gives you a better combination of cushioning and control for so little money.

Check out the Revenge at your Converse dealer. It's the most advanced shoe in its class. Which shouldn't amaze you at all because it's made by Converse.

Women's Revenge

Men's Revenge

CONVERSE
Reach for the stars.

1985: Revenge, 'It'll Amaze You, but It Won't Shock You'

GOOD NEWS FOR BAD KNEES.

At Converse, we've developed two new shoes to help reduce the risk of a problem that has become painfully evident to many runners: knee injuries.

The shoes are called Phaeton™ and Selena.™ And they're based on an exclusive

design philosophy no other running shoe has adopted. We call it the Stabilizer Bar. And simply put, what it does is help control pronation, the brutal side-to-side motion that occurs as your foot rolls inward at heelstrike.

Our Stabilizer Bar gently helps "brake" your foot as it pronates, with the result that it helps lessen the twisting motion. So less of it reaches your ankle, less reaches your leg and obviously, less reaches your knee.

The Stabilizer Bar is not, however, the only advantage the Phaeton and Selena enjoy

a. Normal pronation.
b. Excessive pronation.

over conventional running shoes. The shoes also have Scotch Lite® Reflective Fabric* for night running safety which, under normal circumstances, allows you to be seen in all directions from over 200 yards away.

And they weigh a mere 270 grams in Size 9.

The Converse Stabilizer Bar. It acts as a brake during pronation.

But superlatives aside, there really is only one way to determine what the Phaeton and Selena can do for you: run, *very carefully,* down to your nearest Converse dealer and try a pair on.

*A trademark of 3M Company.

CONVERSE

1982: Phaeton, 'Good News for Bad Knees'

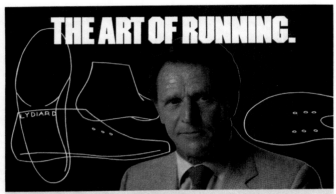

THE ART OF RUNNING.

Arthur Lydiard, the world's greatest distance coach and designer of the new Converse Lydiard Equinox™ and Lydiard Thunderbolt.™ "As a distance coach, I don't base my running methods solely on strength. Running's a science. That's why I chose to work with Converse. Converse is dedicated to biomechanical research. And together we've developed innovative design features that provide major benefits to the serious runner.

We built the new Equinox™ and Thunderbolt™ on my own last…a curved, contoured and balanced last…the first of its kind.

Special features include the extremely lightweight, yet durable Indy 500 outsole. A removable conformal footbed. And a molded mid-sole that keeps its resilience mile after mile. We also designed the Equinox™ in widths.

The results? Shoes that fit your foot and at the same time are lightweight and flexible. Three musts for any shoe you're going a long distance on.

I strongly recommend serious runners train in the new Converse Lydiard Equinox™ and race in the Lydiard Thunderbolt.™ Like I tell all my runners, being good isn't luck. It's a science. Resign yourself to that and you'll go far."

CONVERSE
Reach for the stars. Reach for Converse.
The Official Athletic Shoe of the 1984 Olympic Games.
© 1984 Converse Inc.

1984: Lydiard Equinox and Lydiard Thunderbolt, 'The Art of Running', ft. Arthur Lydiard

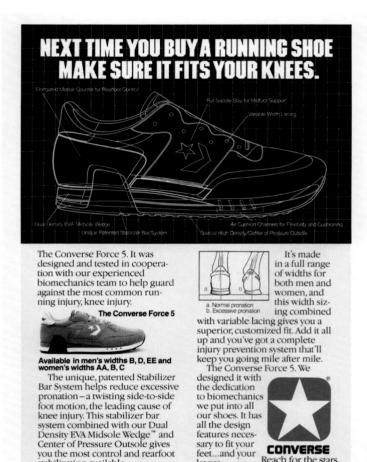

NEXT TIME YOU BUY A RUNNING SHOE MAKE SURE IT FITS YOUR KNEES.

The Converse Force 5. It was designed and tested in cooperation with our experienced biomechanics team to help guard against the most common running injury, knee injury.

The Converse Force 5

Available in men's widths B, D, EE and women's widths AA, B, C

The unique, patented Stabilizer Bar System helps reduce excessive pronation – a twisting side-to-side foot motion, the leading cause of knee injury. This stabilizer bar system combined with our Dual Density EVA Midsole Wedge™ and Center of Pressure Outsole gives you the most control and rearfoot stabilization available.

a. Normal pronation
b. Excessive pronation

It's made in a full range of widths for both men and women, and this width sizing combined with variable lacing gives you a superior, customized fit. Add it all up and you've got a complete injury prevention system that'll keep you going mile after mile. The Converse Force 5. We designed it with the dedication to biomechanics we put into all our shoes. It has all the design features necessary to fit your feet…and your knees.

CONVERSE
Reach for the stars.
© 1985 Converse Inc.

1985: Force 5, 'Next Time You Buy a Running Shoe Make Sure It Fits Your Knees'

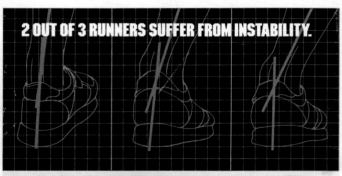

2 OUT OF 3 RUNNERS SUFFER FROM INSTABILITY.

INTRODUCING THE CURE: THE CONVERSE FORCE 5.™

It's a fact. The majority of runners suffer from some degree of pronation—a twisting side-to-side foot motion that can cause serious knee problems, the leading form of running injury.

New Force 5™

Men's available in B, D and EE widths.

Women's available in AA, B and C widths.

But now Converse, in collaboration with Dr. Lloyd Smith, Sports Podiatrist, has designed the ultimate in stabilizer shoes. The Converse Force 5.™ It has a patented rearfoot Stabilizer Bar system. It helps eliminate excessive pronation. So it helps protect your knees. And the concave center-of-pressure outsole brings that injury protection even one step further.

The Force 5™ is also available in widths for men and women. Plus it has variable lacing. And these two features combine to give a more precise fit and make our stabilization system the ultimate on the market. The Converse Force 5.™

We designed it by studying hundreds of serious runners and coming up with improved biomechanical designs to satisfy their needs. Why not put a pair on and see how much further a little extra stability can take you.

CONVERSE
Reach for the stars. Reach for Converse.
The Official Athletic Shoe of the 1984 Olympic Games.
© 1984 Converse Inc.

1984: Force 5, 'Introducing the Cure: the Converse Force 5'

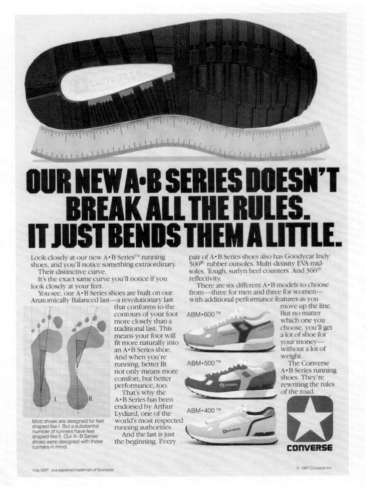

OUR NEW A·B SERIES DOESN'T BREAK ALL THE RULES. IT JUST BENDS THEM A LITTLE.

Look closely at our new A·B Series™ running shoes, and you'll notice something extraordinary. Their distinctive curve.

It's the exact same curve you'll notice if you look closely at your feet.

You see, our A·B Series shoes are built on our Anatomically Balanced last—a revolutionary last that conforms to the contours of your foot more closely than a traditional last. This means your foot will fit more naturally into an A·B Series shoe. And when you're running, better fit not only means more comfort, but better performance, too.

That's why the A·B Series has been endorsed by Arthur Lydiard, one of the world's most respected running authorities.

And the last is just the beginning. Every pair of A·B Series shoes also has Goodyear Indy 500® rubber outsoles. Multi-density EVA midsoles. Tough, surlyn heel counters. And 360° reflectivity.

There are six different A·B models to choose from—three for men and three for women—with additional performance features as you move up the line. But no matter which one you choose, you'll get a lot of shoe for your money—without a lot of weight.

The Converse A·B Series running shoes. They're rewriting the rules of the road.

ABM·600™

ABM·500™

ABM·400™

Most shoes are designed for feet shaped like I. But a substantial number of runners have feet shaped like II. Our A·B Series shoes were designed with these runners in mind.

Indy 500® is a registered trademark of Goodyear.

CONVERSE
© 1987 Converse Inc.

1987: A-B Series, 'Our New A-B Series Doesn't Break All the Rules. It Just Bends Them a Little'

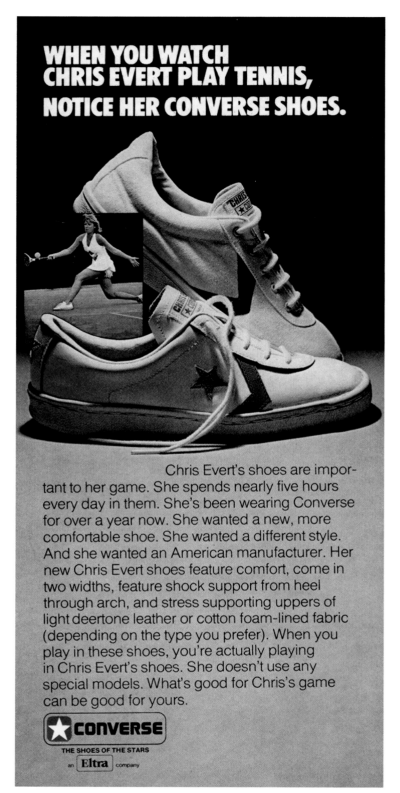

WHEN YOU WATCH CHRIS EVERT PLAY TENNIS, NOTICE HER CONVERSE SHOES.

Chris Evert's shoes are important to her game. She spends nearly five hours every day in them. She's been wearing Converse for over a year now. She wanted a new, more comfortable shoe. She wanted a different style. And she wanted an American manufacturer. Her new Chris Evert shoes feature comfort, come in two widths, feature shock support from heel through arch, and stress supporting uppers of light deertone leather or cotton foam-lined fabric (depending on the type you prefer). When you play in these shoes, you're actually playing in Chris Evert's shoes. She doesn't use any special models. What's good for Chris's game can be good for yours.

★ CONVERSE

THE SHOES OF THE STARS

an **Eltra** company

1977: Chris Evert Pro Model, 'When You Watch Chris Evert Play Tennis, Notice Her Converse Shoes', ft. Chris Evert

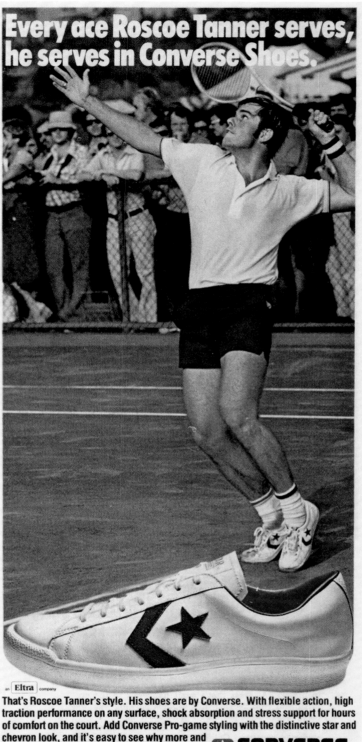

Every ace Roscoe Tanner serves, he serves in Converse Shoes.

an **Eltra** company

That's Roscoe Tanner's style. His shoes are by Converse. With flexible action, high traction performance on any surface, shock absorption and stress support for hours of comfort on the court. Add Converse Pro-game styling with the distinctive star and chevron look, and it's easy to see why more and more tennis players are getting into Converse. It's a whole new way to play.

★ CONVERSE
THE SHOES OF THE STARS

1987: Roscoe Tanner Pro Model, 'Every Ace Roscoe Tanner Serves, He Serves in Converse Shoes', ft. Roscoe Tanner

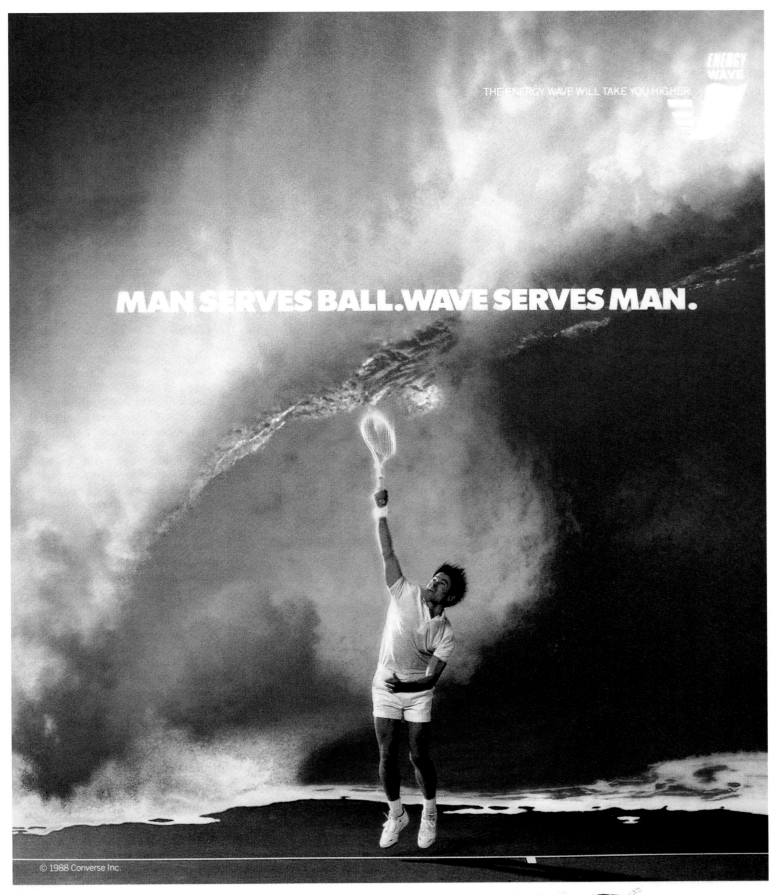

THE ENERGY WAVE WILL TAKE YOU HIGHER.

ENERGY WAVE

MAN SERVES BALL. WAVE SERVES MAN.

Introducing the Converse Energy Wave.™ And our new GSV™ Tennis Series.

With 77% better energy return than Nike Air. Cushioning that lasts longer than EVA. And Wave shoes are cooler for maximum comfort.

All so you can play longer and harder. Read that last sentence again.

Results are based on independent direct material tests of the Converse Energy Wave, Nike Air, and EVA.

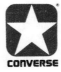

Look for the blue-on-blue Energy Wave.

CONVERSE

1988: Energy Wave GSV Tennis, 'Man Serves Ball. Wave Serves Man'

THE WINNINGEST PAIR IN TENNIS.

Between them, they've won over 200 major tournaments – including all the Grand Slam events – in Converse tennis shoes.

But this year, they're in something new. Introducing the Converse®Grand Slam Victory™ series.

The GSV series is a new line of high-performance tennis shoes for men and women. A line that features soft leather uppers with special overlays for support, durability

and comfort. Plus durable outsoles that give you excellent traction on all kinds of courts. It's a line that delivers both stability and flexibility to the rearfoot.

That's why it's the choice of proven winners like Jimmy Connors and Chris Evert-Lloyd.

So look for the Converse®GSV™ series in your local sporting goods store or pro shop today.

And let it make a winner out of you.

CONVERSE

1987: GSV Series, 'The Winningest Pair in Tennis', ft. Chris Evert and Jimmy Connors

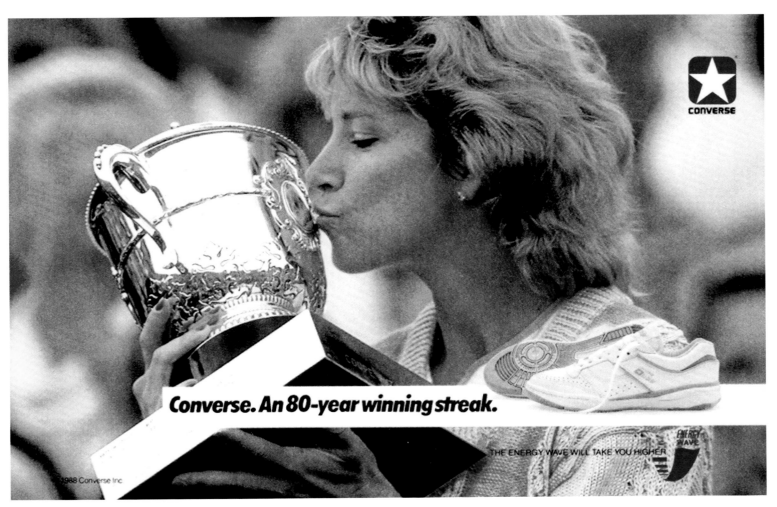

1988: Energy Wave Tennis, 'Converse. An 80-Year Winning Streak', ft. Chris Evert

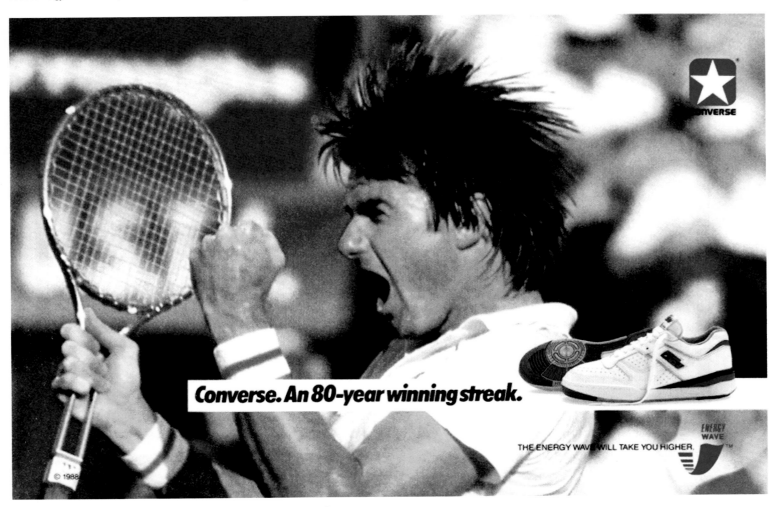

1988: Energy Wave Tennis, 'Converse. An 80-Year Winning Streak', ft. Jimmy Connors

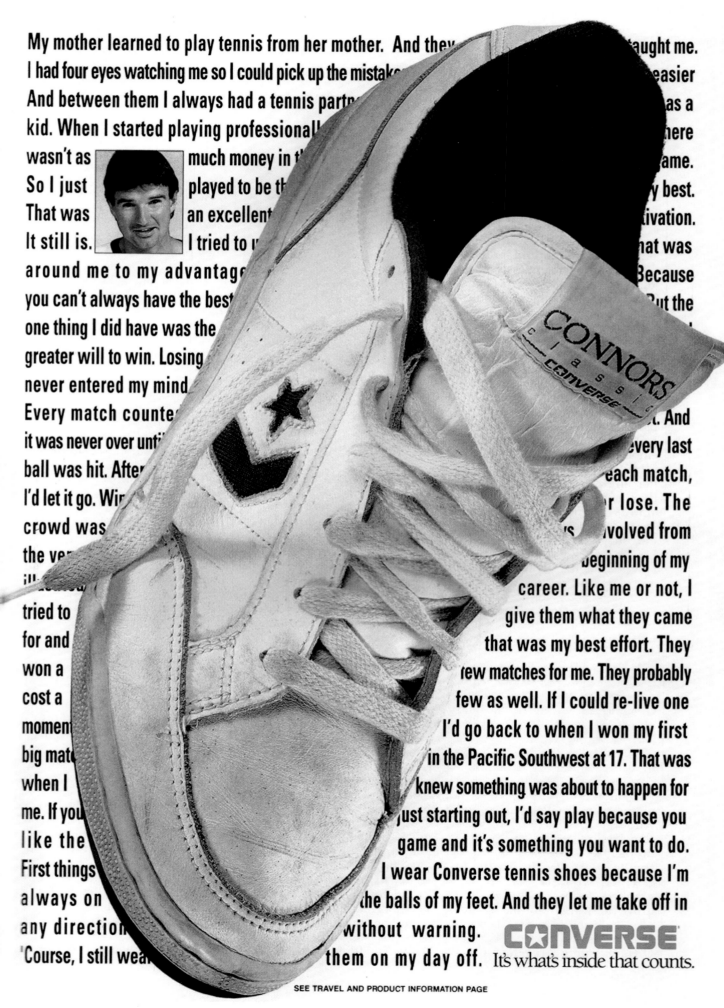

My mother learned to play tennis from her mother. And they ⬛⬛⬛⬛ taught me.
I had four eyes watching me so I could pick up the mistak⬛⬛⬛⬛ easier
And between them I always had a tennis partn⬛⬛⬛⬛ as a
kid. When I started playing professional⬛⬛⬛⬛ here
wasn't as ⬛⬛⬛⬛ much money in t⬛⬛⬛⬛ ame.
So I just ⬛⬛⬛⬛ played to be th⬛⬛⬛⬛ y best.
That was ⬛⬛⬛⬛ an excellent ⬛⬛⬛⬛ ivation.
It still is. ⬛⬛⬛⬛ I tried to u⬛⬛⬛⬛ hat was
around me to my advantage⬛⬛⬛⬛ Because
you can't always have the best⬛⬛⬛⬛ ut the
one thing I did have was the ⬛⬛⬛⬛
greater will to win. Losing ⬛⬛⬛⬛
never entered my mind ⬛⬛⬛⬛
Every match counte⬛⬛⬛⬛ . And
it was never over unti⬛⬛⬛⬛ every last
ball was hit. Afte⬛⬛⬛⬛ each match,
I'd let it go. Wi⬛⬛⬛⬛ r lose. The
crowd was ⬛⬛⬛⬛ s ⬛volved from
the ve⬛⬛⬛⬛ beginning of my
il⬛⬛⬛⬛ career. Like me or not, I
tried to ⬛⬛⬛⬛ give them what they came
for and ⬛⬛⬛⬛ that was my best effort. They
won a ⬛⬛⬛⬛ few matches for me. They probably
cost a ⬛⬛⬛⬛ few as well. If I could re-live one
momen⬛⬛⬛⬛ I'd go back to when I won my first
big mat⬛⬛⬛⬛ in the Pacific Southwest at 17. That was
when I ⬛⬛⬛⬛ knew something was about to happen for
me. If you⬛⬛⬛⬛ just starting out, I'd say play because you
like the⬛⬛⬛⬛ game and it's something you want to do.
First things⬛⬛⬛⬛ I wear Converse tennis shoes because I'm
always on ⬛⬛⬛⬛ the balls of my feet. And they let me take off in
any direction⬛⬛⬛⬛ without warning. **CONVERSE**
'Course, I still wea⬛⬛⬛⬛ them on my day off. It's what's inside that counts.

SEE TRAVEL AND PRODUCT INFORMATION PAGE

1991: Connors Classic, 'It's What's Inside That Counts', ft. Jimmy Connors

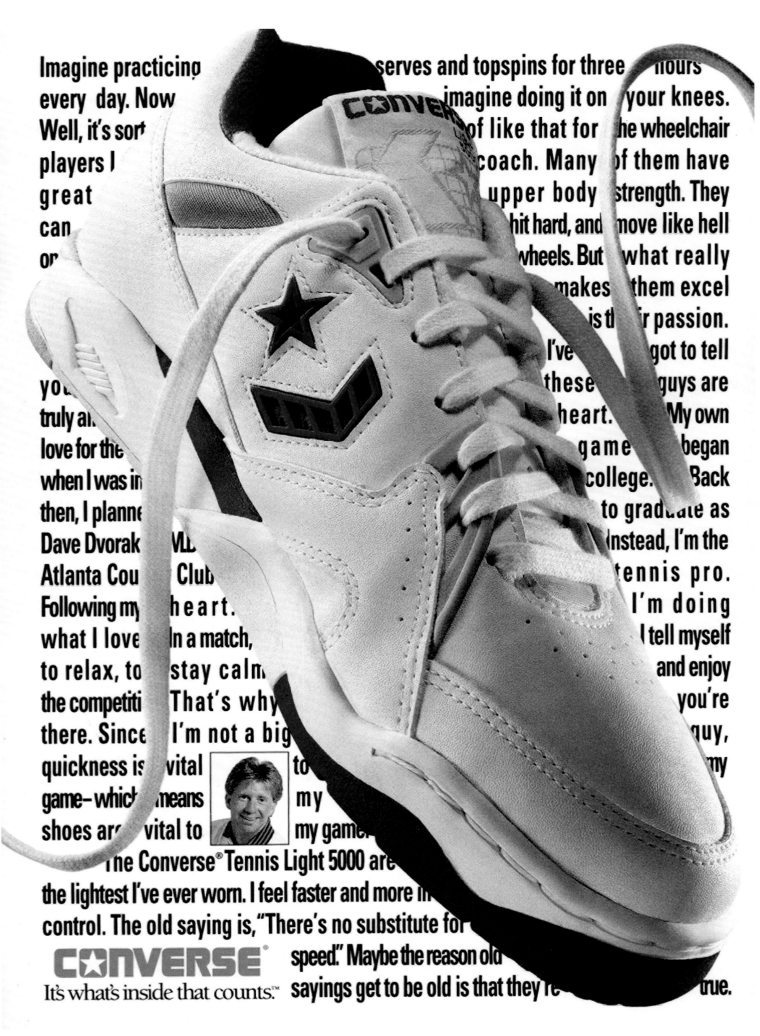

Imagine practicing serves and topspins for three hours every day. Now imagine doing it on your knees. Well, it's sort of like that for the wheelchair players I coach. Many of them have great upper body strength. They can hit hard, and move like hell on wheels. But what really makes them excel is their passion. I've got to tell you these guys are truly all heart. My own love for the game began when I was in college. Back then, I planned to graduate as Dave Dvorak, MD. Instead, I'm the Atlanta Country Club tennis pro. Following my heart. I'm doing what I love. In a match, I tell myself to relax, to stay calm and enjoy the competition. That's why you're there. Since I'm not a big guy, quickness is vital to my game-which means my shoes are vital to my game. The Converse® Tennis Light 5000 are the lightest I've ever worn. I feel faster and more in control. The old saying is, "There's no substitute for speed." Maybe the reason old sayings get to be old is that they're true.

CONVERSE®
It's what's inside that counts.™

1992: Tennis Light 5000, 'It's What's Inside That Counts', ft. Dave Dvorak

JORDAN

Nike's partnership with Michael Jordan is easily the most influential and profitable in the history of the athletic footwear industry. The greatest entertainer the NBA has ever seen crushed his opponents on court with silky showmanship, then achieved all-time sales records as his signature shoes flew off the shelves. From the righteous Air Jordan 1 to the Bugs Bunny-endorsed 'Hare' Jordan 7 and the tuxedo-inspired Air Jordan 11, each groundbreaking iteration was infused with an elaborate narrative. Celebrated moments such as Mike's legendary 1997 'Flu Game' appearance and the 1985 'Shattered Backboard' game in Trieste, Italy, added further layers of marketing mystique. The cult TV spots featuring Spike Lee as Mars Blackmon laid the cultural foundations for Jordan's superhero persona, which was revisited superbly in the 2020 *Last Dance* documentary. Though Blackmon does appear in several cheeky print campaigns, Nike didn't invest heavily in promoting Jordan in magazines, which explains the surprisingly low tally in this chapter. Regardless, some 35 years since it was first released, the original Air Jordan is still ground-zero for Nike's ruthless domination of the basketball category.

●

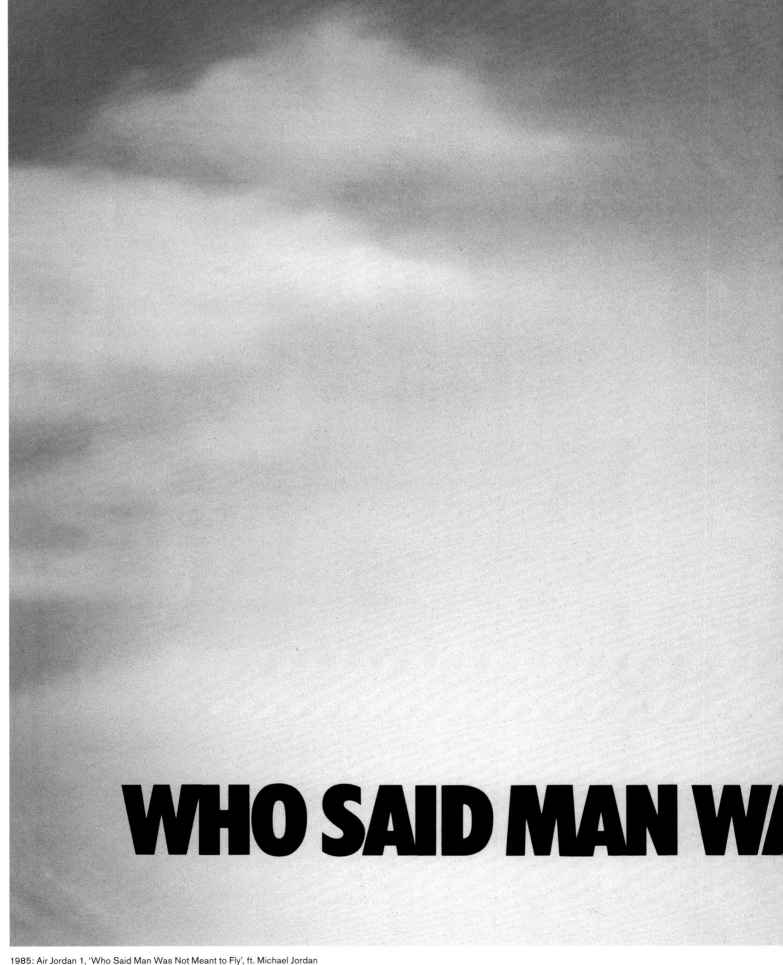

1985: Air Jordan 1, 'Who Said Man Was Not Meant to Fly', ft. Michael Jordan

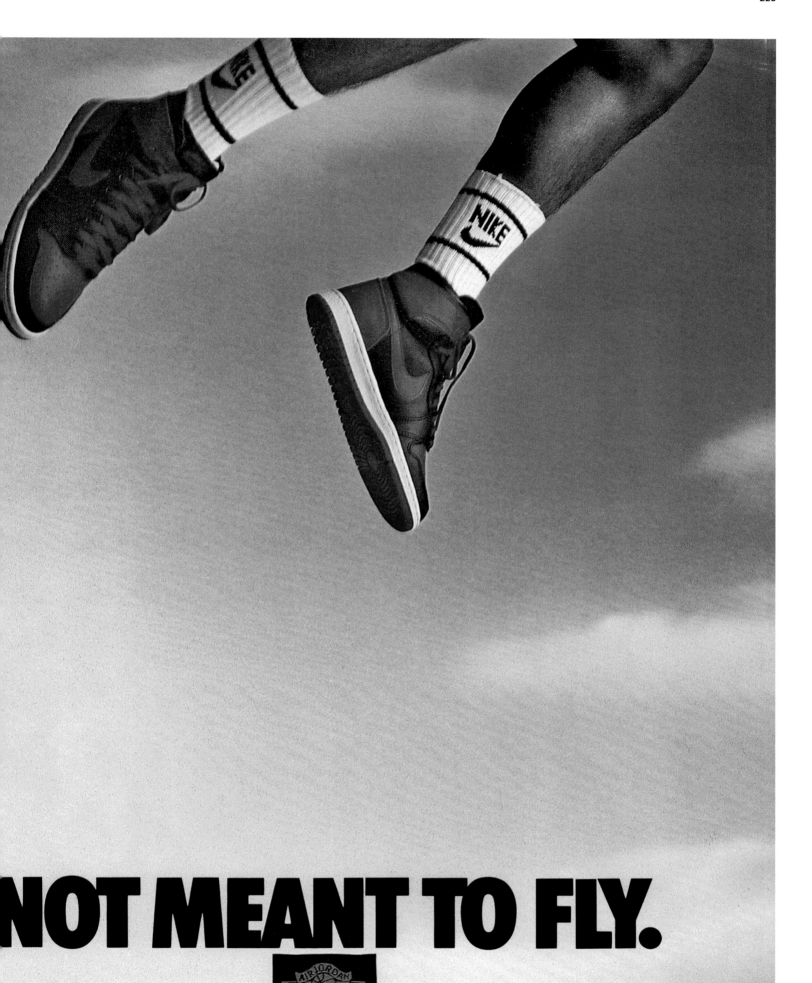

NOT MEANT TO FLY.

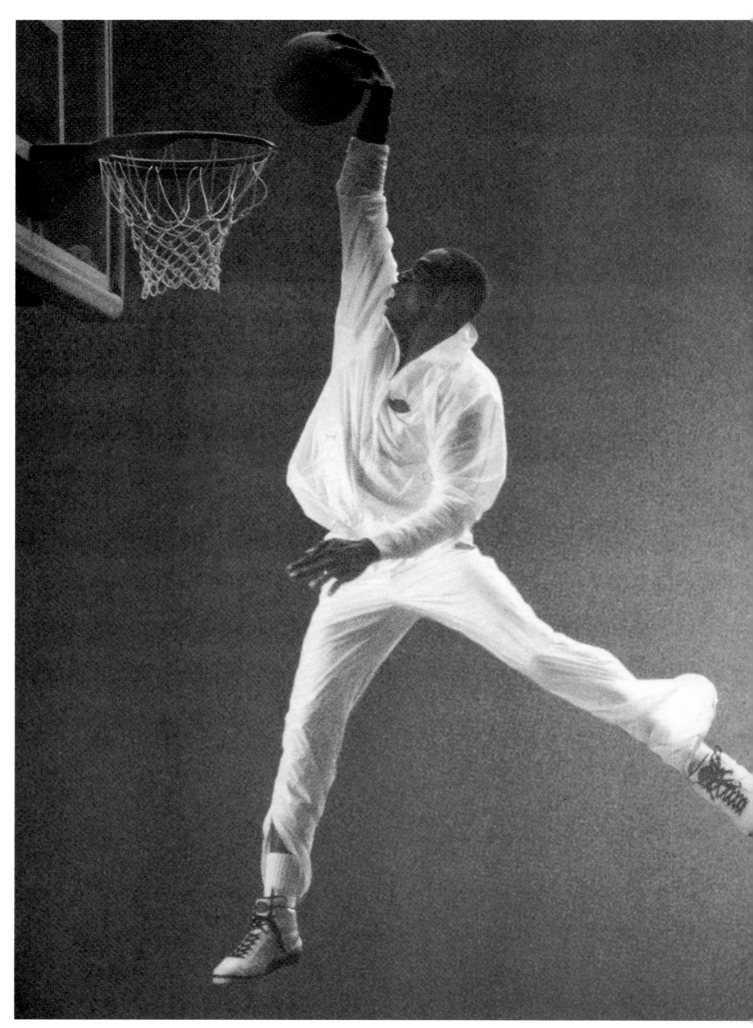

1987: Air Jordan II, 'Look, Up in the Air', ft. Michael Jordan

LOOK, UP IN THE AIR.

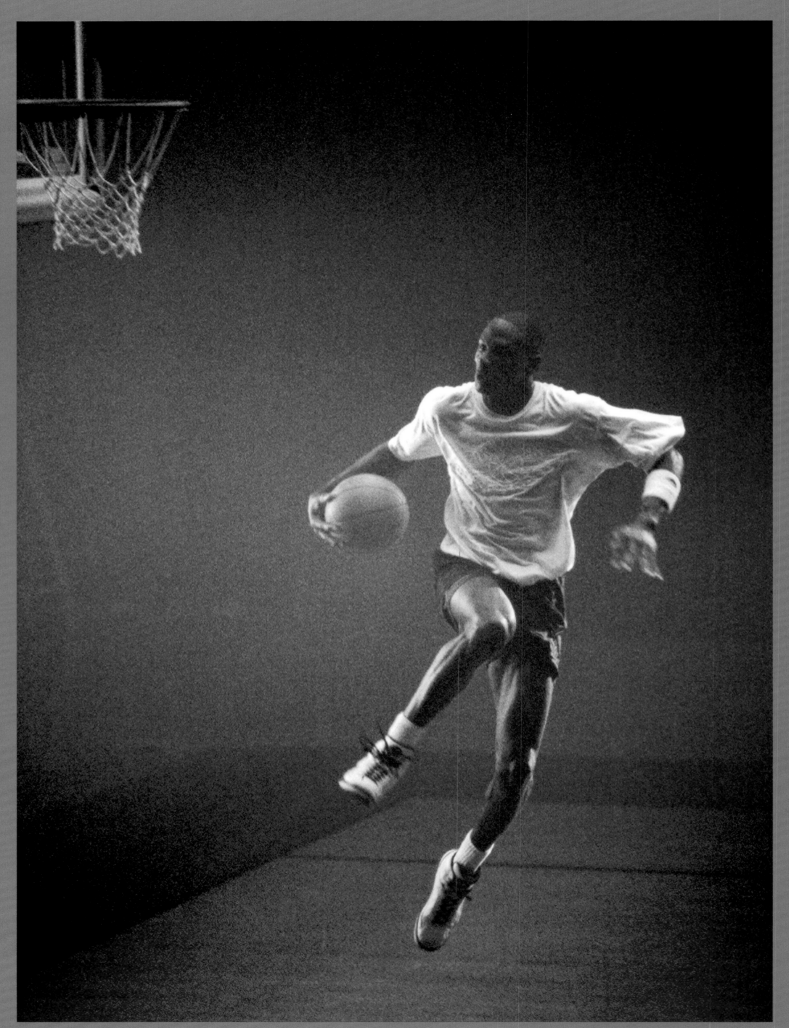

1987: Air Jordan II, ft. Michael Jordan

1987: Air Jordan II

" The first time I met MJ, he held up ten fingers and said 'Ten!' I said, 'What does that mean?' He took the ball, stuffed it and said 'Nine!' His wrists were hitting the rim, so I could see where he was coming from. You could only dunk the ball so many times before it really started to hurt. The next day I was able to shoot 'Look, Up in the Air', which ran as a double page in *Sports Illustrated*. I remember riding on a bus with my son's basketball team when they started running that commercial, which had a slow-motion of Michael elevating off the ground. One of the fathers claimed Nike used plexiglass stairs that Michael climbed up. I said 'Excuse me. That's total bullshit! I was there. Michael just jumped up and dunked it!' **"**

Bob Peterson
'Just Do It'
Sneaker Freaker, issue 35 (2016)

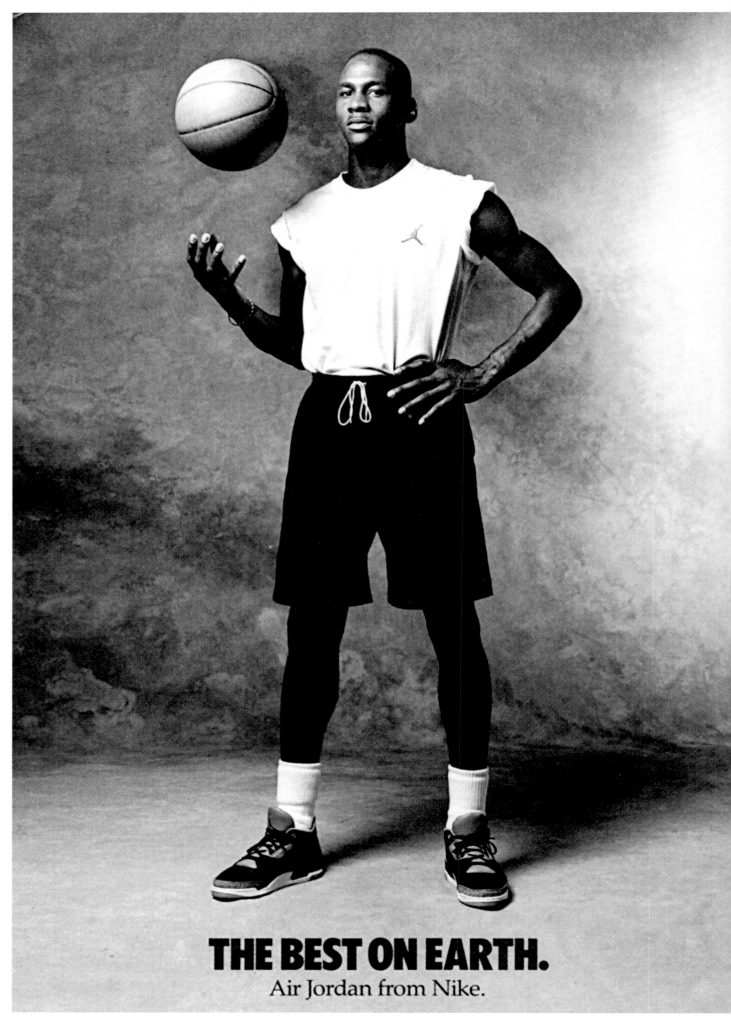

1988: Air Jordan III, 'The Best on Earth…The Best on Mars', ft. Michael Jordan and Mars Blackmon

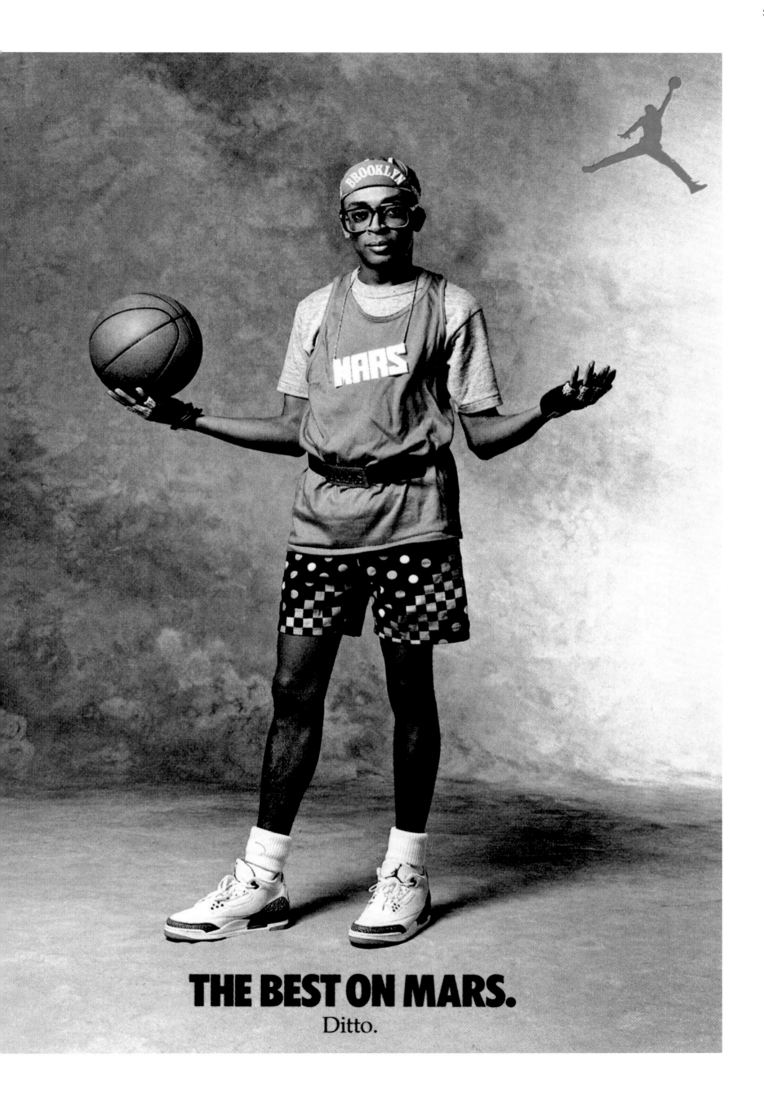

THE BEST ON MARS.
Ditto.

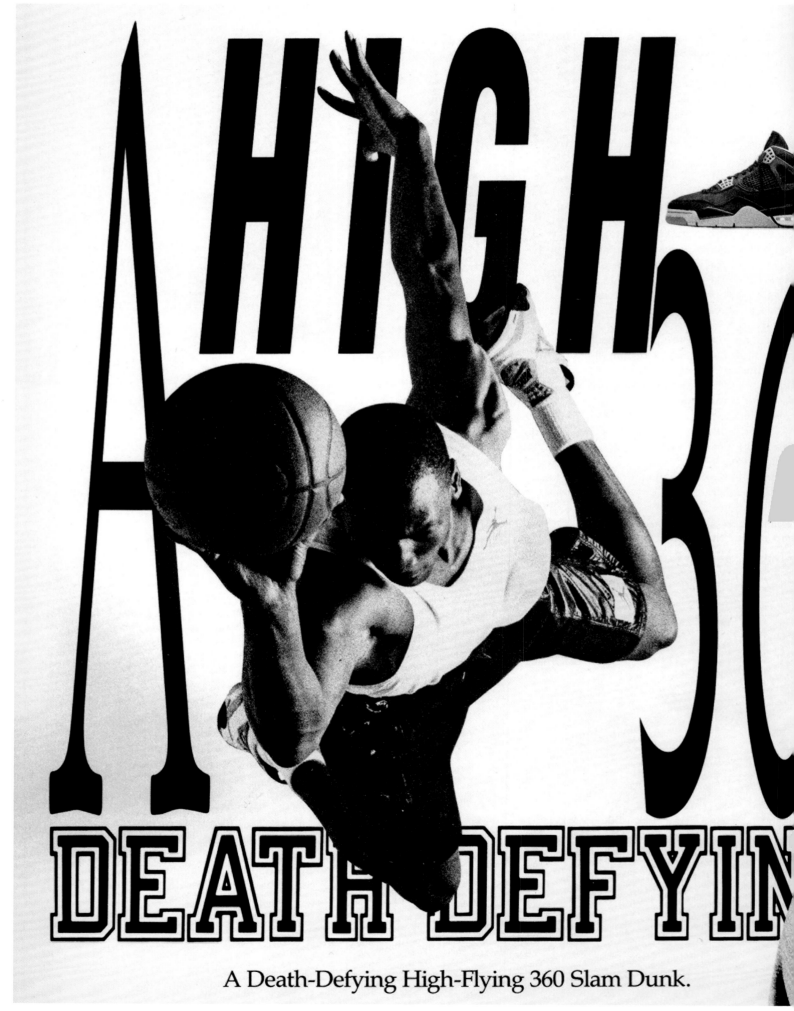

A Death-Defying High-Flying 360 Slam Dunk.

1989: Air Jordan IV, 'A Death-Defying High-Flying 360 Slam Dunk', ft. Michael Jordan and Mars Blackmon

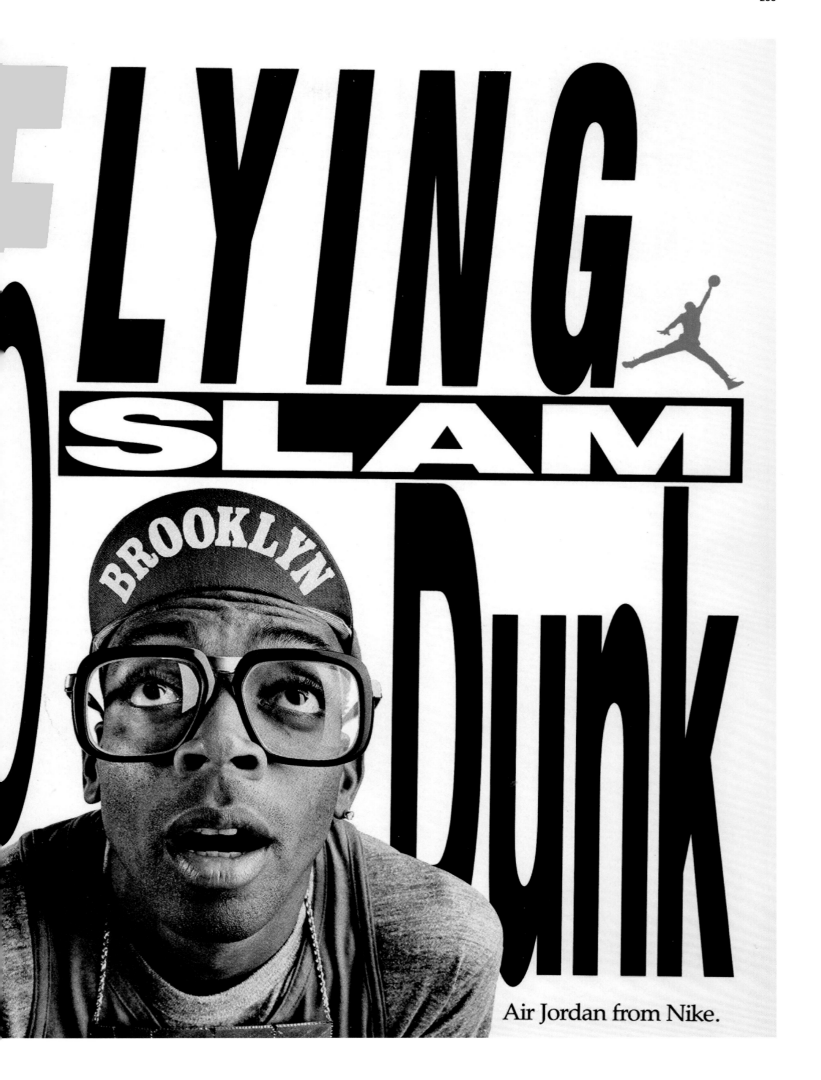

Air Jordan from Nike.

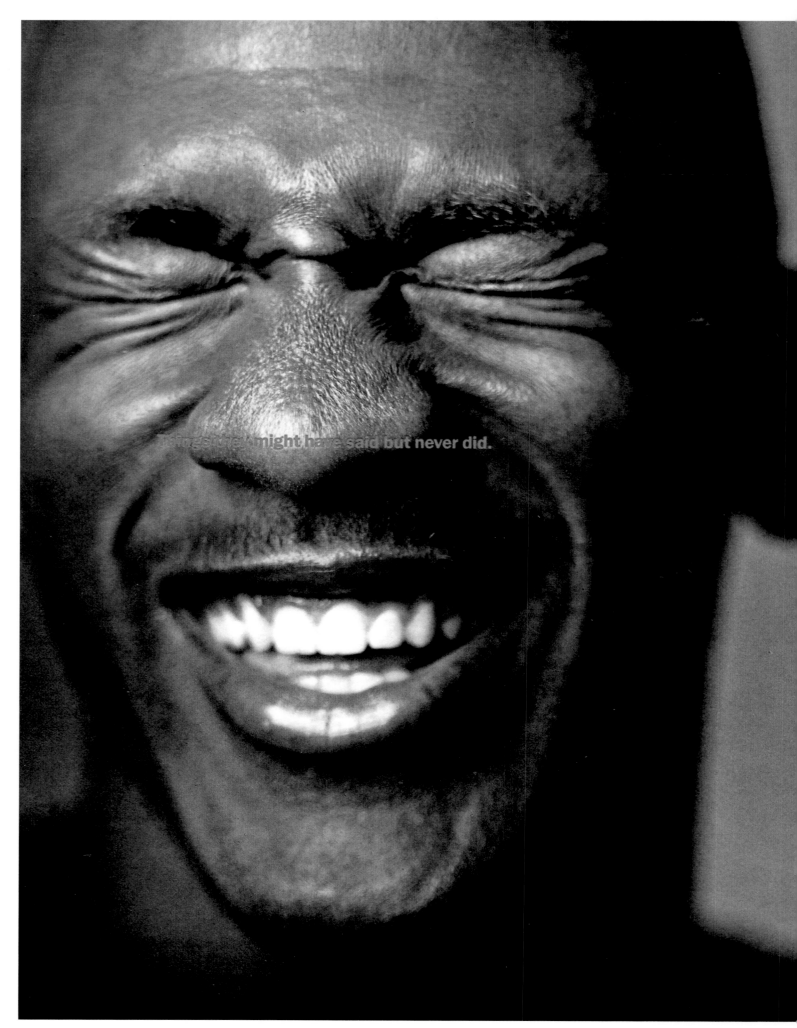

Things they might have said but never did.

1990: Air Jordan V, 'Things They Might Have Said but Never Did', ft. Michael Jordan

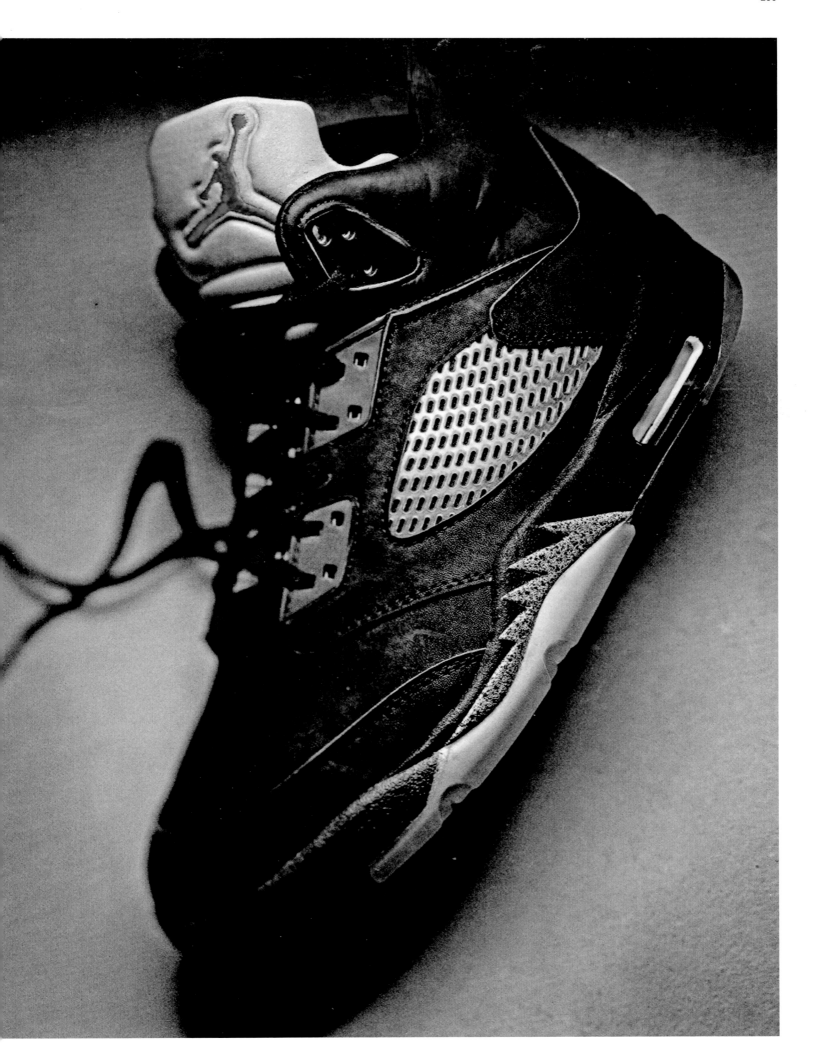

BY NIKE

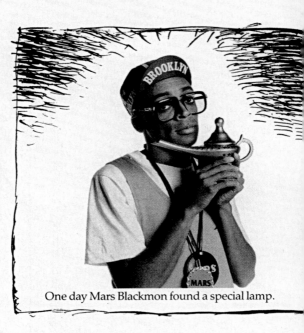

One day Mars Blackmon found a special lamp.

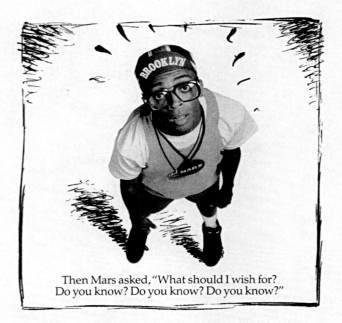

Then Mars asked, "What should I wish for? Do you know? Do you know? Do you know?"

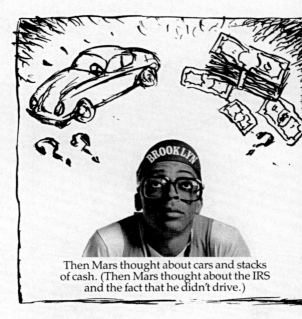

Then Mars thought about cars and stacks of cash. (Then Mars thought about the IRS and the fact that he didn't drive.)

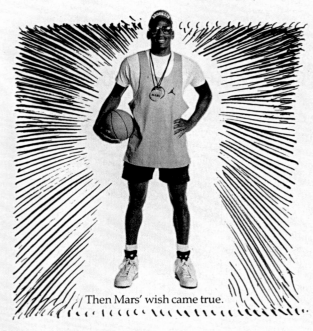

Then Mars' wish came true.

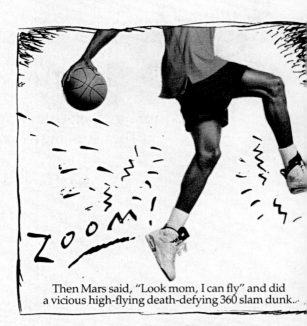

Then Mars said, "Look mom, I can fly" and did a vicious high-flying death-defying 360 slam dunk.

1991: Air Jordan VI, 'Mars Blackmon and Aladdin's Lamp', ft. Michael Jordan and Mars Blackmon

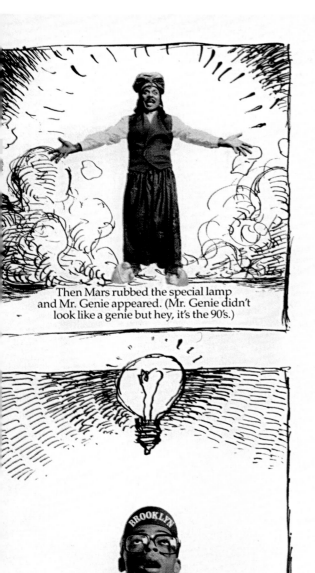

Then Mars rubbed the special lamp and Mr. Genie appeared. (Mr. Genie didn't look like a genie but hey, it's the 90's.)

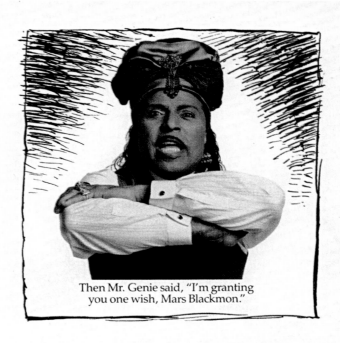

Then Mr. Genie said, "I'm granting you one wish, Mars Blackmon."

Then the one perfect wish came to Mars.

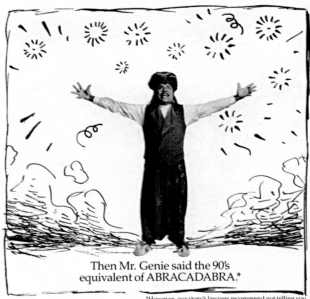

Then Mr. Genie said the 90's equivalent of ABRACADABRA.*

*However, our story's lawyers recommend not telling you what that is because of possible copyright infringement.

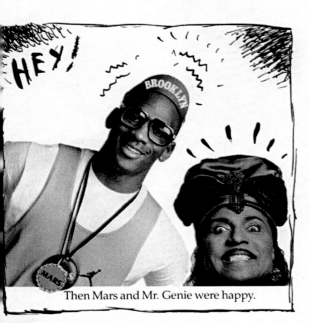

Then Mars and Mr. Genie were happy.

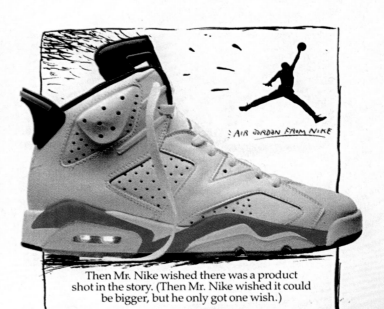

Then Mr. Nike wished there was a product shot in the story. (Then Mr. Nike wished it could be bigger, but he only got one wish.)

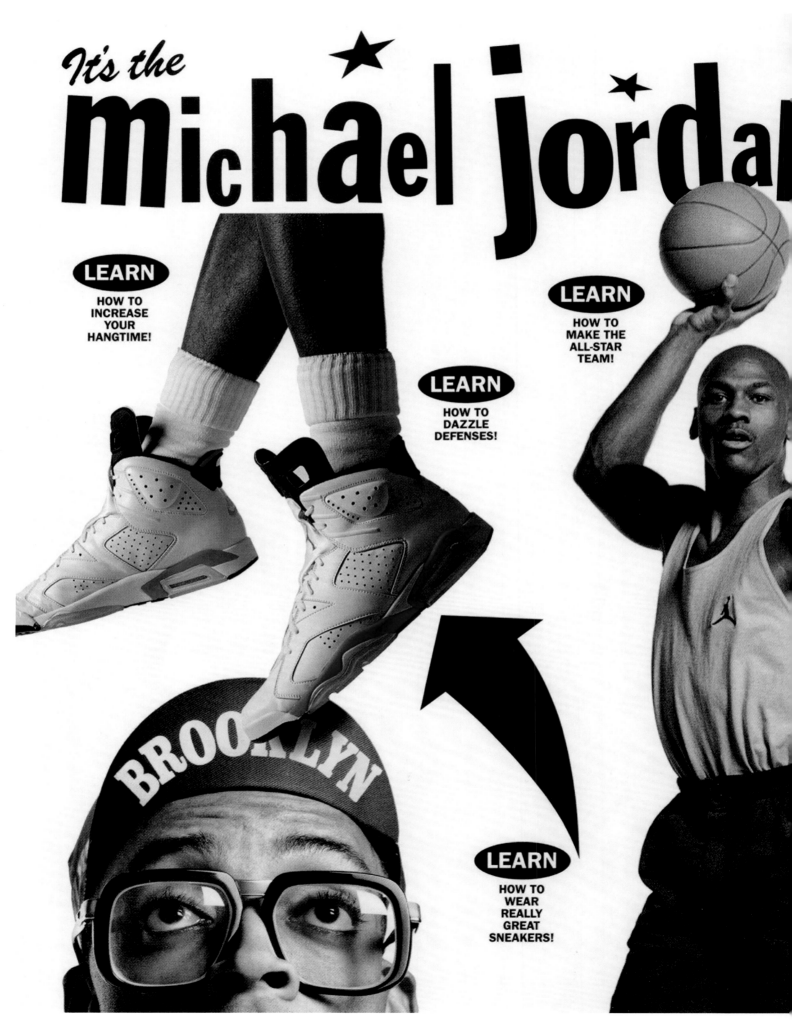

It's the michael jorda

LEARN
HOW TO INCREASE YOUR HANGTIME!

LEARN
HOW TO MAKE THE ALL-STAR TEAM!

LEARN
HOW TO DAZZLE DEFENSES!

LEARN
HOW TO WEAR REALLY GREAT SNEAKERS!

1991: Air Jordan VI, 'It's the Michael Jordan Flight School', ft. Michael Jordan and Mars Blackmon

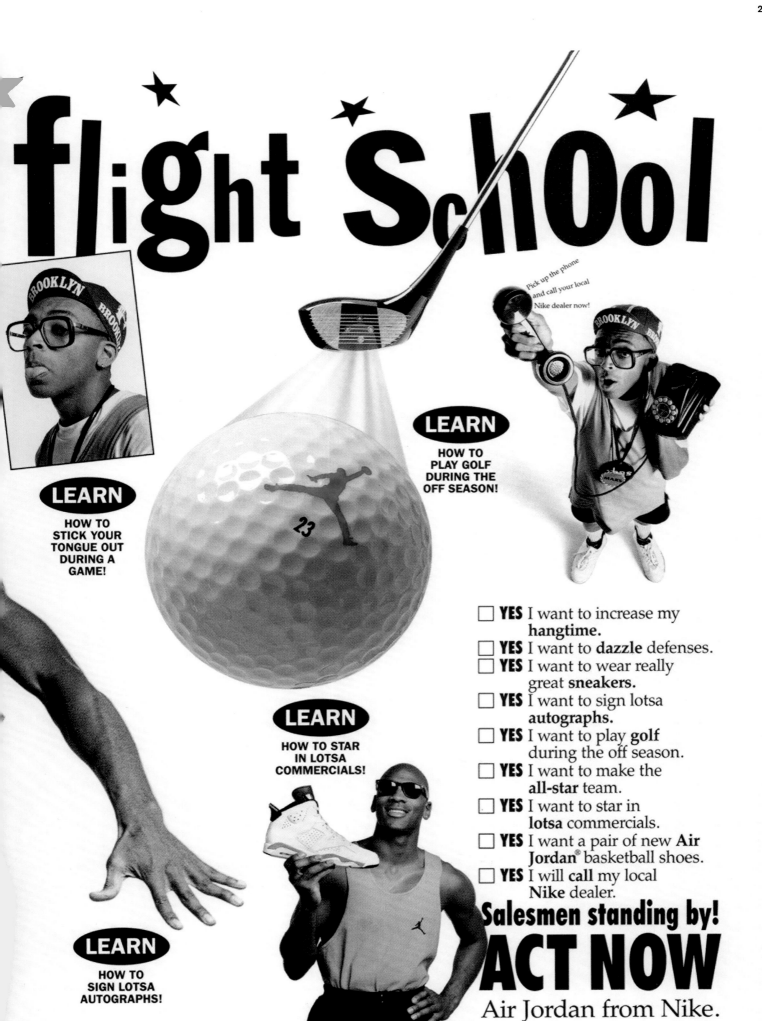

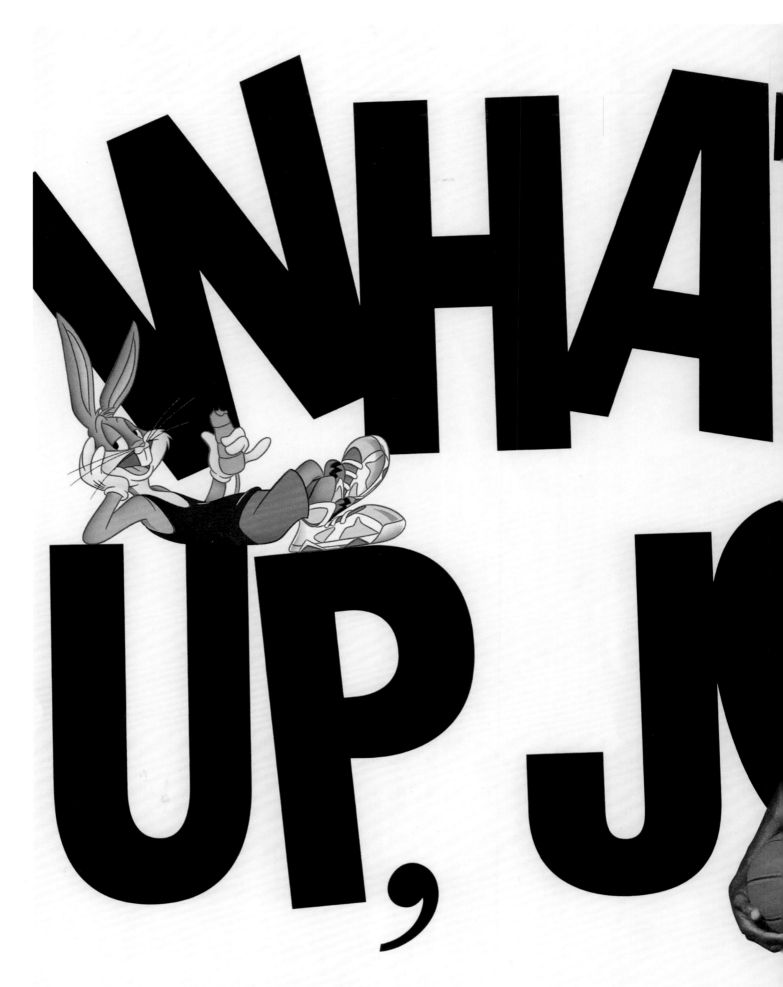

1991: Air Jordan VII, 'What's Up, Jock?', ft. Michael Jordan and Bugs Bunny

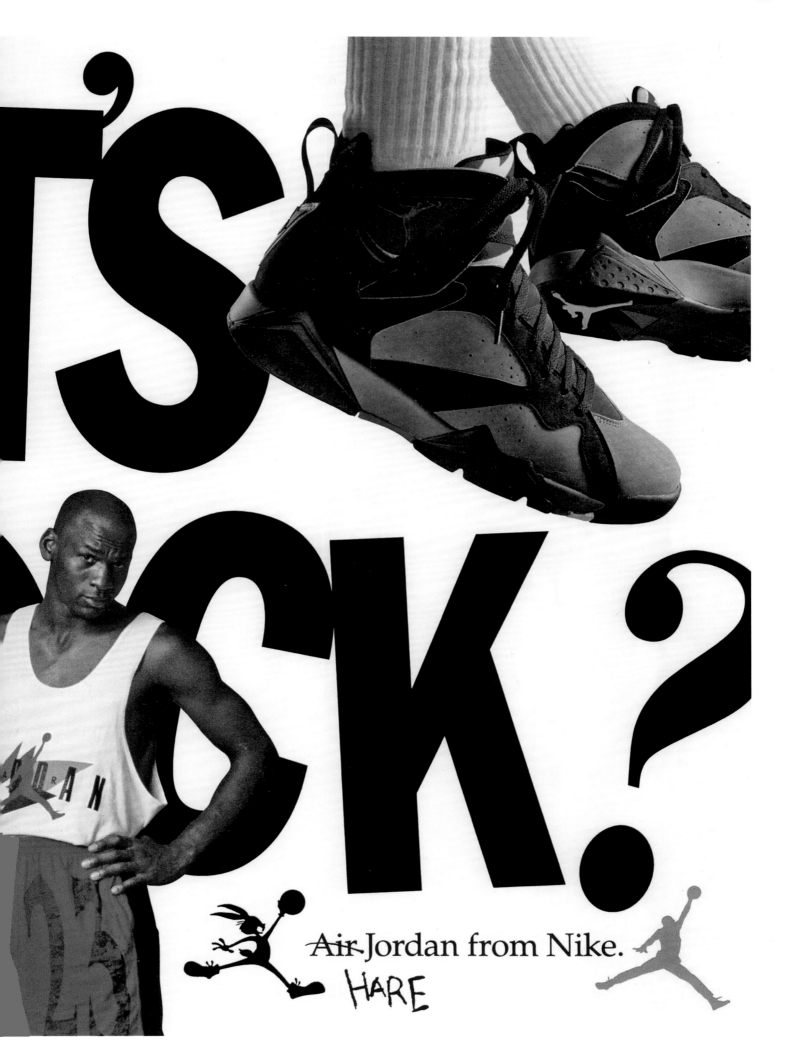

TSK. TSK?

Air Jordan from Nike.

HARE

1-800-645-6031

1995: Air Jordan XI

" The Air Jordan XI is considered the crème de la crème of Jordan sneakers. The design concept reportedly came to Tinker while he was mowing the lawn. Glossy patent material wraps the bottom half of the shoe to protect the polymer-coated ballistic nylon upper, satisfying Jordan's request for a shiny sneaker that could be worn with a tuxedo. Translucent soles exposed the innovative carbon fibre shank that underpinned the construction. The AJ XI is Tinker's favourite design and arguably the most hyped model in the entire Jordan canon. Back in 2011, American malls erupted into scuffles and riots when the 'Concord' retro released, a level of pandemonium no Jordan release has inspired since. "

'The Sneaker Freaker Guide to Jordan'
The Ultimate Sneaker Book
Taschen (2019)

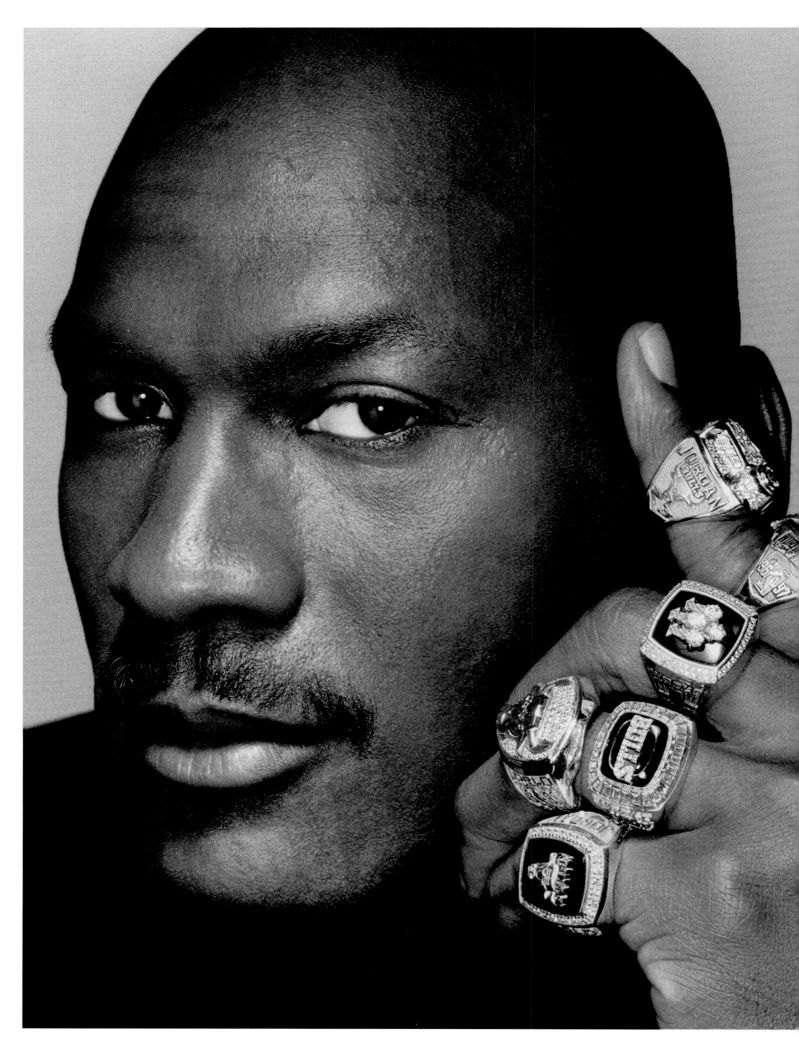

1999: Air Jordan XV, ft. Michael Jordan

L.A. GEAR

The brainwave of entrepreneur Robert Greenberg, L.A. Gear were established in the early 1980s to market roller skates to the Venice Beach crowd in Los Angeles. Shortly afterwards, the brand developed a unique 'fashion athletic' aesthetic that aligned perfectly with celebrity endorsements from pop divas such as Paula Abdul, Belinda Carlisle and Priscilla Presley. Witness the fitness of a young Heather Locklear in perky acid-wash denims and 'unstoppable' L.A. Gears on her feet!

In the late 1980s, L.A. Gear doubled down to duke it out with the sneaker heavyweights by enlisting Hakeem Olajuwon, Kareem Abdul-Jabbar and Karl Malone to champion beefed-up performance models that looked suspiciously like Air Jordan rejects. Super Bowl quarterback Joe Montana was another notable signing to the all-star squad. Mired in counter-claim legal action after a much-ballyhooed Michael Jackson collaboration experiment went awry, the brand collapsed under their own corny weight. At the peak of their game in 1989, L.A. Gear were the third largest footwear brand in America, and that's why their ads made it into this book.

●

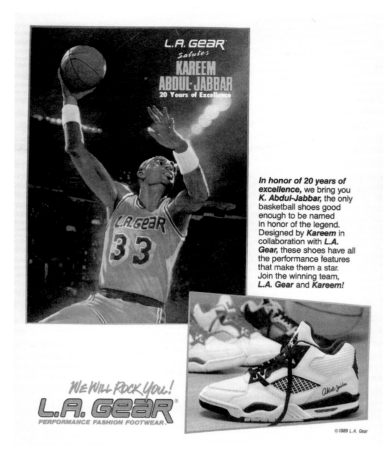

In honor of 20 years of **excellence**, we bring you **K. Abdul-Jabbar**, the only basketball shoes good enough to be named in honor of the legend. Designed by **Kareem** in collaboration with **L.A. Gear**, these shoes have all the performance features that make them a star. Join the winning team, **L.A. Gear** and **Kareem**!

1989: K. Abdul-Jabbar, ft. Kareem Abdul-Jabbar

Introducing the new winning team. The Man . . . world champion, **Kareem Abdul Jabbar.** He defined excellence with his career and sets trends with his style. His shoe of choice . . . the B424 by L.A. Gear.

Style No. B423, B424

1989: B424, ft. Kareem Abdul-Jabbar

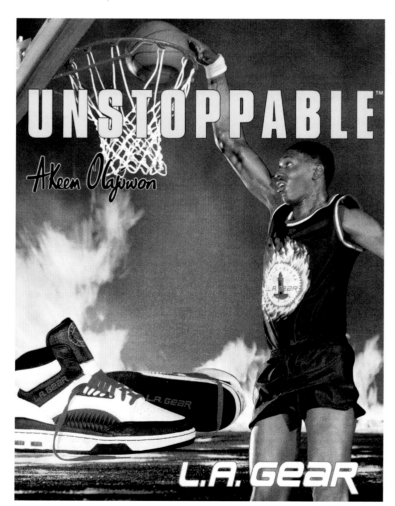

1990: Fire High, 'Unstoppable', ft. Akeem (Hakeem) Olajuwon

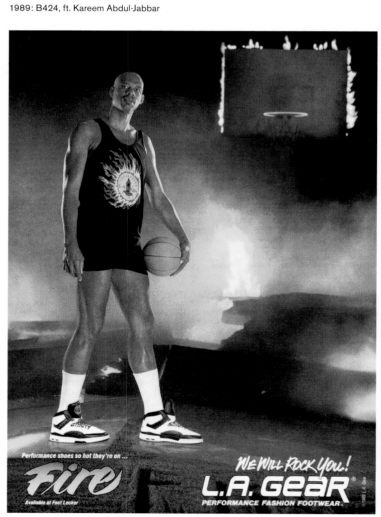

1989: Fire High, 'We Will Rock You!', ft. Kareem Abdul-Jabbar

A phenomenon of light and warmth — a source of inspiration — the flicker of creation that sparked the basketball shoes of the future. Performance basketball shoes that will burn through the nineties with inspired leather detailing, bold colors, and air system support. Fire...the shoes of tomorrow.

WE WILL ROCK YOU!

L.A. GEAR™
PERFORMANCE FASHION FOOTWEAR™

4221 Redwood Ave., Los Angeles, California 90066 • ©1989 L.A. Gear

1989: Fire, 'We Will Rock You!', ft. Joe Montana, Hakeem Olajuwon and Kareem Abdul-Jabbar

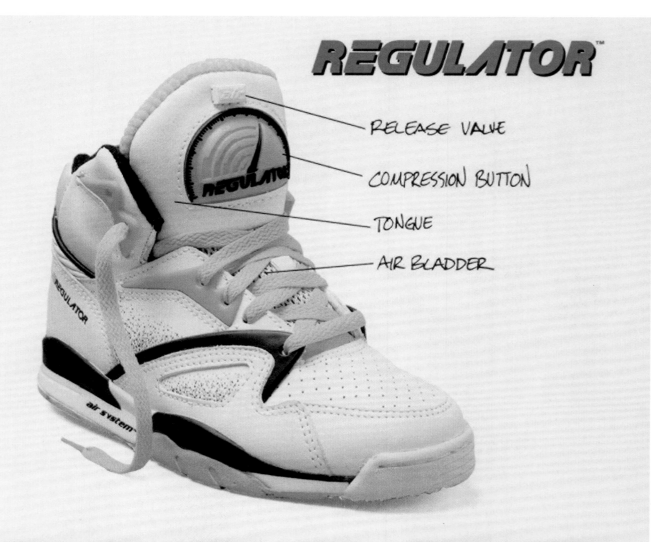

REGULATOR™

- RELEASE VALVE
- COMPRESSION BUTTON
- TONGUE
- AIR BLADDER

BUY THIS HIGH PERFORMANCE VEHICLE AND THE AIRBAG COMES STANDARD.

INFLATABLE TECHNOLOGY FOR PEAK PERFORMANCE.

The latest model athletic shoe from L.A. Gear is built to perform under pressure.

Advanced air technology lets you press a button to customize the fit and then press your advantage on the court.

Air cushioned comfort, stability straps, self-adjusting arches, superior traction and shocks put you in total control.

To experience the ultimate in driving, running, pivoting and jumping pleasure, we suggest you test-drive a Regulator.

L.A. GEAR®

© 1991 L.A. Gear

1991: Regulator, 'Buy This High Performance Vehicle and the Airbag Comes Standard'

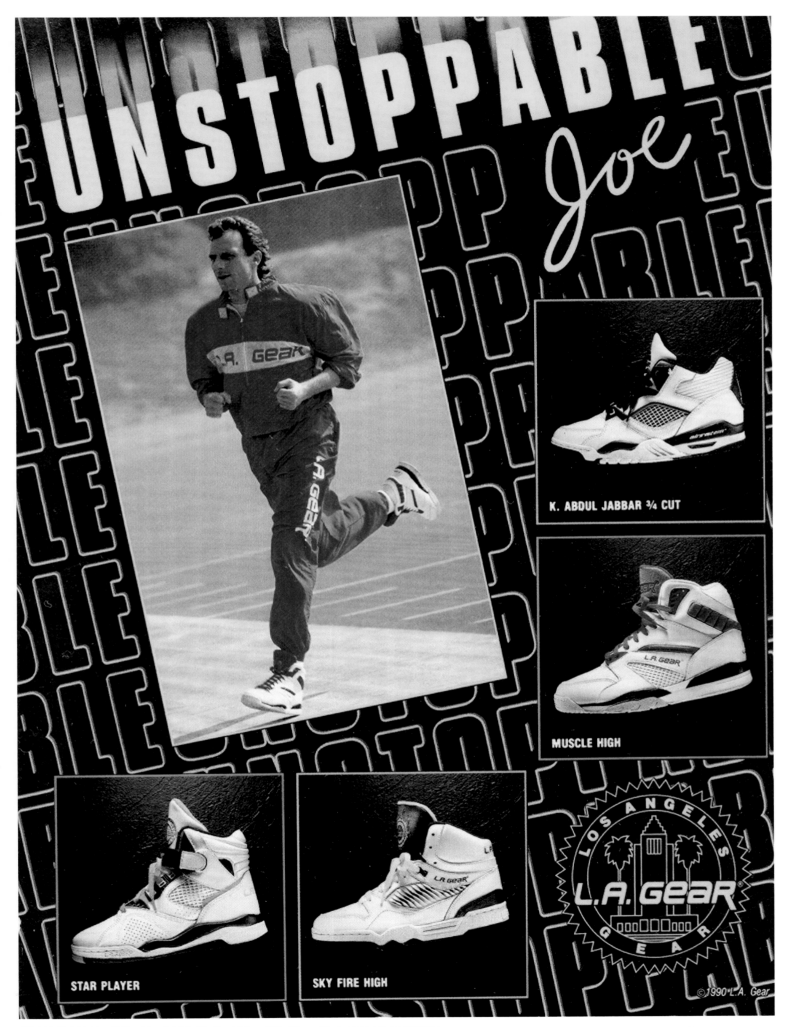

1990: K. Abdul Jabbar ¾ Cut, Muscle High, Sky Fire High and Star Player, 'Unstoppable', ft. Joe Montana

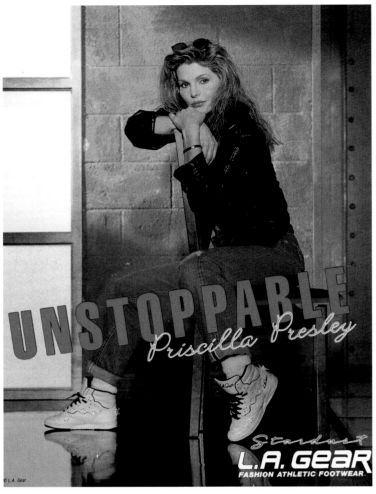

1990: Stardust, 'Unstoppable', ft. Priscilla Presley

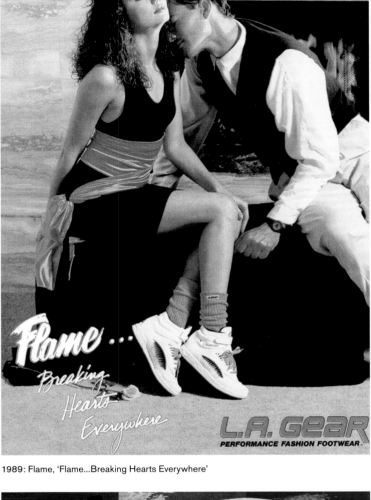

1989: Flame, 'Flame...Breaking Hearts Everywhere'

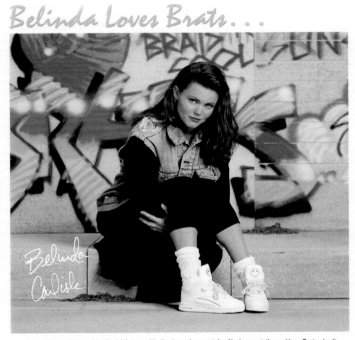

1989: Brats, 'Belinda Loves Brats...', ft. Belinda Carlisle

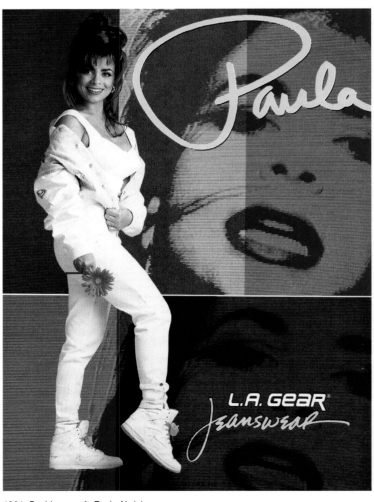

1991: Sunblossom, ft. Paula Abdul

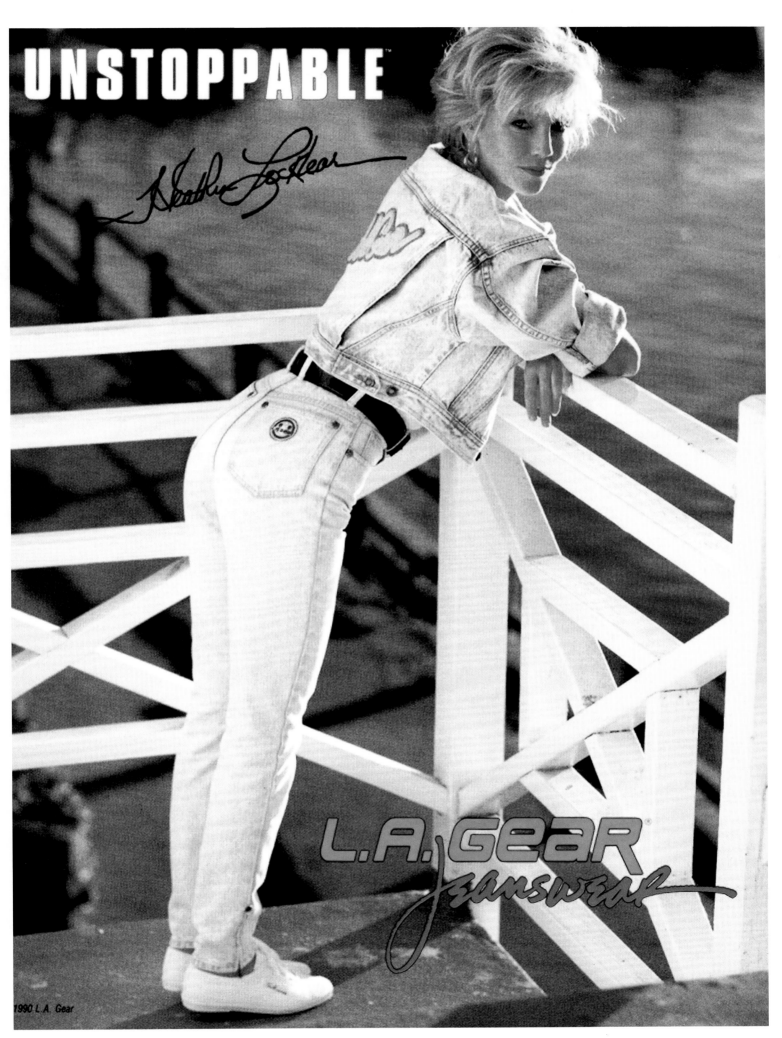

UNSTOPPABLE

L.A. GEAR
Jeanswear

1990 L.A. Gear

1990: 'Unstoppable', ft. Heather Locklear

1990: The Bad, 'Unstoppable', ft. Michael Jackson

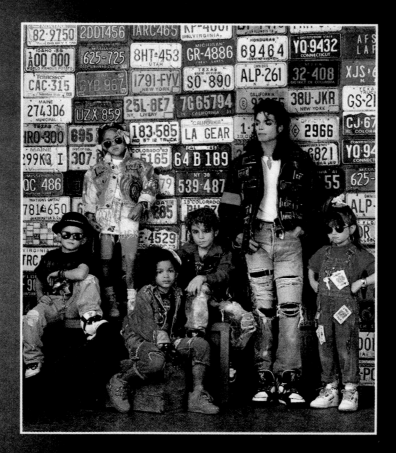

NEW BALANCE

It's somewhat surprising to learn that New Balance have been around since 1906, but the real history of this remarkable brand starts in 1972, when a young Jim Davis purchased the company. At that point, New Balance were making just 24 pairs a day by hand. Today, their annual turnover is close to $5 billion and Jim Davis still proudly oversees production of New Balance shoes in both North America and the United Kingdom.

From offering sneakers in different widths to their ethically motivated 'Endorsed by No One' philosophy, New Balance have always been fearlessly independent and fostered fans who sweat the details. Quiet, devoted, stubborn, polite and modestly confident, New Balance have never needed a megaphone to make themselves heard. The choice of corporate colours is also profound. Grey and navy hardly promise a utopian future, but they do cloak the brand in a gutsy pragmatism that defies fashion. Yet there is a whimsical side to New Balance, one that has embraced a chicken's biomechanics for inspiration and produced vintage advertising that still generates chuckles today.

●

When you're going coast-to-coast.

Go the way James Worthy of the L.A. Lakers goes, in a pair of the shoes he helped design—the Worthy Express,™ by New Balance. With features like its light, cushiony EVA midsole and stabilizing Flextended® saddle, this shoe gives James all the support he needs for his furious fast breaks. So take a trip with James and New Balance. Take the Worthy Express.

THE Worthy Express™

new balance®

1986: Worthy Express 740 and 785, 'When You're Going Coast-to-Coast', ft. James Worthy

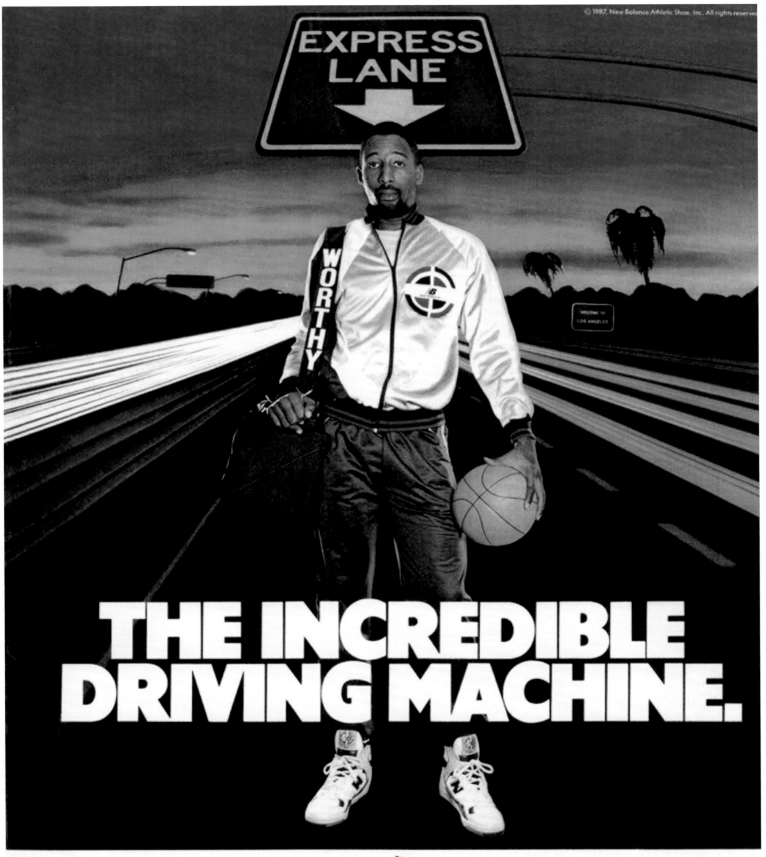

EXPRESS LANE

THE INCREDIBLE DRIVING MACHINE.

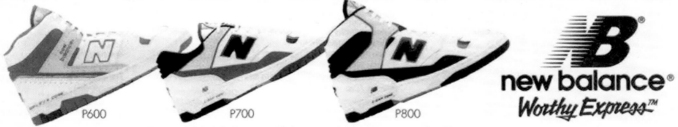

P600 P700 P800

new balance®
Worthy Express™

P600 and P800 are also available in kid's sizes. All shoes available in a variety of widths.

1987: Worthy Express P600, P700 and P800, 'The Incredible Driving Machine', ft. James Worthy

Two new road softeners for women.

Don't let the pavement pound your feet mercilessly. New Balance's top-rated W320 and W355 trainers for women provide superior protection and comfort, a precision fit in widths as well as lengths, and total performance. Both shoes are designed on a special woman's athletic combination last with box toe and two-sizes-narrower heel.

The new vinyl Achilles tendon pads and heel strips prevent slippage; the one-piece, foam-backed uppers provide glove-like comfort; the arch-support saddles cinch your feet snugly and firmly; and the tough, well-cushioned sole/wedge/midsole materials

give durable protection. Both shoes display stylish new colors too — Cal Blue with White for the W320, and Cal Blue with Yellow for the W355 — and both come in women's sizes 4-10 and widths AA-D. (Sizes 11-12 available at additional cost.)

5 OF THE TOP 10 NEW BALANCE COMP 100 '79 BOSTON MARATHON

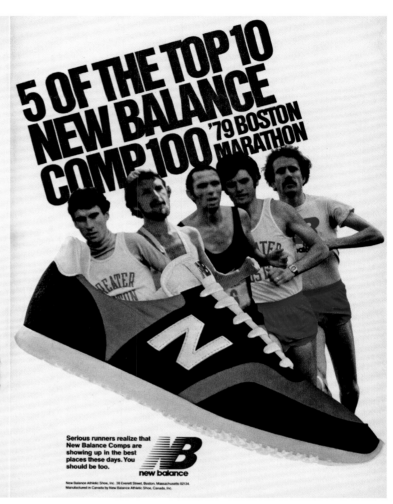

Serious runners realize that New Balance Comps are showing up in the best places these days. You should be too.

New Balance Athletic Shoe, Inc. 38 Everett Street, Boston, Massachusetts 02134.
Manufactured in Canada by New Balance Athletic Shoe, Canada, Inc.

1979: W320 and W355, 'Two New Road Softeners for Women'

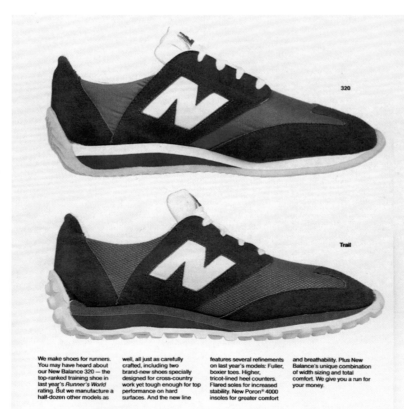

320

SuperComp

Trail

CrossCountry

We make shoes for runners. You may have heard about our New Balance 320 — the top-ranked training shoe in last year's *Runner's World* rating. But we manufacture a half-dozen other models as

well, all just as carefully crafted, including two brand-new shoes specially designed for cross-country work yet tough enough for top performance on hard surfaces. And the new line

features several refinements on last year's models: Fuller, boxier toes. Higher, tricot-lined heel counters. Flared soles for increased stability. New Poron® 4000 insoles for greater comfort

and breathability. Plus New Balance's unique combination of width sizing and total comfort. We give you a run for your money.

320: *Runner's World* rated last year's 320 the best training shoe available, but we haven't been standing around on our laurels. This year's model adds Poron® 4000 insoles, a more spacious toe, a padded, fuller heel counter, and new comfort modifications to the upper. We've also introduced a slight serration to the midsole from ball of foot to shank, for softer, suppler flex as well as unparalleled shock attenuation. Our 320 is still the ultimate training shoe. Men and women, 3½AA to 15EEEE, in Royal Blue with White trim.

Trail: Designed for trail training but tough enough for road work too, our new Trail has a rounded-stud sole of Alphacrepe that sheds dirt and mud easily without sacrificing traction on wet or sandy surfaces. The Softcrepe midsole/wedge combination provides excellent anti-shock cushioning. Backed with 1/6" tricot foam for maximum comfort and breathability, the circular-knit polyester-mesh upper actually wicks off excess heat and moisture. Men and women, 3½AA to 15EEEE, in Electric Blue with Red midsole.

SuperComp: Bright-colored and better, only the name is the same as last year's SuperComp. The breathable polyester-mesh upper maximizes ventilation and allows your foot to "work" freely. The Poron® 4000 insole reduces other friction and heat build-up, while the new wedge/midsole combination of Levitate reduces weight while increasing shock absorbency. The brush-configuration sole is ultra-durable Lydec® for excellent traction on roads and synthetic tracks. Men and women, 3½AA to 15EEEE, in Sunburst Yellow, Burnt Orange, and Flare Red.

CrossCountry: Our new off-road competition shoe that's tough enough and cushioned enough for hard surfaces too. The light, flexible, studded Alphacrepe sole maximizes traction while minimizing dirt pick-up. The soft, comfortable upper incorporates our new, higher toe design for increased lateral support and ampler toe space. Men and women, 3½AA to 15EEEE, in Burnt Orange with White trim.

new balance athletic shoes usa

FOUR TO GO.

1977: 320, SuperComp, Trail and CrossCountry, 'Four to Go'

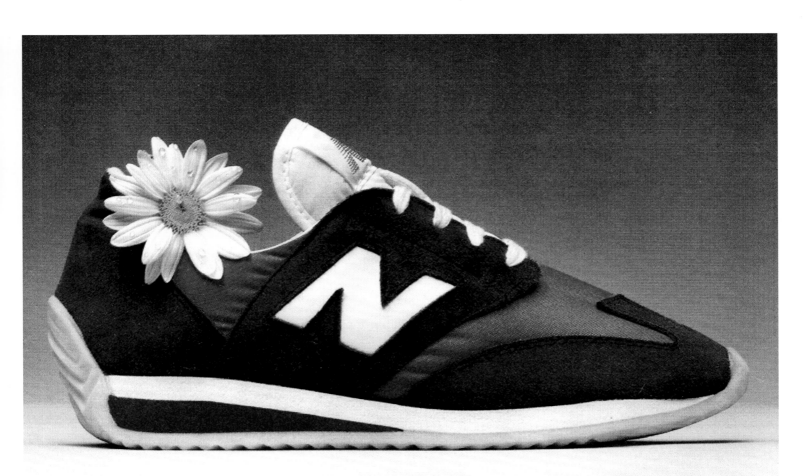

new width sizing for women the W320

Yes, New Balance's top-rated road trainer, the 320, now comes in a special model for women runners. Called the W320, it's designed on a woman's athletic combination last with a heel two sizes narrower for a snugger fit throughout the heel and Achilles tendon area. Otherwise, it's the same great trainer—with full width sizing, soft one-piece upper, unique arch-support saddle, and durable, protective sole/wedge/midsole combination. Women's sizes 4-10; widths AA, A, B, C and D (sizes 11 and 12 available at additional cost), in Royal Blue and White with distinctive Red logo. New Balance's W320—the first running shoe truly fit for women.

new balance
New Balance Athletic Shoe, Inc.
38 Everett Street, Boston, Massachusetts 02134

1979: W320, 'New Width Sizing for Women. The W320'

LIGHTER TH

New Balance Athletic Shoe, Inc., 38 Everett Street, Boston, Massachuse

1979: 620, 'Lighter Than Air'

A runner wearing 620s at a Florida marathon was offered $75 cash for his shoes, even though they were the wrong size for the buyer.

One Boston marathoner found the 620 so comfortable that he refused to take his pair off, wearing them everywhere for a solid week — even, one night, to bed.

The publisher of a running shoe magazine, seeing the New Balance 620 for the first time, exclaimed, ''That's the best-looking shoe I've ever seen!''

A rival salesperson said he'd heard that the 620 would be the most expensive training shoe on the market, retailing at over $100. Assured that he was wrong, that the actual price would be around $45, he remarked, ''Then I guess what I heard was that it's *worth* a hundred dollars.''

A runner wearing 620s at the World Cross-Country Championships in Ireland was approached by one of his Russian counterparts. ''Is nice shoe, very light, very good,'' said Comrade Runner, who then bought them from him for over $100 in rubles.

AN AIR* THE NEW 620

Why there
as the perfec

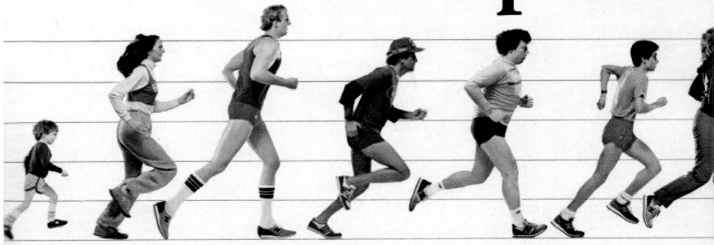

The roads of America are peopled with runners.

Fast runners, slow runners and everywhere-in-between runners.

Long distance runners, middle distance runners and your basic "I'm-going-to-run-my-mile-a-day-even-if-I-have-to- walk-to-do-it" runners.

They come in all different shapes and sizes. They have different gait cycles, training patterns, lifestyles.

So how do you make the one perfect running shoe that satisfies them all? You don't.

THE NEW BALANCE RUNNING SHOE SYSTEM.

For the past several years, New Balance has worked closely with runners, doctors and the gait lab at one of Boston's top medical institutions in an effort to better understand the relationship between running and the human body.

Our R&D people have tested countless combinations of leather, mesh, EVA, SBR, polyurethane and other more exotic compounds.

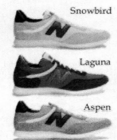

Snowbird

Laguna

Aspen

200 SERIES

We've run thousands of test miles a week in our shoes — changing, refining, expanding their function.

In short, we've been busy. And we've got something to show for it: The New Balance Running Shoe System. Six different series of shoes, each with its own distinct benefits.

By accounting for variations in weight, size, gait, speed, agility and more, the System enables runners to "match" their running style to shoes specifically designed to meet their needs.

THE SIX SERIES.

A brief description of each series should give you a better idea of the scope of the System.

Our *200 SERIES* is designed for beginning/casual and light mileage runners. Built on athletic combination lasts, these shoes feature such quality construction materials as SBR rubber and astrocrepe for above average load dispersion.

300 SERIES

420

455

400 SERIES

Two widths. Inexpensive.

Our *300 SERIES* is ideal for intermediate to serious runners who like a firm ride, for runners who tend to overpronate and for high school athletes looking for superb value in a shoe. Features include 35 Shore A wedge and midsole, a Lunaris Pillow laminated to the insole, leather toe piece sway bars. Width sized.

Comfort and protection are the primary benefits of our *400 SERIES*. Designed for middle and long-distance runners with normal gait cycles, our improved 420 has a triple-layer sole unit and Lunaris Pillow insert for a cushioned feel. Our 455 has similar protective qualities, plus "beefed-up" features such as a carbon rubber studded sole for traction and durability. Especially recommended for larger framed runners and/or those who overpronate. Width sized.

Firmness and lightness are the primary benefits of our *600 SERIES*. Our 620 provides the protection of a

1981: 200 Series, 300 Series, 400 Series, 600 Series, 700 Series and Comp Series, 'Why There's No Such Thing as the Perfect Running Shoe'

no such thing running shoe.

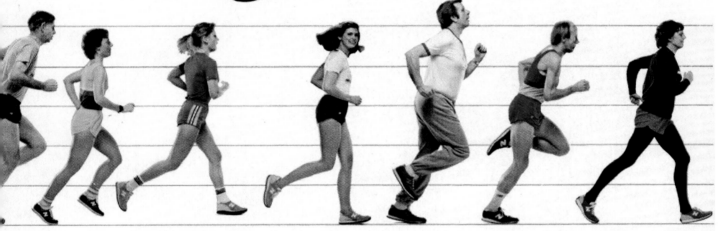

HOW TO CHOOSE THE RIGHT ONE FOR YOU.

Start by being analytical about yourself. Ask yourself these questions. They'll give you a better idea of your needs. Then your running shoe salesperson can better help you select the New Balance running shoe that best satisfies them.

Yes	No	
☐	☐	Do you have a tendency to overpronate?
☐	☐	Do you have a tendency to oversupinate?
☐	☐	Do you injure easily?
☐	☐	Do you prefer the feel of the road to the feel of a shoe?
☐	☐	Do you do interval training?
☐	☐	Are you large-framed?
☐	☐	Are your feet unusually narrow or wide?
☐	☐	Do you run more than 5 miles a day?

training shoe with the lightness of a racing shoe. Features include Extended Saddle, pre-molded Counter and two-way-stretch Collar, in conjunction with light, but flexible, sole, wedge and midsole components. Our 660, likewise, is designed for middle and long-distance runners who like to "feel" the road

600 SERIES
620
660

when they're running. Slightly heavier than the 620, it offers added protection in the form of a morflex outersole and My-T-Lite™ wedge and midsole for state-of-the-art shock dissipation. Both shoes are designed to accommodate a full range of gait cycles, but if you have an abnormal gait, we suggest you consider the 660. Width sized.

Our *700 SERIES* presently consists of a single shoe, the 730. Far and away the most complex training shoe we've ever made, it delivers the "feel" of a soft shoe and the stability of a firm shoe. With a super sine VIBRAM outersole, specially developed midsole (thickest and lightest in the industry), high density wedge and unique double-density counter for remarkable rearfoot stability, the 730 is designed for runners who seek the ultimate in

730
700 SERIES

Spike 100
Spike 200
Comp 200
COMP SERIES

a stable, forgiving training shoe, and are willing to pay for it. Width sized. Limited quantities.

Finally, our *COMP SERIES*. Designed with three criteria in mind — minimal weight, maximum feel of the road or track, optimum protection —, these shoes are for the serious competitive runner.

JUST THE BEGINNING.

We hope that we've conveyed to you some of the thought and care that's gone into the development of the New Balance Running Shoe System.

We intend to expand it, refine it and make it work even harder for you in the years to come.

Because while there may never be a perfect running shoe, we're determined to make one that's just right for you.

For a detailed explanation of the System, write New Balance Athletic Shoe, Inc., Boston, MA 02134.

new balance /NB

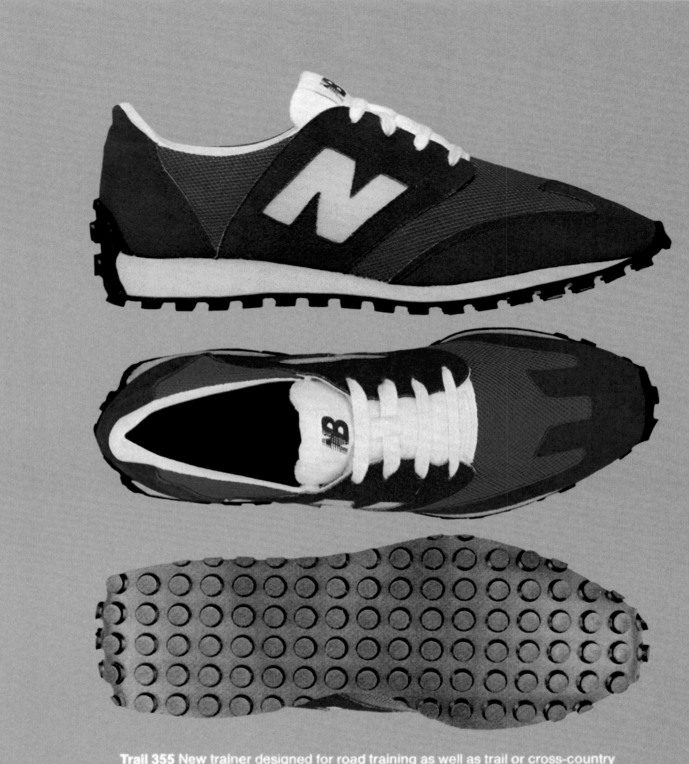

Trail 355 New trainer designed for road training as well as trail or cross-country work, with high-quality carbon rubber sole of Nora-Tuff® for guaranteed road-flat durability. An earlier version was rated number one in cushioning (both ball and heel) during *Runner's World* lab tests, and this new sole has that maximum shock absorption combined now with the durability of a radial tire. The flat-head studs provide excellent traction on all surfaces, and the foam-backed polyester-mesh upper adds great comfort and breathability. Men's sizes 6-13; widths A,B,C,D,E, EE and EEE. (Sizes 13½-15 and widths AA and EEEE available at additional cost.)

See your local authorized New Balance dealer, or send for our free color catalog.
New Balance Athletic Shoe, Inc 36 Everett Street, Boston, Massachusetts 02134

new balance athletic shoes usa /B

1979: Trail 355

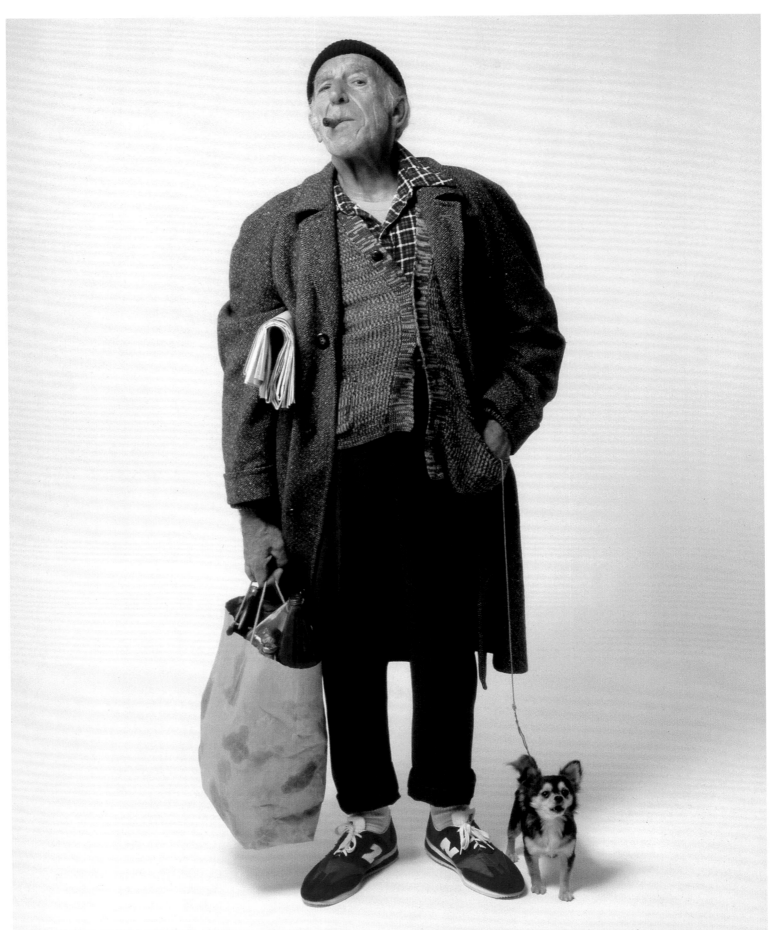

When the going gets tough, the tough get going.

New Balance Athletic Shoes

1980: 'When the Going Gets Tough, the Tough Get Going'

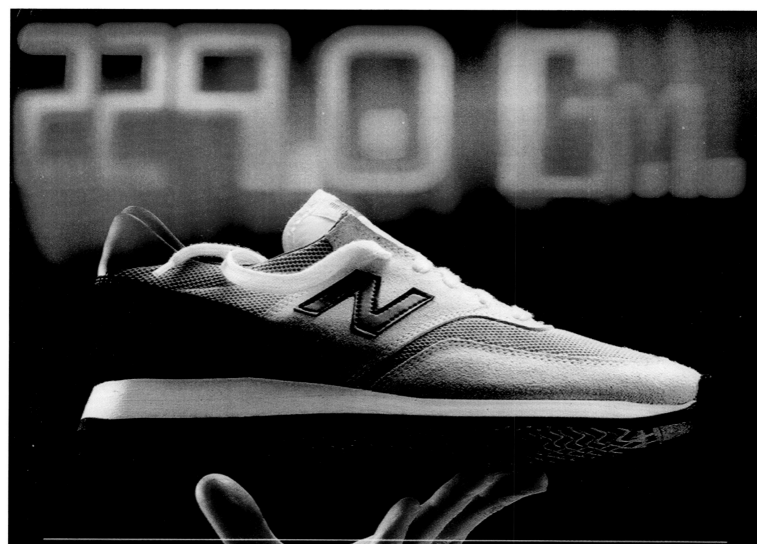

THE LIGHTWEIGHT CHAMPION OF THE WORLD.

The New Balance 620 is the lightest training flat on the market today.

But what makes it even more impressive is the fact that, instead of making it light at the expense of support, we made it light *in combination with* support.

HOW WE MADE IT LIGHT.

Working with Vibram of Italy, we developed a revolutionary outersole for the 620 made of an ethylene vinyl acetate and rubber compound. And for our wedge and midsole, we used 100% E.V.A.

The result is a training shoe lighter in weight than many racing shoes

(229 grams in a standard size 9D). With better shock absorption and flexibility than most training shoes.

HOW WE MADE IT RIGHT.

The 620 wouldn't be drawing accolades from runners and running magazines alike if it didn't offer all the benefits you've come to expect from New Balance.

Like the snug, *critical fit* of our patented Extended Saddle. The added support and motion control of a pre-molded Stanbee™ counter, extended along the medial and lateral sides of the shoe. The comfort and protection of our Volara™ collar.

YOU MIGHT EVEN WANT TO RACE IN IT.

Given the superior features of the 620, it's no surprise that more and more runners aren't only training in it, but racing in it.

The New Balance 620. The lightweight champion of the world.

New Balance Athletic Shoe Inc., Boston, Massachusetts 02134, which is where our shoes are made.

WE'RE WITH YOU EVERY STEP OF THE WAY.

Men's sizes 6-13 (widths B, D, EE and EEEE). Women's sizes 4-10 (widths AA, B and D). Made in U.S.A.

1980: 620, 'The Lightweight Champion of the World'

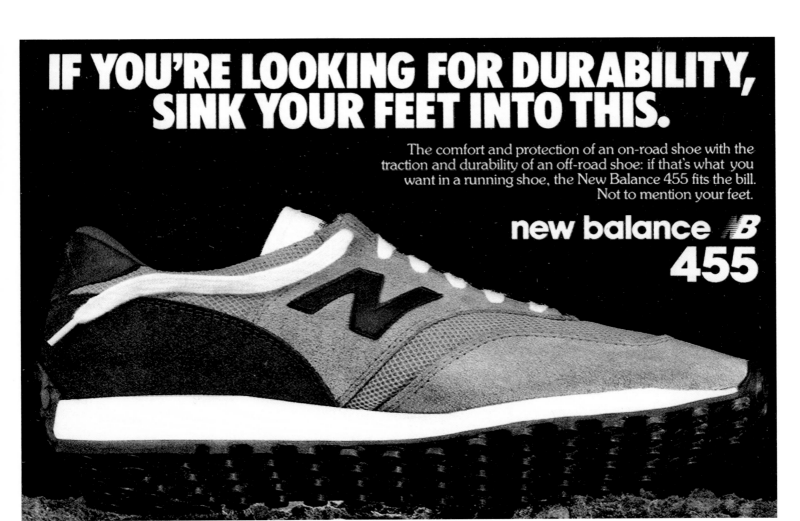

1980: 455, 'If You're Looking for Durability, Sink Your Feet Into This'

IF YOU'RE LOOKING FOR DURABILITY, SINK YOUR FEET INTO THIS.

The comfort and protection of an on-road shoe with the traction and durability of an off-road shoe: if that's what you want in a running shoe, the New Balance 455 fits the bill. Not to mention your feet.

new balance *B*
455

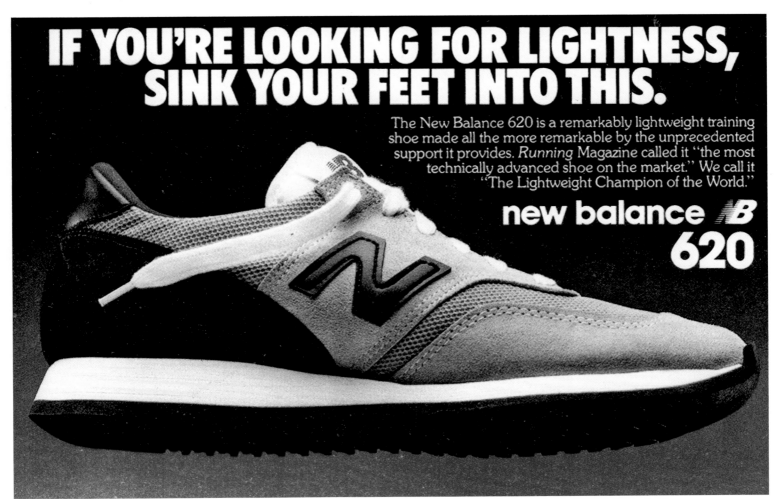

1980: 620, 'If You're Looking for Lightness, Sink Your Feet Into This'

IF YOU'RE LOOKING FOR LIGHTNESS, SINK YOUR FEET INTO THIS.

The New Balance 620 is a remarkably lightweight training shoe made all the more remarkable by the unprecedented support it provides. *Running* Magazine called it "the most technically advanced shoe on the market." We call it "The Lightweight Champion of the World."

new balance *B*
620

IF YOU'RE LOOKING FOR PROTECTION, SINK YOUR FEET INTO THIS.

With features like our Lunaris Pillow™ (shown here in double exposure), Extended Saddle™ and Extended Medial Counter, the New Balance 420 provides unprecedented shock absorption and motion control. It's the most protective training shoe we've ever made.

new balance **B** 420

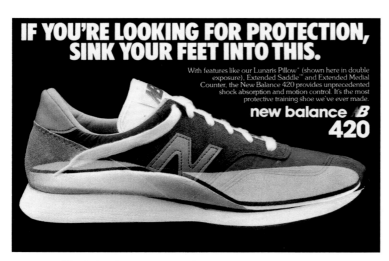

1980: 420, 'If You're Looking for Protection, Sink Your Feet Into This'

A shoe for runners who often prefer to fly.

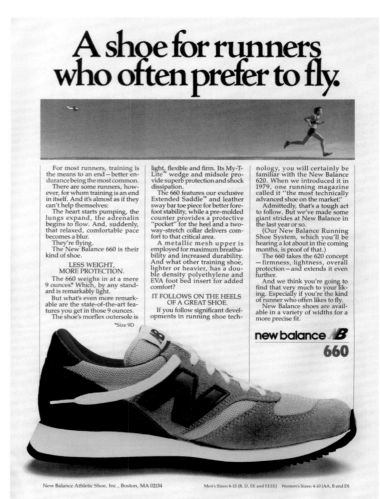

For most runners, training is the means to an end — better endurance being the most common. There are some runners, however, for whom training is an end in itself. And it's almost as if they can't help themselves:

The heart starts pumping, the lungs expand, the adrenalin begins to flow. And, suddenly, that relaxed, comfortable pace becomes a blur.

They're flying.

The New Balance 660 is their kind of shoe.

LESS WEIGHT, MORE PROTECTION.

The 660 weighs in at a mere 9 ounces* Which, by any standard is remarkably light.

But what's even more remarkable are the state-of-the-art features you get in those 9 ounces. The shoe's morflex outsole is

*Size 9D

light, flexible and firm. Its My-T-Lite™ wedge and midsole provide superb protection and shock dissipation.

The 660 features our exclusive Extended Saddle™ and leather sway bar toe piece for better forefoot stability, while a pre-molded counter provides a protective "pocket" for the heel and a two-way-stretch collar delivers comfort to that critical area.

A metallic mesh upper is employed for maximum breathability and increased durability. And what other training shoe, lighter or heavier, has a double density polyethylene and EVA foot bed insert for added comfort?

IT FOLLOWS ON THE HEELS OF A GREAT SHOE.

If you follow significant developments in running shoe tech-

nology, you will certainly be familiar with the New Balance 620. When we introduced it in 1979, one running magazine called it "the most technically advanced shoe on the market."

Admittedly, that's a tough act to follow. But we've made some giant strides at New Balance in the last year or so.

(Our New Balance Running Shoe System, which you'll be hearing a lot about in the coming months, is proof of that.)

The 660 takes the 620 concept — firmness, lightness, overall protection — and extends it even further.

And we think you're going to find that very much to your liking. Especially if you're the kind of runner who often likes to fly.

New Balance shoes are available in a variety of widths for a more precise fit.

new balance **B** 660

New Balance Athletic Shoe, Inc., Boston, MA 02134 Men's Sizes: 6-13 (B, D, EE and EEEE) Women's Sizes: 4-10 (AA, B and D)

1981: 660, 'A Shoe for Runners Who Often Prefer to Fly'

Let's get down to bare bones about the New Balance 420.

The human body is a wonderful piece of equipment. Set it in motion, and there's no telling where it will take you.

Unfortunately, beneath the surface are certain vulnerable areas. And as too many runners

THE VULNERABLE AREAS
1. The Hip Joint 2. The Hamstring
3. The Patella 4. The Tibia
5. The Achilles Tendon 6. The Metatarsus

know, aggravate any of them, and the motion can come creaking to a halt.

DESIGNED TO PROTECT EVEN BETTER THAN BEFORE.

From the moment we introduced the New Balance 420 in 1980, runners and running magazines alike applauded its superior protective qualities.

But we weren't content to rest on our laurels. We talked to runners and running store owners. We trained in our 420's. We ran races in them. We lived in them.

And as a result, we've been able to develop subtle, but significant, improvements in the shoe.

The shoe's new EVA wedge and midsole, for example, provide a higher degree of firmness, plus greater stability and shock absorbency. In combination with a "beefed-up" counter, they help to significantly reduce the chance of painful injuries that can result from excessive overpronation.

What's more, the 420's upper now features a sway bar toe piece. The increased forefoot stability this provides further reduces the chance of injury either to the muscles or to the cartilage, tendons and ligaments.

WE DON'T PLAY DOCTOR.

Lately, more and more running shoe companies have taken to building "corrective" devices into their shoes.

In theory, they can "normalize" a runner's gait. But in fact, they can create problems that never existed before.

At New Balance, we embrace the *neutral plane* concept — the neutral plane being the natural position of the foot at rest and in motion.

To encourage a runner's natural gait cycle, the 420 features an Extended Saddle,™ which provides support along the longitudinal arch and, with our combination athletic last, facilitates an efficient running motion.

The shoe's Lunaris Pillow,™ an Evazote and memory-foam insert, molds to the foot for a custom fit and an extra measure of shock absorption and comfort.

(On the subject of fit, New Balance is the only running shoe company that offers shoes in a variety of widths.)

The point is this: running can do great things for you physically. The New Balance 420 is designed to keep it that way.

new balance **B** 420

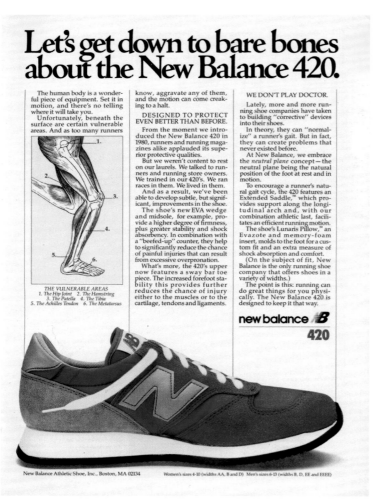

New Balance Athletic Shoe, Inc., Boston, MA 02134 Women's sizes 4-10 (widths AA, B and D) Men's sizes 6-13 (widths B, D, EE and EEEE)

1981: 420, 'Let's Get Down to Bare Bones About the New Balance 420'

THE NEW BALANCE 420 WAS DESIGNED TO PROTECT RUNNERS 6 DAYS OUT OF 7.

The New Balance 420 is the most *protective* training shoe we've ever made. And as every runner knows, training is 99% of running.

So how come we're only recommending that you wear it 85% of the time?

TWO DIFFERENT GOALS. TWO DIFFERENT SHOES.

Training is a means to two ends: improved endurance (strength and fitness) and improved performance (speed over distance).

To further your pursuit of these goals, we developed two different training shoes:

We designed our remarkably lightweight 620 training flat for that one or two days of running a week when *time* is key:

e.g., when you're doing speed work or running in a road race.

It's for all the other days of the week that we developed our new 420.

On the 7th day, we recommend our highly regarded 620 training flat.

HOW THE 420 PROTECTS.

The natural position of the foot at rest and in motion is called the *neutral plane*. When you engage in motion outside this range, you not only waste energy, but invite injury.

Following orthopedic principles, we designed the 420 in such a way to keep your foot in the neutral plane throughout your gait cycle.

Extended along the medial side of the arch, the 420's heel counter provides maximum rear-foot stability while allowing you your full range of motion.

Our Extended Saddle™ provides support along the longitudinal arch and, together with our unique straight last construction, encourages an efficient straight-line motion.

Finally, our exciting new Lunaris Pillow™ serves to stabilize your foot in the neutral plane and helps to provide unprecedented shock absorption.

Indeed, the 420 delivers up to an astonishing 70% shock attenuation experience. And given the structure of the human body, that's as good as you can get.

The neutral plane. Deviations outside of it waste energy and invite injury.

WE COULD RUN ON AND ON....

To fully describe the 420 would take more space than we have here. So we'll simply conclude with the following observation: No other training shoe offers more protection. And that's a statement we'll stand by seven days of the week. New Balance Athletic Shoe, Inc., Boston, MA 02134, U.S.A., which is where our shoes are made.

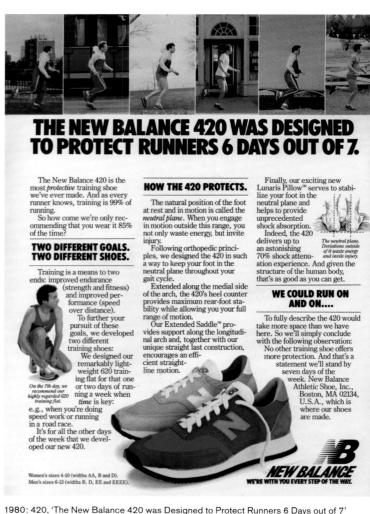

NEW BALANCE
WE'RE WITH YOU EVERY STEP OF THE WAY.

Women's sizes 4-10 (widths AA, B and D).
Men's sizes 6-13 (widths B, D, EE and EEEE).

1980: 420, 'The New Balance 420 was Designed to Protect Runners 6 Days out of 7'

THE DIFFERENCE BETWEEN NEW BALANCE AND OTHER WOMEN'S RUNNING SHOES.

What you're looking at are three New Balance women's *lasts*.

That's industry jargon for the forms on which shoes are built.

And once you understand what makes ours different, you'll understand what makes our women's shoes special.

THE RIGHT "COMBINATION" FOR WOMEN.

Our lasts are what has come to be known in the industry as "combination athletic lasts."

We should know: we coined the phrase.

You see, while other manufacturers were making their women's shoes on ordinary lasts, we were making ours on specially designed lasts up to two widths narrower at the heel than at the ball of the foot.

Why? No mystery:

Anatomically, that's the way a woman's foot is shaped.

THREE WIDTHS ARE BETTER THAN ONE.

You'll notice that the three lasts above are all the same length (in this case, a size 7). But each represents a different width.

As it happens, we are the *only* running shoe company that offers different widths.

And if you don't believe proper width is critical, talk to women who have to wear two pairs of socks and overlapping laces when they run. Or who have to buy their shoes two sizes too long. Or, worst yet, have to buy a man's shoe.

And when they've told you about their blisters, aches and so forth, do them a favor:

Tell them about New Balance.

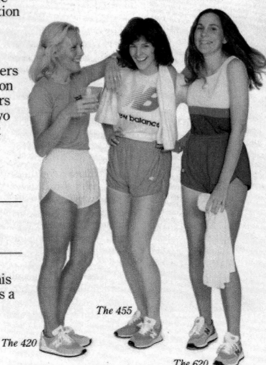

The 455

The 420

The 620

FIT, PROTECTION, COMFORT AND DURABILITY.

To our way of thinking, those are the qualities a superior performance running shoe ought to offer.

And that's why, in addition to their precise fit, our running shoes also offer such features as a patented Extended Saddle,™ designed to provide support along your longitudinal arch. A specially constructed heel counter for rearfoot support and stability. A comfortable padded collar. A protective wedge and midsole. And innovative construction materials throughout.

Because the way we see it, features like these not only make our shoes different.

They also make them better.

New Balance Athletic Shoe, Inc., Boston, MA 02134, U.S.A., which is where our shoes are made.

We should note that New Balance also makes superior performance running shoes for men.

WE'RE WITH YOU EVERY STEP OF THE WAY.

1980: 420, 455 and 620, 'The Difference Between New Balance and Other Women's Running Shoes'

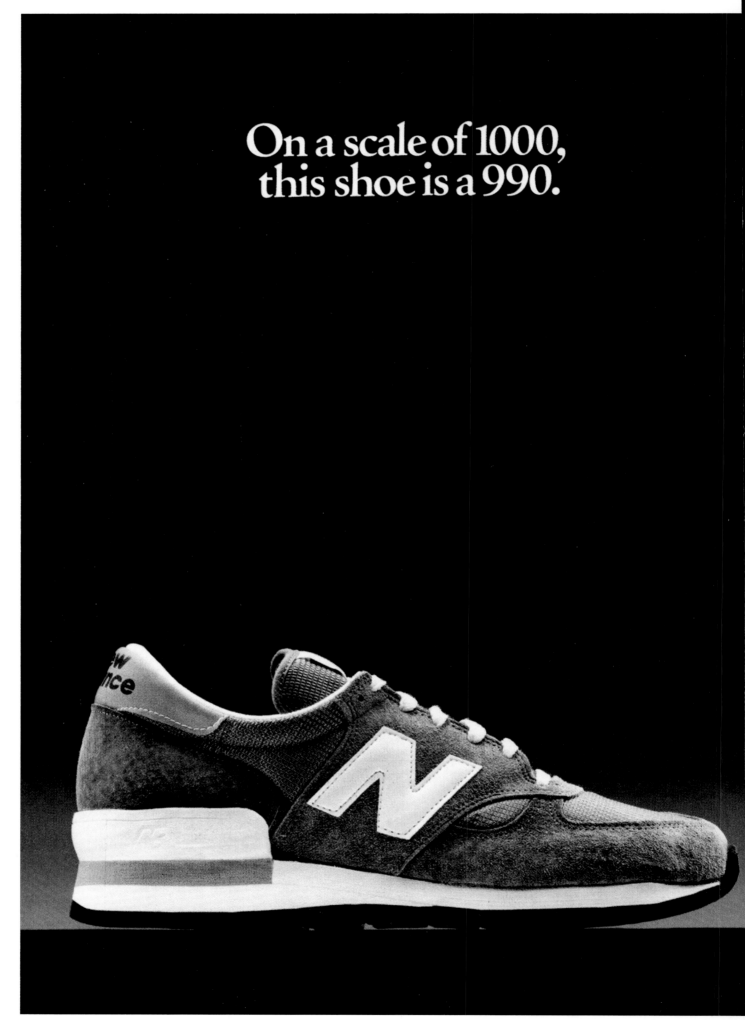

On a scale of 1000,
this shoe is a 990.

1982: 990, 'On a Scale of 1000, This Shoe is a 990'

INTRODUCING THE NEW BALANCE 990: THE MOST TECHNICALLY ADVANCED RUNNING SHOE EVER MADE.

In the Spring of 1978, with no real idea of what we were getting ourselves into, we gave our R & D people the go-ahead on an ambitious undertaking:

They wanted to go for it. They wanted to pull out all the stops. They wanted to develop *the very best* running shoe they were technically capable of, regardless of the time it took and the money it cost us to do it.

A running shoe that would offer maximum flexibility without the slightest sacrifice of motion control. That would set new standards for comfort and fit. That would represent, in effect, the total of everything they had come to know about making running shoes.

Well, again, that was more than three years ago. And now, we're proud to introduce the final result of all their efforts: the New Balance 990.

We think it comes closer than any running shoe ever has to perfection.

THE UPPERMOST IN FLEXIBILITY: SLIP-LASTING.

The uppers of running shoes are built on molded plastic forms called *lasts.* There are three basic construction techniques: conventional-, combination- and slip-lasting.

Of these, slip-lasting requires the most technical skill, and results in the most flexible shoe.

In other lasting processes, the upper is attached to a board. But

Slip-lasting results in an upper with the flexibility of a slipper.

with slip-lasting, *no board* comes between you and the sole. Instead, the upper is wrapped around the last and stitched together, much like a slipper.

The result is a shoe that fits better, feels better and gives you more overall maneuverability.

For these reasons, the 990 utilizes slip-lasted construction.

A NEW DEVELOPMENT IN MOTION CONTROL: POLYURETHANE.

Slip-lasting has one weakness: it's unstable in the heel area.

To compensate for this, R & D labored long and hard on the development of a unique new *external* counter made of polyurethane, instead of conventional materials.

This patented Motion Control Device (MCD) provides maximum motion control and protection against overpronation *without in any way inhibiting a runner's natural gait cycle.*

Moreover, the MCD serves to dissipate shock by distributing it away from the point of impact.

A SOLE WITH ALL KINDS OF LIFE.

The sole unit of the 990 employs sophisticated new materials and design techniques, combined to provide superior performance and exceptional wear.

The unit is made of three different durometers of EVA. The wedge and forepart of the midsole are made of Fethalite, a firmer material that provides a firm base of support. The rearpart of the midsole is made of Goodyear Sofspun, chosen for the comfort it conveys to the heel.

The lug runner outersole is made of VibramFlex, an exclusive new material developed in conjunction with VIBRAM. VibramFlex is high in rubber content, which makes for excellent durability.

The lug runner design also makes for better wear. Reminiscent of a hiking boot outersole, it provides more surface area for a runner to run on. And transverse grooves in the sole promote flexibility and comfort.

AND A HOST OF OTHER FEATURES.

Like a blister-resistant super matte foam collar for added rearfoot comfort. Our new Flextended Saddle for better fit. And a

Scotchlite® reflective back tab for nighttime running.

This is the idea behind our new Motion Control Device.

As if all this weren't enough, the upper of the 990 is made of pigskin. For its weight, there's simply no stronger material.

Inevitably, someone—someday—will build a better running shoe. But on a scale of 1000, this shoe is a 990.

And for now, that's as good as they get.

Like all New Balance shoes, the 990 is available in a variety of widths, for a more precise fit.

New Balance Athletic Shoe, Inc., Boston, MA 02134

COMPONENT	MATERIAL	BENEFIT
Vamp	400 Denier Satellite with Knubby Backing	Very high tensile strength; superb absorption and evaporation of perspiration.
Tip	Extended Tip (through saddle)	Adds support during pronation phase; guards against breakthrough and blow-out.
Saddle	Flextended Saddle (Pigskin)	Supports the arch, especially during pronation and supination phases; allows individual lacing adjustments.
Counter	60 wt. Surlyn	Helps to maintain foot in neutral plane upon impact.
Motion Control Device	Polyurethane	Maximum rearfoot control; stabilizes footbed; shock attenuation 95%.
Collar	Urethane Super Matte Backing	Good abrasion characteristics; high drag; holds the heel better than cloth.
Midsole/Wedge	3-Part EVA Midsole/Wedge	Forgiving at heel; firmer at forefoot; firmer wedge for a better base of support.
Outersole	VibramFlex Lug Runner	High rubber content for long wear; lug design for excellent traction; light and supportive.
Backtab	3M Reflective Transfer Film	Visibility for nighttime running.

new balance /B
990

Are you murder on running shoes?

What some people can do to a pair of running shoes is tragic.

It may be *where* they run in them. Or *how* they run in them. Or it may be the shoes themselves. In any case, the result is the same:

Gonzo. Wasted. Spent. In a matter of months.

Happily, New Balance has designed a shoe that can withstand all kinds of internal and external abuse.

The New Balance 555.

AN OUTERSOLE THAT STOPS AT NOTHING.

Working with Freudenberg of Germany, we developed a carbon rubber *houndstooth* outersole unlike any you've ever seen.

The solid carbon rubber compound is incredibly durable. Unlike a lot of soling materials, it's too firm to

be pushed around. Either by you or the environment you run in.

On the subject of environments, our anatomically contoured houndstooth design provides exceptional traction on all terrains and in all weather conditions. What's more, the studs have a unique *flex action:* they automatically release any turf they may have picked up on downstrike.

Finally, the outersole is reinforced at points of extreme wear, for added life.

A LASTING COMBINATION.

The New Balance 555 is the first combination-lasted shoe we've made available to the general market.

The forefoot is slip-lasted for maximum forefoot flexibility. The rearfoot is conventional-lasted for optimal rearfoot control.

You get the stability you need in the heel area. Plus the unrestricted freedom in the forefoot area so necessary when you run on terrain filled with bumps, rocks, holes and other potential pitfalls.

For *added* flexibility, the 555 features another first—our Flextended Saddle. Designed to allow better adjustment along the instep, it makes for a better fitting shoe. And helps to protect against shoe breakdown and blow-out.

So if you're murder on running shoes, do yourself a favor. Get a pair of New Balance 555's.

The three of you should live happily ever after.

new balance /B
555

New Balance Athletic Shoe, Inc., Boston, MA 02134 Like all New Balance Shoes, the 555 is available in a variety of widths, for a more precise fit.

1982: 555, 'Are You Murder on Running Shoes?'

Are your feet losing touch with the ground?

Most runners need a healthy layer of cushioning between themselves and the road.

But for a small contingent of runners, dense cushioning is not only unnecessary. It's downright *intrusive*.

We are speaking of the most serious runners among us. Athletes who prefer the feel of the road when they run.

For them, we make the New Balance 660.

FIRM FOOTING.

Every feature of the 660 has been designed to contribute to an overall feeling of *firmness*.

The wedge and midsole, for example, are made of fethalite—a light, firm EVA compound.

The difference between fethalite and other midsole/wedge materials lies in the amount of air that's injected into the basic chemical compound. Most materials are blown full of air. But fethalite has relatively less of it. The result is a tauter, more *spring-like* compound.

The 660 also features a double-density footbed insert. Like the patented Lunaris Pillow insert in our more cushioned running shoes, this pillow molds to a runner's foot for stability and protection. But its firmer construction provides a more direct link with the road.

YOU MIGHT FIND YOURSELF RUNNING FASTER.

While a highly cushioned shoe may protect a runner's feet, it can also slow a runner's progress.

You see, instead of being transferred to the running surface, the mechanical energy of the body is absorbed, in part, by the shoe.

With the 660, on the other hand, the transference of energy to the running surface is a more *efficient* one.

There's less between you and the ground. And if you're like a lot of other devoted runners, you may find yourself covering more of it, more quickly, than ever before.

new balance /NB

660

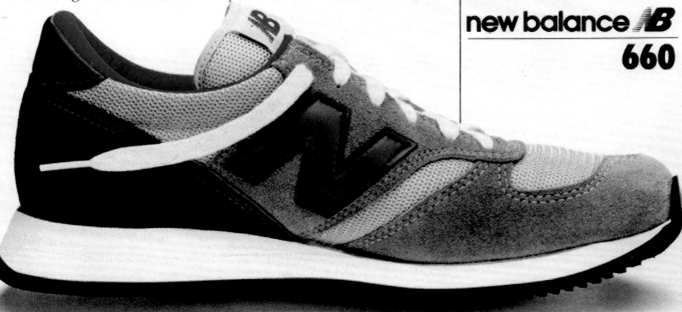

New Balance Athletic Shoe, Inc., Boston, MA 02134 Like all New Balance shoes, the 660 is available in a variety of widths, for a more precise fit.

1982: 660, 'Are Your Feet Losing Touch With the Ground?'

What to wear if you do your running on roads.

Wear the New Balance 390. It's a versatile training shoe specifically designed for the price-conscious road runner.

The 390 features a New Balance-exclusive "houndstooth" outersole developed in conjunction with Freudenberg of Germany and road-tested in Germany and France. This lightweight rubber sole is anatomically contoured, with reinforced studs placed at prime points of wear. The result: extraordinary durability.

And because roads can be as hard on legs as they are on shock absorbers, the New Balance 390 has a two-way-stretch nylon insole and an EVA wedge and midsole. The former is light and virtually blister resistant. The latter give you the cushioning you need to hold up under the most strenuous of road workouts.

Top it all off with a comfortable 200 denier nylon vamp, and you've got a $35 shoe that'll give many of our more expensive models a run for their money.

Especially if you're the kind of runner who does your running on roads.

What to wear if you do your running on trails.

Wear the New Balance 390. It's a versatile training shoe specifically designed for the price-conscious trail runner.

The 390 features a New Balance-exclusive "houndstooth" outersole developed in conjunction with Freudenberg of Germany and tested, for the past year, in Germany and France, where cross-country is a veritable passion. This unique lightweight studded sole provides a degree of traction unmatched by anything you've ever put on your feet.

And because trails can twist and turn a foot the way they twist and turn through the countryside, the New Balance 390 is designed with superior support features: a swaybar toe piece for better forefoot control, a shank support for medial and lateral support and a 60-weight Surlyn counter which provides for better rearfoot stability.

Top it all off with a strong 200 denier nylon vamp, and you've got a $35 shoe that'll give many of our more expensive models a run for their money.

Especially if you do your running on trails.

new balance /NB
390

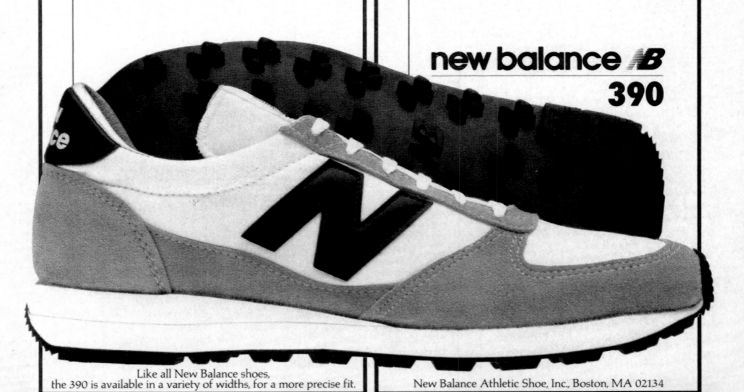

Like all New Balance shoes, the 390 is available in a variety of widths, for a more precise fit.

New Balance Athletic Shoe, Inc., Boston, MA 02134

1982: 390, 'What to Wear if You Do Your Running on Roads. What to Wear if You Do Your Running on Trails'

"This is either a great shoe for casual runners. Or a great shoe for great runners."

Ed Norton, *Head, R&D*

"Your guess is as good as ours."

A funny thing happened when we set out to make a less expensive shoe for casual and intermediate runners.

We made an inexpensive shoe for great runners, too.

"REDUCE THE COST. RETAIN THE FEATURES."

At New Balance, we think we make a technologically superior shoe. But that technology doesn't come cheap.

Our marketing people understand this. Still, they were insistent:

"Can't you make a less expensive shoe with many of the same features?"

So, we went to work. Not from the point of view of, 'What can we sacrifice?' But rather, 'How much can we accomplish?'

We wanted superb shock dispersion—that's a must. So we chose 35 Shore A material for our wedge and midsole.

We wanted comfort, so we took a Lunaris Pillow (originally developed for our 420) and laminated it to the insole.

We wanted protection, so we built leather sway bars on the toe piece for increased forefoot stability.

"You can take 'em off now, guys."

We also found a way to cradle the foot at the base of the longitudinal arch with leather shank inserts for added rearfoot stability.

We made the shoes in a variety of widths for a better fit. Chose three good looking colors. And gave it a name: The *National Class.*

Then, almost as an afterthought, we asked a couple of the guys on the New Balance Track Team—world class athletes—to take 'em for a spin. That was our mistake. They loved them. They loved the firm feel. The stability. The look. They even loved the name. All of which left us feeling greatly gratified. And just a bit puzzled:

How on earth do we market this shoe?

new balance /NB

National Class

New Balance Athletic Shoe, Inc., Boston, MA 02134 Men's sizes: 6-13 (B, D and EE) Women's sizes: 4-10 (AA, B and D)

1981: National Class, 'This is Either a Great Shoe for Casual Runners. Or a Great Shoe for Great Runners'

Three good reasons why New Balance makes running shoes in different widths.

Feet are remarkably like the people who own them.

Some are long and skinny. Some are short and broad. And others are everywhere in between.

At New Balance, we've always held the view that if feet come in different widths, so should our running shoes. It doesn't make it any easier for us to produce them. But it does make our shoes a lot better for a whole lot of runners.

The way we look at it, getting fit starts with your feet.

New Balance running shoes are available for men in four widths— B, D, EE and EEEE. And for women, in three—AA, B and D.

new balance /NB

New Balance Athletic Shoe, Inc., Boston, MA 02134.

1982: 'Three Good Reasons Why New Balance Makes Running Shoes in Different Widths'

Late 1950s: Trackster

" The New Balance Trackster was a lightweight runner with a revolutionary 'ripple sole' design innovation that promised to release the 'Go Power' in athletes from the start to finish of every race. More importantly for New Balance, it was the first time their runners were made available in multiple widths, a pivotal moment in establishing the brand's ongoing philosophy and unique point of difference. Even today, New Balance sneakers are made in a snug size known as 2E (or X-Narrow), right up to 6E, which is more your King Kong Bundy-style of ample fit. "

New Balance Craftsmanship & Imagination
Sneaker Freaker (2011)

Runners ar

It's not that we're crazy. It's just that we're, well . . . *different*.

In fact, there's not a typical or average one of us in the whole bunch. And the bunch now numbers some 25,000,000 people.

Imagine: 25 *million* runners, each with a different running style, training pattern, lifestyle. A different physical construction and emotional make-up. A different level of commitment to the sport.

And each, given these other variables, with different needs.

Needs the New Balance Running Shoe System is designed to satisfy.

A SHOE FOR EVERY RUNNER.

The New Balance Running Shoe System is the product of our on-going efforts to better understand the relationship between running and the human body. It has come about through our involvement in three specific areas:

Sports medicine. Through association with orthopedists, podiatrists and the gait lab of one of Boston's leading hospitals.

Manufacturing technology. The key to our ability to be technologically innovative.

Runners themselves. World-class

375/376 *Recommended for price-conscious runners who seek a comfortable training shoe that can also be worn for casual wear.*

athletes like Dick Beardsley, Kevin Ryan, Lorraine Moller and Francie Larrieu.

The result is a *system* of running shoes that accommodates variations in weight, size, gait, speed, agility and more. And enables individual runners to "match" their personal

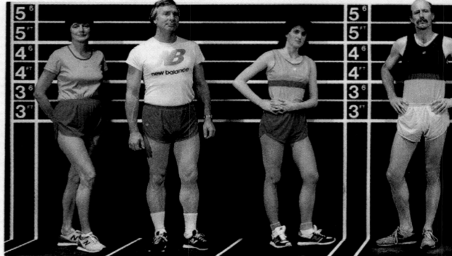

styles and preferences to performance footwear designed to meet their needs.

We even make our shoes in different widths. So that no one has to run in shoes designed to fit someone else.

390 *Recommended for price-conscious runners who seek a versatile on-road/off-road training shoe.*

THE INDIVIDUAL SHOES.

This will briefly introduce you to the shoes in the System. Naturally, you can find out more about them first-hand at better athletic footwear stores.

The 375/376. Excellent values, the NB 375 and 376 for women are impressive examples of what we're able to accomplish within strict economic limits. With all-leather side supports and an extended swaybar tip for superior control, they offer more performance fea-

420 *Recommended for runners who seek the ultimate in comfort.*

tures than any other $35 running shoes.

The 390. A reasonably priced training shoe, the 390 is equally at home on the road or trail. The key to its versatility is its outsole—a New Balance-exclusive carbon rubber houndstooth outsole, anatomically contoured for exceptional wear.

555 *Recommended for runners who wear through shoes quickly; also, for larger runners.*

1982: New Balance Running Shoe System, 'Runners Aren't Normal'

n't normal.

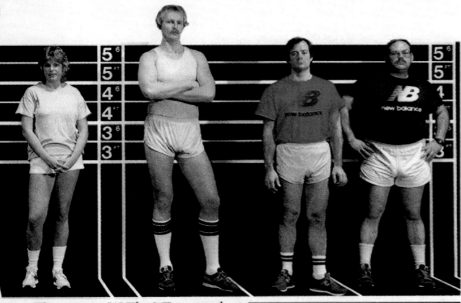

The 420/420 W. The NB 420 is the single biggest selling running shoe in America above $40, and comfort is the reason. With its EVA wedge and midsole, Vibram® Morflex outersole and Lunaris Pillow footbed, the 420 offers a level of comfort that's simply without parallel.

The 555/555 W. A shoe designed specifically for people who are murder on running shoes, or who do their running in areas that are rough on shoes, the 555 is our most

660 *Recommended for serious runners who run middle and long distances and like a firmer feeling shoe.*

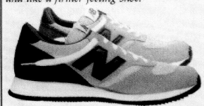

durable training shoe. It's also extremely versatile—thanks in part to a carbon rubber houndstooth sole and combination-lasting construction.

The 660/660 W. Light and firm, the NB 660 is designed for runners who like to feel the road when they run. Factors contributing to its firmer feel are a Fethalite wedge and mid-

730 *Recommended for medium and higher mileage runners who can benefit from exceptional cushioning.*

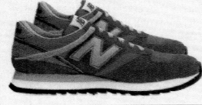

sole, a firm version of our Lunaris Pillow and a double-extended 60-weight Surlyn counter.

The 730/730 W. An impressive combination of comfort and stability, the NB 730 is designed for

990 *Recommended for devoted runners seeking the optimal combination of flexibility and motion control.*

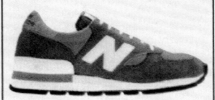

COMPS *Recommended solely for the competitive runner.*

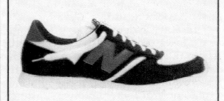

runners who seek a stable, but forgiving, training shoe. Three different materials in the sole unit—an EVA midsole, high density EVA wedge and Morflex outersole—combine to make this the most cushioned running shoe on the road today.

The 990. More than three years in the making, the NB 990 is the most technologically advanced running shoe on the market today. No other training shoe ever built offers a more thoroughly sophisticated combination of protection, comfort and motion control—achieved without the slightest inhibition of the foot's natural range of motion.

Comps. Our Spike 100, Spike 200 and Comp 200 racing shoes are designed with three criteria in mind—minimal weight, optimum protection, maximum feel of the road or track. The results are apparent in race results throughout the world.

IF YOU'D LIKE TO READ MORE, WRITE US.

We'll send you a brochure describing in greater detail the New Balance Running Shoe System.

A System that by satisfying the needs of all different kinds of runners makes New Balance different, too.

New Balance Athletic Shoe, Inc., 38 Everett St., Boston, MA 02134.

new balance NB

Mortgage the house.

There's a good reason why the New Balance 1300 costs more than any running shoe you've probably ever owned. It costs more because it *offers* more.

Give us a minute to explain, and you'll begin to understand what makes a running shoe worth $130.*

EVEN CYNICS WILL AGREE: THE ENCAPSULATED MIDSOLE WARRANTS THE TERM "REVOLUTIONARY."

Revolutionary, because it combines oil and water—cushioning and stability. Here's how:

Long ago, we discovered that a buoyant material called EVA delivers exceptional cushioning. In polyurethane, with its tighter cell structure, we recognized a superior stability compound.

What has driven us the past couple of years has been the intriguing notion of what it would be like if we were able, somehow, to "marry" these two previously incompatible materials. We did it.

The lightweight stability device

Through a patented manufacturing process called "encapsulation," we encased a wedge of EVA within an outer shell of polyurethane. The combination provides phenomenal cushioning without the slightest sacrifice of stability. As a runner moves through his gait cycle, the EVA delivers spring and bounce, while the polyurethane shell cradles the foot and disperses shock.

*Suggested retail price.

Another thing: The Encap™ midsole is virtually compression proof. In test after test of 1,000 miles or more, it showed no signs of flattening out. *None.*

TO CREATE A NEW SENSATION OF SECURITY, WE CREATED A SENSATIONAL NEW LAST.

The remarkable Encap™ midsole

Our R&D people have designed a new last (the SL-2) with a greater circumference at the ball of the foot, a higher toe-box and a higher cone than our traditional SL-1 last. Your feet will tell you, in human terms, what this means.

You'll notice when you try on a pair of 1300's that the forefoot area is broader. This helps to reduce excessive lateral motion. The higher cone means a snugger fit around the ankle and additional motion reduction. There's also considerably more room for orthotics.

And if you've ever lived through the agony of black toe nails, you'll find the higher toe-box absolutely comforting.

IN LIGHT OF HOW PROTECTIVE IT IS, THE 1300 IS SURPRISINGLY LIGHT.

To make a running shoe that offers a lot of protection is usually a weighty matter. The 1300 is proof that a running shoe can be protective without being heavy.

To achieve that goal, we incorporated a stability device into

The Achilles "dip"

the heel design of the 1300. Light but strong, it helps to keep your heel from rocking.

We developed a light, firm footbed insert that we view as another feat of engineering. Made of polyurethane, polyethylene and nylon, it helps to control overpronation with interior heel and arch support. It's also *real* comfortable.

And to reduce irritation of and injury to one of the more critical areas of the foot, we built an anatomically designed Achilles "dip" that allows the Achilles tendon to move more naturally.

OUR MINUTE'S UP.

And we haven't even told you about the supple nu-buck leather. Or the extremely durable carbon rubber outsole. Or the double extended surlyn counter. Or the fact that the 1300 comes in a variety of widths for a more perfect fit.

We will tell you this. If you want to run in the very best running shoe ever made—a shoe that represents a new standard of comfort, support and fit—you should have no qualms about doing something you do every time you run: Digging deep.

WIDTH SIZING
FOR BETTER FIT AND PERFORMANCE

new balance® 1300

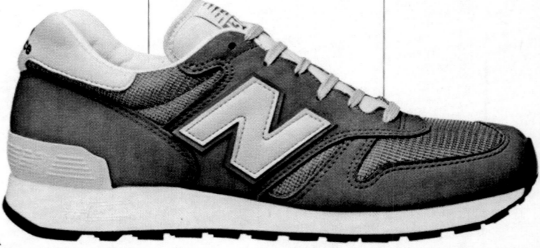

Made in USA

Some guys eat sneakers.

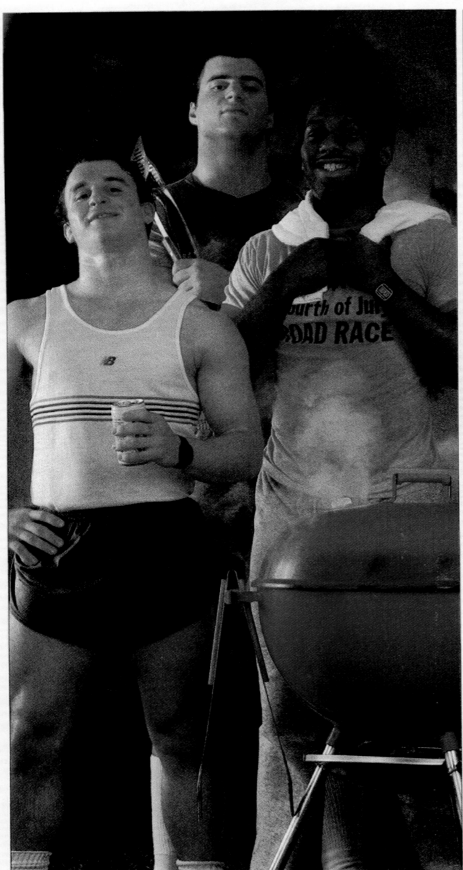

We're talking about your basic one-man wrecking crews. Guys who can turn a perfectly good pair of running shoes into a broken-down pair of sneakers—in a matter of weeks.

If you've had your fill of this problem, you'll be happy to know that long-lasting relief is in sight: the New Balance 850.

The 850's upper is made of one of the toughest materials on the market, cordura— which means your little piggies won't come poking through. It has a strong heel counter that resists collapse. It has a durable midsole and a high-density footbed that won't flatten out on you. And its carbon-rubber outer-sole wears almost as well as a tractor tire.

And since runners who eat up running shoes usually have motion control problems, we've addressed that, too. With features like a sturdy Motion Control Device to keep your heel from wobbling, a cinch strap to better anchor your foot and a wider forefoot design for a more stable stride.

So if you're tired of buying a new pair of running shoes every other month, get a pair of 850's. You'll love 'em. But you won't eat 'em up.

WIDTH SIZING
FOR BETTER FIT AND PERFORMANCE

new balance® 850

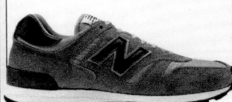

1984: 850, 'Some Guys Eat Sneakers'

The perfect running shoe for not so terra firma.

Come with us now to a land that pavement forgot. Where automobile fumes are excluded, and pedestrians rarely get in one's way. Come with us now as we return to our roots.

And to rocks. And mud. And unexpected holes in the ground. And all the other pitfalls Nature plants in the path of the *off-road runner*. Welcome to New Balance 565 turf.

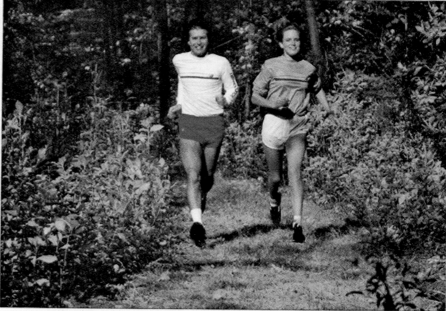

A polyurethane horseshoe helps to bring stability to an unstable world.

OFF-ROAD DOESN'T HAVE TO MEAN OFF-BALANCE.

How do you create a stable shoe for an unstable environment?

We started with a "horseshoe."

An exclusive polyurethane (PU) horseshoe set into the rear portion of a midsole/wedge unit made otherwise of EVA.

Polyurethane has greater resiliency and lower compression set than EVA. So when you run in the 565, the PU horseshoe provides a firm platform for the perimeter of your heel, while the center of your heel "seats" itself comfortably into the somewhat more giving EVA.

To further enhance rearfoot stability, the heel area of the 565's outersole is built up both medially and laterally, thus providing a more stable landing area.

For stability through the midportion of the gait cycle, the shank, or arch, area of the outersole has also been built up and sloped inward. This configuration helps to inhibit overpronation.

Finally, the studs on the perimeter of the outersole have been lengthened and rotated inward in order to reduce foot roll.

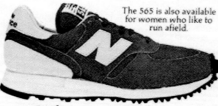

The 565 is also available for women who like to run afield.

At the same time, the houndstooth studs provide superior traction—an obvious must for off-road running.

DESIGNED TO STAND UP TO CIRCUMSTANCES THAT TRY ONE'S SOLE.

If stability is a key component of a superior off-road shoe, dura-bility is equally important. That's why the 565's houndstooth outersole is constructed of high-grade carbon rubber.

That's also why the 565's upper is made of comfortable, breathable, strong denier nylon mesh.

And we'd be remiss if we failed to point out a couple of other features of the 565. Its combination-lasted design, double density counter, "scalloped" Flextended Saddle™ and raised quarter heights for a more secure fit. (Those of you who wear orthotics will find this height accommodating.)

WIDTH SIZING
FOR BETTER FIT AND PERFORMANCE

All of which go into making the New Balance 565 the perfect running shoe for off-road running. Try it and you'll see that we stand on firm ground when we make this claim.

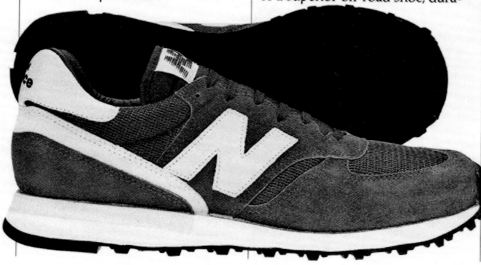

new balance 565

New Balance Inc., Boston, MA 02134
© 1983 New Balance Athletic Shoe, Inc.
The marks New Balance, NB design and N design are trademarks and registered trademarks of New Balance Athletic Shoe, Inc.

1983: 565, 'The Perfect Running Shoe for Not So Terra Firma'

Most lightweight training shoes can make you feel weak in the knees.

The absence of weight in a training shoe has invariably indicated the absence of a couple of other things. Like support. And stability.

The lack of these qualities in most lightweight training shoes has been enough to make a runner feel weak in the knees.

But now, the New Balance 670 provides the missing ingredients.

NEVER HAS A SHOE SO LIGHT BEEN SO SUPPORTIVE.

The 670 is a *third generation* lightweight training shoe from New Balance. Its predecessors included the pioneering 620 and supremely popular 660.

Like them, the 670 is very light —11.4 ounces in size 9D. But the 670 also provides a level of support unavailable before at this weight.

The first reason is the *last*. The 670 is the first New Balance shoe constructed on our new Straight Last 2 (SL2). This new last design produces a running shoe that communicates *security* the moment you put it on.

The forepart of the shoe is wider. The result: added forefoot stability. The arch is narrower and, in conjunction with our Flextended Saddle™ design, allows a more individualized fit through the instep. Finally, raised quarters—the quarter is that portion of the shoe that surrounds the ankle and Achilles area— give a deeper "seat" to the ankle, reducing heel slippage. And the Achilles dip in our padded collar eliminates Achilles tendon irritation.

WIDTH SIZING FOR BETTER FIT AND PERFORMANCE

The 670 doesn't pay lip service to motion control. It delivers it.

A STABLE REAR END.

For rearfoot control through the mid-portion of the gait cycle, the shoe features a polyurethane stability device attached to a strong (60-weight) surlyn counter.

A double-density EVA midsole/wedge provides a firm, but responsive, platform. Because this unit is compression molded, compression set is reduced to a minimum.

An even firmer buffer pad, built into the rear portion of the unit, stabilizes the heel and distributes shock.

There's one other thing we *must* tell you about the 670. It's durable— *real* durable. In tests, runners have put serious miles on the shoe without significant wear to the Superflex outersole or carbon rubber heel pad.

All of which should make you feel very positive about the lightweight 670.

And you have to admit, that's very different from the weak feeling other lightweight shoes can leave you with.

new balance® 670

New Balance Inc., Boston, MA 02134
© 1984 New Balance Athletic Shoe, Inc.
The marks New Balance, NB design, N design and Flextended Saddle are trademarks and registered trademarks of New Balance Athletic Shoe, Inc.

THE RUNNER: JULY 1984 79

1984: 670, 'Most Lightweight Training Shoes Can Make You Feel Weak in the Knees'

After a few miles on the road, answer the call of nature.

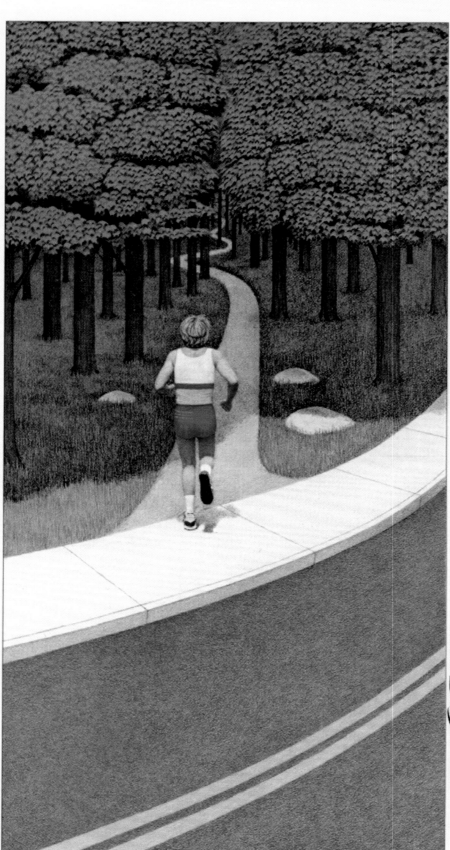

Most running shoes are designed *either* for running on the road or for running off the road. Which means you have to decide what route you're going to run before you put on your shoes. The New Balance 565, on the other hand, is equally at home on the road or the trail.

Among the features that make the 565 the perfect multi-terrain shoe are:

A houndstooth outersole that provides superb traction on a variety of running surfaces. Made of high-grade carbon rubber, it's virtually

indestructible. A polyurethane horse-shoe set into an EVA midsole. The horseshoe provides rearfoot stability, the EVA offers superb cushioning. A double-density surlyn counter that adds to the shoe's motion control characteristics.

So remember: if you want to be able to run both on and off the road, the New Balance 565 is the shoe that's called for.

new balance® 565

Men's

Women's

1985: 565, 'After a Few Miles on the Road, Answer the Call of Nature'

IN THE INTEREST OF A MORE STABLE WORLD, NEW BALANCE HAS BROUGHT SOMETHING SPECIAL TO THE TABLE.

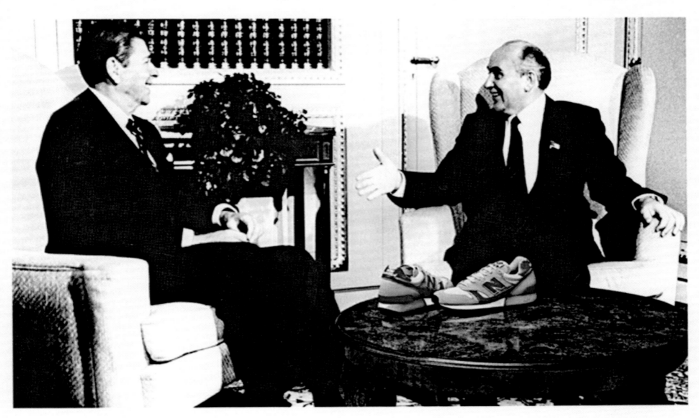

Once again, New Balance is displaying its S.D.I. No, that doesn't stand for Strategic Defense Initiative. It stands for Stability Development Instincts.

We've never demonstrated them more convincingly.

Presenting the New Balance 675.

Of the many features that make it one of the world's more stable running shoes, the most noteworthy is a remarkable new midsole made in our exclusive V-Channel design. The medial and lateral sides of the rearfoot of the midsole are made of a firmer C-Cap® compression-molded EVA to limit overpronation and oversupination. At the same time, the softer C-Cap EVA in the center of the heel provides added cushioning.

The 675 also boasts a newly designed insert unlike any we've ever offered. Double-density EVA/polyethylene foam in the forefoot provides superior cushioning and memory. But the big news is the 675's firmer EVA polyethylene horseshoe in the rearfoot, which provides improved stability during heel strike.

To reduce excessive pronation and supination, the 675 employs a thermoplastic urethane stability device that wraps around the heel. And the 675's highly durable, high-grade carbon rubber outsole provides excellent traction and exceptional stability from heel strike through toe-off.

Achieving stability in the world may be out of your hands. Fortunately, achieving stability when you run is well within the grasp of your feet.

Like most New Balance running shoes, the 675 comes in a variety of widths—B, D, EE, EEEE —for a more perfect fit.

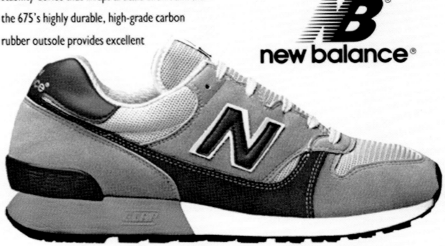

© 1987, New Balance Athletic Shoe, Inc. New Balance, NB design, N on saddle, and C-Cap are registered trademarks of New Balance Athletic Shoe, Inc.

1987: 675, 'In the Interest of a More Stable World, New Balance Has Brought Something Special to the Table', ft. Ronald Reagan and Mikhail Gorbachev

Oddly enough, many people appreciate our racing shoes most when they're standing still.

It's not that the guy in the middle didn't appreciate our shoes *during* the race. It's just that he was concentrating on his pace and splits and kick instead. So the fit and performance of his New Balance racing shoes never even entered his head.

COMPS

Which is just the way we planned it.

You see, we designed our shoes to be so light, so "socklike," so *comfortable*, runners wouldn't have to give them a second thought. (Or even a first thought.)

We did it by combining our racing experience and technological expertise, and developing a special curved racing last. A last that results in a snugger, more precise fit than other lasts. And, because it's curved, it encourages your foot to roll from heel-strike through toe-off more quickly. So you move through your gait cycle a lot faster. After all, isn't that what racing is all about?

Now, to make sure that our designs performed just as well as we thought they would, we gave prototypes to a group of world class sprinters, milers and mara-thoners. They trained in them, raced in them, even *won* in them. And did they tell us they loved our shoes? No—they tore them apart from heel to toe, and told us how to make them better.

Which we did.

The result?

Featherlight spikes and flats that fit like a second skin, and give you comfort *and* support you won't find in any other racing shoes.

In other words, the fit and performance of New Balance racing shoes can do wonders for you.

Even when you're just standing still.

SPIKES

1985: '85 Racing Shoes, 'Oddly Enough, Many People Appreciate Our Racing Shoes Most When They're Standing Still'

Our Track Record Includes The Most Firsts.

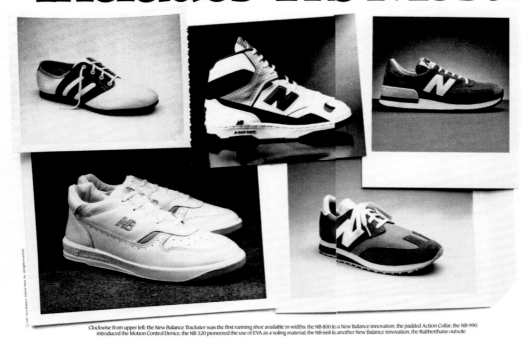

New Balance® has been at the forefront of athletic shoe technology for two decades. We were pioneering component materials, support mechanisms and midsole designs while most of our competitors were still making sneakers.

As a result, many of our innovations have become industry standards. Like the Extended Saddle. The Motion Control Device® Non-skid Rubberthane® in tennis shoes. The wave concept in walking shoes. The padded Action Collar in basketball shoes.

The list reads like a What's What of athletic shoes.

Then there are the aspects of New Balance the shoe world hasn't caught up with. Like offering our shoes in a variety of widths. And producing Encap® midsoles that encapsulate EVA in polyurethane for cushioning that lasts thousands of miles.

When you buy from a company that's had so many firsts, you're certain to get a shoe that's second to none.

new balance®

Clockwise from upper left: the New Balance Trackster was the first running shoe available in widths; the NB 800 fe a New Balance innovation, the padded Action Collar; the NB 990 introduced the Motion Control Device; the NB 320 pioneered the use of EVA as a soling material; the NB 668 fe another New Balance innovation, the Rubberthane outsole.

1987: 'Our Track Record Includes the Most Firsts'

Our Competition Has It Made. We Make It Ourselves.

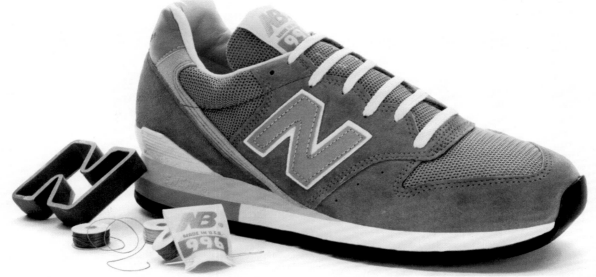

Ironically, most athletic shoe makers don't make athletic shoes. They buy them. From factories in far-away places like Fuchow, Guangchow and Kaohsiung and other names you can't pronounce.

Doing business that way is foreign to New Balance® For the better part of the last two decades, we've made the better part of our line of athletic shoes—running, tennis, walking—at our own facilities right here in America. That's the very best way we know to be sure that our shoes satisfy our strict standards.

We go a step further, too. We make our shoes in a variety of widths. That's the only way we know to ensure that they fit you properly.

The next time you need athletic shoes, get yourself a pair of New Balance. The company that actually makes the shoes it puts its name on.

new balance®

1987: 996, 'Our Competition Has It Made. We Make It Ourselves'

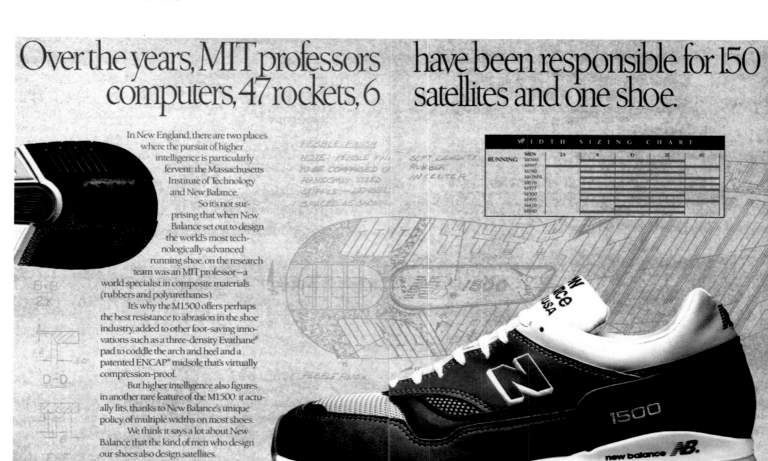

Over the years, MIT professors computers, 47 rockets, 6 have been responsible for 150 satellites and one shoe.

In New England, there are two places where the pursuit of higher intelligence is particularly fervent: the Massachusetts Institute of Technology and New Balance.

So it's not surprising that when New Balance set out to design the world's most technologically-advanced running shoe, on the research team was an MIT professor—a world specialist in composite materials (rubbers and polyurethanes).

It's why the M1500 offers perhaps the best resistance to abrasion in the shoe industry, added to other foot-saving innovations such as a three-density Evathane® pad to coddle the arch and heel and a patented ENCAP® midsole that's virtually compression-proof.

But higher intelligence also figures in another rare feature of the M1500: it actually fits, thanks to New Balance's unique policy of multiple widths on most shoes.

We think it says a lot about New Balance that the kind of men who design our shoes also design satellites.

On the other hand, maybe it says a lot about the satellites.

new balance /NB
A more intelligent approach to building shoes.

WIDTH SIZING CHART						
RUNNING	MEN	2A	B	D	2E	4E
	M1500					
	M997					
	M740					
	M676PA					
	M676					
	M577					
	M500					
	M495					
	M420					
	M840					

1989: M1500, 'Over the Years, MIT Professors Have Been Responsible for 150 Computers, 47 Rockets, 6 Satellites and One Shoe'

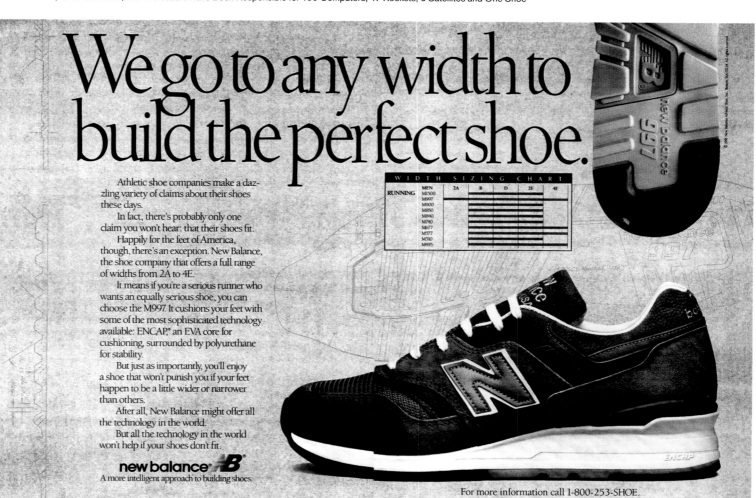

We go to any width to build the perfect shoe.

Athletic shoe companies make a dazzling variety of claims about their shoes these days.

In fact, there's probably only one claim you won't hear: that their shoes fit.

Happily for the feet of America, though, there's an exception. New Balance, the shoe company that offers a full range of widths from 2A to 4E.

It means if you're a serious runner who wants an equally serious shoe, you can choose the M997. It cushions your feet with some of the most sophisticated technology available: ENCAP,® an EVA core for cushioning, surrounded by polyurethane for stability.

But just as importantly, you'll enjoy a shoe that won't punish you if your feet happen to be a little wider or narrower than others.

After all, New Balance might offer all the technology in the world.

But all the technology in the world won't help if your shoes don't fit.

new balance /NB
A more intelligent approach to building shoes.

WIDTH SIZING CHART						
RUNNING	MEN	2A	B	D	2E	4E
	M1500					
	M997					
	M900					
	M850					
	M840					
	M740					
	M677					
	M577					
	M500					
	M495					

For more information call 1-800-253-SHOE.

1991: M997, 'We Go to Any Width to Build the Perfect Shoe'

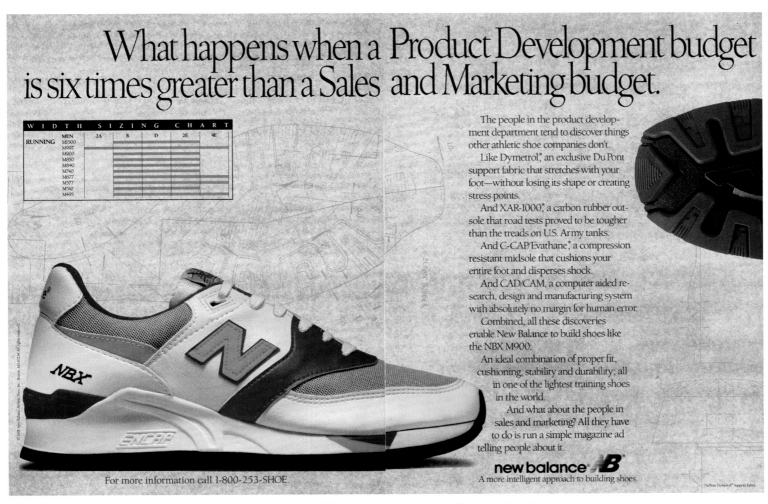

What happens when a Product Development budget is six times greater than a Sales and Marketing budget.

WIDTH SIZING CHART						
RUNNING MEN	2A	B	D	2E	4E	
M1500						
M997						
M900						
M850						
M840						
M740						
M677						
M577						
M510						
M495						

The people in the product development department tend to discover things other athletic shoe companies don't.

Like Dymetrol,® an exclusive Du Pont support fabric that stretches with your foot—without losing its shape or creating stress points.

And XAR-1000,® a carbon rubber outsole that road tests proved to be tougher than the treads on U.S. Army tanks.

And C-CAP/Evathane,® a compression resistant midsole that cushions your entire foot and disperses shock.

And CAD/CAM, a computer aided research, design and manufacturing system with absolutely no margin for human error.

Combined, all these discoveries enable New Balance to build shoes like the NBX M900:

An ideal combination of proper fit, cushioning, stability and durability; all in one of the lightest training shoes in the world.

And what about the people in sales and marketing? All they have to do is run a simple magazine ad telling people about it.

new balance ®**NB**
A more intelligent approach to building shoes.

For more information call 1-800-253-SHOE.

1991: NBX M900, 'What Happens When a Product Development Budget is Six Times Greater Than a Sales and Marketing Budget'

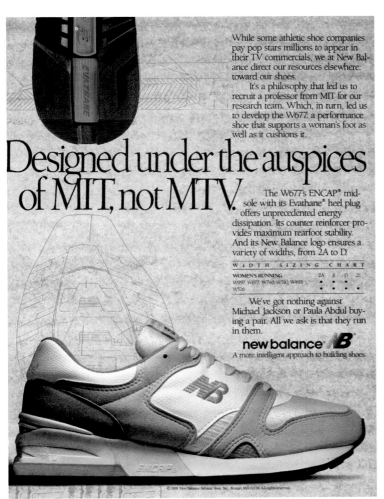

While some athletic shoe companies pay pop stars millions to appear in their TV commercials, we at New Balance direct our resources elsewhere: toward our shoes.

It's a philosophy that led us to recruit a professor from MIT for our research team. Which, in turn, led us to develop the W677: a performance shoe that supports a woman's foot as well as it cushions it.

Designed under the auspices of MIT, not MTV.

The W677's ENCAP® midsole with its Evathane® heel plug offers unprecedented energy dissipation. Its counter reinforcer provides maximum rearfoot stability. And its New Balance logo ensures a variety of widths, from 2A to D.

WIDTH SIZING CHART				
WOMEN'S RUNNING	2A	B	D	2E
W997, W677, W740, W510, W495	•	•	•	
W526		•		

We've got nothing against Michael Jackson or Paula Abdul buying a pair. All we ask is that they run in them.

new balance ®**NB**
A more intelligent approach to building shoes.

1991: W677, 'Designed Under the Auspices of MIT, Not MTV'

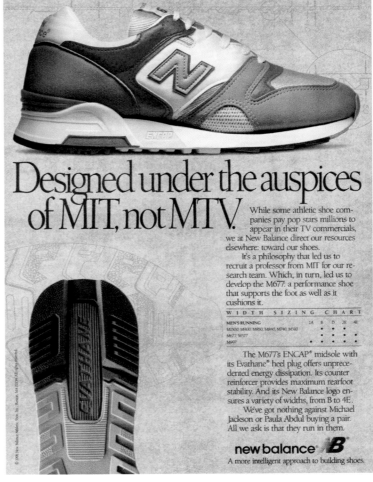

Designed under the auspices of MIT, not MTV.

While some athletic shoe companies pay pop stars millions to appear in their TV commercials, we at New Balance direct our resources elsewhere: toward our shoes.

It's a philosophy that led us to recruit a professor from MIT for our research team. Which, in turn, led us to develop the M677: a performance shoe that supports the foot as well as it cushions it.

WIDTH SIZING CHART					
MEN'S RUNNING	2A	B	D	2E	4E
M1500, M900, M850, M840, M510		•	•	•	•
M677, M577		•	•	•	
M497		•			

The M677's ENCAP® midsole with its Evathane® heel plug offers unprecedented energy dissipation. Its counter reinforcer provides maximum rearfoot stability. And its New Balance logo ensures a variety of widths, from B to 4E.

We've got nothing against Michael Jackson or Paula Abdul buying a pair. All we ask is that they run in them.

new balance ®**NB**
A more intelligent approach to building shoes.

1991: M677, 'Designed Under the Auspices of MIT, Not MTV'

If we can make great athletic shoes in America, why can't our competition?

New Balance is the only company that makes a full line
of athletic shoes here in America.
We've always found quality control is a lot easier when the
factory is in the next room, not the next continent.

A more intelligent approach to building shoes.

1992: 997, 'If We Can Make Great Athletic Shoes in America, Why Can't Our Competition?'

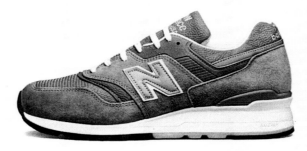

New Balance athletic shoes are one American-made product that's worth buying.

The Japanese buy hundreds of thousands of pairs a year. The German consumer newsletter *Markt Intern* ranks New Balance as the top

Who says buying American has to mean buying junk?

American brand. And the Made In America Foundation included New Balance in its recent collection of the best American products.

The fact is, Americans have been wearing New Balance shoes since 1906. Not just because it shows how they feel about their country, but because it shows how they feel about their feet.

A more intelligent approach to building shoes.

For the New Balance dealer nearest you call 1-800-253-SHOE

1992: 997, 'Who Says Buying American Has to Mean Buying Junk?'

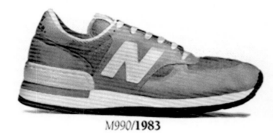

M990/**1983**

*A*s they are inclined to do, the winds of fashion have

changed. Clunky, industrial-strength boots are suddenly all

the rage. Just like that.

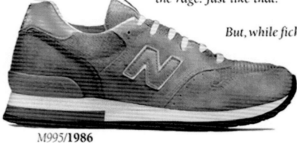

M995/**1986**

But, while fickle fashion-conscious customers are now lacing up the latest in boots,

New Balance customers continue to tie on the latest New Balance.

Our sales have never been better.

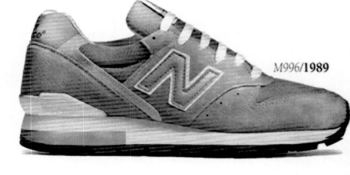

M996/**1989**

Why? Because New Balance customers

prefer to focus on the part of the shoe you can't see.

The part that appeals to the foot rather than to

fashion—the inside.

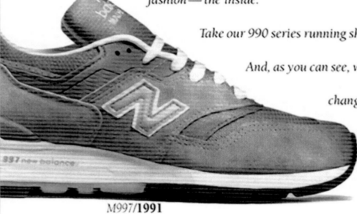

M997/**1991**

Take our 990 series running shoe pictured here. Each successive model has outsold the one before.

And, as you can see, we haven't changed it much on the outside over the years. Nor have we

changed our commitment to building it in multiple widths. On the inside,

however, there have been numerous technological innovations —

the latest being a remarkably shock-resistant material called

Abzorb,® located in the M998's midsole.

WE DON'T LIVE BY FASHION. THEN AGAIN, WE DON'T DIE BY IT EITHER.

It's changes like this, for sound engineering reasons, that bring tangible benefits to our

customers. Like greater comfort, precise fit and improved performance.

Of course, that's not to mention the tangible benefits to our dealers.

Namely, loyal customers. You know, ones who don't

give you the proverbial boot.

new balance /NB

A more intelligent approach to building shoes.

M998/**1993**

1993: M990, M995, M996, M997 and M998, 'We Don't Live by Fashion. Then Again, We Don't Die by It Either'

"New Balance released the 990 runner in 1982. From the Motion Control Device in the heels to dual-density midsoles and reflective 3M highlights – a world-first in footwear – the design was packed with cutting-edge components. Thankfully, runners didn't trip on the triple-figure ask and the 990 flew off shelves. As New Balance's provocative press advertisements from the era promised, 'We've always found quality control is a lot easier when the factory is in the next room, not the next continent.' Now that's the kind of ballsy marketing statement you'll never read in today's risk-averse corporate climate."

Woody
New Balance 997
Sneaker Freaker (2018)

How Many Pieces Of Tennis Equipment Are In This Picture?

If you said two, you must not think of tennis shoes as tennis equipment.

We do. We're New Balance, and we make tennis shoes that are as technologically advanced as tennis shoes get.

If you're male, you might want to play in the extraordinary CT1500. With its specially formulated rubber outsole, Encap® midsole, full-grain leather upper and four-density footbed insert.

If you're female, you'll appreciate the WCT578—built in the belief that women who play with intensity deserve all the support they can get.

One thing about all New Balance tennis shoes: They come in a variety of widths, some from AA to EEEE. So they fit better.

You see, we consider it our duty to make certain that any tennis player who goes out on the court is properly equipped.

new balance®

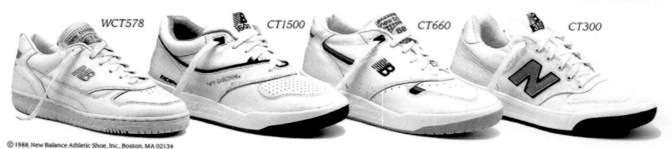

WCT578 CT1500 CT660 CT300

1988: WCT578, CT1500, CT660 and CT300, 'How Many Pieces of Tennis Equipment Are in This Picture?'

Playing tennis is like running a very long race. On a very short track.

During a string of illustrious performances at Wimbledon, Roy Emerson and Virginia Wade estimate they logged, between them, close to a hundred miles ... *on center court alone.*

You may not be playing Wimbledon. But if you take your tennis seriously, chances are you're putting in a few miles of your own, every time you take to the court.

Which is why you may want to take a tip from Emerson and Wade: New Balance.

The Pro Court

RUNNING SHOE TECHNOLOGY GOES TO COURT.

Nobody offers a more technologically advanced running shoe than New Balance. And now we're taking our road-tested expertise to court.

With a line of high performance court shoes that offer unprecedented support, protection, comfort, traction and durability.

The *Pro Court* is a moderately priced canvas winner which features our patented Extended Saddle for better support and a polyethylene insert for comfort and cushioning.

The Emerson/Wade

The *Emerson* (for men) and *Wade* (for women), named for the people who helped us develop them, feature a rubber and Littleway stitched outsole for superior traction, a nylon mesh upper for breathability and a lightweight laminated innersole for comfort.

At the top of our line is the *CT*, which Roy Emerson pronounced "the best shoe to ever set foot on the court." Among its features: a unique gum rubber outsole encased within a polyurethane core and wall, a ballistic mesh upper and an all-leather Extended Saddle and leather side reinforcements.

(By the way, if you've ever wished somebody made court shoes in different widths, you can stop wishing. The Emerson, Wade and CT are available in a variety of widths, for a more perfect fit.)

FINISH

To see the complete line, stop by any quality footwear or athletic store. Or ask your pro.

The New Balance Court Line. If you take your tennis seriously, they'll keep you on track.

The CT

new balance 🅝🅑

Court Line

New Balance Athletic Shoe, Inc., Boston, MA 02134

1977: Pro Court, Emerson/Wade and CT, 'Playing Tennis is Like Running a Very Long Race. On a Very Short Track'

When it comes to performance tennis shoes, we think women have sacrificed enough.

All too often, women who've wanted high performance tennis shoes have had to give up one thing for another. Such as comfort for durability. Durability for comfort. Styling for support. And so on.

With the New Balance WCT 566 and WCT 366, women don't have to give up a thing.

Both of these shoes are made on our new women's last and come in a variety of widths, for a more precise, more comfortable fit. Both feature a

reinforced outersole that delivers exceptional durability. Both contain abundant cushioning. Both sport contemporary styling.

WIDTH SIZING AVAILABLE IN WIDTHS FOR A MORE PERFECT FIT

But there are differences. The WCT 566 has a full-grain leather upper that's sturdy yet supple. The WCT 366 has a combination leather/VISA® mesh upper for lightness and breathability.

No matter which you choose, you'll have a tennis shoe that will really help you cut loose.

WCT 366

WCT 566

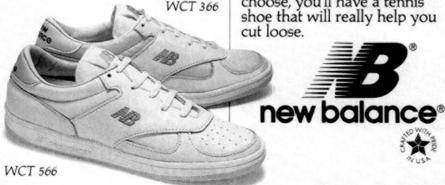

new balance®

CRAFTED WITH PRIDE IN USA

1985: WCT 366 and WCT 566, 'When It Comes to Performance Tennis Shoes, We Think Women Have Sacrificed Enough'

Before You Play Tennis, Consider The Alternatives.

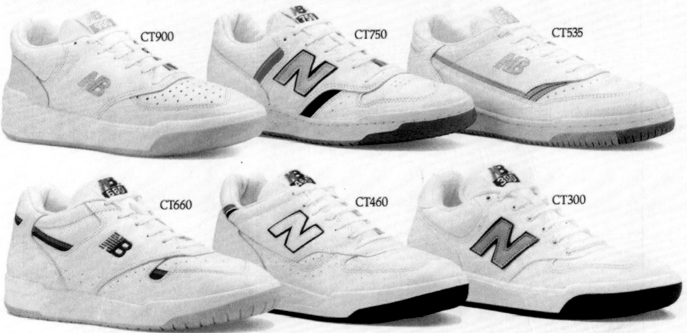

CT900 CT750 CT535

CT660 CT460 CT300

New Balance® makes high-performance tennis shoes for virtually every style of play and every style of player. Built with technical innovations like our Extended Saddle, Rubberthane® outsoles, and EVA or polyurethane midsoles, they offer various combinations of comfort, support and durability—one is sure to be right for you. And, to ensure a better fit, all models come in a variety of widths.

When you think about everything we have to offer, you really have just one alternative.

new balance®

SEE TRAVEL AND PRODUCT INFORMATION PAGE

1988: CT900, CT750, CT535, CT660, CT460 and CT300, 'Before You Play Tennis, Consider the Alternatives'

NIKE

Nike was officially born May 30, 1971. Co-founded by Bill Bowerman and Phil Knight in Portland, Oregon, the first product they released was actually an American football boot known as 'The Nike'. Today, the company turn over close to $40 billion and have 75,000+ employees worldwide.

Nike's long-term dominance is the result of brilliant product design and innovation, but Dan Wieden and David Kennedy can also be credited with inventing much of the mythology that surrounds the brand and their athletes. In the early 1980s, the pair joined forces to form Wieden+Kennedy, with Nike as the foundation client. 'Just Do It' and 'Bo Knows' are just two of their classics that will forever reverberate in pop culture consciousness.

As you flick through this chapter, the reason Nike are numero uno is apparent. Poignant imagery and wicked wit – not to mention balls-out confidence – have long been Nike's advertising hallmarks, but it's the secondary message that makes the Swoosh stand apart. Nike don't just promote shoes, they project a positive manifestation of mental attitude and personal expression, embodied by a prodigious basketball talent by the name of Michael Jordan. Thanks to Phil Knight, the athletic footwear industry is what it is today.

●

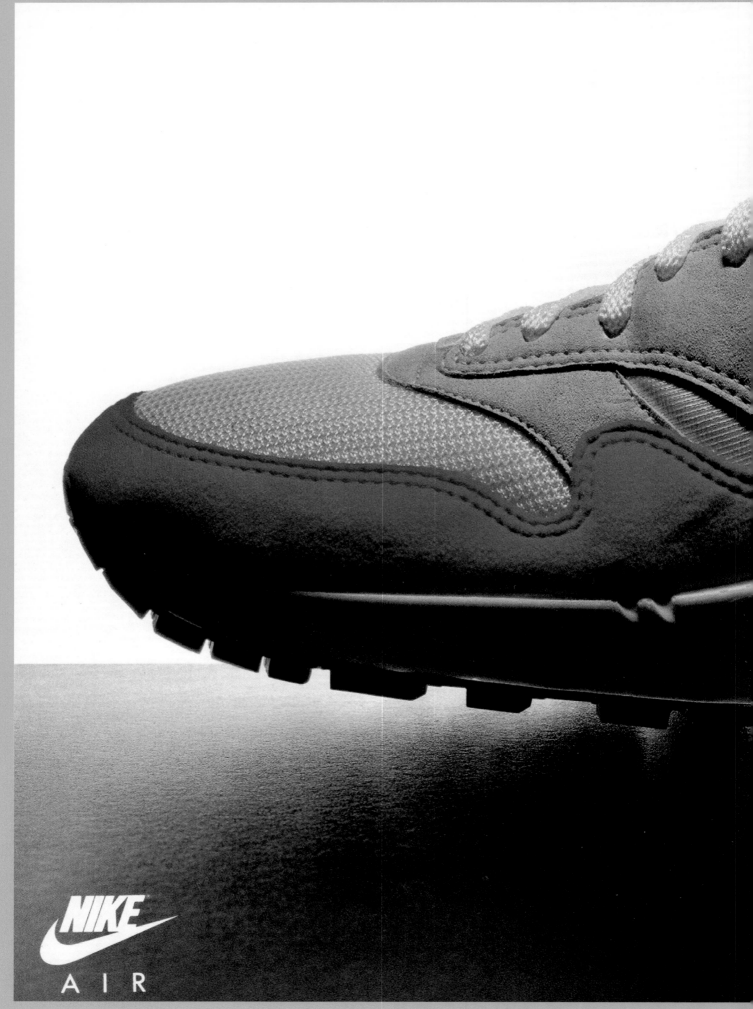

1987: 'Nike-Air is Not a Shoe…' (1 of 3)

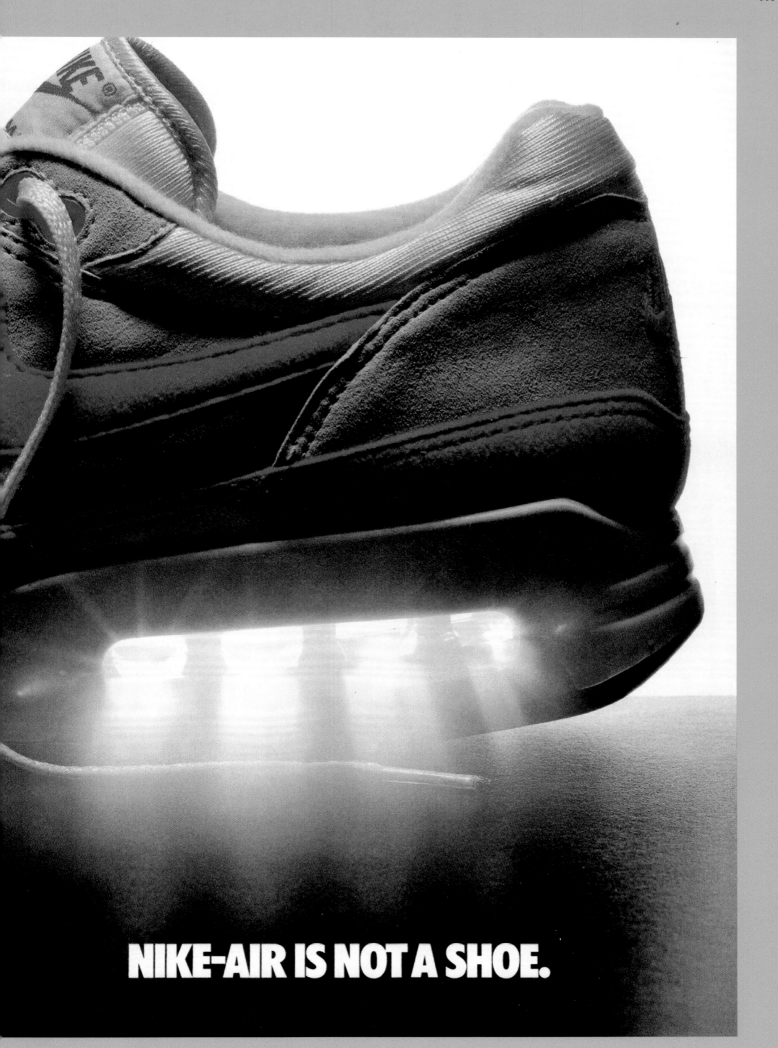

NIKE-AIR IS NOT A SHOE.

IT'S A REVOLUTION.

Like many revolutionary ideas, NIKE-AIR® cushioning is simple. Yet, as a feat of engineering, it remains unmatched. Even eight years after we first introduced it.

NIKE-AIR cushioning is a patented system. It consists of a special gas, pressurized inside a tough, flexible, urethane skin.

Called an Air-Sole® unit, this is what provides the spring-like cushioning. Because after each step or jump, the Air-Sole unit springs back to its original shape.

It provides, far and away, the best cushioning available. Cushioning that reduces the chance of shoc related injury to the bones, muscle and tendons of the foot and lower leg. Cushioning that can reduce th muscular energy it takes to run, walk or jump.

But perhaps most importantly NIKE-AIR cushioning never compacts. It cushions as well after 500 miles as it does after the first.

After years of improvements, of new designs, and new applica-

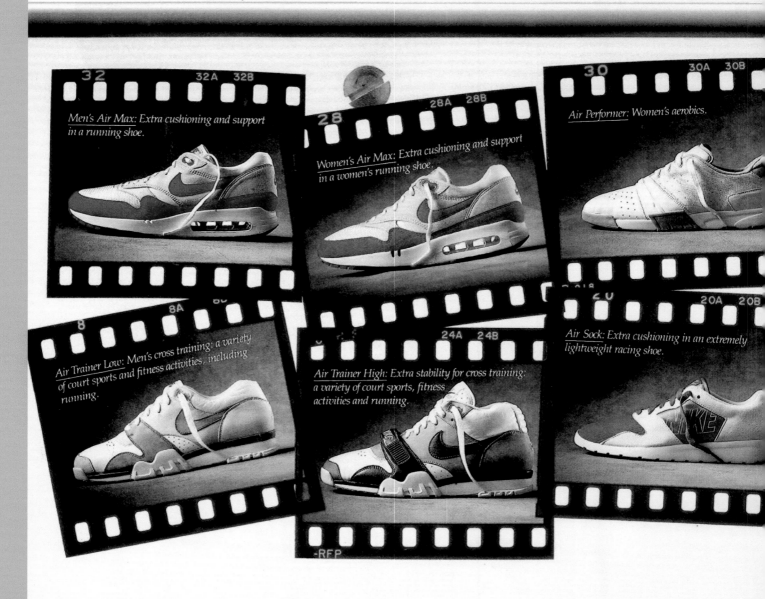

Men's Air Max: Extra cushioning and support in a running shoe.

Women's Air Max: Extra cushioning and support in a women's running shoe.

Air Performer: Women's aerobics.

Air Trainer Low: Men's cross training: a variety of court sports and fitness activities, including running.

Air Trainer High: Extra stability for cross training: a variety of court sports, fitness activities and running.

Air Sock: Extra cushioning in an extremely lightweight racing shoe.

NIKE-AIR cushioning is also gaining in popularity on aerobics floors across the land, making even low-impact aerobic routines less shocking.

And in tennis, John McEnroe is still proving he's years ahead of the conventional, competing on the pro tour in Air Trainer Highs.

Literally hundreds of the world's best professional and amateur athletes wouldn't compete in anything but shoes with NIKE-AIR cushioning.

At their level of competition, NIKE-AIR cushioning is more than a revolutionary idea.

It's a matter of survival.

AND WORKS.

Nothing works like NIKE-AIR® cushioning in the lab.

But just wait till you test it in the field.

It has already carried world class runners like Joan Benoit Samuelson first across the finish line in numerous marathons and road races.

In basketball, NIKE-AIR cushioning is the choice of the big (Moses Malone), the strong (Charles Barkley), and the unstoppable (Michael Jordan).

1987: 'And Works' (3 of 3)

tions, we're still uncovering more potential for NIKE-AIR cushioning.

For instance, our studies showed that we could improve the level of cushioning by enlarging the Air-Sole system. As a result, the new Air Max contains three times more air under the heel than any previous Nike shoe.

We're using separate Air-Sole units under the heel and forefoot of many shoes, to improve flexibility. We're using new systems in combination with Air-Sole units to provide more support. More stability.

NIKE-AIR cushioning in shoes for all kinds of athletic activities. It's in every one of the Nike shoes you see on these pages. All this takes research. Experimentation. Challenges worthy of the most capable scientists and engineers in their fields.

You can see some of their work right here. And more on the next page.

Air Max Heel Air-Sole® Unit

Air Max Forefoot Air-Sole® Unit

Protector: Women's aerobics; ra stability.

Air Support: Men's running shoe with extra stability.

Air Control: Women's running shoe with extra stability.

Safari: All leather; full-length ioning.

Men's Air Force: Men's basketball.

Women's Air Force: Women's basketball.

CAN WE TALK?

You may have heard reports that NIKE is being sued by the Beatles.

That's not exactly true.

NIKE, along with our ad agency and EMI-Capitol Records, is being sued by Apple Records. Apple says we used the Beatles' recording of "Revolution" without permission.

The fact is, we negotiated and paid for all the legal rights to use "Revolution" in our ads. And we did so with the active support and encouragement of Yoko Ono Lennon. We also believe we've shown a good deal of sensitivity and respect in our use of "Revolution," and in how we've conducted the entire campaign.

So why are we being sued? We believe it's because we make good press. "Beatles Sue NIKE" is a much stronger headline than "Apple Sues EMI-Capitol for the Third Time." Frankly, we feel we're a publicity pawn in a long-standing legal battle between two record companies.

But the last thing we want to do is upset the Beatles over the use of their music. That's why we've asked them to discuss the issue with us face-to-face. No lawyers, critics, or self-appointed spokespersons.

Because the issue goes beyond legalisms. This ad campaign is about the fitness revolution in America, and the move toward a healthier way of life.

We think that's a message to be proud of.

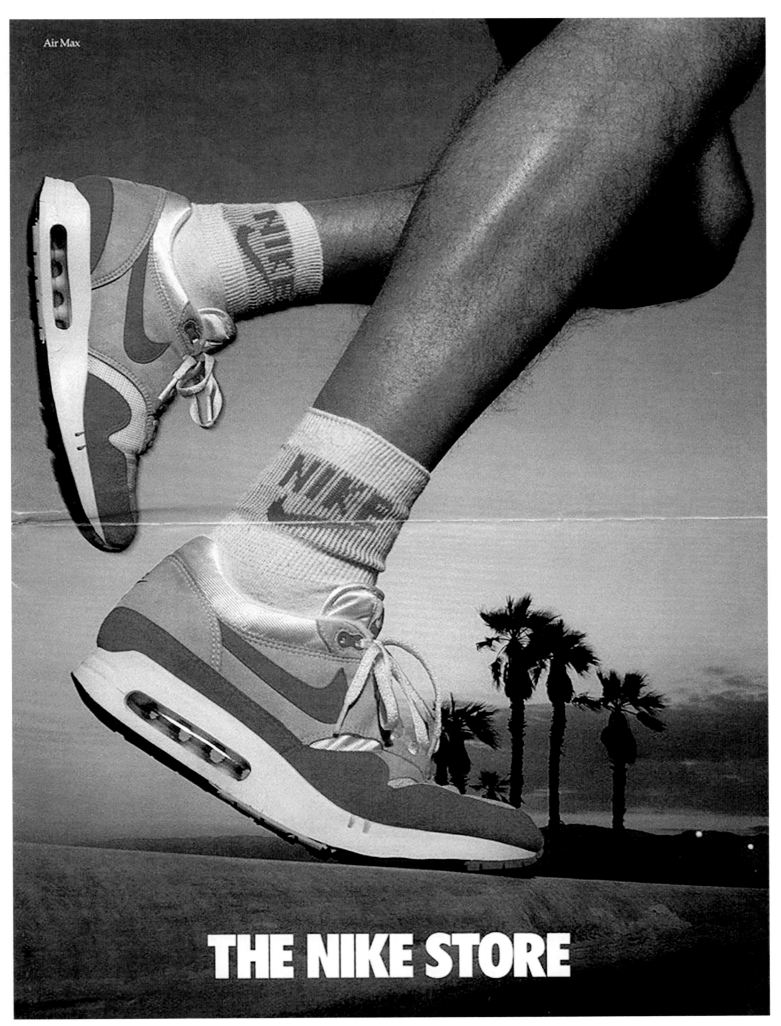

Air Max

THE NIKE STORE

1987: Air Max 1, 'The Nike Store'

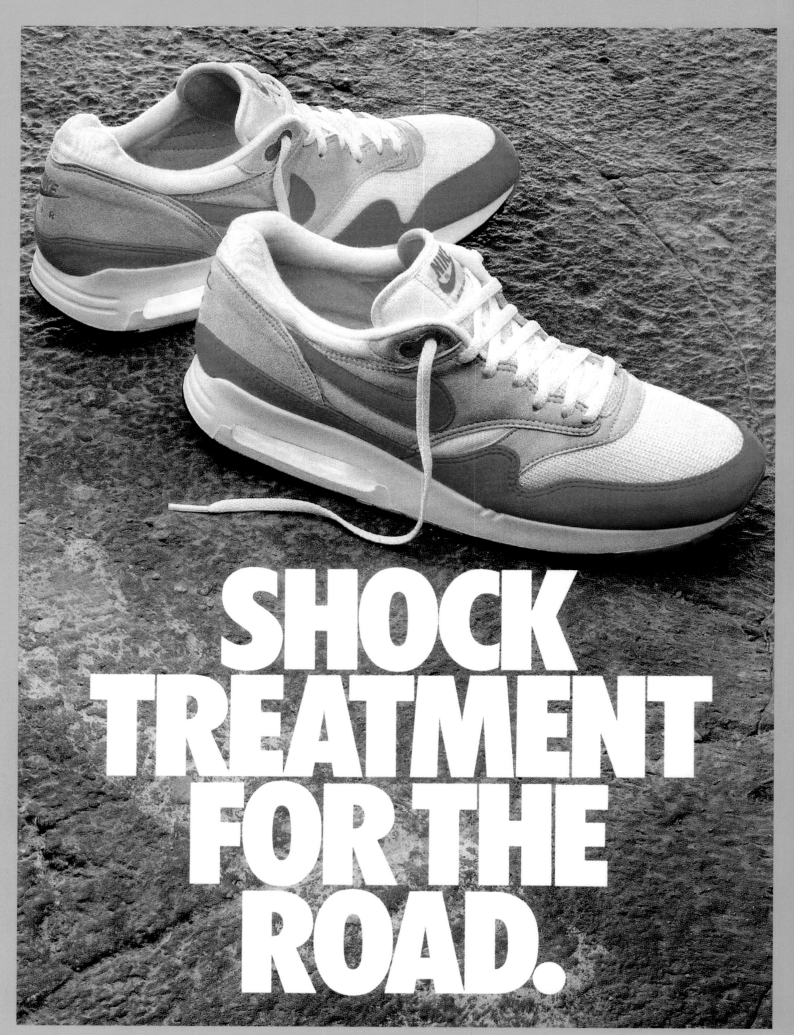

SHOCK TREATMENT FOR THE ROAD.

1987: Air Max 1, 'Shock Treatment for the Road'

1987: Air Max 1 Air Bag

" I remember sitting on a plane with Mark Parker and we didn't want anyone else to see the Air Max sample because we were fresh out of the factory. I'd look at it and he'd look at it and we'd look at each other and go, 'Man this is wild!' I remember us both pretty much thinking the same thing: 'This is crazy, but this is going to work, and people are going to go nuts!' Sure enough it just exploded. "

Tinker Hatfield
'Air Max Retrospective'
Sneaker Freaker, issue 28 (2013)

CUSHIONING: A SIDE-BY-SIDE COMPARISON.

The Nike Air Max has 22% more cushioning than any other running shoe. Plus stability you'd never expect in such a well-cushioned shoe.
All thanks to a system for which there's really no comparison. Nike-Air. A revolution in motion.

1987: Air Max 1, 'Cushioning: A Side-by-Side Comparison'

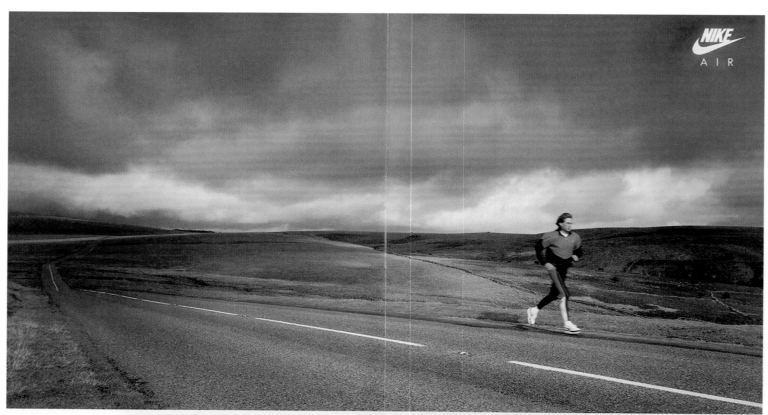

CUSHIONING THAT LASTS FOREVER AND EVER. AMEN.

The Nike Air Max is the world's best cushioned running shoe. Even more important, the cushioning never wears out.
So it'll absorb shock from here to eternity. It's Nike-Air. And it's a revolution in motion.

1987: Air Max 1, 'Cushioning That Lasts Forever and Ever. Amen'

How do you beat the world's best cush-ioned running shoe? With a lighter, faster version. It's called the Nike Air Max Light. And there's only one thing it has less of

AIR IS NOW EVEN LIGHTER.

than the Nike Air Max. Weight. Because even though we've made it significantly lighter, the shoe that started the air revolu-tion hasn't lost a thing in the process. It still

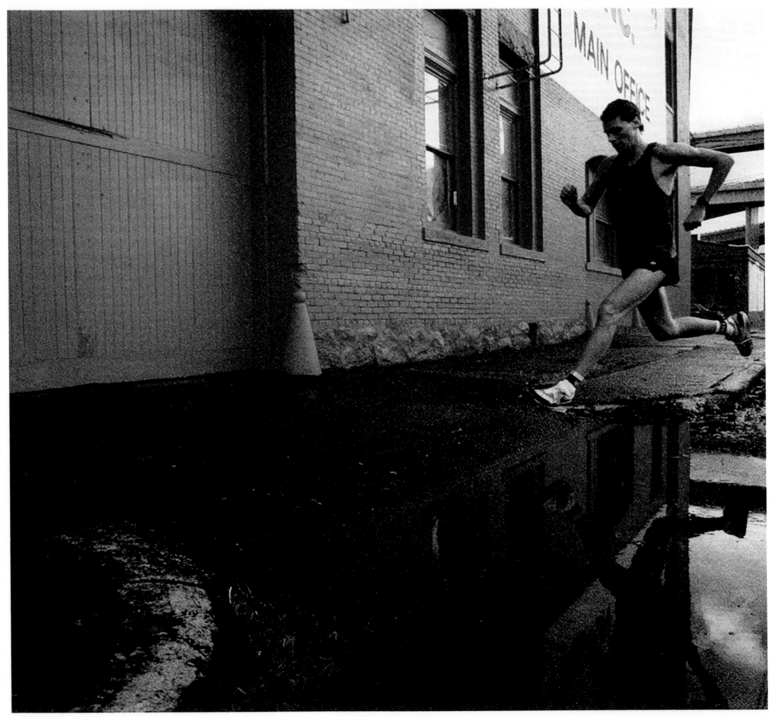

has the Nike Air-Sole, a special gas, pres-surized inside a tough, flexible urethane skin that never loses its cushioning ability. And it still has a lightweight, breathable

NIKE AIR

mesh upper for unequaled comfort. It just happens to be running with a little fas-ter crowd now. Accept no limits.

Men's and Women's Air Max Light

1989: Air Max Light, 'Air is Now Even Lighter'

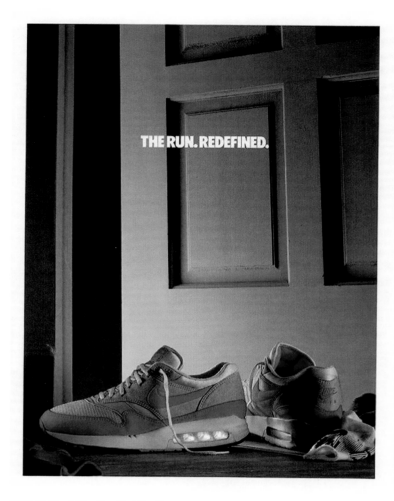

THE RUN. REDEFINED.

Technology has never, and will never, push runners to improved performances. It's when runners push, that technology gets pushed.

Introducing the NIKE Air Max. A running shoe specifically designed to meet the requirements of those who, having experienced the cushioning benefits of NIKE-Air, got greedy and wanted more. Without sacrificing control.

The first step was to radically redefine the NIKE-Air cushioning system. That not only entailed increasing the overall size of the Airsole, but reconfiguring its shape as well.

REPEATED IMPACTING OF MATERIALS

To that end, the Air Max places three times more Air under the heel area where peak impact forces occur. While a separate Airsole, positioned under the forefoot, provides further cushioning to

the metatarsal area. The result is a shoe with more cushioning than any other running shoe on the market. Cushioning that never ends, no matter how many miles you put on it.

As for control, we redefined a few rules of the road there too, giving the Air Max a Contoured Footbed. It cups the heel and forefoot, while supporting the medial arch.

Finally, we finished the Air Max off with a patented BRS 1000 Waffle outsole for added cushioning and durability. Enhancing the road feel of the shoe in the process.

When the results were in, the Air Max surfaced as the best cushioned shoe in running history.

And a stable one at that.

Which only serves to prove what we've been saying all along.

The harder you push, the better we run.

NIKE
A I R

1987: Air Max 1, 'The Run. Redefined'

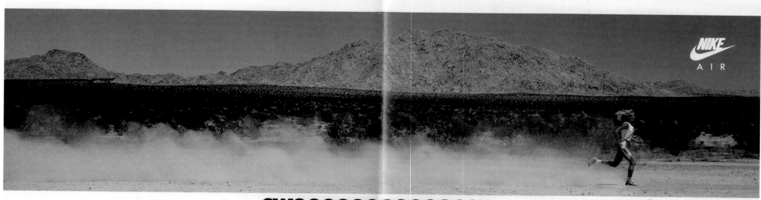

NIKE
A I R

SWOOOOOOOOOOOOSH.

We're talking fast. We have to. After all, we're talking about the Air Max Light. A lighter, faster version of the world's best cushioned running shoe. If you want a pair, you'd better hurry. Word has it they're going fast. Very fast.

Featured on Kim Jones: International Tank; Pursuit Tight.

1989: Air Max Light, 'Swoooooooooooosh'

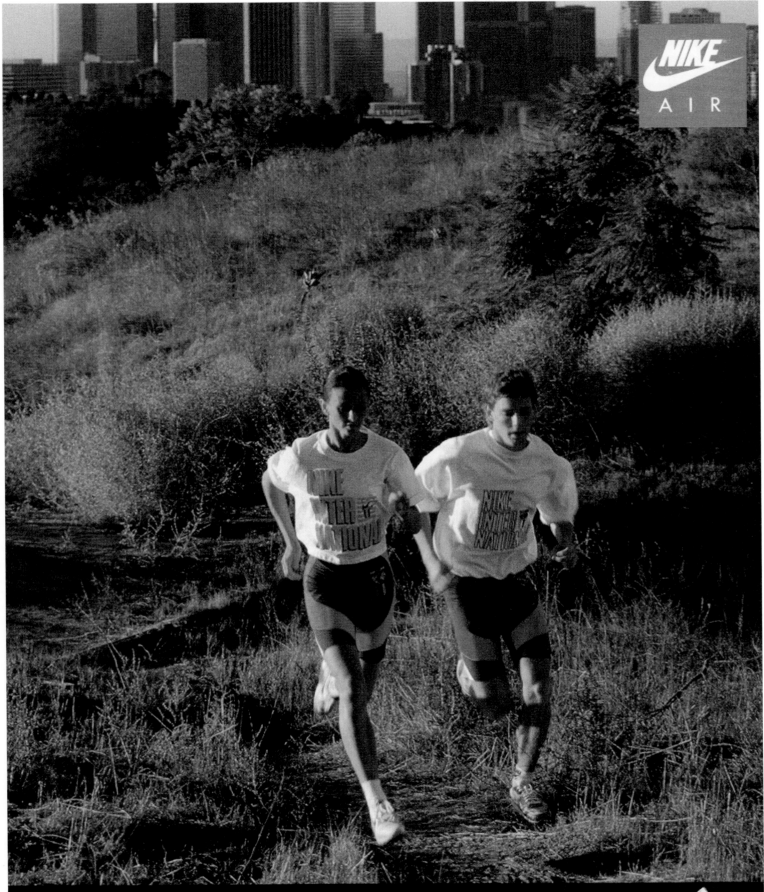

JUST DO IT. *Intensives Lauf-Training erfordert Kondition und Durchhaltewillen. Und einen optimalen Schuh: Nike® Air Max. Durch das Nike Air® System und eine spezielle Mittelsohle bietet dieser Schuh unübertroffen dauerhafte Dämpfung und ein Höchstmaß an Flexibilität.*

Lady Air Max und Air Max

1990: Air Max 90, 'Just Do It'

Mark Allen, accepting the '89 Ironman trophy—

"I would like to thank my parents for giving me the genes.

Nike for giving me the running shoes

My coach for giving me the encouragement.

Nike for giving me the running shoes.

And, finally, my brother for giving me his luggage for the trip to Hawaii."

1990: Air Max 90, ft. Mark Allen

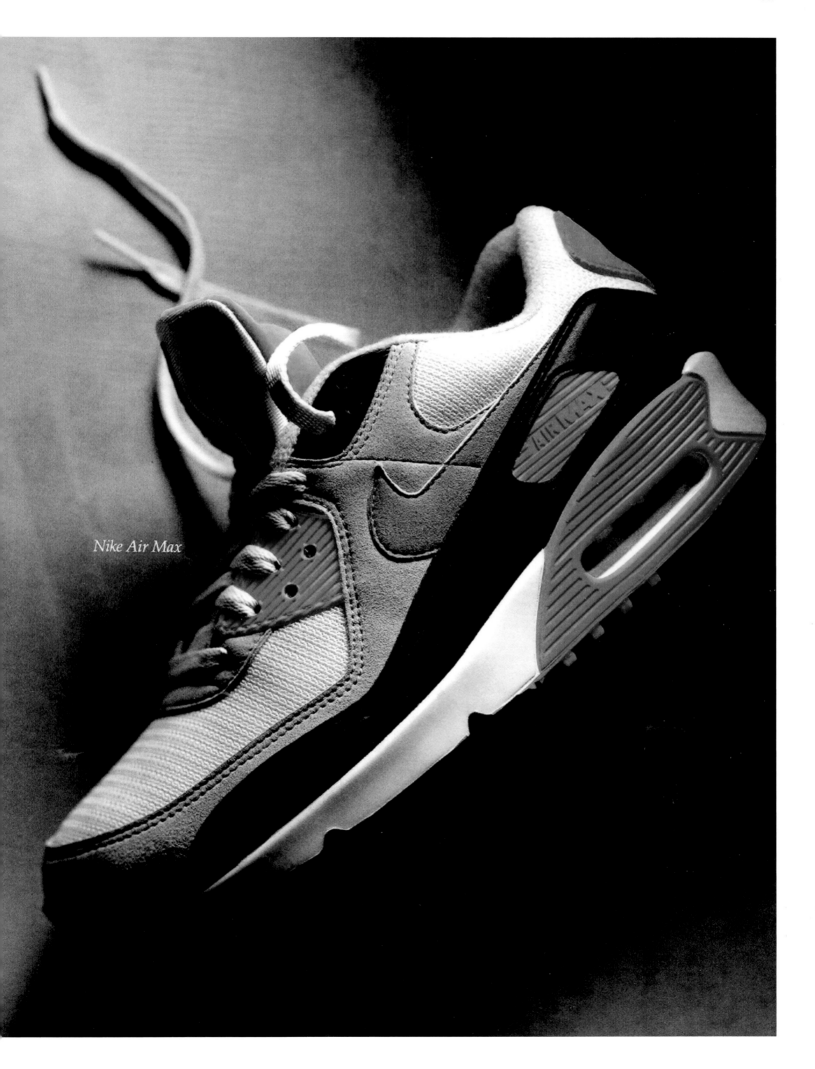

Nike Air Max

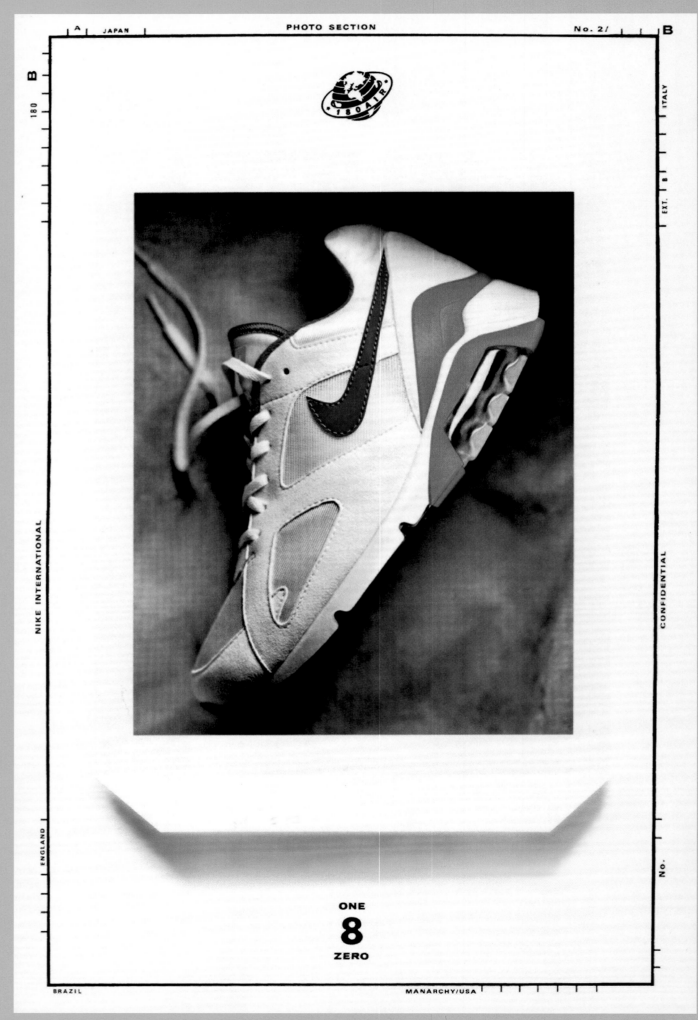

ONE
8
ZERO

1991: Air Max 180 (1 of 4)

1991: Air Max 180, illustrations by Alphonse Holtgreve (top) and Andre Francois (bottom) (2 of 4)

1991: Air Max 180, illustrations by Charles Anderson (top), Ralph Steadman (middle) and Takenobu Igarashi (bottom) (3 of 4)

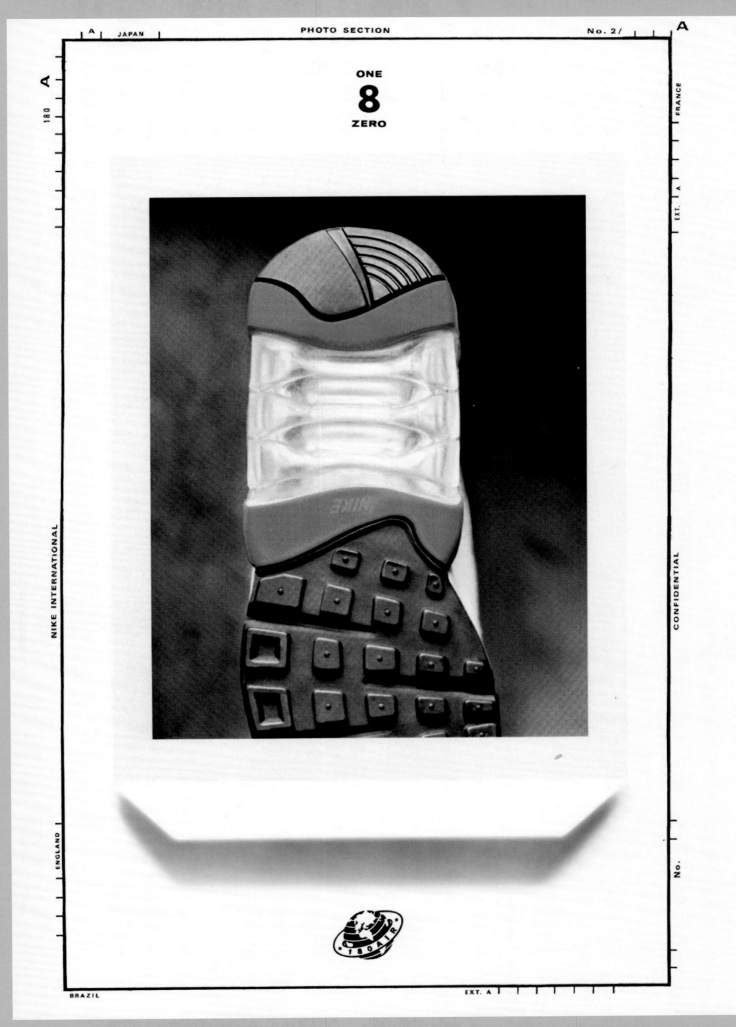

321

AIR MAX.

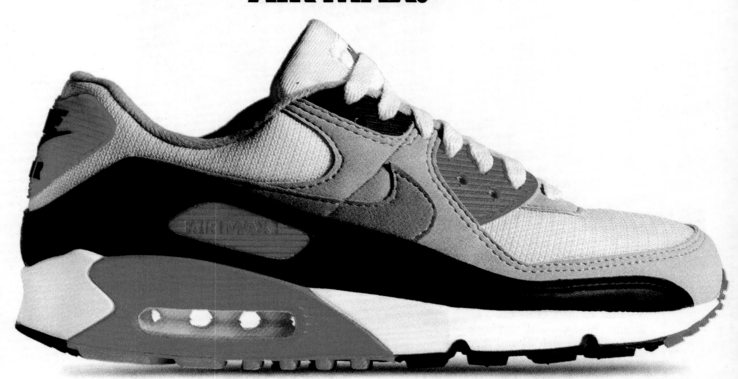

The new Air Max.® With more Nike-Air® cushioning. More plush padding. More sup

1991: Air Max BW, 'Air Max. Air Even More Max'

AIR EVEN MORE MAX.

NIKE
A I R

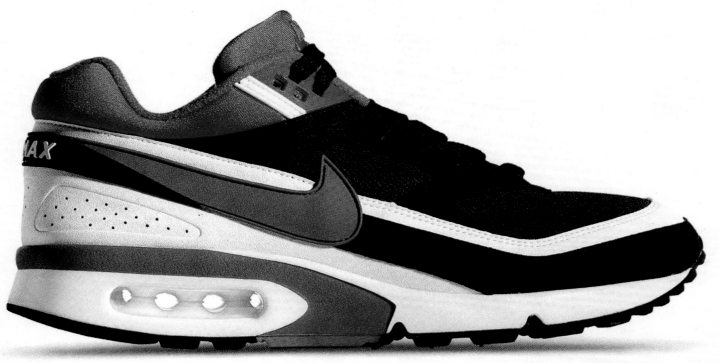

re comfort. More of that great Air Max ride. More attitude. What more could you want?

You might not be able to tell if the sky was 35% bluer today .

Or if the clouds drifting past were 35% softer .

Or if the rolling fields smelled 35% sweeter ,

because the clover was 35% higher ‡

1993: Air Max 93

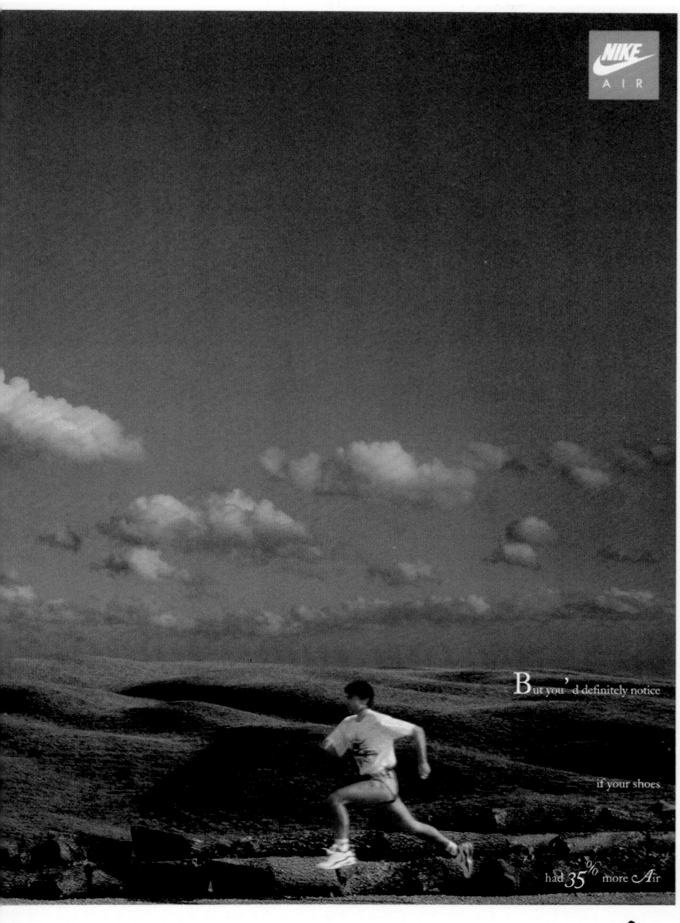

But you'd definitely notice

if your shoes

had 35% more Air

The new Air Max.

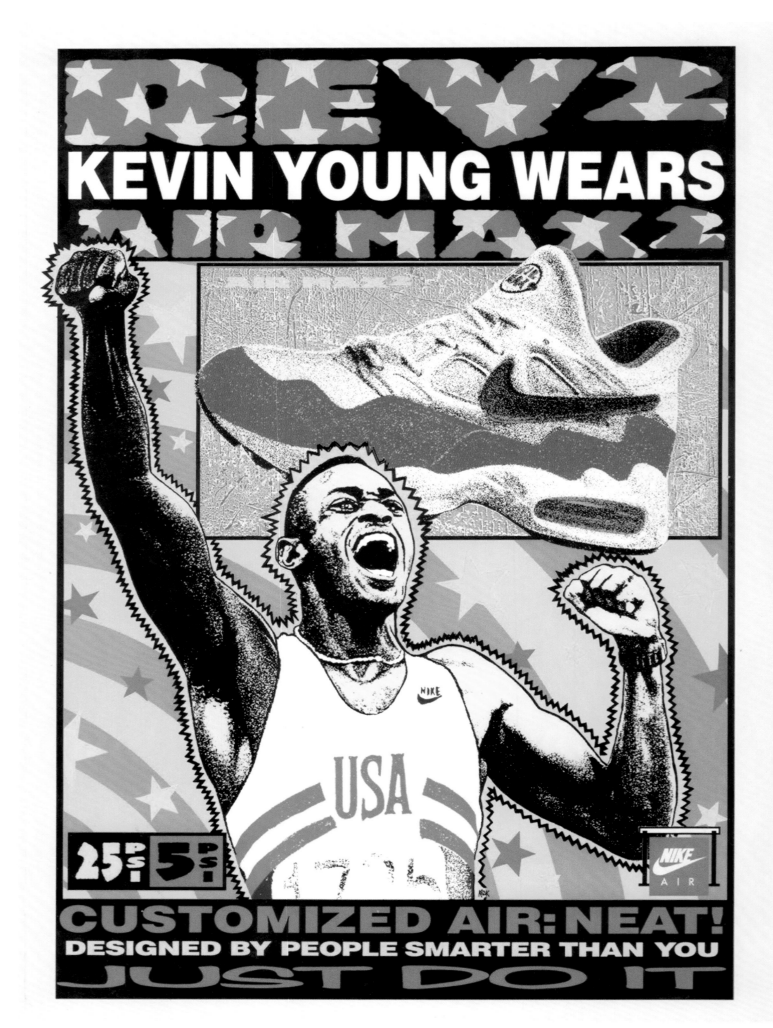

1994: Air Max², 'Kevin Young Wears Air Max²', ft. Kevin Young

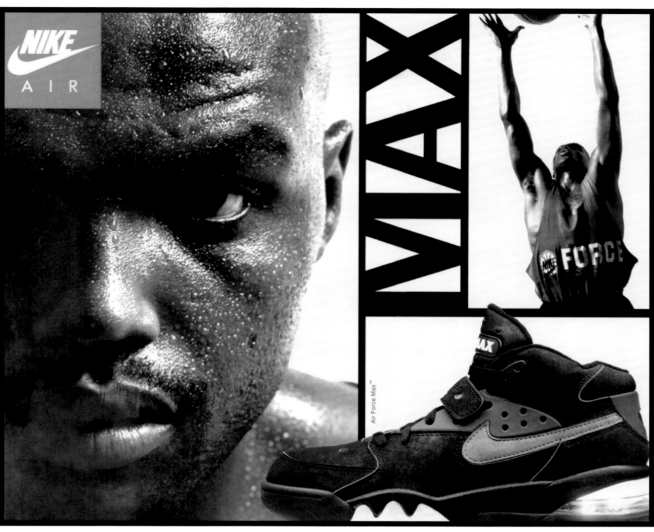

1993: Air Force Max, 'Max', ft. Charles Barkley

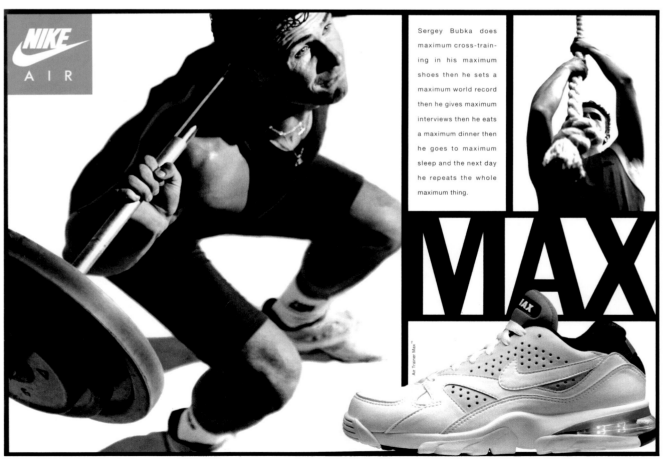

1993: Air Trainer Max, 'Max', ft. Sergey Bubka

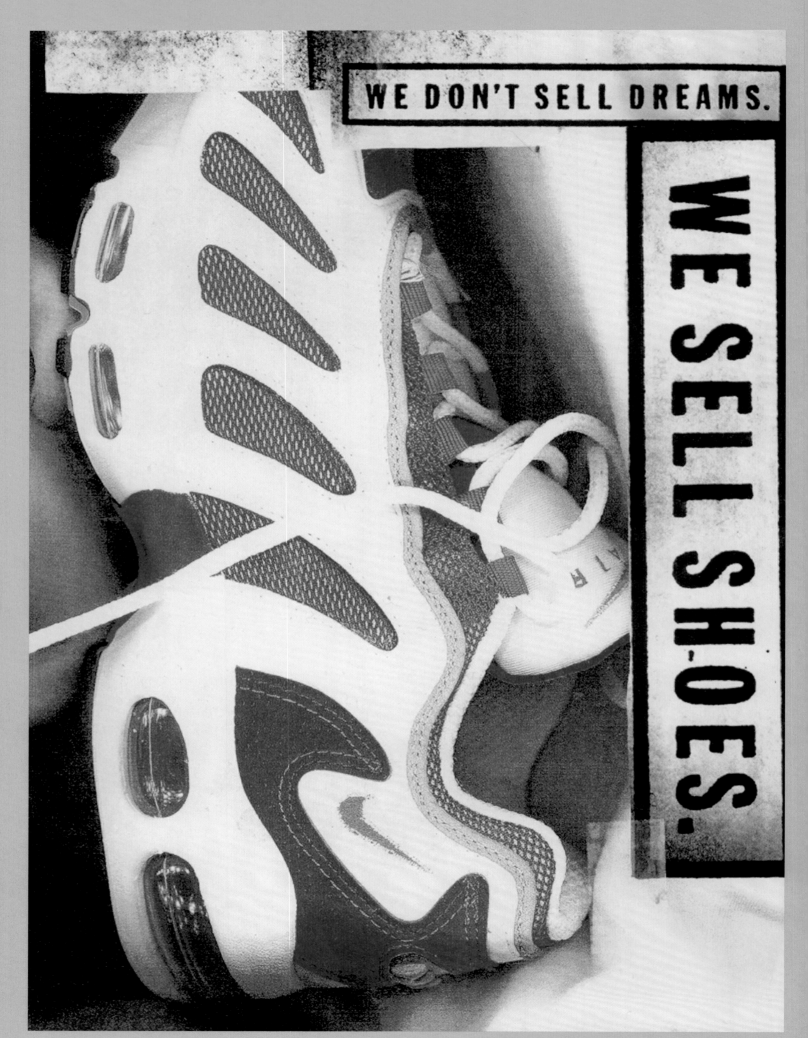

1996: Air Max 96, 'We Don't Sell Dreams. We Sell Shoes' (1 of 2)

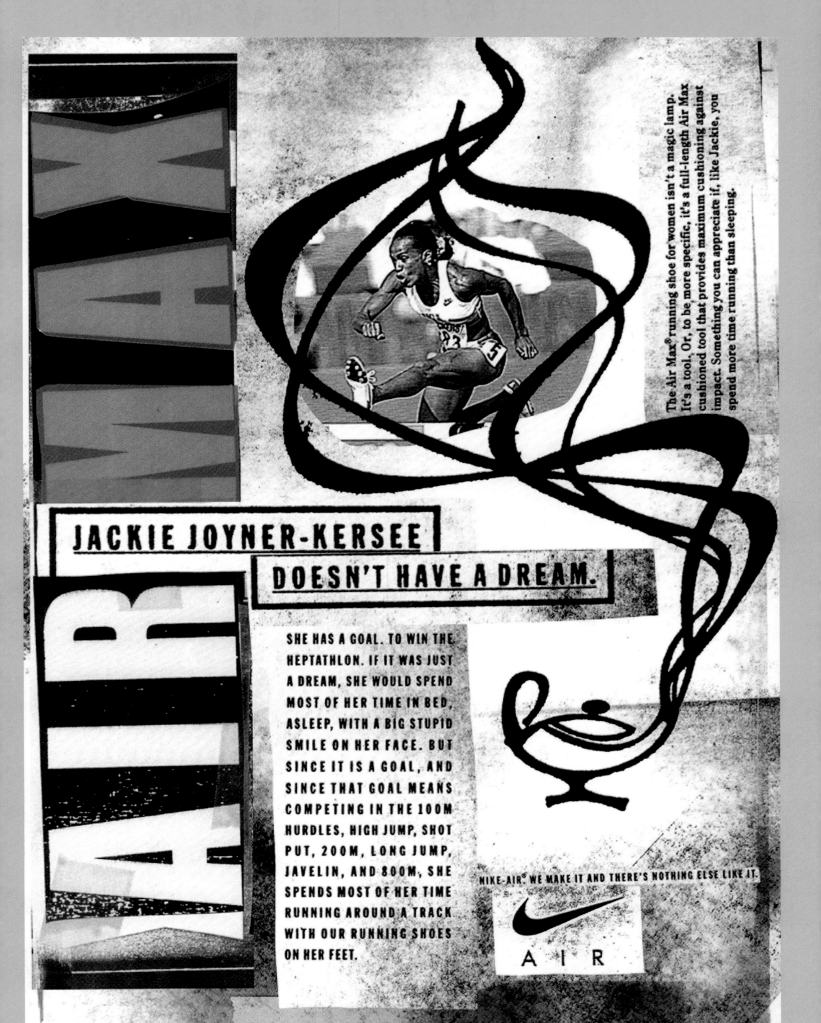

The Air Max® running shoe for women isn't a magic lamp. It's a tool. Or, to be more specific, it's a full-length Air Max cushioned tool that provides maximum cushioning against impact. Something you can appreciate if, like Jackie, you spend more time running than sleeping.

JACKIE JOYNER-KERSEE
DOESN'T HAVE A DREAM.

SHE HAS A GOAL. TO WIN THE HEPTATHLON. IF IT WAS JUST A DREAM, SHE WOULD SPEND MOST OF HER TIME IN BED, ASLEEP, WITH A BIG STUPID SMILE ON HER FACE. BUT SINCE IT IS A GOAL, AND SINCE THAT GOAL MEANS COMPETING IN THE 100M HURDLES, HIGH JUMP, SHOT PUT, 200M, LONG JUMP, JAVELIN, AND 800M, SHE SPENDS MOST OF HER TIME RUNNING AROUND A TRACK WITH OUR RUNNING SHOES ON HER FEET.

NIKE-AIR. WE MAKE IT AND THERE'S NOTHING ELSE LIKE IT.

AIR

1996: Air Max 96, 'Jackie Joyner-Kersee Doesn't Have A Dream', ft. Jackie Joyner-Kersee (2 of 2)

YOU'RE TRAVELLING THROUGH ANOTHER DIMENSION.

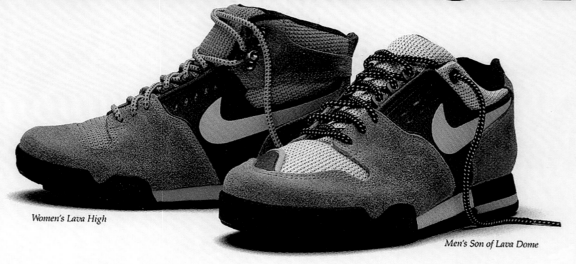

Women's Lava High

Men's Son of Lava Dome

Enter The Lava High, from Nike. A bizarre new way to travel. But don't be sold on looks. These beasts are loaded with just about every tech feature known to man. They're light-weight boots with waxed, plated leather. Single-ply Shin-Shin breathable mesh. Waffle®outsole. Everything for serious hikers, whose only boundaries are that of imagination.

1988: Lava High and Son of Lava Dome, 'You're Travelling Through Another Dimension'

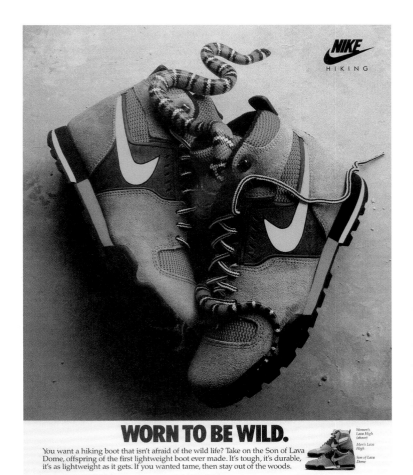

1989: Lava High and Son of Lava Dome, 'Worn to Be Wild'

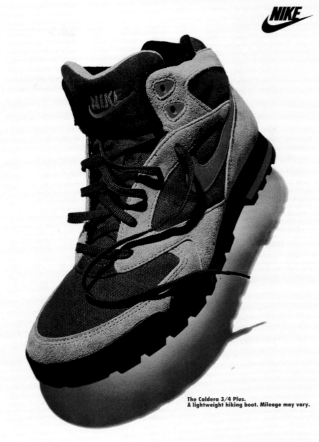

1992: Caldera 3/4 Plus, 'A Lightweight Hiking Boot. Mileage May Vary'

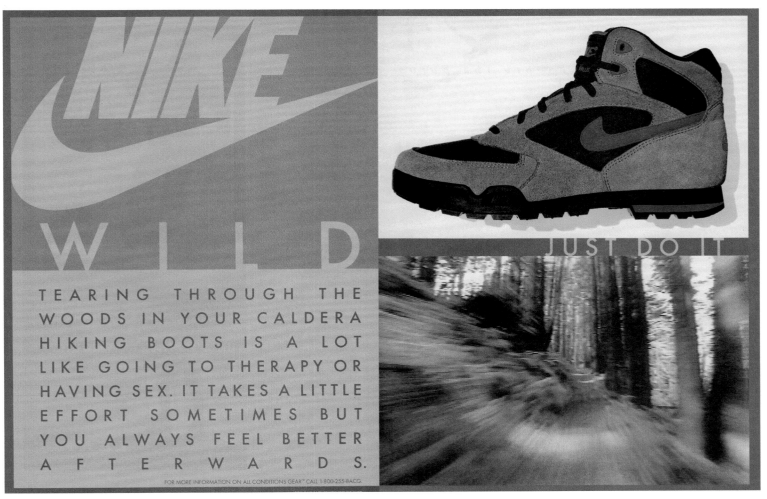

1992: Caldera, 'Nike Wild'

CALL OF THE RE

This is the Air Terra trail running shoe from Nike. Civilized, it ain't. It's got an outsole th
beveled like a mountain bike tire to take you over rocks and branches. It's got Nike-Air® in

For more information on the Air Terra call 1-800-255-8224.

1989: Air Terra, 'Call of the Really Really Wild'

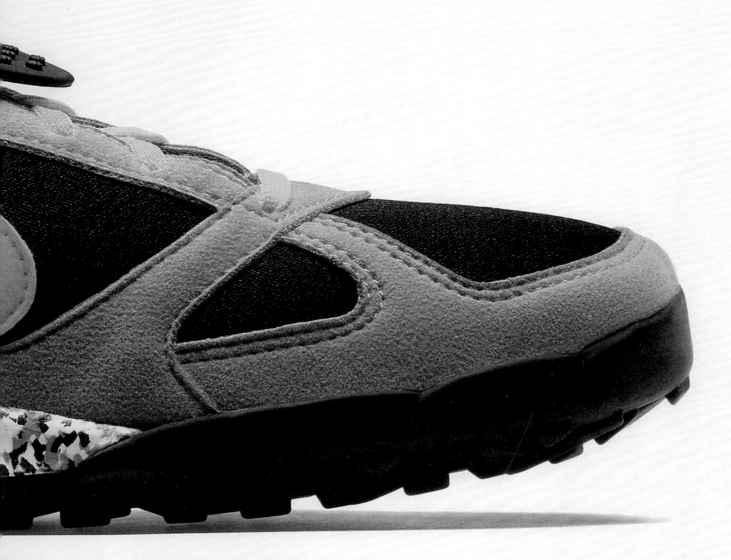

Y REALLY WILD.

l for extra cushioning. It's even got a deflector shield under the forefoot so you won't bruise
rself on any bear or deer. Now put your tongue back in your mouth and go try on a pair.

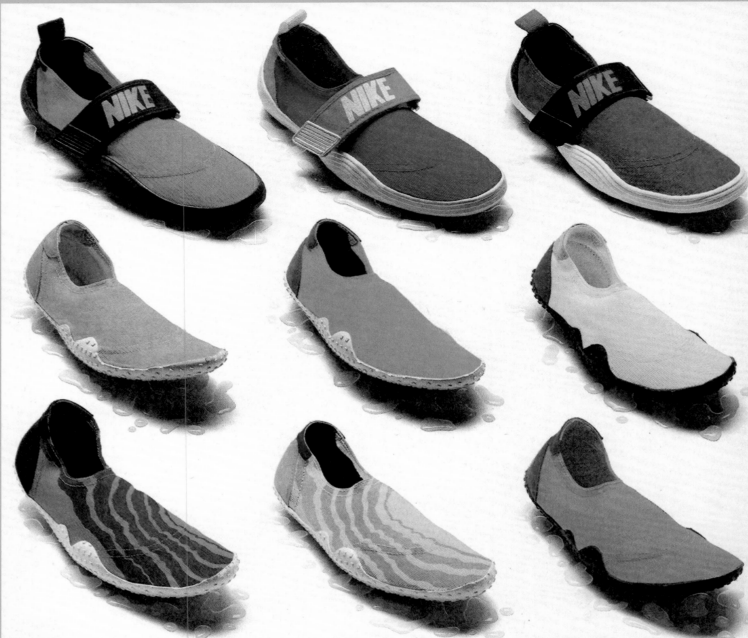

HAWAIIAN SHIRTS FOR YOUR FEET.

You're hanging ten in Maui or you're just stepping into your hot tub. Fine. You'll need a few things. **NIKE**
First, you'll need a solid rubber outsole for traction. Then you'll need a spandex upper for breathability.
Like gills, sort of. And you'll definitely need some wacky colors to make the fish think you're one of them.
In short, you'll need NIKE Aqua Socks. Remember: when the going gets wet, the wet go Hawaiian.

1988: Aqua Sock, 'Hawaiian Shirts for Your Feet'

❝ Geoff Hollister is a genius. He was one of the people at Nike who would go out and help sign athletes to wear new Nike products. The Sock Racer was a stretch-fit, minimalist running shoe. Ingrid Christiansen set a world record in the women's marathon wearing the Sock Racer. Jeff thought this sort of stretchy sock-shoe would work on the beach, on a boat and around the pool, so he basically put a shoe together based on that idea. Nike sold millions of pairs and it was renamed the Aqua Sock. In yet another interesting innovation from Nike, the shoe was all about minimalism. If you know anything about products designed for the water, you'll know this particular product has been imitated many, many, many times. **❞**

Tinker Hatfield
'All Conditions Gear'
Sneaker Freaker, issue 14 (2008)

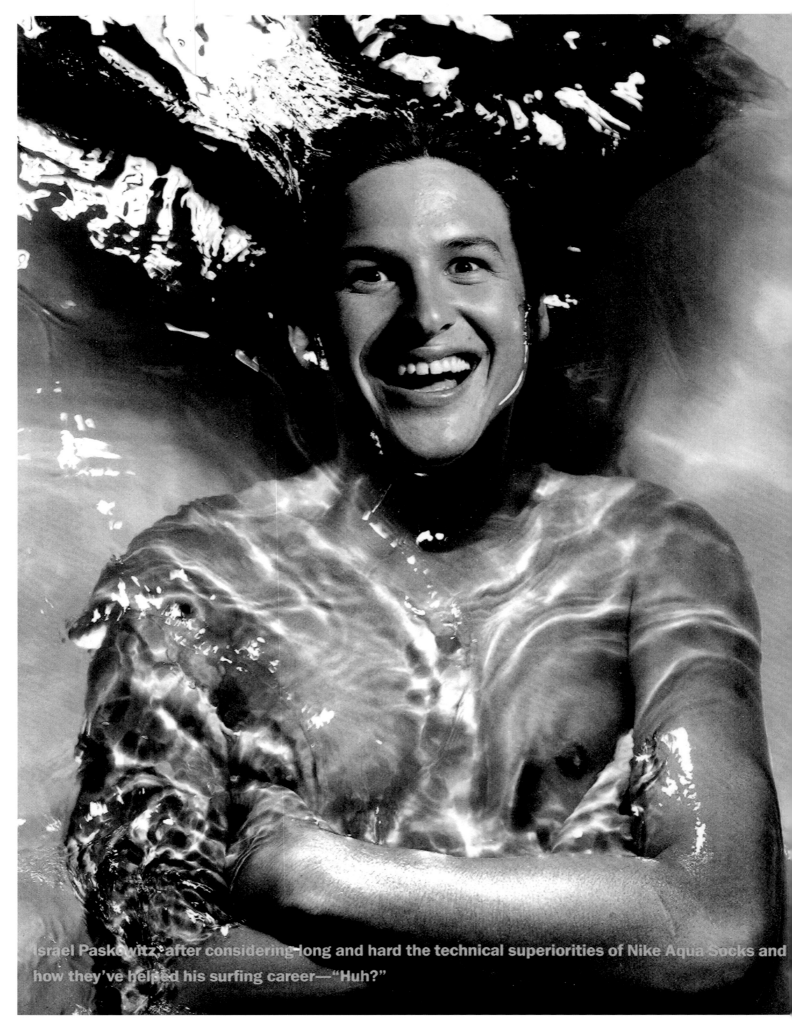

Israel Paskowitz, after considering long and hard the technical superiorities of Nike Aqua Socks and how they've helped his surfing career—"Huh?"

1990: Aqua Sock, ft. Israel Paskowitz

Nike Aqua Sock

THE BOX IS A SHAPE YOU SHOULD BE PRETTY FAMILIAR WITH BY NOW. AFTER ALL, YOU SLEEP IN ONE, EAT IN ONE, COMMUTE IN ONE, SPEND YOUR FREE TIME WATCHING ONE AND, IF YOUR CONSCIENCE IS BOTHERING YOU, EVEN CONFESS IN ONE. YOU COULD EASILY SPEND YOUR WHOLE LIFE IN A BOX.

BUT YOU COULD JUST AS EASILY GET OUT.

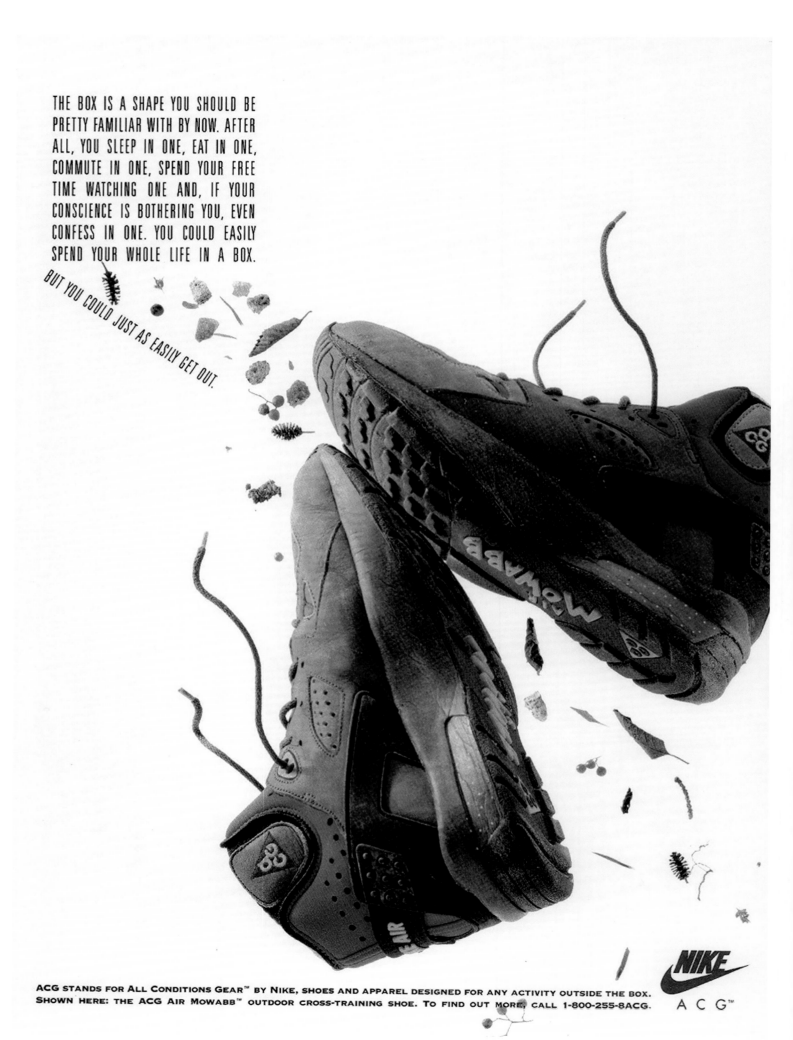

NIKE

ACG™

ACG STANDS FOR ALL CONDITIONS GEAR™ BY NIKE, SHOES AND APPAREL DESIGNED FOR ANY ACTIVITY OUTSIDE THE BOX. SHOWN HERE: THE ACG AIR MOWABB™ OUTDOOR CROSS-TRAINING SHOE. TO FIND OUT MORE, CALL 1-800-255-8ACG.

1989: Air Mowabb

CORPORATE AGENDAS. Partisan politics. Government gridlock.

Left unchecked, all these things can destroy man's ability to enjoy the natural wonder

that is the great outdoors. SO CAN CRAPPY HIKING SHOES.

NIKE

THE AIR KHYBER

1989: Air Khyber

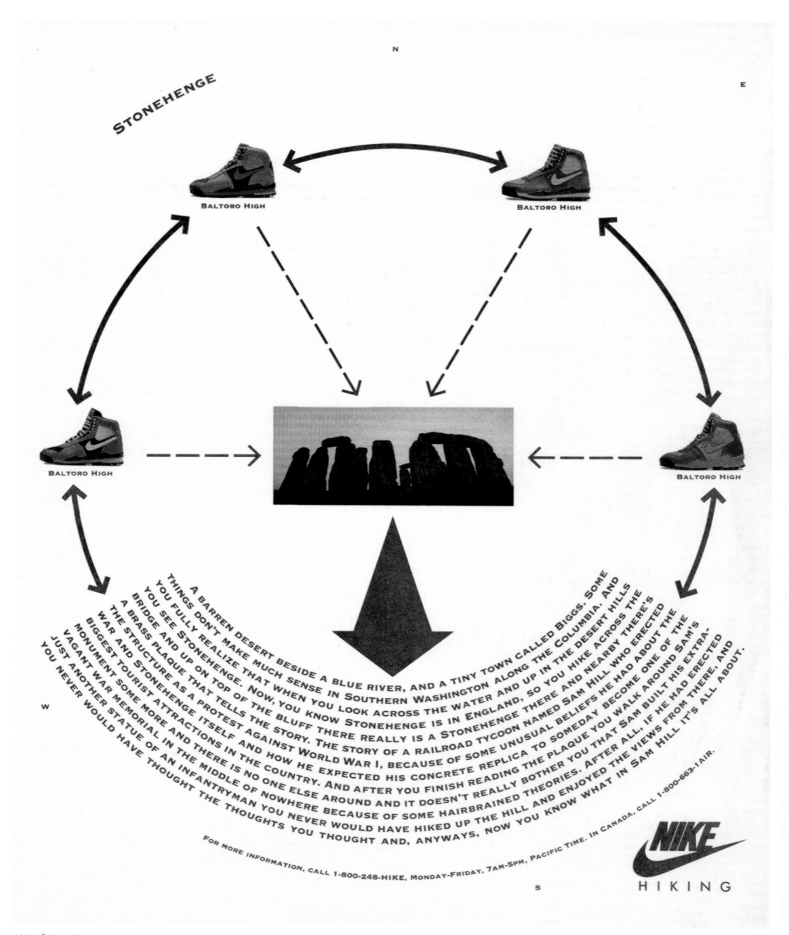

1990: Baltoro High

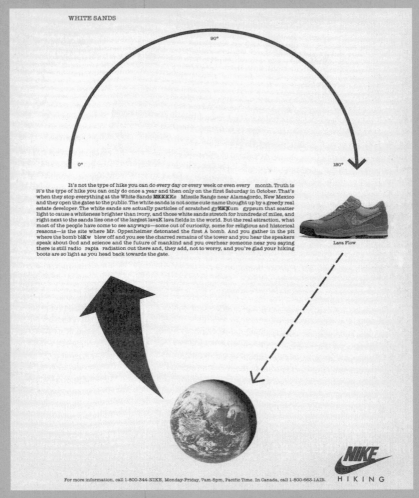

1990: Lava Flow (1 of 2)

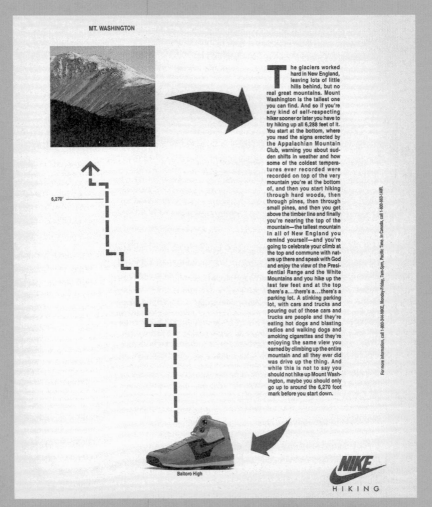

1990: Baltoro High (2 of 2)

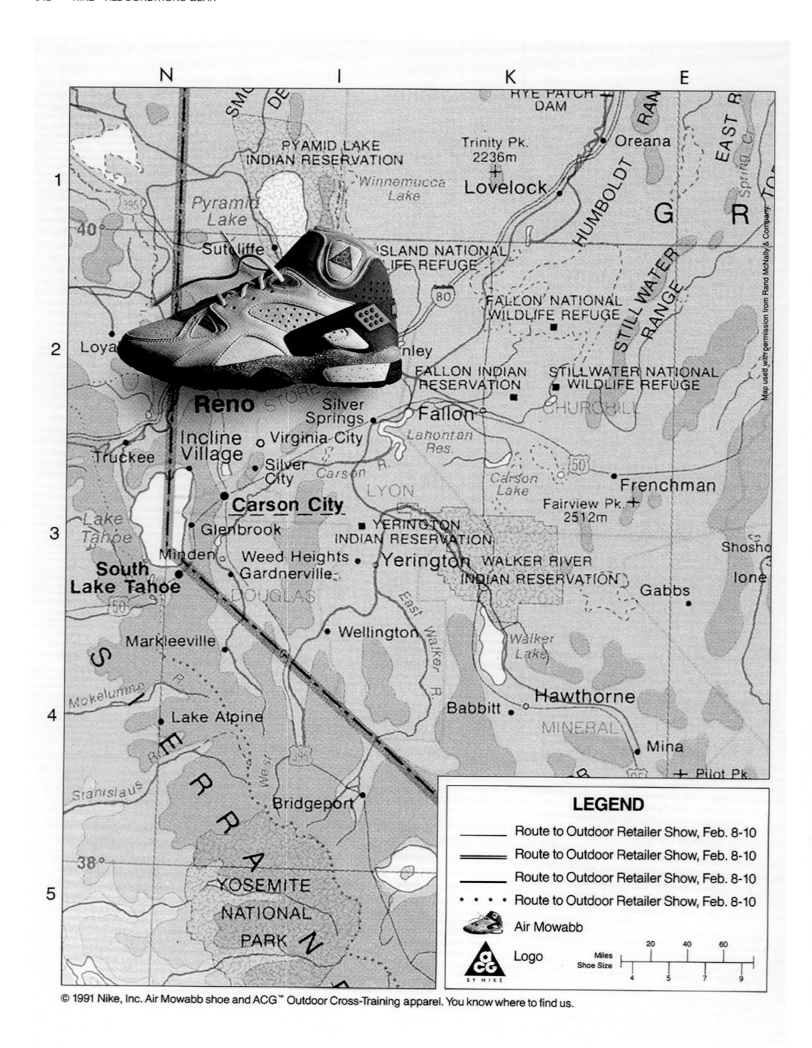

© 1991 Nike, Inc. Air Mowabb shoe and ACG™ Outdoor Cross-Training apparel. You know where to find us.

1992: Air Escape, 'Top Ten Reasons to Start Outdoor Cross-Training'

This is a rodent. It runs but never gets anywhere. It will never know the joy of darting through woods and meadows while fast-moving clouds race across a blue sky. It will live its entire life in a box. It doesn't have a choice.

1992: Air Mowabb, 'Fortunately, You Are Not a Rodent'

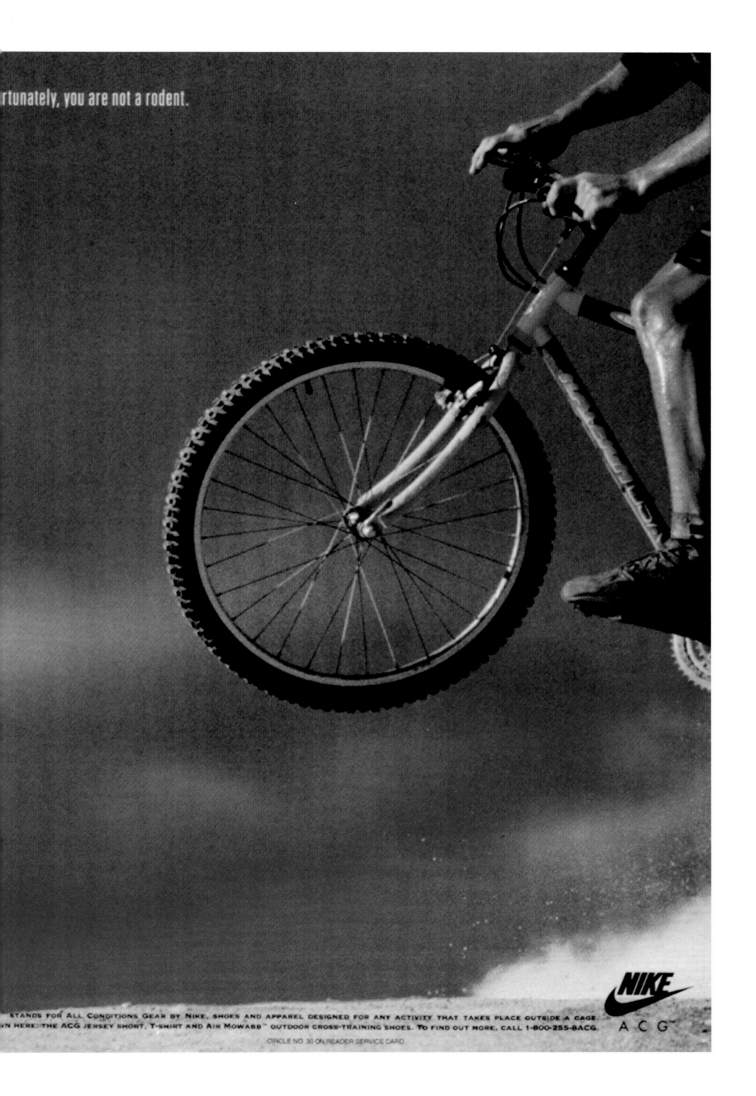

...rtunately, you are not a rodent.

NIKE

A C G™

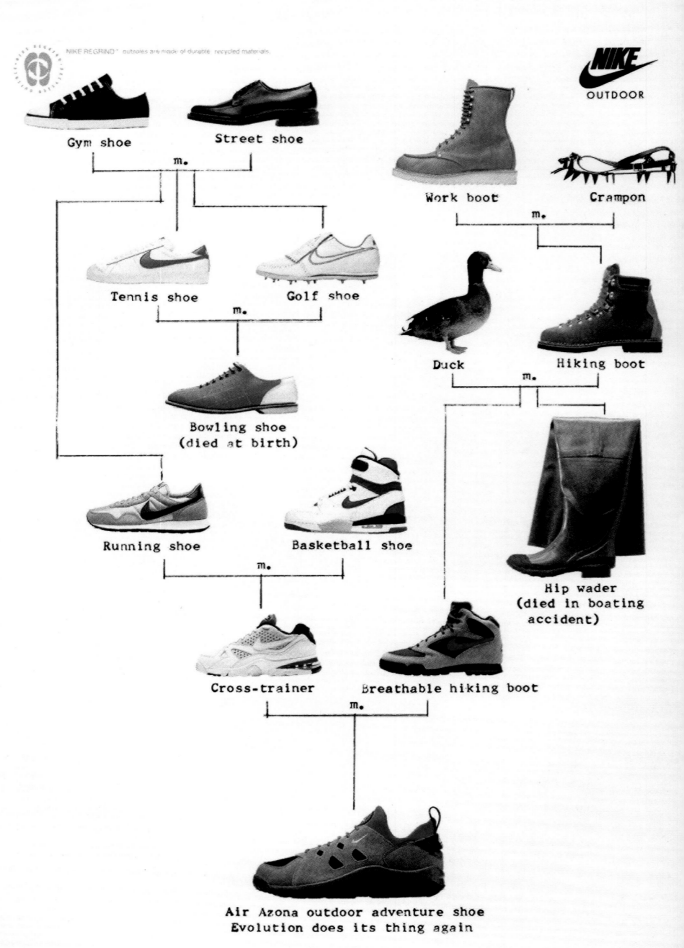

CIRCLE NO. 33 ON READER SERVICE CARD

1994: Air Azona

Surveying the land,
THE AIR RATIC APPROACH SHOE
spies a good place and hollers back,
"Follow me!"

Versatile, lightweight, and
rugged as a tractor tire,
the Air Ratic has a fancy inverted
gussetted tongue
to keep out the rubbish and a high-traction
tread grippy enough
to walk up a waterfall.
Which is where you find
a lot of good places
and not
too many
monuments.

ACG means all conditions gear

1-800-217-4588

1995: Air Ndestrukt

Some people see countryside, we see a stadium.

We've put all Nike's athletics experience into a trail-running shoe, the Air Terra Tor. It's light, flexible and cushioned, with enough grip to turn the steepest hill trail into a sprint track.

1996: Air Terra Tor, 'Some People See Countryside, We See a Stadium'

MINGLE WITH THE REST OF THE FOOD CHAIN.

LIVE LIKE THEY LIVE. SCURRY OVER ROCKS.

SPRINT INTO THE WOODS FOR NO APPARENT REASON

AND WHEN YOU'RE TIRED,

SLEEP ON THE GROUND BENEATH THE STARS.

BUT KEEP IN MIND:

SOME DON'T LIKE THEIR POSITION ON

THE FOOD CHAIN AND THEY COULD TRY TO

MOVE UP WHILE YOU'RE SLEEPING.

Legend:

The Air Harmattan backpacking boot. Nylon shank is exceptionally stiff. Phylon midsole has Air cushioning in the heel. Athletic shoe design is lightweight and breathable. Overall: people love it. And all the rest of God's creatures really couldn't care less.

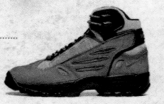

1998: Air Harmattan

WE DON'T THINK WOMEN SHOULD BE STUCK WITH A MAN'S BASKETBALL SHOE.

You don't wear men's dress shoes, why should you have to wear men's basketball shoes?

You may play with the same ball, and the same basket, on the same court, with the same intensity but you don't play in the same body.

Your feet are built different than a man's.

That's why we make a line of basketball shoes especially for women.

Like the low-cut leather Lady Bruins and Lady Bruin Hi-tops up there in the picture. Or our canvas Lady All-Courts in both hi-tops and low-cuts.

They're all designed to fit the bone structure in a woman's foot, and built with the same care for quality we give to all Nike athletic shoes.

So the next time you need a pair of basketball shoes, put your foot down.

Ask for Nike.

World Headquarters:
8285 S.W. Nimbus Ave., Suite 115
Beaverton, Oregon 97005

1978: Lady Bruin and Lady All-Court, 'We Don't Think Women Should Be Stuck With a Man's Basketball Shoe'

THE DYNASTY ON 34TH STREET.

You won't find silk uniforms, million dollar contracts, or Brent Musberger down here.

But this is where dynasties are born. In Watts, Brownsville, South Boston. Anywhere they're hammering out the fundamentals. Jamming the hoop. Crashing the boards.

If you want in this game, you've got to have three things going for you. Your hand. Your eye. And your feet.

That's where the Dynasty comes in. This new basketball shoe is lightweight. For driving and skying. With plenty of toe room and a European shell sole. For quicker cuts. Faster stops.

It's got nylon mesh. So it breathes. Full-grain leather. So it lasts.

We built the Dynasty for the toughest game in town. The kind you won't always find in your T.V. Guide.

NIKE

Beaverton, Oregon

1981: Dynasty, 'The Dynasty on 34th Street'

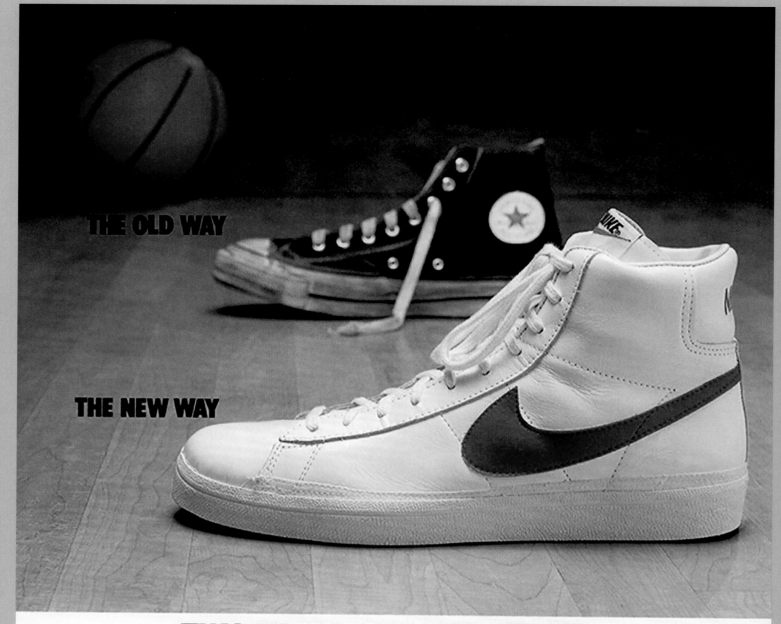

THE OLD WAY

THE NEW WAY

TWO WAYS TO GO TO COURT.

In the last 20 years a lot of things have changed about basketball.

Including shoes.

You don't have to settle for those old black and white canvas hi-tops any more.

Today more and more players are going to court wearing Nikes. Just look at the playgrounds, colleges and the NBA.

Take the Nike Franchise up there in the picture. Uppers of fine grain leather. Soles with a specially designed pattern for quick stops and sharp cuts. Light. Comfortable. And built to give extra support where you need it most.

Try the Franchise.

Or take your pick of our Blazer and Bruin models.

Nike basketball shoes.

They're made to beat the competition.

Beaverton, Oregon

1979: Franchise, 'Two Ways to Go to Court'

" Aside from a Converse All Star appearing in a Nike print ad, there's way more going on in 'Two Ways to Go to Court' than first meets the eye. The battle between both brands at this time was explosive to put it mildly. As detailed by Phil Knight in his brilliant book *Shoe Dog*, a nondescript letter he received in the late 1970s was actually a $25 million invoice for import duties, which would have bankrupted his company. The sneaker business was bareknuckle tough and Knight laid the blame squarely on political machinations instigated by his rivals at Converse. After intense lobbying and a costly legal battle, the case was settled. Fast forward to 2003, when Converse is acquired by Nike for $305 million. Today, Converse turn over $2 billion, making the deal an absolute bargain. Phil Knight has a famously long memory and this surely must have been the ultimate payback. "

Woody
'Nike Versus Converse'
Sneakerfreaker.com (2019)

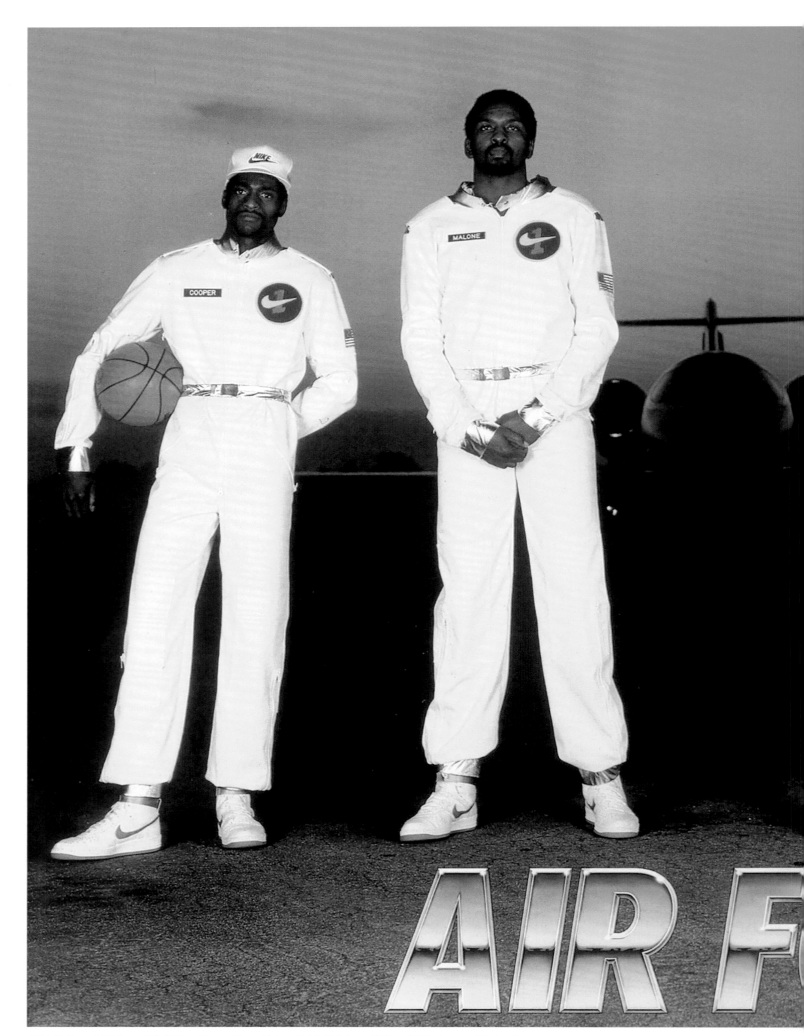

1982: Air Force 1, 'Air Force 1', ft. Michael Cooper, Moses Malone, Calvin Natt, Jamaal Wilkes, Bobby Jones and Mychal Thompson

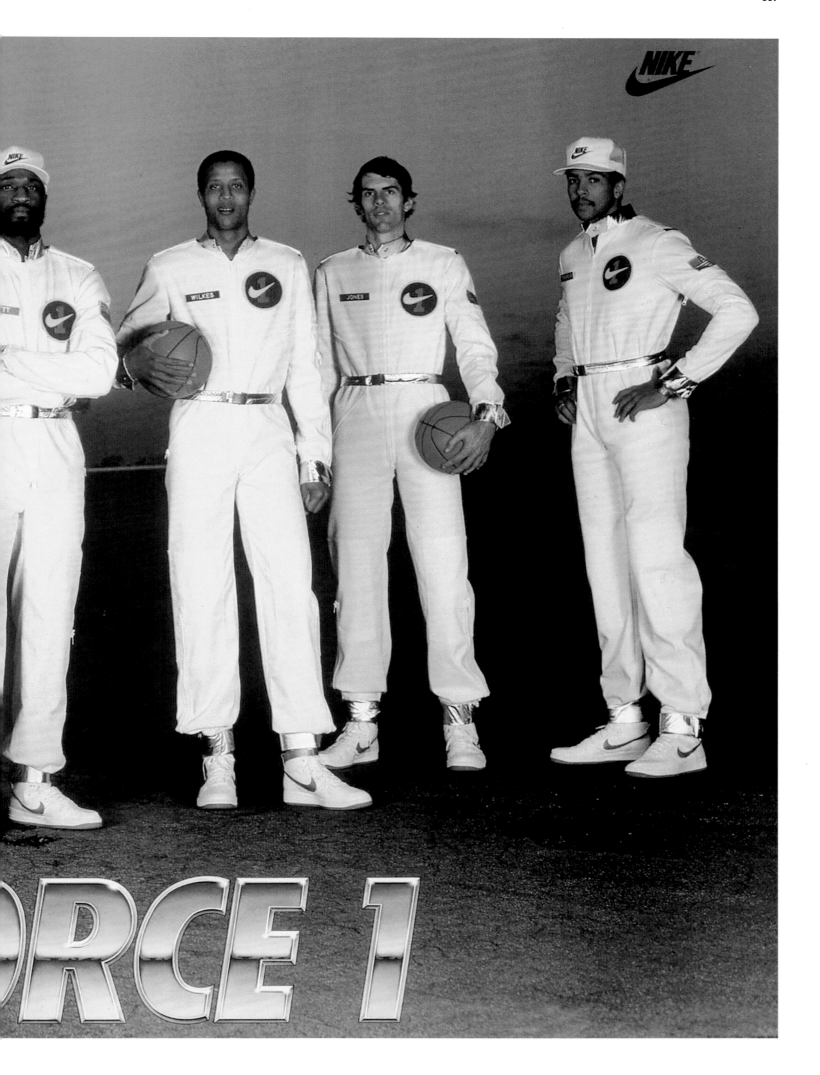

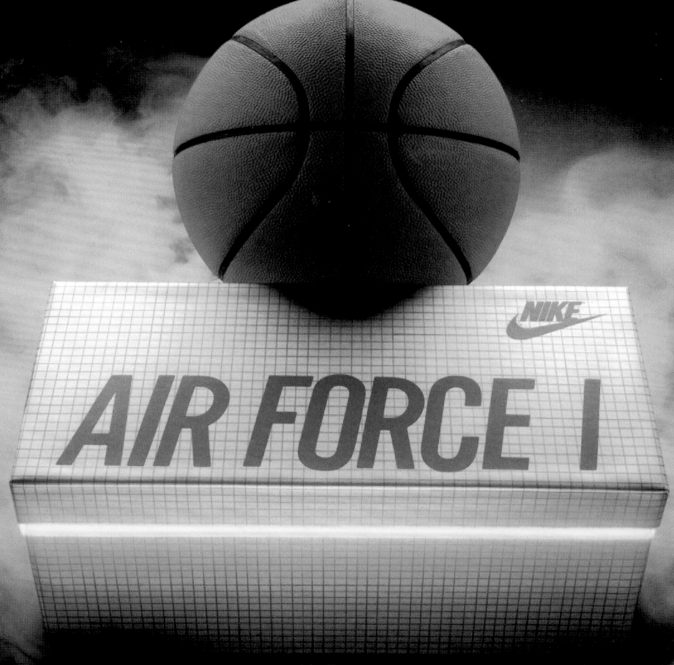

STARTING THIS SEASON, AIR WILL BE SOLD BY THE BOX.

Air Force I.
A shoe so revolutionary, the game of basketball may never be the same.

1983: Air Force 1, 'Starting This Season, Air Will Be Sold by the Box'

" When the Air Force 1 arrived, it was far above and beyond everything that had already come out as a ball sneaker. It wasn't a fashion statement. I didn't wear Air Force 1s to chill off the court. If you compare them to the Nike Legend or Blazer, or even a PUMA Clyde or adidas Shelltoe, Air Force 1s were a lot bulkier. The power of them on the court was so strong that eventually they got their dues as casual shoes. I always expected they would have a long life as a basketball sneaker just because the Air technology was so ridiculously different to anything else that came out, but I would never have guessed in 1983, when I got my first pair, that they would become the whirlwind that they have. **"**

Bobbito Garcia
25th Anniversary Air Force 1 Zine
Sneaker Freaker (2007)

PERMAFOAM SOCKLINER:
Molds to pressure pattern of foot for personalized fit.

FULL-GRAIN LEATHER UPPER

HINGED EYELET:
For better ankle mobility.

VARIABLE WIDTH LACING SYSTEM:
Adjustable for a snug, comfortable fit.

DIPPED ACHILLES PAD:
To prevent irritation of Achilles tendon.

SPENCO REARFOOT PADDING:
Provides heel security, while cushioning and protecting Achilles tendon.

PROPRIOCEPTUS BELT:
Exerts slight pressure to the base of the tibia and fibula so the body can monitor ankle joint positioning and decrease chance of injury.

CONCENTRIC CIRCLE OUTSOLE:
For optimum traction and minimal resistance on the pivot.

NIKE-AIR MIDSOLE:
Provides up to 30% more cushioning than conventional midsoles. Reduces impact on muscles and joints. Helps reduce leg fatigue.

AIR FORCE 1™

NIKE

Beaverton, Oregon

1982: Air Force 1, 'Air Force 1'

THEY'LL EITHER BE ON YOUR FEET OR IN YOUR FACE.

The Big Nike. Available in just about any color under the hoop.*

Black and maroon not shown. Beaverton, Oregon

1986: Big Nike, 'They'll Either Be on Your Feet or in Your Face'

NOW YOU CAN HAVE NIKE BASKETBALL SHOES IN YOUR TEAM COLOR.

Introducing Nike "Jock Stock" basketball shoes.
They have a neutral suede swoosh that can be
colored with *permanent* markers in any color you wish.
And they come in either hi or lowtop.

c.1985: Jock Stock, 'Now You Can Have Nike Basketball Shoes in Your Team Color'

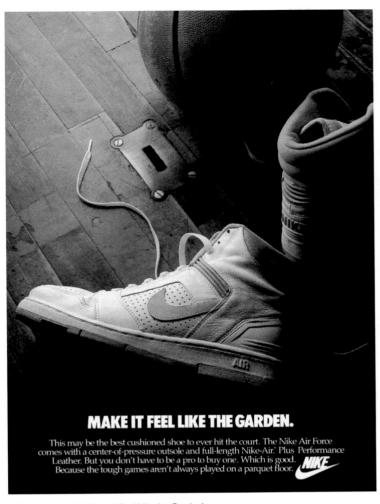

MAKE IT FEEL LIKE THE GARDEN.

This may be the best cushioned shoe to ever hit the court. The Nike Air Force comes with a center-of-pressure outsole and full-length Nike-Air.® Plus Performance Leather. But you don't have to be a pro to buy one. Which is good. Because the tough games aren't always played on a parquet floor.

1986: Air Force 2, 'Make It Feel Like the Garden'

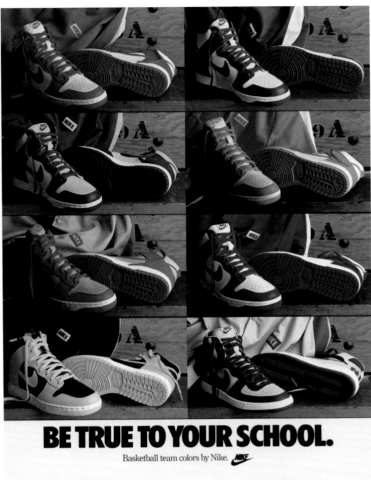

BE TRUE TO YOUR SCHOOL.

Basketball team colors by Nike.

1985: Dunk High and Terminator, 'Be True to Your School'

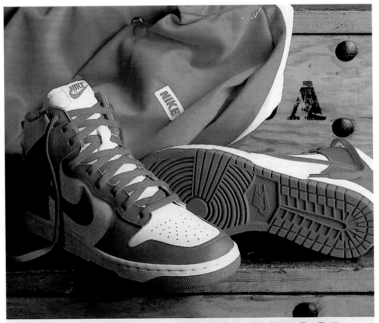

BE TRUE TO YOUR SCHOOL.

Georgia Colors will be available this Spring at these Nike Dealers:

Athlete's Foot	Footlocker
All Locations	Athens, GA
Athletic Club	Union City, GA
Atlanta, GA	Atlanta, GA
Big Sky Shops	Savannah, GA
Duluth, GA	Duluth, GA
Bulldog's Sptg. Goods	Augusta, GA
Athens, GA	Decatur, GA
Lamar Lewis	Columbus, GA
Athens, GA	
Sport Shoe	
Atlanta, GA	

1985: Dunk High, 'Be True to Your School'

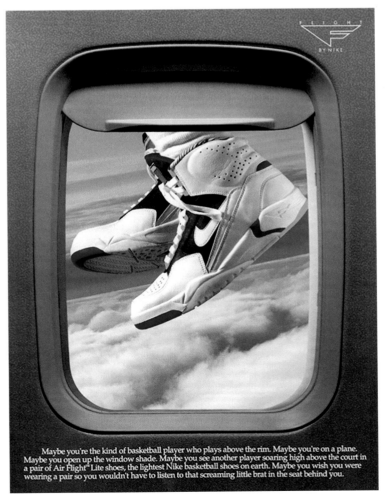

Maybe you're the kind of basketball player who plays above the rim. Maybe you're on a plane. Maybe you open up the window shade. Maybe you see another player soaring high above the court in a pair of Air Flight™ Lite shoes, the lightest Nike basketball shoes on earth. Maybe you wish you were wearing a pair so you wouldn't have to listen to that screaming little brat in the seat behind you.

1991: Nike Air Flight Lite

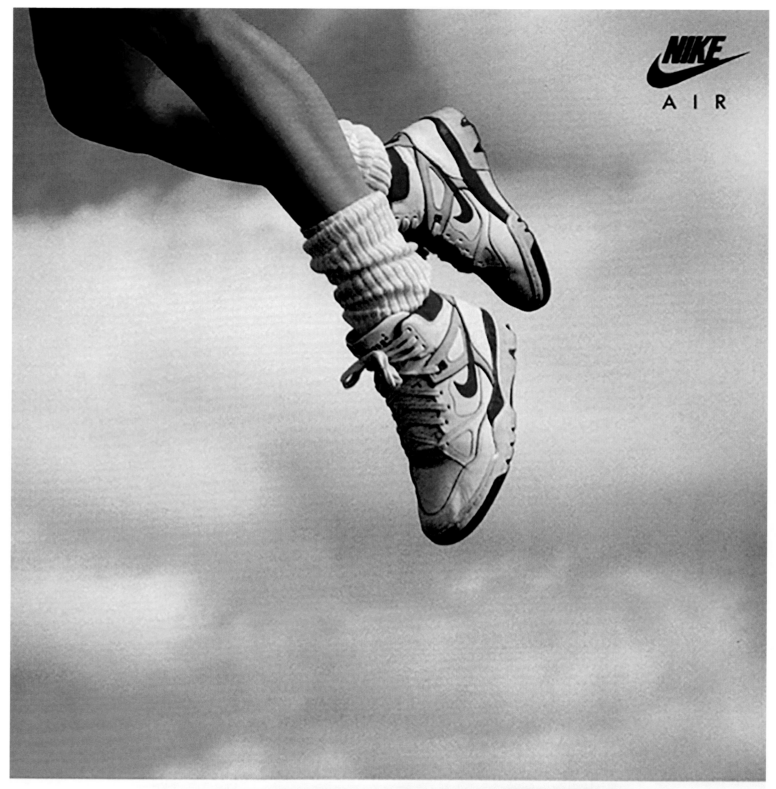

WHO SAID WOMAN WAS NOT MEANT TO FLY.

The Women's Nike Air Force III. It's supportive. It's comfortable. And it fits on a woman's foot like no other basketball shoe. All because it's designed specifically for a woman. More specifically, for a woman who has no fear of flying.

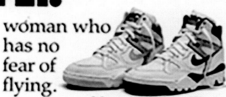

Women's Air Force III

1988: Air Force III, 'Who Said Woman Was Not Meant to Fly'

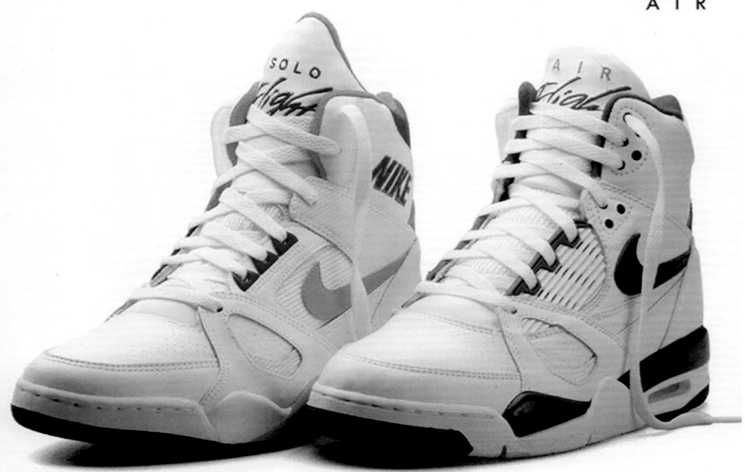

1990: Flight Series, 'Zero Gravity'

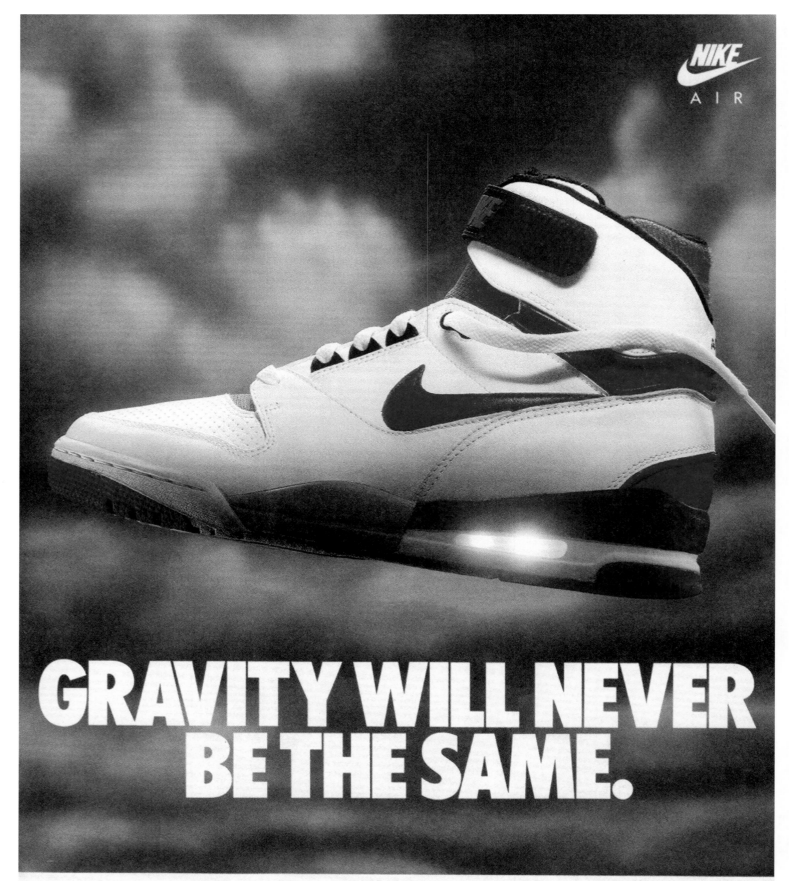

The Air Revolution from Nike. It comes with Nike-Air® cushioning, great stability, and a warning: If you're afraid of heights, buy another basketball shoe.

1988: Air Revolution, 'Gravity Will Never Be the Same'

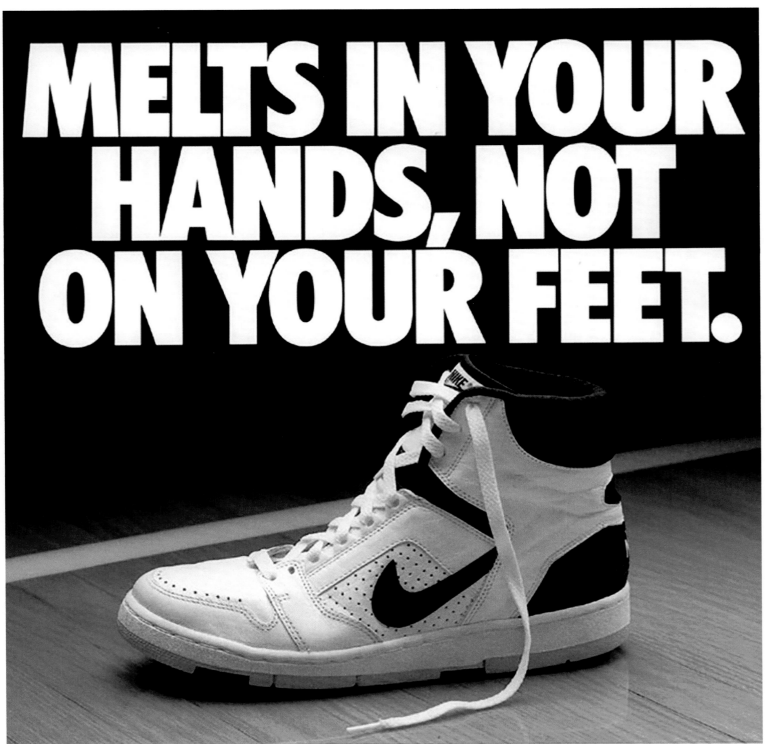

MELTS IN YOUR HANDS, NOT ON YOUR FEET.

Leather so soft, so supple, it feels as if you've worn it forever. From the first day you put it on.

We're not talking about garment leather. Garment leather would be fine if you didn't plan on anything more strenuous than a cocktail party.

But the Nike Air Force is headed to the pros. Where a shoe that stretches, a shoe that blows out, is a shoe that is benched. Permanently.

That's why we developed Performance Leather. From select Western hides. With fibers chemically and mechanically treated to both strengthen and soften. It's an exclusive with Nike.

And once you put it on, it'll be an exclusive with you.

NIKE
Beaverton, Oregon

PERFORMANCE LEATHER

1989: Air Force, 'Melts in Your Hands, Not on Your Feet'

NIKE
AIR

THE SALESMAN SAYS "HERE'S THE PUMP THAT PRESSURIZES THE ANKLE COLLAR IN THE NEW NIKE AIR PRESSURE BASKETBALL SHOE" SO HE STARTS PUMPING AND YOU LAUGH AND SAY "BIIIIG DEAL" BUT HE KEEPS PUMPING IT UP AND ALL OF A SUDDEN THE SHOE STARTS MOLDING TO YOUR ANKLE AND YOUR WHOLE FOOT'S FEELING GREAT AS HE KEEPS PUMPING AND YOU'RE SURE NOT LAUGH- ING NOW HUH?

The Air Pressure from Nike. The world's first basketball shoe with a customized fit system.

1989: Air Pressure

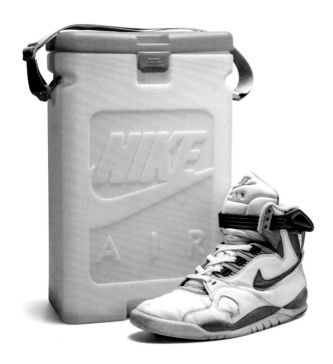

" While Nike's Air Pressure never came close to the popularity of Reebok Pump, there's one thing it had over its rival – a skyscraping sneaker box! Rocking up to the blacktop with this futuristic unit casually slung over your shoulder made you a king on court, though the kooky handheld apparatus must have been a deflating experience compared to Pump's cool-AF tongue widget. Nearly three decades later, original Air Pressures have all succumbed to dreaded sneaker rot but the plastic boxes have generally survived the journey. In 2016, out of nowhere, the Air Pressure finally received a retro release – big box included – and its adjusted-for-inflation price tag of $300 once again left it out of reach for all but the most diehard Nikeheads. "

Woody
'Box Fresh'
Sneaker Freaker, issue 37 (2017)

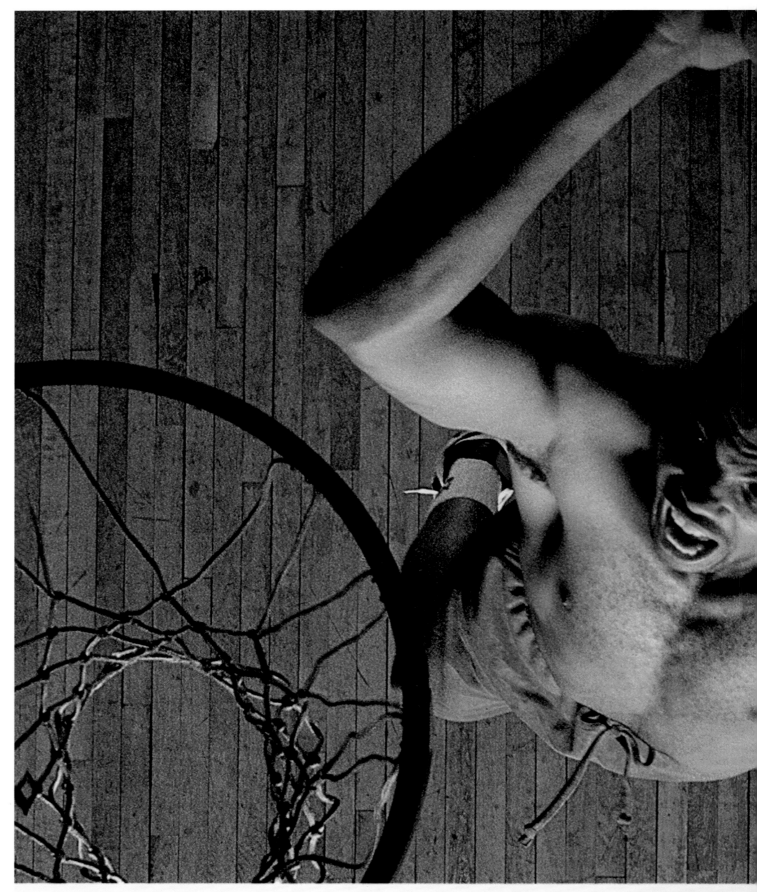

AIR

The Force Series from Nike. When it absolutely,

1988: Air Force III and Air Alpha Force, 'Air Freight', ft. Charles Barkley

371

IGHT.

has to be in someone's face.

Air Force III

Air Alpha Force

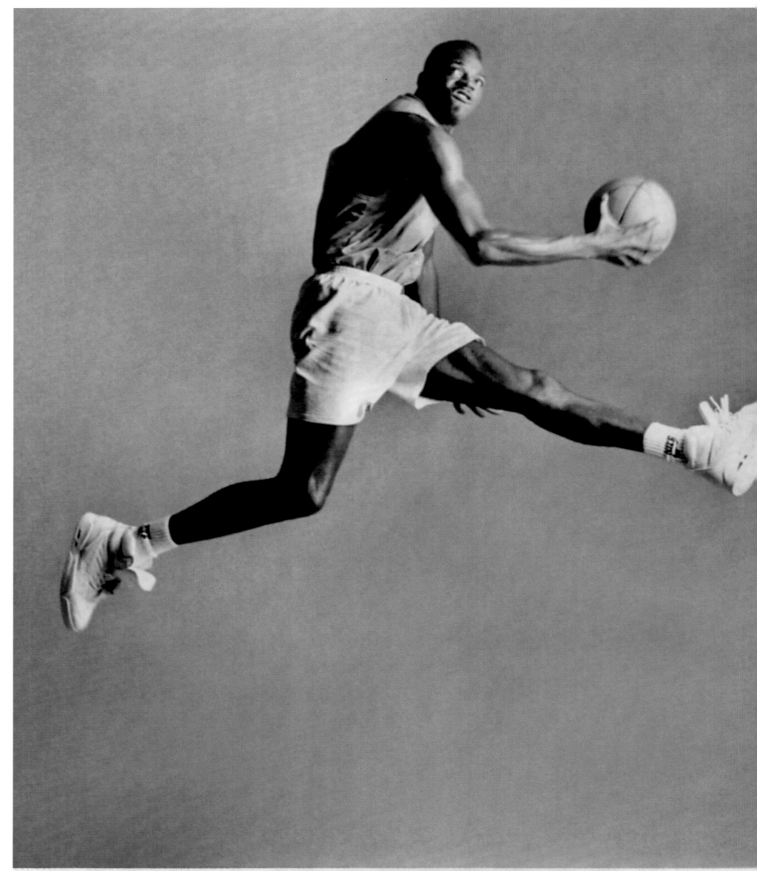

YOU CAN GO OVER THEM OR YO

Look up, it's New York's Gerald Wilkins and the Air Flight from Nike. Lool

1989: Air Flight '90 and Air Force STS, 'You Can Go Over Them or You Can Go Through Them', ft. Gerald Wilkins and Charles Barkley

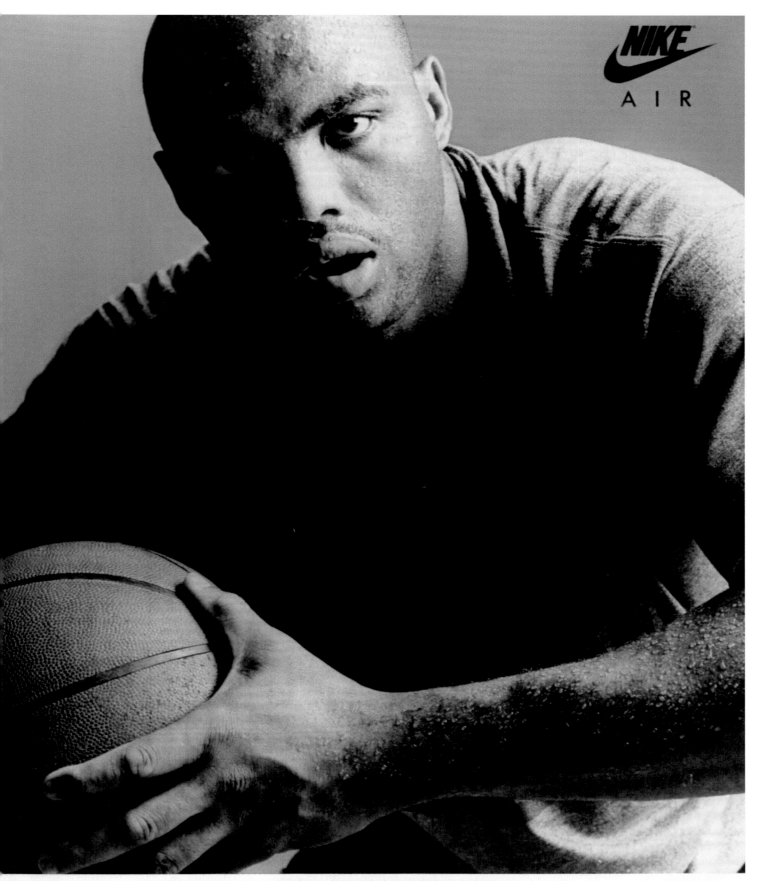

AN GO THROUGH THEM.

'hiladelphia's Charles Barkley and the Air Force from Nike.

Air Flight '90 *Air Force STS*

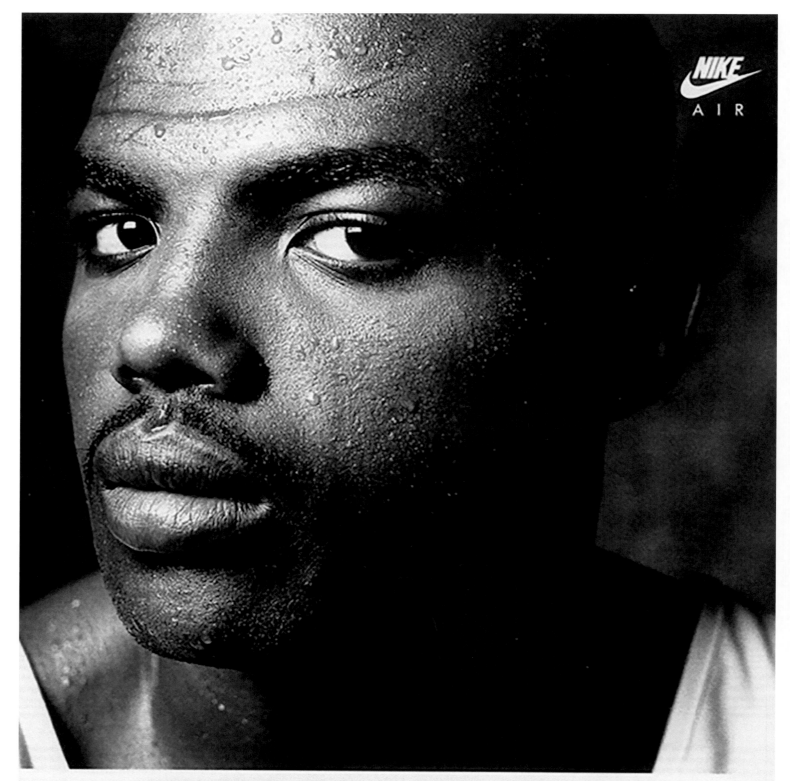

THE MEEK MAY INHERIT THE EARTH, BUT THEY WON'T GET THE BALL.

Just ask Charles Barkley. That's why he likes the Nike Air Force. Especially the cushioning of full-length Nike-Air.® The traction from the Center-of-Pressure™ outsole. And when the league's toughest rebounder thinks the Nike Air Force is the best shoe under the hoop, who's gonna argue?

1989: Air Force, 'The Meek May Inherit the Earth, but They Won't Get the Ball', ft. Charles Barkley

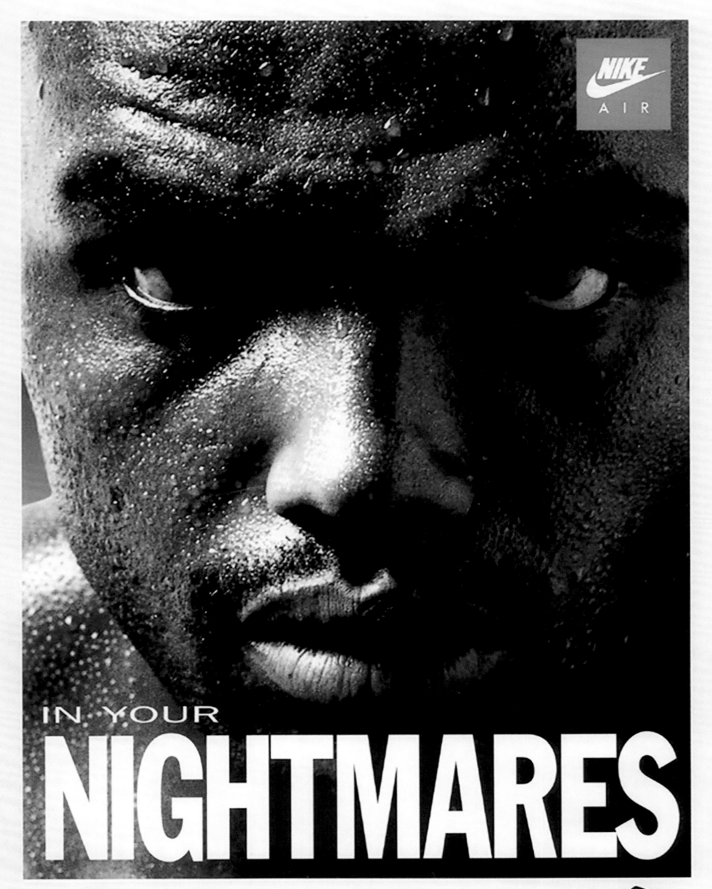

NIKE
AIR

IN YOUR
NIGHTMARES

He's big, he's brooding, he's strong, he's Charles Barkley. And he's wearing the toughest basketball shoes Nike makes, the Air Force Max™. With 35% more visible air, steel-mesh reinforced strapping and extraordinary fit to help you stand your ground. Better hope you wake up soon.

1993: Air Force Max, 'In Your Nightmares', ft. Charles Barkley

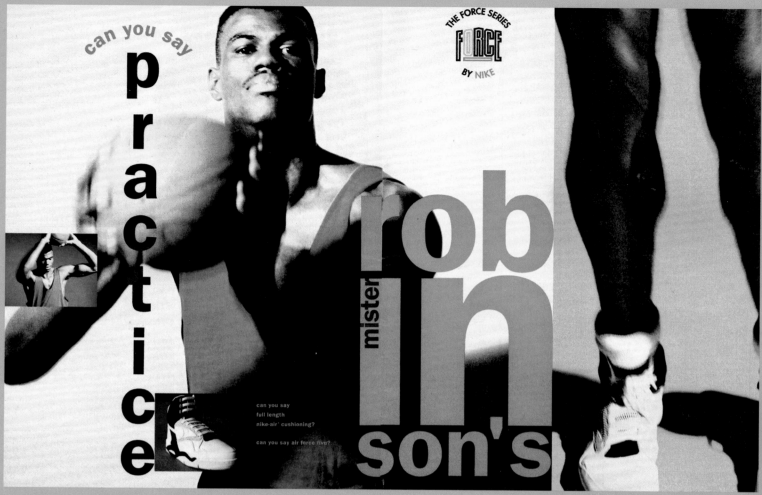

1990: Air Command Force, 'Can You Say Practice Mister Robinson's', ft. David Robinson

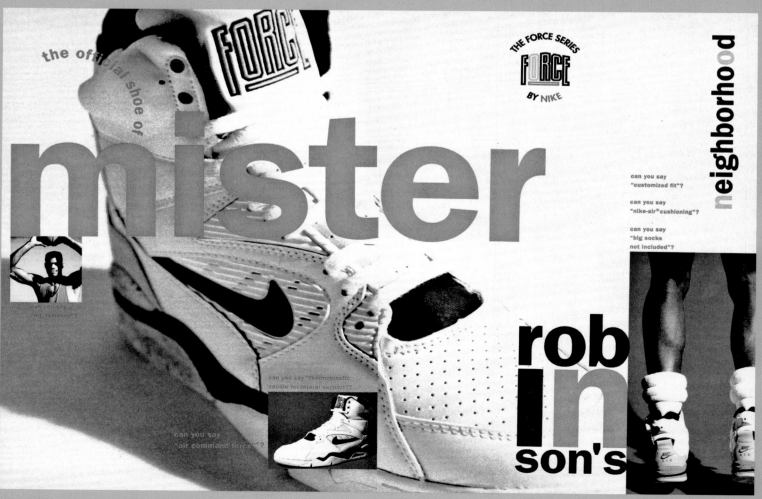

1990: Air Command Force, 'The Official Shoe of Mister Robinson's Neighborhood', ft. David Robinson

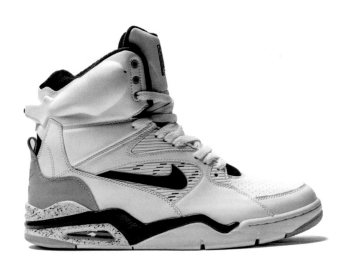

" Signed in 1988 on a five-year deal reportedly worth $1 million, David Robinson slotted perfectly into the Nike Force line-up. His boyish charisma was the perfect foil to Charles Barkley's innate bad-boyism, which Wieden+ Kennedy parlayed brilliantly into the 'Neighborhood' TV campaign. Nicknamed 'The Admiral', on account of his previous life studying maths in the US Navy, Robinson forged a superlative career. A pair of Olympic Gold medals, 2 NBA Championships and 10 times NBA All-Star speaks for itself. However, it was a big-screen cameo that sealed the Air Command Force's pop culture immortality. These ain't just Robinson's Nikes anymore, they're Billy Hoyle's, as played by streetballer Woody Harrelson in the 1992 celluloid classic *White Men Can't Jump*. "

Woody
'The Admiral is Back'
Sneaker Freaker, issue 31 (2014)

WHAT DOES A 6'5", 270 LB. DEFENSIVE LINEMAN DO FOR A WORKOUT?

1987: Air Trainer, 'What Does a 6'5", 270 lb. Defensive Lineman Do for a Workout?',
ft. Howie Long (1 of 4)

WHICH IS PRETTY MUCH WHAT A 5'5", 119 LB. TRIATHLETE DOES.

So Howie Long and triathlete Joanne Ernst aren't exactly the same size. But they cross-train for exactly the same reason:

To become better athletes.

More specifically, to become better competitors in their respective sports.

By the very nature of her sport, Joanne Ernst is the quintessential cross-trainer.

There's no question all of the swimming, running, and cycling do wonders for her aerobic well-being. But supplemental weight training builds her strength like nobody's business.

And that makes her a more complete athlete.

Not to mention a more successful one.

The key for both of these athletes is balance. Howie Long does a lot more than hit the weights. He runs, stretches, and plays basketball to increase his aerobic fitness and agility. All of which have helped make him one of the quickest defensive linemen in the game.

You've learned what cross-training does for two of the world's best athletes...

1987: Air Trainer, 'Which is Pretty Much What a 5'5", 199 lb. Triathlete Does', ft. Joanne Ernst (2 of 4)

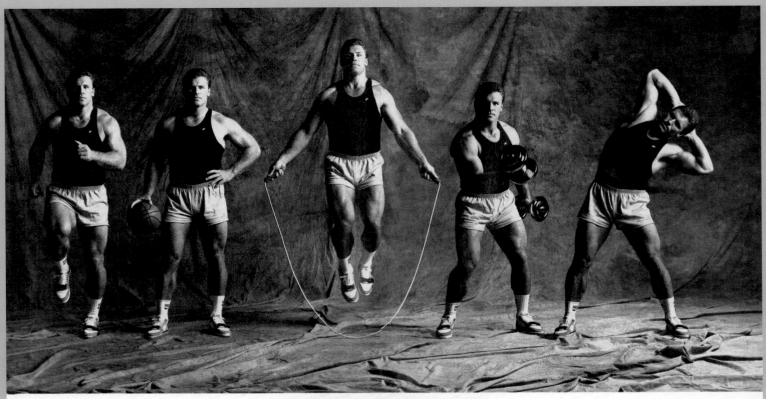

ANYTHING HE WANTS.

Los Angeles Raider defensive end Howie Long doesn't spend every waking minute wreaking havoc on opposing quarterbacks.

That particular joy is reserved for a few Sunday afternoons a year.

Instead, like many athletes, Mr. Long cross-trains.

And what's that?

A fitness regimen that may include running, weight training, aerobics, basketball, racquetball or any number of court sports.

Cross-training is a way for you to add balance to your workout. So you don't get burned out on one sport. So muscles and tendons a one-sport workout wouldn't reach can be developed.

This balance reduces your chance of injury because all the stress isn't concentrated on a single group of muscles, tendons, or joints.

We think cross-training can do a lot for an athlete.

But you don't have to take our word for it.

Just ask any of the quarterbacks who have to face Howie Long.

They know.

1987: Air Trainer, 'Anything He Wants', ft. Howie Long (3 of 4)

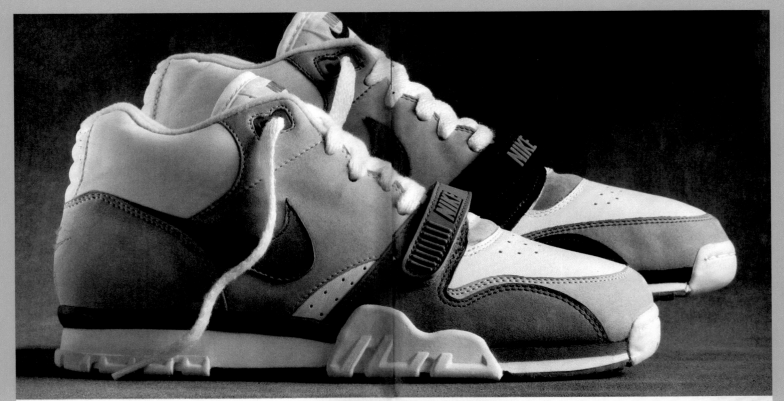

NOW IT'S YOUR TURN.

What we've been trying to tell you is simple: Man does not live by one sport alone. And neither does woman. So get out there and cross-train. And do it in the Nike Air Trainer. It's the first shoe designed for cross-training.

And the first one that can handle the demands of any cross-training program without giving up one iota of comfort or protection.

The Air Trainer has ample support and cushioning for a three to five mile run or any aerobics class—activities where proper cushioning is needed to lessen your chance of injury.

And nothing cuts those chances like Nike-Air® cushioning. It reduces your odds of a shock-related injury to the bones, muscles, and tendons of the lower leg.

But the Air Trainer is stable enough for any court sport. A wide forefoot and a unique footframe hold your foot in place during any and all lateral movements.

With the Air Trainer, it's apparent we have the right shoe for cross-training.

You bring the right attitude.

1987: Air Trainer, 'Now It's Your Turn' (4 of 4)

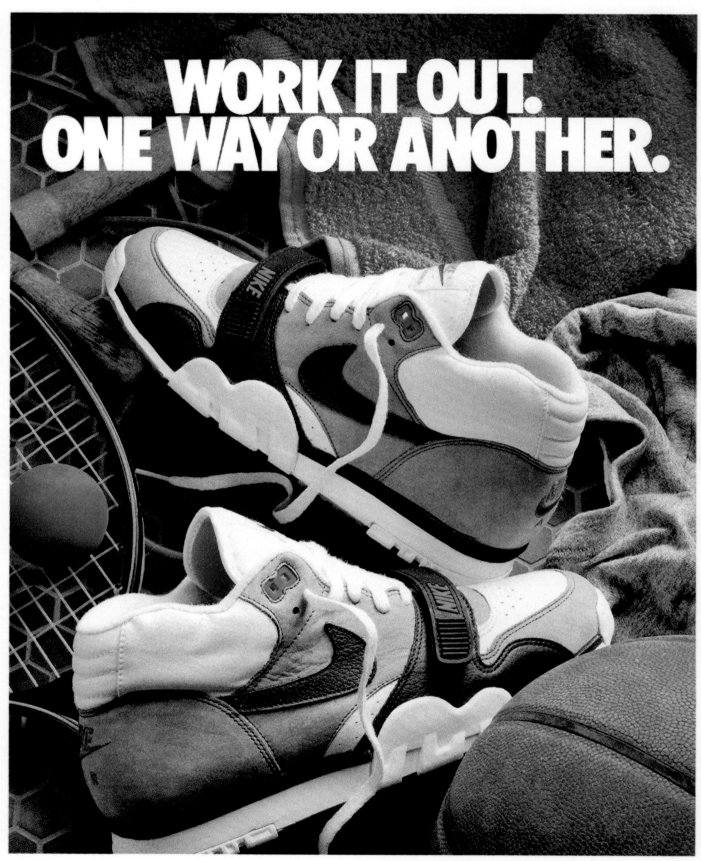

WORK IT OUT.
ONE WAY OR ANOTHER.

More and more, people are turning to cross-training. With workouts that include not only running, but weight training, basketball and other court sports. So Nike has specifically designed a shoe to meet the requirements of all these sports. The Air Trainer.

Flexible enough for quick cuts or sudden stops. Stable enough for the court. And Nike-Air® cushioning to reduce the impact you make under every condition. Cushioning that never wears down. Never gives in.
The Air Trainer. Now you can do it all. And do it well.
Come to the Stripes.

NIKE AIR

1987: Air Trainer, 'Work It Out. One Way or Another'

1987: Air Trainer 1 (owned by John McEnroe)

“ A company out of Finland made these amazing speakers that were green and white and chrome, so that's where the original colourway came from. The Air Trainer was the most memorable project I ever worked on. It was never intended to be shown to John McEnroe. 'What's this?' he says, 'I'm gonna wear this!' and we were like 'Wait a minute, you're not supposed to, here's a whole bunch of other stuff!' This was 1987 maybe. Anyway, he wore it and people just went WHOA! It caused some nerve ends to pop in the market that's for sure. Sometimes you just get lucky right? ”

John Barbour
Nike Genealogy Book
Sneaker Freaker (2014)

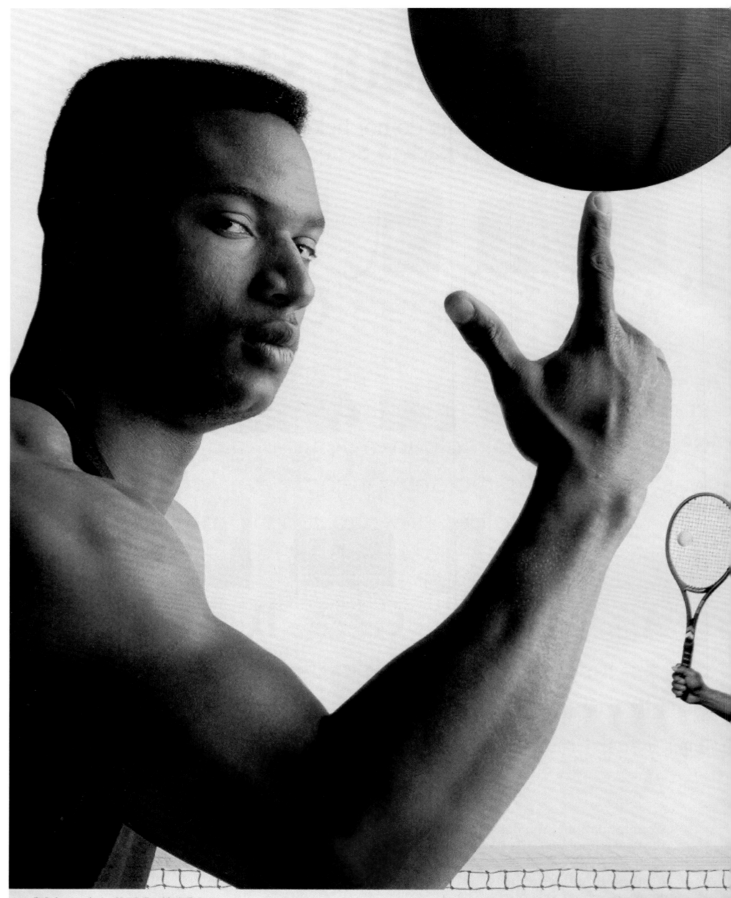

Bo Jackson, professional baseball and football player.

THE JA

See Bo cross-train. See Bo cross-train in a shoe with Nike-Air® cushioning and plenty of sup

For further information on Nike Cross-Training products call 1-800-344-NIKE, Monday through Friday, 7am-5pm Pacific Time.

1989: Air Trainer SC, 'The Jackson 5', ft. Bo Jackson

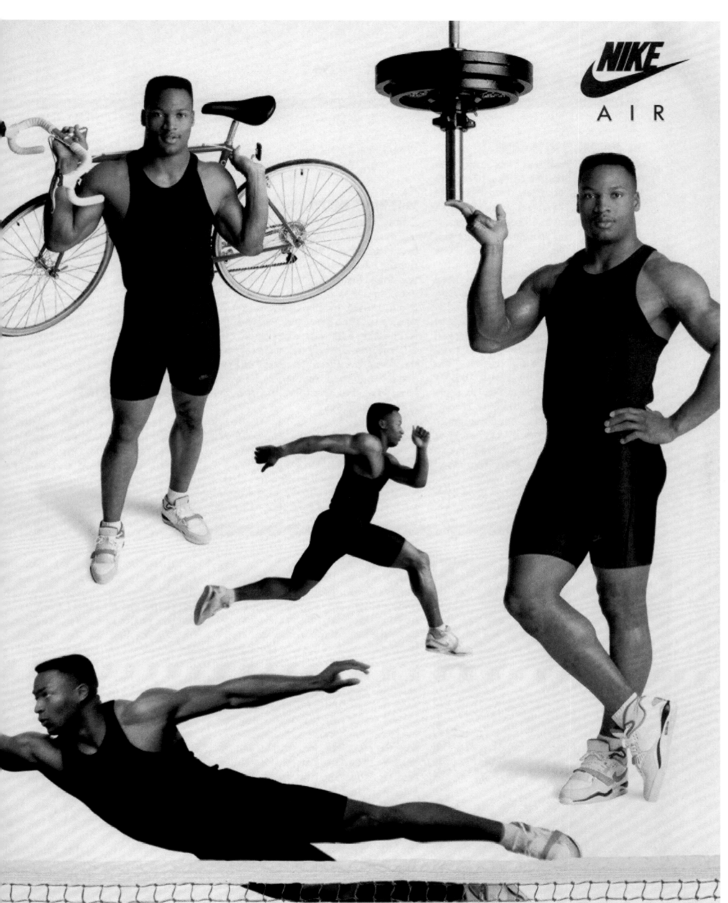

SON 5.

Bo cross-train in the Air Trainer SC. See if you can do everything Bo can do in it.

Air Trainer SC

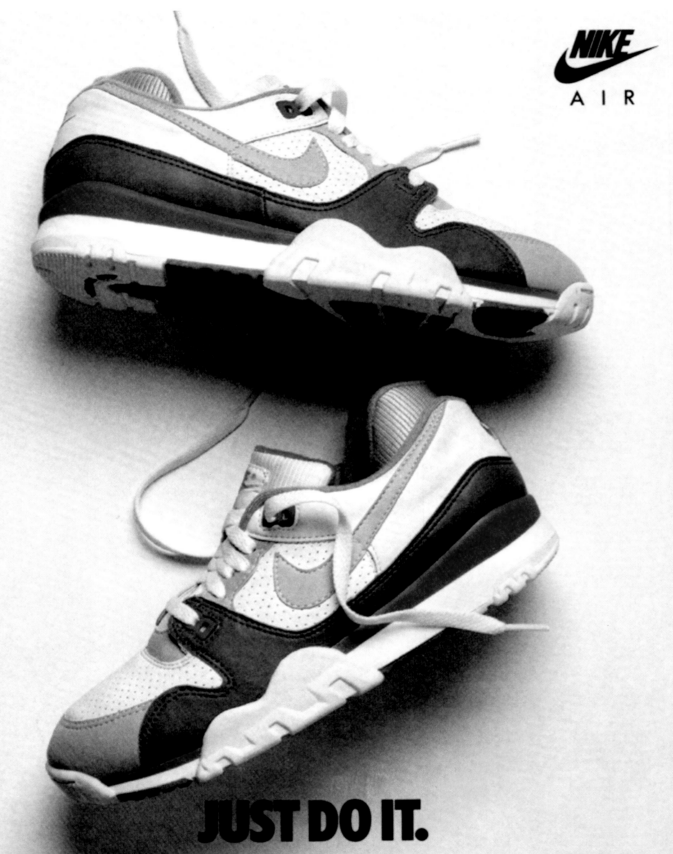

JUST DO IT.

Now you know all about cross-training.
Now you need to know about the one shoe designed specifically for cross-training:
The Nike Air Trainer TW. It has Nike-Air.® It's supportive. It's stable. It's washable.
Now what all that means: You can run in it. You can walk in it. You can lift weights
in it. You can play volleyball in it. You can play tennis in it. You can ride a bike in it.
And yes, you can even do aerobics in it.

So, you want to learn more about cross-training and Nike cross-training shoes. So call toll-free: 1-800-344-NIKE (7 am to 5 pm Pacific Time).
So you don't have a phone, so write: Nike Consumer Relations, 9000 SW Nimbus, Beaverton, OR 97005.

1988: Air Trainer TW, 'Just Do It'

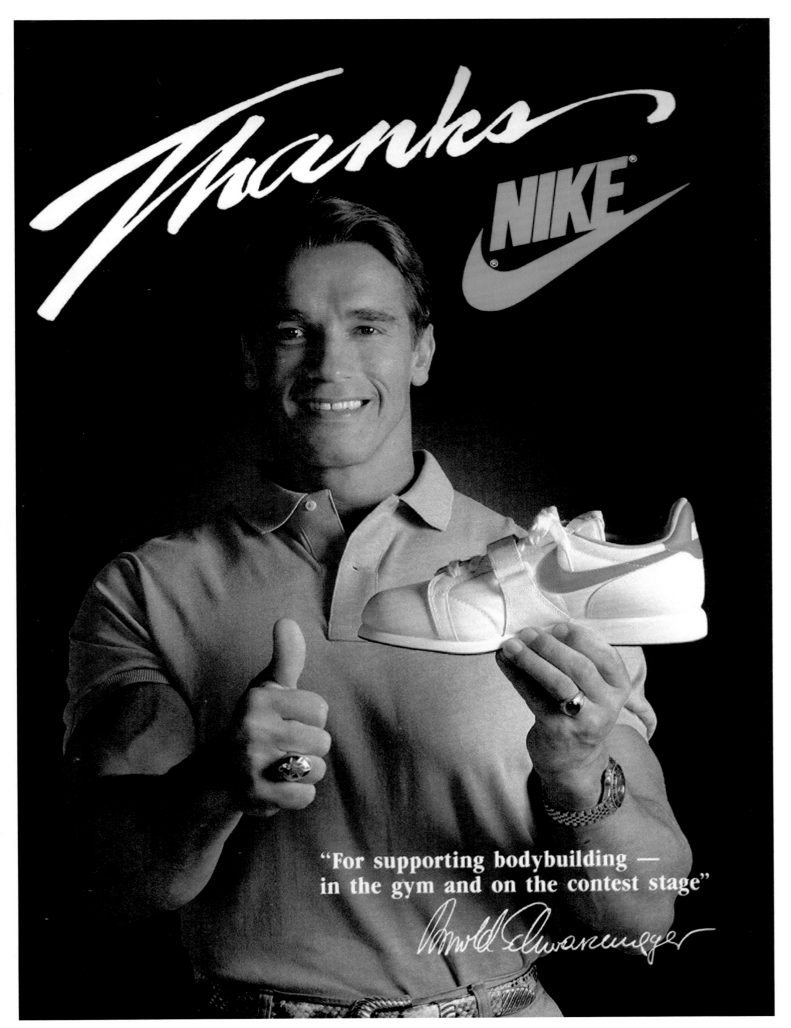

1987: 'Thanks Nike', ft. Arnold Schwarzenegger

1988: Air Trainer

The Nike Air Trainer is designed for everything from basketball to running. In other words, it's a cross-training shoe.

And it features Nike-Air® cushioning. Cushioning that not only reduces your chance of shock-related injury to the bones, muscles, and tendons of the foot and lower leg, but cushioning that can actually reduce the muscular energy it takes to jump or run.

But all this cushioning isn't at the expense of stability. The Air Trainer's wide forefoot and special footframe hold your foot snugly in place during cuts, pivots, starts and stops.

This shoe is for real. Use it accordingly.

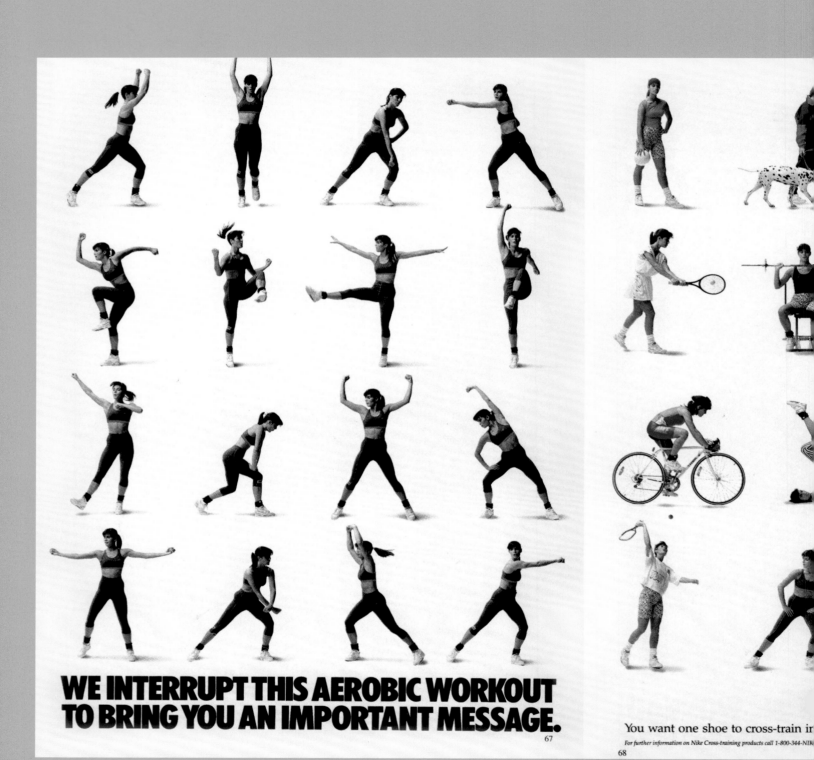

WE INTERRUPT THIS AEROBIC WORKOUT TO BRING YOU AN IMPORTANT MESSAGE.

67

You want one shoe to cross-train in

For further information on Nike Cross-training products call 1-800-344-NIKE

68

1989: Air Cross Trainer Low and Air Trainer SC, 'Cross-Training is More Aerobic Than Aerobics'

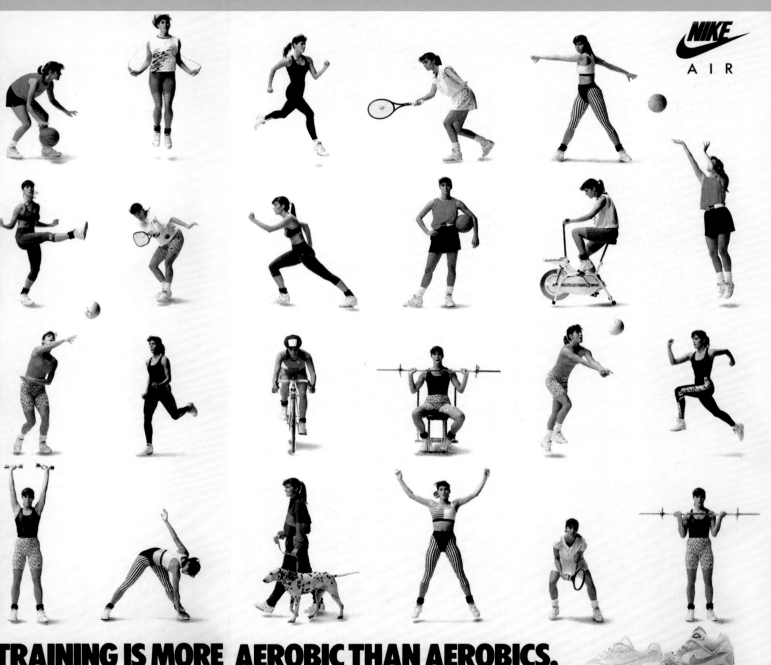

TRAINING IS MORE AEROBIC THAN AEROBICS.

be with Nike-Air.® You want a shoe like the Nike Air-Trainer® SC. Do you always get everything you want?

Time). In Canada call 1-800-663-1AIR. Just do it. Air Cross Trainer Low and Air Trainer® SC

November 1989, Glamour 69

IF BO JACKSON TAKES UP ANY M

Who says Bo has to decide between baseball and football? We encourage him to tak
the Nike Air Trainer SC. A cross-training shoe with plenty of cushioning and sup

For information on starting your own cross-training program, write: Nike Fitness, 9000 S.W. Nimbus Dr., Beaverton, OR 97005 or phone 1-800-344-NIKE.

1989: Air Trainer SC, 'If Bo Jackson Takes Up Any More Hobbies, We're Ready', ft. Bo Jackson

E HOBBIES, WE'RE READY.

rything from basketball to cycling. And to train for them all in
a number of sports. Or should we say, a number of hobbies?

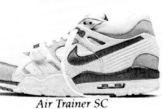

Air Trainer SC

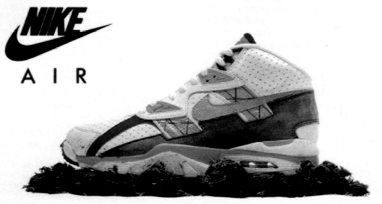

The Kentucky Derby

The Stanley Cup

The Indy 500

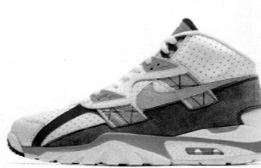

The French Open

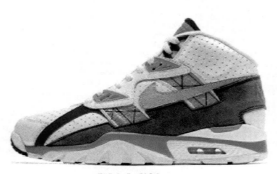

Weightlifting

Fly Fishing

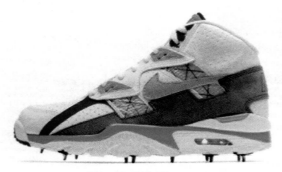

The British Open

The New York Marathon

CAN ANYONE

Can we talk about the Nike Air Trainer®SC? It has Nike-Air.® It has flexibility. It has latera

1990: Air Trainer SC, 'Can Anyone Fill Bo's Shoes?'

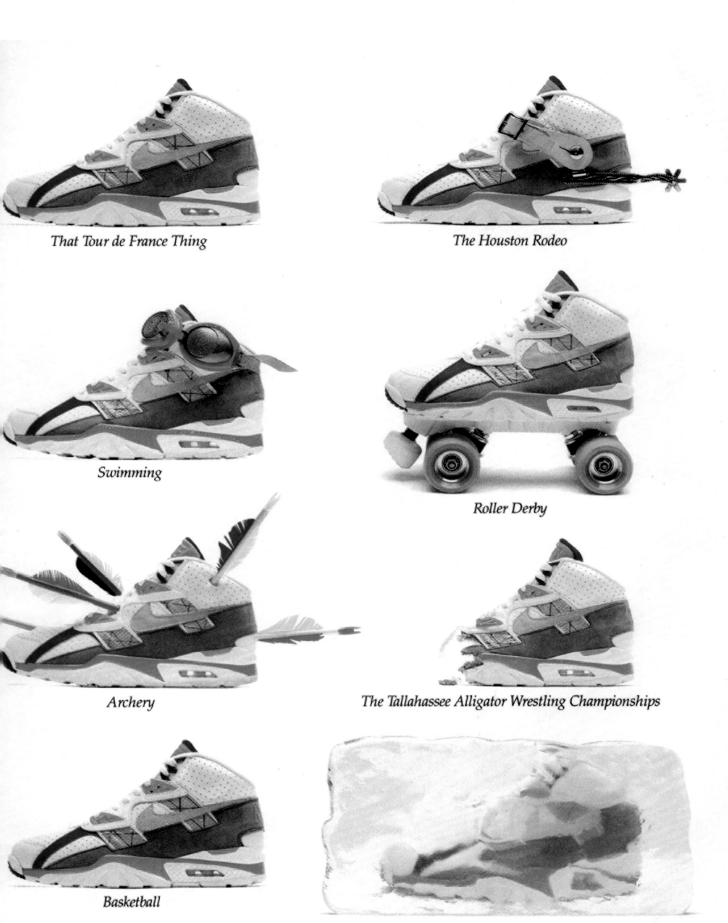

That Tour de France Thing

The Houston Rodeo

Swimming

Roller Derby

Archery

The Tallahassee Alligator Wrestling Championships

Basketball

The Iditarod

BO'S SHOES?

It has lots of fancy colors. It has your name on it. If that name happens to be Bo Jackson.

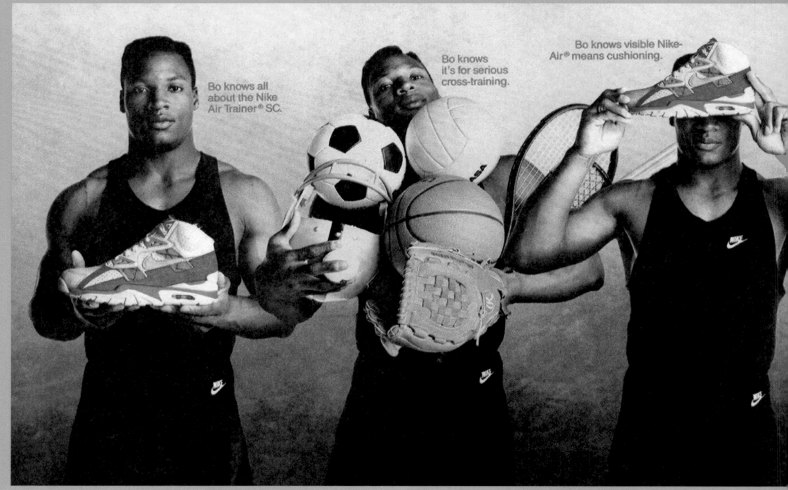

1990: Air Trainer SC, 'Bo Knows', ft. Bo Jackson (1 of 2)

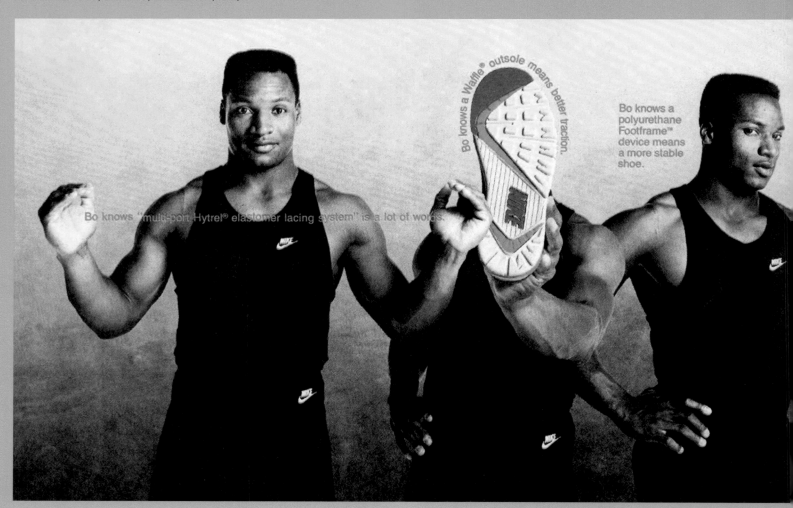

1990: Air Trainer SC, 'Bo Knows', ft. Bo Jackson (2 of 2)

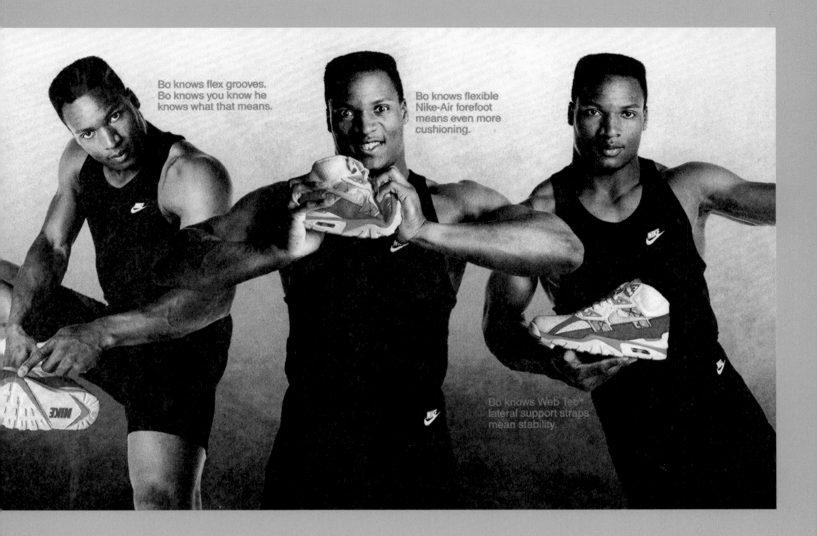

Bo knows flex grooves. Bo knows you know he knows what that means.

Bo knows flexible Nike-Air forefoot means even more cushioning.

Bo knows Web Tec lateral support straps mean stability.

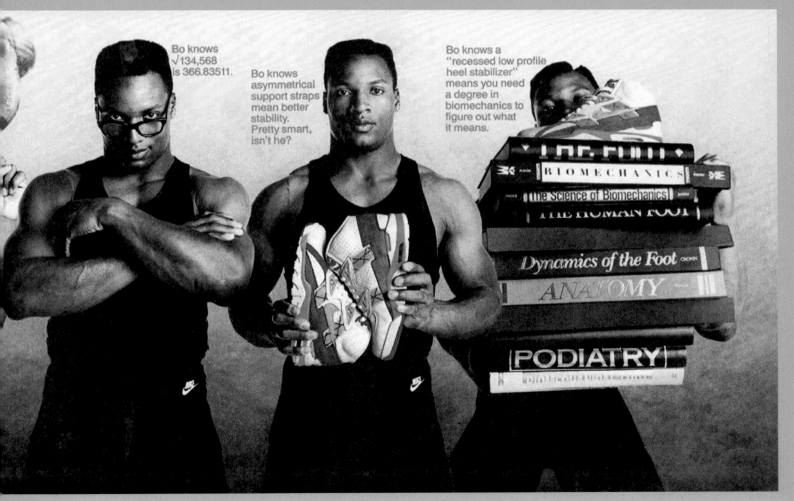

Bo knows √134,568 is 366.83511.

Bo knows asymmetrical support straps mean better stability. Pretty smart, isn't he?

Bo knows a "recessed low profile heel stabilizer" means you need a degree in biomechanics to figure out what it means.

BIOMECHANICS
The Science of Biomechanics
THE HUMAN FOOT
Dynamics of the Foot
ANATOMY
PODIATRY

Early morning, calling from a car phone. I know it's two thirty in the morning. And I apologize for calling

so late. But I just had to call. Whaddya mean who is it? Don't you know Diddley? This is Bo Jackson. Yea

That Bo Jackson. I know I've never called you before. It's just that I was having trouble sleeping and I wa

wondering if you wanted to play football. Come on. I got my Nike cross-training shoes on. OK, so you don

want to play football. Then how about a little kick boxing? No. How about lawn bowling? No. Pole vaulting

Contact bridge? Water ballet? A mini triathlon? Come on, I got my Nike cross-training shoes on. Don't gi

me no lip about having to get sleep before work. I mean, how many jobs do you think I have? And you don

hear me crying about it, do you? OK then, wiffle ball? Log rolling? Wind sprints? Bulgarian folk dancing . .

1990: Air Trainer SC, ft. Bo Jackson

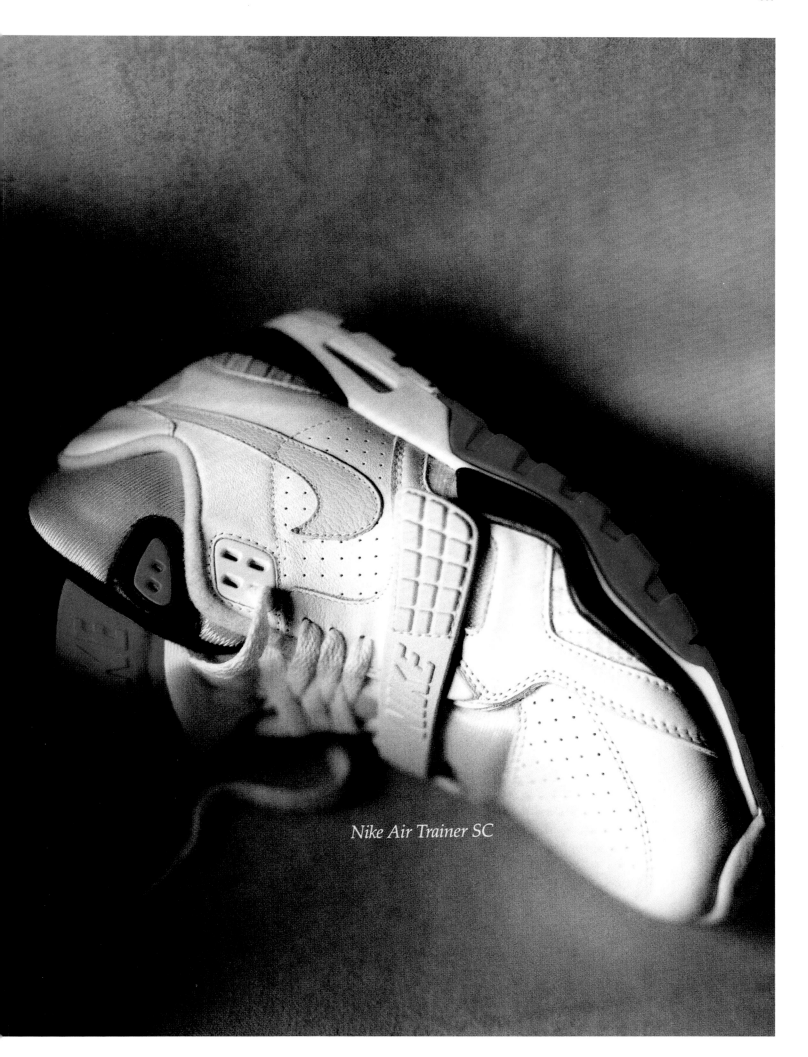

Nike Air Trainer SC

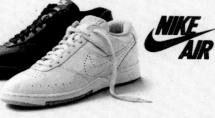

1986: The Rake, 'Fitness for Men'

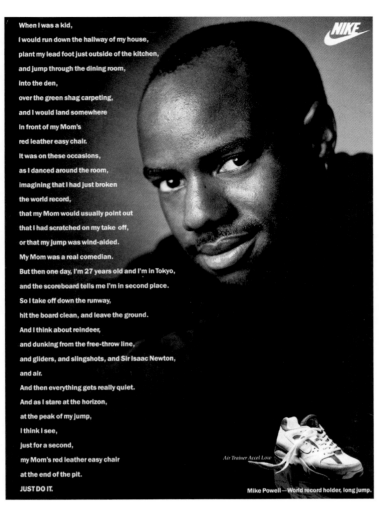

When I was a kid,

I would run down the hallway of my house,

plant my lead foot just outside of the kitchen,

and jump through the dining room,

into the den,

over the green shag carpeting,

and I would land somewhere

in front of my Mom's

red leather easy chair.

It was on these occasions,

as I danced around the room,

imagining that I had just broken

the world record,

that my Mom would usually point out

that I had scratched on my take off,

or that my jump was wind-aided.

My Mom was a real comedian.

But then one day, I'm 27 years old and I'm in Tokyo,

and the scoreboard tells me I'm in second place.

So I take off down the runway,

hit the board clean, and leave the ground.

And I think about reindeer,

and dunking from the free-throw line,

and gliders, and slingshots, and Sir Isaac Newton,

and air.

And then everything gets really quiet.

And as I stare at the horizon,

at the peak of my jump,

I think I see,

just for a second,

my Mom's red leather easy chair

at the end of the pit.

JUST DO IT.

Air Trainer Accel Low

Mike Powell — World record holder, long jump.

1992: Air Trainer Accel Low, ft. Mike Powell

IT HAS AN ANTI-INVERSION ankle strap, a perforated neoprene sleeve Dynamic-Fit™ boot and a DRC durable rubber outsole with a lightweight Durabuck™ exoskeletal mesh vamp upper. Plus some other stuff THAT'S KIND OF TECHNIC.

THE AIR CARNIVORE

1995: Air Carnivore

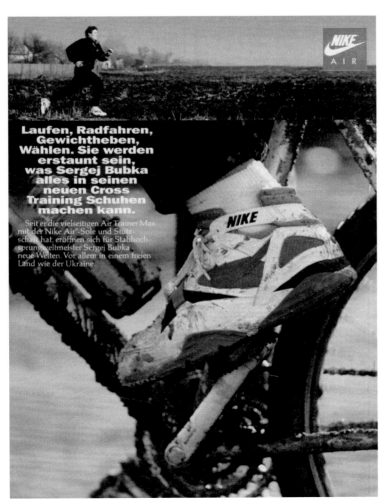

Laufen, Radfahren, Gewichtheben, Wählen. Sie werden erstaunt sein, was Sergej Bubka alles in seinen neuen Cross Training Schuhen machen kann.

Seit er die vielseitigen Air Trainer Max mit der Nike Air™-Sole und Stütz-schaft hat, eröffnen sich für Stabhoch-sprungweltmeister Sergej Bubka neue Welten. Vor allem in einem freien Land wie der Ukraine.

1993: Air Trainer Max, 'Run, Cycle, Weightlift, Vote. You'll Be Surprised by What Sergey Bubka Can Do in His New Cross Training Shoes', ft. Sergey Bubka

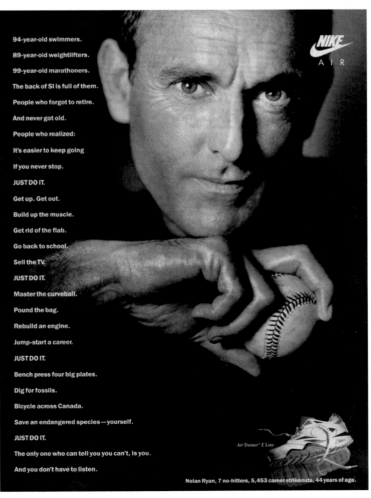

94-year-old swimmers.

89-year-old weightlifters.

99-year-old marathoners.

The back of SI is full of them.

People who forgot to retire.

And never got old.

People who realized:

It's easier to keep going

If you never stop.

JUST DO IT.

Get up. Get out.

Build up the muscle.

Get rid of the flab.

Go back to school.

Sell the TV.

JUST DO IT.

Master the curveball.

Pound the bag.

Rebuild an engine.

Jump-start a career.

JUST DO IT.

Bench press four big plates.

Dig for fossils.

Bicycle across Canada.

Save an endangered species — yourself.

JUST DO IT.

The only one who can tell you you can't, is you.

And you don't have to listen.

Air Trainer® E Low

Nolan Ryan, 7 no-hitters, 5,453 career strikeouts, 44 years of age.

1992: Air Trainer E Low, ft. Nolan Ryan

JUST DO IT.

1992: 'Just Do It', *Instant Karma* booklet (1 of 5)

DER AIR TRAINER HUARACHE. EIN SCHUH FÜR GEWINNER. ERSTENS: WEIL ER MIT DEM
HUARACHE FIT SYSTEM AUSGESTATTET IST. DAS BEDEUTET ÜBERRAGENDEN KOMFORT UND OPTIMALEN HALT.
UND ZWEITENS: WEIL ER DER VIELSEITIGSTE NIKE-SCHUH IST, DEN DU JE GETRAGEN HAST.

1992: Air Trainer Huarache, *Instant Karma* booklet (2 of 5)

WENN DU ALLES AUF DER WELT ERREICHEN KÖNNTEST, WONACH WÜRDEST DU STREBEN?
UND WORAUF WARTEST DU NOCH?

1992: Air Flight Huarache, *Instant Karma* booklet (3 of 5)

TRÄUMST DU VOM FLIEGEN? DANN IST DER AIR FLIGHT HUARACHE DEIN TRAUMSCHUH.
DENN DAS HUARACHE FIT SYSTEM MACHT DIESEN BASKETBALL-SCHUH AUßERGEWÖHNLICH KOMFORTABEL
UND EXTREM LEICHT. MIT DEM AIR FLIGHT HUARACHE
HAT DEIN TRAUM GUTE CHANCEN, WIRKLICHKEIT ZU WERDEN.

DU SELBST BESTIMMST DEIN LEBEN. DU KANNST NACH DEN STERNEN GREIFEN. ODER DICH AUF DAS KONZENTRIEREN, WAS DIR WESENTLICH ERSCHEINT. VERLIEREN KANN NUR, WER NICHTS WAGT.

DER AIR TRAINER HUARACHE. EIN SCHUH FÜR GEWINNER. ERSTENS: WEIL ER MIT DEM HUARACHE FIT SYSTEM AUSGESTATTET IST. DAS BEDEUTET ÜBERRAGENDEN KOMFORT UND OPTIMALEN HALT. UND ZWEITENS: WEIL ER DER VIELSEITIGSTE NIKE-SCHUH IST, DEN DU JE GETRAGEN HAST.

1992: Air Trainer Huarache, *Instant Karma* booklet (4 of 5)

DAS PRINZIP DES KARMA IST EINFACH. WAS DU SÄST, DAS WIRST DU ERNTEN. DEINE TATEN VON HEUTE BESTIMMEN DEIN LEBEN VON MORGEN. URSACHE UND WIRKUNG.

DER AIR HUARACHE RUNNINGSCHUH. SEIN EXTREM LEICHTES OBERMATERIAL AUS STRETCH-NEOPREN UND LYCRA® SCHMIEGT SICH AN WIE EINE ZWEITE HAUT. DU FÜHLST DICH GUT. UND DU LÄUFST BESSER. DEIN PHYSISCHES KARMA GEWINNT AN KRAFT.

LYCRA® IST EIN EINGETRAGENES WARENZEICHEN DER E.I. DU PONT DE NEMOURS & CO. INC.

1992: Air Huarache, *Instant Karma* booklet (5 of 5)

We wish we could say this new shoe design sprung from our extensive knowledge of motion-control theory and the principles of Newtonian mechanics. Actually, some guy dug it up.

In 1938, archaeologist Luther Cressman unearthed the above sandal in Fort Rock, Oregon. Inspired by its minimalist design,

Nike now introduces the Air Trainer Huarache,™ the most flexible and supportive cross-training shoe in about 9000 years.

Check The Athlete's Foot near you for availability.

1992: Air Trainer Huarache

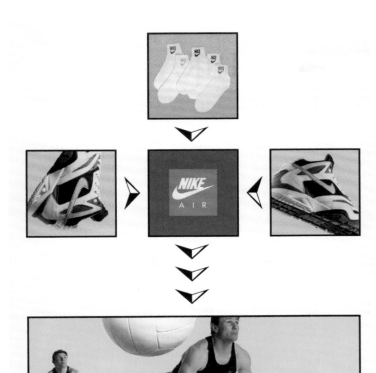

Solange der NIKE AIR TRAINER E ihm ein Höchstmaß an Stabilität verleiht und das NIKE AIR®-System eine optimale Dämpfung garantiert, kann der Weltmeister im Stabhochsprung, Sergey Bubka, monatelang trainieren ohne seine Schuhe wechseln zu müssen. Für seine Socken gilt das allerdings nicht.

1991: Air Trainer E, ft. Sergey Bubka

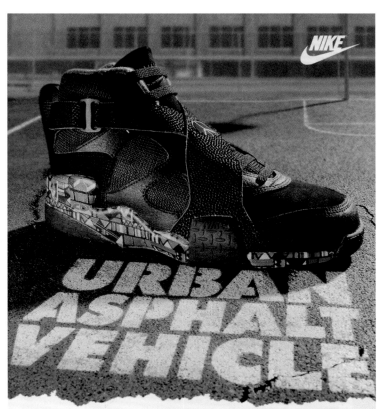

NOW AVAILABLE AT THE ATHLETE'S FOOT.

Before you hit the hardcourt, hit The Athlete's Foot and get the new Air Raid II by NIKE®. Its durable, high-traction outsole is specially designed for outdoor use. And it's just one of the hot, new shoes available at the store that always carries the latest technology and styles. So pave your way to The Athlete's Foot for the new Air Raid II. And get ready to tear up your opponent. Instead of your shoes.

Nobody Knows The Athlete's Foot
Like The Athlete's Foot.

1993: Air Raid II, 'Urban Asphalt Vehicle'

1993: Air Force Max, 'Powerful Force Sucks Crowd Into Shoe Store'

1-800-217-4569

1994: Air Max Sensation

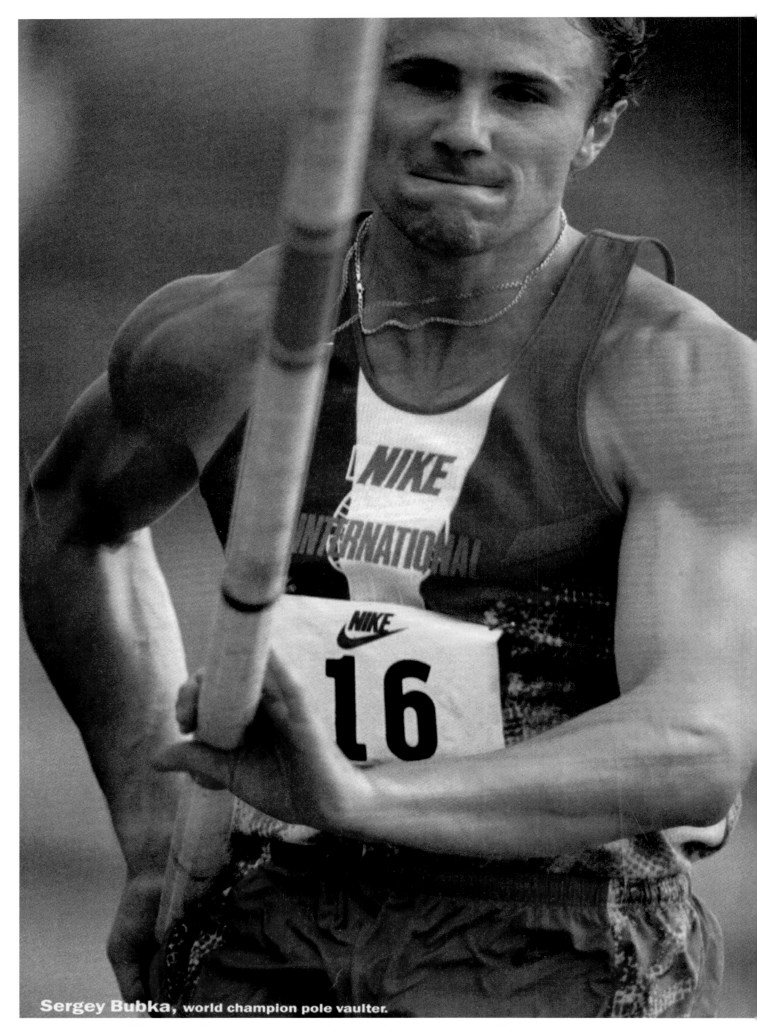

Sergey Bubka, world champion pole vaulter.

1992: Nike International, 'In My Sport, the Only Competition is Gravity. And Gravity Never Has an Off Day', ft. Sergey Bubka

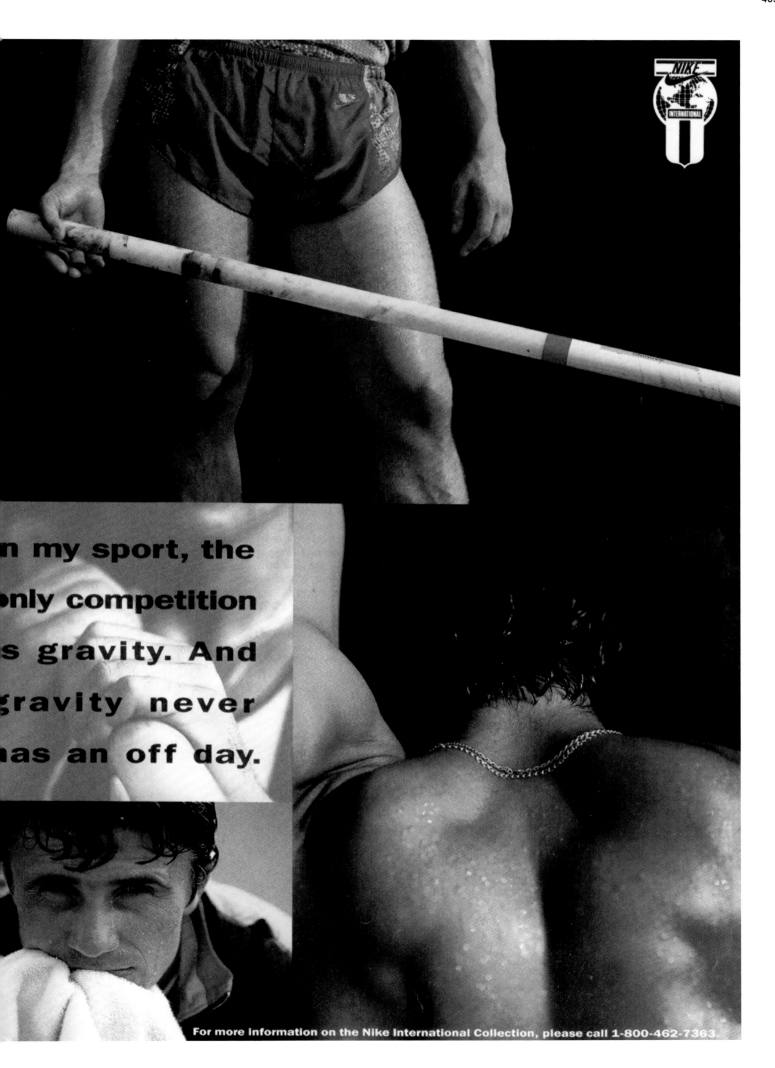

n my sport, the only competition s gravity. And gravity never has an off day.

The Woman in the NOSE Chooses NIKE

For that matter, so does the man in the nose! They also choose specially printed T-shirts from THE ATHLETIC DEPARTMENT, like the **Montréal '76** and the **NIKE** T-shirts pictured at left. These designs are printed on high quality champion T-shirts which feature no-sag necks and full cut sleeves for added comfort and appearance. The designs are available in red, blue, or white on your choice of either a red or blue Heathertone T-shirt with contrasting color knit trim at the crew neck and sleeve ends.

Please specify SIZE (m, L, XL); SHIRT COLOR (blue or red); DESIGN (NIKE or Montréal '76) and DESIGN COLOR (red, white or blue) when ordering. The price is $3.95 plus 50¢ shipping and handling per shirt. (No T-shirt shipping and handling charge, if accompanied by a shoe order.)

Order now and be the first on your block to have a NIKE or a Montreal '76 symbol emblazoned on your chest!

Finland Blue/Kenya Red

NIKE offers the unbeatable combination of high quality and low cost in the Finland and Kenya Racing and Training Flats. Featherweight, weather-resistant swooshfiber uppers, ball to heel midsole cushions and heel wedges, high density herringbone out soles, SPENCO® innersoles, full polyfoam tongues, arch bandages and padded ankle collars. These are the qualities which make the NIKE Kenya and Finland the runners choice for both training and racing. Price $20.00.

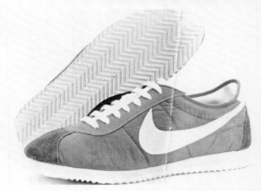

Boston '73

February 23, 1973; Seaside, Oregon, marks the most recent date and place where the winner of a prestigious marathon crossed the finish line in a pair of NIKE Boston 73's. The Boston's track record is impeccable. This shoe which champions prefer has lightweight swooshfiber uppers, stitchfree open-toes construction, full-length sponge midsoles and heel wedges, long wearing suction soles, SPENCO® innersoles, and unique orthopedic arch supports. At $19.25, the Boston is a value you can't pass up.

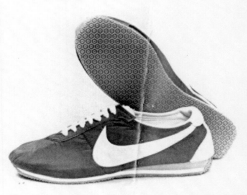

the athletic department

A.D. Mail Order
Dept. D
P.O. Box 743
Beaverton, Oregon 97005

Add $1.50 shipping & handling for 1st pair & 75¢ for each additional pair. Deduct 15% for volume orders of 5 or more pair. Ask for free NIKE Catalog.

1974: Finland Blue, Kenya Red and Boston '73, 'The Woman in the Nose Chooses Nike'

PICK A WINNER FROM THE NIKE LINE

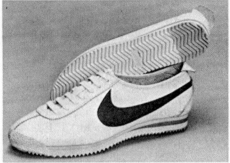

AMERICAS — Nylon racing spike $29.10

LEATHER CORTEZ — Distance training $25.45

INTERVALLE — Nylon training spike $26.55

BOSTON '73 — Nylon distance racing flat $19.25

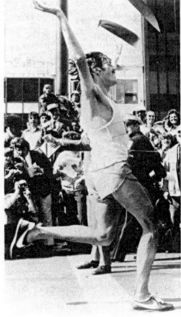

OREGON WAFFLE — Nylon racing flat $22.35

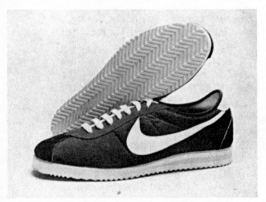

FINLAND BLUE (Kenya red) — Nylon racing and training flat $20.00

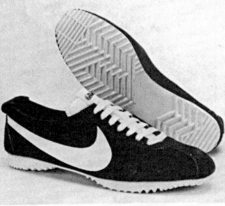

ROAD RUNNER — Suede racing flat $21.80

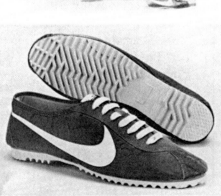

MARATHON — Nylon running flat $15.65

the athletic department

(MAIL ORDER DEPT.)
Post Office Box 743
Beaverton, Oregon 97005

With retail "A.D." stores in Berkeley, Garden Grove, Culver City and Rosemead, California; Natick, Massachusetts; Montclair, New Jersey; and Portland, Beaverton and Eugene, Oregon.

Volume discounts available.

Mail orders require $1.50 shipping & handling per pair.

1974: Americas, Leather Cortez, Boston '73, Finland Blue (Kenya Red), Marathon, Road Runner, Oregon Waffle and Intervalle, 'Pick a Winner from the Nike Line'

LOOK NIKE SECONDS*

FINLAND BLUE KENYA RED	LIGHT NYLON UPPERS AND FULL CUSHION SOLE TO FILL TWO NEEDS IN ONE. SIZES 3 - 13	14.95
MARATHON	NYLON RACING FLAT, SOFT CORDO-CREPE OUTSOLE FOR TOPFLIGHT RACING ON ALL SURFACES. SIZES 6½ - 13	10.95
CROSS COUNTRY	WHITE CANVAS RACING FLAT WITH MARATHON OUTSOLE. SIZES 7½ - 11½	5.50
PRE-MONTREAL	PREMIER RACING SHOE FOR USE ON SYNTHETIC TRACKS ONLY SIZES 5 - 13	24.95
AMERICAS	LIGHTWEIGHT RED NYLON UPPER IS THE MOST POPULAR OF THE NIKE SPIKES. SIZES 3 - 13	18.95
INTERVALLE	BLUE NYLON UPPER, A SPONGE RUBBER HEEL WEDGE, A POPULAR TRAINING AND RACING SPIKE. SIZES 3 - 13	15.95
CANADA QUICK 4	BLUE SUEDE UPPER ON A VERSATILE 4-SPIKE PLATE. SIZES 3 - 13	12.95
NOVA	WHITE LEATHER UPPER, HEEL CUSHION, FULL LENGTH FOAM INNERSOLE FOR COMFORT AND PROTECTION. SIZES 3 - 13	11.95
RED BRUIN	AN OFF COLOR RED SUEDE UPPER. A GOOD SHOE FOR BASKETBALL, TENNIS AND LEISURE. SIZES 3 - 13	13.95

* These shoes contain production-caused imperfections which render their cosmetic quality below that of firstline Nikes. These imperfections will not affect the life and performance of the product, therefore, we are able to offer you fully guaranteed shoes at greatly reduced prices.

Send your order to:

the athletic department

P. O. BOX 743 .. BEAVERTON, OREGON 97005
503/ 643 - 4732 No Collect calls please.

(Please add $1.50 shipping charge for first pair and $.75 for each additional pair. Quantity limited; please state second choice. Out of stock orders promptly refunded.) Free NIKE brochures available upon request. Air Shipment, add $1.00. Outside U.S.A., use Money.Order ONLY and add $1.00 extra charge for shipping.)

1975: 'Look Nike Seconds'

NIKE SPIKES

PRE-MONTREAL - NIKE's premier racing shoe. Patented Suede 'n Swoosh upper gives a glove-like fit. For use on synthetic tracks only. A favorite among distance runners. $39.95 — five or more $32.95.

AMERICAS - The red nylon swoosh fiber shoe is the most popular of the NIKE spikes. This lightweight shoe has hundreds of tiny cones on the sole for sure traction on any surface. $29.95 — five or more $24.50.

INTERVALLE - A popular training and racing spike. It features a sponge rubber heel wedge to protect against heel bruise and Achilles strain. $26.95 — five or more $22.95.

CANADA QUICK FOUR - The finest blue suede uppers on a versatile 4-spike plate makes it the all-around shoe for racing and training. Available in sizes 3-13. $22.95 — five or more - $18.95.

NOVA - Full leather uppers, foam tongue, and padded heel collar are features of this lightweight training and competition shoe. Ideal for young runners. $19.95 — five or more $16.95.

OREGON WAFFLE - The shoe that combines the traction of a spike with the cushioning of a flat. The ideal shoe for interval training and distance racing. $24.95 - five or more $19.95.

Send your order to:

the athletic department

P. O. BOX 743 BEAVERTON, OREGON 97005
503/ 643 - 4732 No Collect calls please.

(Please add $1.50 shipping charge for first pair and $.75 for each additional pair. Quantity limited; please state second choice. Out of stock orders promptly refunded.) Free **NIKE** brochures available upon request. Air Shipment, add $1.00. Outside U.S.A., use Money Order ONLY and add $1.00 extra charge for shipping.)

1975: Pre-Montreal, Americas, Intervalle, Canada Quick Four, Nova and Oregon Waffle, 'Nike Spikes'

THIS SHOE IS NOT FOR EVERYBODY

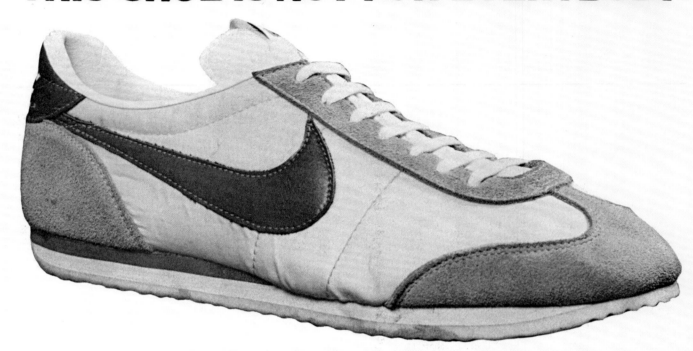

NIKE ROADRUNNER

(IT'S ONLY FOR THOSE WHO WANT THE BEST)

A NEW VERSION OF AN OLD FAVORITE. THE NEW NIKE ROADRUNNER IS A REAL EYE-OPENER. IT COMES IN LIME GREEN NYLON UPPERS, MOD BLUE SWOOSH STRIPE AND HEEL TAB, AND MARIGOLD YELLOW ACCENT. IT FEATURES AN EXTENDED HEEL COUNTER AND REINFORCED TOE FOR STABILITY AND DURABILITY. THE SPENCO® INNERSOLE, ARCH SUPPORT, AND CUSHIONED MIDSOLE PROVIDE MILES OF COMFORT. AND THE LONG LASTING CREPE SOLE INSURES MILES OF WEAR. NOT ONLY DOES THIS SHOE HAVE EYE-OPENING COLORS, BUT IT ALSO HAS AN EYE OPENING PRICE...

$19.95

ASK YOUR LOCAL NIKE DEALER FOR THE NIKE ROADRUNNER
or for information write

6175 S.W.112
Beaverton, Oregon 97005

4 Jeffrey Ave
Holliston, Mass. 01746

—56—

1975: Roadrunner, 'The Shoe is Not for Everybody'

CORTEZ-

THE SUPREME SHOE FOR THE LONG DISTANCE RUNNER. BLISTER PROOF SPENCO INNER SOLE. THICK OUTER SOLE WITH FULL LENGTH MID-SOLE CUSHION TO ABSORB ROAD SHOCK, SIMULTANEOUSLY ELEVATING THE HEEL TO REDUCE ACHILLES TENDON STRAIN.

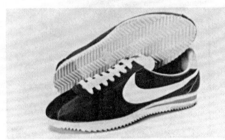

LEATHER - SOFT WHITE LEATHER UPPER GIVES ADDED SUPPORT. EXTENDED HEEL COUNTER LOCKS IN THE HEEL TO MINIMIZE SLIPPAGE. $19.95 FIVE OR MORE $17.95

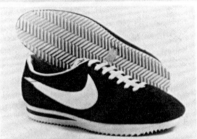

SUEDE - SOFT NAVY SUEDE UPPER MOLDS TO YOUR FOOT, PADDED NIKE HEEL HORN. SUPER SHOE FOR ACTION AND LEISURE. $19.95 FIVE OR MORE $17.95

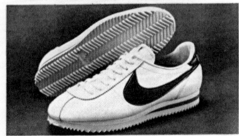

NYLON - LIGHTWEIGHT BLUE NYLON UPPER NEEDS NO BREAK IN TIME, WATER WILL NEVER HURT IT. $17.95

*** These shoes contain production-caused imperfections which render their cosmetic quality below that of firstline Nikes. These imperfections will not affect the life and performance of the product, therefore, we are able to offer you fully guaranteed shoes at greatly reduced prices.**

WE ALSO HAVE A GOOD SUPPLY OF NOVA AND CANADA 4 SPIKES AS SEEN IN THE MARCH ISSUE OF RUNNERS WORLD

Send your order to:

the athletic department

P. O. BOX 743 BEAVERTON, OREGON **97005**
503/ 643 - 4732 No Collect calls please.

(Please add $1.50 shipping charge for first pair and $.75 for each additional pair. Quantity limited; please state second choice. Out of stock orders promptly refunded.) Free **NIKE** brochures available upon request. Air Shipment, add $1.00. Outside U.S.A., use Money.Order ONLY and add $1.00 extra charge for shipping.)

1975: Cortez, 'Nike Seconds'

WAFFLE SALE

GET 'EM WHILE THEY'RE HOT

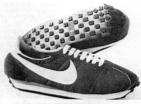

WAFFLE TRAINER--COMBINES ALL THE PADDING OF A TRAINING SHOE WITH THE LIGHTNESS OF A RACING FLAT. THE FLARED SOLE AND UNDER-CUT HEEL PROVIDE STABILITY AND HELP INSURE PROPER FOOTSTRIKE AND TOE-OFF.

$27.95--FIVE OR MORE $22.95

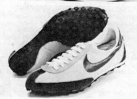

OREGON WAFFLE--THE SHOE MADE FAMOUS IN EUGENE, OREGON. THIS RACING SHOE HAS A BRIGHT YELLOW UPPER WITH GREEN TRIM. THE WAFFLE SOLE COMBINES THE TRACTION OF A SPIKE WITH THE CUSHIONING OF A FLAT. THIS MAY BE THE MOST SOPHISTICATED RACING FLAT EVER MADE.

$24.95--FIVE OR MORE $19.95

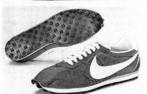

WAFFLE TRAINER I--WE ARE CLOSING OUT THE OLD VERSION OF THE WAFFLE TRAINER. THIS SHOE FEATURES A BLUE NYLON UPPER, SOFT CUSHION MIDSOLE, AND NIKE'S EXCLUSIVE WAFFLE SOLE FOR TRACTION.

CLOSEOUT PRICE $16.95

Send your order to:
the athletic department

P.O. BOX 743 BEAVERTON, OREGON 97005
503/ 643 - 4732 No Collect calls please.

(Please add $1.50 shipping charge for first pair and $.75 for each additional pair. Quantity limited; please state second choice. Out of stock orders promptly refunded.) Free NIKE brochures available upon request. Air Shipment, add $1.00. Outside U.S.A., use Money Order ONLY and add $1.00 extra charge for shipping.)

August, 1975 —49—

1975: Waffle Trainer, Oregon Waffle and Waffle Trainer I,
'Waffle Sale, Get 'Em While They're Hot'

NYLON CORTEZ FROM,

5/16 inch heel lift reduces Achilles tendon problems. Heel counter with leather reinforcing provides support for the light weight nylon.

Width of the heel and size of the counter were determined after months of tests and are constantly being reviewed for correctness.

Leather reinforcing in the toe eliminates toe nail tear in the ultra soft nylon. Polyfoam tongue gives the greatest comfort. Inside the shoe is the sponge arch support and the new 4-way stretch innersole which eliminates blister problems.

May be the best road running sole ever. The secret is in the rubber composition. This particular composition combines light weight with long wear. The traditional herringbone sole pattern provides fine traction on the roads and on grass.

Nylon upper never stiffens or cracks and provides the ultimate in lightness and comfort. Rubber toe cap provides protection on long runs and cements the tri-part bond between nylon soft sponge mid-sole and hard rubber outer sole.

Designed for cross country and road running, the nylon Cortez combines the best features in training and racing shoes. One of America's leading marathoners says, "That's the most comfortable running shoe ever." And we've got 7 other training shoe models.

Like that funny little German automobile we're constantly making those hard to notice but important changes. Nike the shoe for the seventies.

Call your nearest sporting goods dealer or write:

BLUE RIBBON SPORTS 77 W. Burnside Street
Portland, Oregon 97209 75 Middlesex Avenue
Natick, Mass. 01760

Bible of the Sport *11 May 1972 - 31*

1975: Cortez, 'Nylon Cortez from Nike'

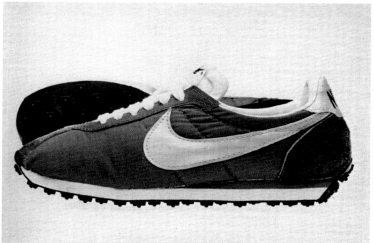

WE NAMED OUR SHOES AFTER A WOMAN.

Nike was the Winged Goddess of Victory in Greek Mythology. Legend tells us she had a mystical presence, and helped to inspire victorious encounters on history's earliest battlefields.

We chose the name Nike because we build shoes that help inspire victory—in athletic contests all over the world.

The shoes of champions.

We put a swooshmark on the side of every pair to symbolize the winged goddess of victory. And also to show people you're wearing the finest athletic shoes available.

Nike. We make all kinds of shoes, for all kinds of women and men and children. And winners.

Try on a pair and fly away from the competition.

NIKE

8285 S.W. Nimbus Ave. Suite 115
Beaverton, Oregon 97005

1977: 'We Named Our Shoes After a Woman'

THE NIKE ELITE IS HERE.

Finally. The running shoe all the runners have been waiting for is here.

The Nike Elite, ranked by Runner's World magazine as the finest racing flat in the world.

Bar none.

The Elite gives you Nike's famous waffle sole for incredible traction.

Wide flared heels spread impact and give you greater stability when you run.

Electric Blue nylon uppers have seamless toe pockets for blister free running.

The Nike Elite. They're here. Now, waiting to give you a run for your money.

Come get 'em.

(STORE NAME)

1980: Elite, 'The Nike Elite is Here'

HOT WAFFLES TO GO.

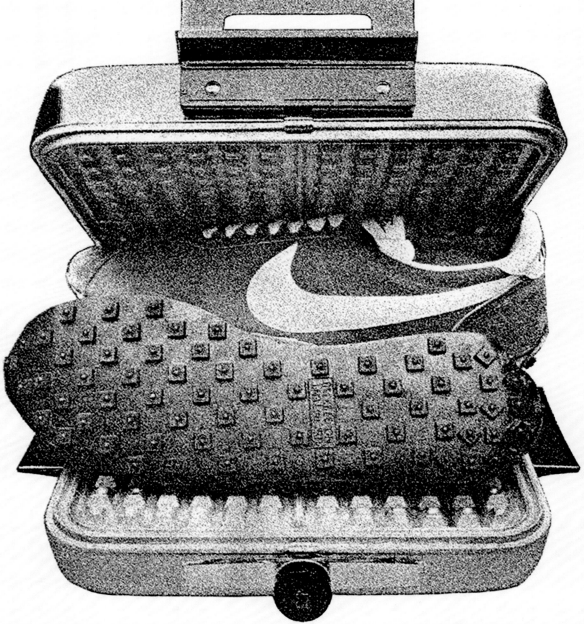

Come and get 'em. The best selling running shoes ever made are here. They're Nike Waffle Trainers. And they give you the kind of stability, cushioning and traction only a waffle sole can. So don't settle for substitutes. And don't wait. Because the original Nike Waffles are selling like hotcakes. Blue with yellow swoosh.

$00⁰⁰

(DEALER NAME)

1977: Waffle Trainer, 'Hot Waffles to Go'

EVERY DAY IS

We always welcome the opportunity to match the quality we've built into Nike shoes against the best any other sports shoe manufacturer can muster.

This is judgment day. But it's by no means the only judgment day of the year for us.

At Nike, every day is judgment day. Day in and day out, we test our shoes against competitive brands. And we also test our shoes against the toughest competition of all—other Nike shoes. We test them against each other for quality workmanship. Construction. Materials. And performance.

Our job is to make sure every pair of Nike shoes is as good as the last. And to improve them. To create new models that perform even better.

So we put them through the lab. We rip them apart.

1977: 'Every Day is Judgment Day'

UDGMENT DAY.

Saw them in two. Evaluate. Weigh. Measure. And try them out for test runs.

We never stop testing because we never stop building new running shoes. In fact, we've developed some new Nike shoes since the cut-off date for submitting shoes to Runner's World for this survey.

We do all this because, frankly, we think the most important review board of all is you, the runner. We know you think for yourself, and make your own judgments based on how the shoe fits and performs for you as an individual.

We also know you judge us every day you run. Runner's World judges us once a year.

This year you be the judge.

Listen to your feet.

NIKE

World Headquarters:
8285 S.W. Nimbus Ave., Suite 115
Beaverton, Oregon 97005

Also available in Canada through Pacific Athletic Supplies Ltd.,
2433 Beta Avenue, Burnaby, B.C., Canada V5C 5N1 (604) 294-5307.

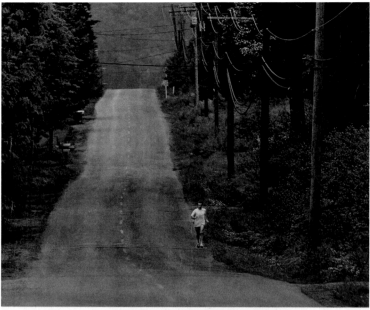

THERE IS NO FINISH LINE.

Sooner or later the serious runner goes through a special, very personal experience that is unknown to most people.

Some call it euphoria. Others say it's a new kind of mystical experience that propels you into an elevated state of consciousness.

A flash of joy. A sense of floating as you run.

The experience is unique to each of us, but when it happens you break through a barrier that separates you from casual runners. Forever.

And from that point on, there is no finish line.

You run for your life. You begin to be addicted to what running gives you.

We at Nike understand that feeling. There is no finish line for us either. We will never stop trying to excel, to produce running shoes that are better and better every year.

Beating the competition is relatively easy.

But beating yourself is a never ending commitment.

NIKE

World Headquarters
8285 S.W. Nimbus Ave., Suite 115
Beaverton, Oregon 97005

Also available in Canada through Pacific Athletic Supplies Ltd., 2433 Beta Avenue, B.C. Canada V5C 5N1 (604) 294-5307
For 22" × 35" poster of this Ad, send $2.50 to the above address.

1977: 'There is No Finish Line'

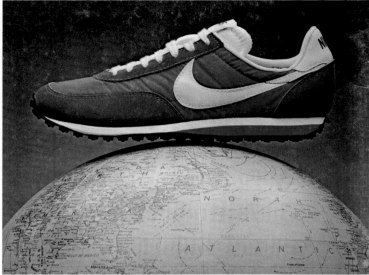

THE RACING FLAT THAT TOOK ON THE WORLD AND WON.

Last year, we developed a totally new kind of racing flat that topped anything we'd ever seen before.

We called it the Nike Elite. And we submitted it to Runner's World magazine to be tested by a panel of experts against the best racing flats on earth.

When the results came in, the Nike Elite came out the winner.

The best racing flat in the world.

Period.

Since then the Elite has rapidly become the most talked about, and the most wanted racing shoe on the market.

Small wonder.

It gives you our famous waffle sole. Wide flared heels. Flyweight nylon uppers. And seamless toe pockets for blister-free running.

The Nike Elite. Try on a pair and see what it feels like to be sitting on top of the world.

NIKE

World Headquarters
8285 S.W. Nimbus Ave., Suite 115
Beaverton, Oregon 97005

Also available in Canada through Pacific Athletic Supplies Ltd., 2433 Beta Avenue, Burnaby, B.C. Canada V5C 5N1 (604) 294-5307.

1977: Elite, 'The Racing Flat That Took on the World and Won'

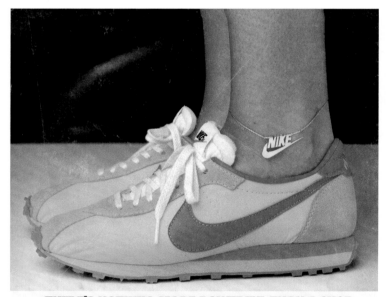

THERE'S NOTHING MORE POWERFUL THAN A SHOE WHOSE TIME HAS COME.

A few years ago there weren't very many women running enthusiasts.

Today that's ancient history. Today women are running all over the country. Day in and day out.

The idea of the woman athlete has come.

That's why we're now building a whole new line of athletic shoes especially designed for women.

The shoe up there in the picture is our new Lady Waffle Trainer. It's inspired by our world famous men's waffle trainer, but we've built it on a new narrow last, especially suited to the bone structure in most women's feet.

It has the same great waffle sole design that's made our other training shoe famous for traction. The same tough, lightweight, long-wearing nylon uppers. Same tapered heel and flared sole.

The lady waffle trainer. One of a long line of powerful new ideas whose time has come at Nike.

It's about time, right ladies?

NIKE

World Headquarters
8285 S.W. Nimbus Ave., Suite 115
Beaverton, Oregon 97005

Also available in Canada through Pacific Athletic Supplies Ltd., 2433 Beta Avenue, Burnaby, B.C. Canada V5C 5N1 (604) 294-5307

1977: Lady Waffle Trainer, 'There's Nothing More Powerful
Than a Shoe Whose Time Has Come'

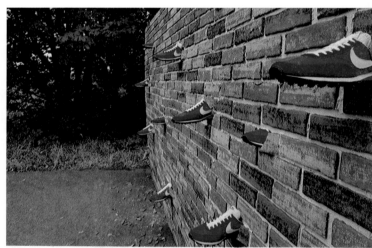

HOW TO BREAK THROUGH THE WALL.

Every marathoner knows about "the wall." You hit it at 20 miles. With six miles to go, the glycogen that feeds your muscles runs out.

Dehydration sets in. You lose blood volume. Some marathoners develop parathesia. Toes tingle. You feel nauseous, dizzy.

Some people try to break through the wall by dissociating—concentrating on other things. Some repeat mantras or do mental math. Others "listen" to rock or Bach.

A few world class runners find it's actually better to concentrate on the pain itself.

But no matter how you deal with it, the wall is pure pain.

We can't say Nike shoes will make that pain disappear. But we can say this:

Your legs and feet will probably feel a lot better wearing a pair of Nike Elites.

We build them especially for marathoning. The Elite nylon uppers have no seams to constrict your toes and cause blisters.

They weigh only 240 grams.

We designed the Nike Elites to give you more help in breaking through the wall than any racing shoe in the world.

But they can in no way do it all. Nobody but you can do that.

NIKE

World Headquarters
8285 S.W. Nimbus Ave., Suite 115
Beaverton, Oregon 97005

1978: Elite, 'How to Break Through the Wall'

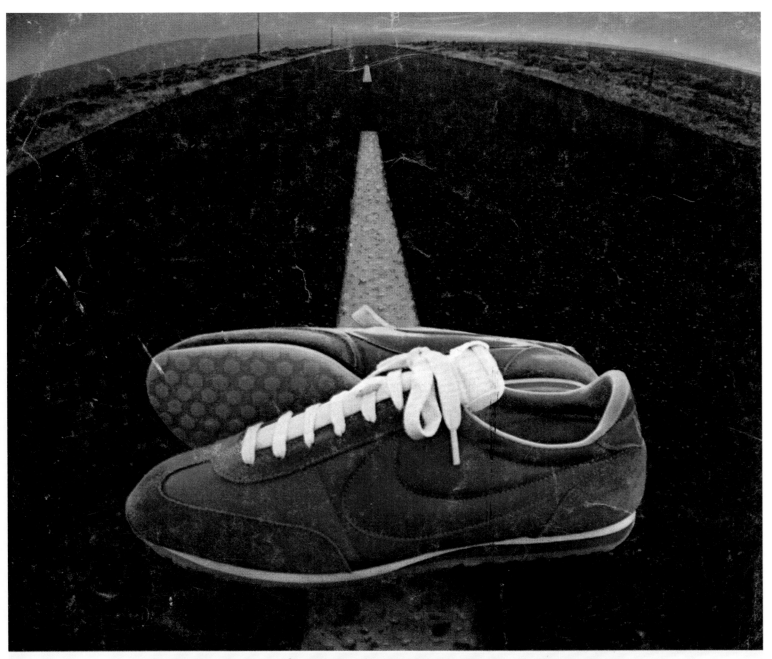

BUILT TO GIVE YOU BETTER MILEAGE.

We designed this shoe to come out ahead in the long run.

We call it the Roadrunner because that's exactly what it's for.

Long distance road running.

We've given it a multi-studded sole design that's built for super traction and long wearing durability.

The soles are topped off with uppers of nylon and suede that make this shoe as light as road dust.

We also give you reinforced toes and heels. Cushioned mid soles. And an extended heel counter for solid support.

You'll find Roadrunners at your nearest Nike dealer. Waiting to give you a long distance run for your money.

NIKE.

8285 S.W. Nimbus Ave., Suite 115
Beaverton, Oregon 97005.

Also available in Canada through Pacific Athletic Supplies Ltd., 2433 Beta Avenue, Burnaby, B.C. Canada V5C 5N1 (604) 294-5307

1977: Roadrunner, 'Built to Give You Better Mileage'

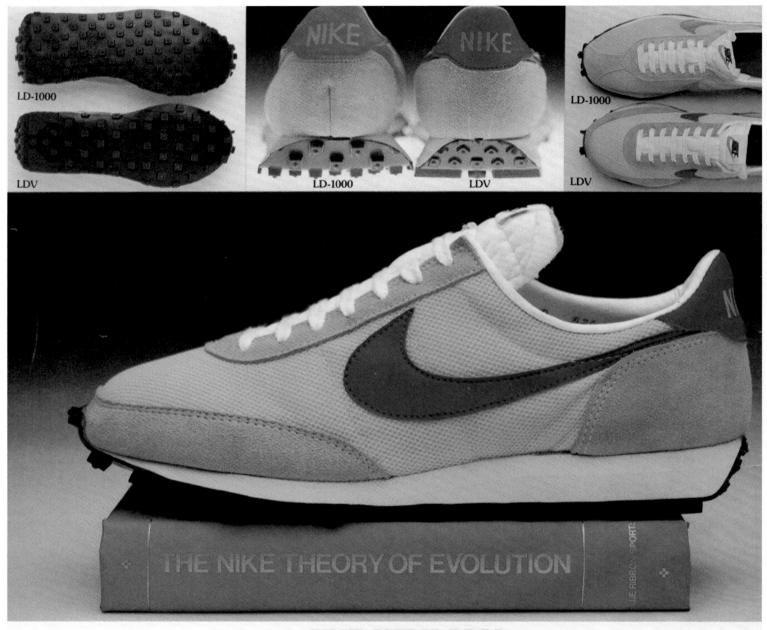

LD-1000

LDV

LD-1000

LDV

LD-1000

LDV

THE NIKE THEORY OF EVOLUTION

THE NEW LDV.
THE EVOLUTION OF THE REVOLUTION.

When we built the original LD-1000, we threw away the book of traditional running shoe ideas, and started a revolution.

It was a radically new shoe that combined our famous Waffle sole with a super-wide flared heel to give runners stability and traction like never before.

Now comes an evolutionary shoe that grew out of the original revolution.

The LDV.

For some runners, it will be a better shoe. Others will still want the original.

We've reduced the flare of the heel. Opened the toe. And built the LDV on a vector last shaped to the natural axis of your foot to decrease over-pronation.

The outer sole is made from tougher rubber with a new Waffle sole pattern that has stabilizers for longer wear.

The new LDV.

We built it because we never stop working to build something better.

It's all part of the Nike theory of evolution.

NIKE®

World Headquarters:
8285 S.W. Nimbus Ave., Suite 115
Beaverton, Oregon 97005

Also available in Canada through Pacific Athletic Supplies Ltd., 2451 Beta Avenue, Burnaby, B.C., Canada V5C 5N1

1978: LDV, 'The New LDV. The Evolution of the Revolution'

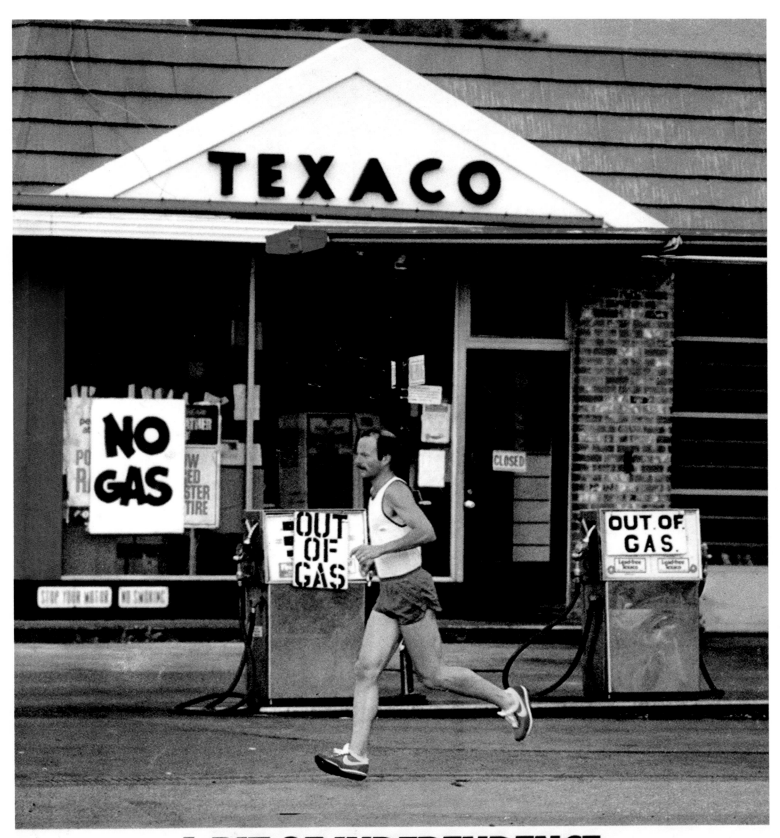

A BIT OF INDEPENDENCE.

Beaverton, Oregon

1979: 'A Bit of Independence'

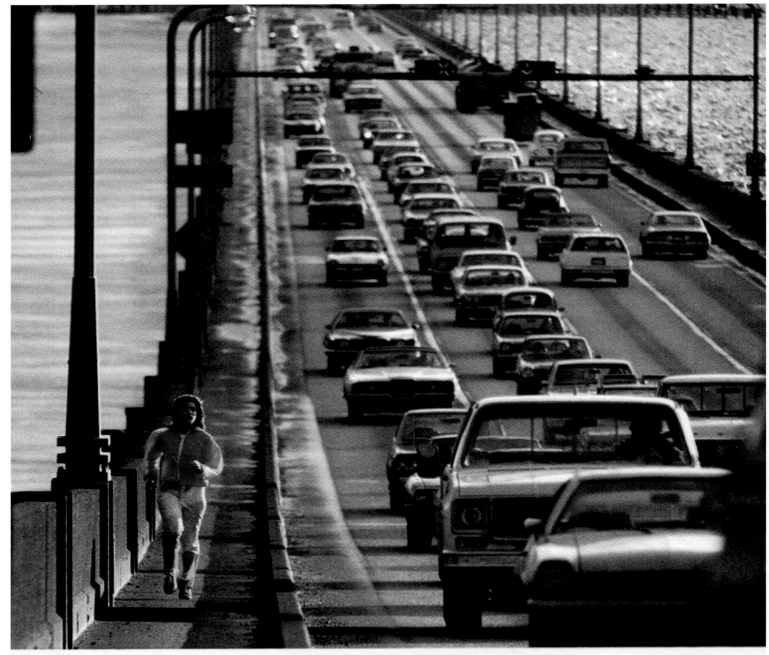

MAN VS MACHINE.

When it comes to making our lives easier, machines have really done a good job.

Maybe too good.

Machines save us so much work, they've actually put our bodies out of a job.

They're killing us.

But runners are bringing this country back to life again. It started about 10 years ago when a small group of people took a good look at the billowing bellies around them, and ran for their lives.

Since then running has swept across America. And it's become more than something that makes you feel better.

It's something you can't live without.

To some of us, running is a way of life.

Nobody understands that better than Nike. Because we're runners, too. By following you, we've become the leaders. So when we design shoes, we don't go to computers, we go to runners.

The reason for that is simple. Machines can't run.

World Headquarters
8285 SW Nimbus Avenue,
Beaverton, Oregon 97005

Also available in Canada through Pacific Athletic Supplies Ltd., 2451 Beta Avenue, Burnaby, B.C., Canada V5C 5N1

1979: 'Man Vs Machine'

A DAY TO REMEMBER.

NIKE-OTC Marathon, Eugene/Springfield, September 9, 1979.

By noon it was a day to remember. So much so that those watching wanted to be out there. And those that ran wanted to watch.

Because special things happened. The results were hard to believe. If you haven't heard what was done by Sandoval, Wells, Lodwick, Quax, Benoit, Atkins, Lindgren, Bright, Manley, 46 Olympic Trials qualifiers and 350 dedicated, prepared race volunteers—write us.

But we don't want to tell you about this race just because good people were there and ran well. Surely they did. Some even called it "a gathering of eagles."

It was more than that.

A time to share with friends and heroes. A rising of the marathoning spirit we hear about, but don't feel as much as we used to.

A runner's race. You should have been there.

NIKE

Beaverton, Oregon

1979: 'A Day to Remember', ft. Tony Sandoval and Jeff Wells

WHY BUY A COPY
WHEN YOU CAN RUN WITH THE ORIGINAL?

A funny thing happened back in 1974 when we came out with our first Nike Waffle Trainer.

Almost everybody except serious runners laughed.

"It'll never last." some said. "Looks like a shoe made to run on ice," they chuckled.

Well, they're not laughing anymore. In fact, most major shoemakers have tried to copy our Waffle Trainer.

Because it has become the best selling training flat ever made. The *classic* running shoe.

So if you're looking for the real thing, accept no substitutes for the original Nike Waffle Trainer.

Because there aren't any.

Only copies

Beaverton, Oregon.

1979: Waffle Trainer, 'Why Buy a Copy When You Can Run With the Original?'

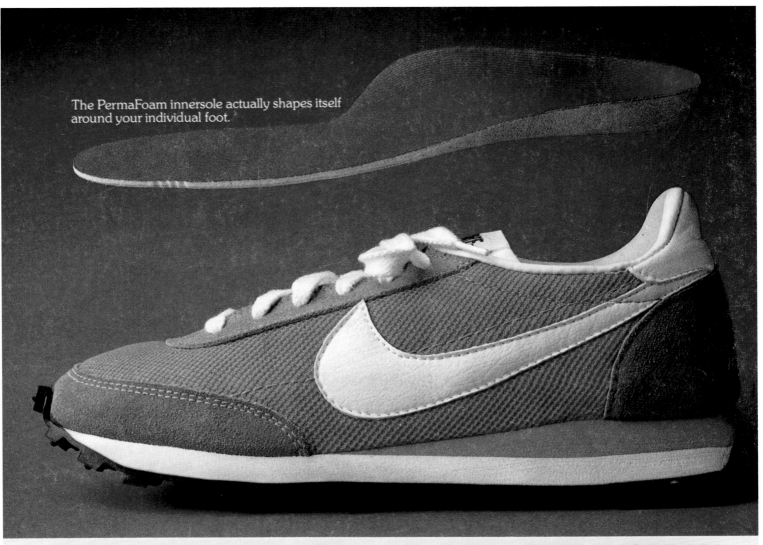

The PermaFoam innersole actually shapes itself around your individual foot.

THE LIBERATOR WILL FIT ONLY ONE WOMAN.

The woman is you.

Our new Liberator is the first woman's training flat we've ever made that actually shapes itself to your foot.

It has a removable, washable innersole made from Nike PermaFoam.™ It's an unusual new styrofoam-type material that allows your individual foot strike impression to create a fit that's unique to you, and you alone.

Run in them for a few miles and the impression is made. Permanently.

The Liberator is slip lasted and sized especially for the bone structure in a woman's foot. It gives you a Nike Waffle outersole for traction and cusion. A flared heel for running stability. And "breathing" polyester uppers for running cool.

They're lightweight, and give you super comfort and support. And once you make your impression on them, they won't fit any other woman in the world.

Except you.

NIKE

Beaverton, Oregon.

1979: Liberator, 'The Liberator Will Fit Only One Woman'

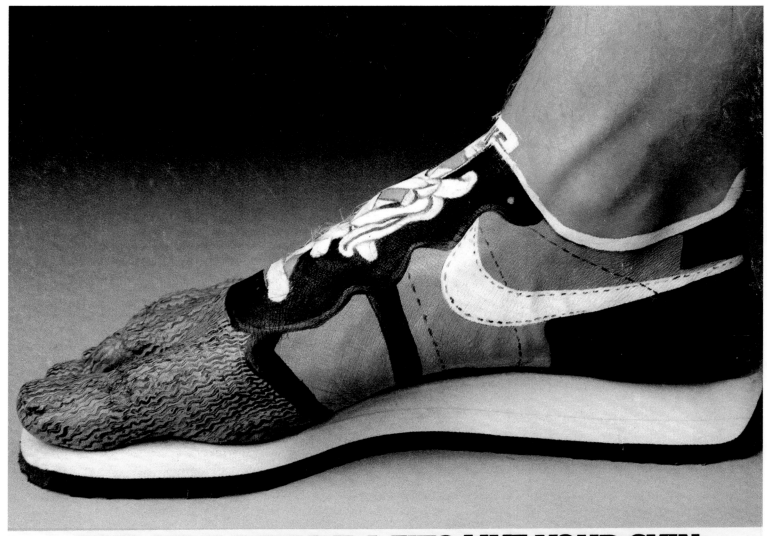

OUR NEW BERMUDA FITS LIKE YOUR SKIN.

When we designed this new training flat, we had two things in mind.

A shoe with a great fit both for men and women, and one that's extremely light.

This is it. The Bermuda. For the fit, it has our new Variable Width Lacing System™ that cinches the shoe around your foot better than any training flat we make.

We've also included our new removable PermaFoam insole that will make a big impression on you after you make an impression on it. It's made from a moldable material that actually shapes itself to your individual foot.

The uppers are long wearing nylon with a completely seamless toe box to help reduce running blisters.

Bermudas. They're fit to be tried.

NIKE

Beaverton, Oregon

1979: Bermuda, 'Our New Bermuda Fits Like Your Skin'

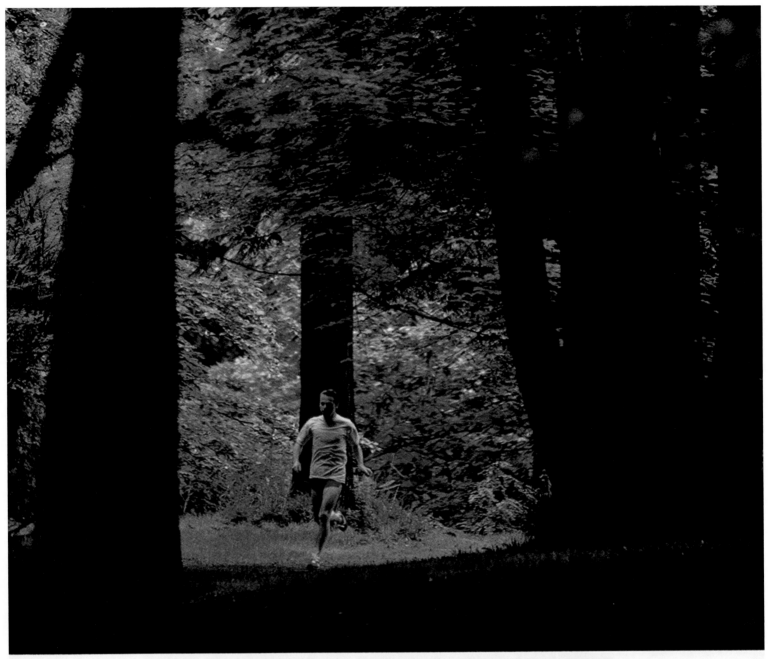

WE RUN OVER A MILLION MILES A DAY.

Men and women all over the world run more than a million miles a day in Nike shoes.

In all kinds of weather. Across all sorts of terrain. Through dozens of different countries.

More than 1,000,000 miles a day.

And that number is getting bigger and bigger every year.

We think that's because we listen to what all those runners tell us about how we can improve our shoes.

And because more people are running now than ever before in history.

And more people like you are communicating with us to give us your ideas, feedback, and in some cases, constructive criticism.

Please don't stop talking to us.

Send your ideas to Carolee Carlson, care of our testing department in Beaverton.

We'll pay attention to what you say.

Because if we are to live up to your expectations, we need you more than you need us.

And that's the truth.

Beaverton, Oregon

1979: 'We Run Over a Million Miles a Day'

These two men demand the best running shoes possible.

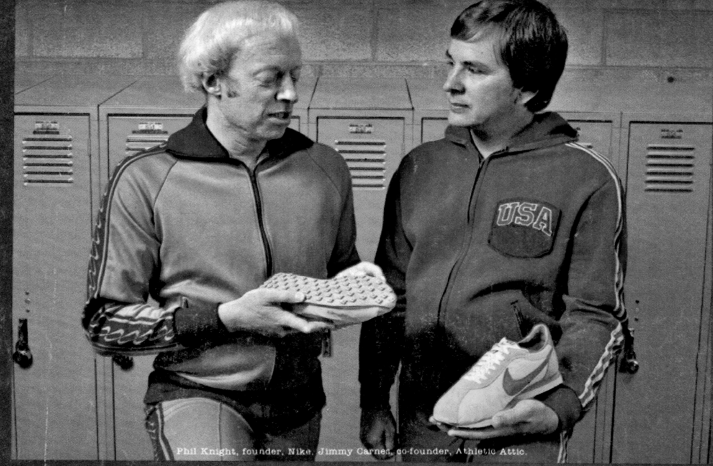

Phil Knight, founder, Nike. Jimmy Carnes, co-founder, Athletic Attic.

And that's exactly why you find Nike Shoes at Athletic Attic.

These men are the founders of two of the leading companies in running. And even though their companies are almost 2000 miles apart, they share one important similarity: both are managed by people who have been thoroughly involved in running all their lives. As a result, they also share a common objective: to bring you the finest running shoes possible.

Nike achieves this objective through a research and development program dedicated to produc-

ing shoes good enough to satisfy the best runners in the world.

Athletic Attic does it through an intensive testing and evaluation effort that allows only the best running equipment to ever reach the shelves of local Athletic Attic stores.

So you'll find a complete selection of Nike Shoes at Athletic Attic. Because both men, and both companies, understand the needs of runners. And because both men demand nothing less than the best.

ATHLETIC ATTIC HAS AMERICA RUNNING TO ITS DOORS . . . ALABAMA: Birmingham, Huntsville, Mobile, Tuscaloosa, CALIFORNIA: Century City, Cupertino, Merced, San Jose, West Covina, CONNECTICUT: Danbury, East Hartford, DISTRICT OF COLUMBIA: Georgetown, Mazza Gallerie, FLORIDA: Altamonte, Clearwater, Coral Springs, Ft. Lauderdale, Fort Meyers, Gainesville-Oaks & Westside Regency, Jacksonville, Lake City, Lakeland, Leesburg, Mary Esther, Melbourne, Merritt Island, Naples, Orange Park, Orlando, North Palm Beach, Panama City, Pensacola, St. Petersburg, Tallahassee, Tampa-Floriland & Westshore, Winter Haven, GEORGIA: Atlanta, Augusta, Brunswick, Decatur, Macon, Savannah, ILLINOIS: Aurora, Evergreen Park, Joliet, INDIANA: Anderson, Lafayette, Marion, Mishawaka, KANSAS: Wichita, KENTUCKY: Bowling Green, Louisville-The Mall & Jefferson Mall, LOUISIANA: Alexandria, MARYLAND: Glen Burnie, MINNESOTA: Burnsville, MISSISSIPPI: Jackson, MISSOURI: Jefferson City, Springfield, NEW JERSEY: Rockaway, Wayne, NEW YORK: Buffalo, Glens Falls, Olean, Manhattan, Staten Island, NORTH CAROLINA: Chapel Hill, Charlotte, Raleigh, Winston-Salem, OHIO: Columbus, Euclid, Marion, Middletown, OKLAHOMA: Oklahoma City, PENNSYLVANIA: Ardmore, Bethlehem, North Wales, Philadelphia, Pittsburgh, Plymouth Meeting, Springfield, State College, Uniontown, Wyomissing, PUERTO RICO: San Quanlas Ampricas & Highland, Johnson City, TEXAS: Arlington, Amarillo, Austin, College Station, El Paso, Galveston, Houston-Memorial & Sharpstown, VIRGINIA: Harrisburg, Manassas, Portsmouth, Richmond, Roanoke, Virginia Beach, WEST VIRGINIA: Morgantown.
FRANCHISES CURRENTLY AVAILABLE. For franchise information write: Director of Franchise Sales, Athletic Attic National Headquarters, P.O. Box 14503 R.W., Gainesville, Florida 32601

1979: LDV, 'These Two Men Demand the Best Running Shoes Possible', ft. Phil Knight and Jimmy Carnes

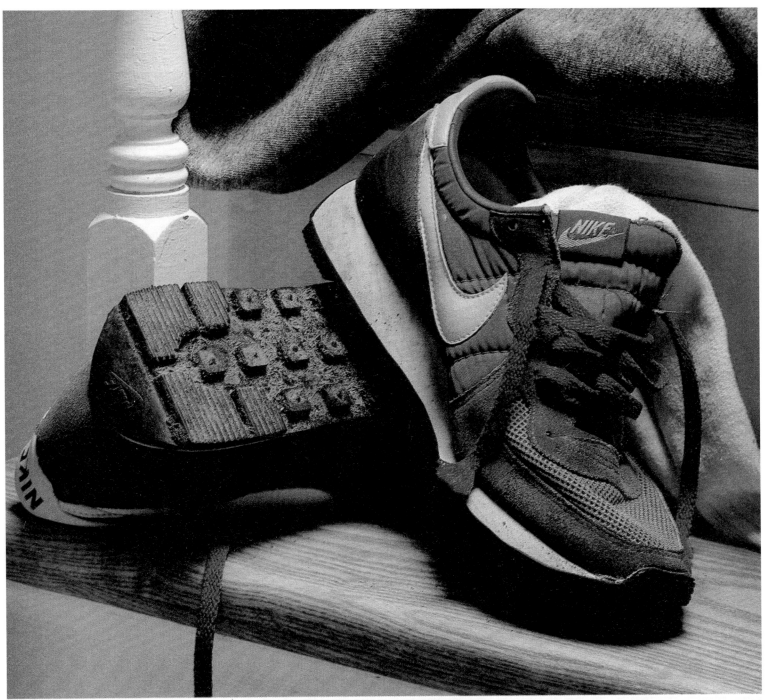

GIVE 'EM HELL.

Don't leave the store with these shoes in a box. Put them on. And take the longest, cruelest way home possible. You won't be punished.

Because we built the Internationalist for runners who think nothing of knocking off 75 to 100 miles a week. On asphalt, dirt, concrete and mud.

That's when comfort isn't a luxury, but a necessity. That's when you need a shoe that can take it.

With thick EVA sponge midsole. A PermaFoam insert that molds to the contour of your

foot. And notched heel counter to eliminate pressure on the lower Achilles.

The Internationalist is curve-lasted, with a Variable Width Lacing System™ for a perfect fit. And a revolutionary new Waffle outsole for greater stability.

But if you're not ready to abuse this shoe, you're not ready to wear it.

The Internationalist. Not for the faint of foot.

NIKE

Beaverton, Oregon

1980: Internationalist, 'Give 'Em Hell'

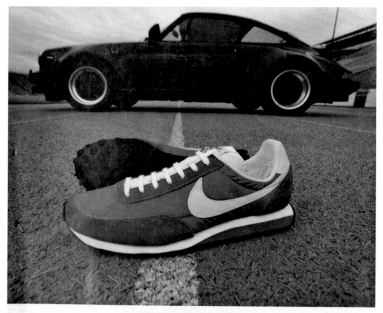

NO SPEED LIMIT.

The Nike Elite. This magazine ranked
it the best racing flat in the world.
Bar none.
We think you'll agree, the moment you
step into a pair.
The Elite gives you our famous waffle
sole for incredible traction on any surface.
The wide, flared heel spreads impact
and gives you greater stabilization.
And the electric blue nylon uppers have
a seamless toe pocket for blister-free racing.
The Nike Elite. Built with the concern
for quality you'll find in
a Porsche.
With no speed limit.

NIKE

8285 SW Nimbus Ave., Suite 115
Beaverton, Oregon 97005

Also available in Canada through Pacific Athletic Supplies Ltd. 2433 Beta Avenue, Burnaby, B.C. Canada V5C 5N1 (604) 294-5307

1978: Elite, 'No Speed Limit'

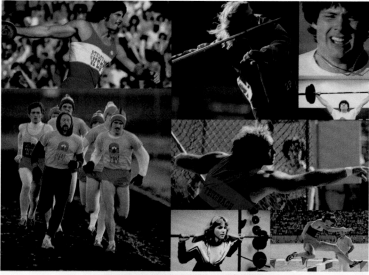

YOUR TIME WILL COME.

Track and field people, take heart. Your time is
coming. And soon.
As all of us know, road running has become a
phenomenal movement in this country.
More and more runners. Bigger races. Bigger spon-
sors. Bigger money. And more publicity for road runners.
We think it's time track and field athletes got their
share of the spotlight, too. We know you're training
at a personal sacrifice to make the 1980 Olympic team.
We know, too, that you're not getting much financial
support from the government, private industry and the
so-called athlete organizations. Or encouragement from
the public.
But hang in there. All eyes will be on you in Moscow,
and if you don't bring home the medals, you're going
to hear about it from people mouthing off. People who
should be supporting you right now.
We're putting our money where our mouth is by
giving financial aid to Athletics West, our post-graduate
track and field club.
We've also never forgotten track
and field when it comes to shoes. **NIKE**
Because we're athletic supporters,
from the ground up. Beaverton, Oregon

1979: 'Your Time Will Come'

THERE IS NO FINISH LINE.

NIKE

Beaverton, Oregon

1979: 'There is No Finish Line'

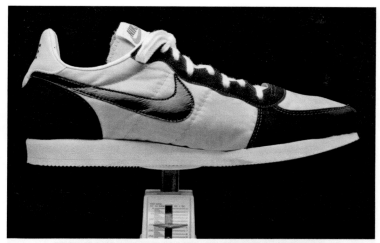

THE EAGLE GIVES YOU ALMOST NOTHING
TO BE EXCITED ABOUT.

When it comes to road racing flats,
5.1 ounces* is almost nothing. Each one
weighs less than the box it comes in.
That's the lightest racing flat we've
ever made. As far as we know, it's the
lightest production model ever made by
anybody.
And we think that's exciting.
Especially when you consider this shoe
has already clocked a 2:10 marathon.
It's definitely not a training shoe. The
Eagle is made to be worn on race day, like
wearing your best pair of competition
spikes.
It combines an unusual spike-like
design through the shank, a PermaFoam
sockliner and a Variable Width Lacing
System™ to give you the best fitting
performance shoe we've ever devised.
And also the lightest.
The Eagle, feather-weight champion
of the road.

NIKE

Beaverton, Oregon

*Approximate weight for size 9

1980: Eagle, 'The Eagle Gives You Almost Nothing to Be Excited About'

THIS NEW AIR-WEDGE IS OVER 10,000 MILES LONG.

It's hard to believe. But we just made something shorter without reducing its length.

Remember the NIKE-Air™ sole? Well, we just came out with a condensed version. The Air-Wedge.™

We did it the minute we learned from our survey that three out of four runners were heel strikers. With the Air-Wedge, we can now give those runners the protection of Air, but only where they need it most. Right under the heel.

True, the Air-Wedge is a lot shorter. But it reaches just as far—about 10,000 miles actually.

After 500 miles, shoes with the Air-Wedge lose none of their cushioning properties. Those with EVA foams, however, will suffer a 15% to 20% loss.

And probably even further. We don't know how much further because our lab technicians threw in the towel after watching the NIKE-Air sole successfully handle over 6,000,000 impacts.

That's the funny thing about

Air. You'd think it would be fragile, susceptible to blow-outs, leaks, etc. When in reality it will outlast virtually every other part of the shoe, from the laces to the outsole.

That's not even the good news. What's truly phenomenal about the Air-Wedge is that its cushion won't break down. It will absorb just as much shock on the first step as it will on the 5,999,999th.

Pretty remarkable. Especially considering the typical shoe with an EVA wedge will lose about 15 to 20 percent of its cushion after just 500 miles.

Such rapid compaction isn't just sad, it could be dangerous. Because, if you're a runner, you might as well hit your heel with a five pound hammer. That's how much shock is generated with every step.

Not so funny.

And, unless you like buying a new pair of shoes every 300 miles, not so cheap.

But the Air-Wedge does more than just keep its cushion. Accord-

When subjected to impact testing, a new shoe with the Air-Wedge doesn't bottom out like a new shoe with EVA foam. Instead, it responds in a more linear fashion, delivering 12% better cushion. The steeper the slope on the curve, the harder the material becomes when it is compressed under your heel.

ing to tests carried out in our sport research lab in Exeter, New Hampshire, it gives better cushion the first day out of the box.

Whenever we stuck an Air-Wedge in a developmental shoe, shock absorption immediately jumped 12 percent. The reason being, the Air-Wedge simply doesn't bottom out, or get stiffer as it is compressed.

Okay, but how stable is it? Answer: surprisingly good. We also ran some direct comparison tests between two similar shoes, one with the Air-Wedge, the other with an EVA foam wedge. As far as controlling rearfoot motion, they both did the job equally well.

One last thing. Not all runners will run on the same amount of Air. We have scaled the pressure in the Air-Wedge according to shoe

size, so that runners of all sizes will receive the appropriate amount of cushion.

Pegasus

Now where can you find this amazing device? In two new Nike models. The Pegasus. And the Odyssey.

We've made many claims about our NIKE-Air shoes. And with the introduction of the Air-Wedge, we're making even more.

But, then, we know it's going to let you down.

A lot easier. And a lot longer. Beaverton, Oregon

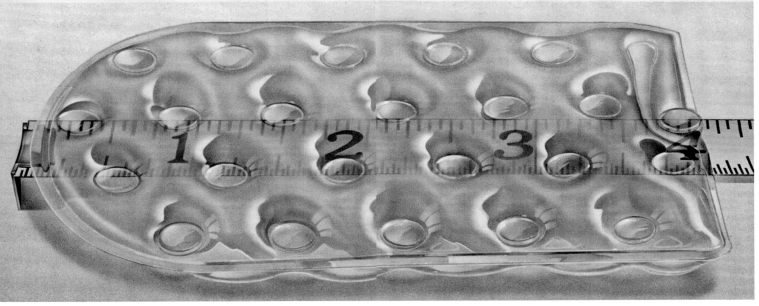

1980: Pegasus, 'This New Air-Wedge is Over 10,000 Miles Long'

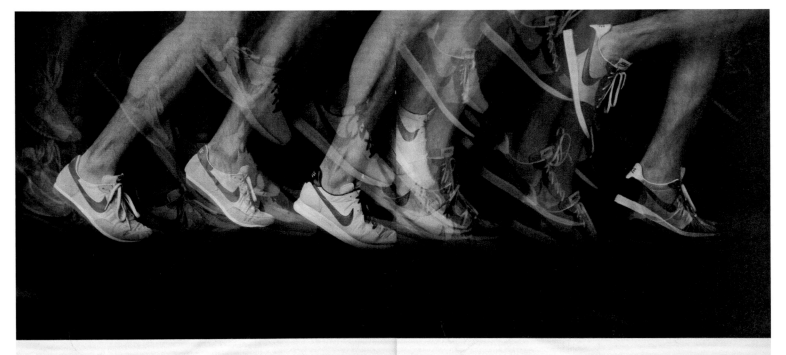

RUN YOUR OWN RACE.

Talk to the leaders this year at Midland. Or Eugene. Honolulu. New York. Or Buffalo.

They'll tell you how they made the race revolve around them. Around their weaknesses, their strengths.

You'll also hear about some unusual shoes they were wearing. New flats specifically designed to help them run their own race.

It isn't just a new Nike racing flat making news this year.

It's three new Nikes. The Magnum. The Mariah. The Eagle.

An awesome threesome. Each with its own unique approach to cushioning, support and weight. Each built with a particular type of runner in mind.

But a single objective. Winning.

The Magnum. The Mariah. The Eagle. Now there's more than one way to the top.

Beaverton, Oregon

1980: Magnum, Mariah and Eagle, 'Run Your Own Race'

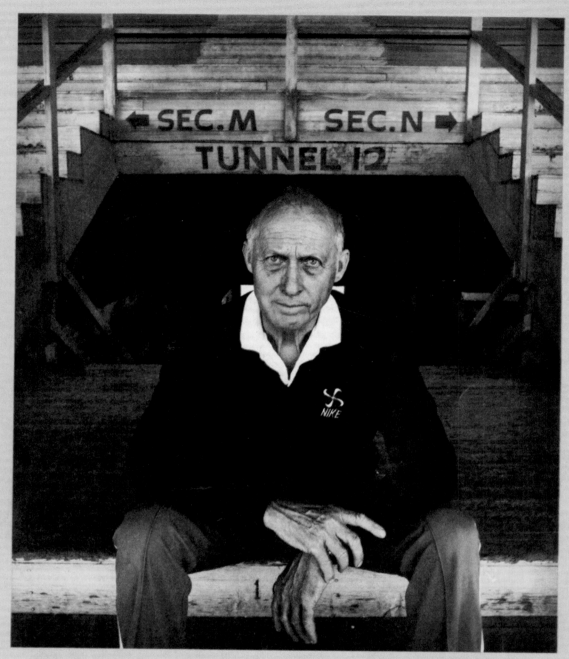

THE SPIRIT THAT MOVES US.

For 24 years at the University of Oregon, he never recruited. And when athletes came to him, he put them to work in sawmills. Cut anyone who couldn't keep up the grades. He knew more people succeed because of mental toughness than physical ability.

He took the U.S. Track and Field team to Munich in '72. And came back complaining the Olympic games aren't conducted for athletes. But for aristocrats and pseudo-aristocrats.

To the A.A.U. and now the Athletics Congress, he remains a thorn in the side. Fighting in the courts for what he calls the emancipation of the athlete.

His literary career has been sporadic at best. But for thousands of Americans he is the writer who convinced them to take to the streets. And pound it out, year after year.

At Nike, we know him as the renegade inventor. Who made an excuse to his wife so he could skip church and fool around with a waffle iron.

He's the guy on our board of directors who comes prepared to raise hell. Share a laugh. And to never let us forget the real point of the whole thing — to help athletes perform.

Bill Bowerman. Stubborn, demanding. Given to sudden outbursts and moments of magical insight.

We wouldn't be the same without him.

Beaverton, Oregon

1980: 'The Spirit That Moves Us', ft. Bill Bowerman

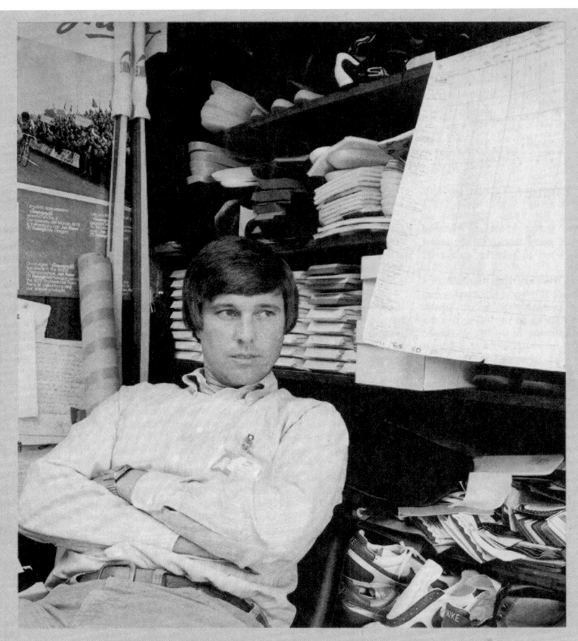

OUR FIRST EMPLOYEE IS STILL WITH US. WE THINK.

Actually, this middle-distance runner out of Stanford had us wondering right from the start.

Shortly after we hired him, he ripped a customer's shoe apart and sewed it to a rubber shower thong. But once that shoe was refined, it won the Boston Marathon and gave rise to the whole concept of full-length midsole cushioning.

Obviously, with Jeff Johnson, we learned to be patient. He is unconventional. Intensely curious. With almost child-like powers of observation.

He was the brains behind the Nike Elite. The new Internationalist. And scores of other models. His fascination with tying his shoes led to our Variable Width Lacing System.

But for all that, the man has no sense of propriety. He'll read dime novels in the middle of a business lunch. Suddenly turn up missing. When we asked him to set up an east coast office in '67, he did it behind a funeral home. And shipped out shoes in embalming fluid boxes.

Under normal circumstances he'd be one of the hard core unemployables.

Because Jeff Johnson is a first class eccentric. A dreamer. In fact, it was during his sleep that he came up with our name.

No wonder we listen.

Beaverton, Oregon

1982: 'Our First Employee is Still With Us. We Think', ft. Jeff Johnson

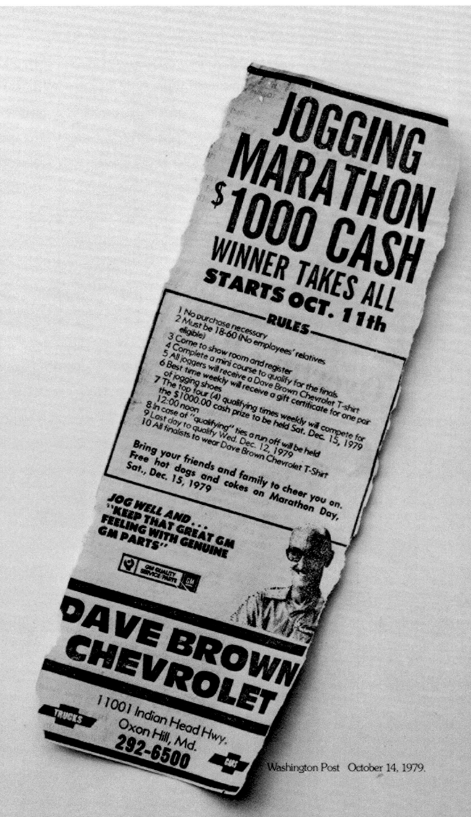

Washington Post October 14, 1979.

WHAT'S HAPPENED?

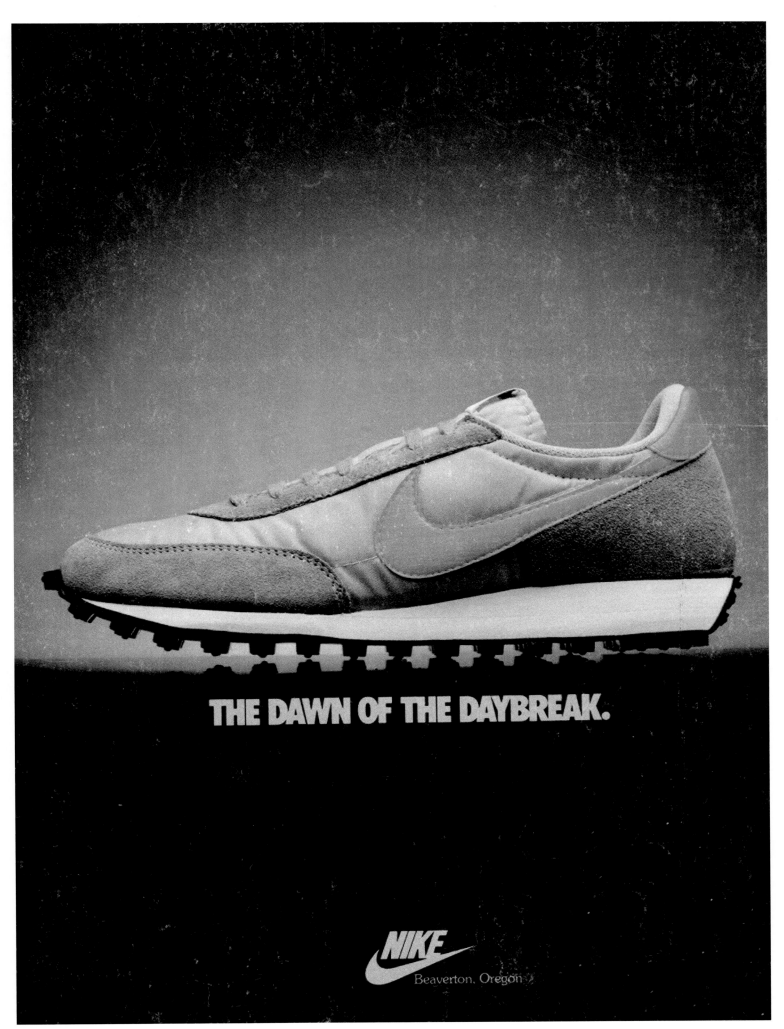

THE DAWN OF THE DAYBREAK.

NIKE
Beaverton, Oregon

1980: Daybreak, 'The Dawn of the Daybreak'

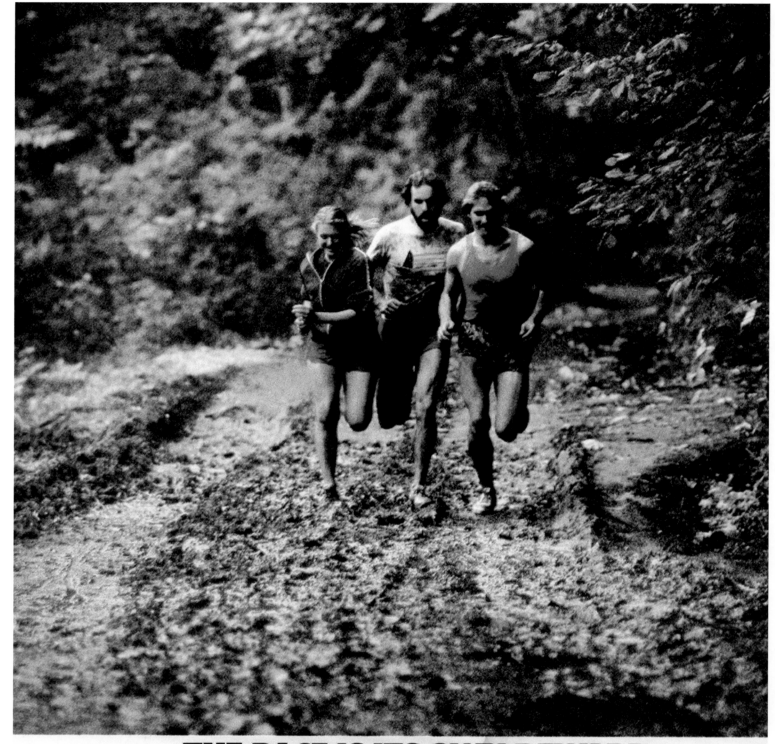

THE RACE IS ITS OWN REWARD.

There was a time when people didn't run to collect T-shirts. Or race numbers.

When the finish line was drawn in the dirt with a stick. And all the winner collected was a cold beer and a thumbs-up.

That's how this revolution got started. And while it may be time to get runners and races organized, too much organization screws up the whole thing.

Because if you can't stay a little crazy, it's damn hard to remain sane.

NIKE

Beaverton, Oregon

1980: 'The Race is Its Own Reward'

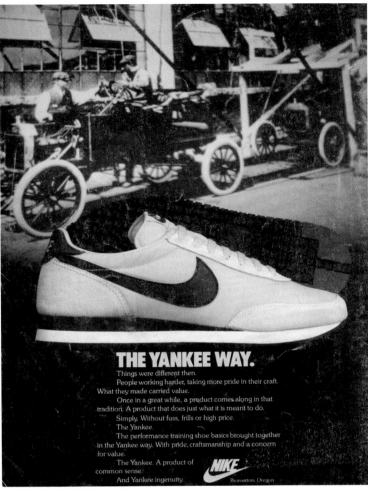

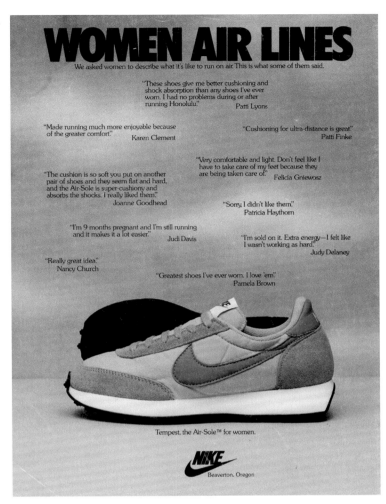

1980: Yankee, 'The Yankee Way'

1980: Tempest, 'Women Air Lines'

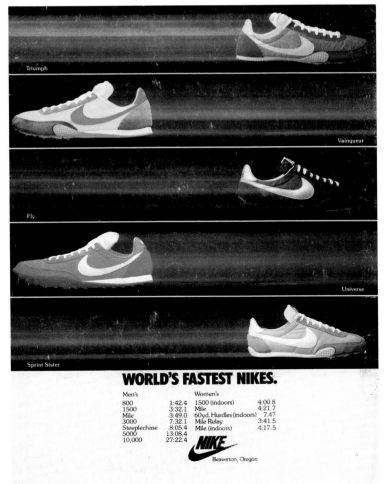

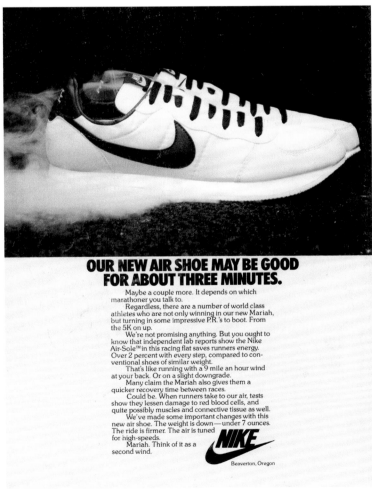

1980: Triumph, Vainqueur, Fly, Universe and Sprint Sister, 'World's Fastest Nikes'

1981: Mariah, 'Our New Air Shoe May Be Good for About Three Minutes'

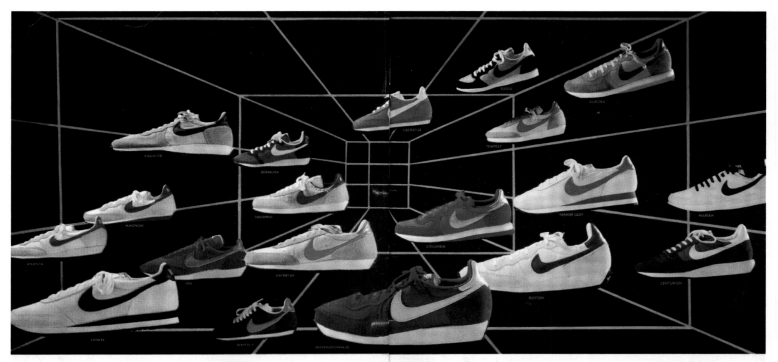

MOST OF THESE SHOES HAVE NO BUSINESS BEING ON YOUR FEET.

But among them are the shoes you were born for.

Because they have been engineered for your foot type, gait pattern, body weight, even your age, sex and training schedule.

You're not like every other runner.

And you shouldn't have to pretend you are.

That's why we spent years working with orthopedists, podiatrists, world class athletes and everyday runners.

We wanted a line of shoes that had nothing to do with the so-called "average" runner. We wanted shoes that could help real people. With real and diverse characteristics.

Now we've got them.

For pronators, heel strikers. Big runners and small. For people who churn out 125 miles a week, and those who run a good ten.

Shoes for the road, the trails and models for both. For feet that are flat or arched, rigid or flexible.

The new Nike Running Line.

Never again will you have to put yourself in the other person's shoes.

NIKE
Beaverton, Oregon

1981: 'Most of These Shoes Have No Business Being on Your Feet'

ALL FEET ARE NOT CREATED EQUAL.

Those little footprints on your birth certificate aren't there for decoration. They were the best way you had of saying—I'm an individual; I'm unique.

And the moment you start treating your feet like they belong to someone else, they're going to let you know about it. Via blisters, shin splints, stress fractures or any number of other ailments.

No one has done more to get on an intimate basis with feet than Nike. We built one of the most sophisticated sports research labs in the world — the only one in the shoe industry — and staffed it with researchers in biomechanics, anatomy and exercise physiology.

Feet, we've found, can be pretty articulate. But you have to know how to listen.

First, pay attention to their prints. There are three basic types, and you can spot yours the next time you step out of the shower.

According to our ongoing anatomy study, nearly 4 runners out of 10 have something other than a normal arch.

High Arch Normal Arch Low Arch

Those with extremely low arches may take solace in the fact they share this trait with Henry Rono and Patti Catalano.

Unfortunately, some low arched feet overindulge. They're so flexible, they love to pronate. A little pronation is a good thing because it absorbs shock. Too much of a good thing, however, can lead to various knee and foot problems.

To give them a bit of self-discipline, we designed the Equator. Through computer analysis of high speed film, our lab reports show this

Nike Equator

Standard Training Shoe

Two rear views of pronation, taken from high speed film. Although runner and speed are identical, angle between lower left leg and rearfoot is less in Nike Equator than standard training shoe.

shoe reduces rear foot motion up to 5 degrees, or slightly less than a hard orthotic.

The high arched foot has its own story to tell. And frequently, it's a shocker. If this foot is also rigid, as is often the case, it will do little to absorb impact.

That's why for the likes of Steve Ovett, Joan Benoit and Herb Lindsay, cushioning is everything.

We want shoes that do more than "feel" soft in the store. So we check out materials with dynamic load displacement tests. And run prototypes across force platforms to judge their shock attenuation.

But don't think because you're blessed with a normal arch that you can give your feet just anything to wear.

After your next shower make two sets of footprints, one while sitting, one standing. If the second set is much flatter than the first, your feet are flexible. Look for a shoe with good motion control. If there's little difference, go for cushion.

Curve Lasted Nike Columbia Straight Lasted Nike LDV

High arched feet are normally better suited to curve lasted shoes, low arched to straight lasted models.

Three dimensional computerized drawing of new prototype last based on preliminary foot morphology study.

tent health problems, don't mess around. See an orthopedist or podiatrist.

For our part, we're seeing runners. In the lab, at the schools, in meets and races all over the country.

We're compiling information. Modifying our lasts, creating new ones. We want to be certain we're making the proper shoe for the proper individual.

Of the thousands of runners we've seen so far, we've never met a foot we didn't like. Or couldn't help.

NIKE
Beaverton, Oregon

1981: 'All Feet Are Not Created Equal'

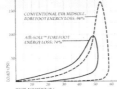

1981: 'To Find a Faster Shoe, We Wasted a Lot of Energy'

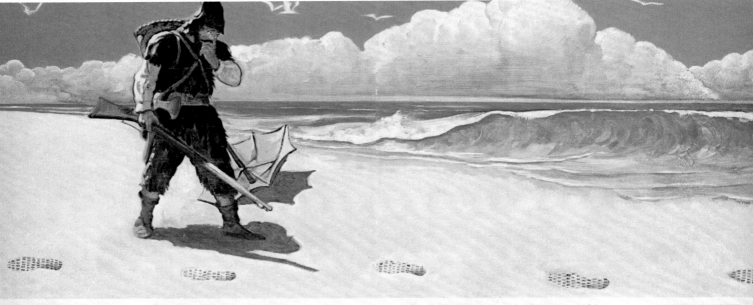

1981: 'My God…Another Heel Striker'

BEFORE INTRODUCING THE ZOOM, WE RAN A FEW TESTS.

They looked good on paper. And even better in the lab. These new spikes were definitely the lightest prototypes we'd ever put together—by about 90 grams.

What made that important was the old physiologist's rule-of-foot: for every 100 grams you knock off a pair of shoes, you also cut energy costs by about one percent.

It appeared we'd come up with the fastest Nikes ever.

But that wasn't the only good news. For all the weight loss, these prototypes showed no loss in cushioning. None.

That really got us going. Because our own studies showed that comfort can also save runners energy.

So we went even further. Introduced the Variable Width Lacing System™, for a nice, snug fit, especially through the arch. And redesigned the spike plate. So during the weight-bearing phase, the spikes would bite the dirt. Not the foot.

We developed models for sprints, distance and indoor. Then the heavy research began. We put them on international tour. And from the Pan American Games, to the Olympic Trials, to Moscow itself, these spikes began rewriting the record books. Taking more than their share of victory laps.

That started a lot of people talking. But nobody, nowhere used their proper name: Prototype #45711 TF.

All they could say was Zoom. Sounded good to us.

NIKE
Beaverton, Oregon

1981: Zoom, 'Before Introducing the Zoom, We Ran a Few Tests'

THIS COUNTRY SHOULD BE RUN BY THE ELITE.

Not so long ago, the Elite did rule.

There was hardly a cross-country title that didn't fall victim to this shoe. In either collegiate or high school competition. In fact, in its heyday, the Elite set the American record for the marathon.

Well, you can kiss those days goodbye.

Because now there's the Elite Classic. And, frankly, it puts the old Elite to shame.

Oh, the colors are the same.

And the patented Waffle outsole is still there—because there is just nothing better suited to both road and trail.

What's missing is the weight. The new Elite Classic is more than an ounce lighter than the original.

By going to a new EVA formulation in the midsole, we were able to knock the weight down and yet leave the cushion right up there.

Pretty astonishing. And so is the fit. The new Elite Classic is made on an improved curved last that gives more room in the toe box and a more stable heel. We

also added our Variable Width Lacing System for a personalized fit.

In short, the shoe that made history is back for a rewrite. So if you have any interest in cross-country or road racing, get your hands on the new Elite Classic.

And run it out of town.

NIKE
Beaverton, Oregon

1982: Elite Classic, 'This Country Should Be Run by the Elite'

NEVER JUDGE A SHOE BY ITS WEIGHT.

If you're looking for the fastest shoe, you've got to do more than count grams.

We know. We've done extensive research on racing flats, and there's one thing we know for sure. Light doesn't always make right.

If it did, the best shoe for race day would be no shoe at all. But things don't work that way. The fact is, you can run faster in just about any training shoe on the market than you can barefoot.

It appears to have something to do with the amount of shock created with every footstrike. Somehow that shock has to be dissipated. If your shoe won't do the work, your body will.

And work, as we all know, takes energy.

energy savings. Even when compared to a pair of shoes weighing 100 grams less.

Then why, you ask, has everyone been so fanatical about reducing shoe weight? It goes back to some earlier research which says that for every 200 grams you knock off a pair of shoes, you gain a 2 percent energy rebate.

But how much? To find out, we ran a series of tests that compared two shoes of identical weight. The only significant difference was that one model was nearly twice as hard as the other. As it turned out, runners saved 1.3 percent more energy when they ran in the model with more cushioning.

Interesting. And it became even more so when we investigated our air shoes. The Mariah, for example, can deliver the same 1.3

so simple. Our tests show that the saving in energy is less the faster you run. At a 7:00 mile pace, that 200 gram difference is actually worth about 2.7 percent added energy. But at a 5:30 pace, the savings—while still noteworthy—drops to 1.7 percent.

Then, you conclude, it's the slower runner who stands to benefit most from a lighter shoe. Well, yes and no. In the longer races, mainly no. Because a 3:00:00 marathoner is going to hit the ground 6,500 times more often than a 2:24:00 marathoner. And that shock accumulates and leads to fatigue.

Another thing to keep in mind. Regardless how fast you train, when the gun goes off and the adrenalin starts pumping, you'll run even faster. That's good. But that's no time to forget cushioning. As our research points out, when speed goes up, so do the impact forces.

A similar thing happens on a hilly course. You struggle uphill—using about 12 percent more energy for every degree of slope—just waiting to get it all back on the downhill side. And what do you really get? A paltry 7 percent energy kickback for every degree of slope.

Because as the grade goes down, the force of impact goes up. And your body has to use more energy to dissipate shock.

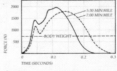

It all boils down to this. Whatever your speed, whatever the conditions, don't throw away cushion to get rid of a few extra grams.

Now, we're not doing all this research just to amuse ourselves. We take all the data and turn it into shoes that are faster, safer. Not according to theory. But according to fact.

With innovations like the Air-Sole® in our Mariah. Or Phylon, in our Terra T/C. And since the right balance of weight and cushioning is going to vary from runner to runner, we offer a choice. From the super lightweight American Eagle, to the Magnum, Elite, and the Boston and Atlanta.

We know it sounds like heresy, but you're better off never trying to pick a racing flat by weight alone.

Even if it's a tough habit to drop.

NIKE
Beaverton, Oregon

1982: 'Never Judge a Shoe by its Weight'

PICK ON A SHOE YOUR OWN SIZE.

If you've got a little meat on your bones, the last thing you want is a little shoe on your foot.

That's why we built the Centurion. It's for athletes who can't afford to be running around in underfed shoes. That don't have the cushion. Don't have the support. Shoes that wear thin about as quickly as your patience.

If you're 30 pounds overweight, you're hitting the ground with about 20 percent more vertical force than normal. And that's enough to send more than a shiver up your spine.

Especially if you do it in a typical training flat. Because most midsoles can't take that kind of pressure. Not without totally compressing. Which makes them about as useful as paper slippers.

The Centurion is a different story. With a firm wedge atop a soft midsole, it allows the hefty foot to sink comfortably without hitting bottom. Lighter weight runners will find the Centurion too firm. But then anyone built like linguini doesn't belong in this shoe.

We also made it on a different last, so it fits the wider foot. Beefed up stability with a flared midsole, leather reinforcements on the upper, plus an extended heel counter locked into place with a Stability Saddle.

And as our wear tests point out, the Centurion has an unheard-of life expectancy.

So if you've been putting up with running shoes built for someone half your size, put on the Centurion. It isn't such a small world, after all.

NIKE
Beaverton, Oregon

1982: Centurion, 'Pick on a Shoe Your Own Size'

TAKE TWO FOR MOTION SICKNESS.

It's not surprising we treat the Equator as serious medicine. It is. And we'll tell you right now—keep it out of the reach of rigid feet. They don't need it. And they're better off without it.

But for runners who suffer from chronic rearfoot motion, this is one over-the-counter shoe that can provide fast, effective relief.

In test after test, the Equator has actually reduced maximum pronation by an average of 22 percent.

However, if you expect this shoe to look like a medical wonder, you're going to be disappointed.

What makes it so innovative is something you can't see.

Placed beneath the Spenco® sockliner is a soft orthotic that coils around the heel to help cushion and control any rocking motion. The Equator is also built to accept the most unusual orthotics. Simply remove ours and slip them into place.

One of the few visual clues as to what this shoe is about is the external arch support that works in conjunction with our Variable Width Lacing System™ to automatically cinch up the medial side of the foot.

There is also a small ridge surrounding the bottom of the extended heel counter. It's called the Stability Saddle, and acts as a foundation for the heel counter giving added support.

With so much emphasis on stability, it was only natural that we board last the Equator. But we only did it in the rear. Up front, it's slip lasted for maximum flexibility.

Finally, a word of caution. For all its advances, the Equator is not to be taken in lieu of a trip to the doctor. Excessive rearfoot motion can have serious side effects. So, if pains persist, see your orthopedist or podiatrist. Don't put it off. With all that's at stake, this is no time to get queasy.

NIKE
Beaverton, Oregon

1982: Equator, 'Take Two for Motion Sickness'

THE CARE AND FEEDING OF A LIGHTWEIGHT.

Believe it or not, one of the most envied group of runners—the lightweights—has a very unenviable problem.

While the rest of us are out there causing street lamps to sway, these folks are hitting the ground with considerably less force. The typical 6 footer who is 20 pounds underweight, is receiving a jolt about 14 percent less than normal.

This is a problem? You bet. Especially when you start cranking out the weekly miles in shoes designed for the average weight runner.

What lightweights should fear most is too much cushioning. An overdose here and the shoe can become dangerously inflexible.

If you're one of nature's more slimmed down versions, you won't be applying enough weight to penetrate the forefoot area as much. And what you lack in pounds, you'll have to make up for in effort. It takes more energy to flex a thicker sole, so you'll run less efficiently.

You may also be flirting with shin splints and Achilles tendinitis, the most common results of too little flexibility.

Unfortunately, things really get sticky if your shoe size is less than a size 9. Because most midsoles aren't scaled the way the human body is.

Until we started investigating, the general assumption was that the forces under the foot were directly proportional to shoe size.

In other words, if a size 7 shoe is 9 percent smaller than a size 10, then a typical runner in a size 7 will experience 9 percent less vertical force.

As it turns out, nature doesn't work that way. In actuality, that size 7 runner will hit the ground with 18 percent less force.

All of which means the smaller sizes of most running shoes have an over-generous amount of cushion. For even the average weight runner.

It was a startling discovery. And we did something about it. First with our air shoes—the

Vertical ground reaction forces for a 150 lb. runner and a 100 lb. runner at a 6:00 mile pace. Forces under the heel and forefoot are both proportionally smaller for the lighter runner.

Are you a lightweight? Draw a line between your height and weight and see where it intersects the somatocrit scale.

The Air-Sole® (top) in the Columbia, Aurora and Tailwind has different air pressure in the various sizes to give more appropriate cushioning. The Terra T/C (below) has a Phylon™ midsole also scaled for cushion as well as the same degree of heel lift in all sizes.

Columbia, Aurora, and the Tailwind. Not only are these shoes slip lasted for the flexibility lightweight runners need, but we also adjusted the air pressure in the various sizes for more appropriate cushioning.

Lightweights will also appreciate the Terra T/C and the Lady Terra T/C. They are slip lasted in the front to make them flexible and board lasted in the rear to make them stable. In addition, the midsole has been molded to give the proper cushion and heel lift for each size.

So if you're on the thin side, put your feet on a diet. When it comes to cushioning, don't ask for second helpings.

Or you'll wind up a glutton for punishment.

NIKE
Beaverton, Oregon

1982: Terra T/C, 'The Care and Feeding of a Lightweight'

SOME RUNNERS NEED A LITTLE EXTRA PROTECTION.

Odyssey

Women's Odyssey

In the end, it is a question of anatomy. Not ability. Only when you come to terms with the structure of your own body—and how it reacts under stress—can you hope to live up to your potential. The Odyssey is an Air shoe. It comes in models for both men and women who, if they want to avoid a world of hurt, had better control that inward roll that occurs on footstrike.

One thing is certain. If anatomy is destiny, you never had so much to look forward to.

NIKE
Beaverton, Oregon

1982: Odyssey, 'Some Runners Need a Little Extra Protection', ft. Joan Benoit Samuelson

A BETTER WAY TO FILLET A SOLE.

Unless you're a perfect size 9, most midsoles just don't cut it.

In all likelihood, they'll give you the wrong amount of cushion. An improper heel lift. And, in the smaller sizes, not nearly enough flexibility.

Surprised? So were a lot of people.

But they knew exactly what we meant the minute they took our Terra T/C out for a test run. It is the first shoe that gives big feet and small feet the anatomical attention they deserve.

Up until now, most running flats ignored the rather funny way nature has of scaling the human body. When she

makes a foot 5 percent larger than another, she doesn't make the average vertical forces it will experience 5 percent greater as well. Normally, they're more like 10 percent.

As a result, the way traditional midsoles are made, the larger foot doesn't get enough cushion. And the smaller foot receives too much. And when there's more cushion than you bargained for, there's also less flexibility.

Heel lift is another problem.

All you have to do is look at a size 3 and a size 15 of the same model. It's fairly obvious that the larger foot is receiving less relative heel lift. In truth, about 30 percent less.

That can lead to some serious repercussions.

But not in the Terra T/C. The midsole is made from a revolutionary new material called Phylon™.

Because of the way it can be molded, we were able to engineer the midsole in the Terra T/C so that it provides the same relative amount of cushion in every size. Along with the same angle of heel lift—4°20'.

Someday, all midsoles will be prepared this way. But in the meantime, we have given athletes a more intelligent shoe. And everyone else a little food for thought.

NIKE
Beaverton, Oregon

1982: Terra T/C, 'A Better Way to Fillet a Sole'

THE SHOE THAT ATE NEW YORK.

It was a typical Sunday morning. Time in the City...10:26. I had just left Marty's diner, wiping the last of a Danish from my mouth, when I spotted them.

The shoes. They were back—jamming the street by the tens of thousands. I swung onto the camera truck. But before I could get settled a shot rang out. The truck lurched forward.

The race wasn't five minutes old when I spotted him. This shoe who said he'd win. This shoe who had never gone the distance. Never raced 26 miles before. But now clearly out in front.

It didn't figure.

Something else was funny. In a way he resembled one of the Nike racers. The Eagle. But the coloring was wrong. We turned a corner.

I fumbled for my notepad. Outsole: not smooth like the Eagle. Getting better traction.

He picked up the pace coming off the bridge. Midsole, I jotted, a good 20 percent more cushioning.

As the finish line approached, I stuffed the pad in my pocket and called to him. If you're not the Nike Eagle...who are you?

He smiled. I am an experiment, he said, breaking the tape. I have no name.

And vanished.

I searched the city for a year, turning up nothing but sore feet. Then it was October. They gathered again. And the shoe,

he was back. And when he was finished, he had a world record...2:08:13. Just like he predicted.

This time it was pandemonium. I elbowed my way through the crowd, slipping past one of New York's finest, and grabbed a moment with the victor on the curb.

Some experiment, I half-laughed.

The last, he said. Tests are complete.

And you are to be called...? The American Eagle.

I walked with him to the waiting van. Makes for a happy ending, I said.

I don't know about that, he replied, turning into the glare of T.V. lights. But you've got a hell of a first chapter.

NIKE
Beaverton, Oregon

1982: American Eagle, 'The Shoe That Ate New York'

BETTER RUNNING THROUGH CHEMISTRY.

Phylon™. A few years ago it was nothing more than a gleam in some chemist's eye.

Now it threatens to rewrite the book on midsole materials. Because it solves the fundamental problem of shoe design: how to cut weight without sacrificing cushioning.

Chapter one. Our new Terra T/C. A 6.7-ounce*racing flat with the cushioning of a trainer. Or is it a well-cushioned training flat that weighs-in like a racer?

You figure it out.

The secret's all tied up with this remarkable new midsole material. A break-

through discovery that delivers 34% greater cushioning than EVA—at a fraction of the weight.

And it's cushioning that just won't quit. In impact tests, the Terra T/C showed nearly the same shock absorption after 600 miles as it did the day we first set foot in it.

Phylon also led us to another interesting breakthrough. Because of the way it can be molded, we

were able to scale the Terra T/C's heel height so the angle of heel lift is the same in every shoe size. The first time a running shoe has been this anatomically accurate.

To improve stability we board-lasted the Terra T/C in the rear. While up front we went with slip-lasting for comfort and flexibility.

Then to top things off, we gave the Terra T/C a molded PermaFoam sockliner and our Variable Width Lacing System for a snug fit.

The end result? (Which is really only the beginning.) Terra T/C and Lady Terra T/C.

Our test tube babies. Try a pair. The chemistry is positively dynamite.

NIKE
Beaverton, Oregon

*Approx. wt., Size 9

1981: Terra T/C, 'Better Running Through Chemistry'

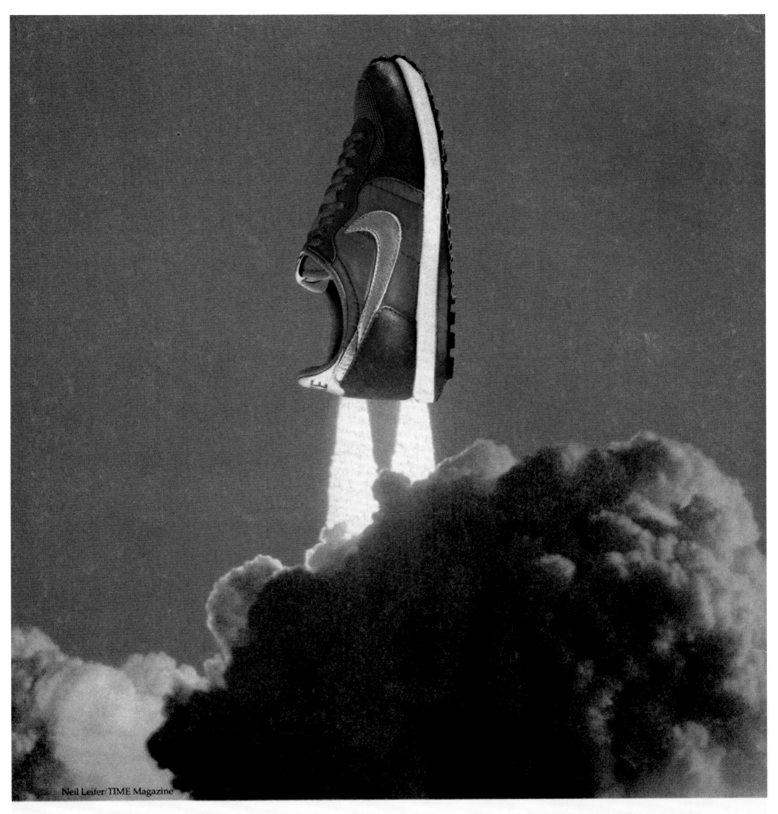

Neil Leifer/TIME Magazine

"WE HAVE LIFTOFF."

To be honest, our Columbia isn't *exactly* like their Columbia.

But talk about thrust. Wait until you're atop that refined Air-Sole™. It's not quite the same as 6.65 million pounds of rocket propellant. But it's enough to move you about two percent faster, or two percent farther.*

And the ride. It's awesome.

Even if you don't experience total weightlessness.

Equally important, it's a ride that will last. Because we built this Columbia strictly for training flights. Big, long ones. After more than 800 miles, laboratory tests showed virtually no loss of cushioning. And wear on the new Anatomical outsole — minimal.

We've even come out with a model that has the exact same per-

formance characteristics. The Aurora. For women only.

Now, you don't see NASA doing that.

Naturally, this kind of technology doesn't come cheap.

But look at it this way. You can buy one of theirs. Or about 20,000,000 of ours.

NIKE

*Compared to shoes of similar weight.

Beaverton, Oregon

1982: Aurora, '"We Have Liftoff"'

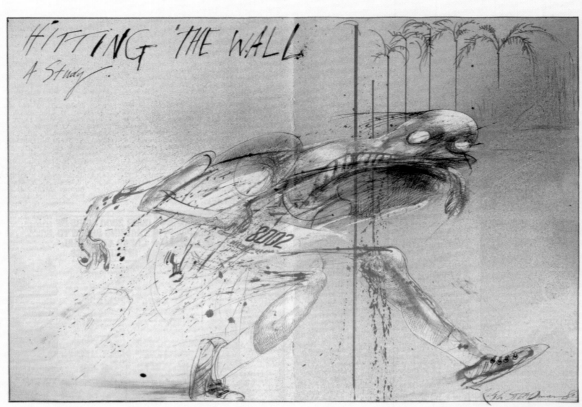

1982: 'Hitting the Wall', illustration by Ralph Steadman

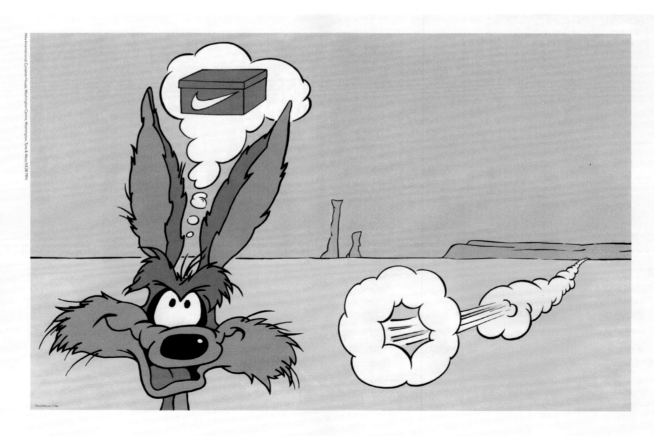

THE TERRA TRAINER. THE LIGHTWEIGHT SHOE FOR SERIOUS ROAD RUNNING.

1984: Terra Trainer, 'The Terra Trainer. The Lightweight Shoe for Serious Road Running' ft. Wile E. Coyote

 THE INTERNATIONALIST. FOR RUNNERS WHO TRAIN 25 MILES A WEEK OR MORE.

1984: Internationalist, 'The Internationalist. For Runners Who Train 25 Miles a Week or More'

 THE ODYSSEY. MOTION CONTROL AT ITS BEST.

1984: Odyssey, 'The Odyssey. Motion Control at Its Best'

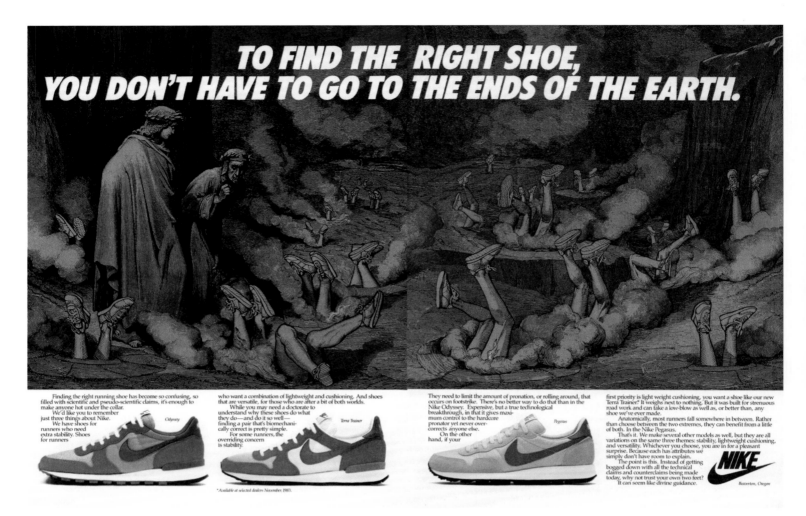

TO FIND THE RIGHT SHOE, YOU DON'T HAVE TO GO TO THE ENDS OF THE EARTH.

Finding the right running shoe has become so confusing, so filled with scientific and pseudo-scientific claims, it's enough to make anyone hot under the collar.

We'd like you to remember just three things about Nike.

We have shoes for runners who need extra stability. Shoes for runners

who want a combination of lightweight and cushioning. And shoes that are versatile, for those who are after a bit of both worlds.

While you may need a doctorate to understand why these shoes do what they do—and do it so well—finding a pair that's biomechanically correct is pretty simple.

For some runners, the overriding concern is stability.

*Available at selected dealers November, 1983.

They need to limit the amount of pronation, or rolling around, that occurs on footstrike. There's no better way to do that than in the Nike Odyssey. Expensive, but a true technological breakthrough, in that it gives maximum control to the hardcore pronator yet never over-corrects anyone else.

On the other hand, if your

first priority is light weight cushioning, you want a shoe like our new Terra Trainer. It weighs next to nothing. But it was built for strenuous road work and can take a low-blow as well as, or better than, any shoe we've ever made.

Anatomically, most runners fall somewhere in between. Rather than choose between the two extremes, they can benefit from a little of both. In the Nike Pegasus.

That's it. We make several other models as well, but they are all variations on the same three themes: stability, lightweight cushioning, and versatility. Whichever you choose, you are in for a pleasant surprise. Because each has attributes we simply don't have room to explain.

The point is this. Instead of getting bogged down with all the technical claims and counterclaims being made today, why not trust your own two feet?

It can seem like divine guidance.

NIKE
Beaverton, Oregon

1983: Odyssey, Terra Trainer and Pegasus, 'To Find the Right Shoe, You Don't Have to Go to the Ends of the Earth'

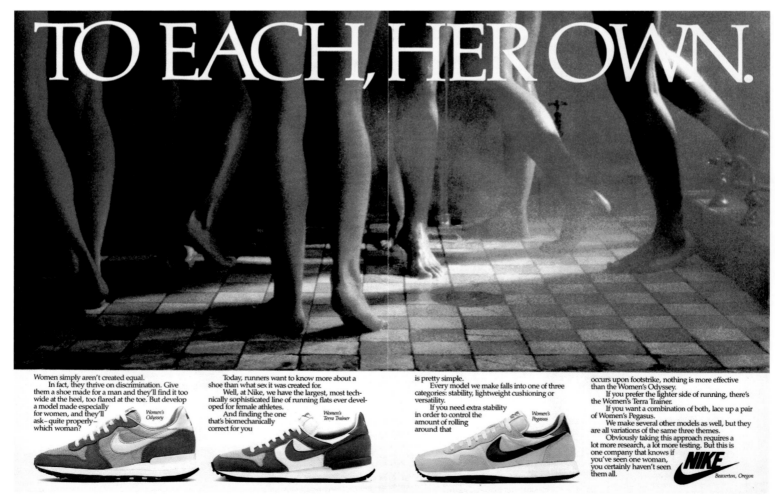

TO EACH, HER OWN.

Women simply aren't created equal.

In fact, they thrive on discrimination. Give them a shoe made for a man and they'll find it too wide at the heel, too flared at the toe. But develop a model made especially for women, and they'll ask–quite properly– which woman?

Today, runners want to know more about a shoe than what sex it was created for.

Well, at Nike, we have the largest, most technically sophisticated line of running flats ever developed for female athletes.

And finding the one that's biomechanically correct for you

is pretty simple.

Every model we make falls into one of three categories: stability, lightweight cushioning or versatility.

If you need extra stability in order to control the amount of rolling around that

occurs upon footstrike, nothing is more effective than the Women's Odyssey.

If you prefer the lighter side of running, there's the Women's Terra Trainer.

If you want a combination of both, lace up a pair of Women's Pegasus.

We make several other models as well, but they are all variations of the same three themes.

Obviously taking this approach requires a lot more research, a lot more testing. But this is one company that knows if you've seen one woman, you certainly haven't seen them all.

NIKE
Beaverton, Oregon

1984: Odyssey, Terra Trainer and Pegasus, 'To Each, Her Own'

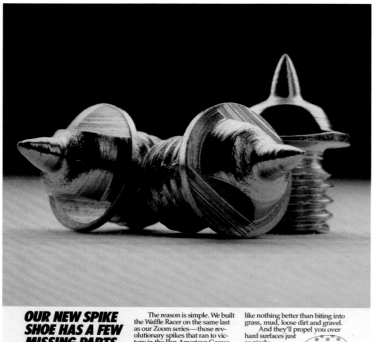

OUR NEW SPIKE SHOE HAS A FEW MISSING PARTS.

Namely, the spikes. You won't find them in our new Waffle Racer. You won't even find a place to screw them in.

That was no oversight, however. We designed the Waffle Racer to take you where spikes fear to tread. Into the fiercest indoor competition. And the most grueling cross-country races.

And it will take you there with a lightness and fit that you thought only possible in a world-class spike.

The reason is simple. We built the Waffle Racer on the same last as our Zoom series—those revolutionary spikes that ran to victory in the Pan American Games, the Olympic Trials and even Moscow itself.

And now, with the Waffle Racer, you don't have to give up the thing that matters most. Traction.

Those independent waffles like nothing better than biting into grass, mud, loose dirt and gravel.

And they'll propel you over hard surfaces just as nicely.

That goes for concrete, asphalt, and wooden indoor tracks. In fact, if you didn't know better, you'd swear you were running in spikes.

So if you want a racing flat that doesn't fit like a normal racing flat, that doesn't act like a normal racing flat, pick up the new Waffle Racer.

The shoe with a spike in its heart.

NIKE
Beaverton, Oregon

1983: Waffle Racer, 'Our New Spike Shoe Has a Few Missing Parts'

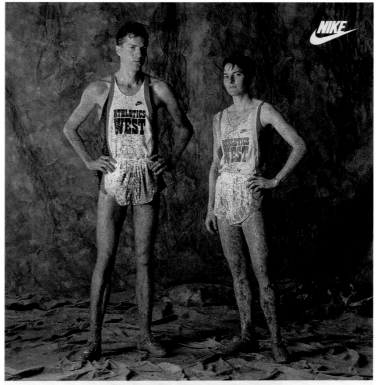

THEIR NAME IS MUD.

Nike Cross-Country shoes will see you through mud, grass, gravel, and anything else Mother Nature has up her sleeve. The Zoom X II does so with spikes; the Waffle Racer II with Waffle® studs.

Pat Porter and Lynn Jennings wear them. In fact, they wouldn't have their reputations dragged through the mud any other way.

Zoom X II Waffle Racer II Women's Waffle Racer II

1987: Zoom X II and Waffle Racer II, 'Their Name is Mud', ft. Pat Porter and Lynn Jennings

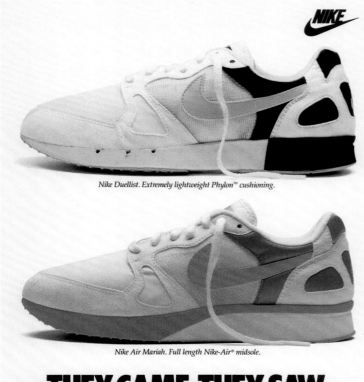

Nike Duellist. Extremely lightweight Phylon™ cushioning.

Nike Air Mariah. Full length Nike-Air® midsole.

THEY CAME. THEY SAW. THEY KICKED BUTT.

Most road racers will look at these shoes and wonder how anyone could run with so little on their feet. Say hello to these people at the beginning of the race. You won't see them later.

1988: Duellist and Air Mariah, 'They Came. They Saw. They Kicked Butt'

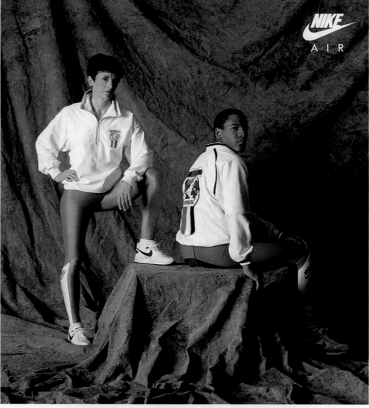

WARP SPEED, CAPTAIN KIRK.

Star date 1988. Seoul. The final frontier. Priscilla Welch and Kirk Baptiste. These are the voyagers of athletic enterprise.

Featured on Kirk Baptiste: Air Pegasus; Zurich tight; International Emblem jacket.
Featured on Priscilla Welch: Air Pegasus; Zurich tight; International Emblem half-zip.

1988: Air Pegasus, 'Warp Speed, Captain Kirk', ft. Priscilla Welch and Kirk Baptiste

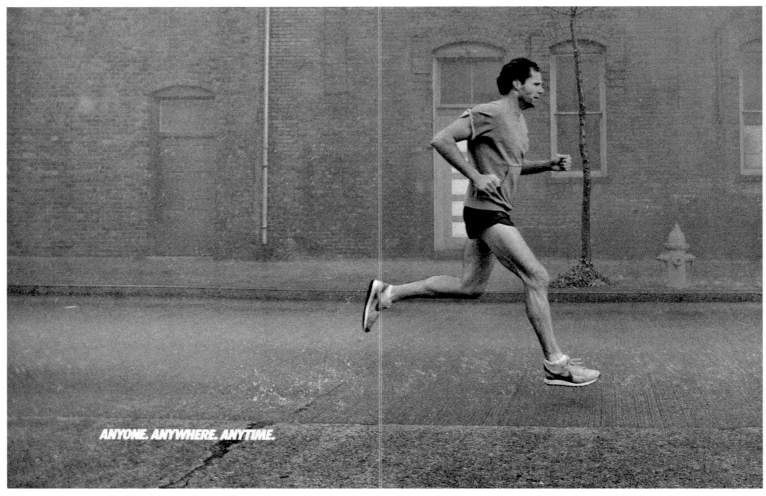

1984: 'Anyone. Anywhere. Anytime'

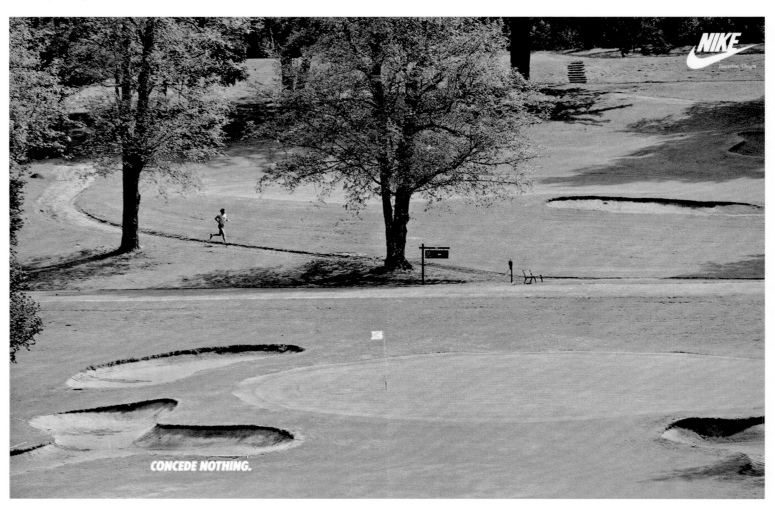

1984: 'Concede Nothing'

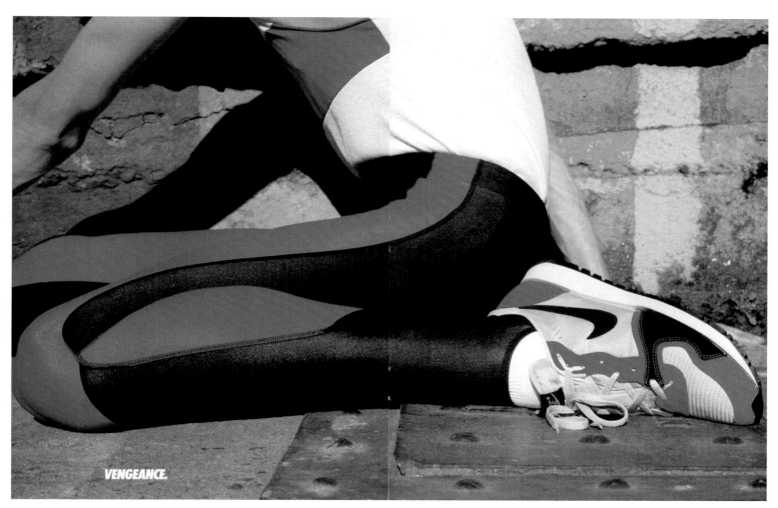

1984: Air Vengeance, 'Vengeance'

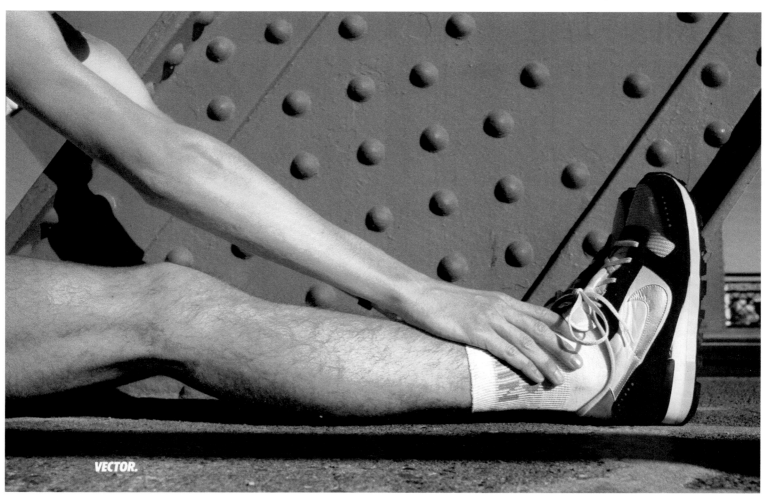

1984: Air Vector, 'Vector'

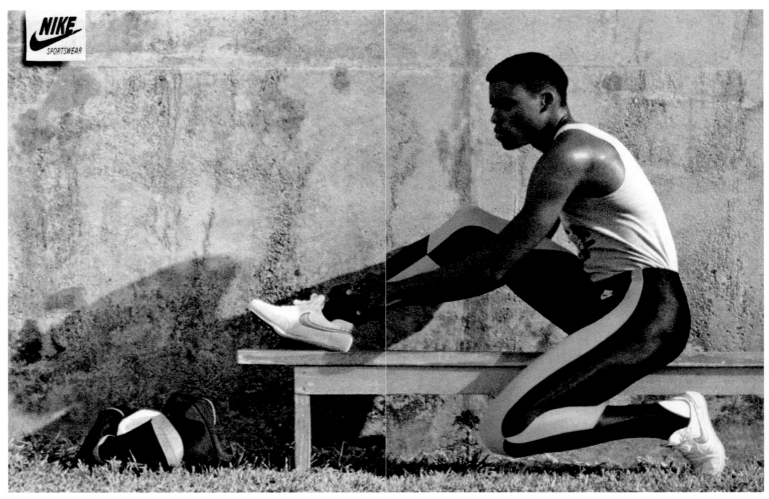

1984: Sportswear

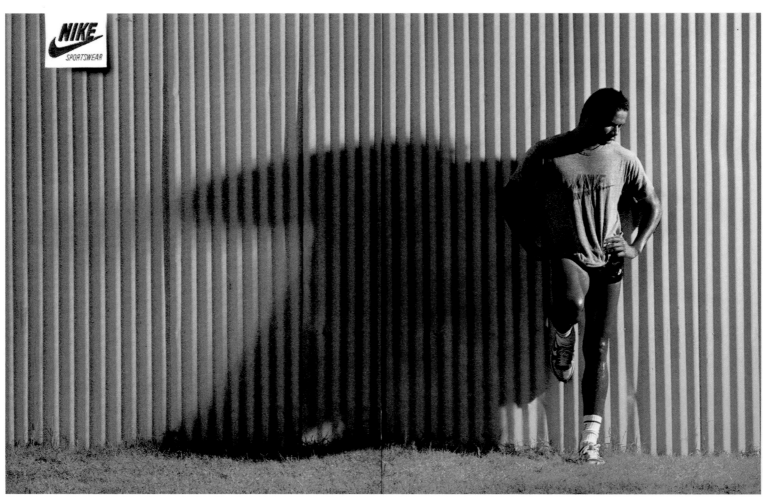

1984: Sportswear

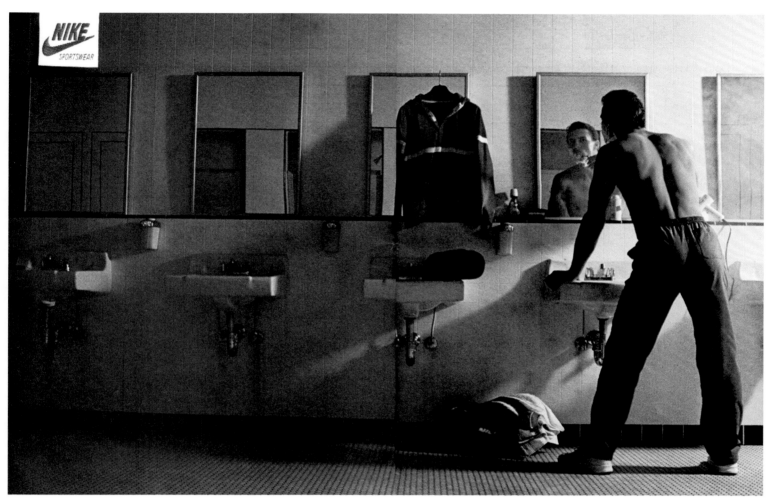

1984: Sportswear

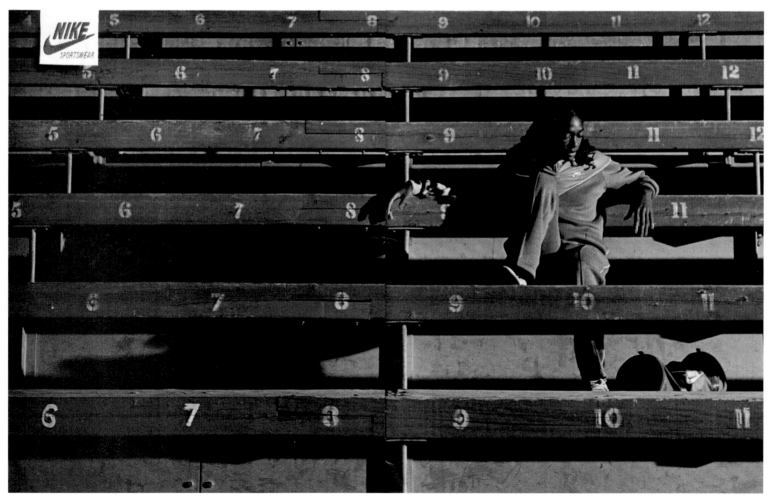

1984: Sportswear

WHEN IN DOUBT, WAFFLE.

It's a complicated, confusing world out there.

Just about the time you have it all figured out, everything turns to dust. Or gravel. Or sand. Or a two mile stretch of concrete. Followed by a rain-soaked field.

If you're a runner, there just aren't many simple answers in life. Save one.

The Waffle.

As familiar as this shape has become, nothing is better qualified to see you through the worst the world has to offer.

Because regardless of changes in terrain, each Waffle will continue to act as an independent shock absorber—penetrating softer surfaces, pushing into the midsole on harder ones.

Acting as an independent shock absorber, the Waffle tends to push into the midsole on harder surfaces while penetrating softer ones.

At our research lab in Exeter, New Hampshire, we found the simple addition of Waffles can increase the cushioning of a running shoe a full 10 percent.

The addition of Waffles to the same shoe significantly reduces impact shock.

Granted, it is possible to achieve somewhat the same thing by going to a flat outsole made of a much thicker, much softer rubber. Unfortunately, that means giving up both traction and wear.

In terms of durability, a solid rubber Waffle outsole will last about 18 percent longer than one made of blown rubber.

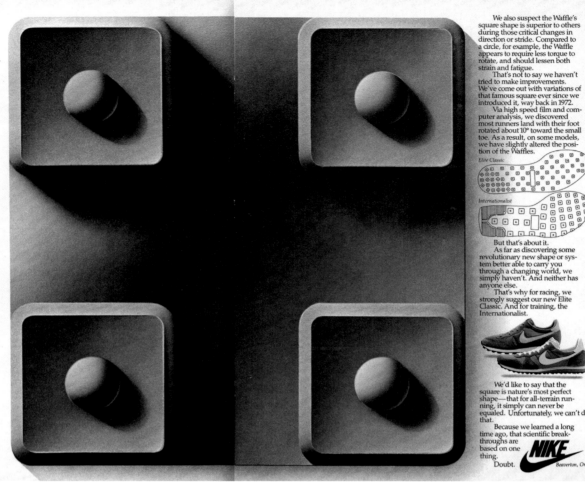

We also suspect the Waffle's square shape is superior to others during those critical changes in direction or stride. Compared to a circle, for example, the Waffle appears to require less torque to rotate, and should lessen both strain and fatigue.

That's not to say we haven't tried to make improvements. We've come out with variations of that famous square ever since we introduced it, way back in 1972.

Via high speed film and computer analysis, we discovered most runners land with their foot rotated about 10° toward the small toe. As a result, on some models, we have slightly altered the position of the Waffles.

But that's about it.

As far as discovering some revolutionary new shape or system better able to carry you through a changing world, we simply haven't. And neither has anyone else.

That's why for racing, we strongly suggest our new Elite Classic. And for training, the Internationalist.

We'd like to say that the square is nature's most perfect shape—that for all-terrain running, it simply can never be equaled. Unfortunately, we can't do that.

Because we learned a long time ago, that scientific breakthroughs are based on one thing.

Doubt.

NIKE
Beaverton, Oregon

1980: Waffle, Elite Classic and Internationalist, 'When in Doubt, Waffle'

CARRY NO LOAD.

When you cover 50, 70 or 100 miles of open road every week, you don't want to be carrying any excess weight. Consider the Terra Trainer. At 7.3 ounces in a woman's size 7, it is light. Very light.

It is also well cushioned. Because it comes with a Phylon™ midsole. Phylon is unusual in that, while it weighs next to nothing, it acts as a suspension system—absorbing shock and reducing road fatigue.

The Terra Trainer. From now on, about the only weight you have to pull is your own.

NIKE
Beaverton, Oregon

1983: Terra Trainer, 'Carry No Load'

TRAVELING LIGHT.

The Terra Trainer is for runners who have one thing on their mind—high mileage—and want almost nothing on their feet. Who know that when you put in a 50-mile week, lifting an extra ounce means lifting an extra 4,625 pounds.

The Terra Trainer is for those whose search for a lightweight shoe has been a brutal, bone-jarring experience.

It comes with a Phylon™ midsole.

It's light. It's cushioned.

It marks the end of hard times.

NIKE
Beaverton, Oregon

1984: Terra Trainer, 'Traveling Light'

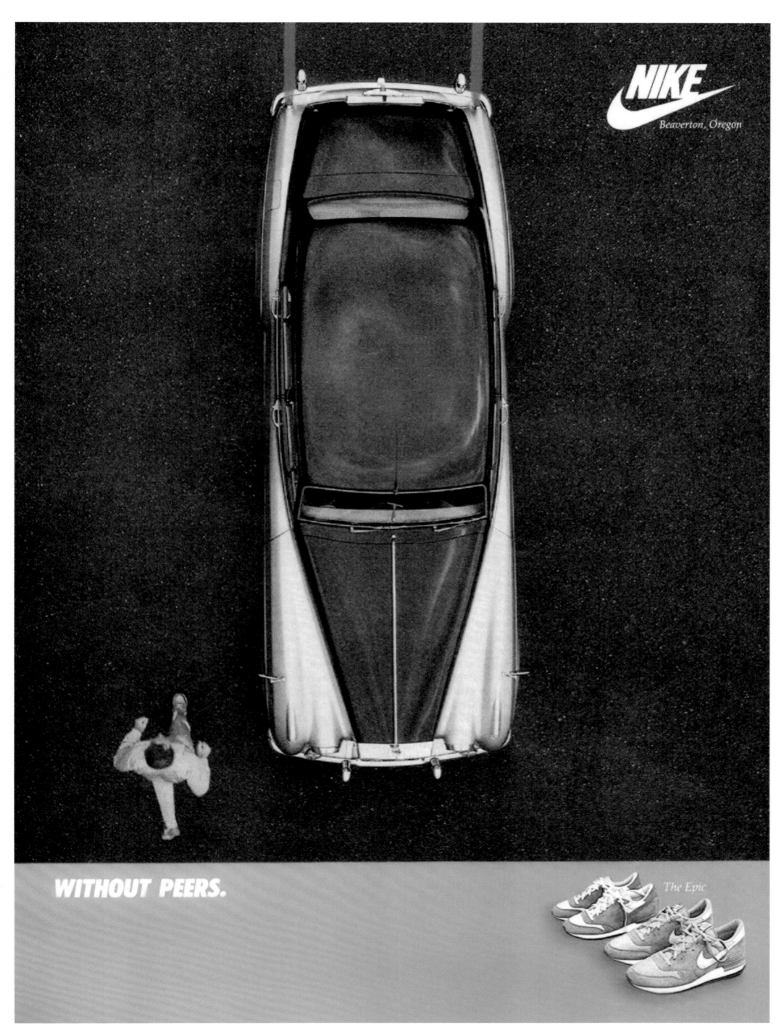

WITHOUT PEERS.

The Epic

1985: Epic, 'Without Peers'

IF GOD WANTED YOU TO RUN 10 MILES A DAY, HE WOULD HAVE MADE YOUR FOOT LOOK LIKE THIS.

In fact, the Nike Sock Trainer looks just like a foot. With a few high-performance options added on.

It cradles your heel, arch, and forefoot inside a contoured foot bed. And it softens every footstrike with full-length Nike-Air® cushioning.

Up top, there's breathable stretch nylon/polyester mesh, for a snug, firm fit, no matter what your width. What's more, it gives your toes about as much freedom as going barefoot.

Sound comfortable? Sound like the ride of your life? You better believe it.

But if you're a doubting Thomas, try a pair on.

And see for yourself.

1985: Sock Trainer, 'If God Wanted You to Run 10 Miles a Day, He Would Have Made Your Foot Look Like This' (1 of 2)

IF HE WANTED YOU TO RUN FAST, HE WOULD HAVE MADE IT LOOK LIKE THIS.

Look again. It's more than just another color.

This is the Sock Racer. And you'll feel the difference with every step. Because while the Sock Trainer is for anyone who's serious enough to wear out a path in the pavement, the Sock Racer is for those who want to do it in a hurry.

This sock is built for speed. It's a racing flat, so we made it light as a feather.

Yet it still has full-length Nike-Air® cushioning and a form-fitting mesh upper.

So if you're out to put everything else behind you, buckle yourself into the Sock Racer. It could be the answer to your prayers.

NIKE AIR

1985: Sock Trainer, 'If He Wanted You to Run Fast, He Would Have Made It Look Like This' (2 of 2)

INGRID KNOCKS THE SOCKS OFF BOSTON.

Congratulations Ingrid Kristiansen. 2:24:55.

1985: Sock Racer, 'Ingrid Knocks the Socks off Boston'

STILL CRAZY AFTER ALL THESE YEARS.

The Nike Sock Racer. A serious racing flat with a full length Nike-Air® midsole. Definitely not for everyone.

NIKE AIR

CIRCLE NO. 4 ON READER SERVICE CARD

1986: Sock Racer, 'Still Crazy After All These Years'

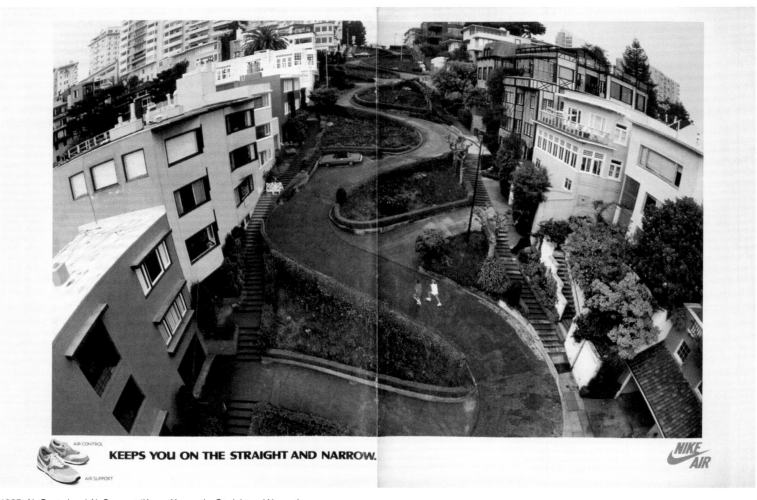

KEEPS YOU ON THE STRAIGHT AND NARROW.

1987: Air Control and Air Support, 'Keeps You on the Straight and Narrow'

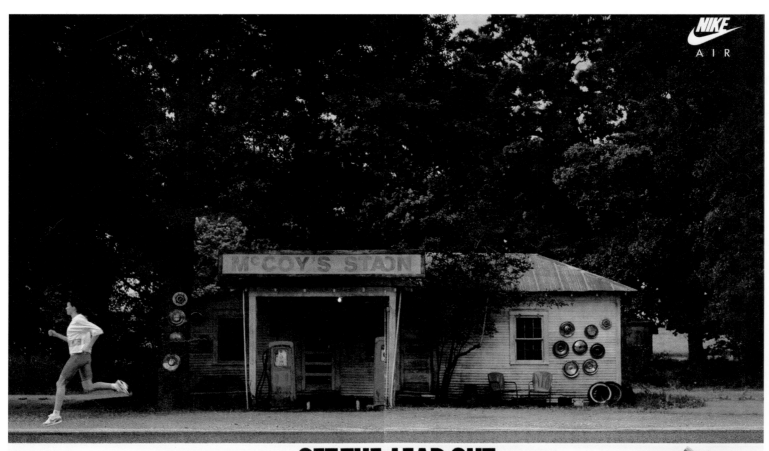

GET THE LEAD OUT.

Take our new Air Span out on the road. Test out the stabilizing Footbridge, the Nike-Air and the lightweight ride. Then give it some gas. And see what happens.

Men's and Women's Air Span

1984: Air Span, 'Get the Lead Out'

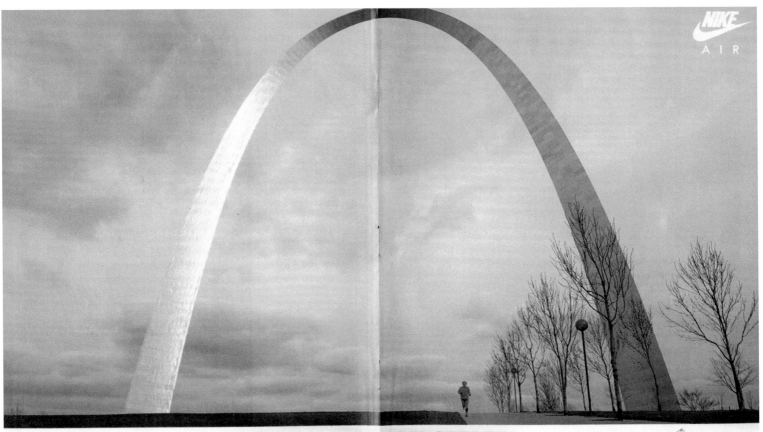

OVER 5 MILLION SERVED.

The Nike Air Pegasus is the fourth generation of the world's best-selling running shoe. It's more stable than ever. Delivers the same great fit and ride. It features special width-sizing for men and women. And comes with twice the Nike-Air cushioning. A revolution in motion.

1987: Air Pegasus, 'Over 5 Million Served'

 THE WINDRUNNER. FOR RUNNERS WHO TAKE IT ALL IN THEIR STRIDE.

1986: Windrunner, 'The Windrunner. For Runners Who Take It All in Their Stride'

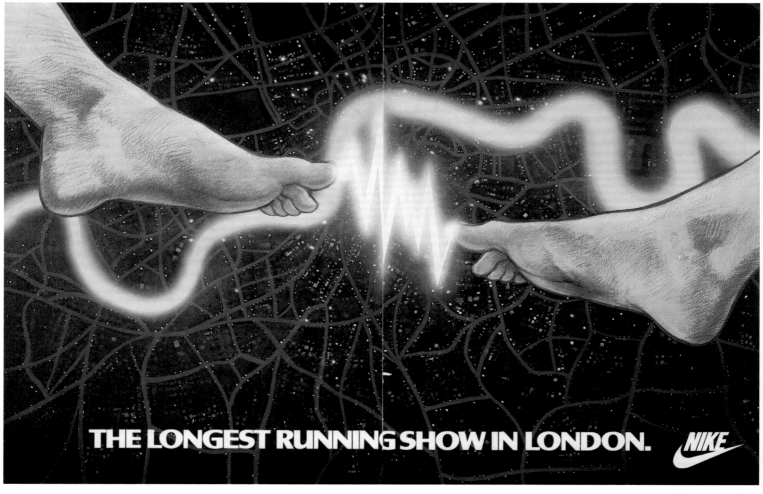

1985: 'The Longest Running Show in London'

A CRASH COURSE ON THE PRINCIPLE BEHIND NIKE-AIR CUSHIONING.

On the average, you'll crash 17,600 times during a 10-mile trip.

And, with every single impact, shock waves will be sent tearing through your body at speeds of up to 120 miles per hour.

We're talking about running. And the most important reason you need Nike-Air' cushioning.

Because if you buy a shoe with a conventional cushioning system, you stand a better chance of sidelining yourself with a painful injury.

What's really shocking is that the same shoe starts losing some of its cushioning almost immediately. And as much as 20 percent after just 500 miles.

But take heart.

It's because of these very reasons we developed Nike-Air cushioning.

Cushioning that reduces the impact and the pounding your body takes while running.

Cushioning that lessens your chance of injury.

Cushioning that won't break down, absorbing every bit as much shock on the first step as it does on the 999,999th.

Without a single leak. Or a single blow-out.

Now, where can you find this amazing cushioning system? Currently, Nike-Air is available in 20 of our high-performance running shoes.

For occasional runners. Everyday runners. World-class runners. Long-distance runners. Men. Women. Children.

Nike-Air. Without it, you can tear up your body. With it, you can tear up the streets.

CIRCLE NO. 12 ON READER SERVICE CARD

1985: 'A Crash Course on the Principle Behind Nike-Air Cushioning'

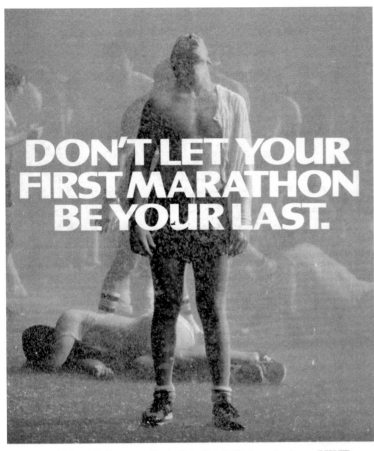

DON'T LET YOUR FIRST MARATHON BE YOUR LAST.

Instead, send a 1st class stamp to Brendan Foster, Dept. AW, Nike International,
Ryburne Mill, Hanson Lane, Halifax, West Yorkshire HX1 4SE.
He'll send you his five page Marathon Training Schedule by return.

1982: 'Don't Let Your First Marathon Be Your Last'

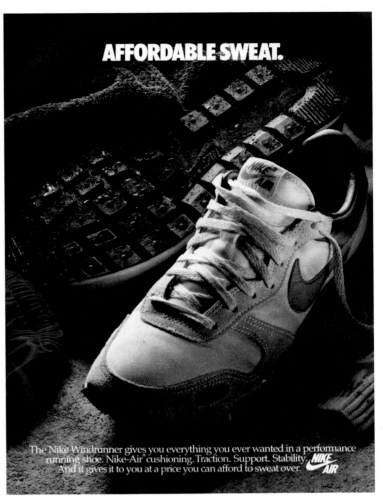

AFFORDABLE SWEAT.

The Nike Windrunner gives you everything you ever wanted in a performance
running shoe. Nike-Air® cushioning. Traction. Support. Stability.
And it gives it to you at a price you can afford to sweat over.

1986: Windrunner, 'Affordable Sweat'

SINCE ROTTERDAM, THE TIME TO BEAT IS 2HRS, 7MINS, 11SECS.

1986: 'Since Rotterdam, the Time to Beat is 2hrs, 7mins, 11secs'

HE CAN'T RUN IN '88. BUT YOU CAN.

The Constitution prevents the President from running again.

But nothing's keeping you from running. Because this year, there are more road races to choose from than ever before.

At Nike, we should know. We sponsor hundreds of races every year, including many of Runner's World's top-ranked events. Everything from the Cascade Run Off to the Freeze Yer Buns Run in Twisp, Washington. Seriously.

For a list of the races we sponsor, just drop us a line: Nike Road Racing Dept., 9000 Nimbus Dr., Beaverton, OR 97005.

So if you're looking for a little competition, we're looking for a few runners.

And guess what? You're nominated.

1988: 'He Can't Run in '88. But You Can', ft. Ronald Reagan

A RACING SHOE SHOULD BE EASY TO FORGET.

At 6.2 ounces, the hardest thing to remember about the Nike Air Sock is that you have it on. It fits like it was custom made. With a Contoured Footbed. Anatomically correct last. Stretch-mesh forefoot upper. And full length Nike-Air. A revolution in motion.

1987: Air Sock, 'A Racing Shoe Should Be Easy to Forget'

A STABILITY SHOE DOESN'T HAVE TO FEEL LIKE HELL.

Most shoes that attempt to save runners from pronation end up punishing them with a hard, inflexible ride. Not the Nike Air Support. Here is a stability shoe that also absorbs shock. Better than any other. With Nike-Air. A revolution in motion.

1987: Air Support, 'A Stability Shoe Doesn't Have to Feel Like Hell'

WIMPS NEED NOT APPLY.

In this circle, only one rule applies. Go all out, or don't bother showing up.

Nike wrestling shoes are available in three different models. And when it comes to performance features like light weight, support, flexibility and traction, they're explosive.

If you take your wrestling seriously, you probably ought to try a pair.

Provided you don't belong in a more delicate sport.

1989: Greco Supreme, Combatant and Takedown XL, 'Wimps Need Not Apply'

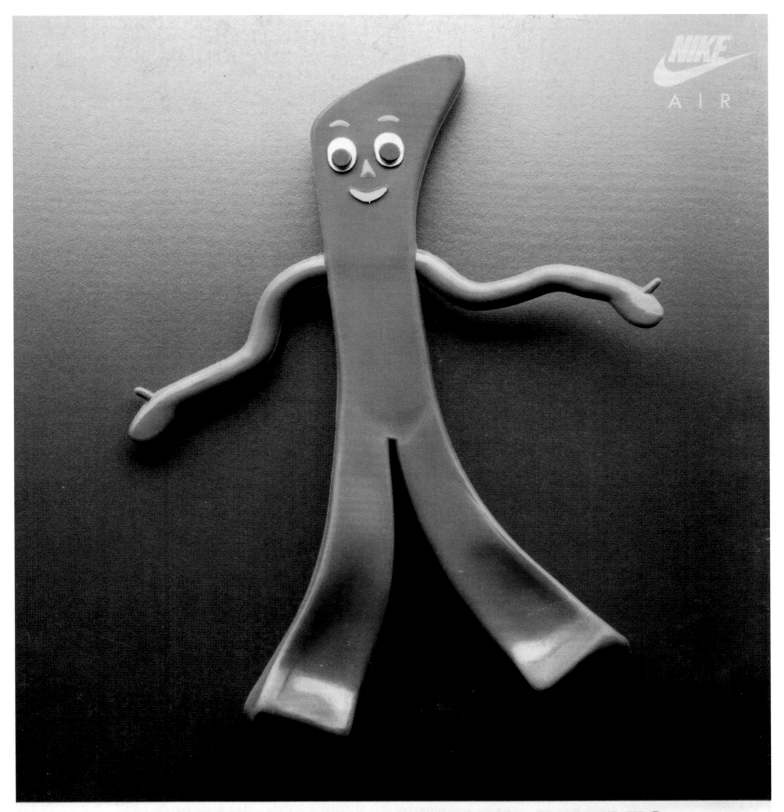

ANYONE WITH RUBBER ANKLES CAN MAKE A COMEBACK.

Some people's bodies are just different. Those with flat, flexible feet tend to overpronate. Which leads to injury. Which should lead to the Nike Air Odyssey. A superior stability shoe with an anatomically correct fit. A heel base width perfected to the millimeter for rearfoot control. Plus Nike-Air. A revolution in motion.

The Air Odyssey

Available in sizes up to 17.

1987: Air Odyssey, 'Anyone With Rubber Ankles Can Make a Comeback', ft. Gumby

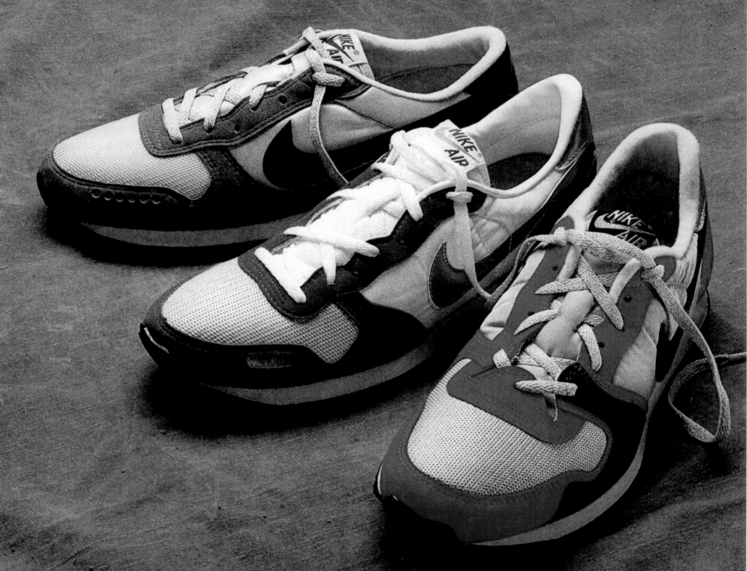

NO PH.D. REQUIRED.

The Nike V-Series. Three different types of running shoes for three different types of runners. All at one price. For extra stability, try the Venue. For lightweight cushioning, it's the Vengeance. For a little of both, lace up the Vortex. Simple. NIKE AIR

For more information, contact Department V, 3900 SW Murray Blvd., Beaverton, OR 97005.

1985: V-Series, 'No Ph.D. Required'

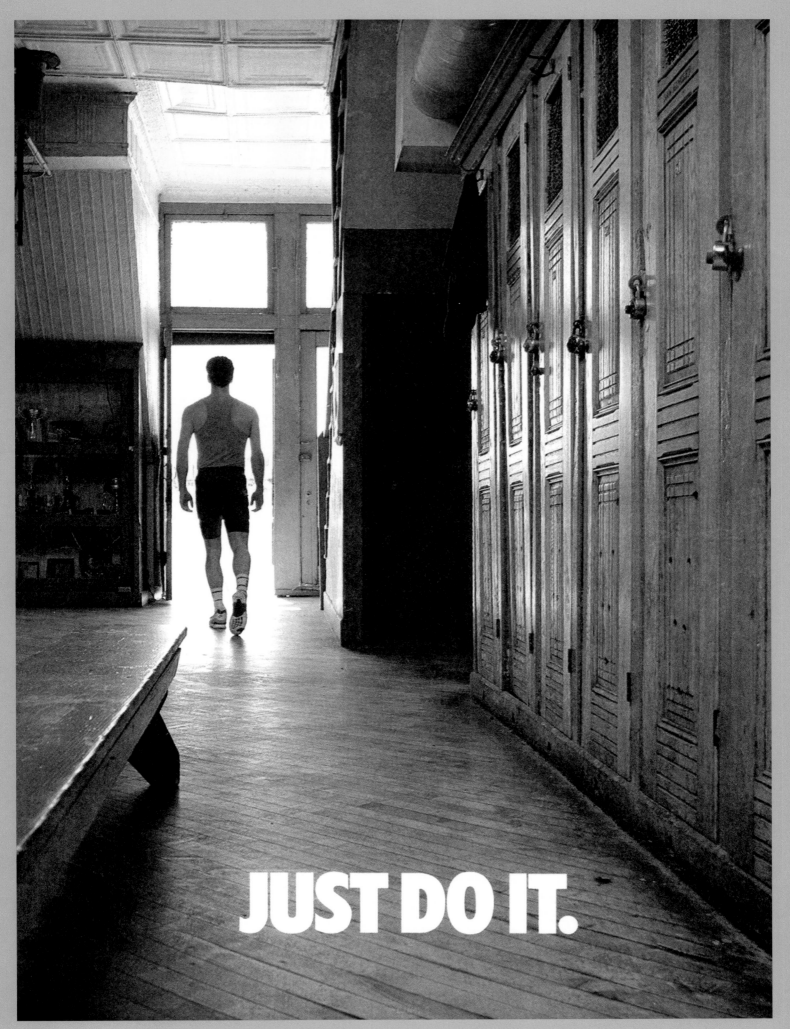

1988: 'Just Do It' (1 of 2)

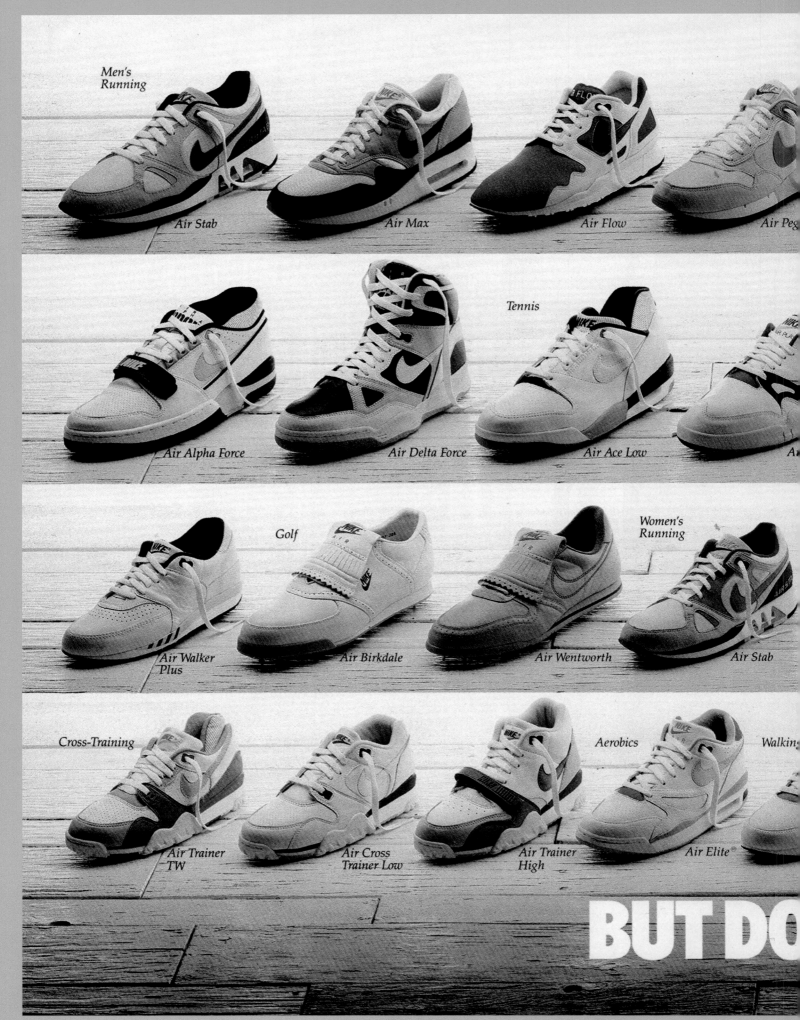

Men's
Running

Air Stab

Air Max

Air Flow

Air Peg

Air Alpha Force

Air Delta Force

Tennis

Air Ace Low

Golf

Air Walker
Plus

Air Birkdale

Air Wentworth

Women's
Running

Air Stab

Cross-Training

Air Trainer
TW

Air Cross
Trainer Low

Air Trainer
High

Aerobics

Air Elite®

Walking

BUT DO

1988: 'But Do It Right' (2 of 2)

465

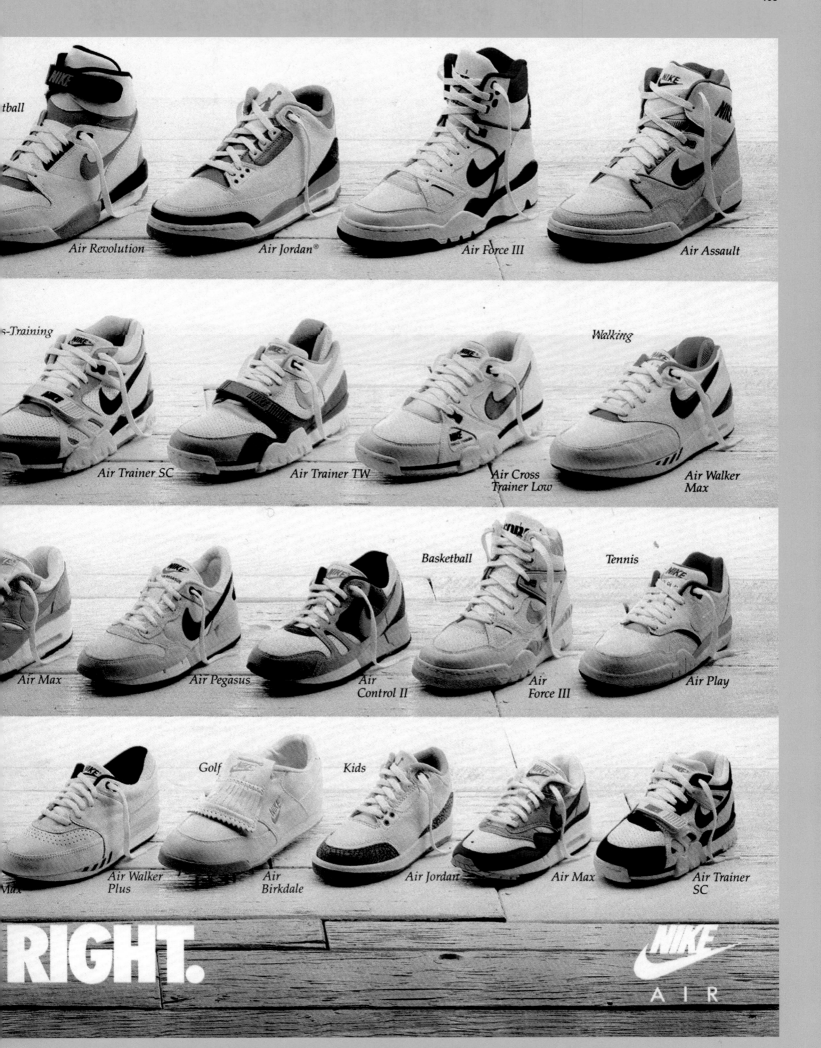

SMOKE 'EM.

Air Edge

Spiridon Gold

Axis

Pursuit

Sock Racer

Beaverton, Oregon

1986: Air Edge, Spiridon Gold, Axis, Pursuit and Sock Racer, 'Smoke 'Em'

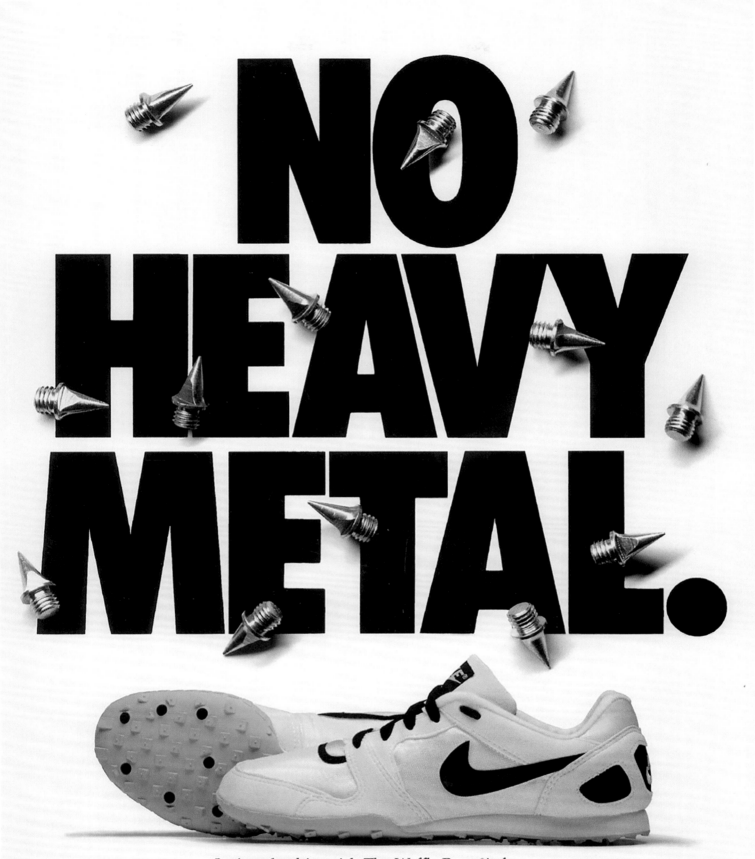

Let's make this quick. The Waffle Racer® is fast.
Real fast. That's because it only weighs 6.0 ounces. It has incredible traction.
And no heavy spikes to slow you down. OK. Enough speed reading.

1989: Waffle Racer, 'No Heavy Metal'

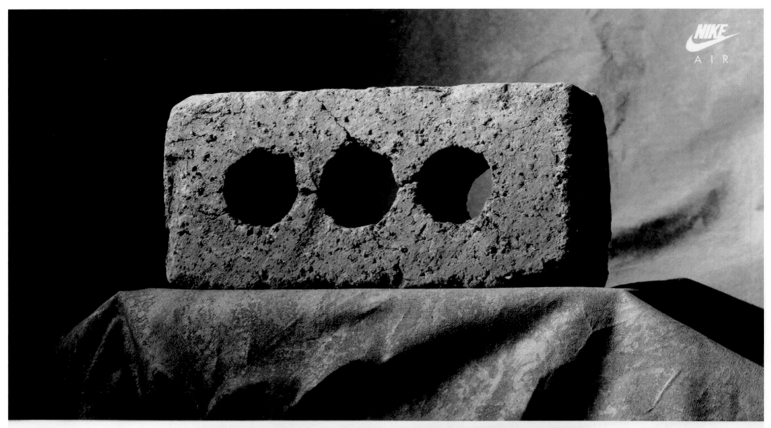

A MODEL OF STABILITY. UNFORTUNATELY.

Most stability shoes are hard and inflexible. Not the Nike Air Support. Sure, it controls pronation. But it's built on the belief that a truly safe shoe must also absorb shock. And research proves there's no better way to do that than with Nike-Air. A revolution in motion.

1987: Air Support, 'A Model of Stability. Unfortunately'

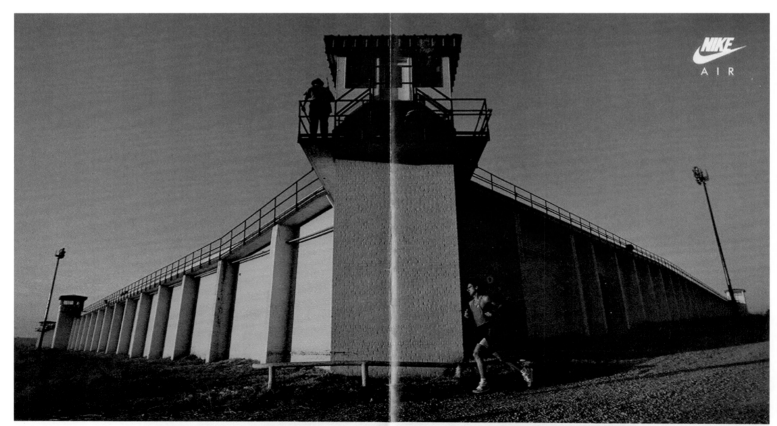

FOR RUNNERS IN NEED OF A LITTLE CORRECTION.

There are a lot of unstable people running around out there. For those who want to go straight, the Nike Air Span could change their lives. It's the lightest stability shoe ever made. It features the Nike Footbridge™ that controls pronation. And it comes with Nike-Air.® All things considered, it's almost criminal.

1989: Air Span, 'For Runners in Need of a Little Correction'

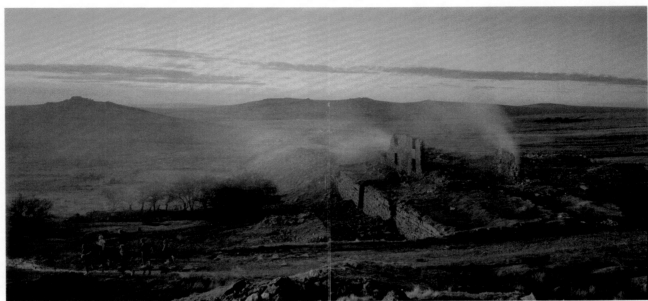

GROUND FORCES NEED AIR SUPPORT.

Combining the utmost stability with the ultimate cushioning, the Nike Air Support. It'll transform the walking wounded into the running fit.

1988: Air Control and Air Support, 'Ground Forces Need Air Support'

DON'T ROLL OVER, BEETHOVEN.

The Nike Footbridge™ answers a pretty basic need of most runners.

Namely, how to get great stability without giving up what you want from Nike-Air® in the first place: the best cushioning out there, anywhere.

And it gives it to you without sacrificing one bit of flexibility or adding unwanted bulk and weight.

The way it works is simple. When you run, you hit the outside of your foot first, then roll to the inside. The Footbridge has five stability fingers and two rigid columns along the inside of the shoe.

These fingers put more and more resistance against your foot, slowing down the rolling motion. The more control you need, the more you get. So, put simply, the Nike Footbridge stops roll over. And gives you one very light shoe with some very sure moves.

So maybe the song stays the same. But from here on out, the steps are going to change.

Women's Air Control II Men's Air Stab Women's Air Stab

1988: Air Control II and Air Stab, 'Don't Roll Over, Beethoven'

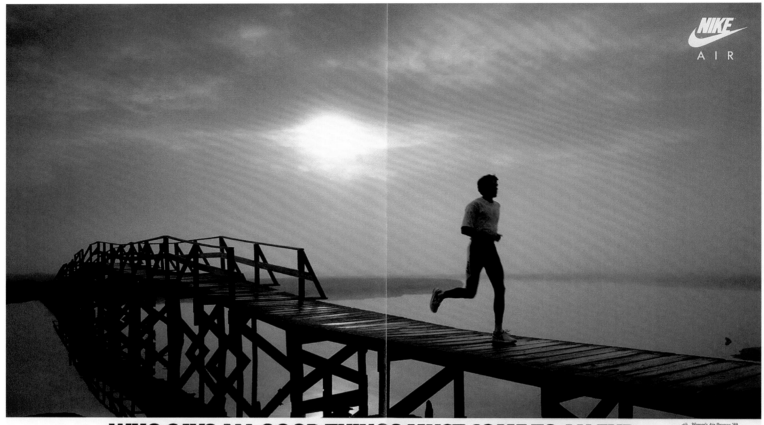

WHO SAYS ALL GOOD THINGS MUST COME TO AN END.

You lace up the Air Pegasus '89 from Nike. You ask yourself what's new about the latest version of the world's most popular running shoe. Have they changed the Nike-Air? No. Have they changed the fit? No. Have they stopped making it in widths? No. Have they raised the price? No. Are you happy? Yes.

Featured on Barry Brown: International Tee; Pursuit Tight.

1989: Air Pegasus '89, 'Who Says All Good Things Must Come to an End'

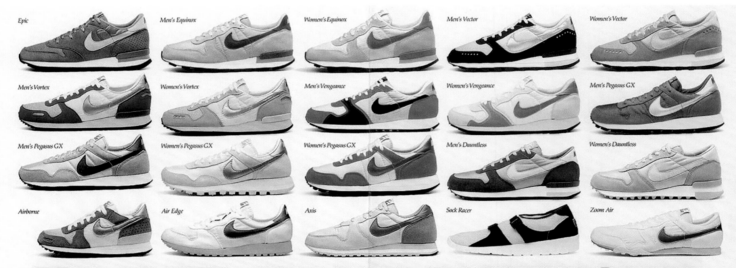

TRAVEL BY AIR WITHOUT ANY RESERVATIONS.

You don't even need an airplane.

In fact, all you really need is an open road and the willingness to take advantage of it.

And any shoe with Nike-Air® cushioning.

Because not only does it provide the best ride this side of the Concorde, Nike-Air lessens the impact of every single step.

Now, if you think any cushioning system does just as much, you're in for quite a shock. And a very painful one at that.

Because running in a conventional shoe is like banging the bottom of your foot solidly with a five-pound hammer. Every time you hit the road.

But instead of this pounding effect, Nike-Air gives you a smooth, rolling sensation. From here to eternity. And back again.

Because Nike-Air never compacts. Never. In all likelihood, it will outlast every other part of the shoe. Including the laces.

One last thing. Not all runners require the same amount of Air. That's why we've scaled the pressure according to shoe size, so every runner receives just the right amount of cushioning.

Where can you find this remarkable cushioning system? Currently, it's available in 20 of our running shoes.

For occasional runners. Everyday runners. World-class runners. Long-distance runners. Men. Women. Children.

Nike-Air. It may not be the only way to fly. But it's sure the only way to land.

1987: 'Travel by Air Without Any Reservations'

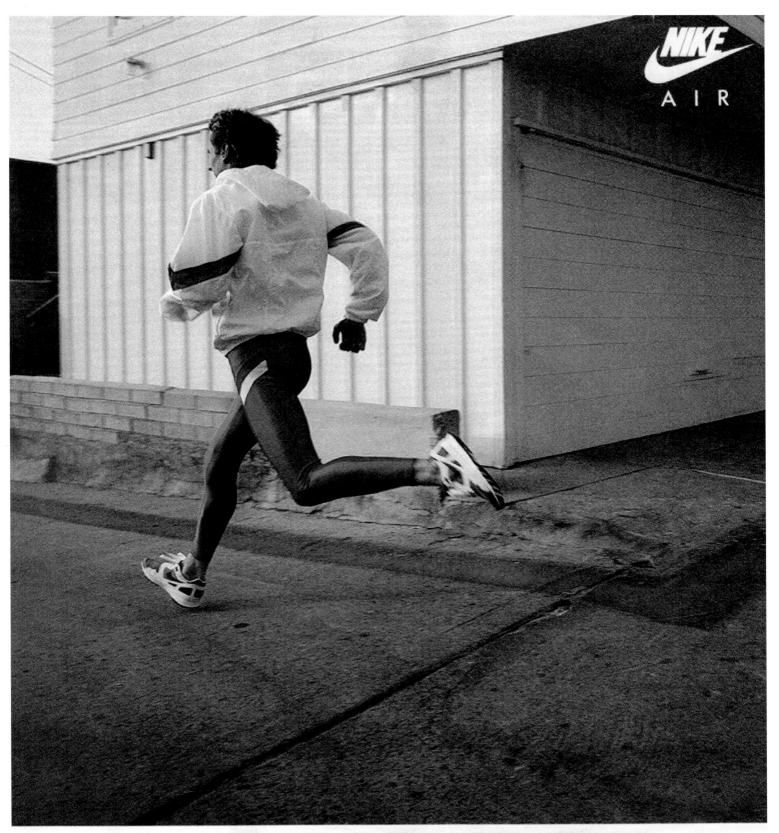

RUN AROUND NAKED. KINDA.

The ultra-light tights feel fast. The featherweight jacket feels fast. The *very* light shoe feels *very* fast. It's the Nike Air

Featured apparel: Chevron Tight; Chevron Jacket.

Flow. With a Phylon™ midsole, a dynamic stretch nylon forefoot. And Nike-Air. Normally, when something feels this good, you

hope nobody's watching.

Air Flow

1988: Air Flow, 'Run Around Naked. Kinda'

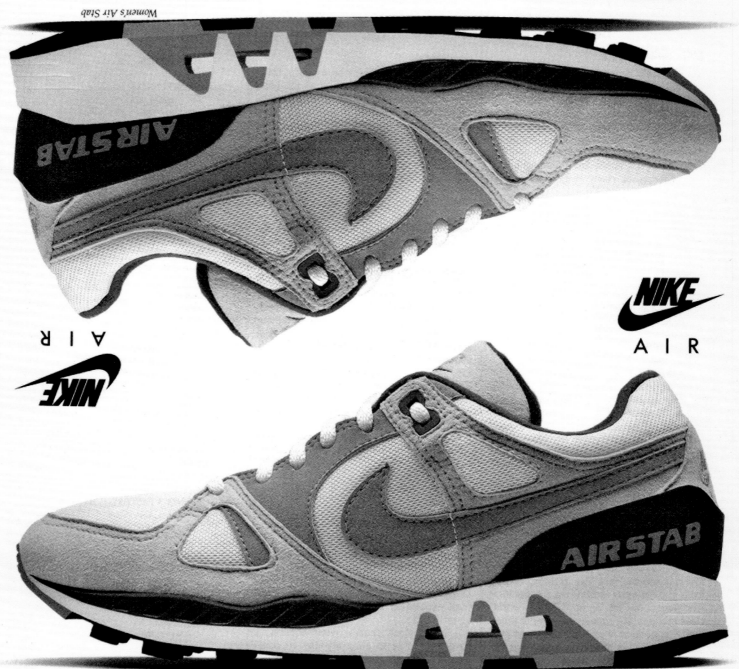

Women's Air Stab

THE MOST STABLE RUNNING SHOE.

First, the good news: The Nike Air Stab is the most stable shoe on the road.

Now, the great news: All this stability doesn't come at the expense of cushioning. Or light weight. Or flexibility. All because of a new stability system we call the Footbridge.™

And it's turning the running world upside down.

Men's Air Stab

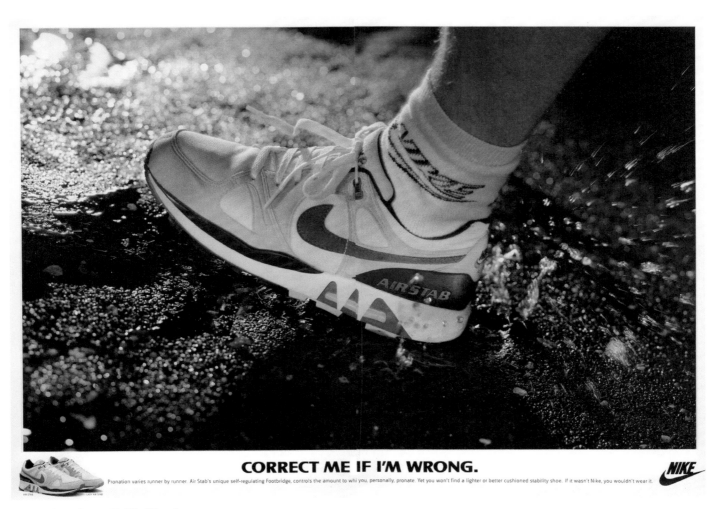

CORRECT ME IF I'M WRONG.

Pronation varies runner by runner. Air Stab's unique self-regulating Footbridge, controls the amount to whi you, personally, pronate. Yet you won't find a lighter or better cushioned stability shoe. If it wasn't Nike, you wouldn't wear it.

NIKE

1989: Air Stab, 'Correct Me if I'm Wrong'

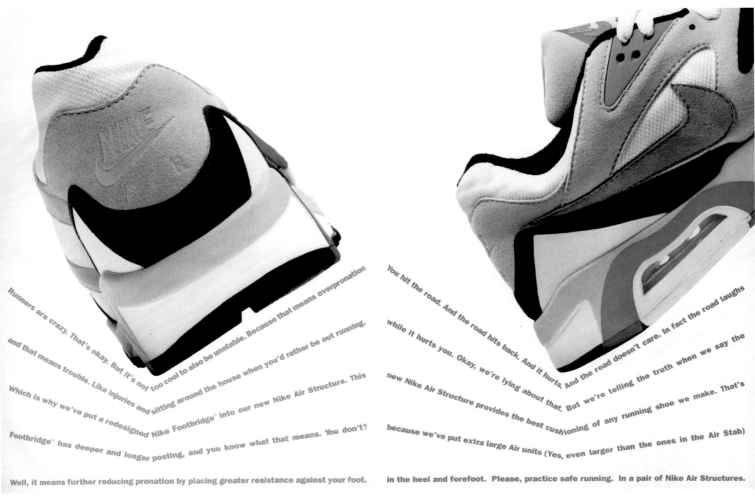

Runners are crazy. That's okay. But it's not too cool to also be unstable. Because that means overpronation and that means trouble. Like injuries and sitting around the house when you'd rather be out running. Which is why we've put a redesigned Nike Footbridge™ into our new Nike Air Structure. This Footbridge™ has deeper and longer posting, and you know what that means. You don't?

Well, it means further reducing pronation by placing greater resistance against your foot.

You hit the road. And the road hits back. And it hurts. And the road doesn't care. In fact the road laughs while it hurts you. Okay, we're lying about that. But we're telling the truth when we say the new Nike Air Structure provides the best cushioning of any running shoe we make. That's because we've put extra large Air units (Yes, even larger than the ones in the Air Stab)

in the heel and forefoot. Please, practice safe running. In a pair of Nike Air Structures.

1990: Air Structure

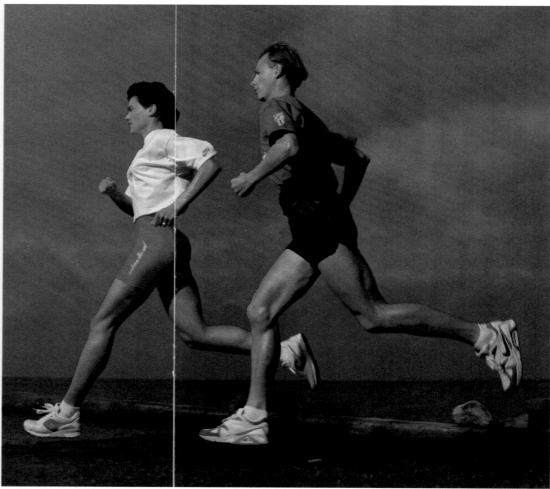

Steve Moneghetti and Vickie Huber. When they're not racing, they're training. And when they're training, they're running the miles in Nike apparel. Steve is wearing a 100% cotton International Heavyweight t-shirt and the International Ripstop Short with a Coolmax® liner. While Vickie is wearing an International Heavyweight t-shirt, and the International Heavyweight Lycra® short. Nike apparel. Worn by leaders. Not by followers.

1990: 'Just Do It 365', ft. Vicki Huber and Steve Moneghetti

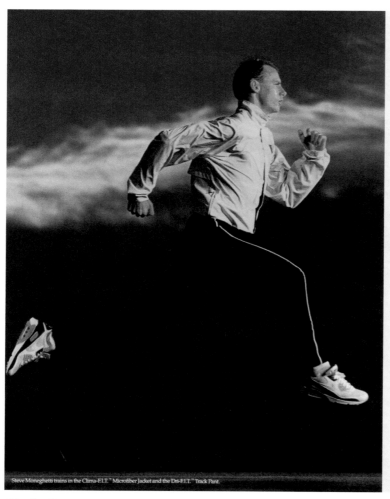

Steve Moneghetti trains in the Clima-F.I.T.™ Microfiber Jacket and the Dri-F.I.T.™ Track Pant.

Running apparel designed to combat the elements and the competition 365 days a year.

1991: 'Just Do It 365', ft. Steve Moneghetti

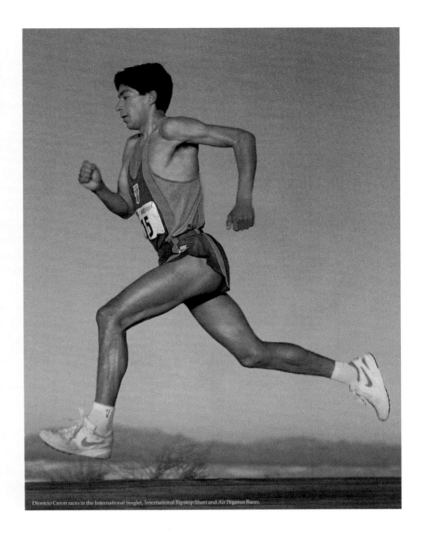

Dionicio Ceron races in the International Singlet, International Ripstop Short and Air Pegasus Racer.

just do it³⁶⁵

Running apparel designed to combat the elements
and the competition 365 days a year.

1990: 'Just Do It 365', ft. Dionicio Cerón

just do it³⁶⁵

Running apparel designed to combat the elements
and the competition 365 days a year.

1990: 'Just Do It 365', ft. Lynn Jennings

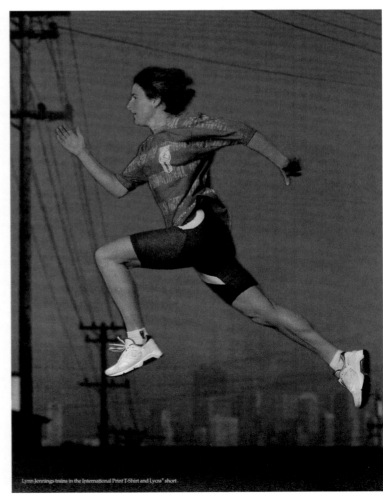

Lynn Jennings trains in the International Print T-Shirt and Lycra® short.

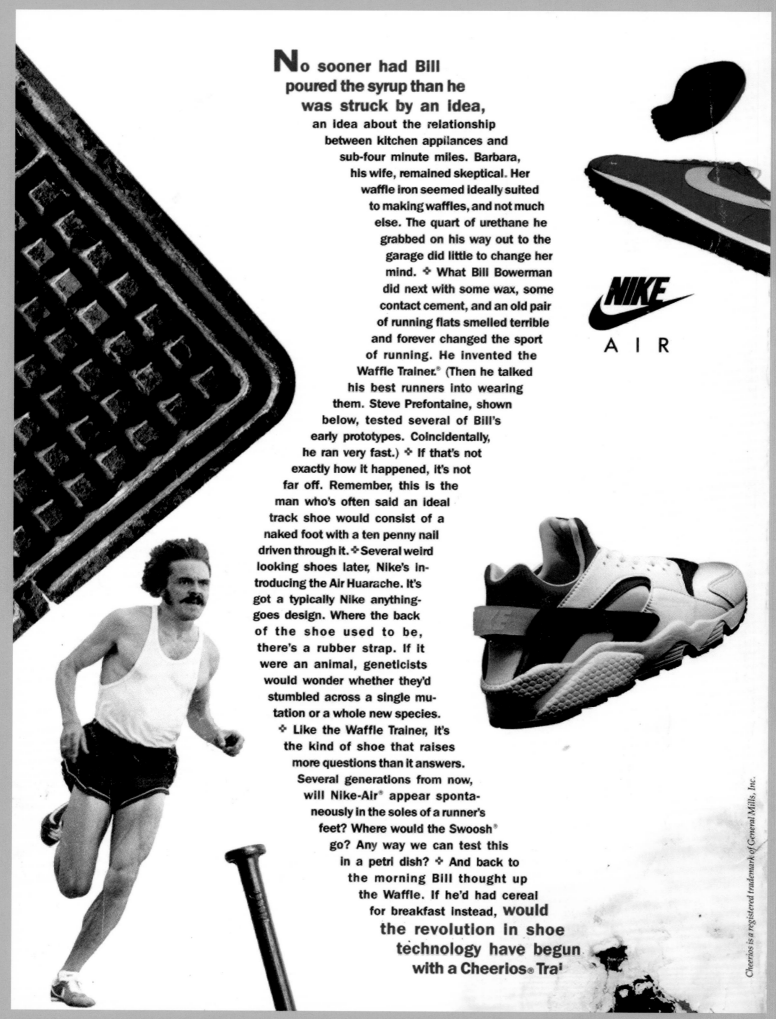

No sooner had Bill poured the syrup than he was struck by an idea, an idea about the relationship between kitchen appliances and sub-four minute miles. Barbara, his wife, remained skeptical. Her waffle iron seemed ideally suited to making waffles, and not much else. The quart of urethane he grabbed on his way out to the garage did little to change her mind. ✧ What Bill Bowerman did next with some wax, some contact cement, and an old pair of running flats smelled terrible and forever changed the sport of running. He invented the Waffle Trainer.® (Then he talked his best runners into wearing them. Steve Prefontaine, shown below, tested several of Bill's early prototypes. Coincidentally, he ran very fast.) ✧ If that's not exactly how it happened, it's not far off. Remember, this is the man who's often said an ideal track shoe would consist of a naked foot with a ten penny nail driven through it. ✧ Several weird looking shoes later, Nike's introducing the Air Huarache. It's got a typically Nike anything-goes design. Where the back of the shoe used to be, there's a rubber strap. If it were an animal, geneticists would wonder whether they'd stumbled across a single mutation or a whole new species. ✧ Like the Waffle Trainer, it's the kind of shoe that raises more questions than it answers. Several generations from now, will Nike-Air® appear spontaneously in the soles of a runner's feet? Where would the Swoosh® go? Any way we can test this in a petri dish? ✧ And back to the morning Bill thought up the Waffle. If he'd had cereal for breakfast instead, would the revolution in shoe technology have begun with a Cheerios® Trai

NIKE
AIR

Cheerios is a registered trademark of General Mills, Inc.

1991: Waffle Trainer and Air Huarache, 'No Sooner Had Bill Poured the Syrup Than He Was Struck by an Idea', ft. Steve Prefontaine

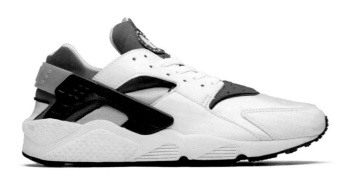

" The Air Huarache arrived in the midst of a golden era at Nike, when bigger was better and bolder was best. The fresh two-colour fusion, chunky rubber heel strap and lycra-lined Neoprene collar were a provocative statement, while mammoth midsoles with 'Air' bumpers and a coalition of silky mesh and synthetic 'tumbled' leather sealed the deal. No surprises then to learn that the Hua was designed by Tinker Hatfield! The booklet that came with the original Huarache described it as 'a radical departure from conventional shoe design' and Nike weren't kidding. The concept was inspired by a water-skiing experience. Noticing how snugly the rubber booties conformed to the contours of his ankles, a lightbulb went off and another quintessential Hatfield hero was born. It's an ideological template that is still apparent today in models such as the Free Flyknit. "

Oliver Georgiou
'Air Huarache'
Sneaker Freaker, issue 29 (2013)

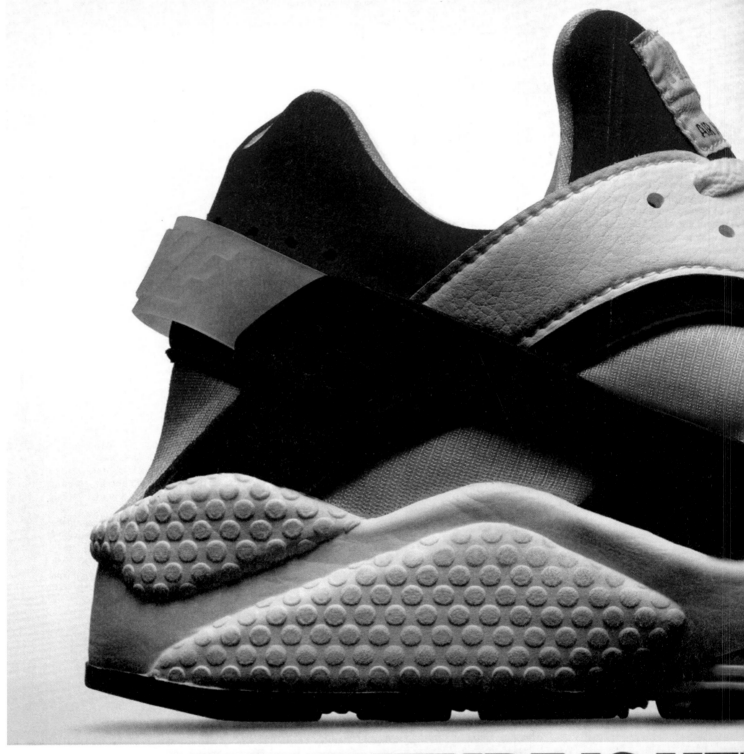

THE FUTURE IS HEI

What will the future be like?

It will be bright green. And blue. It will be lightweight. (Approximately a scant 9.5 ounces.) And it will come in various sizes.

It's the Air Huarache™ from Nike. A radical new running shoe based on the rather old adage that less is more.

Less stuff. More stability, support and

cushioning. The secret lies in the midsole. A unique anatomically-contoured design provides all the stability and support you'll ever need.

But that's not all it does. The midsole design allows the upper to be stripped to the bare essentials without giving up one iota of support or stability.

Lycra® is a registered trademark of E.I. du Pont de Nemours & Co., Inc.

1991: Air Huarache, 'The Future is Here. In Sizes 6 to 15'

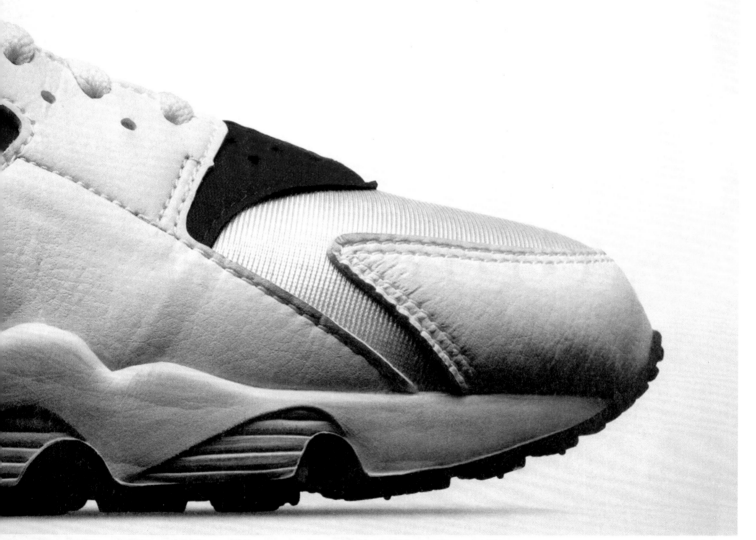

IN SIZES 6 TO 15.

The upper is made from a combination of neoprene and Lycra® fabrics. (FYI: Neoprene is that stuff wetsuits are made from.) It hugs the foot like a second skin, making the fit even more supportive. The result? Less weight. (Again, approximately 9.5 ounces.)

And in case you were wondering, yes, the Air Huarache has Nike-Air® cushioning.

Both in the forefoot and the heel.

Now, if you think all this technology is only for the Mark Allens and Lynn Jennings of the world, you're wrong.

The future is for everyone. Wherever the Air Huarache running shoe is sold.

Women's Air Huarache

Michael Johnson, Weltmeister über 200 m.

1992: Air Huarache, 'For Your Feet, the 21st Century Has Already Begun', ft. Michael Johnson

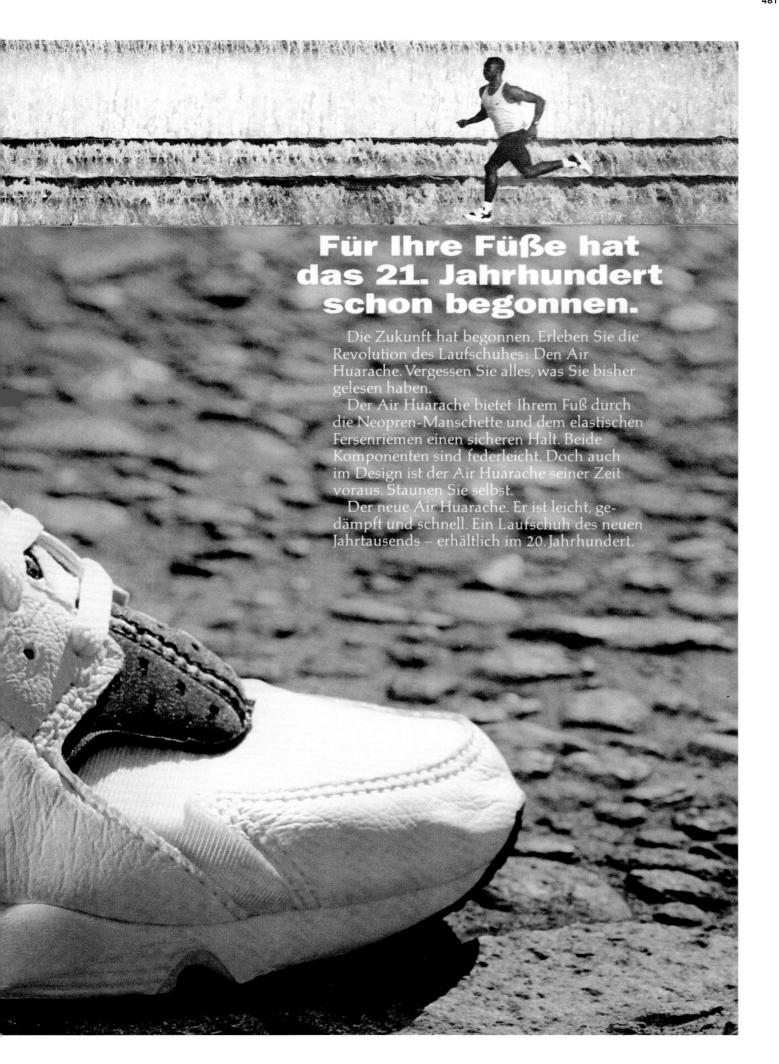

Für Ihre Füße hat das 21. Jahrhundert schon begonnen.

Die Zukunft hat begonnen. Erleben Sie die Revolution des Laufschuhes: Den Air Huarache. Vergessen Sie alles, was Sie bisher gelesen haben.

Der Air Huarache bietet Ihrem Fuß durch die Neopren-Manschette und dem elastischen Fersenriemen einen sicheren Halt. Beide Komponenten sind federleicht. Doch auch im Design ist der Air Huarache seiner Zeit voraus. Staunen Sie selbst.

Der neue Air Huarache. Er ist leicht, gedämpft und schnell. Ein Laufschuh des neuen Jahrtausends – erhältlich im 20. Jahrhundert.

You are here.

1991: Air Huarache, 'You Are Here. The Future is Here'

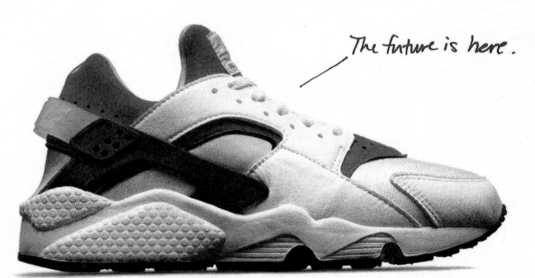

The future is here.

The future is staring you right in the face. And it's incredibly light
(try 9.5 oz. on for size). Incredibly stable. Incredibly well-cushioned. Incredibly
comfortable. Incredibly innovative. It's the Nike Air Huarache
running shoe. Incredible, isn't it, just how well the future turned out.

The average person has a sexual thought every fifteen seconds. Which means if we talk about the Air Huarache® Light running shoe long enough, and go on and on about its unique and comfortable fit, all while using highly descriptive phrases such as "fits like a second skin" and "literally hugs your foot", chances are you'll find it (the shoe we referenced earlier) kind of, you know, sexy.

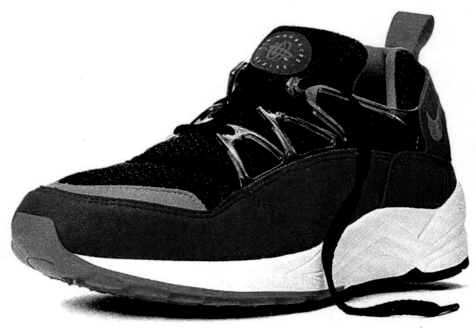

running

1993: Air Huarache Light

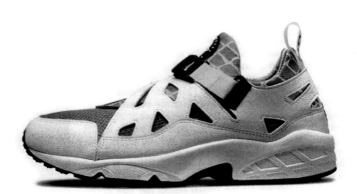

LEANER, LIGHTER AND LACELESS. THE SURPRISING, SNUG AND SLEEK AIR HUARACHE™ PLUS
RUNNING SHOE.

1993: Air Huarache Plus, 'Leaner, Lighter and Laceless. The Surprising, Snug and Sleek Air Huarache Plus Running Shoe'

I like to train and run and lift
train
train
train,
you get the drift.
How do I train and still have knees?
With advanced technologies!

It's the hot new Air Max® shoe
With a third more air, it's true!
All that light and whooshy air
Cushions my feet everywhere.

In Air Max my feet feel good
not like chunks
of nerveless wood.
So I can train
and I can run,
I may be small
but I have big fun!

1993: Air Trainer Max, ft. Barry Sanders

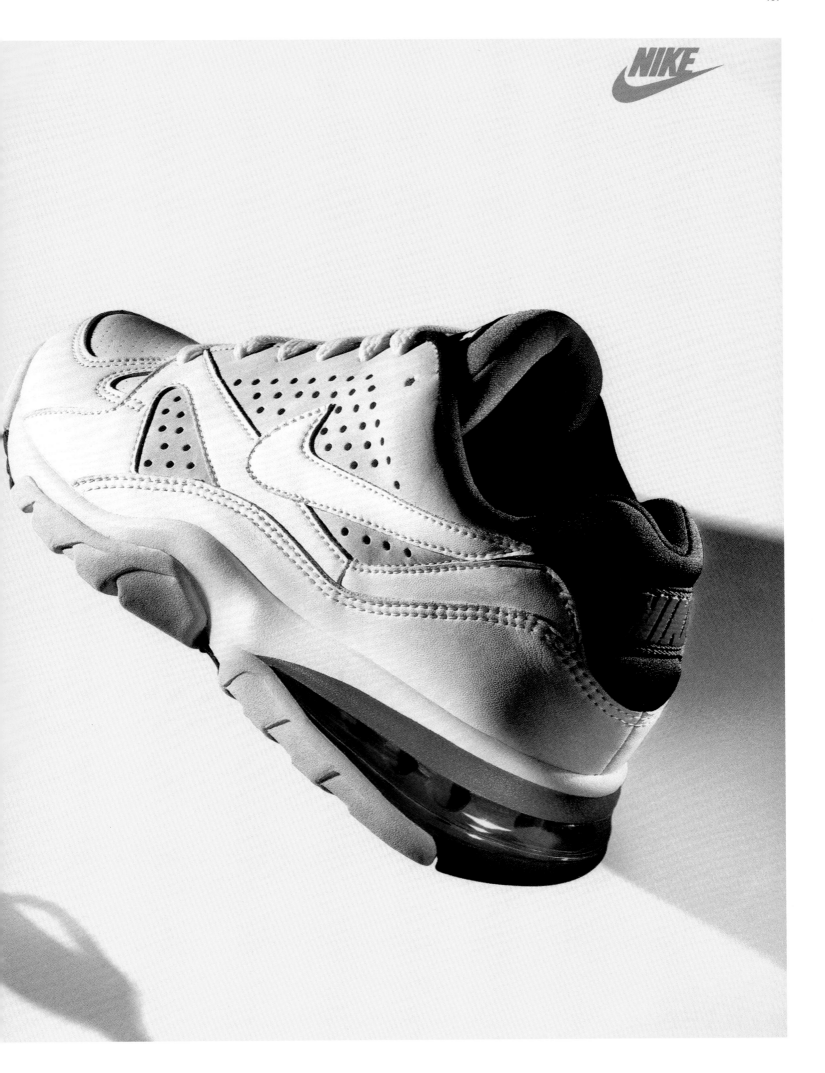

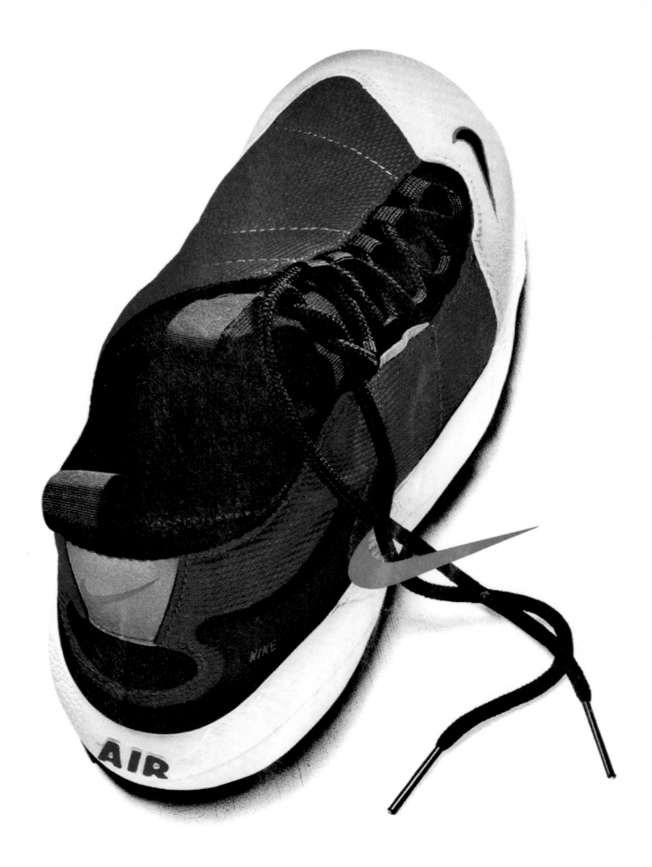

1-800-645-6023

1995: Air Footscape

" I vividly remember the first time I saw the Nike Footscape. The asymmetric lacing, mini Swooshes and abstract midsole were nothing I'd ever seen before. That 'Varsity Royal/Zen Grey' colourway with that sweet pop of teal was total perfection. Over the years I have rocked Footscapes with cords, chinos, vintage military pants, sweatpants and even a suit, and they all look good! I once offered to buy an original pair off the feet of an old rich guy I saw stepping out of his Porsche, but he politely declined. They're definitely one of those, 'If you know, you know' shoes, if you know what I mean. "

Yoblessed
'The Great Footscape'
Sneaker Freaker, issue 33 (2015)

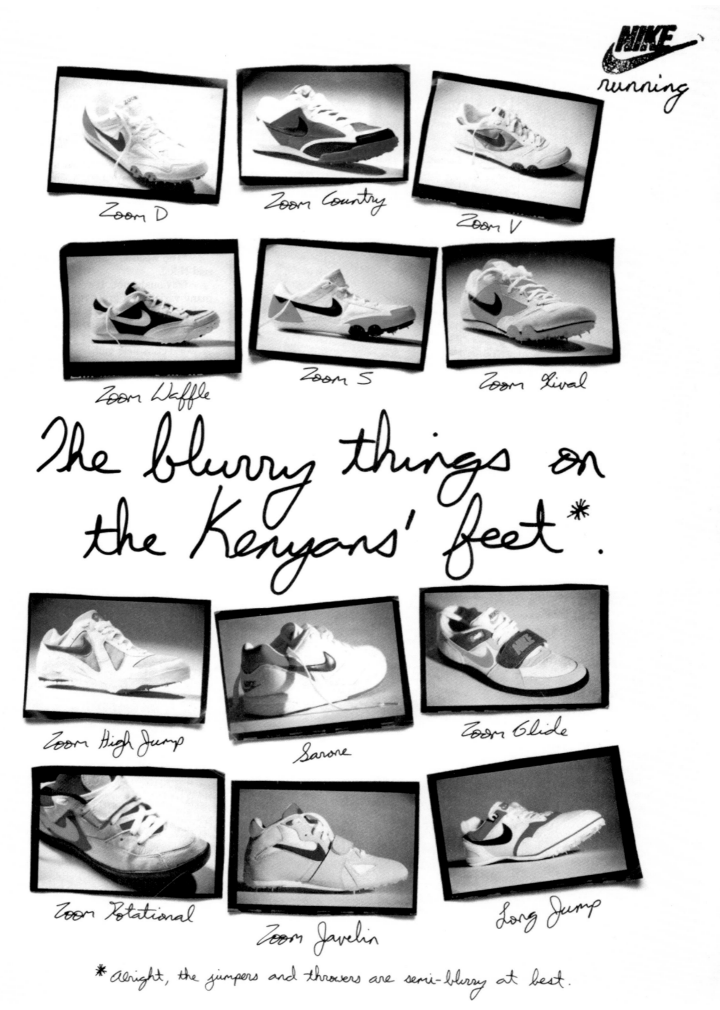

New Year's Running Resolution:

Jan. 1st

Dec. 31st

1993: 'New Year's Running Resolution'

Baseball players hug baseball players.
Basketball players hug basketball players.
Football players hug football players.

And the new Air Huarache International
shoe hugs runners. (And it never
pats them on the butt either.)

1992: Air Huarache International

We design a running shoe with maximum cushioning and maximum stability, and the lead news story is something about some hole in the ozone layer?

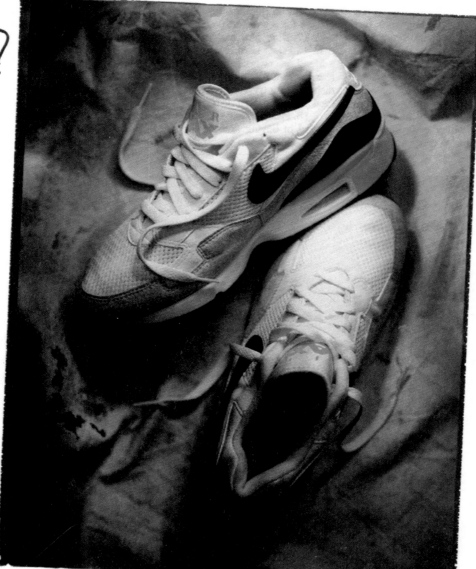

Where are the world's priorities?

1992: Air Max Triax

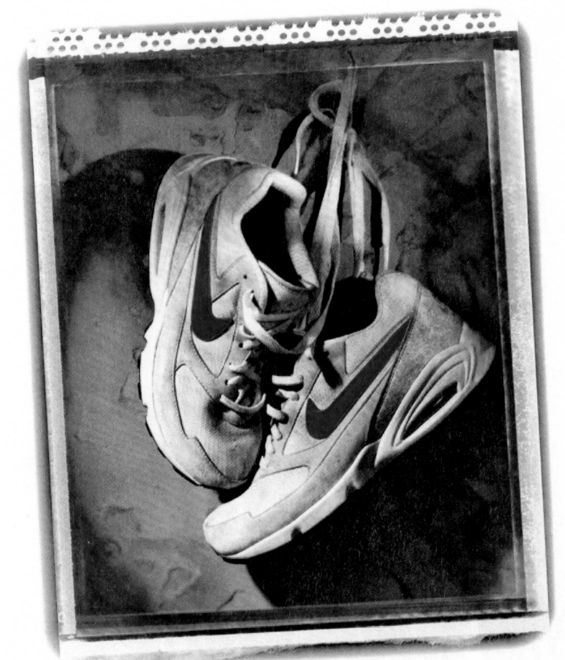

*The Air Verona for women.
The opposite of being barefoot
and in the kitchen*

1992: Air Verona

running

The prince knelt down and slipped the glass slipper over Cinderella's foot. And it fit just right. T...

In fact, it fit almost as comfortably as the new Nike Air Huarache™ Plus. Which is built on a woman's last and which has a foot-hugging neoprene upper. So a woman can stop waiting for her stupid prince to come and go for a nice long run instead.

Call 1-800-462-7363 for free brochure. U.S. only. Sorry Morocco.

1993: Air Huarache Plus

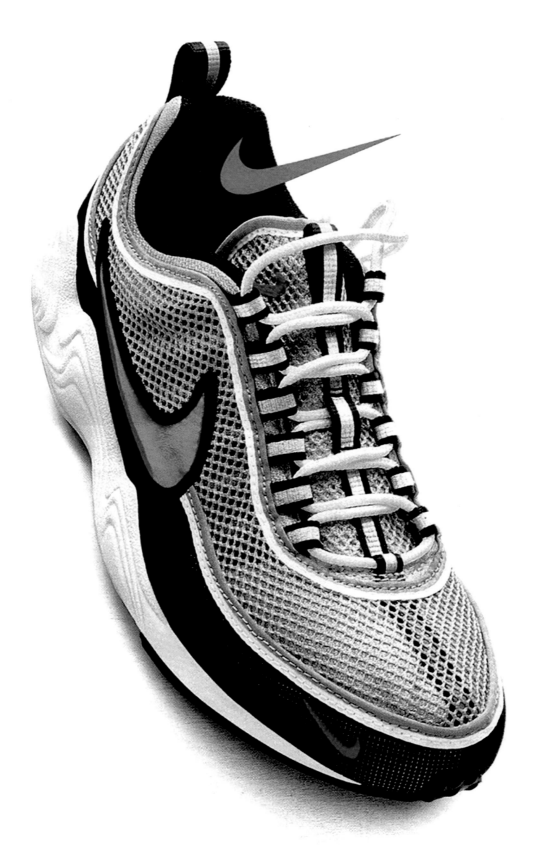

1-800-305-2305

1997: Air Zoom Spiridon

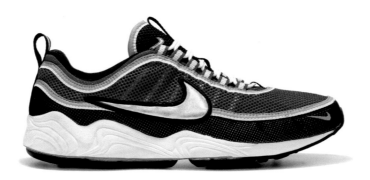

" There are sneakers that are easy to love and then there are those that appeal only to ultra aficionados. Case in point is the Air Zoom Spiridon. Released in 1997, the lightweight runner was named after Spyridon Louis, the marathon Gold-medal winner at the 1896 Athens Olympics. Penned by Christian Tresser, the genius responsible for the Air Max 97 'Silver Bullet', the Spiridon features reflective tape and a concert of mini Swooshes applied over a layer of wide-open mesh. Tresser's sci-fi design left Nike's better-known running franchises looking like the fossilised remains of a primitive tribe. **"**

Woody
'The Air Zoom Spiridon'
Sneaker Freaker, issue 42 (2019)

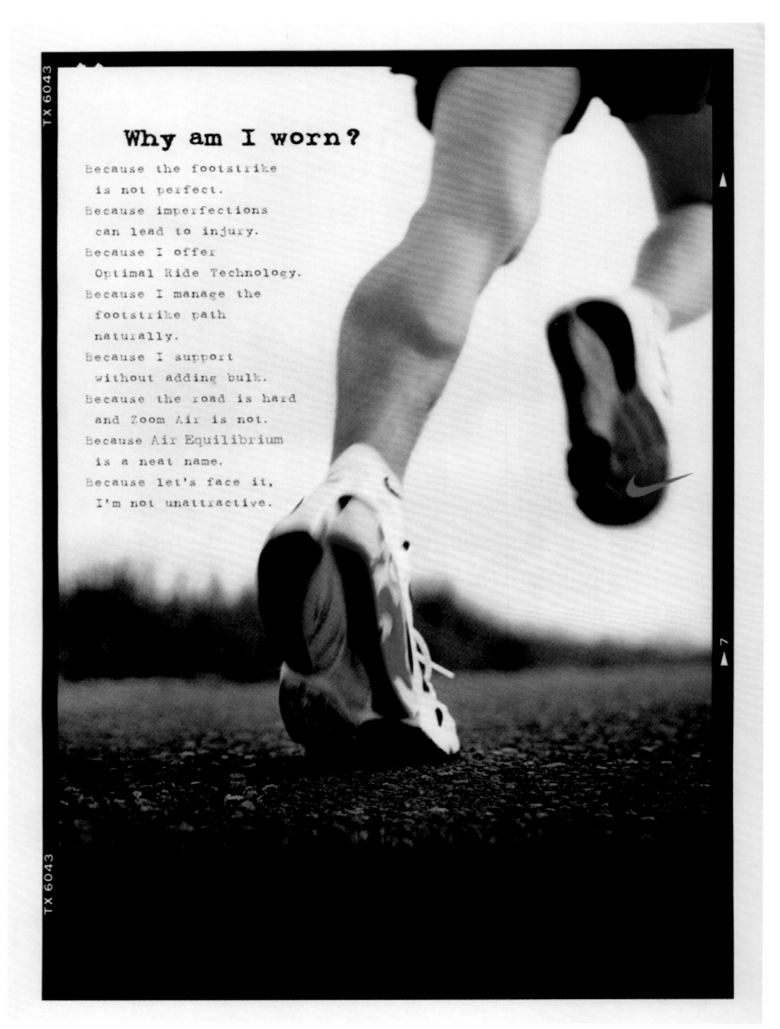

Why am I worn?

Because the footstrike
 is not perfect.
Because imperfections
 can lead to injury.
Because I offer
 Optimal Ride Technology.
Because I manage the
 footstrike path
 naturally.
Because I support
 without adding bulk.
Because the road is hard
 and Zoom Air is not.
Because Air Equilibrium
 is a neat name.
Because let's face it,
 I'm not unattractive.

1997: Air Equilibrium, 'Why Am I Worn?'

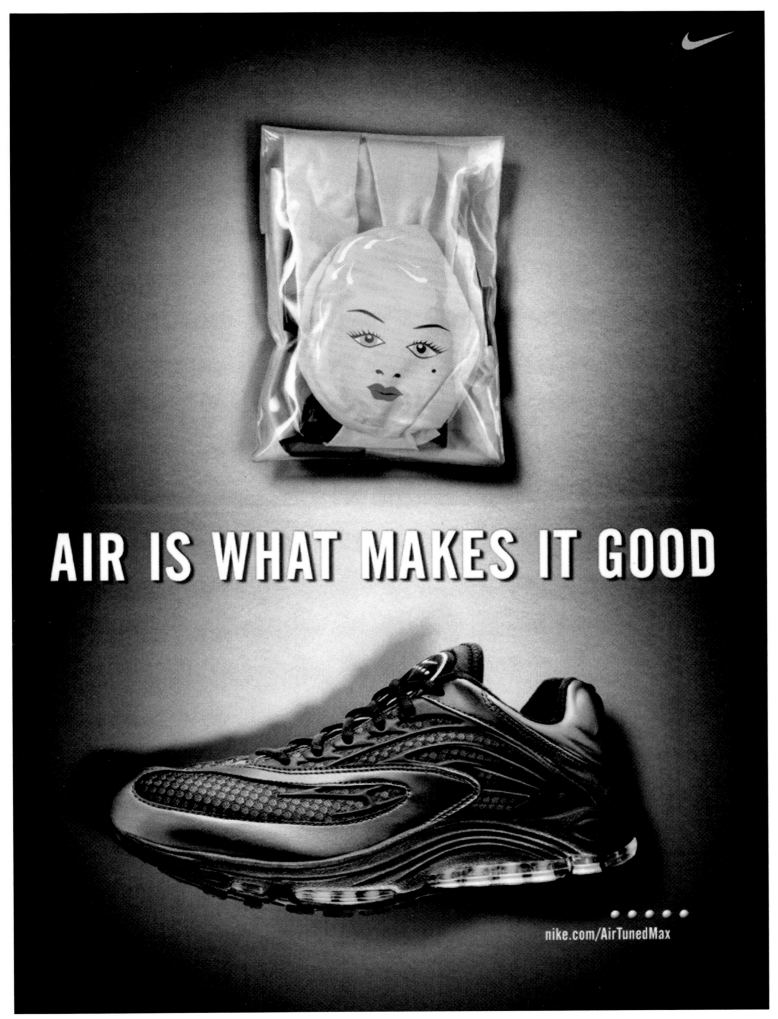

1999: Air Tuned Max, 'Air is What Makes It Good'

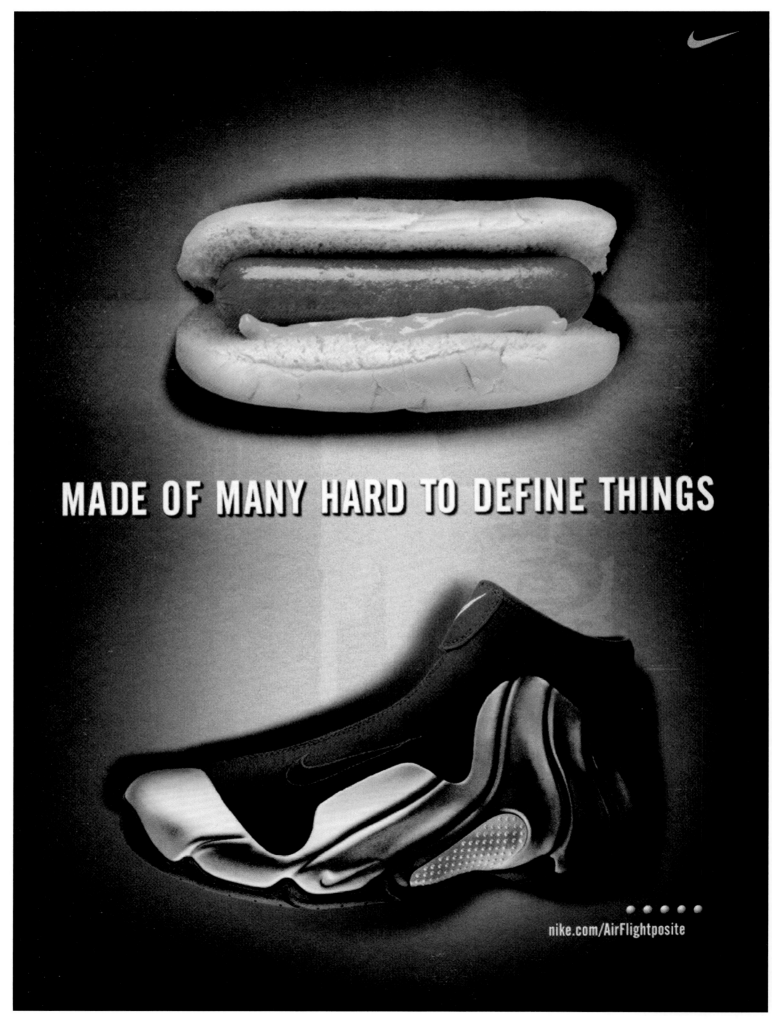

MADE OF MANY HARD TO DEFINE THINGS

nike.com/AirFlightposite

1999: Air Flightposite, 'Made of Many Hard to Define Things'

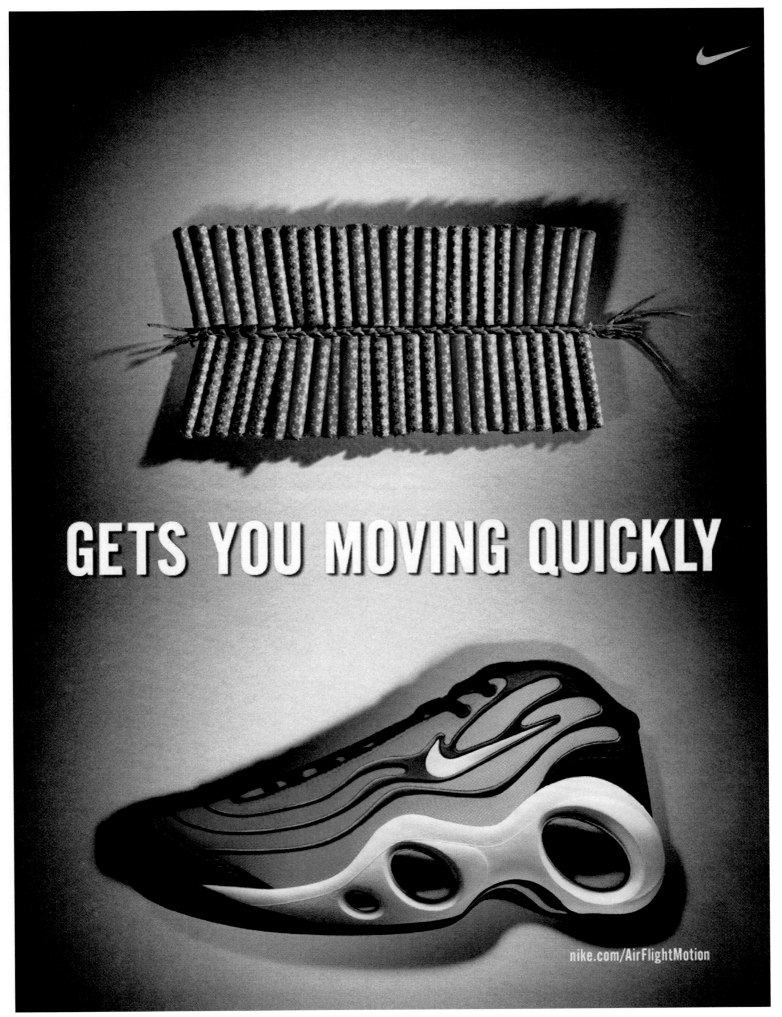

1999: Air Flight Motion, 'Gets You Moving Quickly'

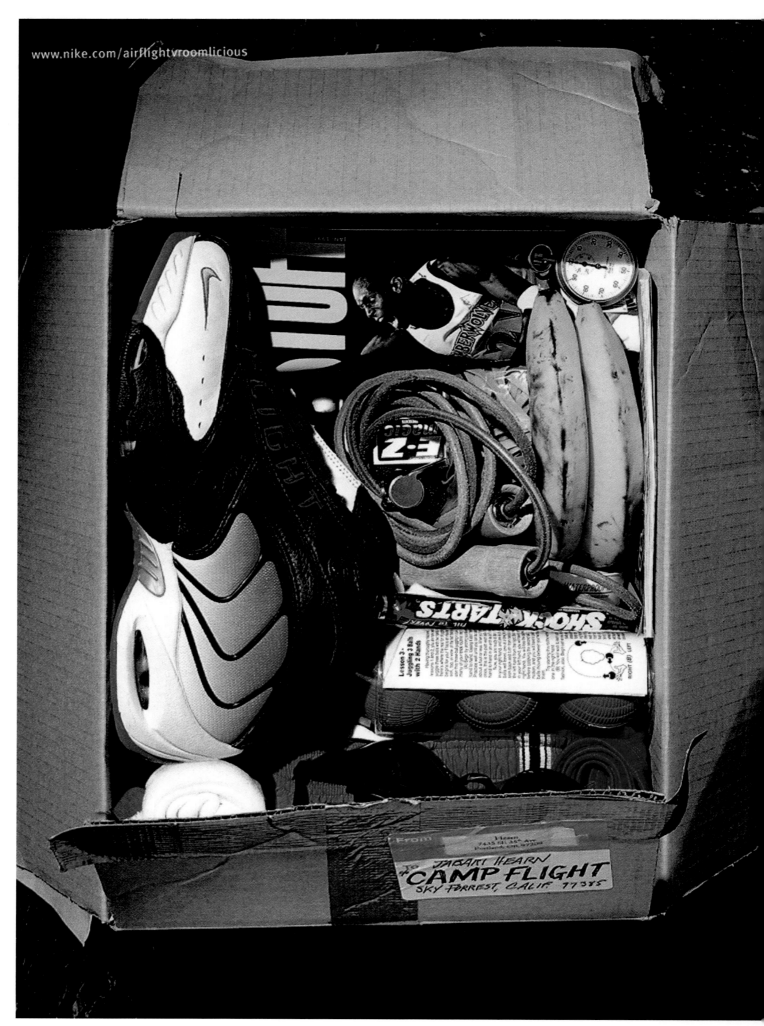

www.nike.com/airflightvroomlicious

1999: Air Flight Vroomlicious and Air Tuned Force, 'Which Camp Are You In?'

www.nike.com/airtunedforce

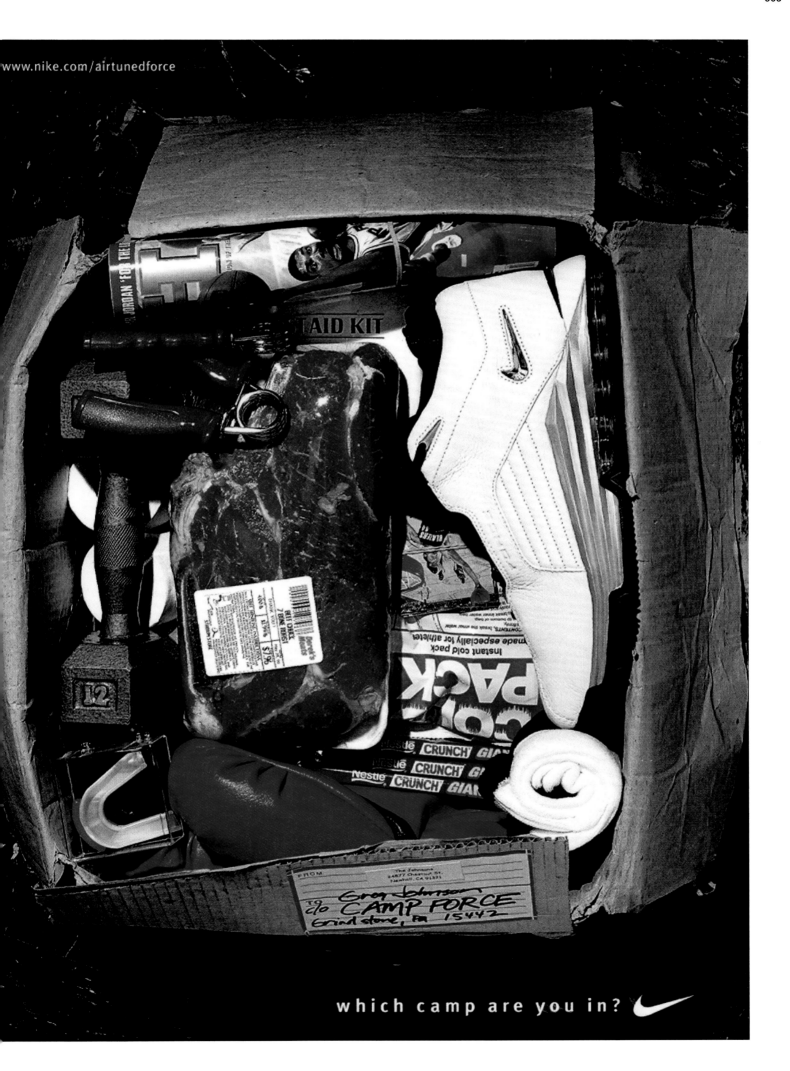

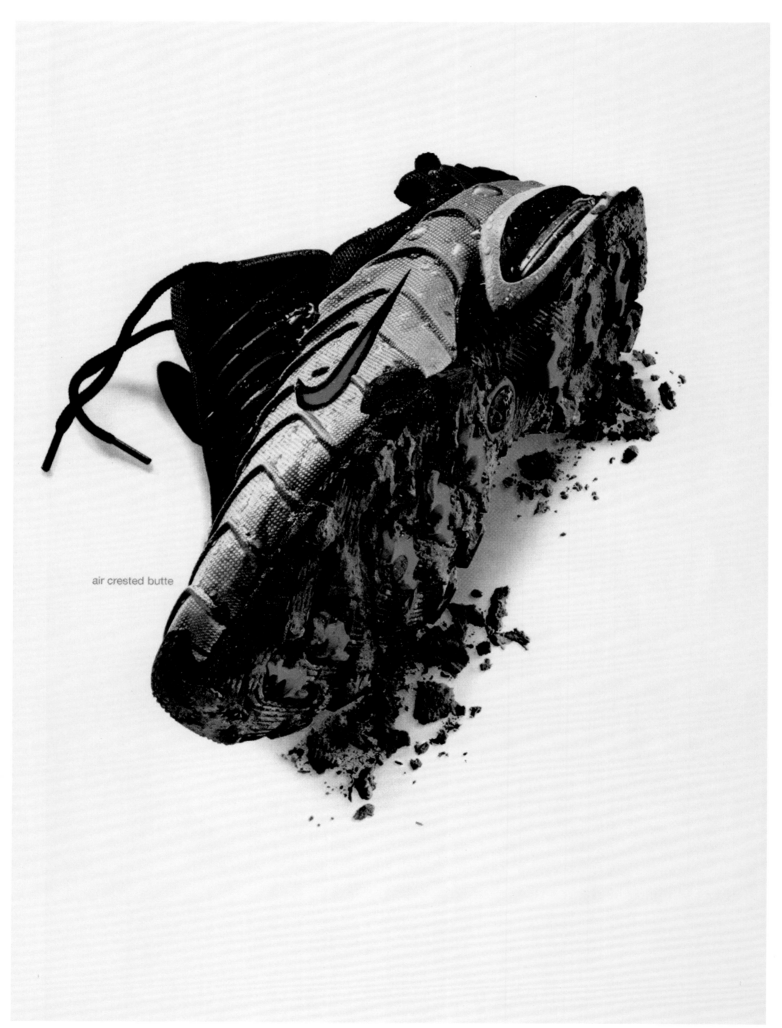

air crested butte

1999: Air Crested Butte

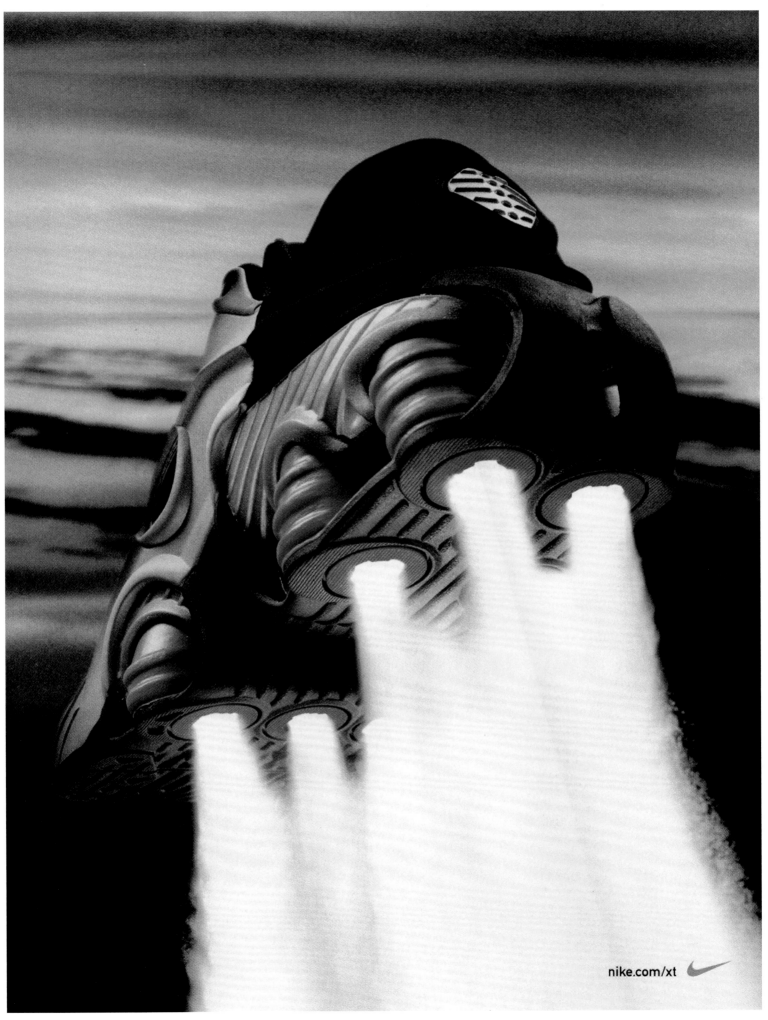

nike.com/xt

1999: Air Shox XT

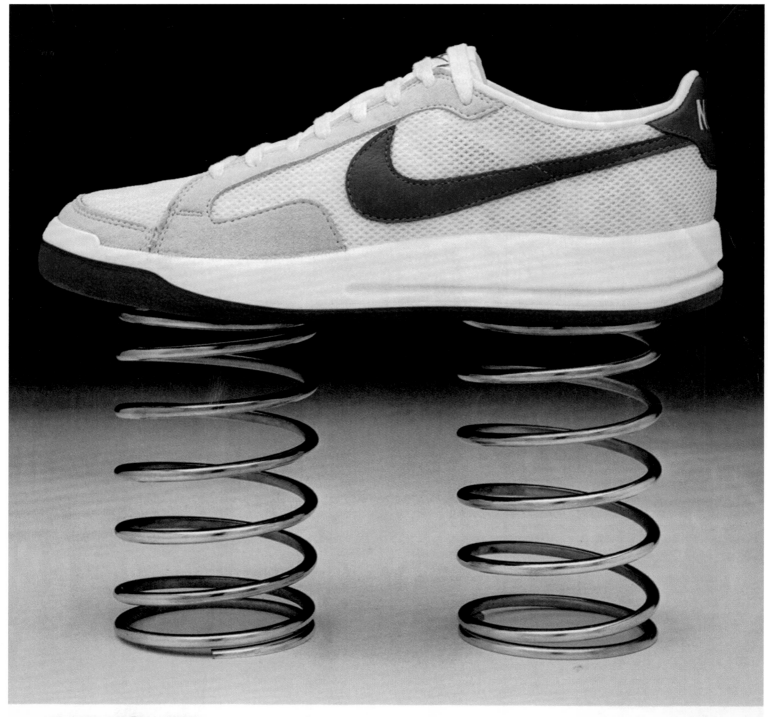

WHAT IT'S LIKE TO PLAY TENNIS IN OUR NEW SHOE.

If you've never been on the court in anything but conventional tennis shoes, wait until you play a few sets in our new Rivalry.

We didn't really put springs on the bottom. But it certainly feels that way.

All the bounce is actually coming from a polyurethane sole. A material that's lighter and more resilient than rubber.

Now we didn't invent PU, as it's called in the trade. We weren't even the first to use it. Because there were a few shortcomings.

So rather than turn out a shoe we were less than proud of, we turned to our chemists. Who turned out a remarkable new Nike compound.

We immediately put it into a bi-density outsole. It has all the cushion you'd ever want. Without sacrificing performance.

We also decided to make this one of the most breathable shoes we've ever created. So we used a lightweight nylon mesh and a non-woven backing.

And check out the lacing system. That extended eyelet gives more heel support and a customized fit. And there's a liner in the bottom that does the same thing— molds to the contour of your foot.

See the soft, supple leather? It isn't really leather. But it has better stretch, is less apt to crack and takes more abuse than the real thing.

The only way to really appreciate the Rivalry, however, is to play tennis in it. Hard, grueling tennis. Then you'll know what we mean.

Sometimes you have to go to a lot of trouble if you want a shoe to be taken lightly.

NIKE

Beaverton, Oregon

CIRCLE **237** ON READER SERVICE CARD

1981: Rivalry, 'What It's Like to Play Tennis in Our New Shoe'

WOULD YOU BUY PANTY HOSE FROM THIS MAN?

Vitas Gerulaitis is one of the world's best professional tennis players.

And getting better with every match.

So, like a lot of other professional athletes, he is often asked to endorse products in the hopes of getting you to buy them. Sometimes that makes sense, and sometimes it's ridiculous.

Vitas could wear any tennis shoe on the market, but he wears Nike.

We're proud of that. But to be honest with you, we think the way our shoes perform should be why you buy Nike, not simply because Vitas wears them.

We've built our reputation on listening to athletes like Vitas and using research and craftsmanship to constantly improve our shoes.

And today we think Nike tennis shoes outperform them all. But you'll have to decide that for yourself. Just like Vitas Gerulaitis did.

NIKE

World Headquarters, 8285 SW Nimbus Avenue, Suite 115, Beaverton, Oregon 97005.

1977: Wimbledon, 'Would You Buy Panty Hose From This Man?', ft. Vitas Gerulaitis

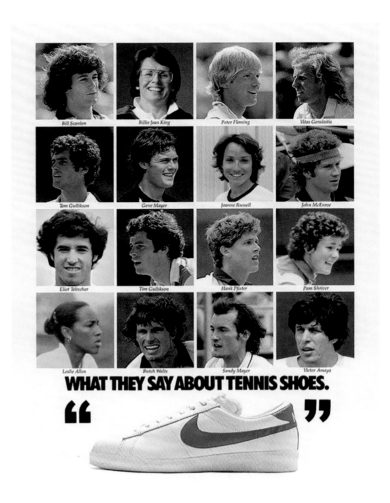

WHAT THEY SAY ABOUT TENNIS SHOES.

1976: Wimbledon, 'What They Say About Tennis Shoes'

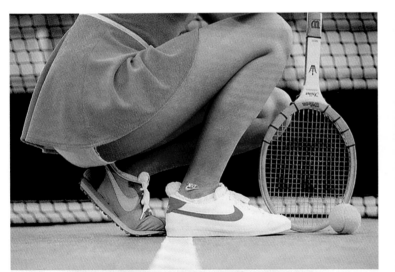

OUR RUNNING SHOES CAN TELL YOU A LOT ABOUT OUR TENNIS SHOES.

If you know anything about running shoes, you already know a lot about the superior design and construction of Nike tennis shoes.

And the same thing that made us famous in running is making us successful in tennis.

Word of foot advertising. People see Nike tennis shoes on the court and try them.

And when they find out how well Nike tennis shoes perform, the word gets around fast.

People talk about how comfortable they are. About the support they give you. The extra traction. And how they outwear almost any other major brand you can buy.

The woman up there in the photo is wearing Lady All Courts.

A great shoe, but far from your only choice. We also make the Racquette with fine grain leather uppers, and the Racquette II with long wearing canvas uppers.

All of them are designed especially to fit the bone structure of a woman's foot.

So take your feet to court in a pair of Nikes. And start your game two steps ahead of the competition.

NIKE Beaverton, Oregon

1976: Lady All Court, 'Our Running Shoes Can Tell You a Lot About Our Tennis Shoes'

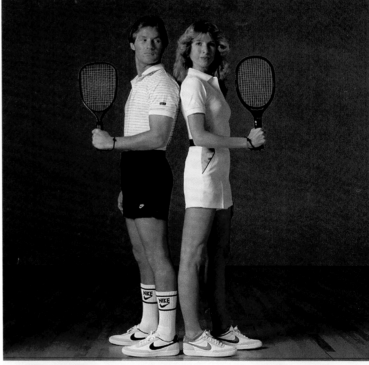

DRESS TO KILL.

Once that little door closes behind you, there's no such thing as mercy.

You're going to be jammed. Jarred. Driven into the wall. By some of the nicest people you know. About the time you're totally stressed-out, they'll rip a 100 mph shot into the corner.

Take a tip from the pros. The first chance you get, move in for the kill. Move into Nike.

We've got the shoes that know how to hold center court. For any level of play.

Take our Killshots in the photo. Their bi-level hobnail cupsole gives you traction for the most sudden move. In any direction. And the open toe design lets you accomplish it in total comfort. Naturally, there are both men's and women's models, with mesh uppers so they

breathe, and suede toe caps so they last.

We can even give you some help upstairs. With court attire made for the most grueling match. Lightweight. Durable. Designed and cut so you never feel hemmed in.

Obviously, when you come dressed in Nike, you'll look terrific.

But in this outfit, looks can kill.

NIKE Beaverton, Oregon

1979: Killshot, 'Dress to Kill'

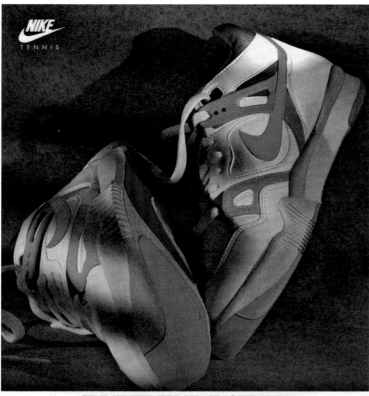

IRREVERENCE. JUSTIFIED.

Listen up.
See that color? It's not just there to make noise. It's where we put Durathane, a revolutionary new material that doubles the toe piece life. And that's just half of it.
The Air Tech Challenge has full-length Nike-Air cushioning, and Durabuck uppers for repeated machine washing. So go ahead. Be irreverent and make some noise on the court. It's justifiable.

1989: Air Tech Challenge, 'Irreverence. Justified'

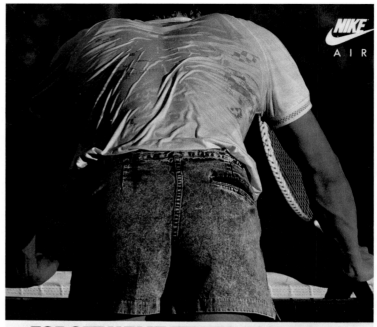

FORGET WHAT TENNIS USED TO BE.

It's changed.
The Nike Air Ace is a tennis shoe for players who want to change with it.
It features Nike-Air® in both the rearfoot and forefoot. The same cushioning that's redefined the performance criteria for running, cross-training and a myriad of other sports. And the cushioning benefits of the Air Ace are accompanied by something else most tennis players simply can't get enough of.
It's called stability.

With a patented Foot-frame™ that cradles the foot within the midsole, the Air Ace provides a stable platform. While a Dynamic Fit Sleeve™ holds the foot in place. Both promote a comfortable, yet snug fit. Which means, no matter how fast you react, the shoe stays with you.
And the experience lasts. Because the Air Ace also comes

with a Durathane™ forefoot cup that will outwear a conventional rubber outsole by nearly three to one.
Of course, as you may have noticed, the Nike Air Ace tends to part with tradition in not-so-subtle fashion. Which, in all likelihood, means you'll probably be shaking a few people up out there.
Maybe they could use it.

Air Ace

Air Ace 3/4

1988: Air Ace and Air Ace 3/4, 'Forget What Tennis Used to Be'

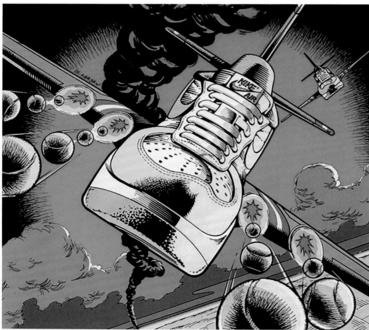

INVASION BY AIR.

Want to catch your opponent by surprise? Slip into the new Nike Air Ace. A shoe so revolutionary it can actually save you energy.
The secret? The NIKE-Air™ midsole. No other tennis shoe has it. Which may explain why no other shoe can cushion as well or cushion as long.
Because of its unique ability to reduce shock to both muscles and joints, the Air Ace will send you flying into those grueling fifth set duels with an extra burst of energy.

And thanks to its innovative outsole design, the Air Ace will provide excellent traction in any direction. Yet, the concentric circle design lets you pivot with minimal stress to the ankle, knee and hip joints.
Aggression.
Plus, this is a shoe that endures. The outsole is made from a special high-density polyurethane that gives better wear—even when the court temperatures and action heat up.
The Nike Air Ace.
Not just a shoe. An adventure.

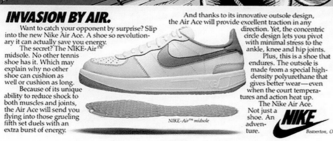
NIKE-Air™ midsole

NIKE *Beaverton, Oregon*

1983: Air Ace, 'Invasion by Air'

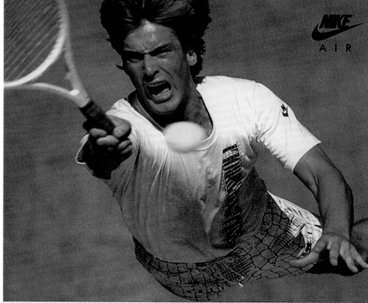

FORGET WHAT TENNIS USED TO BE.

There are people out there who seem to bring something extra to the game every time they walk onto the court.
Aggression.
The Nike Air Play is a tennis shoe for players who would rather dish it out than be on the receiving end.
It comes with Nike-Air.® The only cushioning that lets you play longer, in greater comfort, match after match. With no breakdown.
And the Air Play is stable. We incorporated a patented Footframe™ that surrounds the foot and cradles it

within the midsole. The result is a more comfortable, yet snug fit. So no matter how fast you move, or in which direction, the shoe goes with you.
And keeps going. Because the Air Play also features a Durathane™ forefoot cup that

will outwear conventional rubber outsoles by nearly three to one.
One more thing. If you decide to wear the Nike Air Play, be patient.
While your opponent checks his gut.

Women's Air Play

Men's Air Play

1988: Air Play, 'Forget What Tennis Used to Be'

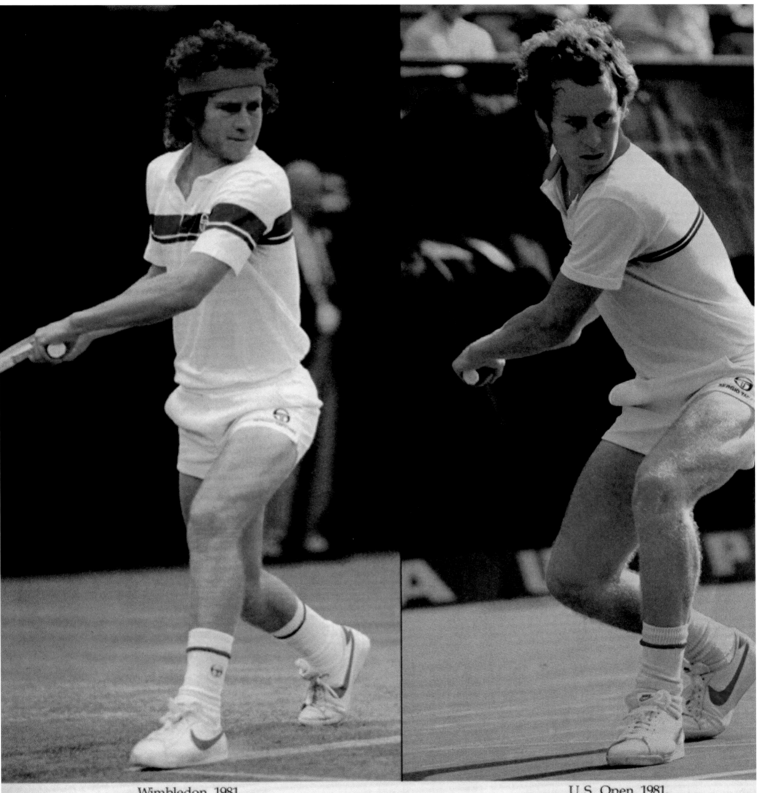

Wimbledon, 1981.
Singles and Doubles Champion.

U.S. Open, 1981.
Singles and Doubles Champion.

IT WAS A VERY GOOD YEAR.

Beaverton, Oregon

1981: 'It Was a Very Good Year', ft. John McEnroe

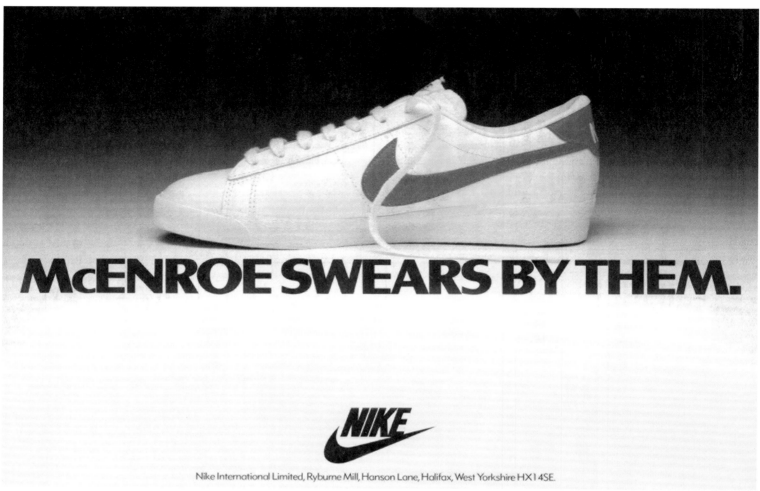

McENROE SWEARS BY THEM.

NIKE

Nike International Limited, Ryburne Mill, Hanson Lane, Halifax, West Yorkshire HX14SE.

1982: Wimbledon, 'McEnroe Swears by Them'

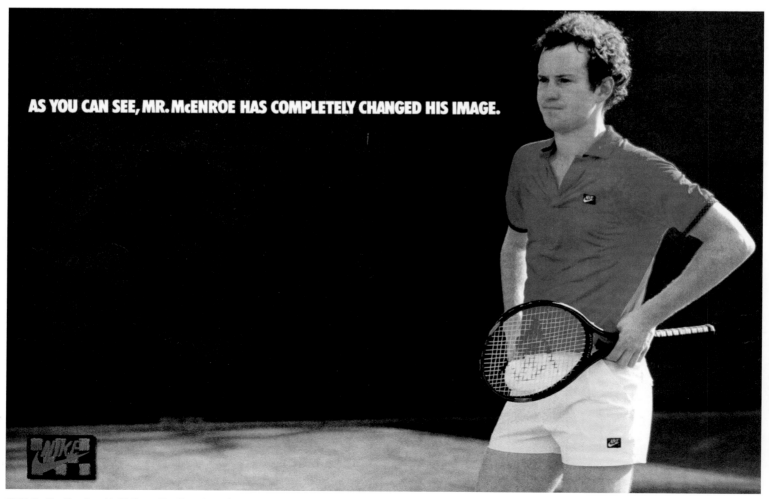

AS YOU CAN SEE, MR. McENROE HAS COMPLETELY CHANGED HIS IMAGE.

1985: 'As You Can See, Mr. McEnroe Has Completely Changed His Image', ft. John McEnroe

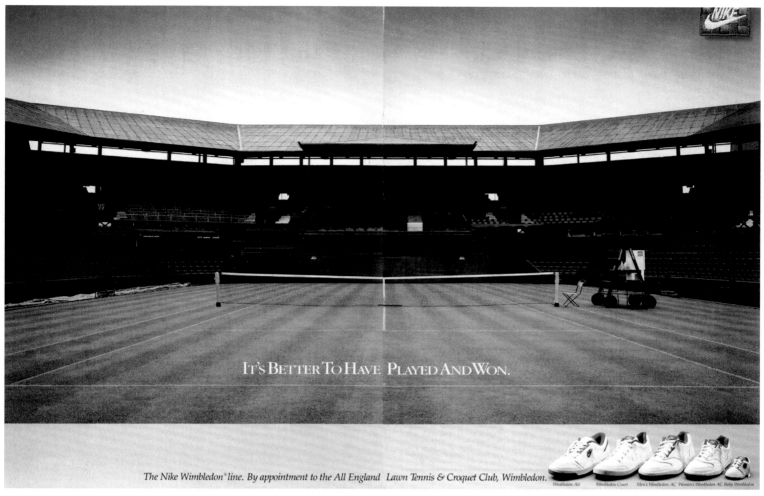

IT'S BETTER TO HAVE PLAYED AND WON.

The Nike Wimbledon® line. By appointment to the All England Lawn Tennis & Croquet Club, Wimbledon.

Wimbledon Air *Wimbledon Court* *Men's Wimbledon AC* *Women's Wimbledon AC* *Baby Wimbledon*

1987: Wimbledon Air, Wimbledon Court, Wimbledon AC and Baby Wimbledon, 'It's Better to Have Played and Won'

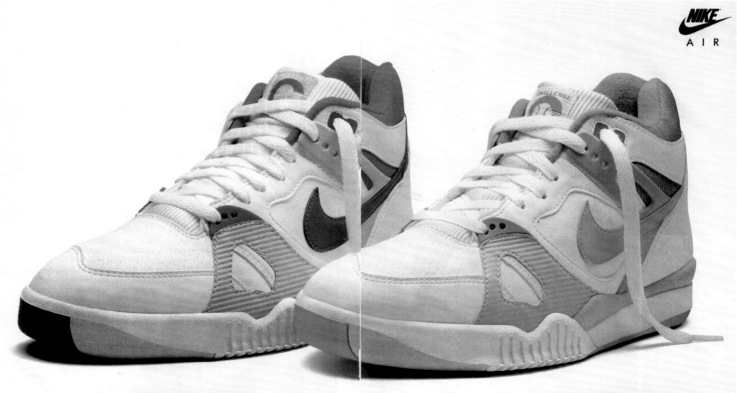

REGULAR. EXTRA STRENGTH.

The Nike Air Tech Challenge is clearly a shoe to be reckoned with, no matter what color Durabuck uppers and a Durathane forefoot that doubles toe-piece life. However, there is a will only start to get nervous when you arrive at courtside. But with the neon-orange combination you choose. Both have full-length Nike-Air® cushioning, machine-washable difference in the way the two shoes perform. With the berry and blue model, your opponents and green ones, you'll be able to scare them from all the way across the parking lot.

SEE TRAVEL AND PRODUCT INFORMATION PAGE

1988: Air Tech Challenge, 'Regular. Extra Strength'

THIS IS THE ONLY WAY TO PLAY TENNIS.

1990: 'This is the Only Way to Play Tennis' (1 of 3)

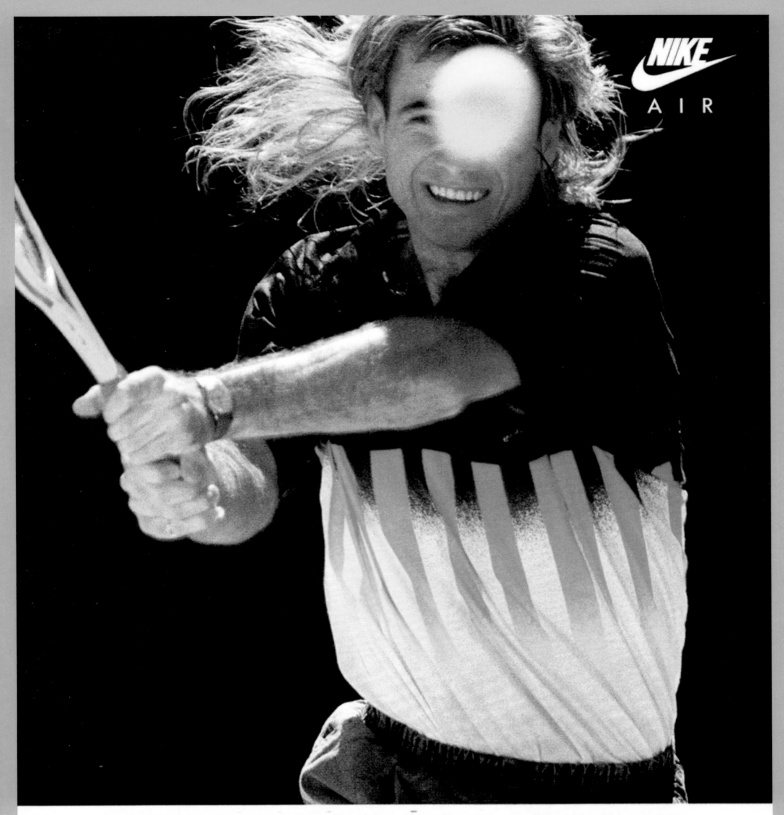

AND THIS IS YOUR GRANDMOTHER.

Tennis has changed. It used to be conservative and traditional. Now it's performance, Agassi and the Air Tech Challenge.

Just look at the shoe: it's all attitude and performance.

Want details? How about a Durathane toe-piece for extra-long life, machine washable Durabuck uppers, a lateral support footframe, and Nike-Air® for superior cushioning.

The Air Tech Challenge

from Nike, part of the Challenge Court Collection. It's not the only way to play tennis. Well, yeah it is.

Air Tech Challenge II

For more information about Nike shoes, apparel, accessories or your grandmother, call 1-800-344-NIKE, Monday-Friday, 7am-5pm, Pacific Time. In Canada, call 1-800-663-1AIR.

1990: Air Tech Challenge II, 'And This is Your Grandmother', ft. Andre Agassi (2 of 3)

AND THIS IS THE

Whatever tennis used to be, it ain't now. It ain't stiff. It ain't stuffy. It ain't the Que of England. It's performance. It's McEnroe. It's the Air Tech Challenge.

Just look at the shoe: it's all attitude. Now look under the hood: it's all engine. W details? How about a highly resilient Durathane toe-piece for extra-long life, fully mac

For more information about Nike shoes, apparel, accessories or the Queen of Engl

1990: Air Tech Challenge II, 'And This is the Queen of England', ft. John McEnroe (3 of 3)

EN OF ENGLAND.

washable Durabuck uppers, a lateral support footframe, and
ke-Air® for superior cushioning no matter what the surface.
The Air Tech Challenge from Nike, part of the Challenge
urt Collection. It's not the only way to play tennis. Well, yeah it is.

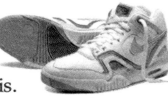

Air Tech Challenge II

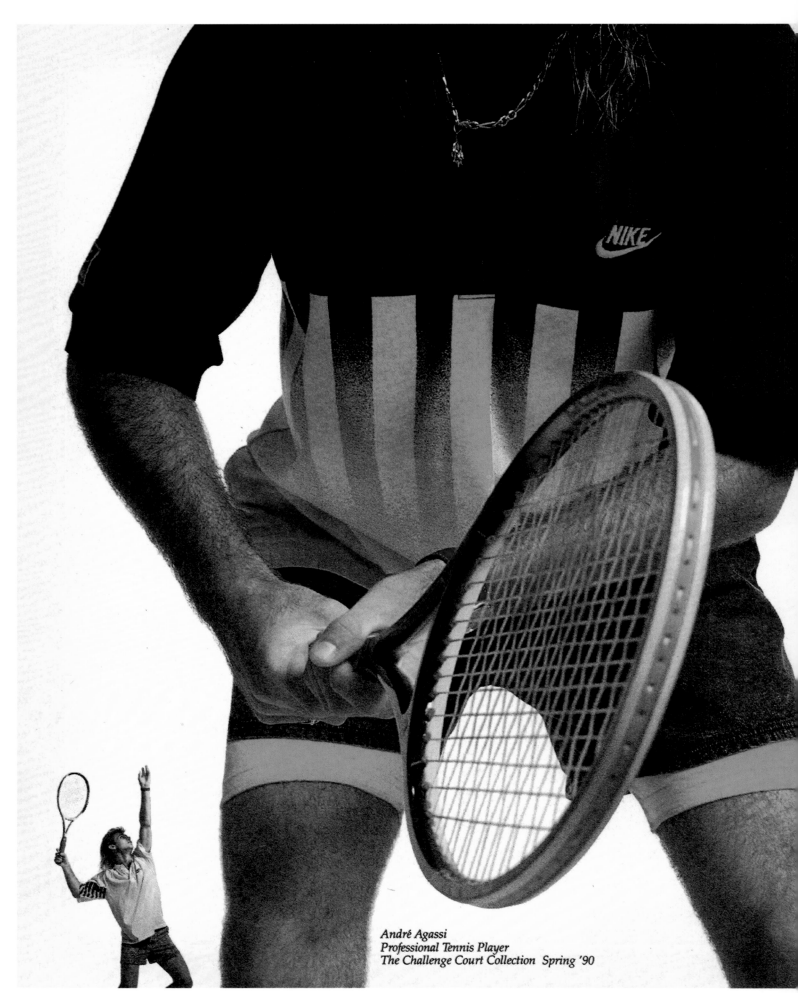

André Agassi
Professional Tennis Player
The Challenge Court Collection Spring '90

1990: Challenge Court Collection, ft. Andre Agassi

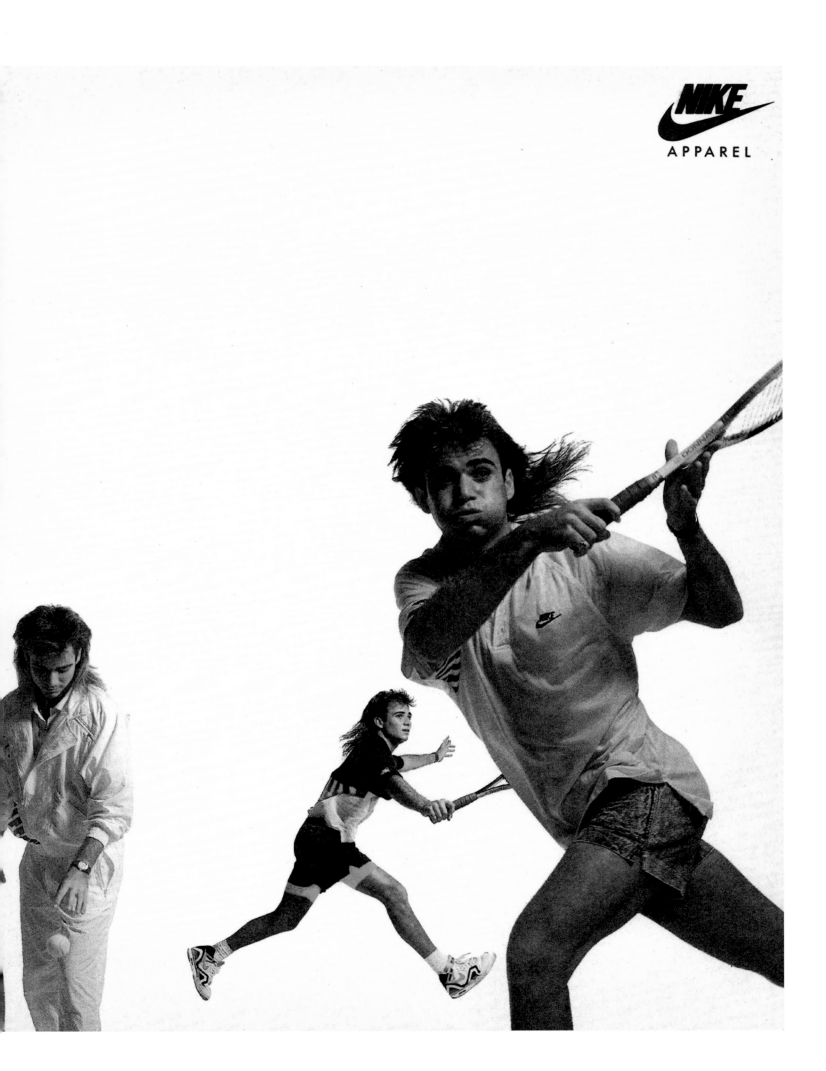

Andre Agassi, addressing a crowd of young, screaming, adoring females—
"I love all you girls and I just want to say to each of you:

Yes, my Nike tennis shoes do have Durathane toe-tips which prolong the life of the outsoles.

Full-length Nike-Air. And washable Durabuck uppers…Yes, girls, washable!"…(the screaming gets so loud Andre is unable to continue).

1990: Air Tech Challenge II, ft. Andre Agassi

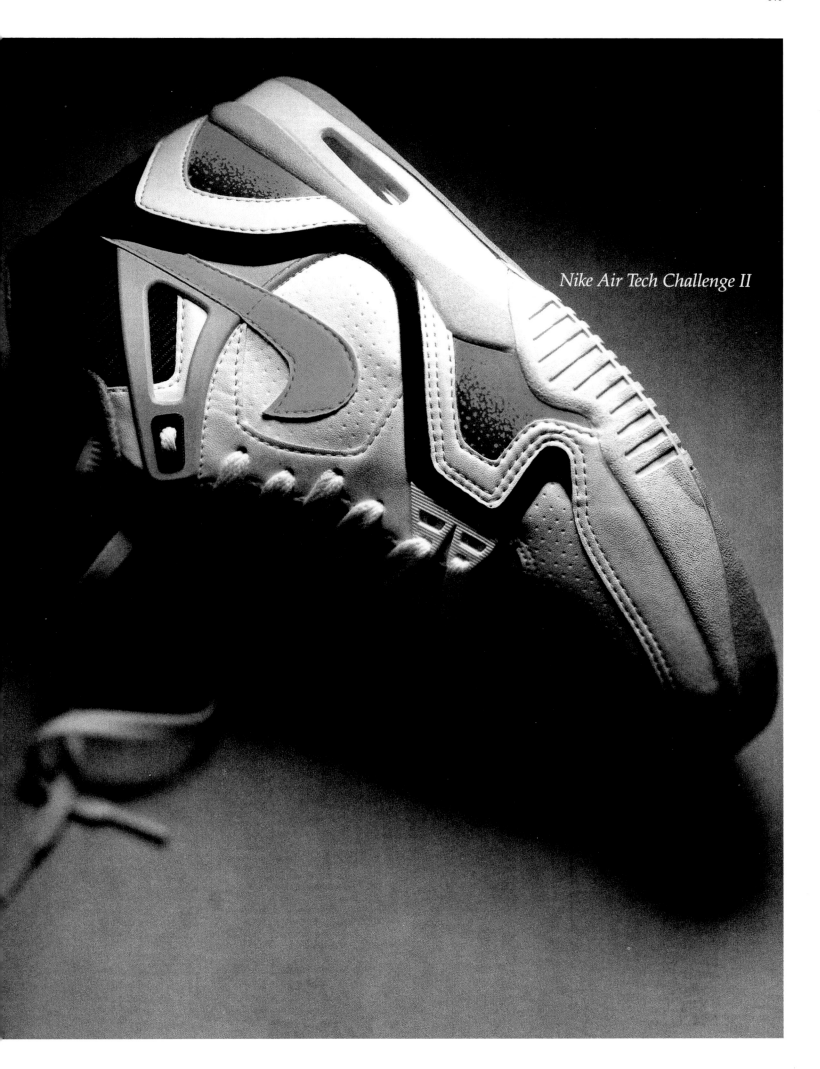

Nike Air Tech Challenge II

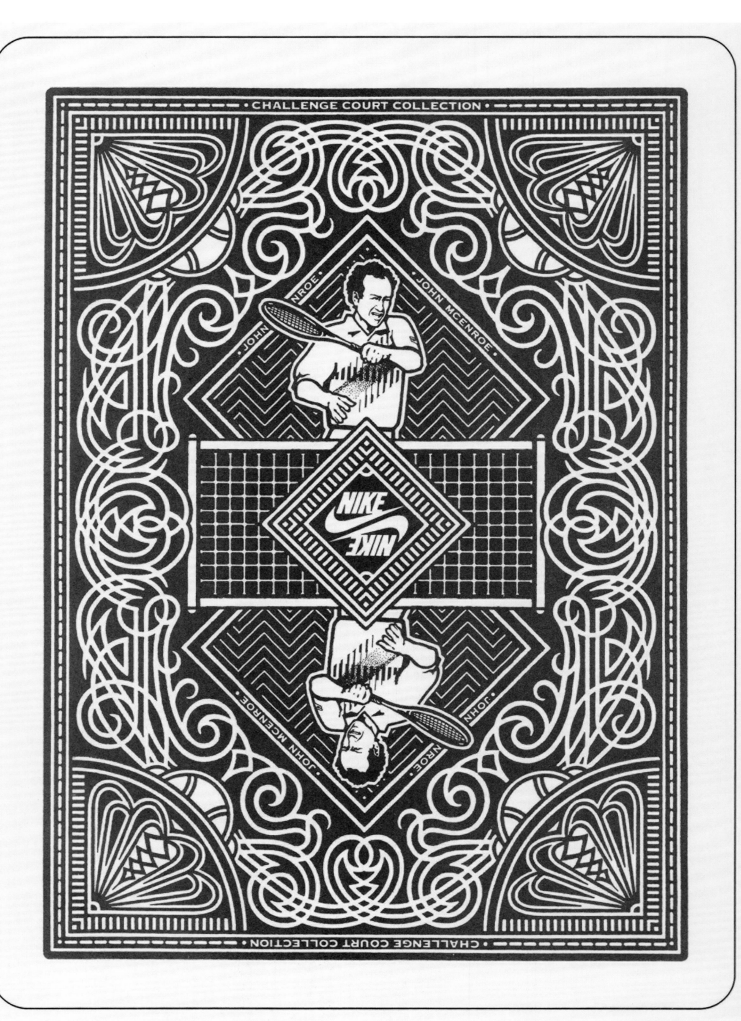

1990: Challenge Court Collection and Air Tech Challenge 3/4, 'Deal With It', ft. John McEnroe

THE NIKE AIR TECH CHALLENGE 3/4.

DEAL WITH IT.

DEAL WITH IT.

THE NIKE AIR TECH CHALLENGE 3/4.

THE NIKE AIR TECH CHALLENGE 3/4.

DEAL WITH IT.

DEAL WITH IT.

THE NIKE AIR TECH CHALLENGE 3/4.

1990: Challenge Court Collection and Air Tech Challenge 3/4, 'Deal With It', ft. Andre Agassi

523

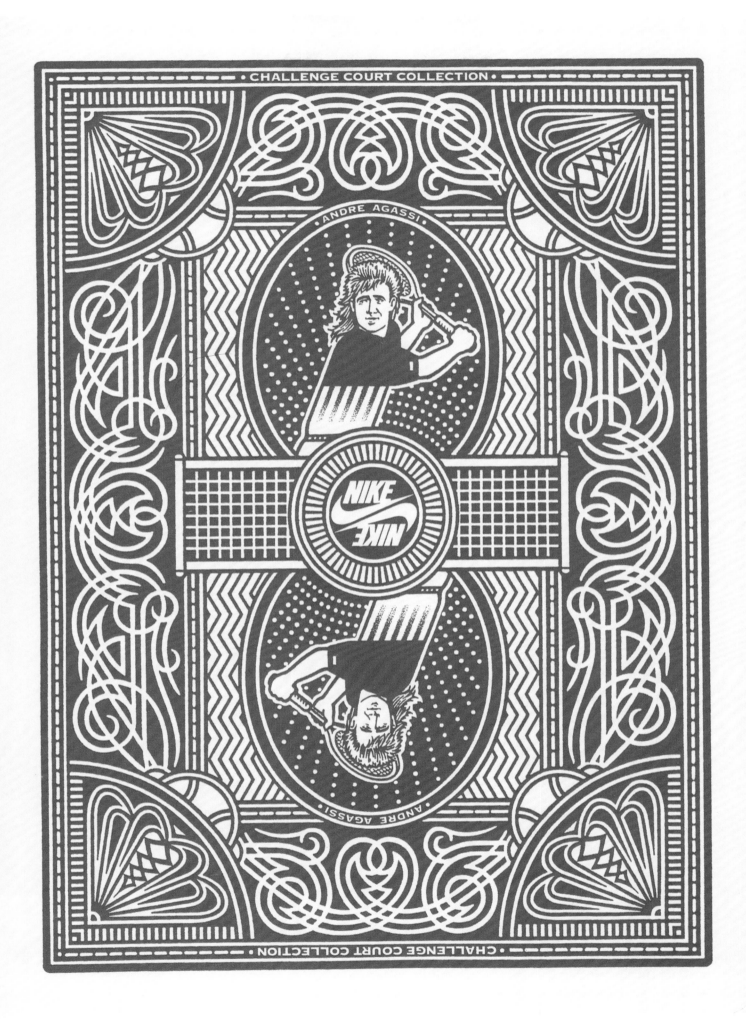

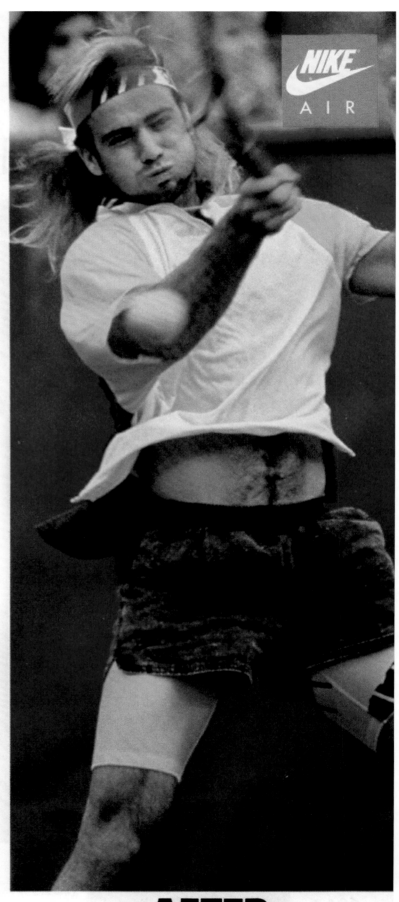

BEFORE.

AFTER.

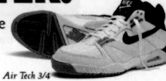

Air Tech 3/4

Eigentlich könnten Sie so weiter Tennis spielen wie bisher. Wenn es nicht die Schuhe mit der unübertroffen dauerhaften Dämpfung des Nike Air®-Systems und die Nike Challenge Court Collection mit dem starken Design gäbe.

1990: Challenge Court Collection and Air Tech Challenge 3/4, 'Before. After', ft. Andre Agassi

White shoes white shirt No Service.*

A bit loud, you say? Maybe. But there's a great deal more to The Nike Challenge Court Collection than actual color. Our shirts are made of CoolMax® fabric to move moisture away from your skin and keep you cool and dry. And our shorts are made with spandex fabric to give your muscles extra support and keep you extra responsive.

So. Is it ever appropriate to wear white? Only if you're planning to surrender.

***(EXCEPT, OF COURSE, AT WIMBLEDON)**

For more information, see Readers' Service Page

CoolMax® is a registered trademark of E.I. du Pont de Nemours & Co., Inc.

1991: Challenge Court Collection, 'White Shoes. White Shirt. No Service', ft. Andre Agassi

1992: Challenge Court Collection and Air Tech Challenge 3/4, 'Ball-Crushing, Liver-Stomping Game. Played in Very Nice Shoes', ft. Andre Agassi

Hit the ball as loud as you can.

There's nothing quiet about the Nike Challenge Court Collection. But noise don't mean a thing unless you back it up. That's why our shirts are made of

CoolMax® fabric to help your body breathe at high volume. And our Lycra® fabric shorts give your muscles extra support to keep you responsive. So now that you've got the gear, how can you tell if you're playing loud enough? The police will let you know.

Cool Max® and Lycra® are registered trademarks of E.I. du Pont de Nemours & Co.,Inc.

SEE TRAVEL AND PRODUCT INFORMATION PAGE

CHALLENGE COURT
BY NIKE

1991: Challenge Court Collection, 'Hit the Ball as Loud as You Can', ft. Andre Agassi

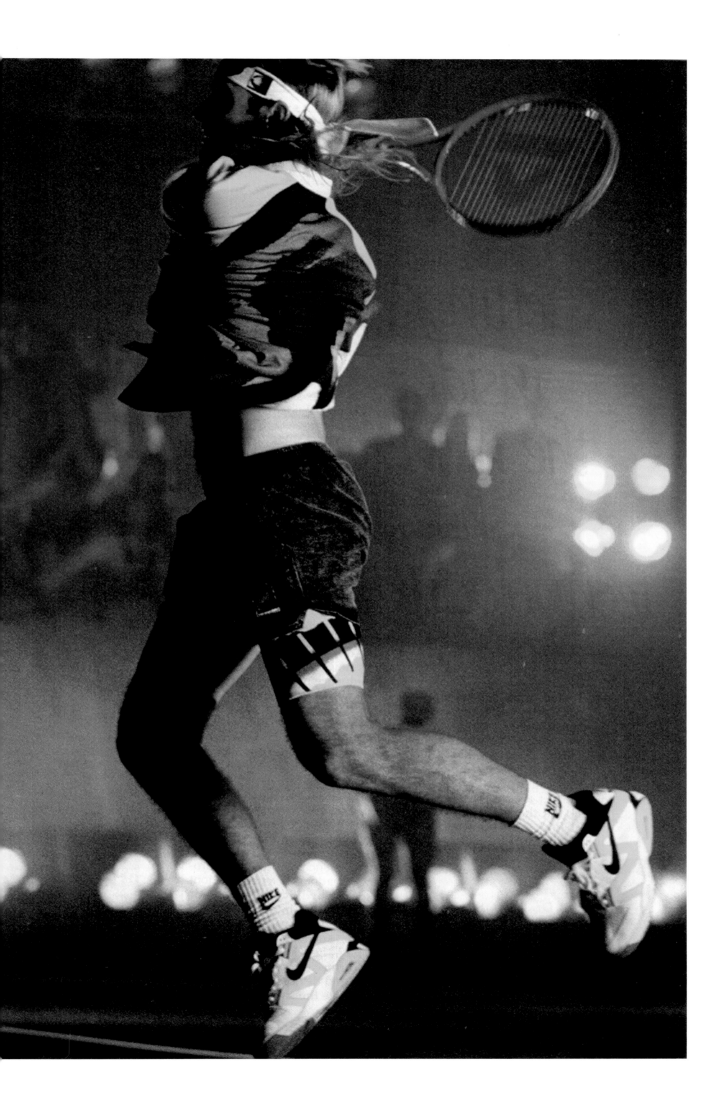

ROCK N' ROLL TENNIS
is not allowed at places where it is needed most. Rock n' Roll tennis is rugby with a racket. Rock n' Roll tennis is not the tennis your parents had in mind. Rock n' Roll tennis is hitting the ball as loud as you can. Rock n' Roll tennis is rated NC-17 Rock n'Roll tennis plays fair, but not by the rules. Rock n' Roll tennis doesn't have polite applause. Rock n' Roll tennis doesn't play on AM radio. Rock n' Roll tennis is a no-no, in Britain. Rock n' Roll tennis doesn't send flowers.

If you want rock n' roll tennis, you want the Nike Air Tech Challenge 3/4.

If you want Nike-Air® cushioning, you want the Nike Air Tech Challenge 3/4. If you want a Durathane™ toe piece for extra wear, you want the Nike Air Tech Challenge 3/4.

If you want flowers, you want another shoe.

1991: Air Tech Challenge 3/4, 'Rock n' Roll Tennis'

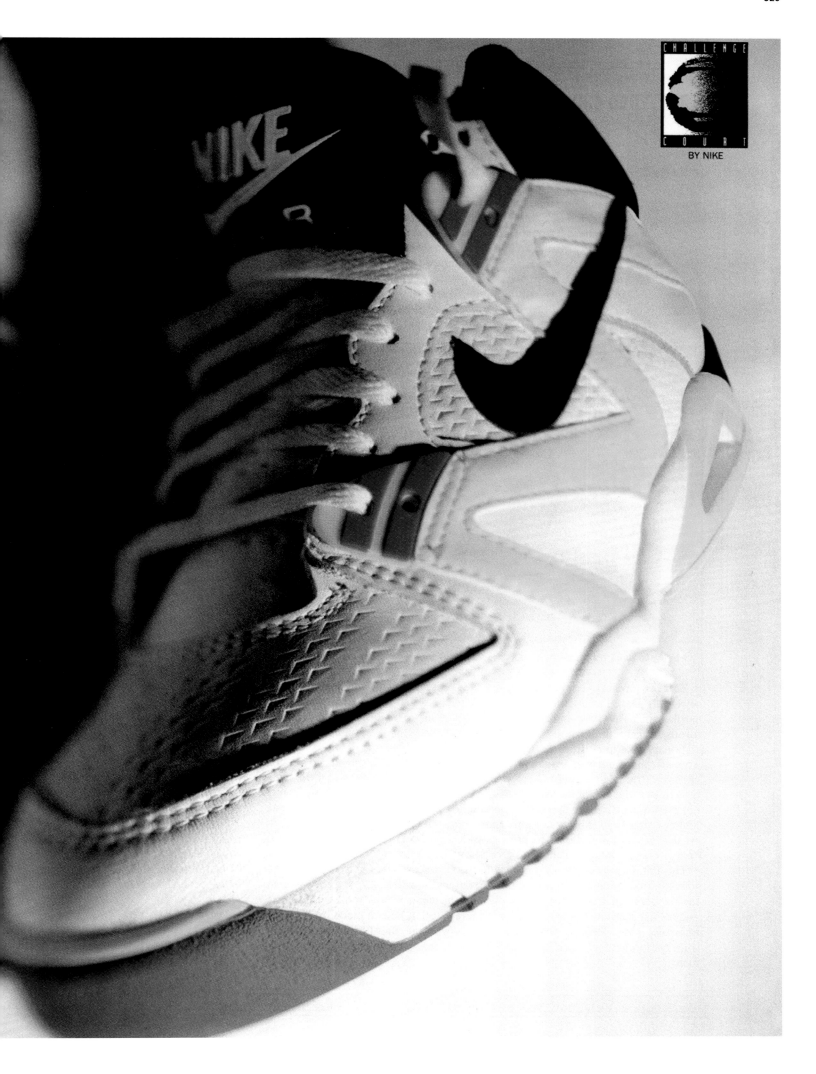

CHALLENGE COURT
BY NIKE

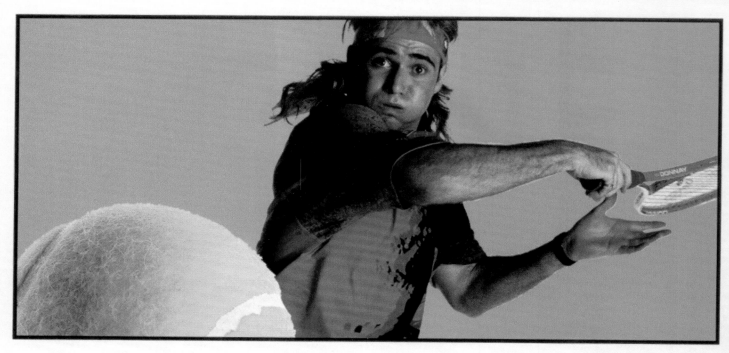

Kein Mensch würde mit einem Tennisball tauschen wollen, wenn ihn Andre Agassi bei seiner Vorhand mit einer Geschwindigkeit vor 160 km/Std. übers Netz haut. Da wäre man dann schon lieber einer von Agassis Füßen. Denn die stecken im AIR TECH 3/4 mit dem NIKE AIR®-System für optimale Dämpfung.

1992: Air Tech Challenge 3/4, ft. Andre Agassi

" 'Rock n' Roll Tennis' and 'Hit the Ball as Loud as You Can' are just a couple of the power-packed slogans Wieden+Kennedy devised for Andre Agassi. Like Bo Jackson, Andre was such a transcendent salesman his Air Tech Challenge line of sneakers is still referred to as 'Agassis' decades after his flaming tennis ball logo last lit up the court. His rebellious persona was a gigantic one-fingered riposte to the traditional tennis establishment. He even had the balls to opt out of Wimbledon from 1988 to 1990, publicly stating he wasn't playing due to the event's all-white dress code. **"**

Nick Santora
'Anyone for Tennis?'
Sneaker Freaker, issue 23 (2011)

I don't mind losing as long as I give my best. Okay I mind it but I don't hate it.

okay

JIM COURIER
WOULD WIN A LOT OF
MATCHES PLAYING IN
HIS SOCKS. BUT HE WINS
EVEN MORE IN HIS
AIR SUPREME COURT
LOW SHOES.

I hate it

1992: Air Supreme Court, ft. Jim Courier

Some men are born great. And some men wrestle greatness to the ground and kick it in the head and stomp on its guts until it just gives in.

NIKE AIR

Jim Courier now wrestles, kicks, and stomps in Supreme Court tennis shoes and apparel.

1992: Air Supreme Court, ft. Jim Courier

PONY

PONY was founded in 1972 by maverick mogul Roberto Muller. Devised as an acronym for 'Product of New York', PONY was based on Muller's strategic vision that sportswear – until then relegated to the gymnasium only – was set to cross over and become day-to-day casual clothing. Within a few short years, Muller's irrepressible Uruguayan swagger had PONY strutting the globe at the vanguard of a new era in American sport.

Big-name athletic endorsements underpinned PONY's meteoric rise. Pelé, Larry Holmes, Franco Harris, Reggie Jackson, Spud Webb, Dan Marino and Earl Monroe were among the greats to rock the chevron. Detours into gymnastics and tennis added big name female athletes Mary Lou Retton and Tracy Austin to the brand's eclectic roster. Fixated on team sports, sales grew fast across myriad categories, but the brand struggled to adapt as the running boom fundamentally changed the industry. This collection of ads is a legacy of the days when PONY were one of the most innovative sports brands in North America.

●

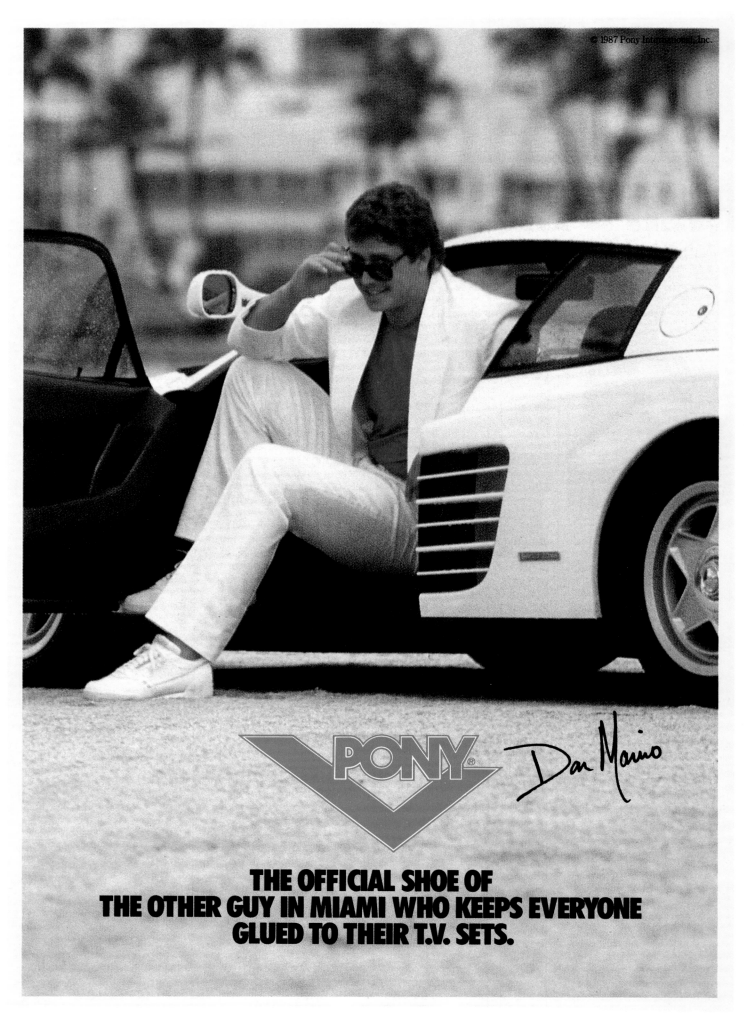

1987: 'The Official Shoe of the Other Guy in Miami Who Keeps Everyone Glued to Their T.V. Sets', ft. Dan Marino

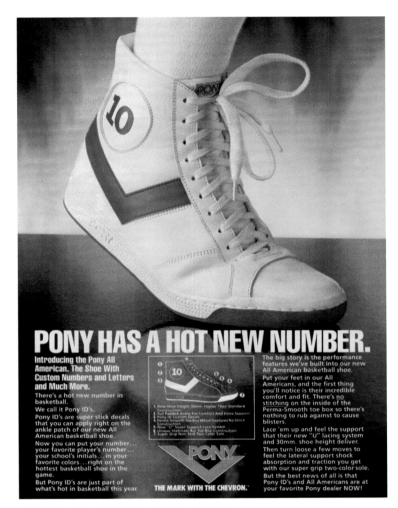

1979: Starter and Pro 80, 'For the Right Moves, Get the Right Shoes', ft. David Thompson

1983: All American, 'PONY Has a Hot New Number'

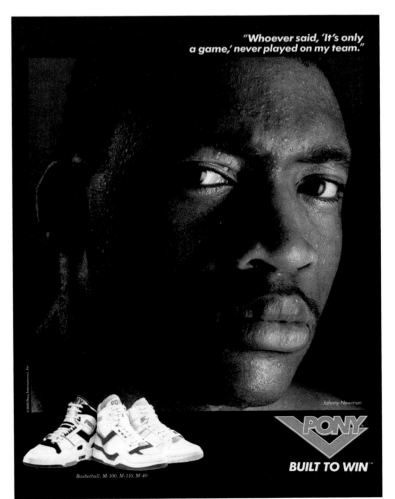

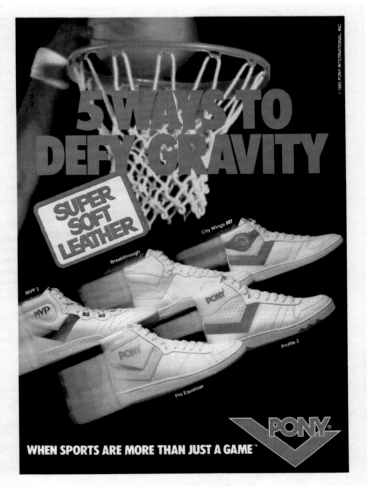

1989: M-100, M-110 and M-40, 'Built to Win', ft. Johnny Newman

1985: MVP 2, Breakthrough, City Wings, Pro Equalizer and Profile 2, '5 Ways to Defy Gravity'

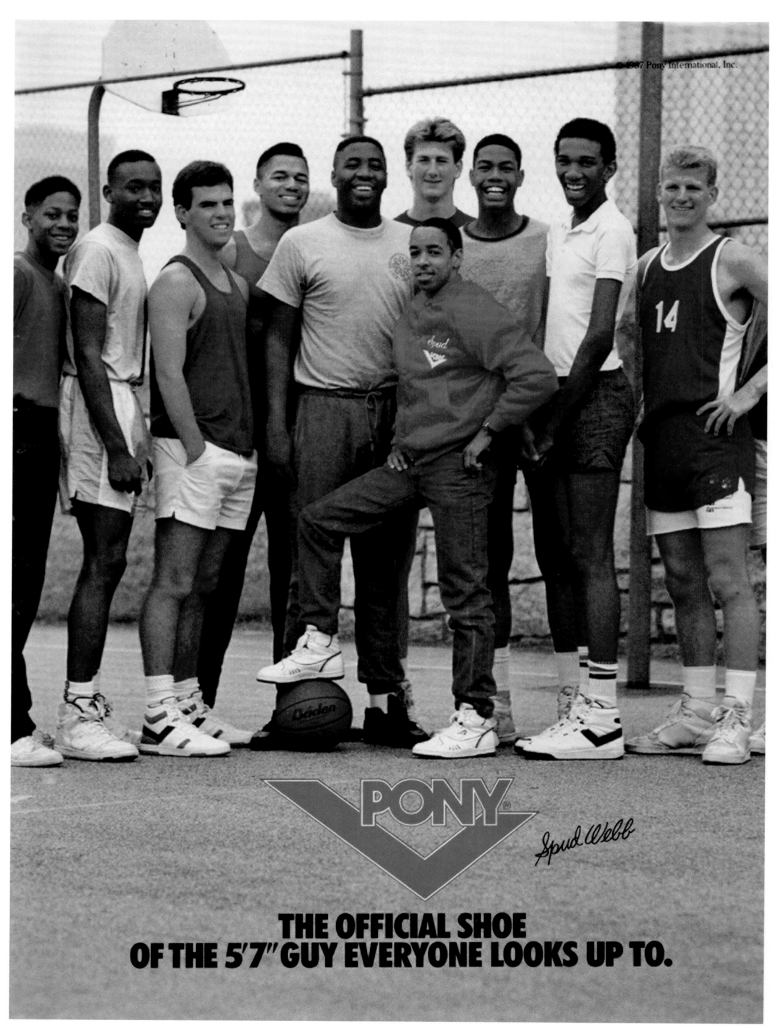

1987: 'The Official Shoe of the 5'7" Guy Everyone Looks Up To', ft. Spud Webb

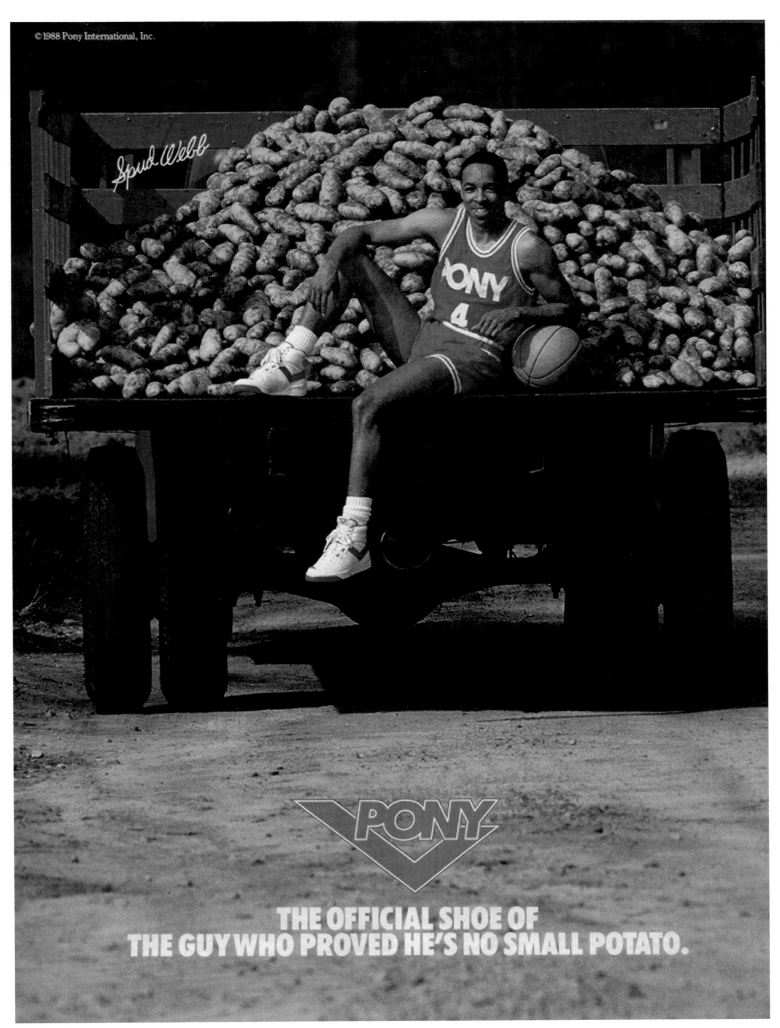

© 1988 Pony International, Inc.

Spud Webb

PONY

THE OFFICIAL SHOE OF
THE GUY WHO PROVED HE'S NO SMALL POTATO.

1988: 'The Official Shoe of the Guy Who Proved He's No Small Potato', ft. Spud Webb

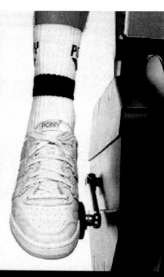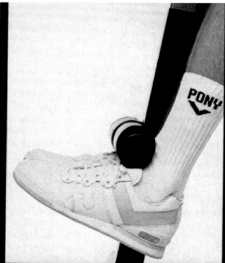

THE TOTAL WORKOUT SHOE

©1986 PONY INTERNATIONAL, INC.

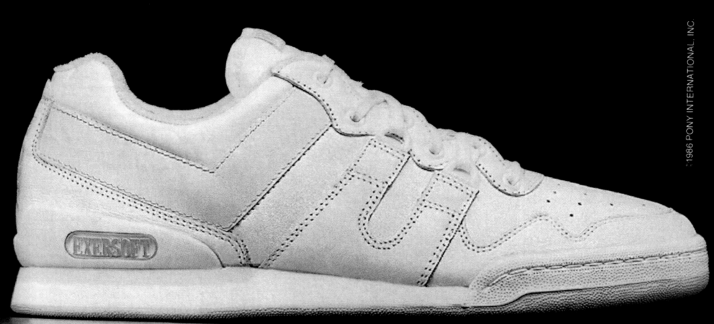

EXERSOFT™
THE SOFT SHOE FOR HARD WORKOUTS.

Super soft leather for comfort. A total support system for fit. The Exersoft offers a range of performance features designed to take you through a total workout in comfort. The Exersoft is available in black, light grey and white. Exersoft, the most comfortable exercise equipment in all of fitness.

PONY®

WHEN SPORTS ARE MORE THAN JUST A GAME™

1986: Exersoft, 'The Total Workout Shoe'

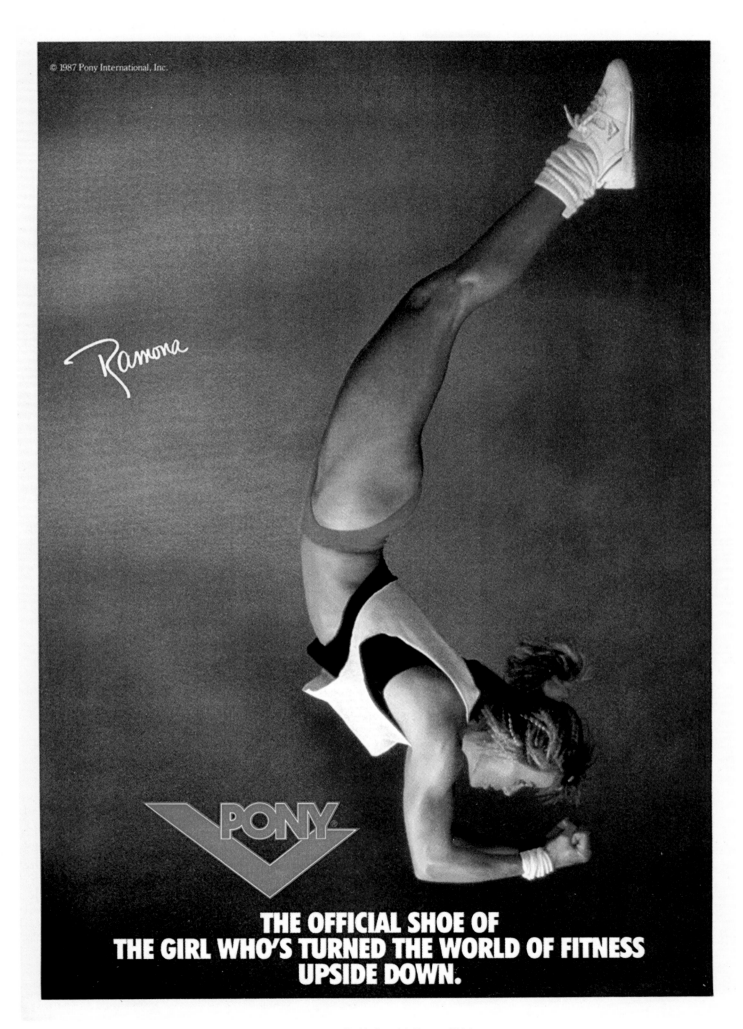

© 1987 Pony International, Inc.

Ramona

PONY

THE OFFICIAL SHOE OF THE GIRL WHO'S TURNED THE WORLD OF FITNESS UPSIDE DOWN.

1987: Ramona, 'The Official Shoe of the Girl Who's Turned the World of Fitness Upside Down', ft. Ramona Melvin

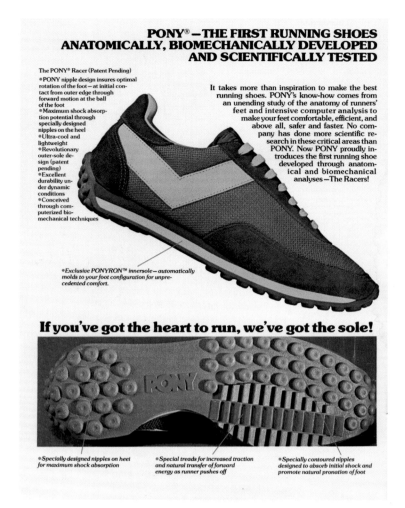

PONY® – THE FIRST RUNNING SHOES ANATOMICALLY, BIOMECHANICALLY DEVELOPED AND SCIENTIFICALLY TESTED

The PONY® Racer (Patent Pending)
*PONY nipple design insures optimal rotation of the foot – at initial contact from outer edge through forward motion at the ball of the foot
*Maximum shock absorption potential through specially designed nipples on the heel
*Ultra-cool and lightweight
*Revolutionary outer-sole design (patent pending)
*Excellent durability under dynamic conditions
*Conceived through computerized bio-mechanical techniques

It takes more than inspiration to make the best running shoes. PONY's know-how comes from an unending study of the anatomy of runners' feet and intensive computer analysis to make your feet comfortable, efficient, and above all, safer and faster. No company has done more scientific research in these critical areas than PONY. Now PONY proudly introduces the first running shoe developed through anatomical and biomechanical analyses – The Racers!

*Exclusive PONYRON™ innersole – automatically molds to your foot configuration for unprecedented comfort.

If you've got the heart to run, we've got the sole!

*Specially designed nipples on heel for maximum shock absorption

*Special treads for increased traction and natural transfer of forward energy as runner pushes off

*Specially contoured nipples designed to absorb initial shock and promote natural pronation of foot

1977: Racer, 'If You've Got the Heart to Run, We've Got the Sole!'

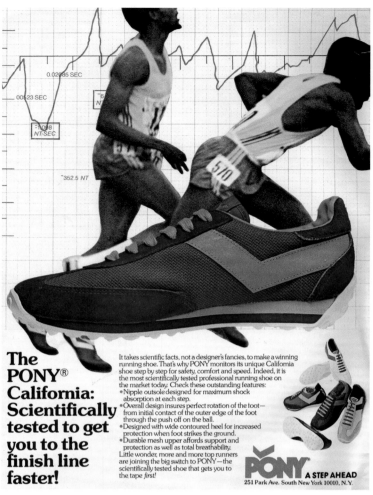

The PONY® California: Scientifically tested to get you to the finish line faster!

It takes scientific facts, not a designer's fancies, to make a winning running shoe. That's why PONY monitors its unique California shoe step by step for safety, comfort and speed. Indeed, it is the most scientifically tested professional running shoe on the market today. Check these outstanding features:
*Nipple outsole designed for maximum shock absorption at each step.
*Overall design insures perfect rotation of the foot – from initial contact of the outer edge of the foot through the push off on the ball.
*Designed with wide contoured heel for increased protection when foot strikes the ground.
*Durable mesh upper affords support and protection as well as total breathability.
Little wonder, more and more top runners are joining the big switch to PONY – the scientifically tested shoe that gets you to the tape first!

PONY® A STEP AHEAD
251 Park Ave. South New York 10010, N.Y.

1977: California, 'The PONY California: Scientifically Tested to Get You to the Finish Line Faster!'

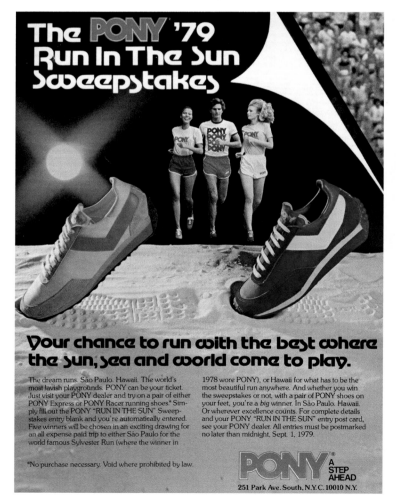

The PONY '79 Run In The Sun Sweepstakes

Your chance to run with the best where the sun, sea and world come to play.

The dream runs. São Paulo. Hawaii. The world's most lavish playgrounds. PONY can be your ticket. Just visit your PONY dealer and try on a pair of either PONY Express or PONY Racer running shoes.* Simply fill out the PONY "RUN IN THE SUN" Sweepstakes entry blank and you're automatically entered. Five winners will be chosen in an exciting drawing for an all expense paid trip to either São Paulo for the world famous Sylvester Run (where the winner in

1978) wore PONY), or Hawaii for what has to be the most beautiful run anywhere. And whether you win the sweepstakes or not, with a pair of PONY shoes on your feet, you're a big winner. In São Paulo. Hawaii. Or wherever excellence counts. For complete details and your PONY "RUN IN THE SUN" entry post card, see your PONY dealer. All entries must be postmarked no later than midnight, Sept. 1, 1979.

*No purchase necessary. Void where prohibited by law.

PONY® A STEP AHEAD
251 Park Ave. South, N.Y.C. 10010 N.Y.

1979: Racer, 'The PONY '79 Run in the Sun Sweepstakes'

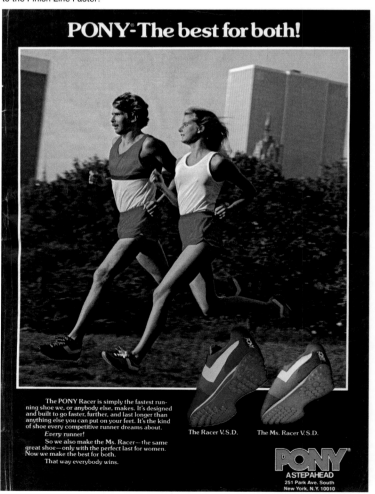

PONY® – The best for both!

The PONY Racer is simply the fastest running shoe we, or anybody else, makes. It's designed and built to go faster, further, and last longer than anything else you can put on your feet. It's the kind of shoe every competitive runner dreams about.
Every runner!
So we also make the Ms. Racer – the same great shoe – only with the perfect last for women. Now we make the best for both.
That way everybody wins.

The Racer V.S.D. The Ms. Racer V.S.D.

PONY®
A STEP AHEAD
251 Park Ave. South
New York, N.Y. 10010

1978: Racer, 'PONY – The Best for Both!'

WE DON'T MAKE GREAT CLAIMS.

The ad read "THE LIGHTEST RUNNING SHOES YOU'VE EVER WORN". So you tried them and after a couple of miles, you felt as if you were wearing two slabs of concrete.

The copy claimed "EXTRAORDINARY SHOCK ABSORPTION CHARACTERISTICS". After a couple of miles, you realised that the only thing that was absorbing shock was your feet. And the only thing that was "extraordinary" was the pain.

Or how about those "superbly crafted running shoes" that left your feet green and red the first time you ran through a puddle?

The point is that it is easier to make great claims than it is to make great running shoes. At PONY, when we say our shoes are comfortable, lightweight, shock absorbent and quality crafted, we prove it. Again and again. **IN THE LABORATORY. ON THE TRACK. AND ON THE ROAD.**

When you buy a pair of PONY Express or Targa Running Shoes you get exactly what you pay for.

No ifs. Ands. Or buts.

And, happily, you don't end up with multi-colored feet.

The PONY Express and Targa Running Shoes are available in Men's, Women's and Junior sizes.

INTRODUCING THE NEW
EXPRESS:PONY®

Nylon upper incorporating unique ultra cool breathable mesh panel. Dual density midsole and heel wedge. Revolutionary variable sole design for optimal shock absorption and traction.

WE MAKE GREAT RUNNING SHOES!

Lightweight nylon upper with unique hyperbolic extension eyestay which positions the ball of the foot properly in the sole and facilitates flexion. Special compound VSD sole. Breathable mesh upper.

PONY wins at '79 PAN AM Games in Puerto Rico because it's quality that counts!

INTRODUCING THE NEW
TARGA:PONY®

1979: Express and Targa, 'We Don't Make Great Claims. We Make Great Running Shoes!'

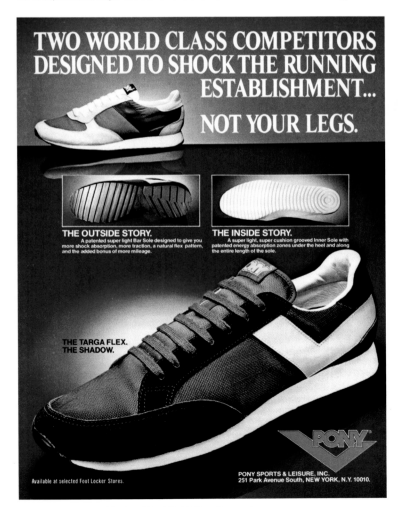

TWO WORLD CLASS COMPETITORS DESIGNED TO SHOCK THE RUNNING ESTABLISHMENT... NOT YOUR LEGS.

THE OUTSIDE STORY.
A patented super light Bar Sole designed to give you more shock absorption, more traction, a natural flex pattern, and the added bonus of more mileage.

THE INSIDE STORY.
A super light, super cushion grooved Inner Sole with patented energy absorption zones under the heel and along the entire length of the sole.

**THE TARGA FLEX.
THE SHADOW.**

Available at selected Foot Locker Stores.

PONY SPORTS & LEISURE, INC.
251 Park Avenue South, NEW YORK, N.Y. 10010

1980: Targa Flex and Shadow, 'Two World Class Competitors Designed to Shock the Running Establishment...Not Your Legs'

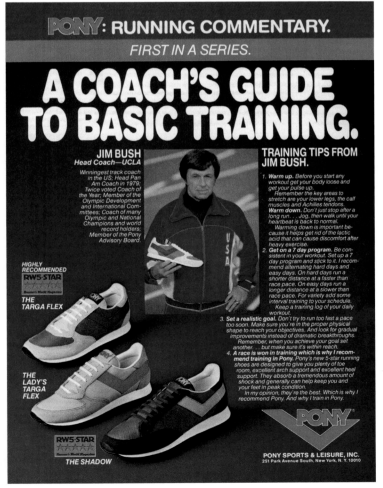

PONY: RUNNING COMMENTARY.
FIRST IN A SERIES.

A COACH'S GUIDE TO BASIC TRAINING.

JIM BUSH
Head Coach—UCLA

Winningest track coach in the US; Head Pan Am Coach in 1979; Twice voted Coach of the Year; Member of the Olympic Development and International Committees; Coach of many Olympic and National Champions and world record holders; Member of the Pony Advisory Board.

HIGHLY RECOMMENDED
RW 5-STAR
Runner's World Magazine

THE TARGA FLEX

THE LADY'S TARGA FLEX

RW 5-STAR
Runner's World Magazine
THE SHADOW

TRAINING TIPS FROM JIM BUSH.

1. **Warm up.** Before you start any workout get your body loose and get your pulse up.
Remember the key areas to stretch are your lower legs, the calf muscles and Achilles tendons.
Warm down. Don't just stop after a long run... Jog, then walk until your heartbeat is back to normal.
Warming down is important because it helps get rid of the lactic acid that can cause discomfort after heavy exercise.

2. **Get on a 7 day program.** Be consistent in your workout. Set up a 7 day program and stick to it. I recommend alternating hard days and easy days. On hard days run a shorter distance at a faster than race pace. On easy days run a longer distance at a slower than race pace. For variety add some interval training to your schedule.
Keep a training log of your daily workout.

3. **Set a realistic goal.** Don't try to run too fast a pace too soon. Make sure you're in the proper physical shape to reach your objectives. And look for gradual improvements instead of dramatic breakthroughs.
Remember, when you achieve your goal set another... but make sure it's within reach.

4. **A race is won in training which is why I recommend training in Pony.** Pony's new 5-star running shoes are designed to give you plenty of toe room, excellent arch support and excellent heel support. They absorb a tremendous amount of shock and generally can help keep you and your feet in peak condition.
In my opinion, they're the best. Which is why I recommend Pony. And why I train in Pony.

PONY SPORTS & LEISURE, INC.
251 Park Avenue South, New York, N.Y. 10010

1981: Targa Flex and Shadow, 'A Coach's Guide to Basic Training', ft. Jim Bush

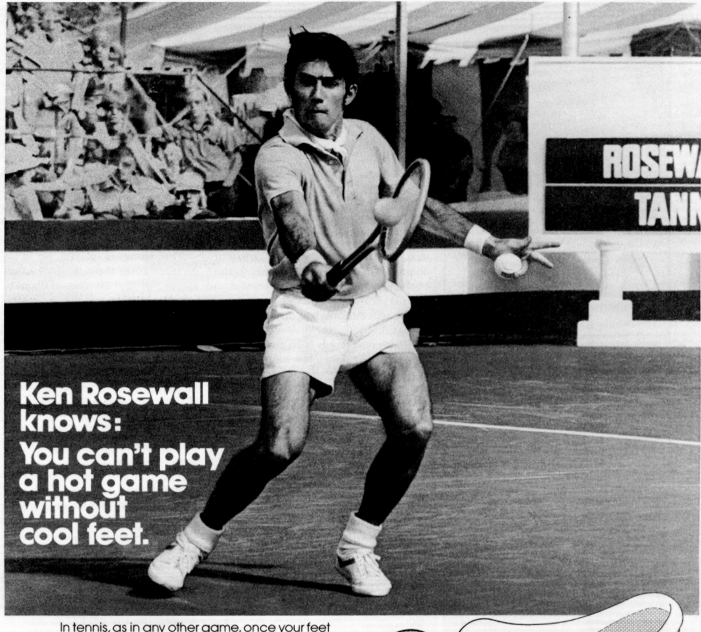

Ken Rosewall knows: You can't play a hot game without cool feet.

In tennis, as in any other game, once your feet quit, you're finished. And unless the sneaker you're wearing can provide <u>total heat release</u>, you, your game and your feet are in for a long, hot afternoon. That's why Pony™ has introduced The Breathables—the first and only tennis shoe to use a revolutionary polyester mesh that cools feet down like a breath of fresh air. This new, lightweight, extraordinarily durable material reduces perspiration so effectively that it simply ceases to be a problem. You can play as hard as you have to with the complete assurance that the one thing that will never beat you is hot feet. The Breathables from Pony™ also feature high abrasion soles, toe guards, fully padded collars, terry cloth insoles, superb arch supports and soft, comfortable tricot linings. They also feature a terrifically sensible price tag. About $25.00 the pair. The Breathables. Another winning idea from Pony,™ the official team shoe selected by the Canadian Olympic Association for the 1976 games in Montreal. And worn by many professional and amateur athletes worldwide.

ENLARGEMENT

POLYESTER MESH UPPERS FOR TOTAL HEAT RELEASE

TOE GUARD

HIGH ABRASION TOE BUMPER

FULLY PADDED COLLAR

ORTHOPEDIC ARCH SUPPORT & TERRY CLOTH INSOLE

HIGH ABRASION SOLE

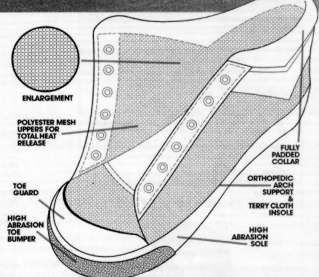

The Breathables

PONY™
A STEP AHEAD

1976: Breathables, 'Ken Rosewall Knows: You Can't Play a Hot Game Without Cool Feet', ft. Ken Rosewall

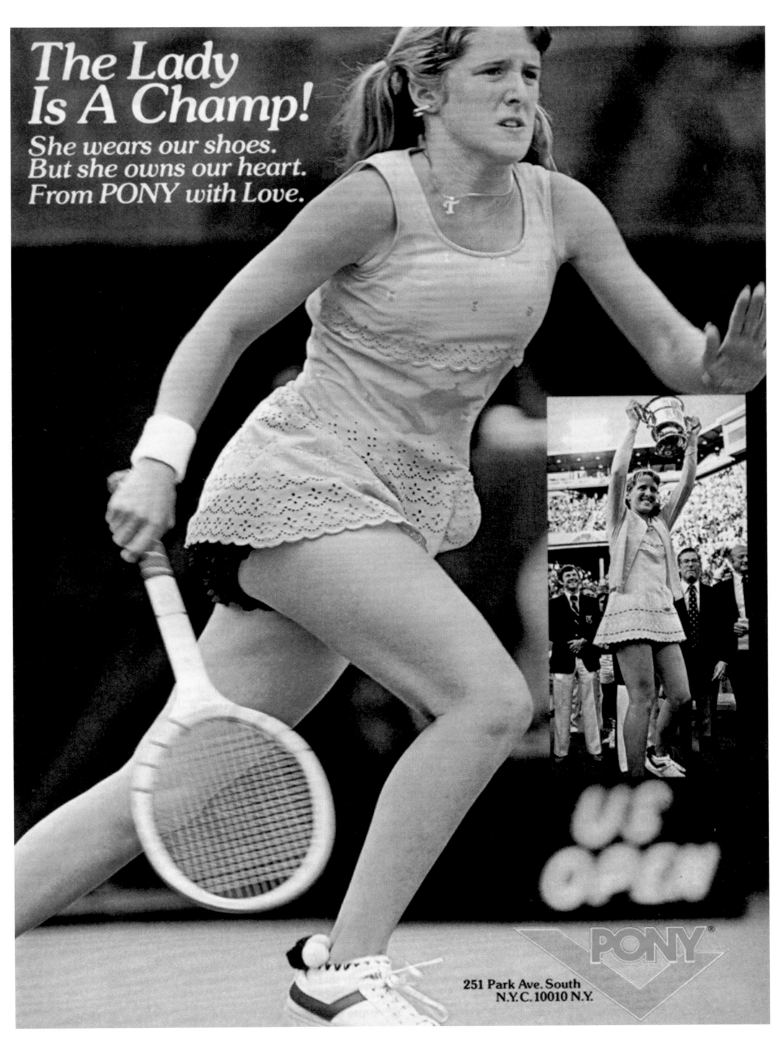

The Lady
Is A Champ!

She wears our shoes.
But she owns our heart.
From PONY with Love.

251 Park Ave. South
N.Y.C. 10010 N.Y.

1979: 'The Lady is a Champ!', ft. Tracy Austin

PRO-KEDS

While some brands have a founding father to eulogise, the PRO-Keds story has decidedly blue-collar roots. Back in 1916, the US Rubber Company was formed when nine small firms merged to create Keds, a range of basic canvas shoes. In 1949, PRO-Keds were launched as their premium division.

 Born in an era that celebrated the purity of amateur sport, PRO-Keds signed George Mikan, basketball's original big man. Another pivotal point arrived with the classic 69er model, which finally gave the brand some ammunition to challenge the supremacy of the Converse All Star. Pete Maravich, Nate 'Tiny' Archibald and Jo Jo White lined up to represent. By the 1970s, PRO-Keds were the quintessential New York sneaker brand, staking a claim as both a style innovator and budding hip hop staple. Things changed quickly, however, and by the mid-1980s, the brand ran out of puff. These vintage advertisements capture a time when PRO-Keds were a legit brand with aspirational dreams of mixing it with the big league. As one of their cocky ads boasted, 'We Challenge Any Other Shoe. Anytime. Anywhere.'

●

The nation's top players count on pro-Keds Meteors for slip-free footwork in big-time competition.

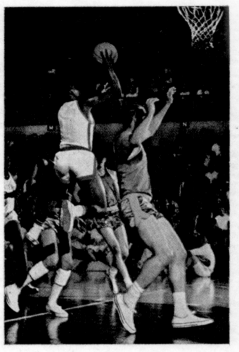

But go ahead.
Wear your
Meteors to
the
movies.

It doesn't really take very fancy footwork
to sit through a movie. But so what? It's nice to
know you're wearing the shoes that top athletes
wear...with pro details like: high-service reinforced
toe guards, pull-proof eyelets, shock-proof arch cushions.
Anyway, who's to know you're not a basketball star?
They go to the movies, too.
You can choose your Meteors
in black, white, or chino.

pro-Keds

UNIROYAL

U.S. RUBBER

Rockefeller Center, New York, N.Y. 10020 • In Canada: Dominion Rubber Company, Ltd.

1965: Meteor, 'The Nation's Top Players Count on PRO-Keds Meteors for Slip-Free Footwork in Big-Time Competition'

For those of you who think we only make basketball shoes.

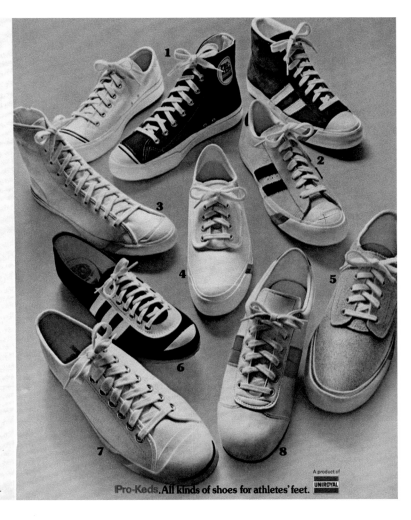

1 ROYAL® HI-CUT AND LO-CUT BASKETBALL SHOE. Loose lined, smooth toe wing tongue construction, cushioned insole, tough durable convex design molded outsole for superior traction and extra-long wear and protective toe bumper. Washable. For men.

2 ROYAL PLUS® HI-CUT AND LO-CUT BASKETBALL SHOE. Sueded leather uppers, cushioned insole, tough durable convex design molded sole for superior traction and extra-long wear, foam padded tongue, vent holes and protective toe bumper. For men.

3 WRESTLING SHOE. Strong uppers, double stitched eyelet stay and invisible pull-proof eyelets, mat gripping crepe outsole, reinforced heel piece and protective toe bumper. For men.

4 TROPHY® TENNIS SHOE. Extremely lightweight, sturdy polyester and cotton uppers, foam cushioned counter, special instep saddle, cushioned insole and zigzag design molded rubber outsole. For men and women.

5 TROPHY PLUS® TENNIS SHOE. Sueded leather uppers, smooth inside finish, foam cushioned counter, special instep saddle, cushioned insole and zigzag design molded rubber outsole. For men and women.

6 TRACK SHOE. For indoor and outdoor track and cross country races. Fabric eyelet stay, cushioned insole, genuine crepe outsole with traction tread, anti-scuff toe cap. For men.

7 COURT KING® TENNIS SHOE. Designed for tennis and casual wear in lace to toe pattern, cushioned insole, flexible shank and reinforced toe guard. For men.

8 FIELD SHOE. A multi-purpose athletic shoe, ideal for soccer, football or baseball, cushioned heel collar and padded tongue, cushioned insole, molded rubber multi-cleated outsole for speed, traction and stability. Little League approved. For men.

16 THE ATHLETIC JOURNAL

Pro-Keds. All kinds of shoes for athletes' feet. A product of UNIROYAL

1972: 'For Those of You Who Think We Only Make Basketball Shoes'

Shoes for Athletes' Feet.

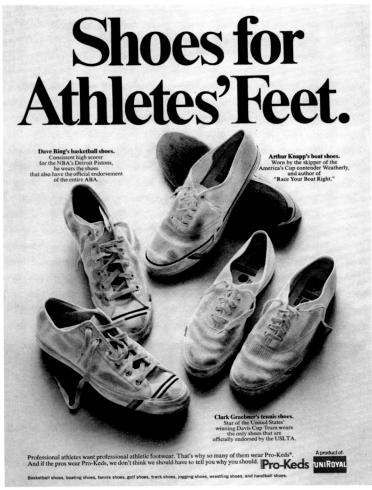

Dave Bing's basketball shoes. Consistent high scorer for the NBA's Detroit Pistons, he wears the shoes that also have the official endorsement of the entire ABA.

Arthur Knapp's boat shoes. Worn by the skipper of the America's Cup contender Weatherly, and author of "Race Your Boat Right."

Clark Graebner's tennis shoes. Star of the United States' winning Davis Cup Team wears the only shoes that are officially endorsed by the U.S.L.T.A.

Professional athletes want professional athletic footwear. That's why so many of them wear Pro-Keds®. And if the pros wear Pro-Keds, we don't think we should have to tell you why you should. **Pro-Keds** A product of UNIROYAL

Basketball shoes, boating shoes, tennis shoes, golf shoes, track shoes, jogging shoes, wrestling shoes, and handball shoes.

1965: 'Shoes for Athletes' Feet'

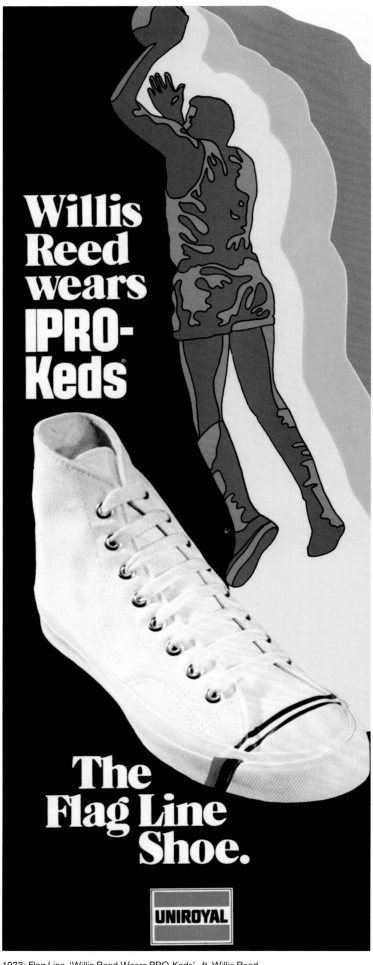

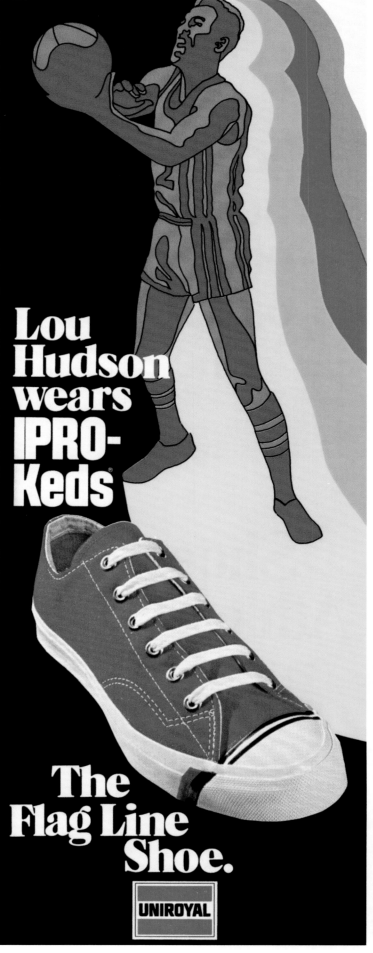

1973: Flag Line, 'Willis Reed Wears PRO-Keds' , ft. Willis Reed

1973: Flag Line, 'Lou Hudson Wears PRO-Keds' , ft. Lou Hudson

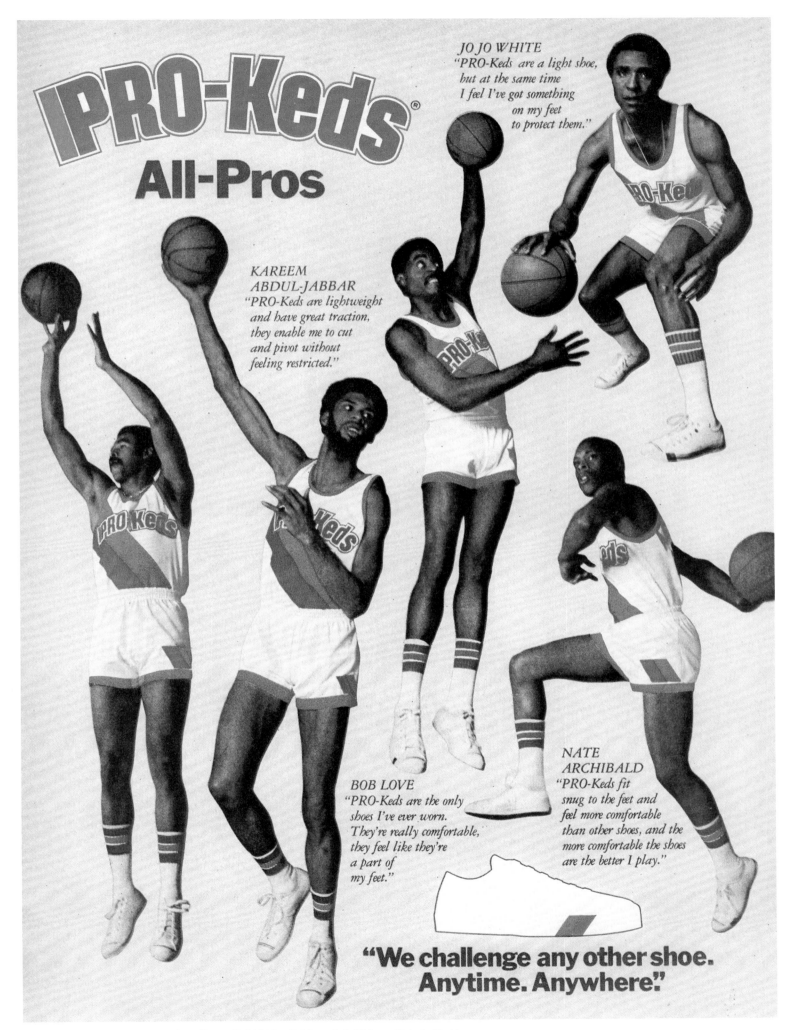

1974: 'PRO-Keds All-Pros', ft. Lou Hudson, Kareem Abdul-Jabbar, Bob Love, Jo Jo White and Nate Archibald

It's not PRO-Keds®that make players like Jo Jo White. It's players like Jo Jo White that make PRO-Keds.®

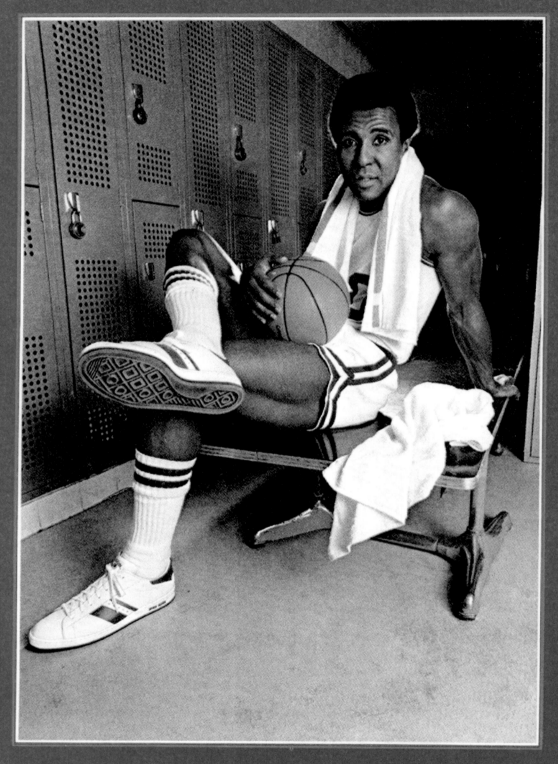

Is Jo Jo White a better basketball player because he wears PRO-Keds?

To be perfectly honest, we don't think so. With the kind of talent Jo Jo has, he could play well without shoes.

But because he does wear the new Royal® Master from PRO-Keds, none of his talent goes to waste.

What does the Royal Master have?

Everything a Jo Jo White could possibly need.

A light but tough sole with plenty of traction. Super-cushioned arch support. Extra protection in the heel and toe. And handsome full-grained leather on top.

While it's hard to find another player like Jo Jo White, it's easy to find his shoes. They're available wherever quality athletic shoes are sold.

PRO-Keds®

FOR ALL THOSE MOMENTS YOU FEEL LIKE A PRO.™

1979: Royal Master, 'It's Not PRO-Keds That Make Players Like Jo Jo White. It's Players Like Jo Jo White That Make PRO-Keds', ft. Jo Jo White

MAKE TRACKS WITH THE WILD ONES.

Among the Wild Ones, the Lynx is renowned for its cunning and agility.

Cushioned from heel to toe with a high-rise back and foam-lined nylon uppers, the elusive Lynx springs into action.

At home on any surface thanks to a rugged sole and shockproof arch cushion, the stealthy Lynx is seldom heard. And, until now, rarely seen.

UNIROYAL

PRO-Keds®

1976: Lynx, 'Make Tracks With the Wild Ones'

Put yourself in Nate Archibald's shoes.

Nate spends a lot of time on his feet. So it's no wonder his feet spend a lot of time in our shoes.

Sure, the Royal Plus is tough. But with our cushioned arch support, padded tongue and collar, it's not tough on your feet.

And to a pro like Nate, comfort counts. Because to win, you've got to stay on your toes.

UNIROYAL

PRO-Keds®

1976: Royal Plus, 'Put Yourself in Nate Archibald's Shoes'

SOME PROS TAKE A SHOT AT OUR NEW SHOE.

"Light on the feet. It floats."
LOU HUDSON, Los Angeles Lakers, Member of PRO-Keds® Advisory Staff.
(Thanks to revolutionary construction, our new Powerlite may just be the lightest basketball shoe ever made.)

"Light. Excellent traction. And very durable."
Head Coach TOM YOUNG, Rutgers University, Member of PRO-Keds® Advisory Staff.
(A unique molded, multi-configured sole grips the court for short stops or long shots.)

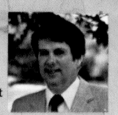

"Big on lightness. And a giant on performance."
NATE "TINY" ARCHIBALD, Boston Celtics, Member of PRO-Keds® Advisory Staff.
(Like Tiny says, they're light but very powerful whether you're cutting, pivoting or breaking.)

"No sacrifices. A pro's shoe."
JOJO WHITE, Golden State Warriors, Member of PRO-Keds® Advisory Staff.
(There are no trade-offs between lightness and traction, comfort or support.)

"Once you get into a pair of new Powerlites, they've got you."
GERRY LYNN BOOKER, Milwaukee Does.
(We couldn't have said it better ourselves.)

"In short, it's the breakthrough basketball shoe we've been begging for."
Coach FRED BARAKAT, Fairfield University, Member of PRO-Keds® Advisory Staff.
(Performance-tested by college teams, PRO-Keds® Powerlite scored high on everything from lightness to glove-like fit.)

PRO-Keds®

INTRODUCING ROYAL® POWERLITE FROM PRO-KEDS.®
For all those moments you feel like a pro.™

1979: Royal Powerlite, 'Some Pros Take a Shot at Our New Shoe', ft. Lou Hudson, Tom Young, Nate Archibald, Jo Jo White, Gerry Lynn Booker and Fred Barakat

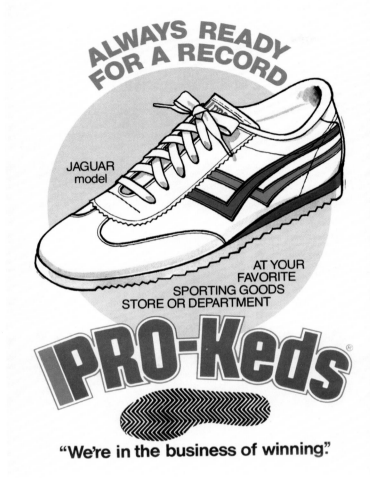

ALWAYS READY FOR A RECORD

JAGUAR model

AT YOUR FAVORITE SPORTING GOODS STORE OR DEPARTMENT

PRO-Keds®

"We're in the business of winning."

1976: Jaguar, 'Always Ready for a Record'

Introducing the PRO-Keds® T/Racer.™ The shock absorption and durability of a training shoe combined with the lightness and flexibility of a racing flat. A shoe so new, you won't be able to buy it until early 1979.

It will be available in men's and women's sizes that were specially developed on separate lasts to scientifically conform to the foot structure of each sex.

And to ensure a more accurate fit, we're making it available in men's half sizes 5-12, 13 in slim, medium and wide; and women's half sizes 4-10 in slim and medium.

Foam-padded Royalon® covered collar and tongue, with a high-rise back to cushion and protect your Achilles tendon, the lifeline of the running foot.

Uppers of breathable nylon with suede at high-stress abrasion areas. For increased comfort and protection.

Sturdy, thermo-formed heel counter around a cuboid-shaped heel area to reduce lateral "wobble."

Soft cellocrepe heel wedge for superior shock absorption on heel strike, mile after mile.

Fully contoured insole support system featuring extra-firm arch support.

Longer-wearing steep-grade outsole featuring high-traction cleated bar design and built-in heavy wear points.

Exclusive patented lightweight Ensolite® shock absorbent insole to cushion the entire length of the foot for the life of the shoe.

Wider and higher toe box to reduce abrasion, blistering and toenail blackening.

DOES YOUR RUNNING SHOE STAND UP TO OUR NEW T/RACER™?

PRO-Keds®

FOR ALL THOSE MOMENTS YOU FEEL LIKE A PRO.™

1978: T/Racer, 'Does Your Running Shoe Stand Up to Our New T/Racer?'

3,168 MILES IN JUST TWO PAIRS OF KEDS.

Ultra-Marathoner Stan Cottrell Runs Coast-To-Coast In Keds Millennium Trainers.

He ran 66 miles a day, 48 days in a row. He set a new world record. Ultra-Marathoner Stan Cottrell kept up this blistering pace, without a blister, in just two pairs of Keds Millennium trainers. 3,168 miles in just 48 days without his Keds (or himself) wearing out once. That's durability.

What makes this feat even more incredible is that Stan put over 2,000 miles on one pair of Keds.

In fact, he probably could have gone the entire distance in just one pair of Millenniums had he not needed a spare dry pair to switch into when the going got wet.

Keds created the first 2,000 mile running shoe by looking at runners' needs from a common-sense point of view.

Durability. The Simple Solution to Wearout: Wearplugs.

We put wearplugs at the critical wear areas of the sole. These SBR rubber wearplugs are constructed of a compound so durable that it received the highest abrasion score in Runners World 1979 Shoe Survey. You can replace each wearplug yourself. Additional wearplugs are available wherever the Millennium or Renaissance trainers are sold.

Stability. A Solid External Heel Counter Keeps the Foot Firmly in Place.

The heel counters on the Millennium and Renaissance are made of solid Dupont Hytrel.* This advanced thermoplastic compound is tough enough to keep the foot firmly in place yet light enough to hardly be

noticed. The heel counter is located on the outside of the shoe. This allows for more padding to be placed between it and the foot.

These layers of soft nylon padding cradle the foot, keeping the heel comfortably in place.

Coolness. New Open Flow Mesh Design Works Like an Air Conditioner for the Feet.

The new upper design allows more cool air to circulate over and around the foot.

A durable nylon mesh combined with the suede toe reinforcement makes this one of the toughest uppers in the business.

Comfort. No Inside Seams Mean Less Chance of Painful Blistering.

Lining this unique upper is a thin layer

of brush nylon which comforts the foot every step of the way.

We're Off And Running To Be Number One.

The Millennium and Renaissance trainers are just two of a whole new line of running shoes developed for men and women by Keds. Add to this line an incredible five-ounce racing flat and you can see just how serious about running Keds really is.

At Keds, we're determined to make technical innovations that will put us strides ahead in our field. It's going to be tough. But, like Stan Cottrell, we're not going to stop pushing ourselves until we succeed.

*Dupont registered trademark.

Weight. Just 9 Ozs. (Men's Size 9)

Keds

2094 1/8 1074 1/2 00000

1980: Millennium, '3,168 Miles in Just Two Pairs of Keds', ft. Stan Cottrell

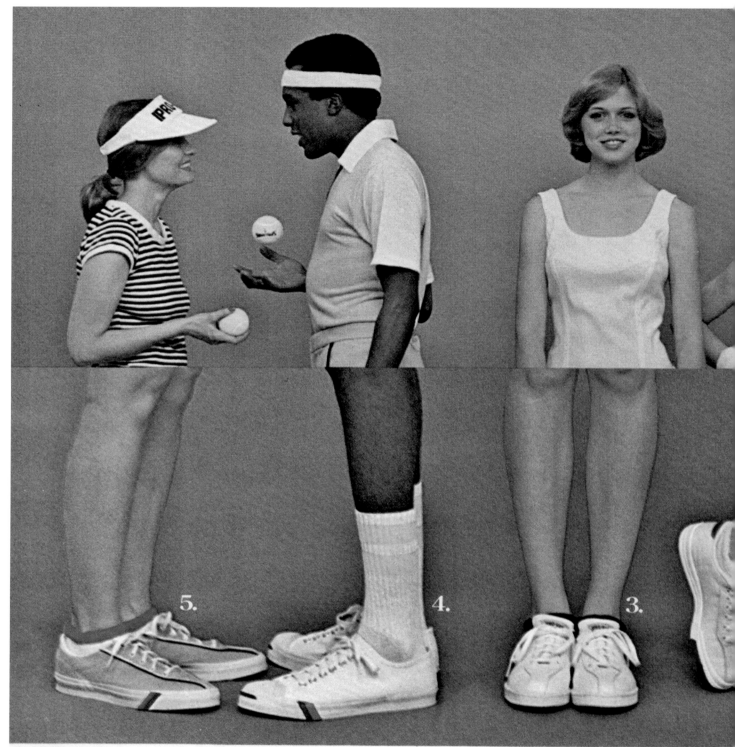

If there were only one kind of tennis playe

It seems as if everyone is playing tennis these days. And the net result is the sale of a lot of tennis shoes. It takes a wide assortment of shoes to serve all those tennis players. But PRO-Keds does the job from baseline to baseline.

1.The Royal Edge® is our high-performance tennis shoe for the serious player. It features a blue Protecto-plate urethane toe insert on the outsole which increases durability in this critical toe-drag area. The Royal Edge comes in leather and Dura-Kool® polyester mesh in men's and women's sizes and in fabric for men. The Royal Edge is built to a tennis player's advantage.

2.The Royal® Court is another top perform-ance model. It comes in men's, women's and boys' sizes in smooth white leather featuring a super-comfortable terry cloth-covered sponge arch cushion and insole. A classic-looking tennis shoe, it has a comfortable foam-padded collar and tongue and a soft cushion-comfort insole.

3.The Royal® Serve is another great tennis shoe for men and women that's made in smooth leather and Dura-Kool mesh also. It has the same super-comfortable terry cloth-covered sponge arch cushion and insole. The Royal Serve Dura-Kool has the new show-through, color-coordinated styling.

1976: Royal Edge, Royal Court, Royal Serve, Court King and Trophy Deluxe, 'If There Were Only One Kind of Tennis Player There'd Be Only One Kind of PRO-Keds'

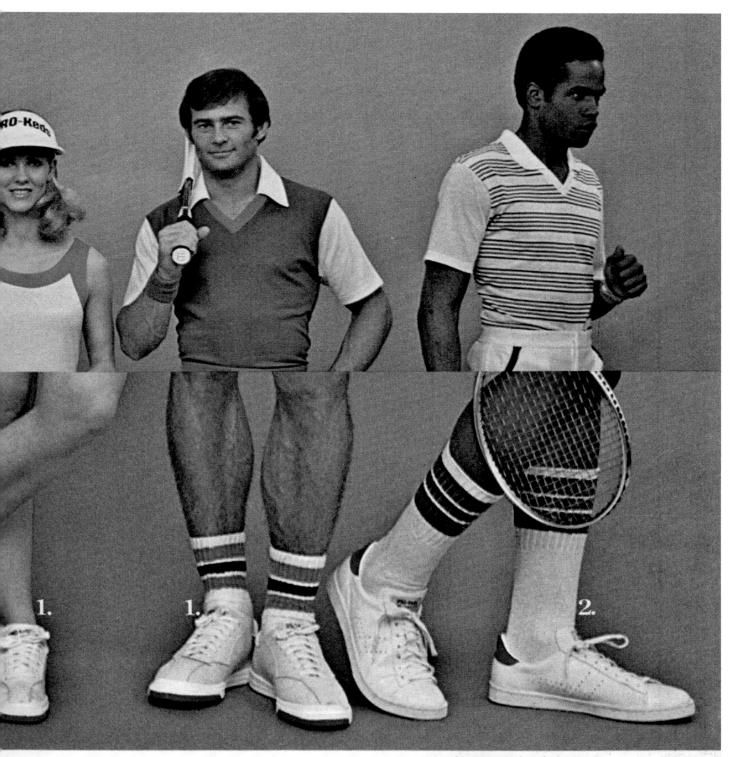

there'd be only one kind of PRO-Keds.®

4. The Court King® is America's classic tennis shoe for all kinds of players. It's made with uppers of the highest quality duck, a reinforced toe, full shockproof arch cushion and heel and comes in sizes for men and women. Performs as well off the court as on.

5. The Trophy Deluxe is a great all-around tennis shoe for men, women and boys. Available in a variety of colors in both fabric or Dura-Kool mesh and offers PRO-Keds quality at a reasonable price.

With all this, we think you can see PRO-Keds has the tennis court covered in performance and style. No matter what kind of shoe a tennis player is

looking for, he can find a PRO-Keds to suit his play. Because PRO-Keds does it all.

If your PRO-Keds salesman hasn't already given you one, write for a catalog.

Another fine product from

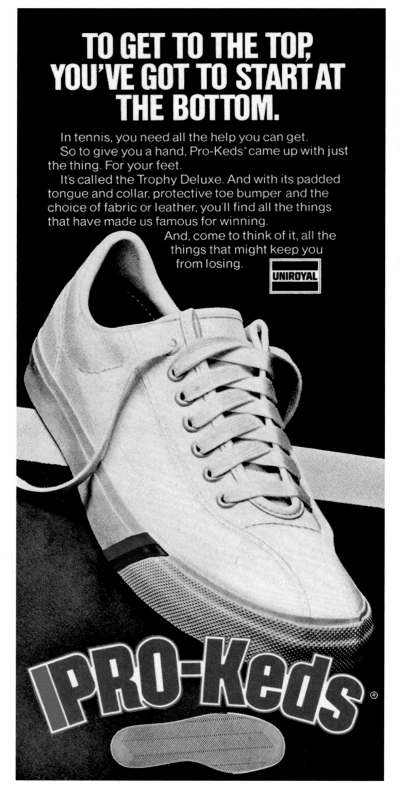

TO GET TO THE TOP, YOU'VE GOT TO START AT THE BOTTOM.

In tennis, you need all the help you can get.

So to give you a hand, Pro-Keds® came up with just the thing. For your feet.

It's called the Trophy Deluxe. And with its padded tongue and collar, protective toe bumper and the choice of fabric or leather, you'll find all the things that have made us famous for winning.

And, come to think of it, all the things that might keep you from losing.

UNIROYAL

1976: Trophy Deluxe, 'To Get to the Top, You've Got to Start at the Bottom'

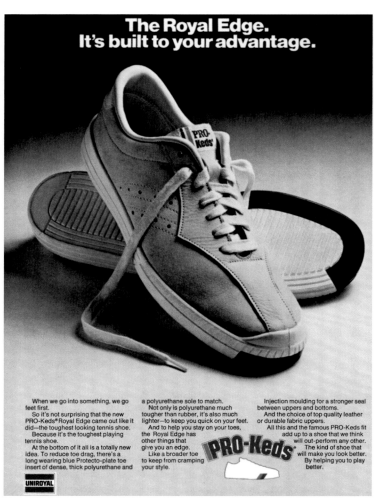

The Royal Edge. It's built to your advantage.

When we go into something, we go feet first.

So it's not surprising that the new PRO-Keds® Royal Edge came out like it did—the toughest looking tennis shoe. Because it's the toughest playing tennis shoe.

At the bottom of it all is a totally new idea. To reduce toe drag, there's a long wearing blue Protecto-plate toe insert of dense, thick polyurethane and

a polyurethane sole to match.

Not only is polyurethane much tougher than rubber, it's also much lighter—to keep you quick on your feet.

And to help you stay on your toes, the Royal Edge has other things that give you an edge.

Like a broader toe to keep from cramping your style.

Injection moulding for a stronger seal between uppers and bottoms.

And the choice of top quality leather or durable fabric uppers.

All this and the famous PRO-Keds fit add up to a shoe that we think will out-perform any other. The kind of shoe that will make you look better. By helping you to play better.

UNIROYAL

1976: Royal Edge, 'The Royal Edge. It's Built to Your Advantage'

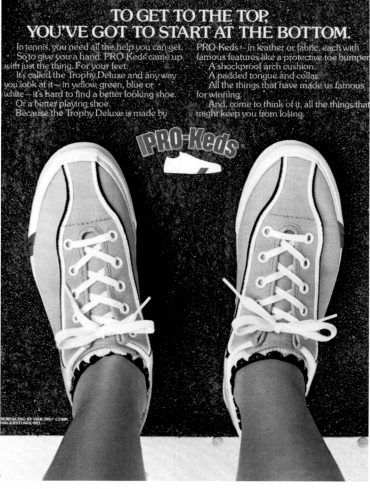

TO GET TO THE TOP, YOU'VE GOT TO START AT THE BOTTOM.

In tennis, you need all the help you can get.

So to give you a hand, PRO-Keds came up with just the thing. For your feet.

It's called the Trophy Deluxe and any way you look at it — in yellow, green, blue or white — it's hard to find a better looking shoe. Or a better playing shoe.

Because the Trophy Deluxe is made by

PRO-Keds — in leather or fabric, each with famous features like a protective toe bumper.

A shockproof arch cushion.

A padded tongue and collar.

All the things that have made us famous for winning.

And, come to think of it, all the things that might keep you from losing.

1976: Trophy Deluxe, 'To Get to the Top, You've Got to Start at the Bottom'

The Royal Edge.
It's built
to your advantage.

From top to bottom, the PRO-Keds Royal Edge is designed to give you the edge.

To reduce toe drag, there's a long-wearing Protecto-plate toe insert and a broader toe to keep from cramping your style.

And to keep you quick on your feet, the soles are lightweight polyurethane for maximum speed and toughness.

Add to this the choice of leather or fabric, and you've got the Royal Edge, a great shoe for tennis or paddle.

A shoe that can make you look better.

On or off the court.

UNIROYAL

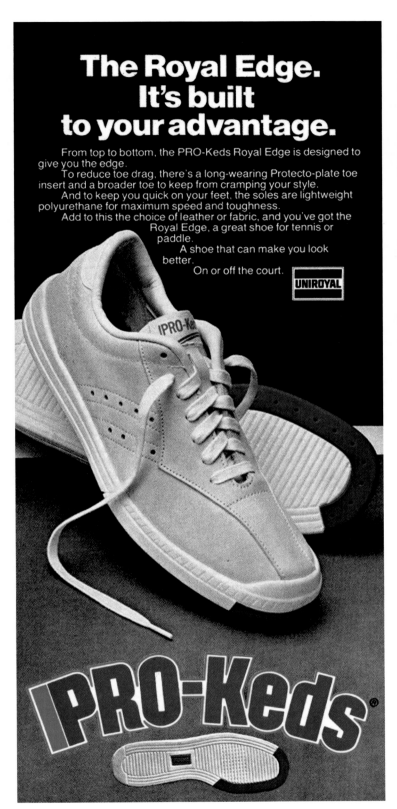

PRO-Keds®

1977: Royal Edge, 'The Royal Edge. It's Built to Your Advantage'

Does Virginia Wade wear PRO-Keds for love or for money?

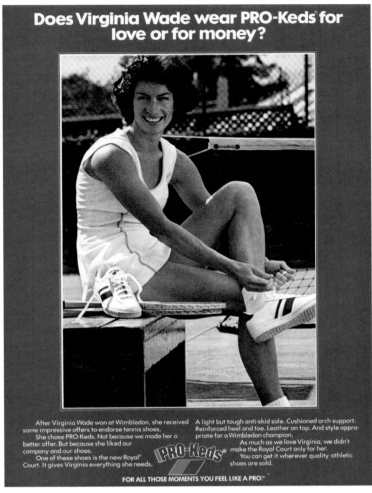

After Virginia Wade won at Wimbledon, she received some impressive offers to endorse tennis shoes.

She chose PRO-Keds. Not because we made her a better offer. But because she liked our company and our shoes.

One of these shoes is the new Royal Court. It gives Virginia everything she needs.

A light but tough anti-skid sole. Cushioned arch support. Reinforced heel and toe. Leather on top. And style appropriate for a Wimbledon champion.

As much as we love Virginia, we didn't make the Royal Court only for her. You can get it wherever quality athletic shoes are sold.

PRO-Keds®

FOR ALL THOSE MOMENTS YOU FEEL LIKE A PRO.™

1979: Royal Court, 'Does Virginia Wade Wear PRO-Keds for Love or for Money?', ft. Virginia Wade

If you really want to be comfortable, run around in a towel.

You know how great it feels to be cuddled up in a soft towel. Well, that's how your feet will feel in our new Court Aces.

Because inside we put soft, absorbent terrycloth. From heel to toe.

We also use an airy cotton mesh fabric to help keep you cool. And anti-skid treads to help you keep your feet.

We cushion the insole, the tongue and the collar with a layer of foam.

And we even make narrow Court Aces just in case you have narrow feet.

Court Aces are great for playing tennis. But they're so comfortable you'll want to wear them all the time.

If you get them dirty, no problem. Just throw them in the washer and they'll come out soft and comfortable as ever.

Court Aces. We think they're the most comfortable shoes in the world. And so will your feet.

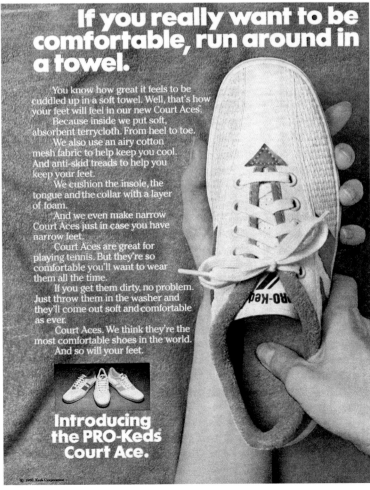

Introducing the PRO-Keds Court Ace.

1980: Court Ace, 'If You Really Want to Be Comfortable, Run Around in a Towel'

PUMA

Founded in 1948 by Rudolf Dassler, PUMA was initially registered under the 'Ruda' name, which was derived from the first two letters of his names. A monumental bust-up with his brother Adolf, who went on to found adidas, divided Herzogenaurach down the middle and inspired the 'town of bent necks' nickname, due to townsfolk always checking which brand was worn. Family loyalties were torn asunder as workers pledged allegiance to either the Three Stripes or the Formstripe.

PUMA didn't hit full stride until the 1970s, when charismatic athletes put the brand firmly on the world sporting stage. The great Pelé played some of his most beautiful football in the legendary PUMA King, famously stopping play at the start of the 1970 World Cup quarter-final to lace up his new wheels for a global television audience. Walt 'Clyde' Frazier was another cat entirely. His flamboyant style and fly demeanour made his signature suede sneakers a must-have for the new breed of Big Apple b-boys. PUMA's golden era extended into the 1980s and 90s as the brand added Trinomic cushioning and the revolutionary Disc closure system to their running, basketball and tennis line-up. Today, PUMA are the third largest sneaker brand and employ more than 14,000 people around the world.

●

I steal for a living

by 'Clyde' Frazier

The art of the steal.

There is a time and a place for stealing.

If you miss, your man should not be able to go in for a basket or create a two-on-one situation. So a good place to steal is just when your man is crossing half-court—in the outside corners. The sideline plays like an extra man for your team. If you go for the ball and miss, the guy can only go out of bounds.

There are times early in a game when I could make a steal, but I might prefer to keep the other guy feeling complacent. Then he's easier to steal from later, when the game gets tight and everything is crucial. A steal then could really crush the other team.

Heads-up dribbling.

You'll never be a good dribbler if you watch the ball.

While your head is down, you're out of touch. Guys are coming open, and you can't see them to make a pass. When you look up, everybody is moving and it's hard to figure out what's happening. It's chaos.

It's not chaos to me because I can see the whole court while I'm dribbling. It's like my symphony, and I'm the guy who's controlling the movements.

I've got the ball, and the guys are moving to my beat.

Why I play it cool.

Most guys show strain on their faces. If I'm applying pressure, I can see they don't like it. So I do it even more. Whereas if you pressure me, I still look the same way. You don't know whether to keep it up or back off.

On the inside, I'm just like everybody else. But I've developed a technique of not showing any emotion. So you can't read me. That's why people say I'm cool.

One big mistake.

If you face-guard your man, you won't know *when* the ball is coming to him. Or *which side* it's coming from.

He could fake you to one side, take the pass on the other side, and just walk in back-door.

So always see the ball *and* your man.

Traction & action.

I always tell kids to go for the best in a basketball shoe. Some of it is psychological. If the shoes feel right on your feet, then you're going to feel better playing in them.

I wear Puma.® They give me the traction and action I need. I like the grip of them, the way you can cut…you can *move* in them. They're a part of you, so you feel *ready*.

I have a wide foot. When it smacks down on the court it gets even wider. The guys at Puma think about things like that. They build their shoes on a wider last—for athletes.

Should *you* wear Puma? Listen, it's going to cost you. But if you're good enough —if you've earned your stripes— a shoe this good can make a difference in how you play.

The Puma 'Basket'
Imported by Beconta

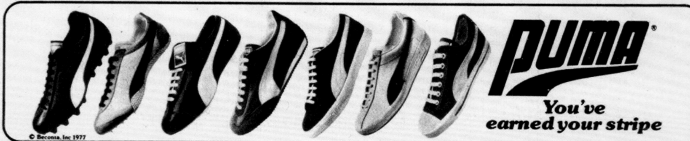

PUMA ®

You've earned your stripe

© Beconta, Inc 1977

1977: Basket, 'I Steal for a Living', ft. Walt 'Clyde' Frazier

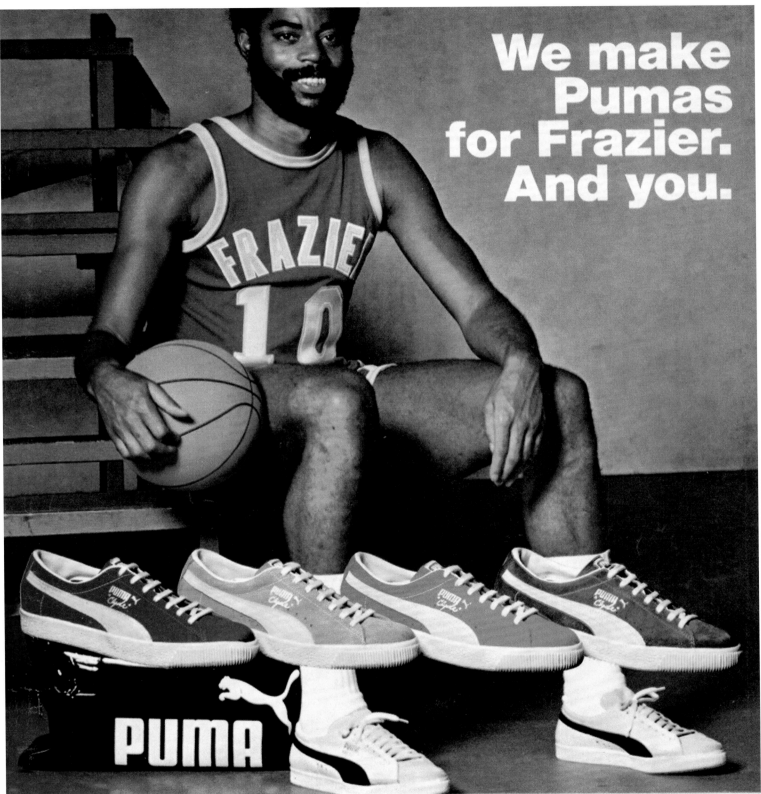

We make Pumas for Frazier. And you.

Basketball shoes. Really great basketball shoes. The kind that help the pros and your players score. Like the No. 9681 Clyde, designed with the assistance of Walt "Clyde" Frazier. And made by Puma with uppers of top grade suede leather in bright Kelly Green, Scarlet, Gold or Blue with contrasting white Puma stripe. With heavy sponge insole and arch support. Wide last.

White non-slip rubber sole. Padded heel and ankle and Achilles Tendon pad. It's only one of the top-performing shoes we make for today's teams. Another: our No. 680 Puma Basket, made on wide last with uppers of top grade white cowhide and contrasting black Puma stripe. And praised by coaches and players for its durability, quality and comfort. And for features

like its white rubber non-slip sole, heavy sponge insole and orthopedic arch support, padded ankle, heel and Achilles Tendon pad. To see the entire line of Pumas for your players, write for free full color catalog and full information to Sports Beconta, Inc., 50 Executive Blvd., Elmsford, N.Y. 10523 or 91 Park Lane, Brisbane, Calif. 94005.

PUMAS from Sports Beconta.

1972: No. 9681 Clyde and No. 680 Basket, 'We Make PUMAs for Frazier. And You', ft. Walt 'Clyde' Frazier

Reggie Jackson plays in Pumas.

On or off the field Reggie Jackson, the American League's MVP, appreciates the comfort and support of Puma's full line of leisure and baseball shoes. Like the comfortable shoe shown here. All available at your sporting goods store or shoe store or write Sports Beconta, Inc., 50 Executive Blvd., Elmsford, N.Y. 10523. Or 340 Oyster Pt. Blvd., So. San Francisco, Calif. 94080.

PUMA from Beconta.

1976: 'Reggie Jackson Plays in PUMAs', ft. Reggie Jackson

Clyde Frazier plays in Pumas.

On or off the court Clyde Frazier appreciates the comfort and support of Puma's full line of leisure and basketball shoes. Like the comfortable Clyde Frazier shoe shown here. All

available at your sporting goods store and shoe store or write Sports Beconta, Inc., 50 Executive Blvd., Elmsford, N.Y. 10523. Or 340 Oyster Pt. Blvd., So. San Francisco, Calif. 94080.

PUMA from Beconta.

1976: Clyde, 'Clyde Frazier Plays in PUMAs', ft. Walt 'Clyde' Frazier

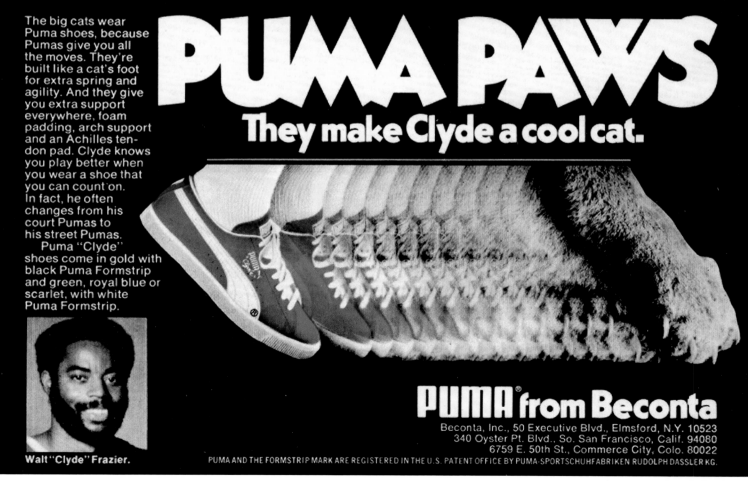

The big cats wear Puma shoes, because Pumas give you all the moves. They're built like a cat's foot for extra spring and agility. And they give you extra support everywhere, foam padding, arch support and an Achilles tendon pad. Clyde knows you play better when you wear a shoe that you can count on. In fact, he often changes from his court Pumas to his street Pumas.
 Puma "Clyde" shoes come in gold with black Puma Formstrip and green, royal blue or scarlet, with white Puma Formstrip.

PUMA PAWS
They make Clyde a cool cat.

Walt "Clyde" Frazier.

PUMA AND THE FORMSTRIP MARK ARE REGISTERED IN THE U.S. PATENT OFFICE BY PUMA-SPORTSCHUHFABRIKEN RUDOLPH DASSLER KG.

PUMA® from Beconta
Beconta, Inc., 50 Executive Blvd., Elmsford, N.Y. 10523.
340 Oyster Pt. Blvd., So. San Francisco, Calif. 94080
6759 E. 50th St., Commerce City, Colo. 80022

1976: Clyde, 'PUMA Paws. They Make Clyde a Cool Cat', ft. Walt 'Clyde' Frazier

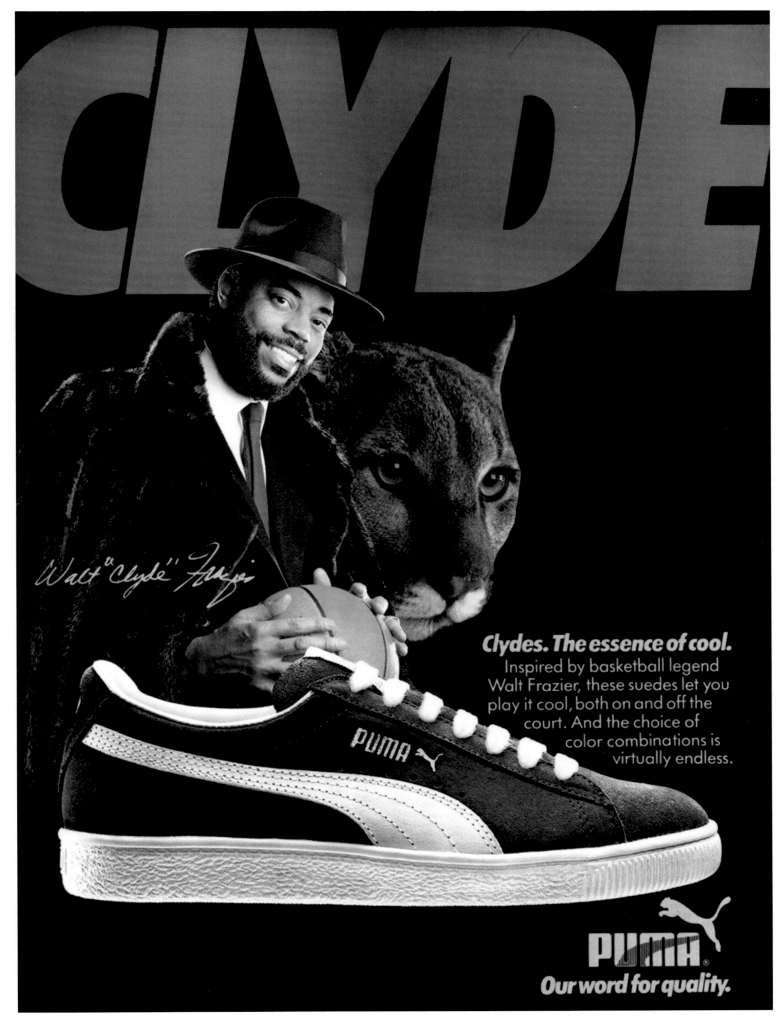

1985: Clyde, 'Clydes. The Essence of Cool', ft. Walt 'Clyde' Frazier

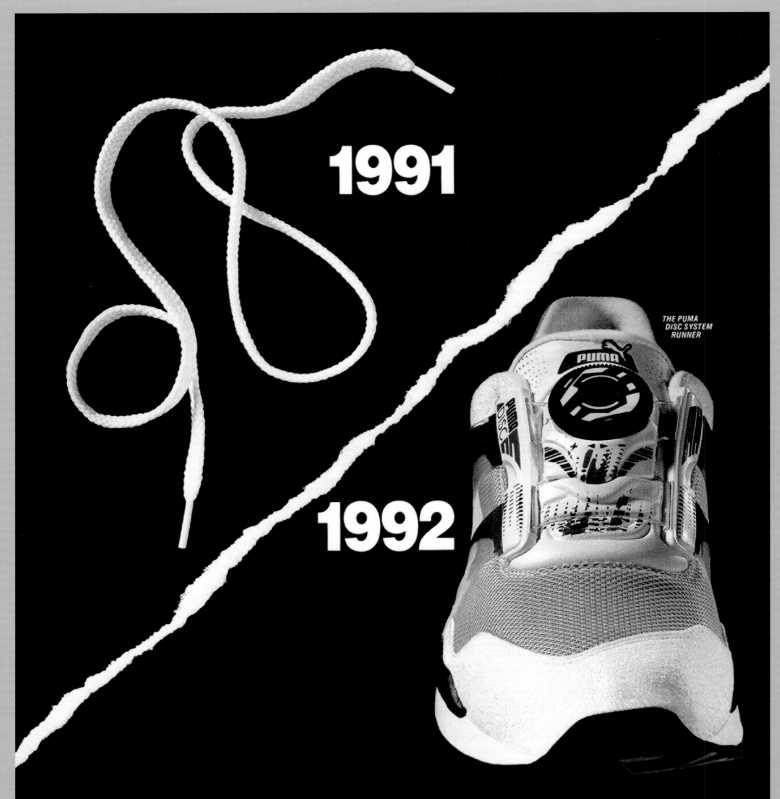

1991

1992

THE PUMA
DISC SYSTEM
RUNNER

Introducing the athletic shoe of the future. The PUMA DISC SYSTEM. Athletic shoes with new, breakthrough technology that "customizes" the fit of the shoe to each individual

Only the PUMA DISC SYSTEM custom fits the heel, midfoot, and instep.

foot by turning a disc, making traditional shoe-laces obsolete. The result is a total fit that supports, controls, and promotes natural foot movement. Our Trinomic midsole technology

also adds stability, cushioning and continuous shock absorption. The Puma Disc System. For running, cross-training, and tennis, it's the perfect synergy between foot and shoe. TURN IT ON.

PUMA
DISC
SYSTEM

1992: Disc System Runner, '1991/1992'

1996: Disc TX 4000

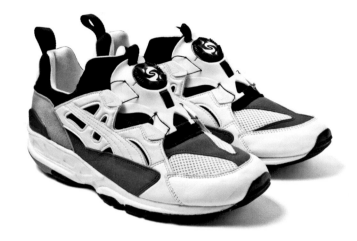

" Named in honour of the plastic 'frisbee' that featured front-and-centre on the tongue, PUMA's radical Disc system created a snug fit by retracting and releasing a series of wires that wrapped around the foot. Promoted under a vaguely hallucinogenic slogan that incited runners to 'Turn It On', the most successful model in the franchise was the Trinomic-endowed Disc Blaze. Crate digging through PUMA's archives reveals multi-sport variations including the Disc System Weapon for basketball and the Disc Indoor Pro II for tennis. A track version was also worn by Olympic athletes, most notably by German long jumper Heike Drechsler. "

PUMA Running Book
Sneaker Freaker (2011)

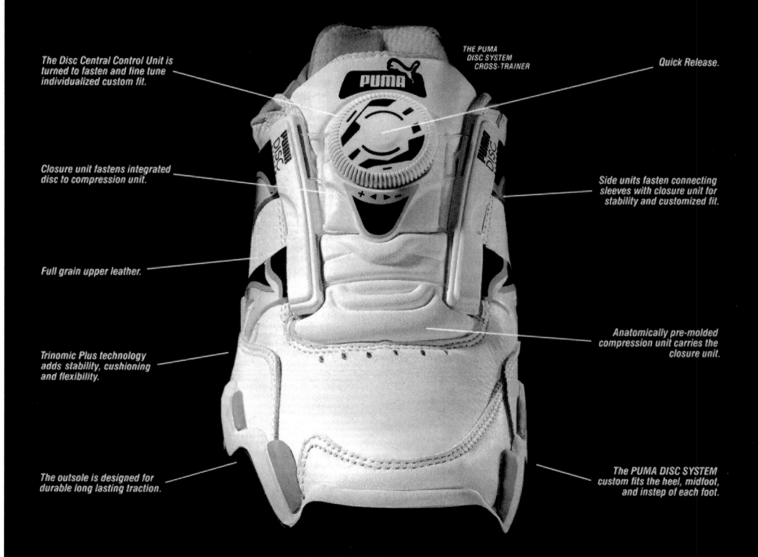

IT SEEMS GERMAN ENGINEERS WERE A LITTLE BORED JUST MAKING CARS.

THE PUMA DISC SYSTEM CROSS-TRAINER

The Disc Central Control Unit is turned to fasten and fine tune individualized custom fit.

Quick Release.

Closure unit fastens integrated disc to compression unit.

Side units fasten connecting sleeves with closure unit for stability and customized fit.

Full grain upper leather.

Anatomically pre-molded compression unit carries the closure unit.

Trinomic Plus technology adds stability, cushioning and flexibility.

The outsole is designed for durable long lasting traction.

The PUMA DISC SYSTEM custom fits the heel, midfoot, and instep of each foot.

Introducing the Puma Disc System. The latest high performance technology from Germany's finest engineers. What makes the Puma Disc System unique is that it "customizes" fit to each individual foot by turning a "disc," making the traditional athletic shoelace obsolete. The result is a total fit that supports, controls, and promotes natural foot movement. Our Trinomic midsole also adds stability, cushioning and shock absorption. The Puma Disc System. For tennis, cross-training, or running, it's the perfect synergy between foot and shoe. TURN IT ON.

PUMA
DISC SYSTEM

1992: Disc System Cross-Trainer, 'It Seems German Engineers Were a Little Bored Just Making Cars'

WIN. LOSE. BUT NEVER TIE.

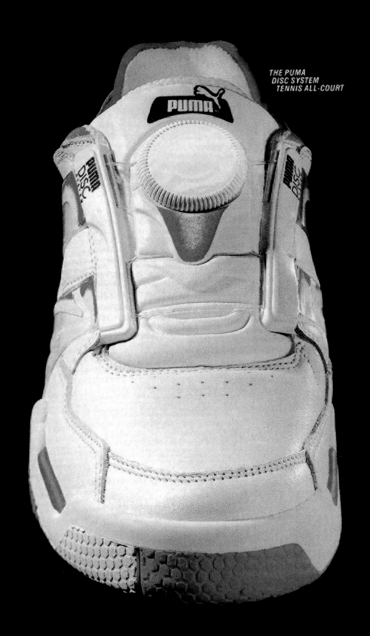

THE PUMA
DISC SYSTEM
TENNIS ALL-COURT

Introducing the PUMA DISC SYSTEM. A high performance athletic shoe with no shoelaces, but a "disc" that's turned to customize the fit of the shoe to

Only the PUMA DISC SYSTEM envelops the rear, midfoot, and instep for a custom fit.

each individual foot. A new technology for a total fit that supports, controls, and promotes natural foot movement. Plus, our Trinomic midsole adds stability,

cushioning and shock absorption. The Puma Disc System. For cross-training, running, and tennis, it's the perfect synergy between foot and shoe. TURN IT ON.

PUMA
DISC
SYSTEM

1992: Disc System Tennis All-Court, 'Win. Lose. But Never Tie'

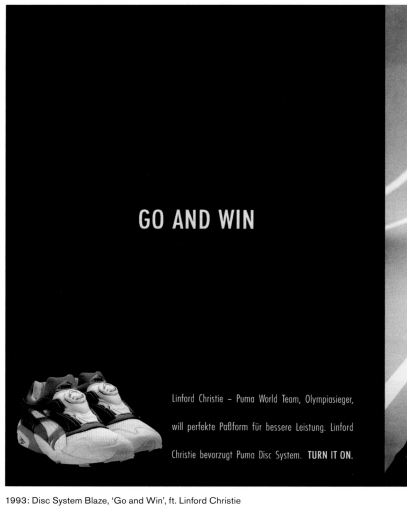

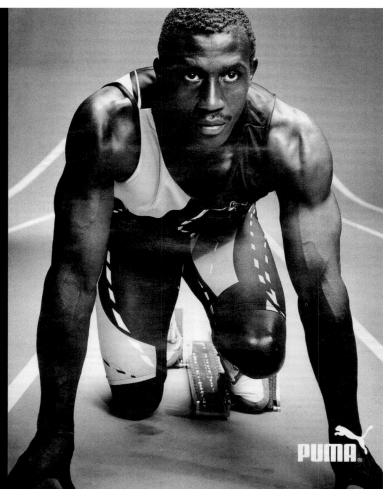

GO AND WIN

Linford Christie – Puma World Team, Olympiasieger,
will perfekte Paßform für bessere Leistung. Linford
Christie bevorzugt Puma Disc System. **TURN IT ON.**

1993: Disc System Blaze, 'Go and Win', ft. Linford Christie

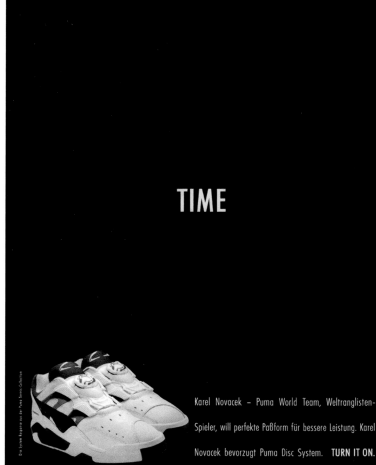

TIME

Karel Novacek – Puma World Team, Weltranglisten-
Spieler, will perfekte Paßform für bessere Leistung. Karel
Novacek bevorzugt Puma Disc System. **TURN IT ON.**

1993: Disc System Response, 'Time', ft. Karel Novacek

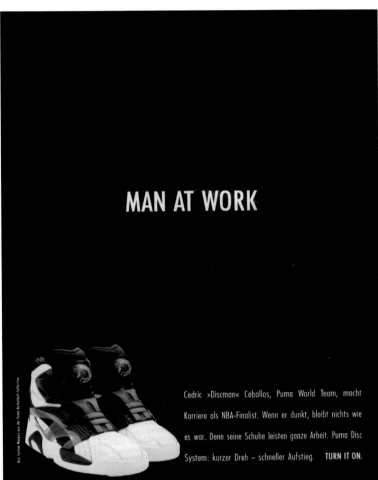

MAN AT WORK

Cedric »Discman« Ceballos, Puma World Team, macht Karriere als NBA-Finalist. Wenn er dunkt, bleibt nichts wie es war. Denn seine Schuhe leisten ganze Arbeit. Puma Disc System: kurzer Dreh – schneller Aufstieg. **TURN IT ON.**

PUMA®

1993: Disc System Weapon, 'Man at Work', ft. Cedric Ceballos

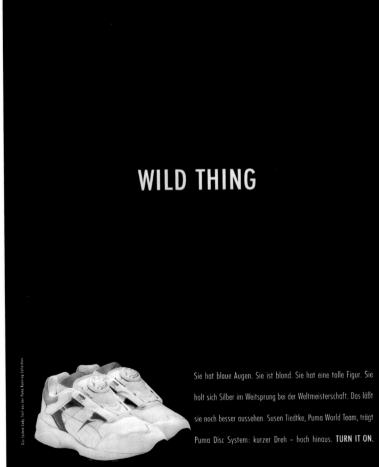

WILD THING

Sie hat blaue Augen. Sie ist blond. Sie hat eine tolle Figur. Sie holt sich Silber im Weitsprung bei der Weltmeisterschaft. Das läßt sie noch besser aussehen. Susen Tiedtke, Puma World Team, trägt Puma Disc System: kurzer Dreh – hoch hinaus. **TURN IT ON.**

PUMA®

1993: Disc System Lady Trail, 'Wild Thing', ft. Susen Tiedtke

Who makes the best jogging shoe?

by Don Riggs

The distance-running coach at San Jose State University examines the new Puma® 'Easy Rider.'

Distance-running coach Don Riggs.

A startling find.

I've tested every major brand of jogging shoe and I've come to a pretty startling discovery: *Puma is the only one that toes-off properly*—that bends the right way under the ball of your foot. Only one other brand comes even close.

Is this important? You'd better know it! Improper toe-off can lead to all kinds of foot and leg problems.

But don't take my word for the way Puma toes-off. You can test it for yourself. Grab hold of the new 'Easy Rider' and bend the sole (see photograph). The bend is exactly where the foot bends, at the head of the metatarsal, and it's rounded the way your foot is rounded.

Now try the same thing with other shoes. Some bend too sharply. Some bend in the wrong place altogether. I've even found shoes that bend right in the middle, which can tear the heck out of your metatarsal.

Puma is the only big-name shoe that toes-off properly, says Riggs.

A 1,000-mile sole?

The sole on the new 'Easy Rider' is going to make a few people sit up and take notice. Look closely and you'll see it's covered with rows of truncated cones—*in two different heights.*

The tall cones give you traction and help to cushion impact and insulate your foot from surface heat. The comfort is fantastic, but that's only half the story.

When you run, the tall cones are squashed down. This is when the short cones come into play.

They're placed where the greatest wear occurs in a shoe—at the heel. They act like firm little bumpers to keep the tall cones from mashing down and wearing out too fast.

Going by the three years of testing I've done—and this depends, of course, on weight, running surface, and how hard you run—don't be surprised if you rack up a thousand miles on this sole.

The 'Easy Rider' sole. Note the two different heights of the cones.

Beware of mushy counters.

Another way to spot a first-class jogging shoe is by checking the counter—which is what they call the part that surrounds your heel.

You take a poor shoe and push against the side or back of the counter with your thumb. You'll find it's soft and mushy. When it breaks down, your heel is going to start wobbling around in there, which can cause anything from shinsplints to knee problems. Avoid this kind of shoe like the plague.

Now, try the same test with the 'Easy Rider'. The counter is strong, *firm* (like the photograph shows). It holds and protects the calcaneus (or heel bone) and its muscle group all the way down.

I like the way Puma pays careful attention to details like this.

The 'Easy Rider' stays firm when you push here. A poor shoe is soft and mushy.

Should you wear Puma?

Run your hand around the inside of an 'Easy Rider' and you won't find a rough edge anywhere.

Look at the nylon outside and you'll see why the rate of breakdown is so phenomenally low on Puma: all the stretch points are reinforced with leather.

That kind of careful thinking goes into all the other new Puma jogging-running shoes: the soft-leather 'Stud' with its ventilating holes…the less-expensive 'Rocket'…the 9191 'Pavement Jogger' with its traditional herringbone sole…and the 'Whirlwind', built on the Puma spike last for cross-country competition and interval training.

I'll tell you the same thing I tell my athletes: A good shoe can make a difference in how you run. If you take pride in what you're doing, you've earned the right to wear Puma. You've earned your stripe.

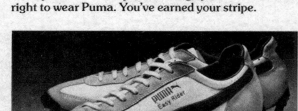

The new Puma 'Easy Rider.'

You've earned your stripe

1977: Easy Rider, 'Who Makes the Best Jogging Shoe?', ft. Don Riggs

THE GREAT CAT FAMILY

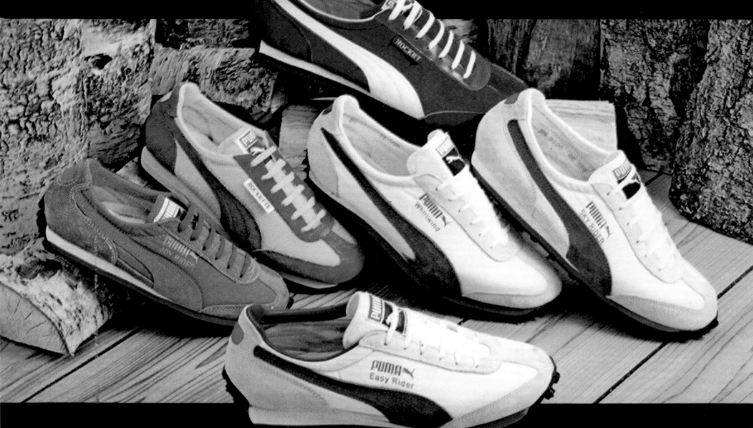

PUMA's Easy Rider has spawned a generation of great cats
for training and racing. All of the Easy Rider features — sturdy
heel counter, improved foot support system, shock absorbing
cones and thick, tough wedge — are found in its bold new family.

Easy Rider and its offspring are built to cushion the foot,
minimizing stress on the ankle, heel and surrounding tendons.
Tall cones on the soles of some models cushion the shock of impact
while shorter cones cut down wear by checking compression of the
taller ones. Reinforced uppers provide comfort and
foot-gripping support.

The Great Cat Family is designed for mile after mile of
injury-free, pleasurable running using the same superior
technology that outfitted nine of eleven starters on Argentina's
World Cup soccer champions.

PUMA — The Great Cat Family. Grrrr.

1978: Easy Rider, 'The Great Cat Family'

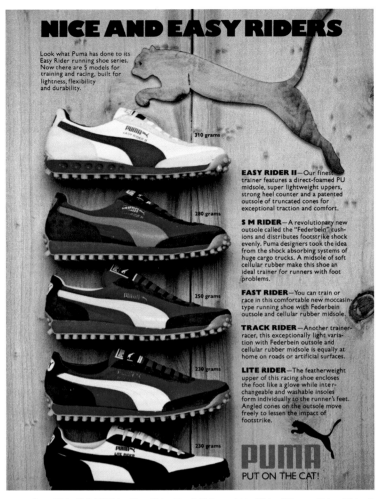

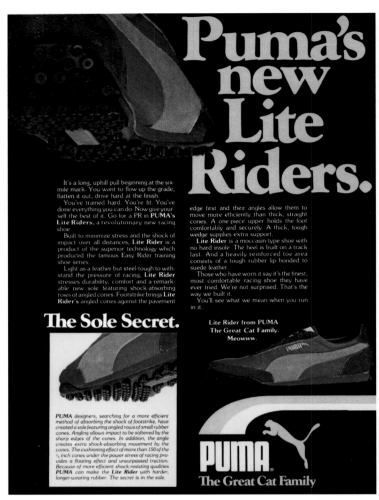

1979: Easy Rider II, S M Rider, Fast Rider, Track Rider and Lite Rider, 'Nice and Easy Riders'

1979: Lite Rider, 'PUMA's New Lite Riders'

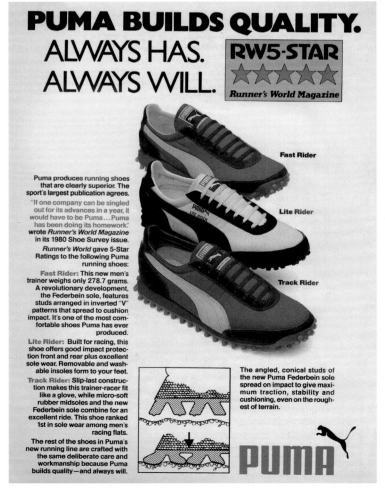

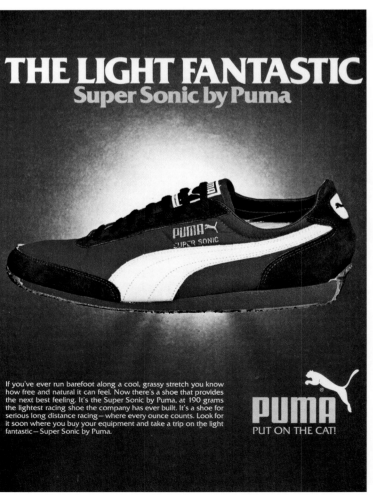

1980: Fast Rider, Lite Rider and Track Rider, 'PUMA Builds Quality. Always Has. Always Will'

1979: Super Sonic, 'The Light Fantastic Super Sonic by PUMA'

PUMA– SOFTEST TOUCH IN RUNNING!

It's easier to experience Puma than you think. In fact, we're the softest touch in running. Puma people know Puma shoes give something beyond 5-Star performance, finest quality and innovative design— something wild and free. You can capture it today at your favorite running store. **PUMA**

1980: 'PUMA – Softest Touch in Running!'

PUMA. OUR STORY IS ON THE BOX.

Puma is quality. We print that fact on every box because we design our running shoes by rigid standards, even when it means going against the trend. Case in point: our new Elite Rider training shoe. Elite Rider will never score high marks for lightness because we added weight to make it more stable. We built in an extended orthotic footbed* that we believe will make this shoe the finest trainer in the world for runners of all weights. That's why Puma is quality. We stand on it.

*A semi-rigid insert cups the heel and sides of the foot, running almost to the ball of the foot to reduce G forces and provide added rearfoot stability.

PUMA

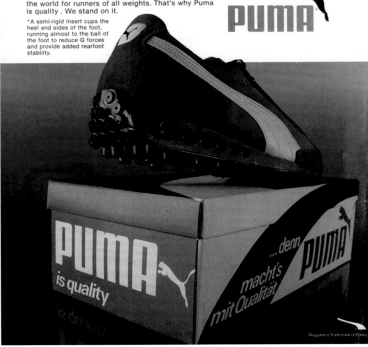

1980: Elite Rider, 'PUMA. Our Story is on the Box'

PUMA. 5-STAR QUALITY TWO YEARS RUNNING.

Fast Rider trainer. Track Rider and Lite Rider II racers. We selected these three shoes to carry Puma's legendary Olympic excellence into the highly competitive area of road running. Now, their five star ratings* for two straight years have confirmed our own tests. Did you expect anything less? As we say on the box--Puma is quality. We stand on it.

*Runner's World 1980 and 1981 running shoe surveys

PUMA

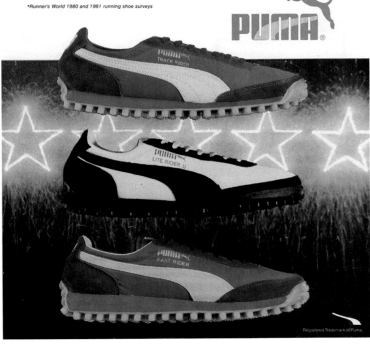

1980: Track Rider, Lite Rider II and Fast Rider, 'PUMA. 5-Star Quality Two Years Running'

HOW MUCH TOTAL WEIGHT DO YOU PUT ON EACH FOOT EVERY TIME YOU RUN? HERE'S HOW TO FIGURE IT OUT.

$$(3W \times n \times M) \div 2,000 \div 2$$

Take your weight (W) and multiply by 3. Then multiply by the number of steps (n) you take in each mile. (An average running step is three feet, so you take 1,760 steps per mile.) Next, multiply by the number of miles (M) you run, and divide by 2,000 for the number of tons put on your feet. Finally, divide by 2 for the total number of tons on *each* foot. *Tons.*

Now you can see why it's important to wear the right shoe.

Which is where The Athlete's Foot® comes in. We're the stores that specialize in athletic footwear—for just about any sport you can name.

To start with, we sell only shoes from top manufacturers. We know that the materials used in soles and uppers, the last, the construction, are all-important when it comes

to keeping you out of trouble and helping you run in top form.

So come in now and see why the slogan fits: Nobody knows the athlete's foot like The Athlete's Foot.

Runners all over the world respect Puma shoes.

Like the Fast Rider in a special, supportive last with narrow heel and wider forefront—a light, comfortable moccasin-type shoe for training, jogging, or racing.

Or the Easy Rider II, with sturdy nylon uppers and excellent rear-foot stability for heavy training or heavier-weight runners.

Or the Track Rider, an extra-lightweight model for light training or racing.

All three reflect Puma's commitment to quality for meeting your needs in a running shoe.

354 stores nationwide
The Athlete's Foot

PUMA

Fast Rider/Easy Rider II/ Track Rider

Nobody knows the athlete's foot like The **Athlete's Foot.**

1980: Fast Rider, Easy Rider II and Track Rider, 'How Much Total Weight Do You Put on Each Foot Every Time You Run? Here's How to Figure It Out. (3W×n×M)÷2,000÷2'

PUMA. OUR STORY IS ON THE BOX.

It's a strong statement — Puma is quality. And because we mean it, because we believe in it, because we can back it up, we put that claim on every box. Lift the lid and you step out of the ordinary and into the extraordinary world of action shoes for action athletes — marathon, cross-country, training, sprinting and jogging, we make them all. Go to your favorite running store today and look for our claim on the box. Puma is quality. We stand on it.

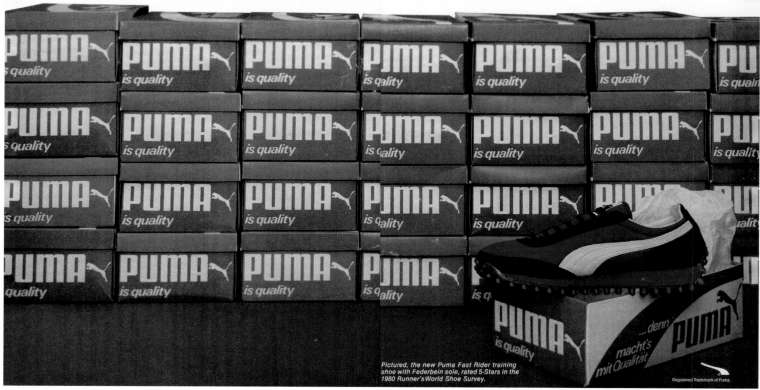

Pictured, the new Puma Fast Rider training shoe with Federbein sole, rated 5-Stars in the 1980 Runner's World Shoe Survey.

1980: Fast Rider, 'PUMA. Our Story is on the Box'

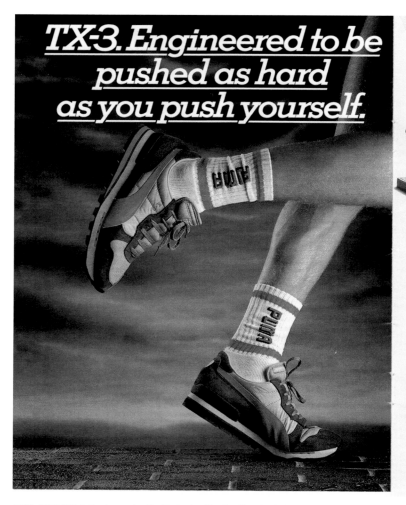

TX-3. Engineered to be pushed as hard as you push yourself.

A Puma running shoe is never simply cobbled together.

In truth, every shoe is precision engineered according to the research and designs of the Puma Sports Laboratory in the USA.

Where the world's leading authorities in biomechanics, using the latest computer technology, engineer shoes to work in perfect harmony with the human body.

(For the non-scientific among us, biomechanics is the study of the mechanics and workings of the human body.)

Comfort, injury free running and improved performance are the things we strive for.

THE COMPUTER RUN. And our track record is second to none. You have to take the punishing sport of running very seriously indeed if you wish to avoid serious injury.

So never compromise when it comes to choosing the correct shoe.

TX-3 has been specifically designed for the serious runner who is into a heavy training schedule.

Lightweight and constructed from meticulously selected materials–with the aid of advanced computer technology–these running shoes offer the correct, subtle balance of shock absorbtion, stability, flexibility and motion control.

And finally, they're biomechanically lasted for durability.

Even with all this technology, don't run away with the idea that each pair of TX-3's is built by unfeeling robots.

The uppers are hand-sewn for the ultimate in comfort and fit.

We take the same scientific approach to all our shoes, be they for track, court or field.

So no matter how punishing your sport or training schedule, the Puma name will be of great comfort to you.

PUMA
We've made a science out of running.

1985: TX-3, 'TX-3. Engineered to Be Pushed as Hard as You Push Yourself'

ARE RUNNING INJURIES NECESSARY?

Nobody has to tell a serious runner that his feet and legs (and hips and back) take a beating. Nobody has to tell him or her that it's important to have good shoes. But PUMA thinks it's time someone told the serious runner about an elemental and crucial step in the building of running shoes that running shoe companies have been hesitant to discuss.

Running's Best Kept Secret: The Last. Every shoe starts with the last. It's also called a mold. But it would be better to think of it as the blueprint for the shoe, because everything that comes after depends on how it is designed. The stress points peculiar to a running shoe, as opposed to a tennis shoe or basketball shoe, are built into the last.

If The Last Is Important, Why Is It Neglected? Far, far away in the Far East many of the top running shoes are made in the same factory, side by side, with a standard last. A last, by the way, that is not specifically designed for a running shoe. Why would they do such a thing, you might ask.

It Takes A Lot To Build A Last. It took PUMA thousands of feet of film showing what happens to every part of the foot in training

and racing situations. It took PUMA hundreds of exact-dimension measurements of hundreds of runners' feet. When we were finally ready to build our running lasts, we knew exactly where the stress points were for training *and* racing, and we knew the dimensions and proportions of the feet we were making shoes for. Then we made five different lasts. Four for running, and one for racing. (They are considered so valuable, by the way, that only a few people know where they are kept.)

Only A Running Last Can Give Running Support And Running Fit. PUMA lasts were designed according to the unique stresses of long distance running and racing, and according to true averages of foot dimensions. Our lasts tell us *exactly* where the uppers should give support. We know *exactly* where there should be lateral and medial stability, and where there should be flexibility. The differences in our lasts and others may, in some

One of our five running lasts.

cases, seem subtle. But when one is talking about 35 or more miles of running a week, these differences are magnified many times. Almost every serious runner is familiar with the slight nag that becomes a chronic injury.

A PUMA Running Last Bends Where The Running Foot Bends. Here you see a simple demonstration you can verify for yourself. A running foot bends precisely at the ball of the foot, at a precise angle! Press any PUMA between your hands as shown, and it will bend at precisely the same place, *and*

at the same degree of angle. Now press another running shoe and see what you get.

PUMA Is One Of Only Two Companies That Absolutely Controls How Its Shoes Are Made. PUMA and one other company try to use factories that make shoes for them alone. As we mentioned before, many running shoes start out in one factory in the Far East. We're willing to pay to see that our design specs are carried out exactly; and to keep a tight rein on quality control via our own PUMA inspectors.

PUMA Believes Running Injuries Can Be Prevented. Dr. Donald Riggs is PUMA's Chief Technical Consultant in the USA. When he was the distance running coach at San Jose State, he never had a shoe-related injury. He attributes this to thoughtful conditioning of his athletes, and to PUMA running shoes, which were the only running shoe worn at San Jose State.

There is a wealth of information today on how to condition oneself properly, and run so as to prevent injuries. And we know there is at least one shoe that is thoughtfully designed, down to the *last* detail, so as to prevent injuries. Injuries don't have to happen. Let's all pass the word.

1981: Easy Rider, 'Are Running Injuries Necessary?'

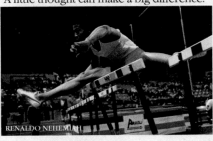
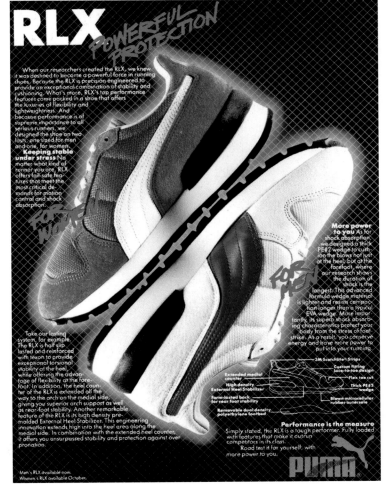

1983: RLX, 'RLX. Powerful Protection'

PEOPLE WHO RUN IN PUMAS KNOW A LOT MORE THAN PEOPLE WHO DON'T.

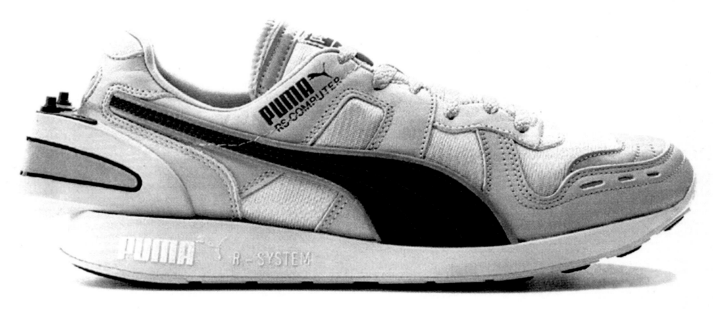

Serious runners know that it takes the latest technology to make a great running shoe. Heel stabilizers to control pronation. Midsoles that combine polyurethane and EVA to absorb shock. Biomechanical designs to increase stability.

But serious runners also know that it takes more than a great shoe to improve performance. It takes knowledge. Introducing the RS Computer Shoe from Puma.

The RS Computer Shoe not only incorporates the latest in footwear technology – including our unique Multiplex IV Midsole with durability and shock attenuation far superior to conventional midsoles – it combines it with computer technology. Creating a running shoe unlike any other.

The RS Computer Shoe has a custom-designed computer chip built into its heel. This computer chip records your run, then communicates the results to any Apple IIE, Commodore 64 or 128 or IBM PC computer. A software program included with the shoe automatically calculates your time, distance and calories expended. Then graphically compares them to past performances and future goals.

The RS Computer Shoe from Puma. It's the intelligent way to run.

Apple is a registered trademark of Apple Computer, Inc.; Commodore 64 and 128 are trademarks of Commodore Computer Systems; IBM and IBM PC are registered trademarks of IBM.

PUMA
OUR WORD FOR QUALITY

1986: RS Computer Shoe, 'People Who Run in PUMAs Know a Lot More Than People Who Don't'

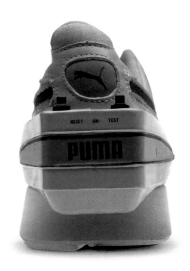

" PUMA reached for the stars with this high-tech addition to their running range in 1986. The RS Computer Shoe was based on a redesigned RS100 runner and featured a stop watch, circuit boards loaded with micro-processors and an inertia switch triggered by the impact of feet hitting the ground. Following each session, the shoes were plugged into Apple II or Commodore 64 computers using a 16 pin cord to download the data, which included distance, speed and estimated calorie intake. The 5-inch floppy disk required a thumping 48k system! Unfortunately for PUMA, the RS Computer Shoe technology was 25 years ahead of schedule. Software glitches – not to mention an outrageous $200 price tag in the mid-1980s – scuppered any chance of mainstream success. The gigantic wedge contraption affixed to the heel didn't help either! "

PUMA Running Book
Sneaker Freaker (2011)

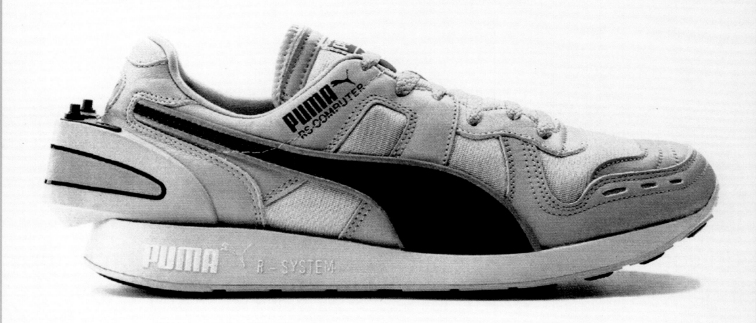

IT HELPS YOU SET THE RECORDS.

In the constant pursuit of longer distances and shorter times, success depends on more than a routine training schedule and the latest biomechanical running shoe designs.

It calls for knowledge. Facts about your performance and how to improve it. Whether you seek to break other people's records or just your own.

Now there's a running shoe that gives you both physical support and training information. The RS Computer Shoe from Puma. The first training shoe to combine the latest footwear technology with the latest computer technology.

The RS Computer Shoe has a custom-designed computer chip built into its heel. This electronic device records your run, then plugs into your Apple IIE, Commodore 64 or 128, or IBM PC computer. Showing you time, distance and calories expended.

Easy to use software, included with the shoes, lets you log each of your runs and graphically measure progress in comparison with training goals.

Apple is a registered trademark of Apple Computer Inc.; Commodore 64 and 128 are trademarks of Commodore Computer Systems, IBM and IBM PC are registered trademarks of IBM.

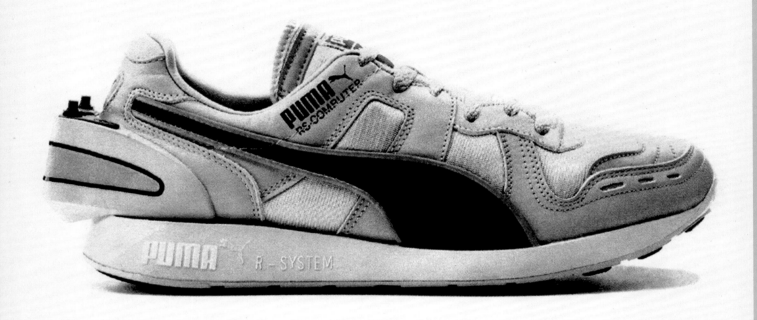

ITALSO HELPS YOU KEEP THEM.

The RS Computer Shoe is a technological break-through even without its computer. It incorporates numerous biomechanical innovations including Puma's unique Multiplex IV Midsole. A new four-part wedge combines lightweight polyurethane with rigid foam stabilizers and an EVA Impact Sector.™ Collectively reducing the weight of the shoe while achieving durability and shock attenuation far superior to conventional midsole technology.

The RS Computer Shoe from Puma. When it comes to running shoe technology, it holds the record.

The Computer Shoe comes with easy-to-use software that plots time, distance and calories expended, plus makes graphic comparisons to past performances and training goals.

PUMA

OUR WORD FOR QUALITY

Renaldo Nehemiah turns a Puma inside out.

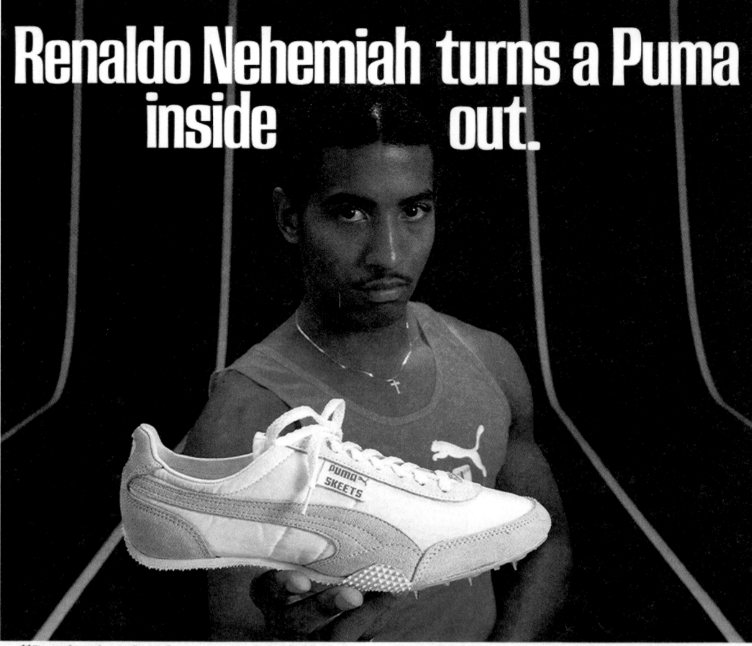

"Puma has always been the name in track and field. That's where they really excel. I've been in Pumas ever since I started running, because I feel they help me perform better.

"This Skeets shoe is really light, which is what you want. But it also has a special design that gives you great support.

"On the exterior of the shoe there's a special leather strip for support and on the inside there are nylon reinforcement strips. Your foot is held extra stable and that helps you go fast.

"The heel has a unique curved design which gives you the maximum in achilles tendon support and rear foot stability.

"Puma invented the six spike design that Skeets has. The spikes are placed along the outside of the foot where your weight is when running. This increases your traction and improves your performance.

"And Skeets are comfortable. They fit perfectly, and they've got a non-abrasive sock lining and padded tongue.

"Puma makes a line of track and field shoes for men and women. You're bound to find the shoe that's right for you when you go with Puma."

PUMA
In a class by itself. World Class.

1983: Skeets, 'Renaldo Nehemiah Turns a PUMA Inside Out', ft. Renaldo Nehemiah

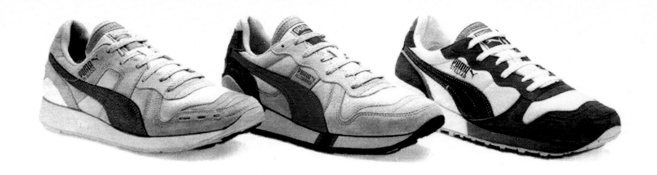

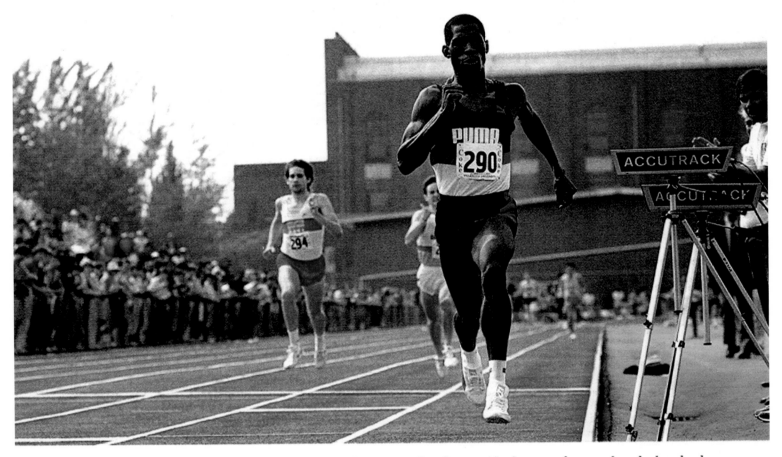

*The Summer of 1985
Sydney Maree sets three American running
records in fewer than three months.*

Sydney Maree breaks records almost as frequently as he breaks the tape at the finish line.

In the summer of 1985, they re-wrote the record books three times as Maree set new American marks for 5000 meters (13.01.15), 2000 meters (4.54.20), and 1500 meters (3.29.77).

The odds are that when Maree's records are broken, it will be Sydney Maree who breaks them. He runs 100 miles a week. He runs 30 races a year. And he runs them all wearing Pumas.

Running shoes for the serious runner. Designed for stability, comfort, shock absorption and flexibility.

When the quality of performance counts, athletes in every sport have a word for it. Puma.

PUMA.
OUR WORD FOR QUALITY

1985: 'Our Word for Quality', ft. Sydney Maree

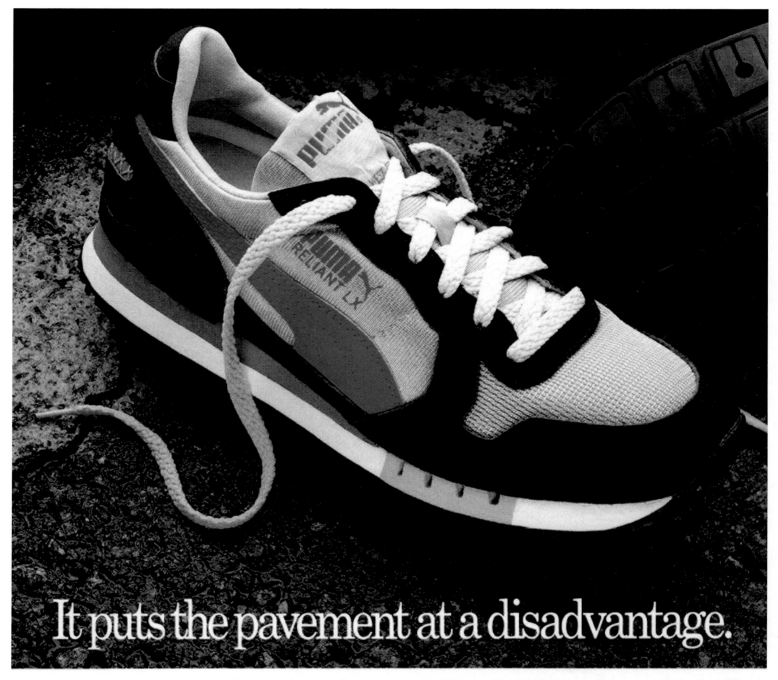

It puts the pavement at a disadvantage.

At Puma, we believe endurance is a quality that should be found not just in runners, but in running shoes.

A conviction you'll find convincingly expressed in the Reliant LX.

This shoe was designed to overcome the unavoidable fact that the road is tougher than the foot.

It has a carbon outsole rugged enough to withstand hundreds of miles before wearing down.

A new EVA midsole that combines high density struts to protect against over pronation, metatarsal channels to promote flexibility, and extra firmness on the forefoot to fight excessive supination.

Plus a polyurethane wedge so resilient it will remain shock absorbent for the life of the shoe.

The uppers of the Reliant LX further insulate you from the harsh realities of life on the road. Suede and leather reinforce the shoe's mesh quarters. An external heel counter adds stability. And a reflective 3M safety patch surrounds the heel just below the soft tab achilles protector.

The Reliant LX from Puma. Plenty of running shoes consider your feet. This running shoe considers the street.

Our word for quality.

1987: Reliant LX, 'It Puts the Pavement at a Disadvantage'

Introducing the Strider.™ A training shoe that can take all the punishment you can give it and still give you all the protection you need.

Every day, rain or shine or snow, you're out there pounding out the miles.

Across asphalt, gravel, dirt and mud.

Pushing yourself.

Endlessly training to make your personal best a little better.

You're a serious runner and you need serious protection. That's why Puma has used the most advanced biomechanical research in the running shoe industry to design a shoe for runners like you. The Puma Strider.

NO MATTER HOW YOU PUNISH IT, THE STRIDER OFFERS GREAT PROTECTION.

Through years of research in a world-famous university biomechanics lab, Puma's sports scientists have developed some remarkable tools to better understand the running motion.

For instance, they invented an Interior Pressure Mat™, which, for the first time, actually measures the forces generated *inside* the shoe, and exactly how they're distributed underneath the foot.

By using these tools to analyze the footstrike of hundreds of runners, our researchers discovered the need for, and then developed, the Strider's unique Impact Sector.™ This is a scientifically designed mid-sole wedge of soft, microcellular rubber that provides maximum shock absorption during footstrike.

They also learned that, contrary to popular belief, the duration and magnitude of pressure in running is greatest at the forefoot. As a result, they designed a double layer of dense, microcellular rubber that protects the forefoot from vertical pressure.

Strider's unique Impact Sector™ mid-sole wedge of soft, microcellular rubber provides maximum shock absorption during footstrike.

A double layer of dense, microcellular rubber protects the forefoot from vertical pressure.

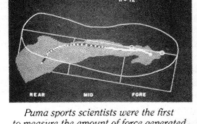

IT'S AS DURABLE AS IT IS WELL-DESIGNED.

At the same time, the Strider is engineered to take all the grueling punishment that even the heaviest trainer can give it.

Its outer sole is made of highly carbonized rubber to withstand the abrasion of hundreds of road miles.

The upper is made of tough, ripstop nylon, reinforced with pigskin for maximum durability and minimum weight.

The Strider is slip-lasted for excellent flexibility.

An extended TPR counter (both medially *and* laterally) and unique unitized heel design provide superior stability and protect against moderate pronation and supination.

The Puma Strider. The most advanced biomechanical research has made it a superior training shoe. Which should come as no shock to anyone.

Puma sports scientists were the first to measure the amount of force generated inside the shoe.

Special men's and women's lasts and sizes.

Introducing the Puma Lab I. The product of the most advanced biomechanical research and development program in running shoe history.

For more than a year, Puma sports scientists have been working in a world-renowned university biomechanics lab on the most advanced study of the running process ever.

Under the direction of the man who created the criteria used by most major running magazines to evaluate all shoes, they studied a wide spectrum of runners, ranging from top marathoners to weekend joggers.

Runners of all ages and weights. Runners with

Interior Pressure Mat invented by Puma sports scientists to measure force inside shoe.

all kinds of gait abnormalities and injury histories.

The research team used slow-motion cinematography to record the running motion, which was then plotted frame-by-frame and analyzed by computer.

They used a force platform to measure the pressure of the shoe hitting the ground.

And most important, they invented an Interior Pressure Mat whose electronic sensors revealed what no one else had ever isolated before: the amount of force generated *inside* the shoe. Unlike other researchers who had only been able to measure pressure *outside* the shoe, Puma's sports scientists discovered the missing link that

enabled them to study the impact on the foot itself.

Their findings were revolutionary. And so is the shoe they created. The Puma Lab I.

A NEW BREED OF SHOE CONCEIVED IN THE LAB.

Much of the Lab I's design was dictated by an extraordinary discovery made by Puma's sports scientists: that, contrary to what was previously believed, the duration and magnitude of pressure in running is greatest at the forefoot. Not just for forefoot strikers, but for mid- and rearfoot strikers as well.

This discovery enabled us to design a shoe that distributes shock absorption along the pressure path *exactly* where it is needed, with a greater concentration at the forefoot than is found in most other running shoes. And we could eliminate cushioning where it was *not* needed, to lighten the shoe.

In addition,

Computer graphic dramatizes intensity of pressure at forefoot.

thanks to our slow-motion cinematography and pressure-distribution studies, we were able to address the crucial problem of over-pronation in an entirely new and effective way.

HOW BIOMECHANICAL RESEARCH TRANSLATES INTO A BETTER RUNNING SHOE.

Slow-motion cinematography reveals that most runners first contact at the outside border of

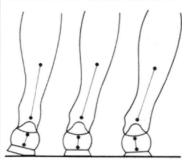

Computer-generated angle/time plot shows how over-pronation occurs.

the shoe. The foot then rolls to the inside and forward to toe-off. Unfortunately, many runners roll in too much. And authorities believe that this over-pronation leads to knee injuries.

To control pronation, we created a unique dual-density Tri-Wedge™ system.

The Tri-Wedge system begins with a soft microcellular section at the outside border to absorb the shock of the initial impact.

Some running shoes attempt to completely stop pronation with a rigid control feature. But your foot naturally turns slightly inward on impact; the Puma Lab I permits this normal movement, while controlling *over-pronation* with an innovative Stability Sector,™ the second part of the Tri-Wedge system. The Stability Sector is a hard piece of carbonized rubber that resists compression during the "roll-in" portion of footstrike and keeps the runner's foot close to the neutral position where it functions best.

Also contributing to rearfoot stability are a rigid TPR heel counter, extended at the medial aspect; a new narrower

heel; and an asymmetrically flared sole.

As the foot rolls forward and pressure increases, the third part of the Tri-Wedge system comes into play. The Lab I's midsole provides crucial forefoot cushioning with soft, thick microcellular rubber. However, where findings show virtually no pressure, the midsole is drilled for weight relief. Result: the Lab I weighs in at a surprisingly light 232 grams.

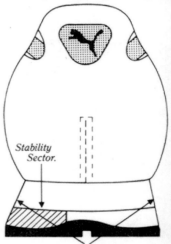

Stability Sector.

Asymmetrical flare.

ONLY THE BEGINNING.

The Lab I is the beginning of a whole new generation of Puma shoes, a whole new era of Puma in the laboratory. And there's a lot more to the story. Your authorized Puma dealer has an in-depth booklet describing the biomechanical findings that have led to the Lab I and have opened the door to a whole new breed of running shoe in the future. Go in today for your copy and try on the Puma Lab I. An animal conceived in the lab. And born to run.

To order the Lab I story by mail, write P.O. Box 4184, Chester, PA 19016 or visit one of the authorized Puma dealers listed below.

A runner's gait as plotted by computer from high-speed cinematography.

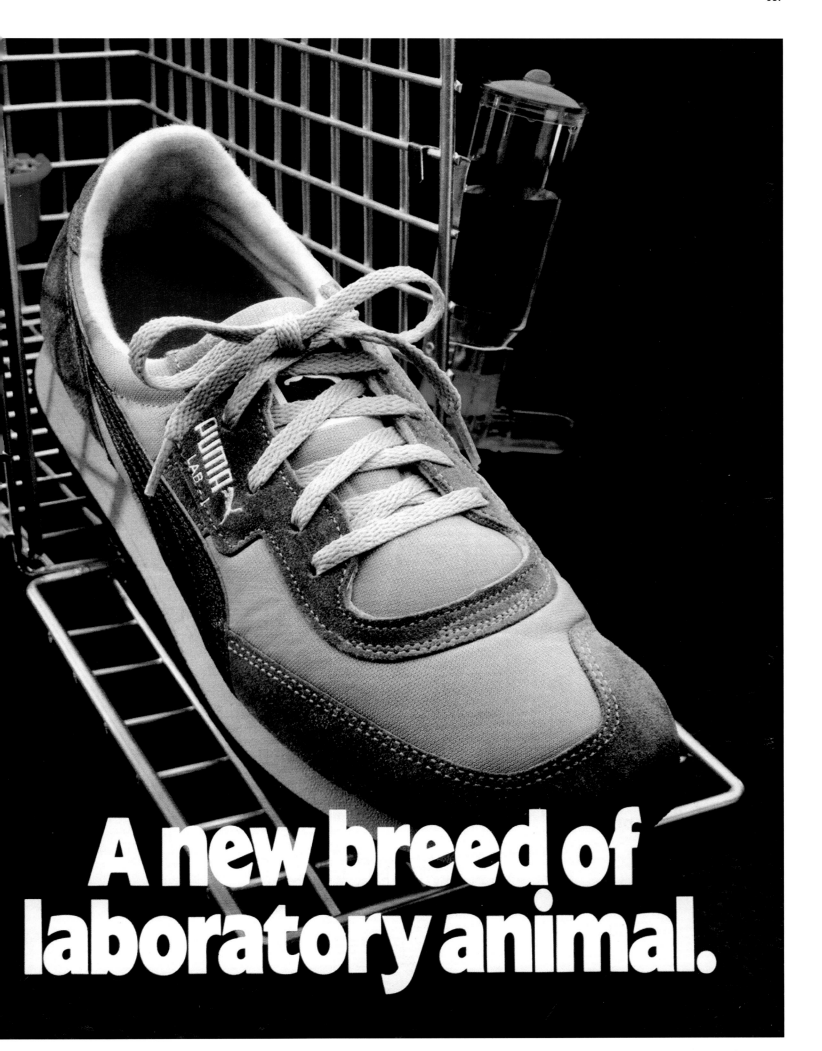

A new breed of laboratory animal.

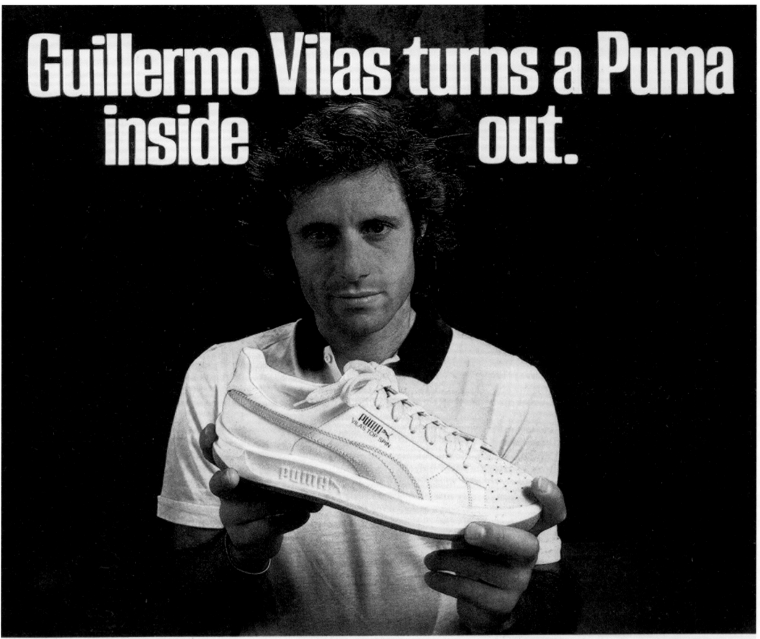

Guillermo Vilas turns a Puma inside out.

" To me, this is a real breakthrough.
" It has a completely new kind of sole—actually two soles in one. One part is pliable and springy. It cushions and protects. The other part is tough. Together they give you great shock absorption and traction. Plus the toe cap is reinforced to stand up to toe drag from serving.
" But probably most innovative is the anatomical footbed. It actually molds to the shape of your arch. So whether your arch is high, medium, or low, this shoe conforms to fit your foot. And the entire shoe was built extra light on a special last, to match the way your foot moves in tennis.

" The tread is great. Herringbone pattern for grip. Turning circle for easy pivoting. And something completely new—this five-ribbed arch, to keep your foot stable and prevent wobbling.
" The uppers and tongue are made of light, full-grain leather, perforated to keep your feet cool and dry. And there's Puma's asymmetrical ankle cut—higher on the inside—so it won't chafe or rub your ankle bone.
" All together, this shoe gives you absolutely fantastic comfort, protection, and performance. On all playing surfaces. I have to say it's a great shoe—and I would say that even if they hadn't named it for me. The Puma Vilas Top Spin."

PUMA
In a class by itself. World Class.

1983: Vilas Top Spin, 'Guillermo Vilas Turns a PUMA Inside Out', ft. Guillermo Vilas

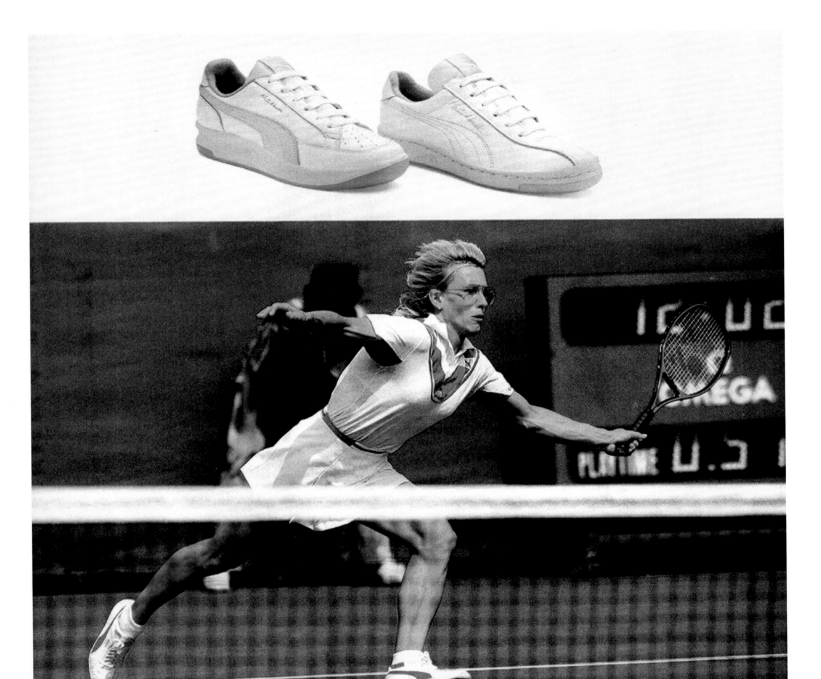

Flushing Meadows, New York
The U.S. Open
Martina Navratilova wins a second major
on her way to the Grand Slam.

Consecutive victories at Wimbledon, the U.S. Open, the Australian Open, the French Open. It is one of the most elusive quests in all of sport.

Yet in 1984, Martina Navratilova conquered the world of tennis, completing the Grand Slam with her victory over Chris Evert Lloyd in the French Open. That year she was the epitome of consistency. She won 74 straight matches. She won a record 13 straight tournaments.

All of them she won wearing Pumas. Tennis shoes that can stand up to grueling 30-game matches. Whether they're played on grass, clay or hard court surfaces.

When the quality of support, stability and comfort are critical, when the quality of performance counts, athletes in every sport have a word for it. Puma.

PUMA®
OUR WORD FOR QUALITY

1986: 'Our Word for Quality', ft. Martina Navratilova

WE'RE TAKING BORIS BECKER AND MARTINA NAVRATILOVA TO COURT.

If you want evidence of why Boris and Martina depend on Puma to help them prosecute their court opponents, just visit your athletic shoe dealer.

There you'll find the Becker Ace, as well as our full line of tennis shoes, clothes and rackets.

Puma. Judged by Boris and Martina as the best way to make a court appearance.

OUR WORD FOR QUALITY

1986: Becker Ace, 'We're Taking Boris Becker and Martina Navratilova to Court'

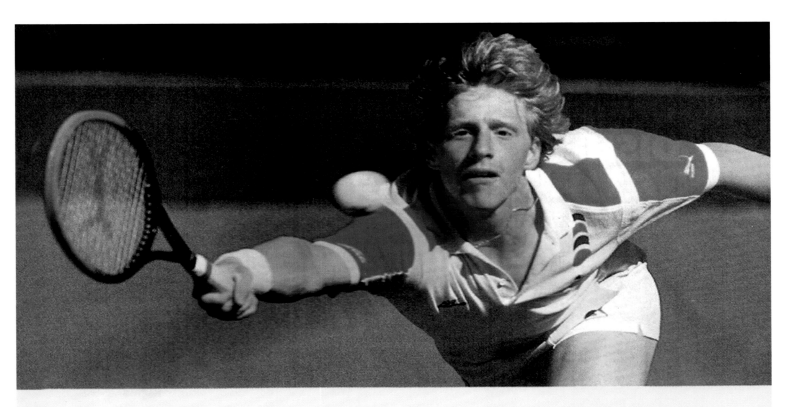

Introducing tennis gear for people who play the game like it's never been played before.

In the game of tennis, there have always been players who've dominated the sport. But rarely have there been athletes who've changed the way the sport is played. That is until Boris Becker came on the scene.

Now Puma has captured the strength, style and spirit of Becker to create a line of performance tennis gear as dramatic as its namesake.

It begins with three new Becker tennis shoes, the Pro, the Ace and the Whirlwind. Each is faithful to Becker's own belief of how a shoe should perform. With soft, full-grained leather uppers and durable outsoles

that provide the comfort necessary to withstand grueling, five set matches and the toughness to last through more games than any tennis shoe has a right to.

Our Becker rackets integrate the tradition of the game with the originality of the athlete who'll play with no other. Combining fiberglass and graphite in a low profile racket that *World Tennis* calls "solid and powerful."

And our new lines of apparel guarantee that even if you can't play like Becker, you can look as good.

Find it all at the Boris Becker Tennis Center wherever you buy tennis gear.

PUMA ®

Our word for quality.

The Becker line of tennis shoes is available at selected FootLocker stores.

1987: The Becker Line, 'Introducing Tennis Gear for People Who Play the Game Like It's Never Been Played Before', ft. Boris Becker

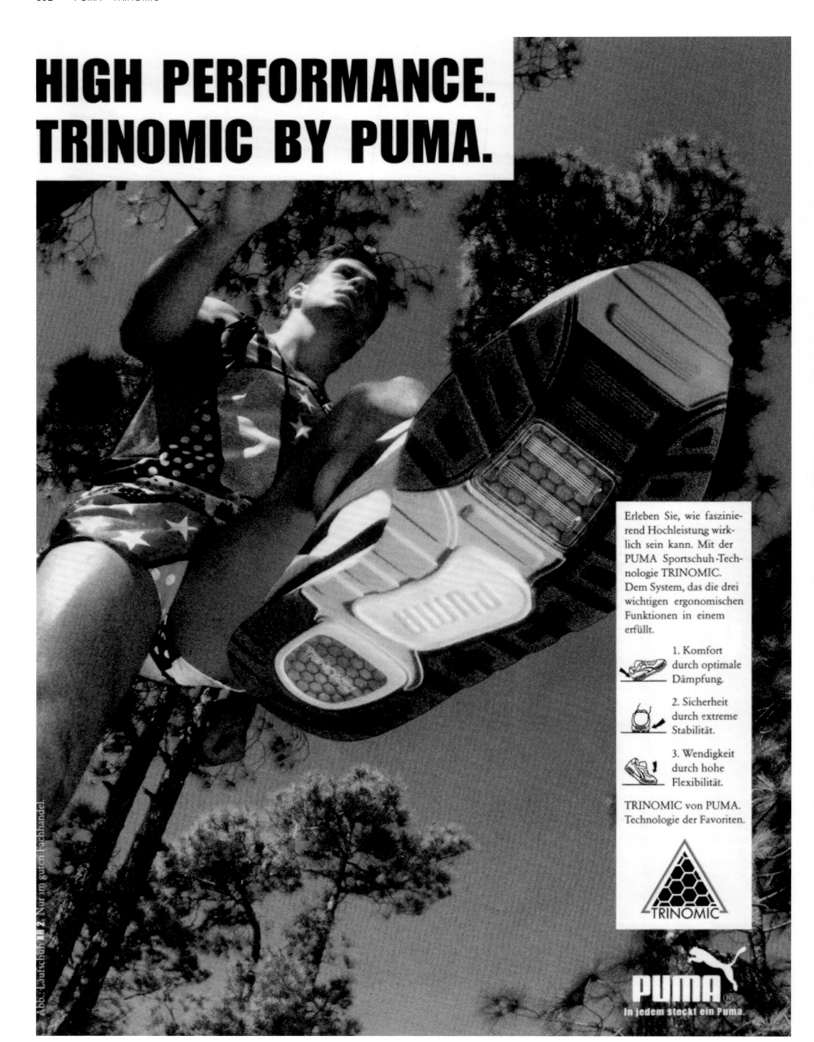

HIGH PERFORMANCE.
TRINOMIC BY PUMA.

Erleben Sie, wie faszinie-rend Hochleistung wirk-lich sein kann. Mit der PUMA Sportschuh-Tech-nologie TRINOMIC. Dem System, das die drei wichtigen ergonomischen Funktionen in einem erfüllt.

1. Komfort durch optimale Dämpfung.

2. Sicherheit durch extreme Stabilität.

3. Wendigkeit durch hohe Flexibilität.

TRINOMIC von PUMA. Technologie der Favoriten.

TRINOMIC

PUMA ®
In jedem steckt ein Puma.

Abb.: Laufschuh XR 2. Nur im guten Fachhandel.

1990: XR 2, 'High Performance Trinomic by PUMA'

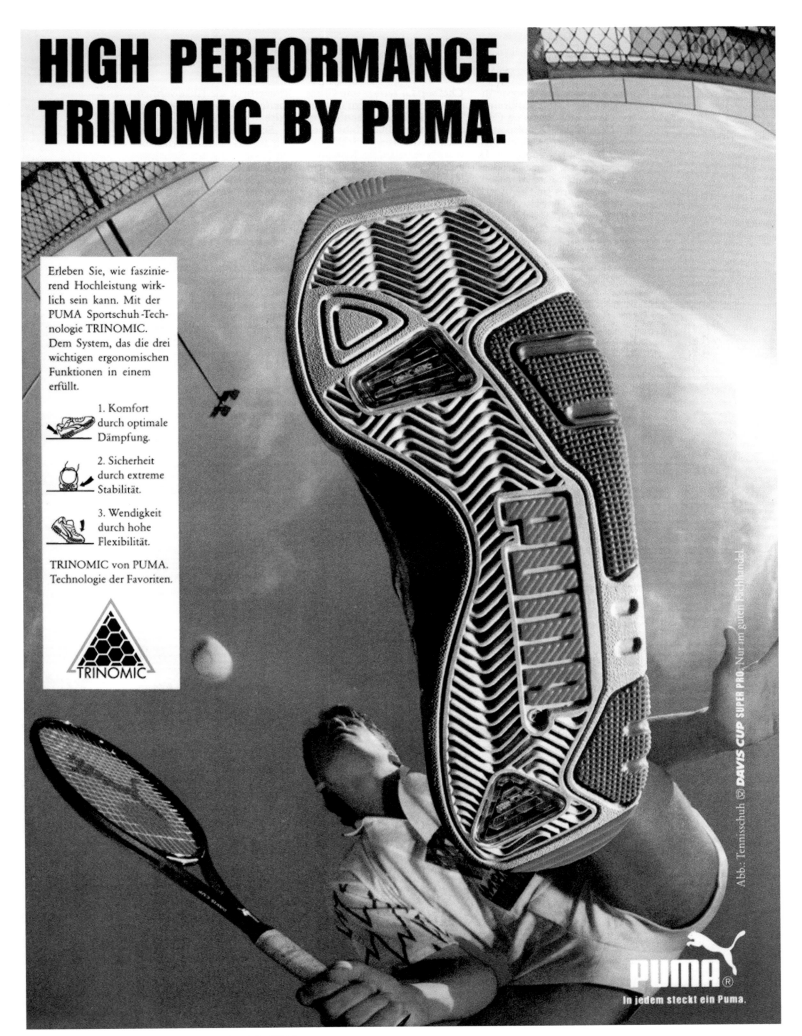

HIGH PERFORMANCE. TRINOMIC BY PUMA.

Erleben Sie, wie faszinie-
rend Hochleistung wirk-
lich sein kann. Mit der
PUMA Sportschuh-Tech-
nologie TRINOMIC.
Dem System, das die drei
wichtigen ergonomischen
Funktionen in einem
erfüllt.

1. Komfort
durch optimale
Dämpfung.

2. Sicherheit
durch extreme
Stabilität.

3. Wendigkeit
durch hohe
Flexibilität.

TRINOMIC von PUMA.
Technologie der Favoriten.

TRINOMIC

Abb.: Tennisschuh ⊗ *DAVIS CUP SUPER PRO*. Nur im guten Fachhandel.

PUMA ®
In jedem steckt ein Puma.

1990: Davis Cup Super Pro, 'High Performance Trinomic by PUMA'

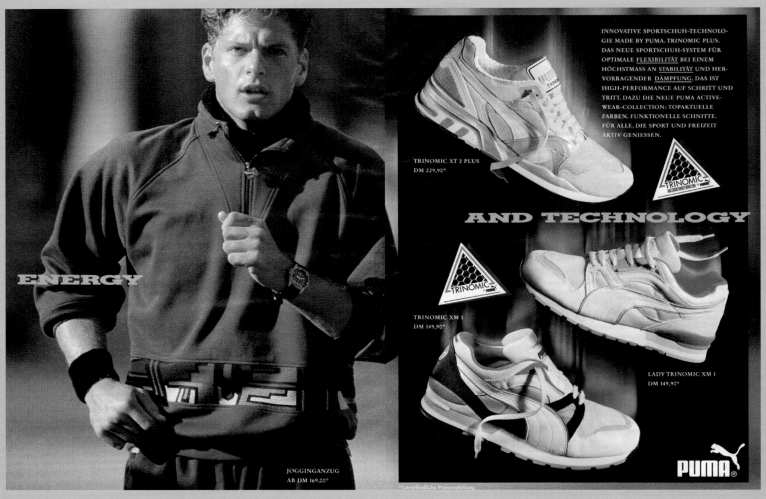

1991: XT 2 Plus and XM 1, 'Energy and Technology'

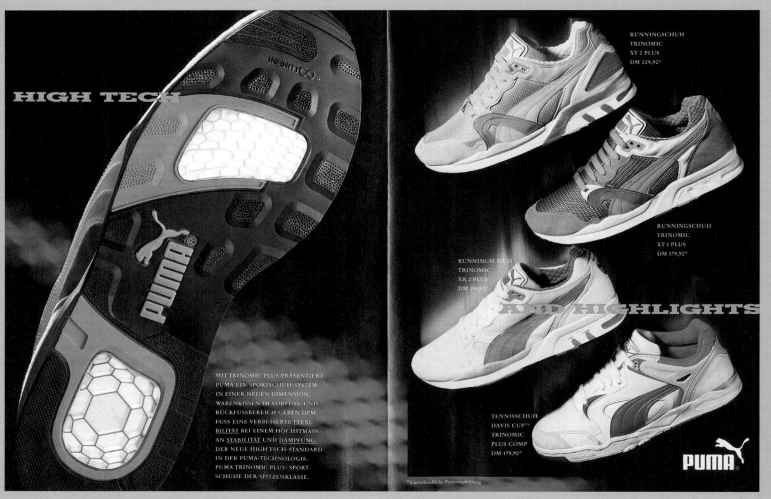

1991: XT 2 Plus, XT 1 Plus, XR 2 Plus and Davis Cup Plus Comp, 'High Tech and Highlights'

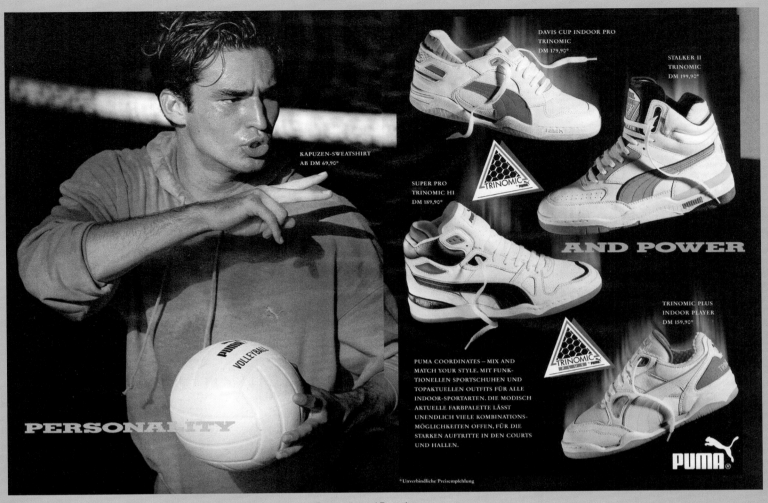

1991: Davis Cup Indoor Pro, Stalker II, Super Pro Hi and Plus Indoor Player, 'Personality and Power'

We'd like to compress the story of TRINOMIC® cushioning, but we can't.

FOR decades, EVA foam in its various forms, has been the basis of midsole cushioning technology. This despite two very glaring weaknesses in EVA foam performance:

1. Even the best EVA foam midsole compresses enough to seriously degrade its shock absorbency after relatively few miles; and

2. The molding process that creates EVA foam is inherently imprecise. The degree of cushioning can vary by up to 10% from left shoe to right shoe. A variance that can cause spinal misalignment of even the most balanced runner, creating an artificial gait cycle, increasing the chance of injury.

Figure 2: **Under peak force, TRINOMIC will "give" far more than EVA for a reduced impact. Then it reforms more completely to cushion the next hit.**

As a result, PUMA is the first performance running shoe company

TRINOMIC FOOTBED • *Men's Size 9*

Figure 1: **The TRINOMIC design features a single integrated footbed. The size and configuration of the hexagonal cells vary over the topology of the foot to provide specific properties where needed. (More cushioning under the heel. More stability around it.)**

Unlike traditional designs, it requires no EVA foam in the midsole to provide comfort, and no additional structures to provide support or stability. You run on an integrated solution, not just a bunch of features.

that enhances the comfort and performance in their running shoes by eliminating the rearfoot EVA foam as a shock absorber and stability material.

WHAT GIVES?

PUMA TRINOMIC is made from a Polyurethane Elastomer that "gives" but doesn't break down like EVA foam. It's configured in a pattern of interlocking hexagonal cells. The size and placement of the cells are plotted across the footbed to provide desired properties to specific portions of the foot. (See Figure 1.)

No other single technology can achieve this. The compression is determined by the TRINOMIC configuration, not by a couching medium (EVA foam) surrounding the technology. It's not only more defined cushioning, it's more complete cushioning. (See Figure 2.)

MORE CUSHIONING WHERE YOU NEED IT MOST.

As we all know, the greatest shock almost always occurs during heel strike.

By increasing the dimension of the hexagonal cell directly under the heel (See Figure 3), the TRINOMIC bed absorbs more force for greater cushioning.

This is confirmed by extensive biomechanical research and testing.

The point where the pressure is greatest on the midsole, is the point where the TRINOMIC gives the most. That's where conventional cushioning actually hardens. An EVA foam layer would reduce the cushioning and comfort.

Figure 3: **With each step, the sole gives. Softer at the heel. Firmer on the sides.**

MORE STABILITY WHERE YOU NEED IT MOST.

By decreasing the dimensions of the cells, we bring the "walls" closer together for increased firmness and stability at the medial and lateral edges around the heel "sweet spot". This provides greater structure and stability to reduce injury. Because no additional structures are necessary to provide all this support,

Figure 4: **Unlike EVA foam, which loses a third of its cushioning within a few hundred miles, PUMA's TRINOMIC maintains 90% of its cushioning properties for the life of the shoe.**

TRINOMIC is very flexible, allowing natural rear and forefoot movement throughout the gait cycle.

MORE MILES.

From the day you put on a new pair of EVA foam midsoled running shoes, the cushioning starts hardening. And the cushioning degrades more with every step. (See Figure 4.) Then it's just a matter of time until your body asks you to get rid of them.

It could be that first twinge in your knee. Or your ankle. Or your back. But the issue is the same: If you wear them today, will you be off the road tomorrow?

Life has enough stress.

TRINOMIC Technology was designed to relieve it. Because, TRINOMIC does not degrade as fast as EVA foam. While compression set reduces the performance of EVA foam cushioning to below 70% within a few hundred miles, the PUMA TRINOMIC structure retains more of its cushioning properties for the life of the shoe.

PUMA TRINOMIC Concept

That means you'll now spend less time thinking about your shoes, less time looking for new shoes and more time running.

We could go on forever on PUMA TRINOMIC cushioning. But that's the beauty of it. So can you. Because it's the first running shoe to break the foam barrier.

To truly appreciate what we've

accomplished, you have to go to a retailer that carries PUMA TRINOMIC Concept and try them.

Call 1-800-662-PUMA. We'll be glad to tell you the dealer who carries it near you.

Should these be your next pair of running shoes? It wouldn't hurt.

1996: Concept, 'We'd Like to Compress the Story of Trinomic Cushioning, But We Can't'

REEBOK

Reebok was founded in 1958 by the grandsons of Joseph William Foster, who was among the first to manufacture spiked track shoes back in the 1890s. Named after a fleet-footed African gazelle, the brand was principally known for competitive running shoes and their Union Jack logo. That all changed in 1979 when Paul Fireman acquired the North American rights. The Bok rocketed to number one thanks to their new Freestyle high-top. Cushy white 'garment' leather shoes for aerobics suddenly ruled the fashion world and celebrities flocked to the fitness-obsessed brand. By 1984, Fireman was the proud owner of the entire company.

A tactile gimmick so intuitively brilliant the shoes sold themselves by the bazillion, Reebok's inflatable Pump technology reset the industry once again in 1989. The advertising message was simple, 'Pump Up and Air Out'. Millions did just that. Dominique Wilkins, Shaquille O'Neal, Michael Chang and Greg Norman were just a few of the athletes who promoted Pump. Reebok were on fire once again, but it wouldn't last forever. In 2006, adidas acquired Reebok for $3.8 billion in a furious bid to up the ante in their decades-long battle with Nike.

●

The BB5600. The shoe that puts you at the top of your game.

Whether you're going baseline on the playground or taking a foul line jumper in the Boston Garden, the Reebok BB5600 High Top has all the support, stability and comfort you'll ever need.

Take it from professionals like Dennis Johnson and Danny Ainge of the Boston Celtics and Wayman Tisdale of the Indiana Pacers. They choose the BB5600 because they can't afford to wear anything but the most technologically advanced shoe available. A shoe that provides them with the features necessary for proper support and protection.

The *Rearfoot Lacing Harness System* is one such feature. This system holds the ankle snugly inside the shoe while providing superior stability and motion control.

Forefoot Stabilizer Straps also contribute to improved motion control—control that's critical when you consider the sudden starts and stops, and quick side-to-side movements inherent to the game.

The bottom line of this shoe is its unique outsole which features our *Lateral Side-Rail Stabilizers*. It also incorporates our specially designed flex points for proper flexing, turning and stopping. And topping it all off is a padded ankle collar that ensures outstanding comfort.

The BB5600. It's what they wear in the pros. It's what you should wear on your way up.

Reebok
Because life is not a spectator sport.®

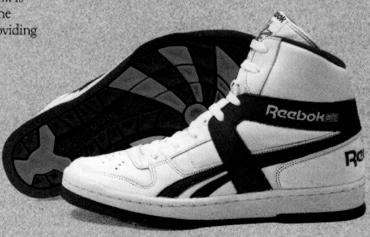

1987: BB5600, 'Reebok is Performance'

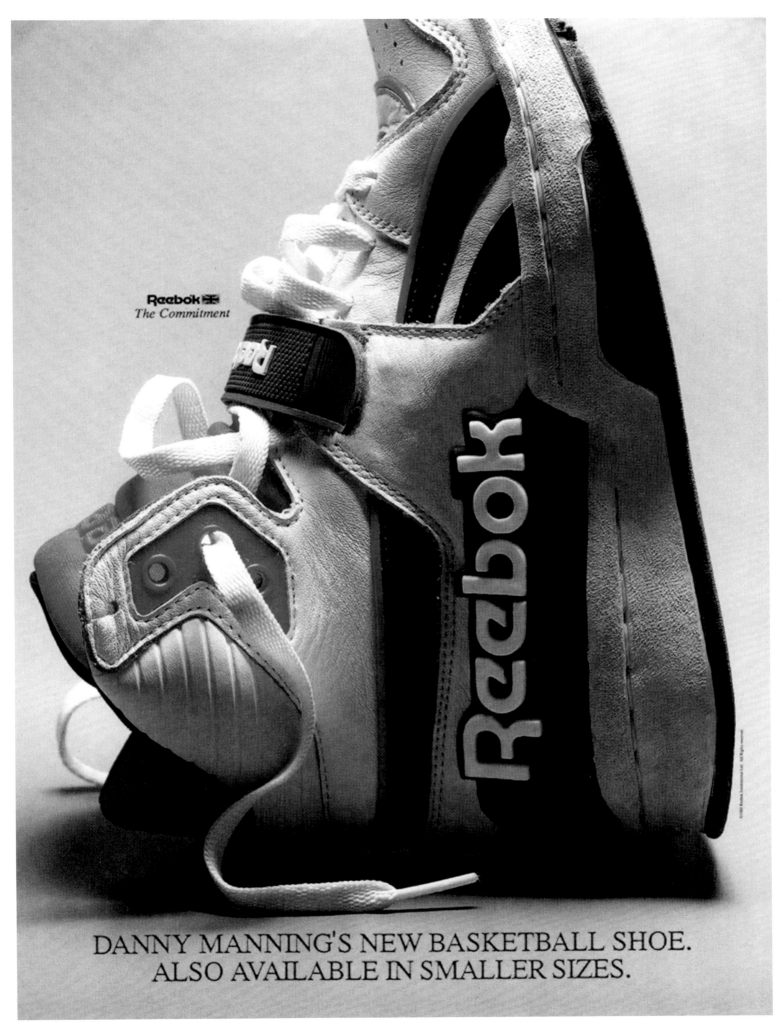

Reebok 🇬🇧
The Commitment

DANNY MANNING'S NEW BASKETBALL SHOE.
ALSO AVAILABLE IN SMALLER SIZES.

1989: Commitment, 'Danny Manning's New Basketball Shoe'

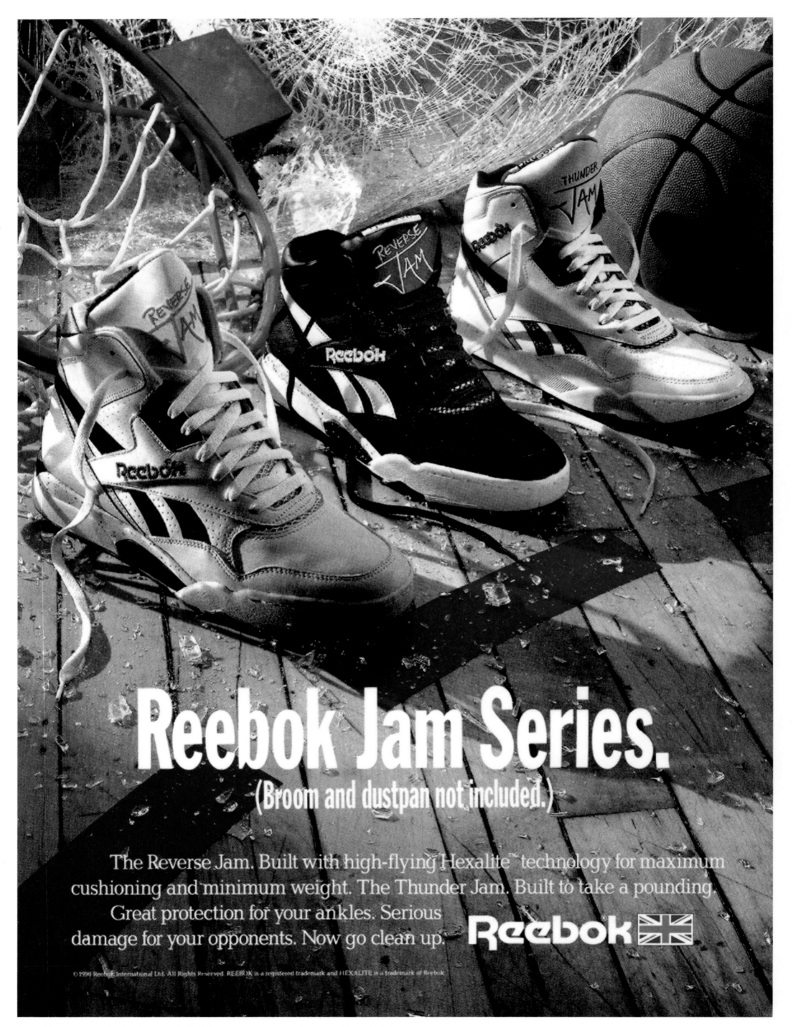

1990: Reverse Jam and Thunder Jam, 'Reebok Jam Series. (Broom and Dustpan Not Included)'

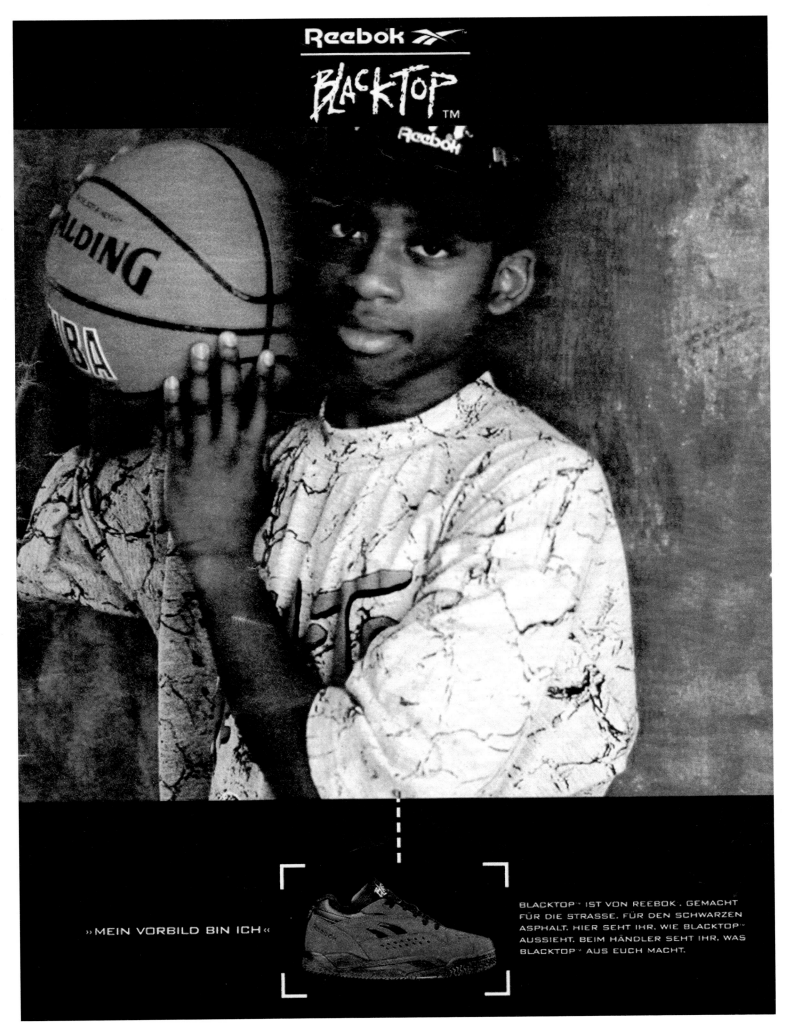

1993: Blacktop, 'I Am My Own Role Model'

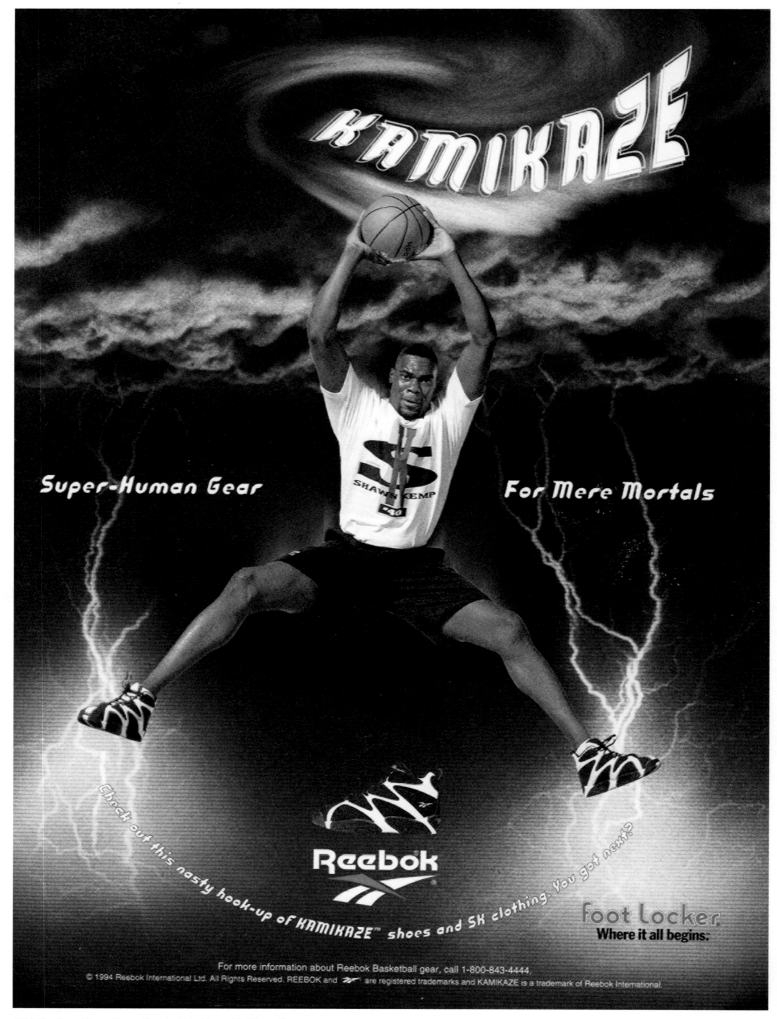

1994: Kamikaze, 'Super-Human Gear for Mere Mortals', ft. Shawn Kemp

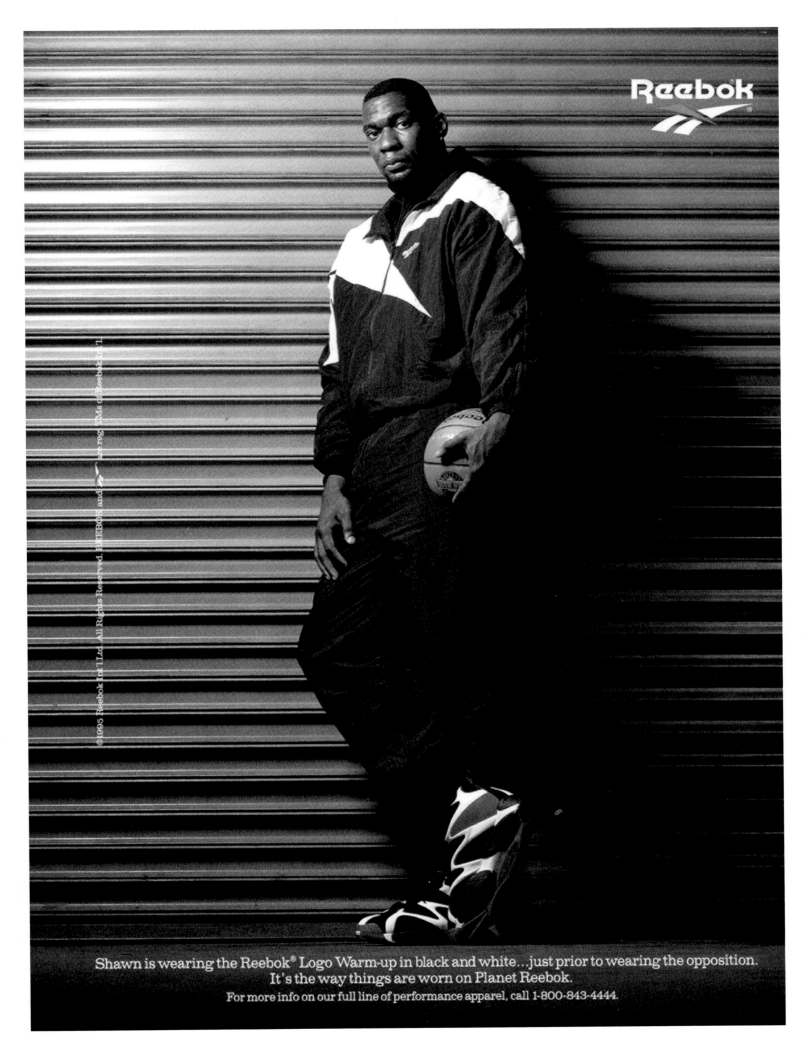

Shawn is wearing the Reebok® Logo Warm-up in black and white…just prior to wearing the opposition.
It's the way things are worn on Planet Reebok.
For more info on our full line of performance apparel, call 1-800-843-4444.

1995: Logo Warm-up and Kamikaze, ft. Shawn Kemp

Introducing the ProWorkout.™ The one fitness shoe for your total conditioning program.

The true test of a fitness shoe is how well it stands up to the rigors of a complete conditioning workout— from weight training to sprints. The ProWorkout is one shoe that can pass any test.

Years in the making, the ProWorkout represents the pinnacle of fitness shoe technology—a shoe for serious fitness athletes which was engineered and designed in close association with some of the most respected strength and conditioning coaches in the country.

For stability, the ProWorkout features a polyurethane strap that stretches across the arch for

maximum mid-foot support. Support that's critica for weightlifting and exercises that involve excessiv lateral stress.

What's more, this shoe has a special heel sup port system specifically designed to lessen the effec of pronation and supination. And our unique coll. design provides additional ankle support while still affording exceptional flexibility.

Cushioning is key, whether you're doing a few sets or a few miles. That's why we've given the ProWorkout a dual-density EVA midsole that resists compression while providing excellent stability and comfort.

The ProWorkout can also stand the test of time because it's reinforced in key stress areas with heav 420 denier nylon. It also has an extended toe-ca for added durability.

1987: ProWorkout, 'Reebok is Performance'

605

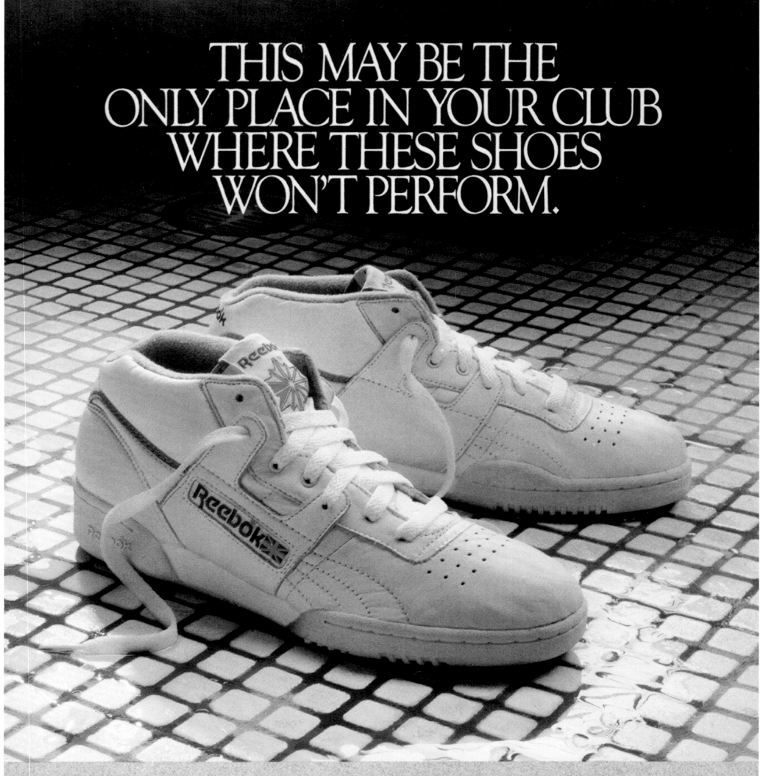

THIS MAY BE THE ONLY PLACE IN YOUR CLUB WHERE THESE SHOES WON'T PERFORM.

They will perform in the weight room, exercise class, on the track and racquetball court. The Reebok Workout Mid-Cut is the one shoe designed to take you through your toughest fitness routine and give your feet all the support and cushioning they need.

Technical features of several sport-specific shoes are combined in the Workout. Our patented H-strap and ¾ height offer outstanding support for weight training. The maximum cushioning and forefoot flexibility make these suitable for light running. Heel and toe wraps provide lateral stability for court sports. And, our notched back tabs allow your feet to flex more freely.

When you work out, put your feet into the Reebok Workout Mid-Cut.

Also available in leather Low-Cut, for men and women. Leather/mesh Low-Cut for men only.

Reebok® Because life is not a spectator sport.™

1986: Workout Mid-Cut, 'This May Be the Only Place in Your Club Where These Shoes Won't Perform'

We didn't pay the top strength coaches just to endorse the Reebok Sports Conditioning shoe.

1988: Sports Conditioning, 'We Didn't Pay the Top Strength Coaches Just to Endorse the Reebok Sports Conditioning Shoe' (1 of 2)

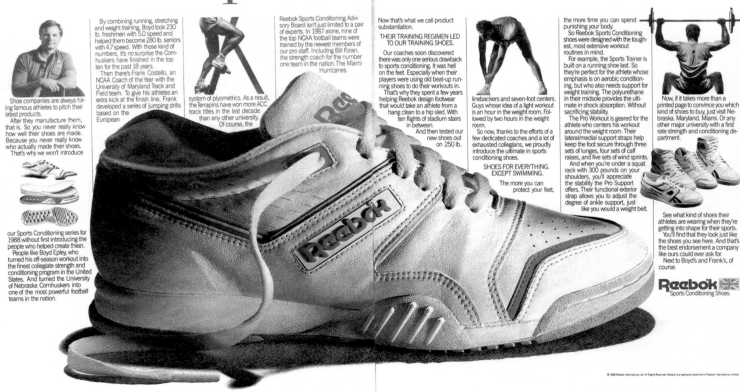

1988: Sports Conditioning, 'We Paid Them to Invent It' (2 of 2)

Before.

After.

1989: AXT, SXT and CXT, 'The Physics Behind the Physiques'

Introducing the Cross-Training System by Reebok.

Three shoes designed for any kind of workout, starting with what you do best.

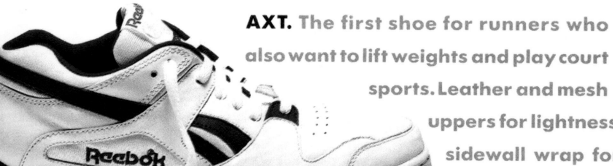

AXT. The first shoe for runners who also want to lift weights and play court sports. Leather and mesh uppers for lightness. Forefoot sidewall wrap for stability. You can run, and you won't have to hide.

speed
$$V = \frac{2\pi R}{C} N$$

power
$$P = \frac{W}{t}$$

SXT. The first shoe for weight lifters who also want to run and play court sports. Midfoot and ankle straps for maximum support. Wide base ensures maximum stability for you, and total insecurity for everyone around you.

CXT. The first shoe for court players who also want to run and lift weights. Midfoot strap for medial support. Midfoot sidewall for lateral support. Good for adjusting the attitude of that poor geek who beat you in tennis last week.

force
$$F = ma$$

The physics behind the physiques.™

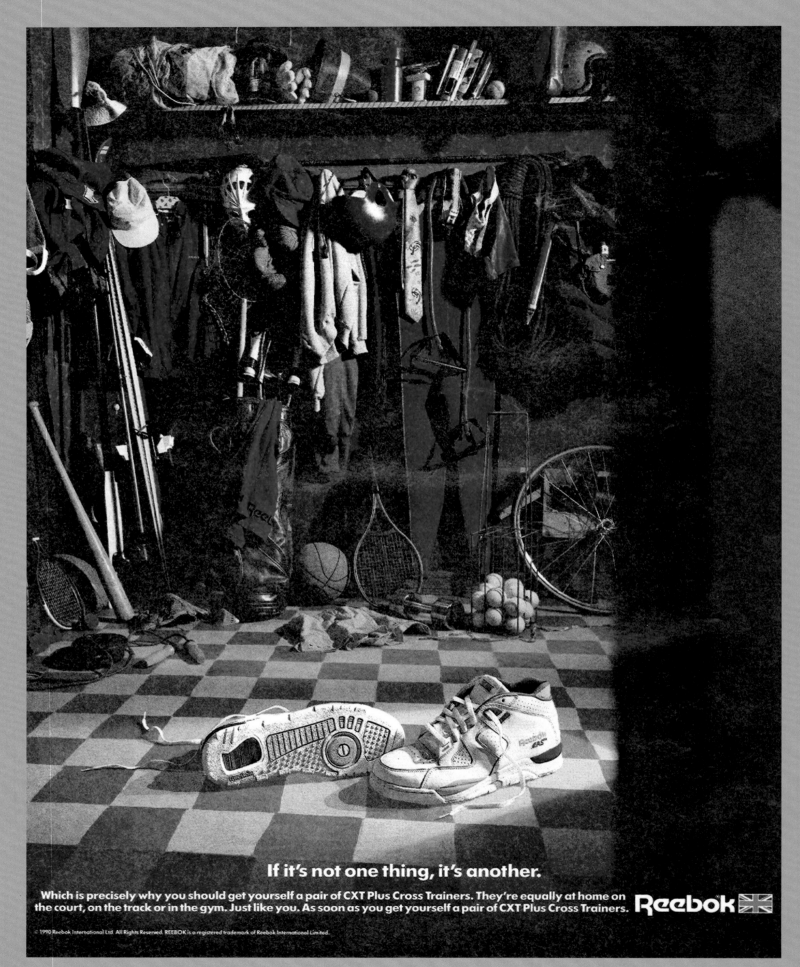

1990: CXT Plus, 'If It's Not One Thing, It's Another'

1989: CXT Ultra

" In 1989, Reebok finally entered the cross-training design war. Since the success of their Freestyle model for women, Reebok hadn't maintained their innovative credibility but with the brilliant gimmickry of Pump, they suddenly had a potent new weapon on their hands. Models such as the ProWorkout, SXT, CXT, AXT and Paydirt were released, the latter worn by baseballer Roger Clemens and Emmit Smith from the Dallas Cowboys. By 1992, trends shifted once again. Neon colours had run their course and sophisticated tastes craved more subdued hues and hiking-inspired euro-style. Expressed through pop culture – using athletes as entertainers – cross-training was exactly what Nike needed to steal market share back from Reebok and reclaim their number-one status. **"**

Nick Santora
'Cross-Training'
Sneaker Freaker, issue 24 (2012)

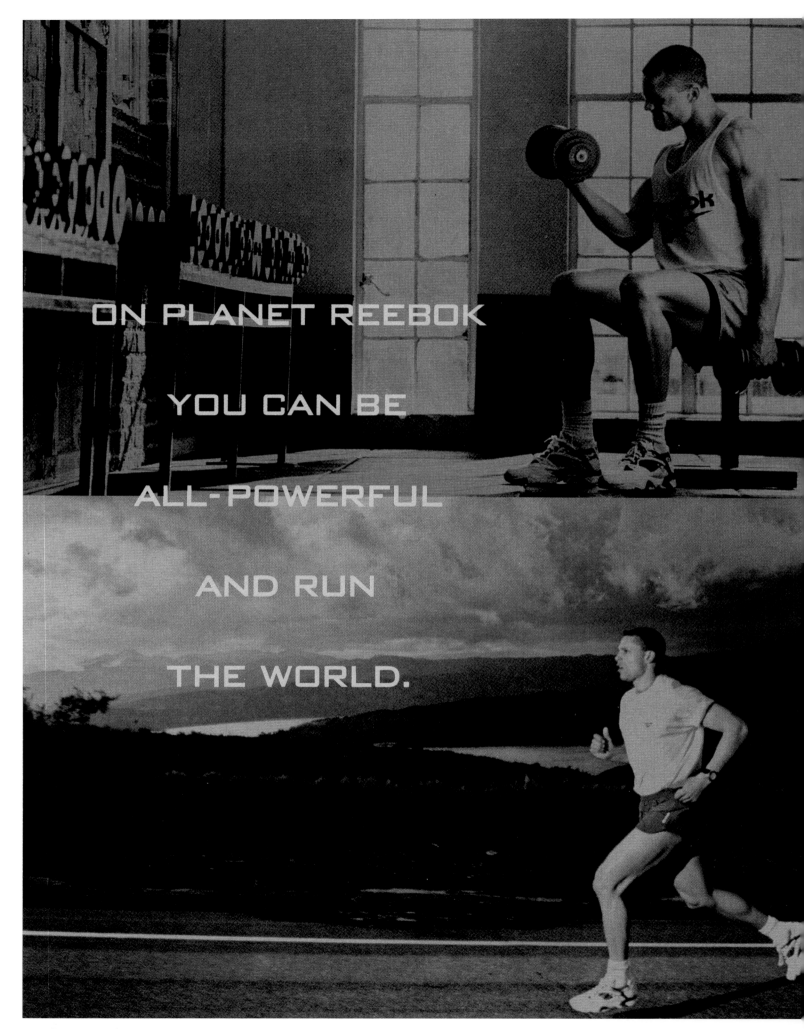

ON PLANET REEBOK

YOU CAN BE

ALL-POWERFUL

AND RUN

THE WORLD.

1993: GraphLite Pro, 'On Planet Reebok You Can Be All-Powerful and Run the World'

PLANET REEBOK

THE REEBOK GRAPHLITE® PRO IS THE FIRST CROSS-TRAINING SHOE THAT'S ACTUALLY FIT TO RUN IN. (YOU READ IT RIGHT...YOU CAN ACTUALLY RUN IN IT.) BECAUSE THE GRAPHLITE PRO ISN'T JUST BUILT FOR PUMPING IRON. IT'S ALSO DESIGNED FOR CHEWING UP ASPHALT. THIS VERSATILITY IS DUE TO A GRAPHLITE BRIDGE UNDER THE ARCH INSTEAD OF THE USUAL CLUMP OF RUBBER. AND FOREFOOT FLEX GROOVES INSTEAD OF A CONVENTIONAL RIGID SOLE. SO INSTEAD OF CLOMPING AROUND ON PLANET EARTH IN CROSS-TRAINING SHOES THAT ARE LITTLE MORE THAN RUNNING JOKES, GET INTO A PAIR OF GRAPHLITE PROS. YOU'LL FEAR NO MAN. AND STILL BE READY TO TURN AND RUN.

Reebok

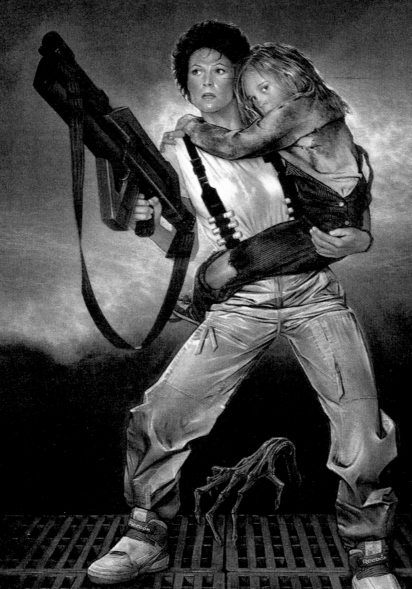

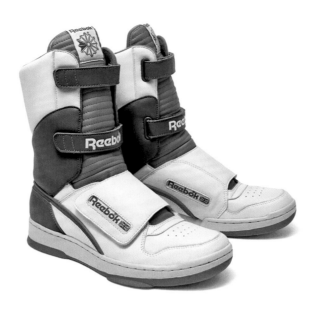

" The year is 1986. Having just made *Terminator*, James Cameron is entrusted with directing the sequel to *Alien*, Ridley Scott's masterclass in claustrophobic film noir. As history shows, *Aliens* wasn't just a half-decent follow-up, it more than held its own. Cameron also managed to defy genre standards by creating one of the first female action heroes. Sigourney Weaver's character Ellen Ripley was a fearless 'Rambolina' who kicked Xenomorph ass with a pulse rifle in one hand and Reebok boots on her feet. Along with her striking Seiko watch, the grey, white and bright red hightops were a stark contrast against the drab military garb worn by her squadmates. According to Reebok, the 'Aliens Fighter Shoe' wouldn't be released for 150 years – a nod to the film's 2136 setting – though a limited run of mid-cut 'Alien Stompers' did hit Japanese stores in 1987. "

'The Aliens Fighter is Back!'
Sneakerfreaker.com (2016)

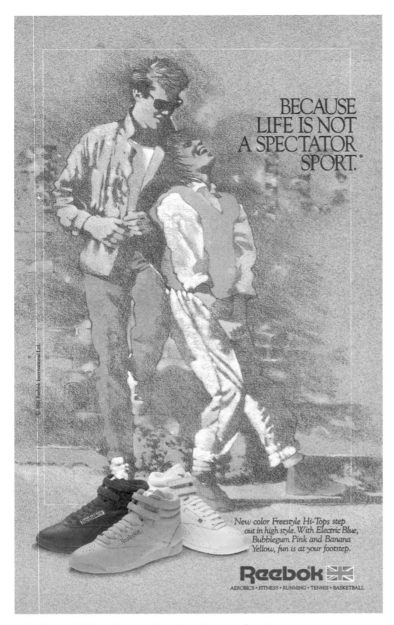

1986: Freestyle Hi-Top, 'Because Life is Not a Spectator Sport'

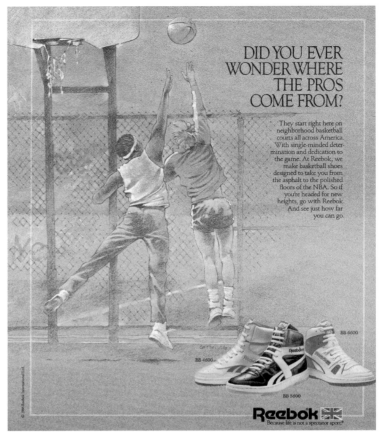

1986: BB 4600, BB 5600 and BB 6600,
'Did You Ever Wonder Where the Pros Come From?'

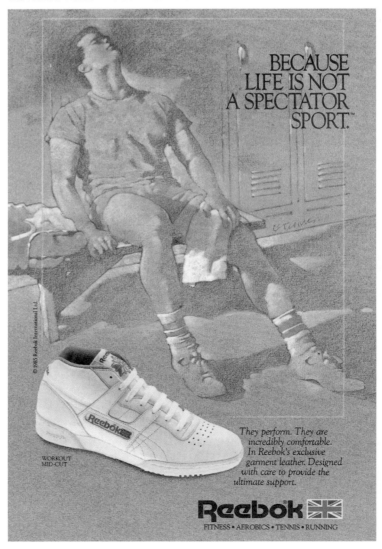

1986: Workout Mid-Cut, 'Because Life is Not a Spectator Sport'

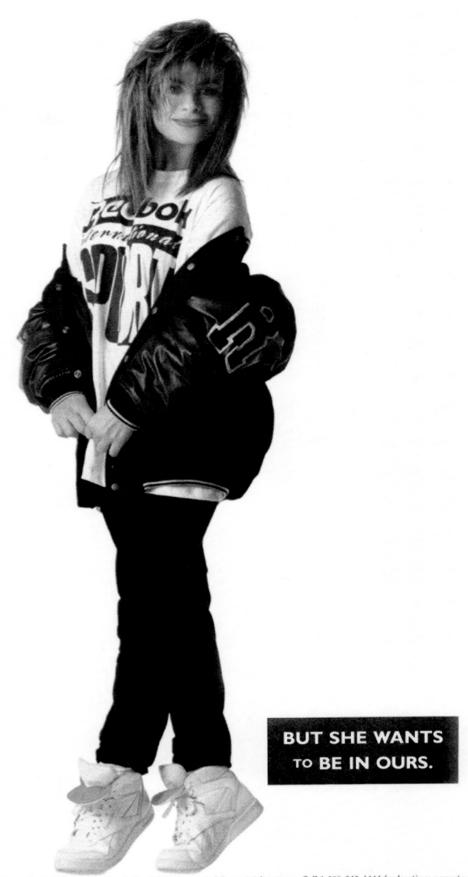

MILLIONS OF GIRLS WANT TO BE IN HER SHOES.

BUT SHE WANTS TO BE IN OURS.

Paula Abdul is wearing shoes from the Dance Reebok® Collection. Available at department and fine specialty stores. Call 1-800-843-4444 for locations nearest you.

1989: Dance Reebok Collection, 'Millions of Girls Want to Be in Her Shoes. But She Wants to Be in Ours', ft. Paula Abdul

LISTEN TO THE BEAT OF THE STREET.

Take a walk on the wild side with the hottest look on the street: Reebok's new
Freestyle Hi-Top. It's all leather—soft garment leather to fit you like a second skin. It's sizzling
high-fashion—in black or white or red all over. And when you feel like dancing
or strutting your stuff, it'll make your every move magic!

Reebok ®
FREESTYLE HI-TOP™

1985: Freestyle Hi-Top, 'Sizzlin' Hot Reebok'

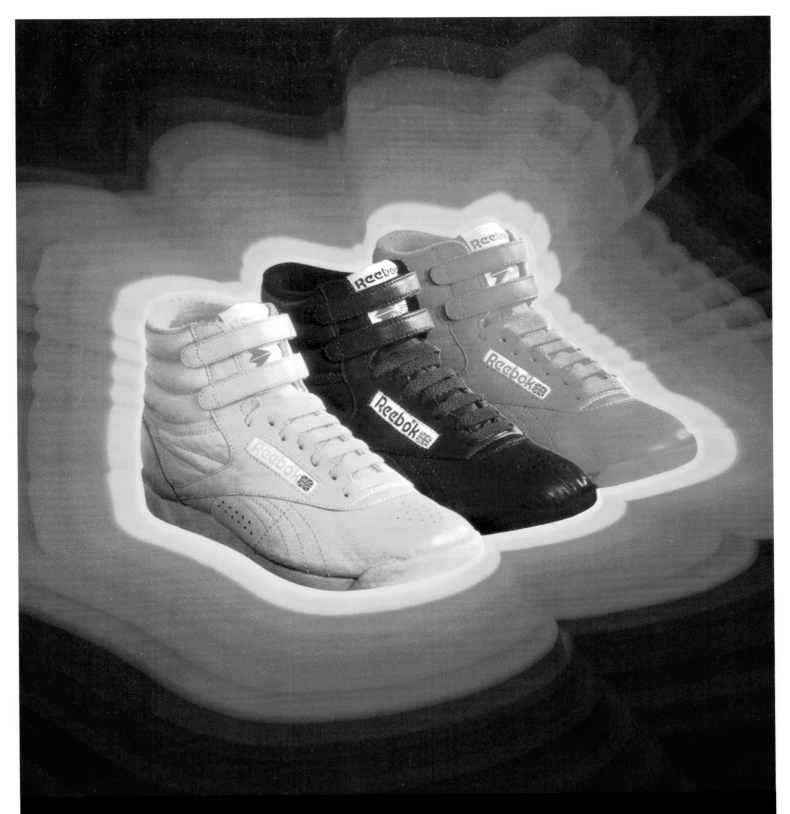

SIZZLIN' HOT NEON.

Neon <u>Freestyle Hi-Tops.</u> Perfect for aerobics and for the fun of it all.
Kick up your heels in soft Reebok garment leather. Now in bold new colors that
make even a rainbow blush. Also available in red, black, grey or white.

Reebok®
Because life is not a spectator sport.™

1985: Freestyle Hi-Top, 'Sizzlin' Hot Neon'

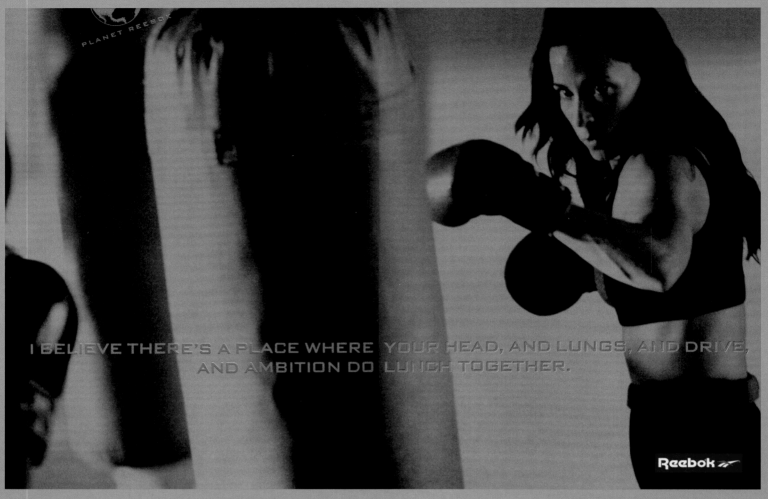

1993: 'I Believe There's a Place Where Your Head, and Lungs, and Drive, and Ambition Do Lunch Together' (1 of 3)

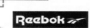

1993: Hyperlite, City Beat, Aerostep Pro and Weathermax,
'The Place is Planet Reebok, and There Are Lots of Ways to Get There' (2 of 3)

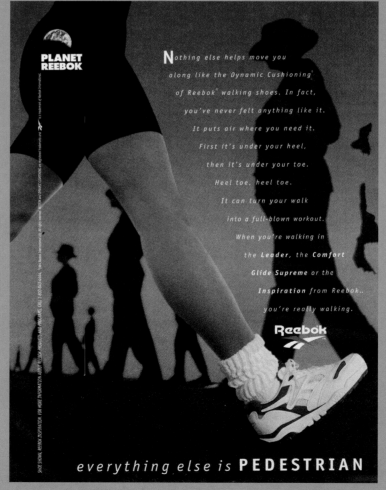

1993: 'Everything Else is Pedestrian' (3 of 3)

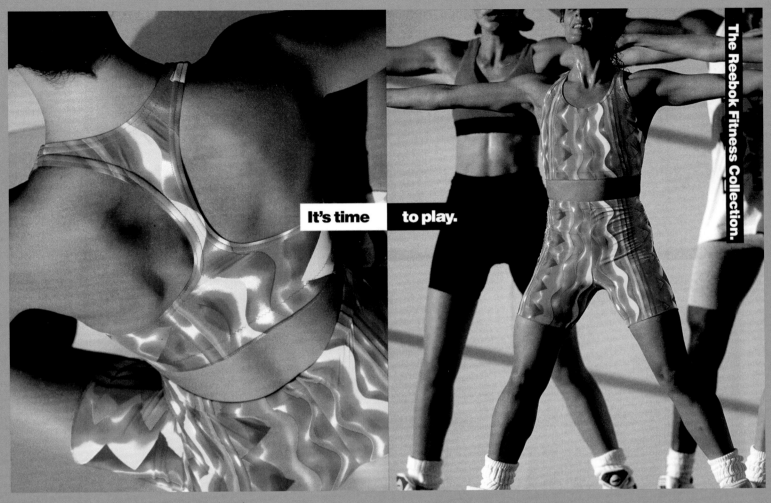

The Reebok Fitness Collection.

It's time to play.

1991: Reebok Fitness Collection, 'It's Time to Play' (1 of 2)

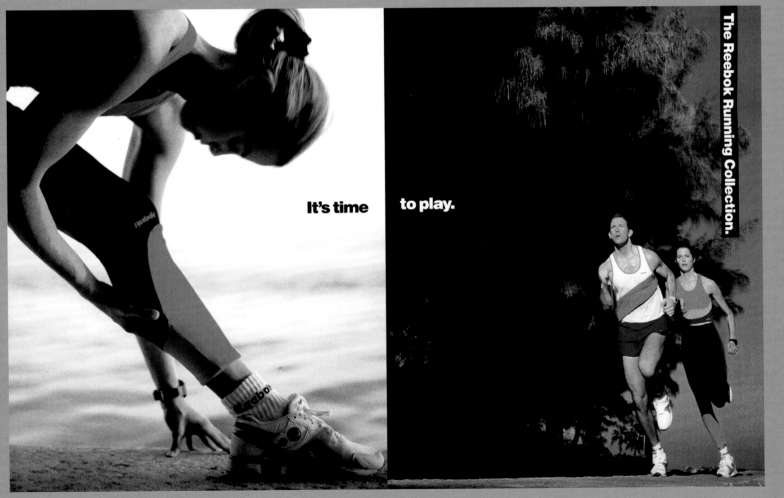

The Reebok Running Collection.

It's time to play.

1991: Reebok Running Collection, 'It's Time to Play' (2 of 2)

Official shoe of the Varsity Cello Team, University of Wisconsin at Madison.

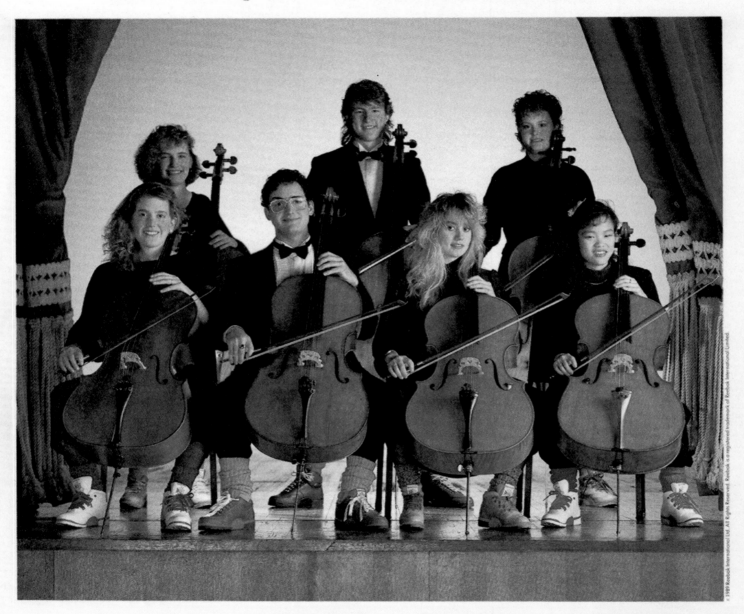

For years, they labored in obscurity. No stadium gigs. No flashy entourage. It seemed the Varsity Cello Team would never be discovered.

Then came the Reebok Rugged Walker national talent search. The competition was fierce, the odds weren't in their favor. It all came down to these guys and a naked kazoo marching band from Georgetown.

This being a family magazine, discretion won out. So congratulations to the Varsity Cello Team for winning a free trip to *Rolling Stone*'s Spring Break in Daytona Beach, Florida. Like we always said. With Reebok Rugged Walkers, there's no telling how far you can go.

Reebok

1989: Rugged Walker, 'Official Shoe of the Varsity Cello Team, University of Wisconsin at Madison'

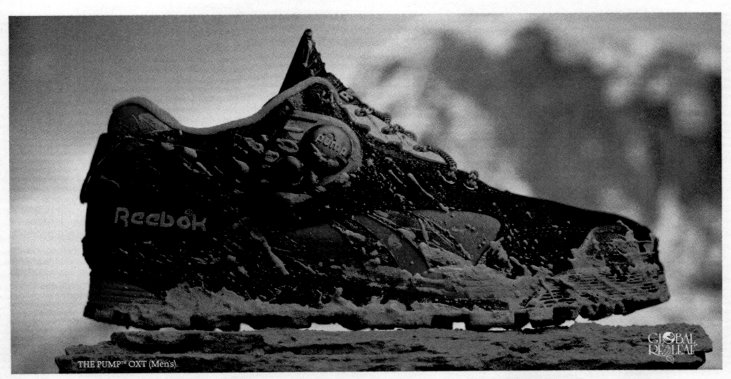

THE PUMP™ OXT (Men's).

REEBOK INTRODUCES OFF-ROAD VEHICLES FOR YOUR FEET.

For all of you who want to spend more time in the outdoors, Reebok introduces a category

of shoes designed to get you there. It's called Reebok® Outdoor. And it's led by an Outdoor Training (OXT)

Collection for everything from mountain biking to hiking. Featuring THE PUMP™ OXT shoe, for custom fit and

support, the collection boasts water resistant Nu-Buc leather, lightweight Hexalite™ cushioning, and high

abrasion soles. Plus, during September and October every time you buy a pair of shoes from the OXT

collection, Reebok and Global ReLeaf® will plant a tree in your name.* So pick up a pair. After all,

not only will they help you get back to the outdoors, they'll actually help preserve it.

OXT MID (Men's) OXT MID (Men's) OXT LO (Men's & Women's)

OUTDOOR

1991: OXT Outdoor Training Collection, 'Reebok Introduces Off-Road Vehicles for Your Feet'

Pump it up.

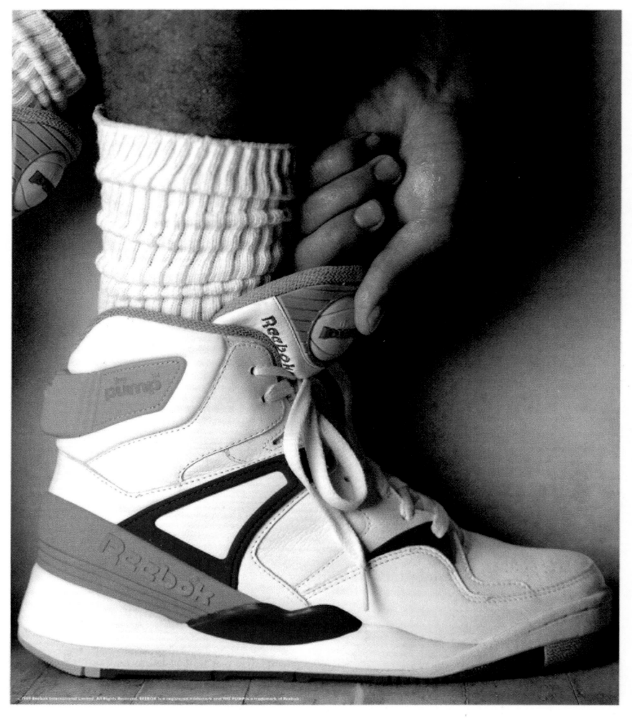

Introducing The Pump™ by Reebok. It's the first shoe with a built-in pump that inflates to give you a personalized fit you control with your fingertips. You pump up by squeezing the ball on the tongue, and release air with the valve on back. You've never seen or felt a shoe like this before. Check it out. **Reebok** Basketball

" On November 24, 1989, Reebok Pump ('A new idea that's going to fly') hit shelves. Complete with a 'deflate' button on the heel, the basketball branding was instantly appealing and the $170 price tag lofty enough to confer aspirational status. It's still a crazy price all these years later, but remember kids, this was the 80s and bigger was infinitely better. Will we ever see another period of creativity, sneaker brand warfare and bizarre one-upmanship like the first chapter of the Pump story? Doubtful. Things are shrewder, safer and positively blander in comparison. The Pump system and all the attention surrounding it deserves much, much more than to remain a footnote in accounts of just how outrageous the late 80s and early 90s were. This was a boomtime for Reebok and the results were some of the most exciting shoes of the decade. "

Woody
'The Greatest Story Never Told'
Sneaker Freaker, issue 16 (2009)

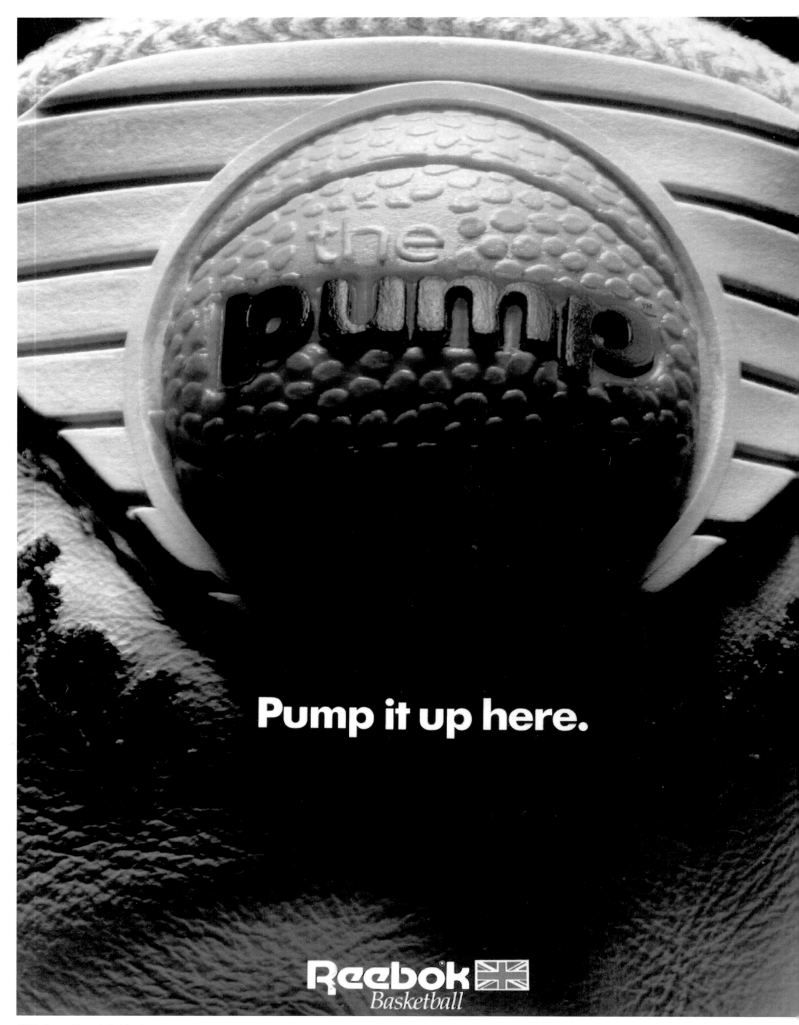

1990: Pump, 'Pump It Up Here'

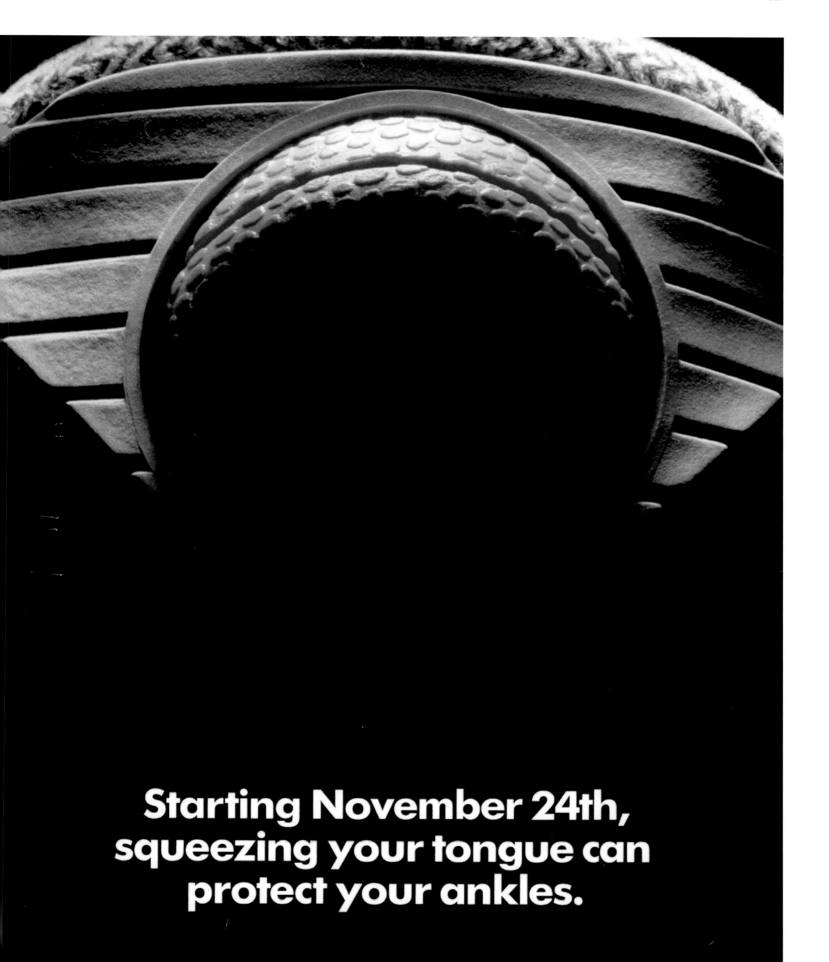

Starting November 24th, squeezing your tongue can protect your ankles.

No Two Feet Are Alike. Not Even Your Own.

1990: Pump, 'No Two Feet Are Alike. Not Even Your Own' (1 of 3)

Had a good look at your feet lately? Unlike shoes, they do not come in standard sizes.

In fact, they actually change size and shape significantly over the course of a ball game.

Your shoes, on the other hand, are formed on a last to fit the average person with the average foot. Which, unfortunately, doesn't exist. So it's a safe bet you've never had the benefit of playing ball in two shoes that really fit.

With THE PUMP™ System, you will. Because

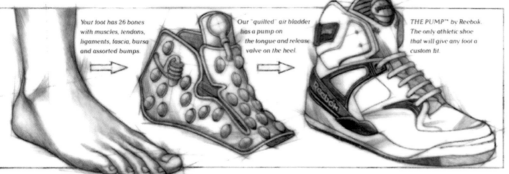

Your foot has 26 bones with muscles, tendons, ligaments, fascia, bursa and assorted bumps.

Our "quilted" air bladder has a pump on the tongue and release valve on the heel.

THE PUMP™ by Reebok. The only athletic shoe that will give any foot a custom fit.

THE PUMP technology lets you customize the shape of each shoe to fit the precise shape of each foot.

What makes it possible is a construction that integrates an inflatable urethane bladder, with an air compressor at the top of the tongue and a pressure release valve on the heel.

So when you first lace up THE PUMP, it fits pretty much like the athletic shoe you wear now. But when you press the orange ball, you inflate the lining until it molds to the shape of your foot. Much like a good ankle wrap. Only a lot more comfortable.

The air bladder is "quilted" to control the amount of air you can pump into specific locations around your foot. Less to the places where the foot flexes. More to the hard-to-fit areas like the hollow between your heel and ankle, where you ordinarily find gaps between the foot and shoe.

In ordinary athletic shoes, these gaps give the foot room to slide around. And once you've worn THE PUMP, you'll realize just how much your feet do move in ordinary athletic shoes. No matter how tightly you lace them.

And that movement can affect your game.

Because when you're making a move, you want your shoes to be doing the same thing as your feet. And if they aren't, you have to make adjustments. Adjustments that do nothing for your concentration or confidence. With THE PUMP™ from Reebok,® you just adjust the fit in each shoe.

So, will THE PUMP make a difference in your game?

Anyone will tell you the single most important performance feature in any athletic shoe is fit. And you can't get a better fit from any shoe.

Go down to your local athletic shoe retailer and try on THE PUMP™ by Reebok. For the first time you'll appreciate the difference between ordinary athletic footwear and two shoes that are custom fit to your feet.

And don't be surprised if, compared to THE PUMP, your other shoes suddenly feel like they don't fit. Because the truth of the matter is, they probably don't.

the pUMP

Performance Under Maximum Pressure

Reebok®

Next time you take your shoes off, stand with your heels against a wall and, with your feet together, take a look at your toes. According to statistics, your left foot is probably bigger than your right. (Don't worry if it's the reverse, you're still quite normal.) And if it were possible to compare their profile, you'd see a surprising difference there, too.

Your shoes, on the other hand, are virtually identical. And therein lies the problem. They're formed to fit the average person with the average foot. Which, unfortunately, doesn't exist. So it's a safe bet you've never had the benefit of performing in two shoes that fit exactly.

With THE PUMP™ System, you will. Because THE PUMP technology lets you customize the shape of each shoe to fit the precise shape of each foot.

THE PUMP.™ With the full bladder system, your entire foot is surrounded by pillows of air. The inner lining of the shoe inflates to give you the extra ankle, mid-foot and heel support that's crucial for better mobility.

What makes it possible is a construction that integrates an inflatable urethane bladder with an air compressor and a release valve.

The air bladder is "quilted" to control the amount of air you can pump into specific locations around your foot. Less to the places where the foot flexes. More to the hard-to-fit areas where you normally find gaps between the foot and shoe.

In ordinary athletic shoes, these gaps give the foot room to slide around. And once you've worn THE PUMP™ shoe, you'll realize just how much your feet do move in ordinary athletic shoes. No matter how tightly you lace them. And that movement can affect your performance.

Because ideally, your shoes should be doing the same thing as your feet. And if they aren't, you have to make adjustments. Adjustments that do nothing for your concentration or confidence. With THE PUMP from Reebok®, you just adjust the fit in each shoe.

Drop in to your local athletic shoe retailer and try on a pair.

But don't be surprised if, compared to THE PUMP™ shoes, your other shoes suddenly feel like they don't fit. Because the truth of the matter is, they probably don't.

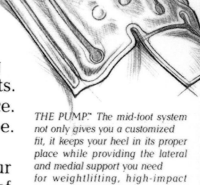

THE PUMP.™ The mid-foot system not only gives you a customized fit, it keeps your heel in its proper place while providing the lateral and medial support you need for weightlifting, high-impact aerobics, basketball or tennis.

Call 1-800-843-4444 for the athletic specialty store nearest you.

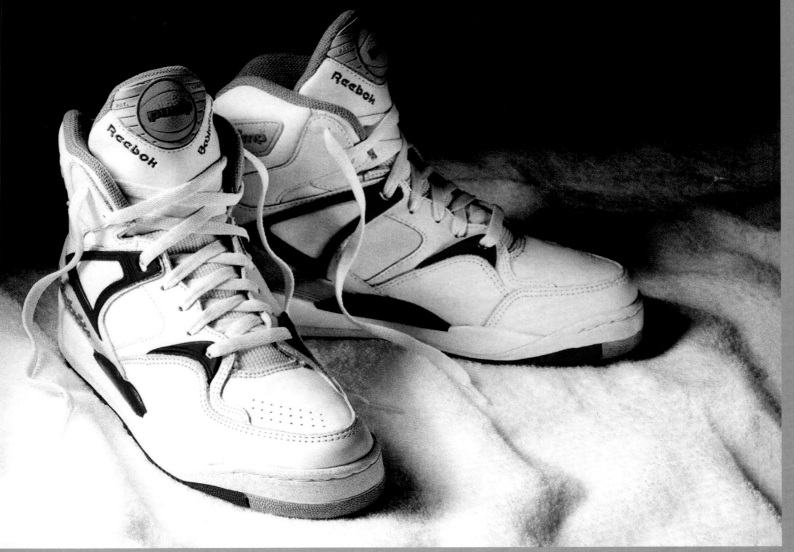

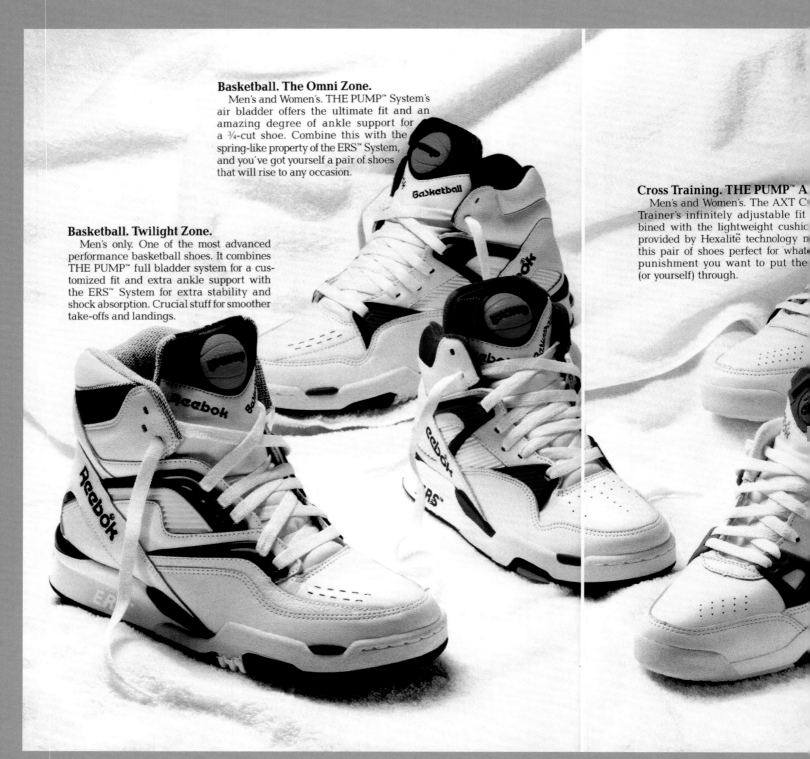

Basketball. The Omni Zone.

Men's and Women's. THE PUMP™ System's air bladder offers the ultimate fit and an amazing degree of ankle support for a ¾-cut shoe. Combine this with the spring-like property of the ERS™ System, and you've got yourself a pair of shoes that will rise to any occasion.

Basketball. Twilight Zone.

Men's only. One of the most advanced performance basketball shoes. It combines THE PUMP™ full bladder system for a customized fit and extra ankle support with the ERS™ System for extra stability and shock absorption. Crucial stuff for smoother take-offs and landings.

Cross Training. THE PUMP™ A

Men's and Women's. The AXT C Trainer's infinitely adjustable fit bined with the lightweight cushic provided by Hexalite™ technology m this pair of shoes perfect for whate punishment you want to put the (or yourself) through.

1990: Twilight Zone, Omni Zone, AXT, SXT, Aerobic Lite and Court Victory (3 of 3)

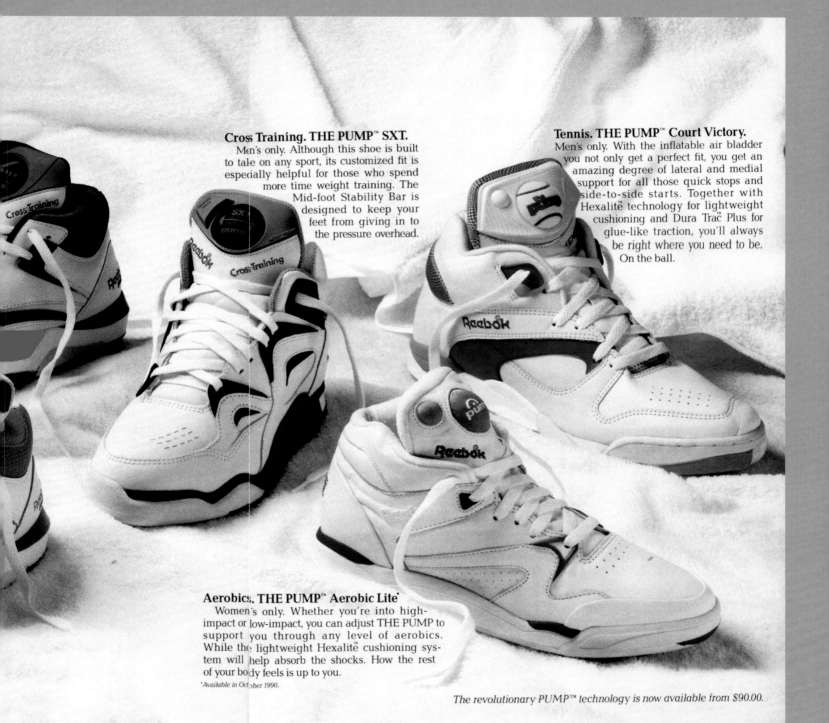

Cross Training. THE PUMP™ SXT.
Men's only. Although this shoe is built to take on any sport, its customized fit is especially helpful for those who spend more time weight training. The Mid-foot Stability Bar is designed to keep your feet from giving in to the pressure overhead.

Tennis. THE PUMP™ Court Victory.
Men's only. With the inflatable air bladder you not only get a perfect fit, you get an amazing degree of lateral and medial support for all those quick stops and side-to-side starts. Together with Hexalite™ technology for lightweight cushioning and Dura Trac™ Plus for glue-like traction, you'll always be right where you need to be. On the ball.

Aerobics. THE PUMP™ Aerobic Lite*
Women's only. Whether you're into high-impact or low-impact, you can adjust THE PUMP to support you through any level of aerobics. While the lightweight Hexalite™ cushioning system will help absorb the shocks. How the rest of your body feels is up to you.

*Available in October 1990.

The revolutionary PUMP™ technology is now available from $90.00.

HOW TO ADJUST FOR INFLATION.

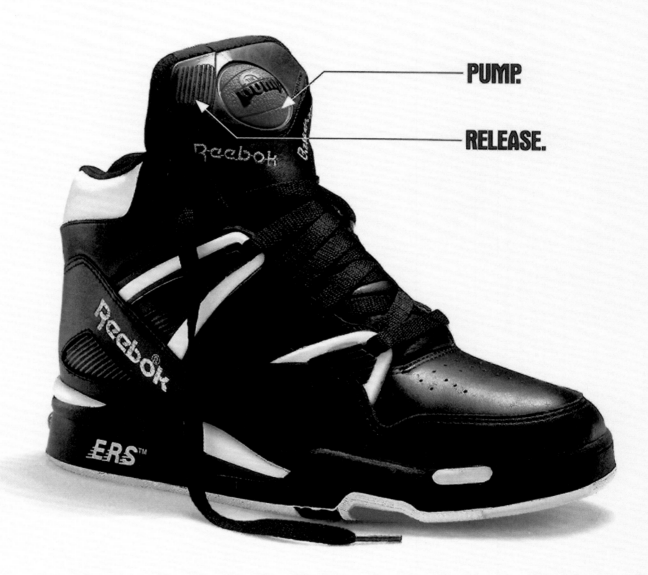

PUMP.

RELEASE.

Times are tough these days. 🇬🇧 And when the going gets tough, the tough get THE PUMP™ from Reebok. Whether it's basketball, tennis or cross-training, THE PUMP™ System can give you the edge. 🇬🇧 But first you've got to give them a squeeze. Right on the tongue. And before you know it, 🇬🇧 you'll have a custom fit. You see, the shoes' pump and release valves fill internal quilted air chambers that mold around the shape of your foot, giving you the added control you need. 🇬🇧 And if you have a pair of THE PUMP™ Omni Zone Basketball Shoes, you can inflate the lining to give you extra ankle and mid-foot support. 🇬🇧 THE PUMP™ from Reebok. 🇬🇧 The world's most advanced athletic performance shoe you fill with air. If only Congress could control inflation this easily.

Reebok 🇬🇧
It's time to play.™

1990: Omni Zone, 'How to Adjust for Inflation'

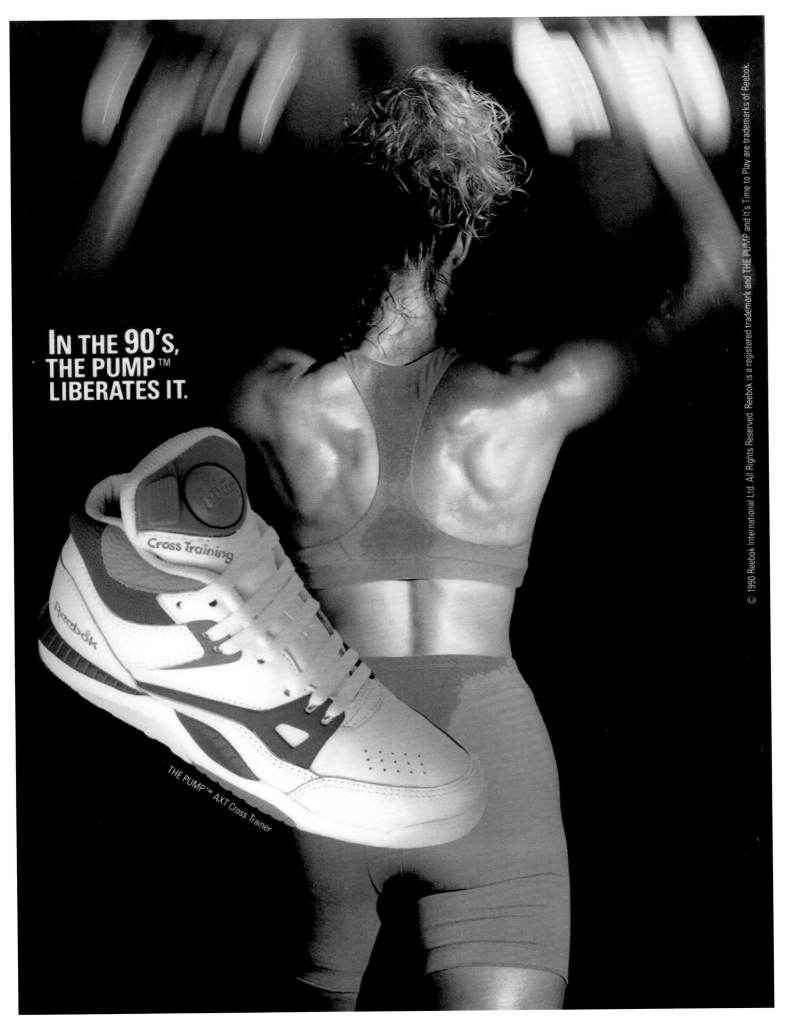

IN THE 90'S, THE PUMP™ LIBERATES IT.

Cross Training

THE PUMP™ AXT Cross Trainer

1990: AXT, 'In the 90's, the Pump Liberates It'

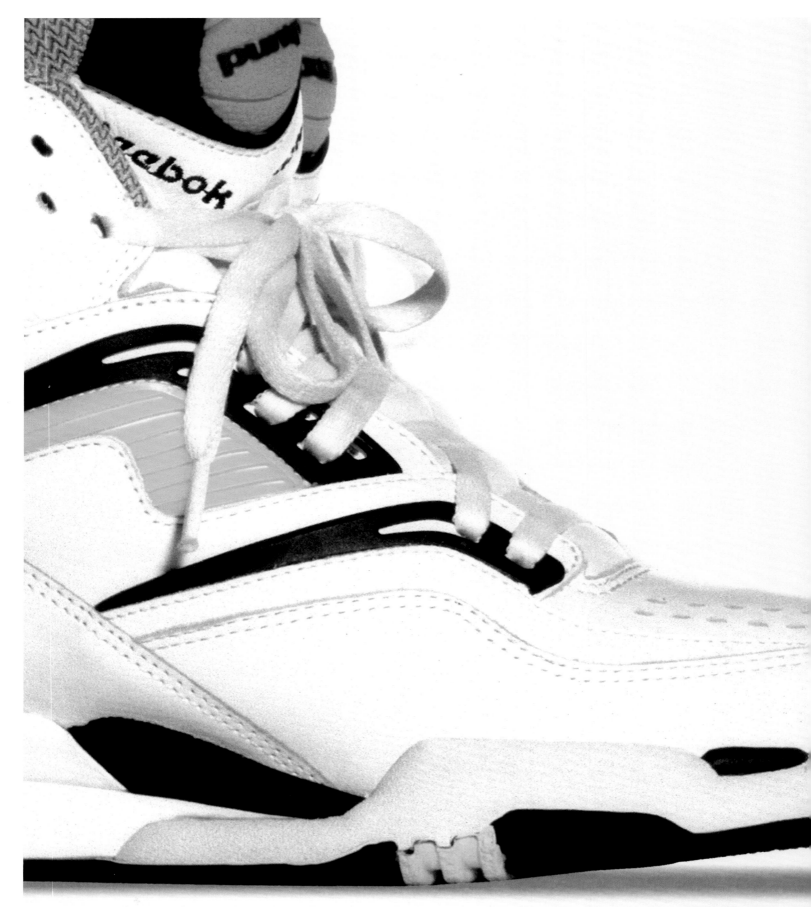

You may not be big enough to play Dominique Wilkins. B

We've taken Dominique's favorite shoes (size 13), and customized them especiall

1990: Pump, 'You May Not Be Big Enough to Play Dominique Wilkins. But You're Big Enough to Wear His Shoes'

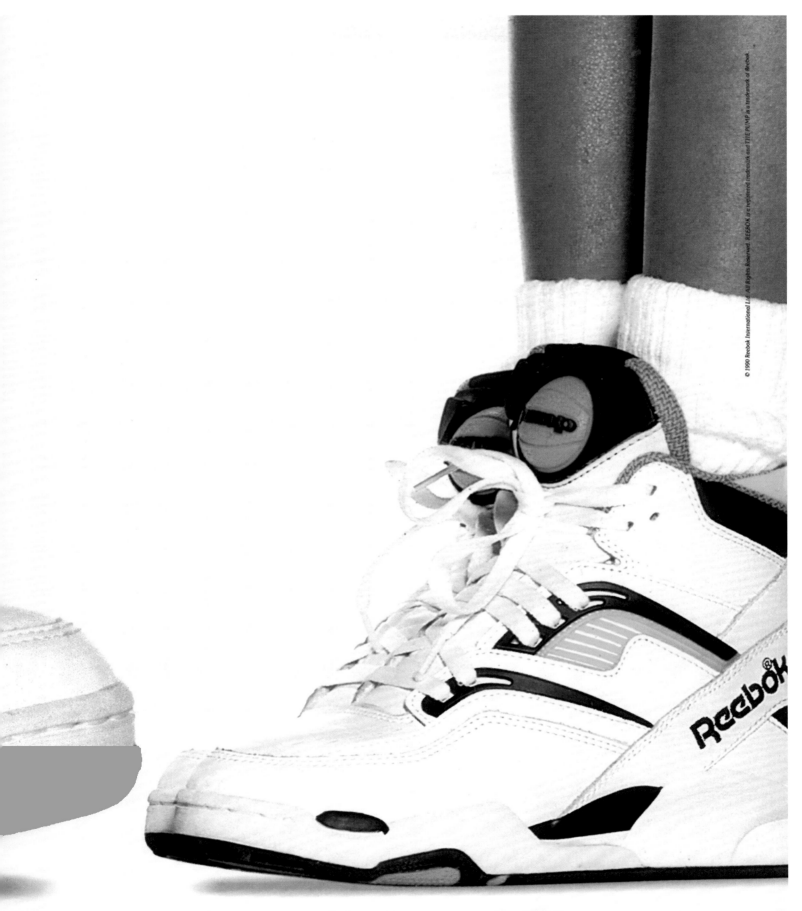

ou're big enough to wear his shoes.

ds* (boys', size 12½ through 6). So look out big guy.

TO LOWER THE RIM JUST FLIP THE SWITCH.

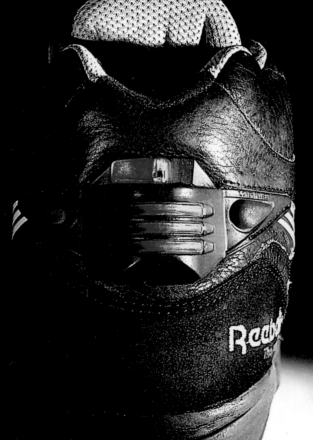

It's just above your heel. A two-way valve that regulates the flow of air through THE PUMP™ dual chamber system in Reebok's newest basketball shoe. Turn it to the left and fill the upper chamber for custom support. Switch to the right to fill the footbed chamber for custom cushioning. Then just add your two feet to fill your opponent with fear.

LIFE IS SHORT. PLAY HARD.

Reebok

1991: Pump, 'To Lower the Rim Just Flip the Switch'

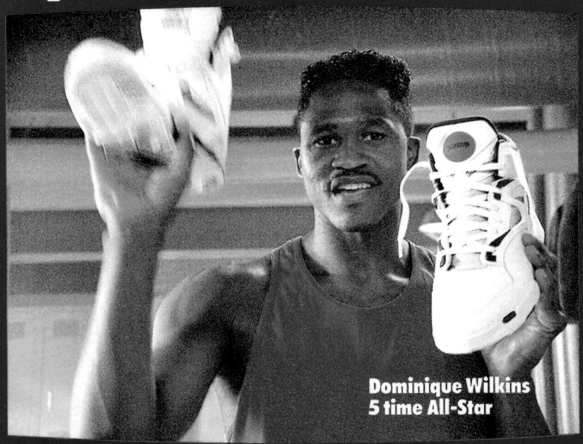

"Michael, my man, if you want to fly First Class...

Dominique Wilkins
5 time All-Star

Pump up *and Air out!"*

Reebok **pump**
THE

Reebok 🇬🇧

1991: Pump, 'Michael, My Man, if You Want to Fly First Class…Pump Up and Air Out!', ft. Dominique Wilkins

MICHELLE GERARD ■ AERIAL FREESTYLE SKIER

As a U.S. World Cup Freestyle Ski Jumper, Michelle Gerard
did a lot of cross-training. But this year she's training even harder. Running three
miles a day. Biking seventy-five miles a week. And doing aerobics everyday.
Because this winter, Michelle plans to make the biggest jump of her career. All the
way from amateur to pro status, a jump that will allow Michelle Gerard
to earn a living doing what she's always done best. And in the process, achieve
something she's always wanted, a personal best.

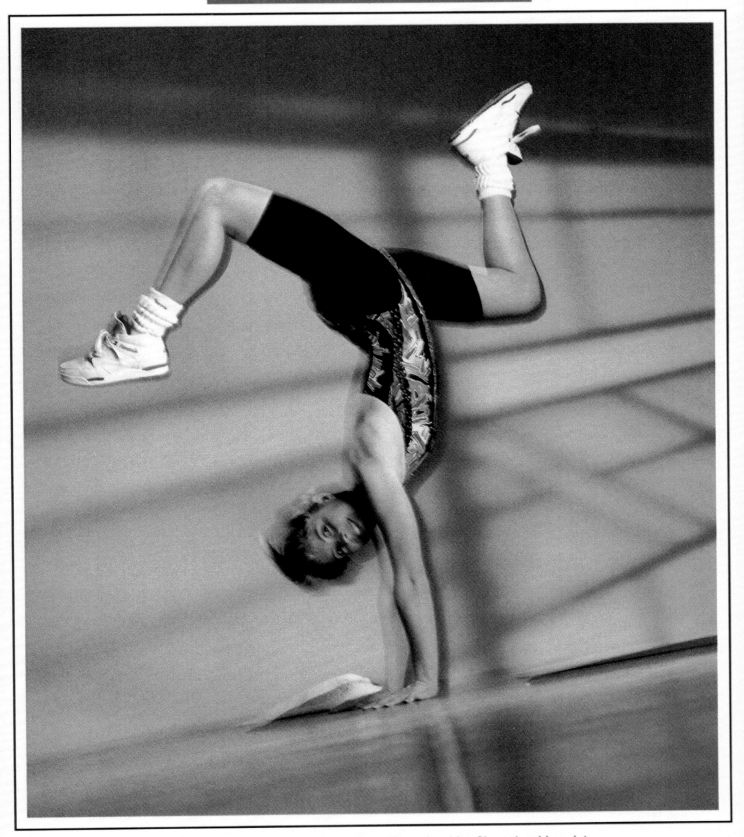

When Heather Wilson won the Arizona State Aerobics Championship, a lot of people thought she'd gone about as far as she could go. Fortunately, Heather wasn't one of them. In fact, the day after the competition, Heather was back in the gym pushing herself even harder. A move that explains why, today, she's a contender in the Southwestern Regional Aerobics Championship. And proves, that when it comes to personal bests, the only opinion that matters is your own.

1991: Pump, ft. Heather Wilson (2 of 4)

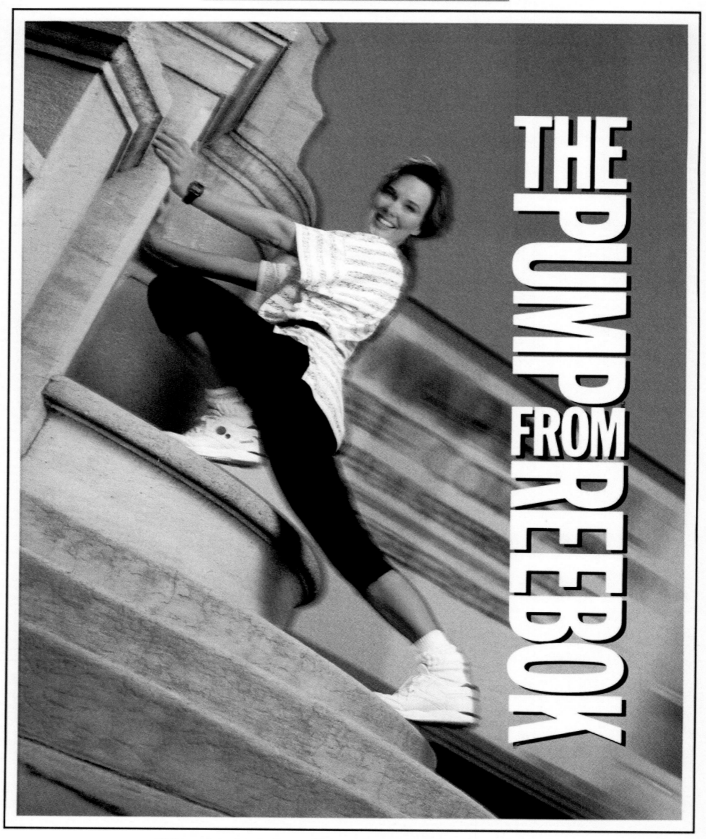

THE PUMP FROM REEBOK

This spring, Linda Frey will set out. With four kids. A husband.
And a plan to walk across Indiana. And if things go as planned, eight days and
357 miles later, she'll finish her walk. A walk that won't set any records.
Won't earn her any money. And won't even make her famous. A walk whose only
aim and biggest accomplishment will be that, for Linda Frey, it will
be the realization of a dream. A personal best.

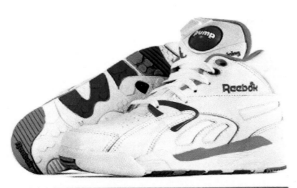

CROSS TRAINING ▪ THE PUMP™ AXT

Our popular AXT cross trainer with THE PUMP™ system offers the perfect fit for those who are serious about working out. The molded Hy-Elvaloy™ midsole and exclusive Hexalite™ technology provide the flexibility and support you need to get the most out of your training.

WALKING ▪ THE PUMP™ WALKING

THE PUMP™ system now offers custom fit and maximum support in a high performance walking shoe. Our patented Energaire® outsole and removable sockliner will help you to take great strides in your workout.

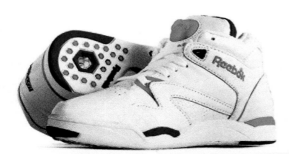

AEROBICS ▪ THE PUMP™ AEROBIC LITE

THE PUMP™ system in our high performance aerobic shoe will give you a custom fit while the Hy-Elvaloy™ midsole and Hexalite™ material offer the ultimate in lightweight cushioning. A molded sockliner with Coolmax® vamp helps control moisture while you're working up a sweat.

BASKETBALL ▪ THE PUMP™ OMNI ZONE

THE PUMP™ midfoot air chamber system offers you personalized fit and support. Visible ERS™ technology in the heel and a polyurethane midsole absorb shock and cushion impact to give you a foot up on the competition.

TENNIS ▪ THE PUMP™ DL

A Hy-Elvaloy™ midsole combines with Hexalite™ material at the heel and forefoot to absorb shock and cushion impact. THE PUMP™ system is in the heel for optimum fit and support. Goodyear Indy 500® rubber in the forefoot and toe-off areas will give you a distinct advantage.

RUNNING ▪ THE PUMP™ RUNNING

THE PUMP™ dual chamber system has two separate inflatable chambers in both the collar and arch to give you a customized fit. Hy-Elvaloy™ tri-density midsole for motion control and Hexalite™ technology in the heel for maximum shock absorption will keep you way out front.

1991: AXT, Walking, Aerobic Lite, Omni Zone, DL and Running (4 of 4)

YO!
I'M YOUR
TENNIS
SHOE.

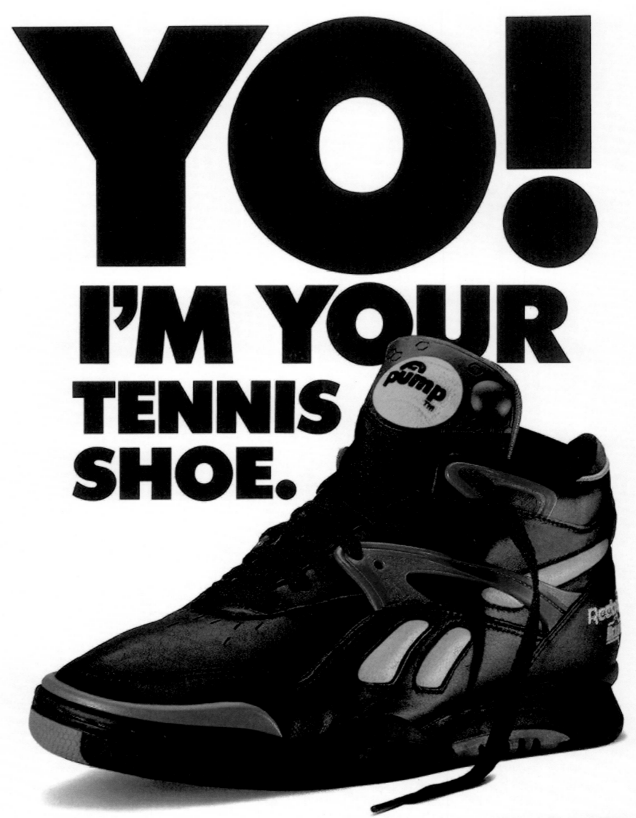

The new Reebok Court Victory II is the loudest member of our radical
Court Victory collection. It comes with THE PUMP™ technology for an all-
around custom fit. A Hexalite™ midsole for cushioning. A Goodyear® Indy 500®
Plus sole for durability and a bunch of plastic things in loud colors that not only
lend support but also distract your opponent so you can beat his brains in.

**LIFE IS SHORT.
PLAY HARD.**

1991: Court Victory II, 'Yo! I'm Your Tennis Shoe'

IF YOU REALLY WANT TO PSYCH OUT YOUR OPPONENT, WEAR THEM WITH BLACK SOCKS.

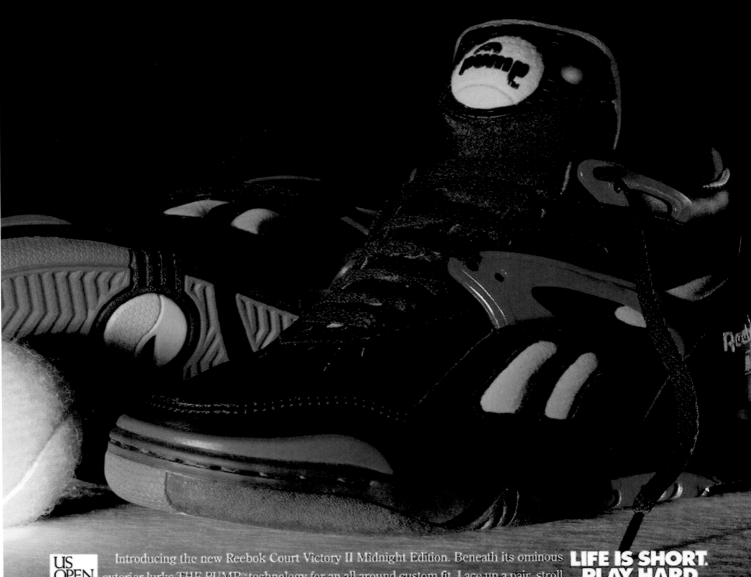

Introducing the new Reebok Court Victory II Midnight Edition. Beneath its ominous exterior lurks THE PUMP® technology for an all around custom fit. Lace up a pair, stroll onto the tennis court, and watch as your opponent runs for cover. The Reebok Court Victory II Midnight Edition's reign of terror begins August 26th at the U.S. Open.

US OPEN 1991

Reebok is a proud sponsor of the 1991 U.S. Open.

LIFE IS SHORT. PLAY HARD.
Reebok

1991: Court Victory II, 'If You Really Want to Psych Out Your Opponent, Wear Them With Black Socks'

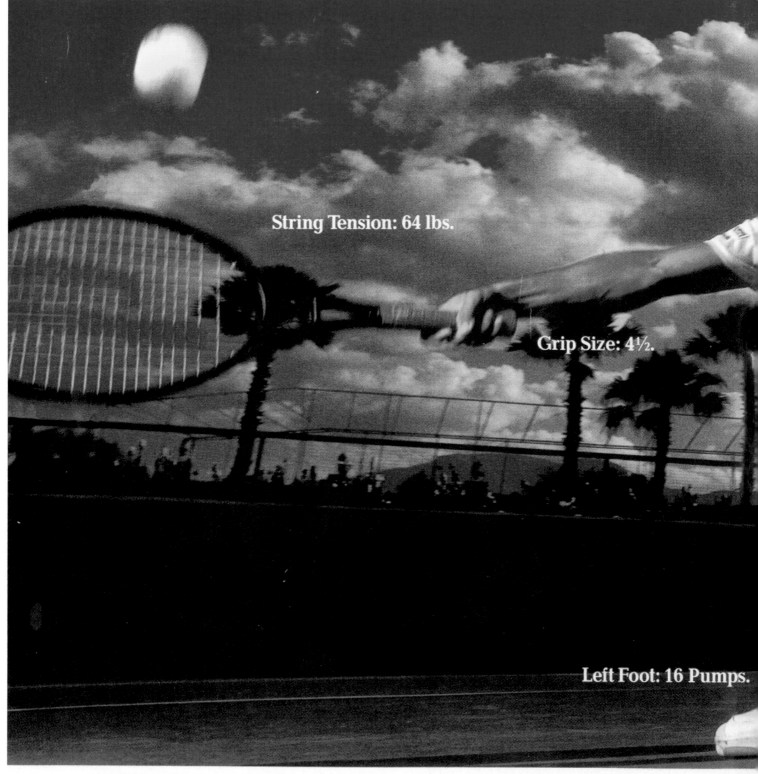

String Tension: 64 lbs.

Grip Size: 4½.

Left Foot: 16 Pumps.

THE PUMP™ Court Victory. A fully customized fit. Even for odd-sized feet.

If your interest in sports extends beyond tennis, then you're probably already aware of THE PUMP™ basketball shoe.

Well, now the benefits of this revolutionary technology have been built into a tennis shoe.

By squeezing the ball on the tongue, an air-bladder inflates around the mid-foot area to give both feet a perfect, personalized fit.

The net effect, aside from being extremely

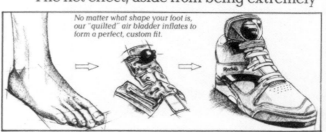

No matter what shape your foot is, our "quilted" air bladder inflates to form a perfect, custom fit.

1991: Court Victory, ft. Michael Chang

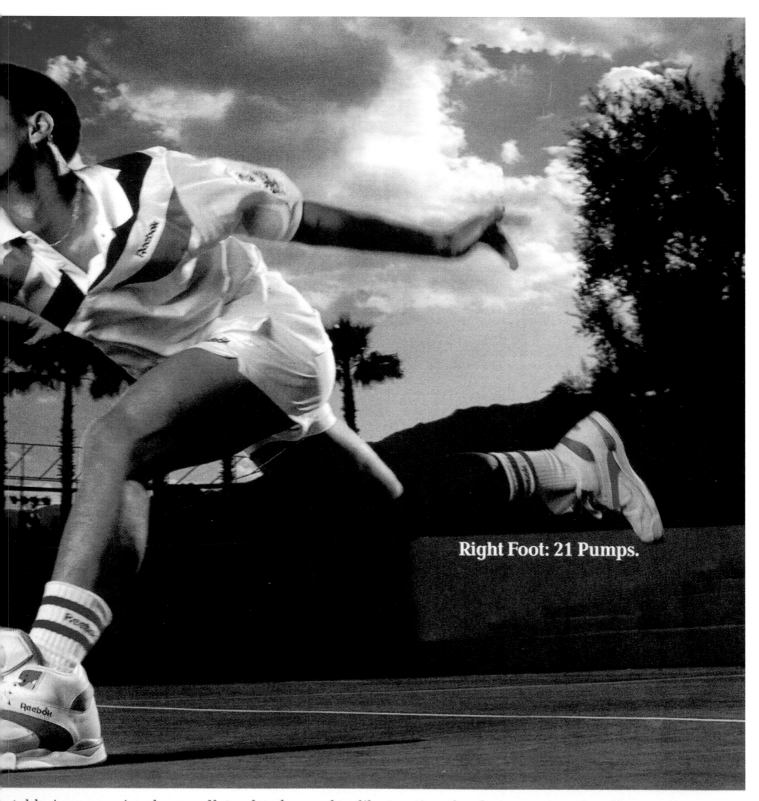

Right Foot: 21 Pumps.

ortable, is an amazing degree of lateral and al support and stability.

So you'll be able to move around the court total confidence.

And move you will. For THE PUMP™ Court ry tennis shoe is surprisingly light, due to sole of Hexalite™ technology. A honeycomb rial that offers maximum cushioning with num weight. While the outsole gives you

glue-like traction, thanks to an exceptionally durable compound called Dura Trac™ Plus.

All of which means that you'll spend less time thinking about your feet. And more time thinking on them.

Reebok 🇬🇧

"If you want to beat those Rock n' Roll tennis guys...

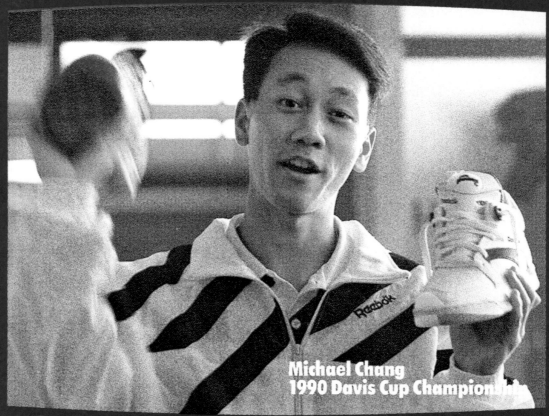

Michael Chang
1990 Davis Cup Championships

Pump up
and Air out!"

Reebok **pump**

Reebok

1991: Court Victory, 'If You Want to Beat Those Rock n' Roll Tennis Guys…Pump Up and Air Out!', ft. Michael Chang

649

1991: Court Victory

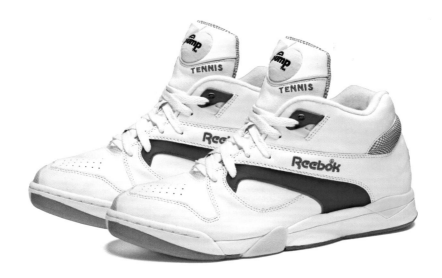

" Updates to the Pump bladder design subsequently allowed the technology to be added in a less bombastic 'robo-shoe' style, so why not shift to another type of court? Michael Chang was duly added to the Reebok roster. Chang was an appealing proto of the Energizer Bunny – fast and relentless – and the youngest-ever male winner of a Grand Slam singles title (French Open 1989). His signature model became known as the Court Victory and contained Hexalite as well as a nifty tennis ball trade on the usual basketball Pump mechanism. The same year saw the release of the Twilight Zone, which streamlined Pump DNA. Getting John Paxson and Horace Grant from the Chicago Bulls on the books didn't hurt either. "

Woody
'The Greatest Story Never Told'
Sneaker Freaker, issue 16 (2009)

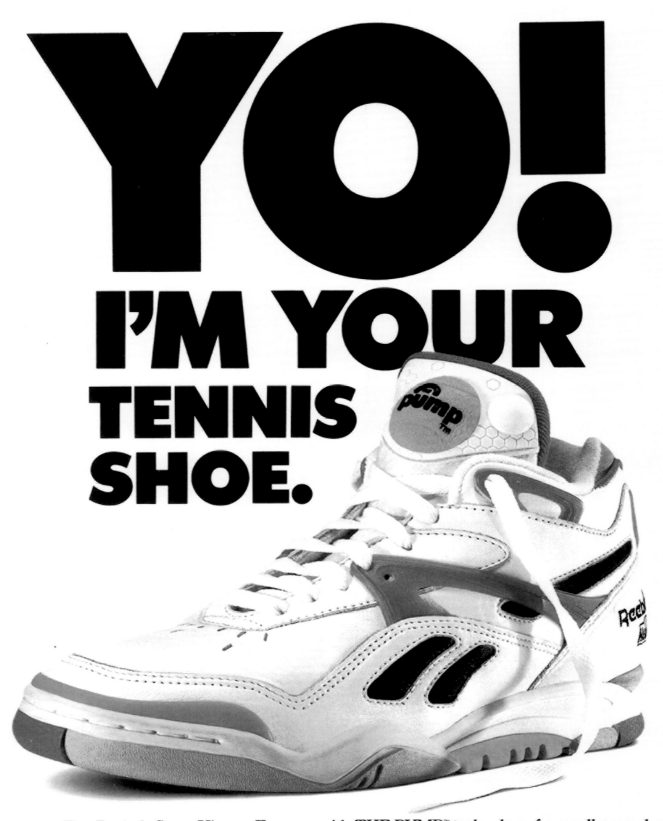

YO!
I'M YOUR
TENNIS
SHOE.

The Reebok Court Victory II comes with THE PUMP™ technology for an all-around custom fit. A Hexalite™ midsole for cushioning. A Goodyear® Indy 500® Plus sole for durability and a bunch of plastic things in loud colors that not only lend support but also distract your opponent so you can beat his brains in.

Reebok 🇬🇧

1991: Court Victory II, 'Yo! I'm Your Tennis Shoe'

Hello, I'm your tennis shoe.

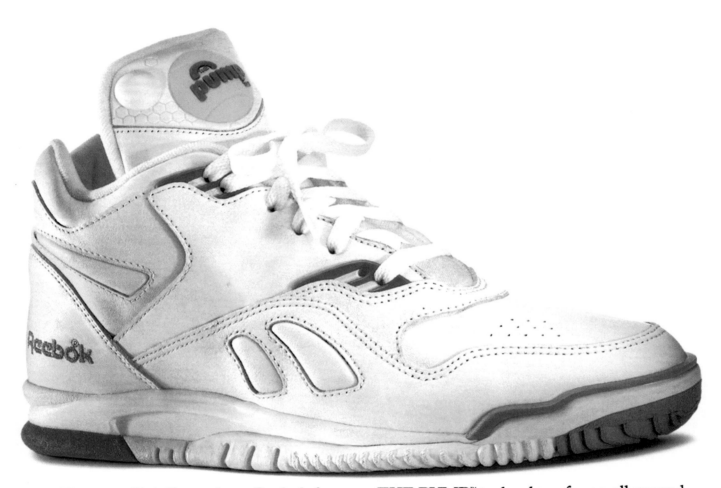

The new Club Pump from Reebok features THE PUMP™ technology for an all-around custom fit. A Hexalite™ midsole for cushioning. A Goodyear® Indy 500® Plus sole for durability. And simple, classic, understated styling so you can be as subtle as possible when you crush your opponent like a grape.

Reebok ⚑

1991: Club Pump, 'Hello, I'm Your Tennis Shoe'

NOBODY TOTALLY UNDERSTANDS A RUNNER'S MIND. BUT WE HAVE A PRETTY GOOD HANDLE ON THEIR FEET.

GO ANYWHERE.

THE INFERNO. There are light shoes. There are very light shoes. And then there is the Inferno. In case the name didn't tip you off, these shoes were made for burning up long stretches of pavement. What exactly do we mean by light? Try a skeletalized Hypalon® HP outsole, a Hexalite™ cushioned heel, a removable sock liner, ventilated side panels and an open-weave mesh upper. Try a minuscule 8.9 ounces in all.* Simply put, if you want a lightweight road or racing shoe— you just ran into one.

GO LIGHT.

THE BOLTON. If you want a highly versatile shoe that's perfect for every-day training, you want the Bolton. The Bolton delivers incredible stability in the way of a Dynamic Cradle system, high sidewalls and a filled-in base around the arch to help keep your foot from rolling left or (you guessed it) right. But while all this may sound like a cast, it feels more like a cushion. You can attribute that to our Hy-Lite midsole with Hexalite™ cushioning in the heel and a tough RB blown-rubber outsole that features an MC5000 heel plug for superior wear and traction. For added comfort, we've even given it a lightweight sandwich mesh upper for exceptional breathability. We could go on and on. But lace up a pair of these and we'll leave that up to you.

1991: Inferno, Bolton, Ventilator and Pump Running, 'Go Light. Go Anywhere. Go Safe. Go Your Own Way. Go Run'

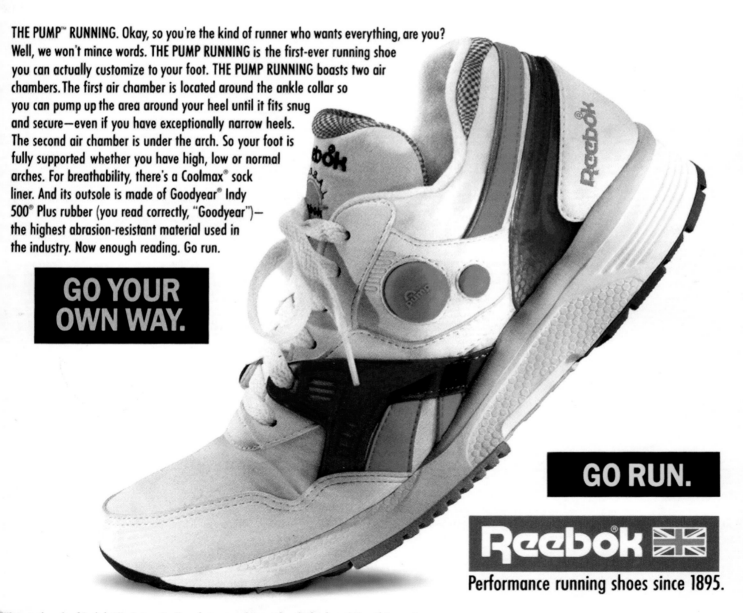

GO SAFE.

THE VENTILATOR. Running shoes that provided extra motion control used to feel more like army boots. They were too stiff and heavy. But thanks to a little Reebok® ingenuity, you can now have the stability you need and still have one of the lightest shoes on the market. We call it the "Ventilator" but we could have just as easily called it the "seeyalater" because this shoe is built for running on or off-road. A Hy-Elvaloy™ midsole with Hexalite™ technology in the heel gives you optimal cushioning, while a visible arch support system helps control pronation. For increased breathability, we incorporated ventilated side panels and for durability, we gave it a tough-as-nails outsole that provides terrific traction. All of which means you can now run and truly leave your problems behind.

THE PUMP™ RUNNING. Okay, so you're the kind of runner who wants everything, are you? Well, we won't mince words. THE PUMP RUNNING is the first-ever running shoe you can actually customize to your foot. THE PUMP RUNNING boasts two air chambers. The first air chamber is located around the ankle collar so you can pump up the area around your heel until it fits snug and secure—even if you have exceptionally narrow heels. The second air chamber is under the arch. So your foot is fully supported whether you have high, low or normal arches. For breathability, there's a Coolmax® sock liner. And its outsole is made of Goodyear® Indy 500® Plus rubber (you read correctly, "Goodyear")—the highest abrasion-resistant material used in the industry. Now enough reading. Go run.

GO YOUR OWN WAY.

GO RUN.

Reebok 🇬🇧
Performance running shoes since 1895.

MP are trademarks of Reebok. *Men's size nine. Hey, what are you doing reading this legal copy? We said, "go run."

Yes, they really look like that. And yes, we meant for them to look like that.

By combining the technologies of GraphLite™, THE PUMP,™ and HEXALITE™ as well as years of research and development by the Reebok Advanced Concept Group, Reebok has created not only the world's most unusual-looking

radically designed underfoot arch bridge, THE PUMP GraphLite™ offers exceptional lightweight support to the serious runner. The bridge retains its shape no matter how much one pronates or supinates, and dramatically reduces the weight of the sole (by almost 20%) without sacrificing support.

THE PUMP™ Everyone knows that running is great for your health. But it's not always great for your feet. In fact, heel slippage is a problem that can lead to blisters or more severe injuries.

By incorporating THE PUMP™ technology in the collar of the shoe, the THE PUMP GraphLite™

NEVER HAS A SHOE THIS COMPLETE

running shoe, but also the world's most complete running shoe: THE PUMP GraphLite™

GRAPHLITE™ BRIDGE Graphite technology (now you know where we got the name) has been around for years. It makes things like tennis rackets, golf clubs, and skis lighter and stronger. And it never loses its shape.

Sound like the perfect technology for the world's most complete running shoe? It is.

By combining graphite technology with a

provides the serious runner with a customized heel fit. Just four or five pumps completely cradle the heel in a cushion of air, allowing individual runners to adapt each shoe to their own personal foot profile, and giving each foot a superior fit.

1992: GraphLite, 'Never Has a Shoe This Complete Looked So Incomplete'

HEXALITE™ For years runners have looked for a way to overcome the contradiction of a well-cushioned, lightweight shoe. Now they can stop looking. HEXALITE™ is one of the first foot protection systems that successfully incorporates lightweight technology with superior cushioning. Located in the midsole, HEXALITE™ gives THE PUMP GraphLite™ all the critical cushioning and support necessary to protect your feet from the severe shocks your body endures every time you run.

LOOKED SO INCOMPLETE.

Add to all this a high-durability outsole, reflective 3M ScotchLite® piping (to keep you alive), and an anatomically fitted arch (to keep you running), and you can see why Reebok considers THE PUMP GraphLite™ to be the world's most complete running shoe. So, even though it looks like the people in Research and Development have forgotten something, trust us. They haven't.

LIFE IS SHORT. PLAY HARD. Reebok ⚑

ZERO GRAVITY

(Null Schwerkraft)

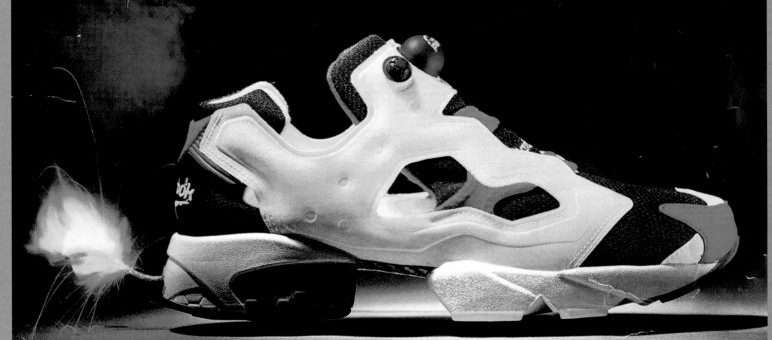

The Pump™ Fury

Reebok® zündet die nächste Stufe zum perfekten Schuh. Zero Gravity.
In Deutschland zuerst auf der ISPO, 31. 8. – 3. 9. 93, Halle 6.

Reebok®

1993: Pump Fury, 'Zero Gravity'

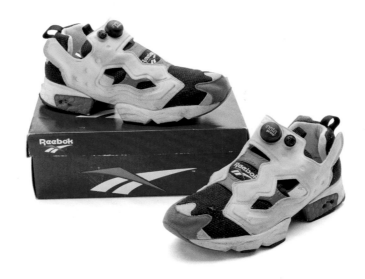

" Launched in 1994, Steven Smith's Instapump Fury design is little more than an inflatable exo-skeleton with two chunks of foam attached to a carbon fibre plate. The avant-garde construction was so inherently radical that even laces were considered an excessive embellishment. Though billed as a serious track prospect, the Fury found refuge among mid-90s early-adopters and London's W1 sneaker scenesters. Recalibrated with a design update in 1995, the Fury was wholeheartedly embraced in Asia, dragging Jackie Chan into its orbit. A subsequent hookup with Chanel added high fashion cred to its Far East connections. Some 25 years after it was released, the Instapump Fury still looks more like 2044 than 1994. **"**

Woody
Reebok Instapump Fury 1994–2019
Sneaker Freaker (2019)

Energy

(CO$_2$/O$_2$)

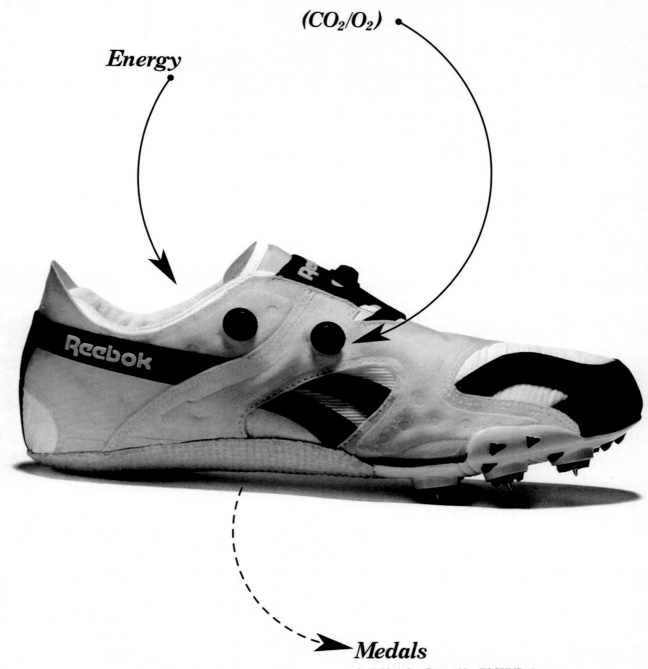

Medals

Gold, Marie Jose-Perec, 400m, XO PUMP™ shoes
Silver, Sandra Farmer-Patrick, 400m hurdles, XO PUMP shoes
Silver, LaVonna Martin, 100m hurdles, XO PUMP shoes
Bronze, Dave Johnson, Decathlon 1500m, XO PUMP shoes

Six months ago, we told you the gas-inflated Reebok® XO PUMP™ shoe with the custom performance fit was destined for greatness. Now, we don't wanna say we told you so, but.....four medals in Barcelona. Clearly, this shoe's proven itself. It's revolutionary. It's cool-looking. It's coming to retail in '93. And most important, it's left people in the dust.

LIFE IS SHORT.
PLAY HARD.
Reebok®

1992: XO Pump, 'Energy. CO$_2$/O$_2$. Medals'

MEET THE INSTAPUMP™ FURY.

IT COMBINES ALL OUR TECHNOLOGIES DEVELOPED ON THE ROADS, OVER THE

YEARS. AND WHEN YOU CONSIDER THE FACT THAT LAST YEAR, BOSTON,

BERLIN, BLOOMSDAY, AND FALMOUTH (TO NAME A FEW) WERE ALL WON WEARING

REEBOK® RUNNING SHOES, YOU CAN SEE HOW FAR WE'VE COME.

THIS IS TRULY THE SHOE DESIGNED FOR THE RIDE OF YOUR LIFE.

FEATURING NEW INSTAPUMP™ TECHNOLOGY, THAT ALLOWS YOU

INSTANT CUSTOMIZATION. THIS IS ACHIEVED BY DIRECTING A CO_2 INFLATOR

INTO A SPECIAL PORT WHICH INFLATES A SERIES OF AIR CHAMBERS

AROUND THE SHOE. THE SHOE CAN ALSO BE INFLATED MANUALLY FOR

ON-THE-RUN ADJUSTMENTS. TALK ABOUT PERFORMANCE.

THEN THERE'S THE GRAPHLITE® ARCH BRIDGE.

THIS LIGHTWEIGHT, YET RESPONSIVE MATERIAL IS AS STRONG AS STEEL,

SO IT ALLOWS US TO REMOVE 30% OF THE VOLUME FROM THE

MIDSOLE/OUTSOLE, WHILE STILL GIVING YOU EVERY BIT OF STABILITY.

ADD TO THIS THE TRIED AND TESTED HEXALITE®

LIGHTWEIGHT CUSHIONING TECHNOLOGY, AND YOU CAN SEE YOU'RE ABOUT

TO EMBARK ON THE RUN OF YOUR LIFE.

NO APOLOGIES WHATSOEVER FOR THE CRAZY COLOR SCHEME;

THIS IS YOUR BIG CHANCE TO RUN WILD.

PLANET REEBOK

1994: Instapump Fury

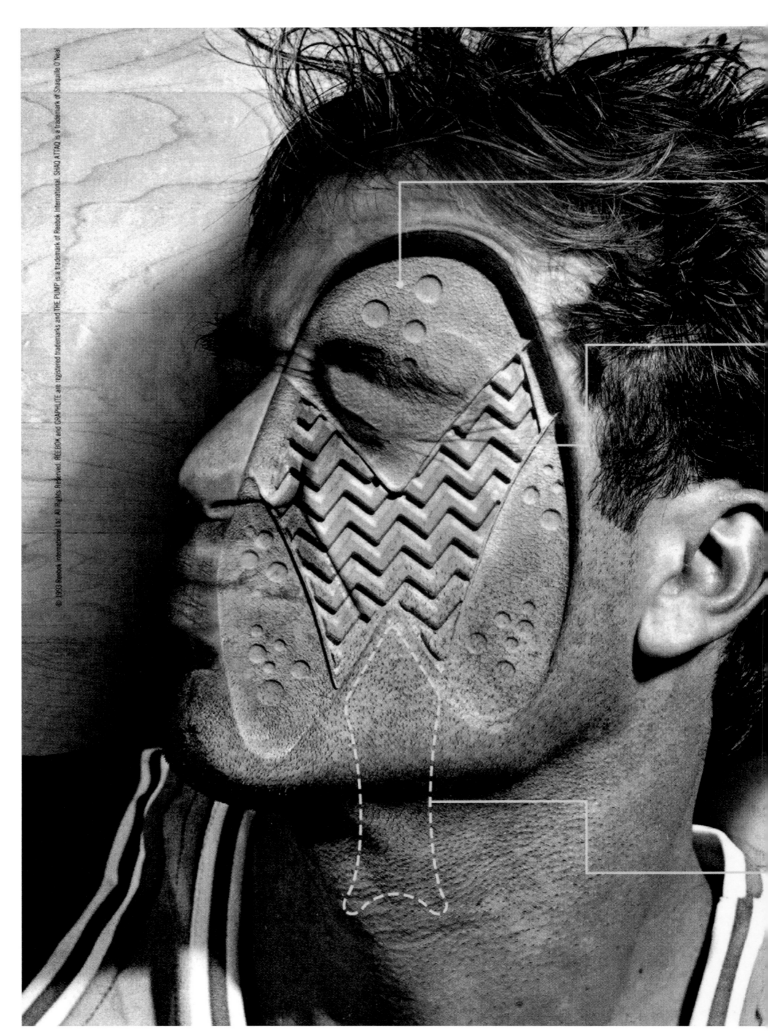

1993: Shaq Attaq, 'Shaq isn't the Only Player in the League Wearing His Shoe'

High-abrasion rubber for increased durability.

Shaq isn't the only player in the league wearing his shoe.

Herringbone tread pattern for added traction.

Shaquille O'Neal. Shaq. 300 pounds of rim-wrecking force. On March 13th, Reebok® introduced the Shaq Attaq.™ A shoe built for the way Shaq plays the game. For the way Shaq dominates the lane and clears the boards. It's built for the man who's made the greatest impact on the game in the last 20 years. Not to mention the impact he's made on other players.

THE PUMP™ system for custom fit and support.

Extended GraphLite® arch bridge for lightweight support.

Radically sculpted sole area to reduce weight.

The 26 pound* running shoe.

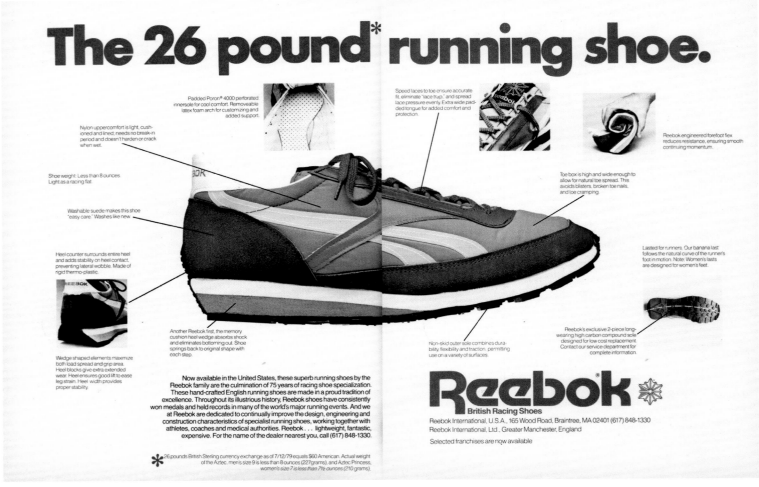

Padded Poron® 4000 perforated innersole for cool comfort. Removeable latex foam arch for customizing and added support.

Speed laces to toe ensure accurate fit, eliminate "lace trap," and spread lace pressure evenly. Extra wide padded tongue for added comfort and protection.

Reebok engineered forefoot flex reduces resistance, ensuring smooth continuing momentum.

Nylon uppercomfort is light, cushioned and lined, needs no break-in period and doesn't harden or crack when wet.

Shoe weight: Less than 8 ounces. Light as a racing flat.

Washable suede makes this shoe "easy care." Washes like new.

Heel counter surrounds entire heel and adds stability on heel contact, preventing lateral wobble. Made of rigid thermo-plastic.

Wedge shaped elements maximize both load spread and grip area. Heel blocks give extra extended wear. Heel ensures good lift to ease leg strain. Heel width provides proper stability.

Another Reebok first, the memory cushion heel wedge absorbs shock and eliminates bottoming out. Shoe springs back to original shape with each step.

Toe box is high and wide enough to allow for natural toe spread. This avoids blisters, broken toe nails, and toe cramping.

Lasted for runners. Our banana last follows the natural curve of the runner's foot in motion. Note: Women's lasts are designed for women's feet.

Non-skid outer sole combines durability, flexibility and traction, permitting use on a variety of surfaces.

Reebok's exclusive 2-piece long-wearing high carbon compound sole designed for low cost replacement. Contact our service department for complete information.

Now available in the United States, these superb running shoes by the Reebok family are the culmination of 75 years of racing shoe specialization. These hand-crafted English running shoes are made in a proud tradition of excellence. Throughout its illustrious history, Reebok shoes have consistently won medals and held records in many of the world's major running events. And we at Reebok are dedicated to continually improve the design, engineering and construction characteristics of specialist running shoes, working together with athletes, coaches and medical authorities. Reebok . . . lightweight, fantastic, expensive. For the name of the dealer nearest you, call (617) 848-1330.

Reebok
British Racing Shoes

Reebok International, U.S.A., 165 Wood Road, Braintree, MA 02401 (617) 848-1330
Reebok International, Ltd., Greater Manchester, England

Selected franchises are now available

***** 26 pounds British Sterling currency exchange as of 7/12/79 equals $60 American. Actual weight of the Aztec, men's size 9 is less than 8 ounces (227 grams), and Aztec Princess, women's size 7 is less than 7½ ounces (210 grams).

1979: Aztec, 'The 26 Pound* Running Shoe'

The sole difference makes all the difference.

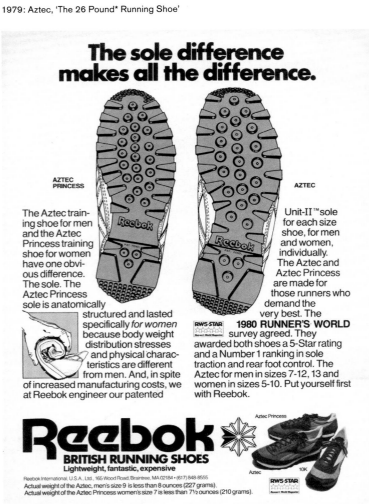

AZTEC PRINCESS

AZTEC

The Aztec training shoe for men and the Aztec Princess training shoe for women have one obvious difference. The sole. The Aztec Princess sole is anatomically structured and lasted specifically *for women* because body weight distribution stresses and physical characteristics are different from men. And, in spite of increased manufacturing costs, we at Reebok engineer our patented

Unit-II™ sole for each size shoe, for men and women, individually. The Aztec and Aztec Princess are made for those runners who demand the very best. The **RW5-STAR** **1980 RUNNER'S WORLD** survey agreed. They awarded both shoes a 5-Star rating and a Number 1 ranking in sole traction and rear foot control. The Aztec for men in sizes 7-12, 13 and women in sizes 5-10. Put yourself first with Reebok.

Reebok
BRITISH RUNNING SHOES
Lightweight, fantastic, expensive

Reebok International, U.S.A., Ltd., 165 Wood Road, Braintree, MA 02184 • (617) 848-8555
Actual weight of the Aztec, men's size 9 is less than 8 ounces (227 grams).
Actual weight of the Aztec Princess women's size 7 is less than 7½ ounces (210 grams).

Aztec Princess

Aztec 10K

RW5-STAR
Runner's World Magazine

1980: Aztez Princess and Aztec, 'The Sole Difference Makes All the Difference'

The Reebok Shadow SPECIAL

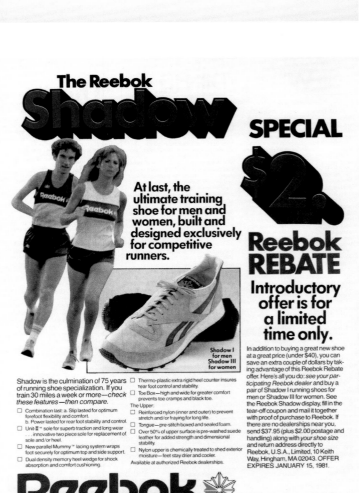

At last, the ultimate training shoe for men and women, built and designed exclusively for competitive runners.

Shadow I for men
Shadow III for women

Shadow is the culmination of 75 years of running shoe specialization. If you train 30 miles a week or more—*check these features—then compare.*

- ☐ Combination last: a. Slip lasted for optimum forefoot flexibility and comfort. b. Power lasted for rear foot stability and control.
- ☐ Unit-II™ sole for superb traction and long wear . . . innovative two piece sole for replacement of sole and/or heel.
- ☐ New parallel Mummy™ lacing system wraps foot securely for optimum top and side support.
- ☐ Dual density memory heel wedge for shock absorption and comfort cushioning.

- ☐ Thermo-plastic extra rigid heel counter insures rear foot control and stability.
- ☐ Toe Box—high and wide for greater comfort prevents toe cramps and black toe.

The Upper:
- ☐ Reinforced nylon (inner and outer) to prevent stretch and/or fraying for long life.
- ☐ Tongue—pre-stitch boxed and sealed foam.
- ☐ Over 50% of upper surface is pre-washed suede leather for added strength and dimensional stability.
- ☐ Nylon upper is chemically treated to shed exterior moisture—feet stay drier and cooler.

Available at authorized Reebok dealerships.

Reebok REBATE

Introductory offer is for a limited time only.

In addition to buying a great new shoe at a great price (under $40), you can save an extra couple of dollars by taking advantage of this Reebok Rebate offer. Here's all you do: *see your participating Reebok dealer* and buy a pair of Shadow I running shoes for men or Shadow III for women. See the Reebok Shadow display, fill in the tear-off coupon and mail it together with proof of purchase to Reebok. If there are no dealerships near you, send $37.95 (plus $2.00 postage and handling) along with *your shoe size* and return address directly to Reebok, U.S.A., Limited, 10 Keith Way, Hingham, MA 02043. OFFER EXPIRES JANUARY 15, 1981.

Reebok
RUNNING SHOES

Reebok U.S.A., Limited, Inc. 10 Keith Way, Hingham, MA 02043 (617) 749-8540

1980: Shadow, 'The Reebok Shadow Special'

INTRODUCING THE MOST ADVANCED FOUL WEATHER RUNNING SHOE EVER BUILT.
THE REEBOK VICTORY G.

UNTIL REEBOK AND GORE-TEX® GOT TOGETHER, NO ONE HAD THE FOGGIEST IDEA HOW TO HANDLE FOUL WEATHER.

Not that a lot of people haven't tried. Talk to the inventor of electric socks. Talk to the guys who've run in Saran Wrap. Talk to anyone who has ground out 10 miles in a downpour. Nothing works.

UNTIL THE VICTORY G.

We've built it with a Gore-Tex® inner liner like no one has ever done before. The liner has no stitch holes

or seams, so it doesn't leak. But because it's Gore-Tex® II it breathes fresh air to your feet.

Gore-Tex® filters out water, while letting shoe breathe.

The Victory G is handcrafted one shoe at a time in Bolton, England. It has a strong, new support system

based on the Foster Cradle, which is designed to staunchly support the subtalus joint where most pronation problems begin. But to appreciate all its advances in cushioning and support, you need to see a Reebok Victory dealer.

We think it's the most technically advanced foul weather shoe ever made. But more than that it's built to help you do your best. Which is the biggest Victory after all.

Reebok 🇬🇧
British Running Shoes

1981: Victory G, 'Introducing the Most Advanced Foul Weather Running Shoe Ever Built'

We will run on the beaches, we will run in the streets, we will run in the hills, and we will never give up.

In England, we've always had an indomitable attitude towards winning, that no matter how rough the road, we refuse to give up.

It's been our attitude at Reebok towards the design and development of the running shoe for over 76 years. All along we've had one aim in mind: making the best running shoes in the world, no matter what it takes. We've never given up in our continual concern with research, training, testing and state-of-the-art design. It's the kind of dedication that has resulted in Reebok being rated by runners number one in the world, in the Quality Control of the running shoes we build.*

WITH OUR SHADOW THERE'S NO DOUBT.

The Reebok Shadow is the product of a history of running excellence that has included world record-breaking times in the mile, two mile, ten mile and Boston Marathon. Meticulous craftsmanship combined with constantly improving design has been our tradition and the Reebok Shadow is without a doubt one of the finest training shoes ever made. Whether you look at 5-Star ratings, or run with your own results.

THE REEBOK ADVANTAGE.

The Shadow is anatomically structured and lasted for high mileage runners' specific body weight distribution on areas of maximum stress. In the tradition of our world-

beating Aztec, it has Reebok's exclusive 2-piece longwearing high-carbon compound sole that combines durability, flexibility and traction, while maintaining light weight. The shoe is built with Reebok's lasting system that follows the natural curve of a runner's foot in motion and allows for a smooth, powerful weight transfer from outer heel plate on landing, to inside toe plugs on exit.

These are all the same high speed design features made famous by our ultra high-performance Aztecs, with added stability and lateral strength. Which we think

protection for the heel while retaining rear foot stability and control. Even at high speed, this incredibly resilient cushioning returns to maximum expansion between each stride, for continual comfort under the most intense impact. Our Memory Cushion just won't pound down. It never gives up.

NO BARBECUE SHOES.

Shadows are for committed runners. They're not for barbecues, bowling, cocktail parties or anything else *but running*. In fact, if you're not a serious runner, they're not the shoes for you. But if you are, you'll be damn glad you're running with Reebok. We never give up.

is all the more impressive when you see that the Shadow I and Shadow III have a list price under 45 dollars.

MORE THAN A MEMORY.

The Shadow uses a combination of dual density sole materials to form a Memory Cushion, that was first developed by Reebok. This cushioning system, with a rigid heel counter, provides

*Consumer Study Runner's World, October 1980

Reebok 🇬🇧
British Running Shoes

1981: Shadow, 'We Will Run on the Beaches, We Will Run in the Streets, We Will Run in the Hills, and We Will Never Give Up'

YOU'LL FIND IT HARD TO BEAT OUR P.B.

Our new running shoe is designed to be a winner. It's called the P.B. and it's actually two shoes rolled into one. For starters, the P.B. is a racing shoe. And as you'd expect from a good racing shoe, it won't weigh you down.

For example, the P.B. has a sole that's made from an exceptionally light, flexible and hard wearing material called Goodyear Indy 500 rubber.

This helps it tip the scales at only 200 grams and it'll help you get around the course a bit faster.

But what makes the P.B. miles better than most racing shoes is that you can actually train in it as well.

It has a dual density midsole which will cushion your feet and allow you to do any number of sessions.

It also has a sturdy heel counter which will support your foot on every run.

But there's another reason why you should make tracks for the P.B. It's also an extremely comfortable shoe to wear.

The upper is made from nappa pigskin and polypag nylon. So it's very light and supple, and it'll mould around the natural shape of your foot. What's more, it's also cut low around the heel so it won't irritate your achilles tendon.

You can try on the P.B. at any good sports shop.

But you'll have to be quick. Because when a shoe's this good, there's bound to be a run on it.

Reebok
At the heart of sport.

1987: P.B., 'You'll Find It Hard to Beat Our P.B.'

EVERY ONE A WINNER

Reebok
· CATCH US IF YOU CAN ·

26, St George's Quay, Lancaster LA1 1RD. Telephone 0524 33317. Fax No. 0524 382044.

Unless stated all Reebok shoes are made abroad to designs and specifications created in Bolton England and Boston USA.

1982: 'Every One a Winner'

The most advanced foul weather running shoe ever built...
The Reebok VICTORY G

THIS REMARKABLE RUNNING SHOE HAS GORE-TEX* FABRIC UPPERS ALLOWING YOUR FEET TO BREATHE

What is Gore-Tex fabric and how does it work?

Gore-Tex fabric is a remarkable laminated material which incorporates a membrane with 9 billion pores to every square inch. Each pore is too small to permit water entry but large enough to allow perspiration vapour to disperse.

These unique qualities offer the wearer of Gore-Tex products complete weather protection and interior comfort.

*Gore-Tex is the Registered Trade Mark of W. L. Gore & Assoc. Inc.

The VICTORY G is HAND MADE IN ENGLAND.

It has a strong, new support system based on the Foster Cradle, which is designed to staunchly support the subtalus joint where most pronation problems begin. But to appreciate all its advances in cushioning and support, you need to see a Reebok Victory stockist.

We think it's the most technically advanced foul weather shoe ever made. But more than that, it's built to help you do your best. **Which is the biggest Victory after all.**

A list of stockists is available from:

**Carter Pocock Limited
235 Southwark Bridge Road
London, SE1 6NN**

British Running Shoes

1982: Victory G, 'The Most Advanced Foul Weather Running Shoe Ever Built…'

Reebok Hurricane...
The Runaway Winner

Introducing the Reebok Hurricane! The cost: under $30.
A Reebok every runner can afford!
Durability, safety, comfort...we haven't skimped on a thing.
We compared Reebok Hurricane with the competition and
left them flat-footed. We knew we would.
When you make the best running shoes in the world,
you let the same experts design, test, and construct
the best under $30 running shoe. It's that simple!

Name	Mid-Sole	Out-Sole	Lacing System	Upper	Counter	'82 Sug. Retail
Reebok Hurricane	Dual Density	High Abrasion Carbon Reinforced Rubber*	Speed Lacing	Bound Sealed Tongue*	New Pre-Molded Nylon*	$29.95
Nike Yankee	Single Density	High Abrasion Rubber	U-Throat	Open Edge Tongue	Thermo Plastic	34.95
New Balance 390	Single Density	High Abrasion Rubber	U-Throat	Open Edge Tongue	Thermo Plastic	34.95
Etonic Trans-Am	Single Density	Low Abrasion Micro Cell Rubber	U-Throat	Open Edge Tongue	Coated Fiber	32.95
Adidas Boston	Single Density	High Abrasion Rubber	U-Throat	Bound Sealed Tongue	Coated Fiber	33.95

*Reebok lasts longer and runs better. These three exclusive Reebok features are part
of the reason why. The Foster Endurance Outer Sole (1982 Pat.Pend.) is designed for
endurance. The bonded, sealed tongue prevents fraying and adds comfort. And, the
pre-molded nylon counter provides extra protection and increases durability.

Price comparison as of March 1, 1982.

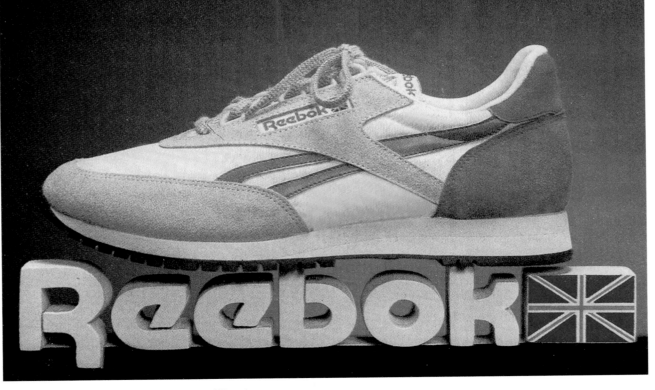

1982: Hurricane, 'Reebok Hurricane...The Runaway Winner'

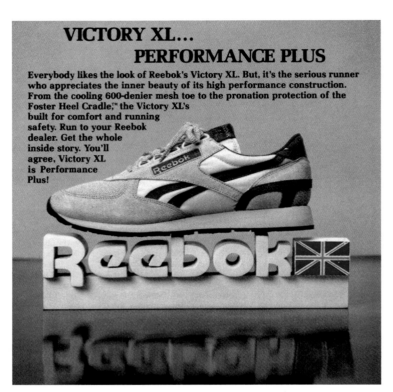

1982: Victory XL, 'Victory XL…Performance Plus'

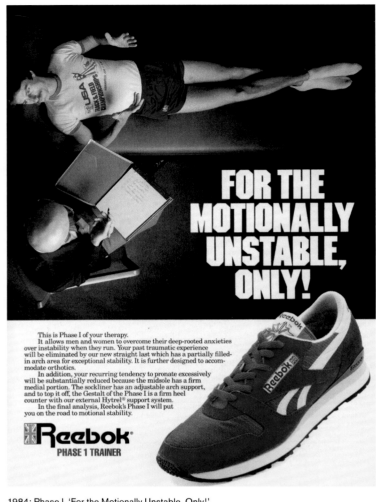

1984: Phase I, 'For the Motionally Unstable, Only!'

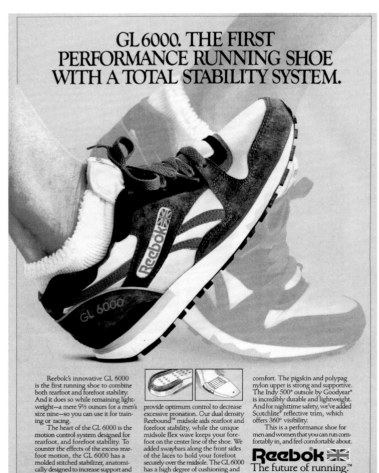

1986: GL 6000, 'GL 6000. The First Performance Running Shoe With a Total Stability System'

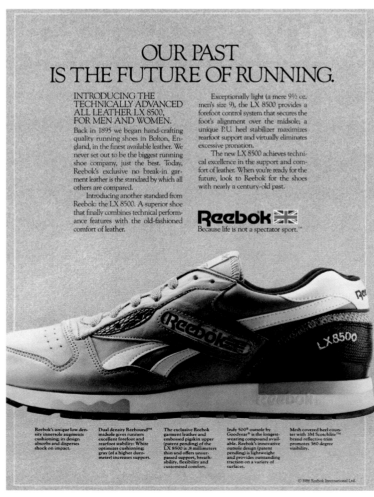

1986: LX 8500, 'Our Past is the Future of Running'

WHAT EVERY WOMAN SHOULD KNOW ABOUT COMMITMENT.

You've made a commitment to running, and to running your personal best. And you look for excellence in products that will help you achieve your goals.

Since 1895, our family has been committed to providing the finest hand-made specialty track, field and running shoes available. We have combined our 19th century heritage of experience, care and dedication with 20th century technology to develop a line of performance running shoes designed exclusively to fill your particular running needs.

We are proud to introduce our series of women's running shoes. Our GL 6000 gives women trainers and competitors extra forefoot and rearfoot stability. The DL 5600 offers forefoot strikers additional forefoot support, shock absorption and motion control. Our LC 3000 provides lightweight cushioning and flexibility.

Our commitment is to you.

Reebok
Because life is not a spectator sport.™

1986: GL 6000, 'What Every Woman Should Know About Commitment'

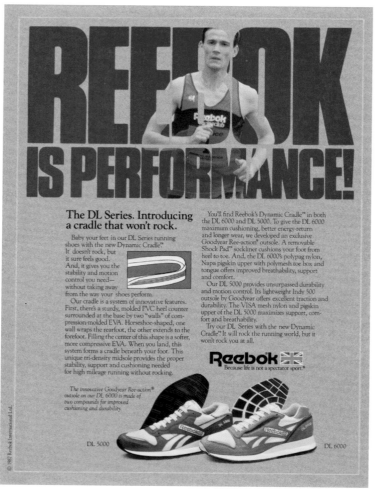

1987: DL 5000 and DL 6000, 'Reebok is Performance!'

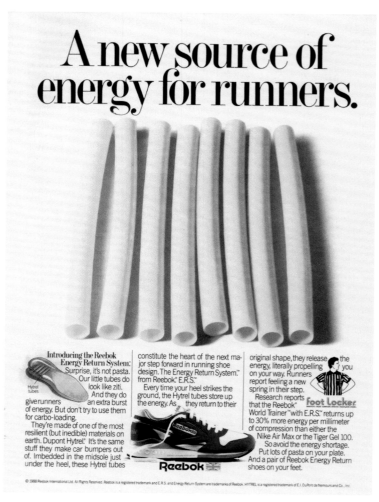

1988: World Trainer, 'A New Source of Energy for Runners'

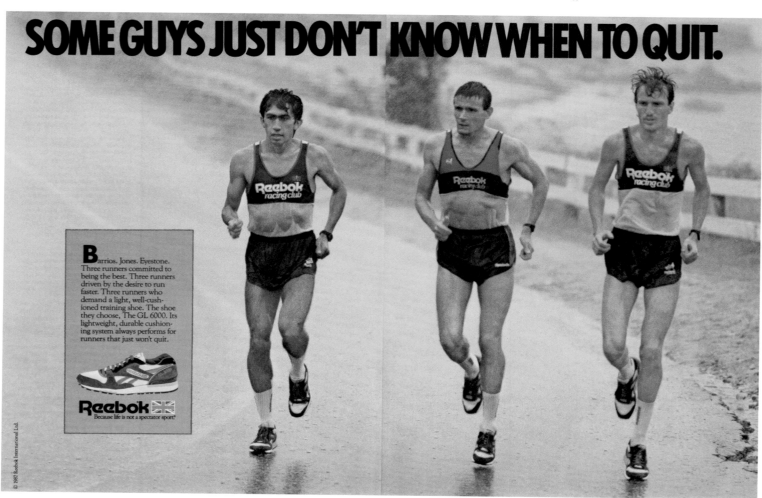

1987: GL 6000, 'Some Guys Just Don't Know When to Quit', ft. Arturo Barrios, Steve Jones and Ed Eyestone

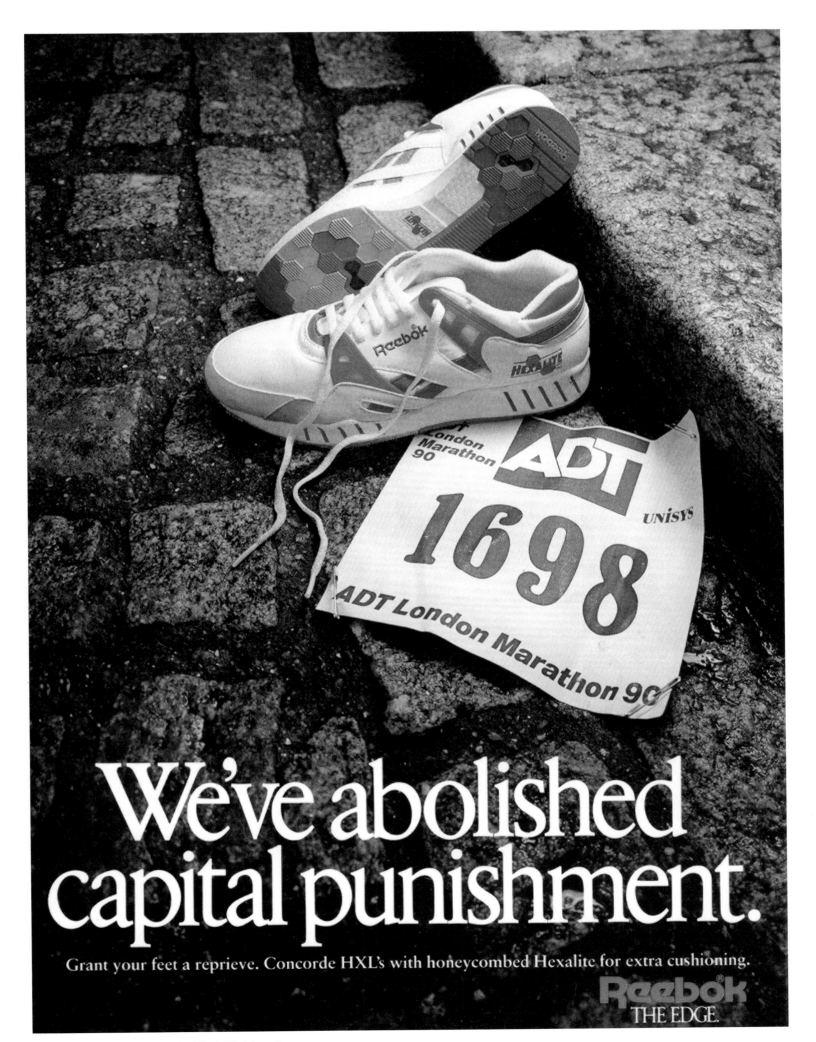

1989: Concorde HXL, 'We've Abolished Capital Punishment'

The revolu

Introducing the Reebok Energy Return System.™

While Nike is singing the praises of their revolution, let us introduce you to something that really deserves the term.

The Energy Return System from Reebok.® E.R.S.™

This system actually saves a significant amount of the energy you put into running… and then returns it to you just when you need it most.

No other shoe has ever been designed to do this. That's why the Reebok World Trainer™ with E.R.S. actually returns up to 30% more energy per millimeter of compression than either the Nike Air Max or the Tiger Gel 100.

What's more, this energy return is accomplished with no loss in either cushioning or stability. In fact, the World Trainer surpasses most shoes on *both* counts.

AIR, GEL AND E.R.S. EACH HAVE THREE LETTERS. THAT'S WHERE THE SIMILARITY ENDS.

ENERGY RETURNED
FOR 10MM/COMPRESSION

Lots of everyday objects have natural energy return systems. Springs. Pogo sticks. Diving boards.

But no running shoes did.

The challenge was to put such a system into a running shoe that would propel the runner on his way.

Our Energy Return System is basically a series of tubes in the midsole. Six tubes under the ball of your foot. Four under your heel.

These tubes are made of one of the most resilient materials on earth. DuPont Hytrel.® It's the same stuff they make car bumpers out of.

When your foot strikes the ground, the Hytrel tubes store up the energy. As your foot rolls forward, the tubes return to their original shape and

release the energy.

Kind of like a spring being sprung.

The Reebok World Trainer.™
The first running shoe with E.R.S.™

1988: World Trainer, 'The Revolution is Over'

ion is over.

NNING SHOE AS FINELY
JNED AS A RACE CAR.

ning is everything. In a
-performance engine. In
nning shoe.
rtunately, Reebok's E.R.S.
actually be 'tuned.' By
lating the size and posi-
of the Hytrel tubes, we
make sure the
gy re-

is exactly synchronized with
the forward motion of your foot.
Your energy is used instead
of lost. Your running is more
efficient because your shoe
is more efficient. Imagine.
A running shoe as
efficient as a race-
ready Porsche. It
kind of deflates all
that talk about Air.

E.R.S. IS THE NEXT LOGICAL
STEP IN SHOE DESIGN.

Which means others will
surely follow.
But leading the race is not
an unfamiliar position for
Reebok. For the first half of
this century, the family that
founded Reebok made the
running shoe to beat.
It was their shoe
that went to the
1924 Olympics
dramatized
in 'Chariots
of Fire.'

But we're not so foolish as to
think we could create a rev-
olution out of thin Air. Revo-
lutions require bigger ideas.
Like giving power back
to the people. Or in this case,
energy back to the runner.

Reebok 🇬🇧
Running Shoes.

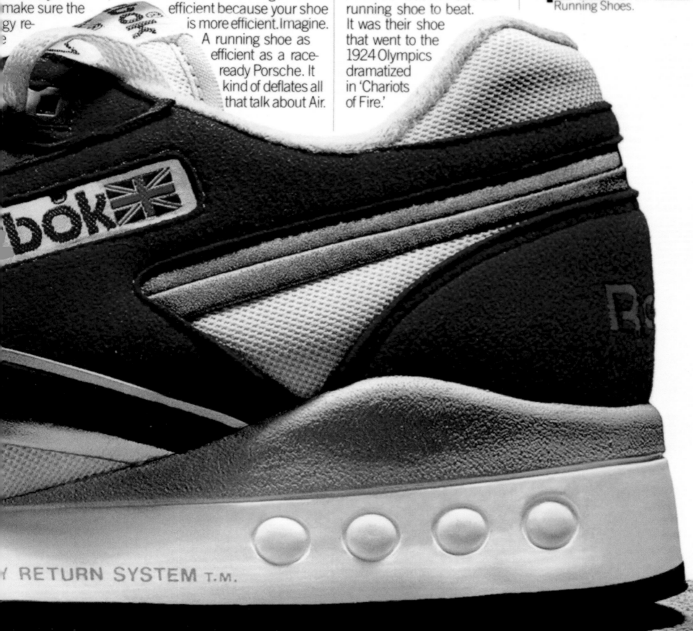

Y RETURN SYSTEM T.M.

...to his 13th mile ...d the reservoir, he began to think, "What am I doing ...h my meager life?" Three ...ps of sweat quietly made ...ay down his red cheeks, ...mbled down his heaving ...and rolled off his neon ...en Spandex shorts. He ...d to reason through it ...'s not this darned city ...ll of its putrid smells. ...ot my high-powered, ...w-paying ad agency ...'s not my root canal ...intment scheduled ...r tomorrow. It's not ...fact that my wife's ...g an affair with my ...st friend's shrink. ...And all they do is ...ze our marriage. ...d talk to my best ...end about it. It's ...ot that my own ...hrink resigned ...case just last ...veek because ...e was bored. ...y golly, what ...s it?"

...s Friedman ...came upon ...15th mile, ...ting, high ...running, ...he had a ...velation.

Ultra lightweigh cushioning for those who don't.

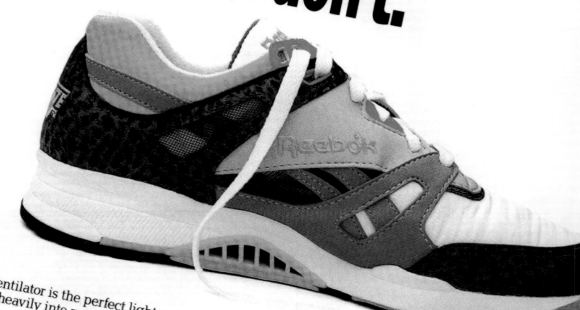

The new Ventilator is the perfect lightweight shoe if you're heavily into running and need extra support.

Designed especially for the pronator or supinator, it combines maximum stability and cushioning with minimum weight. Sound like a contradiction in terms?

Just lace up a pair. The first thing you'll notice is the Ventilator shoe's support. The molded footframe and firm archbridge (the green thing in the middle of the shoe) are designed to offer optimum motion control.

Do a lap or two around the store, an experience the patented Hexalite cush system and the soft yet resilient Hy-Elv midsole.

Keep running (preferably outside the note the durability and traction of the ou Tests show virtually no sign of wear even 300 grueling miles.

Whether you're training or racing, off, the Ventilator shoe is designed to the most obsessed runner lighten up. straighten up.

Reebok ⚑

1990: Ventilator and Sole Trainer 5000, 'Ultra Lightweight Cushioning for Those Who Run Straight. Ultra Lightweight Cushioning for Those Who Don't'

Ultra lightweight cushioning for those who run straight.

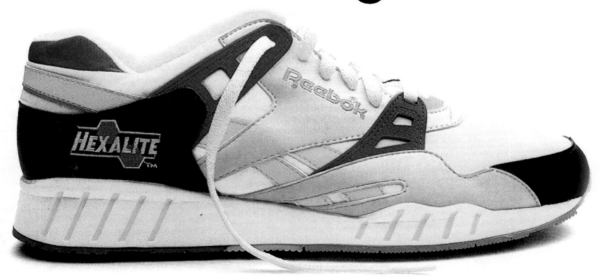

Weighing in at a mere 10.5 ounces, the new Sole Trainer 5000 is the perfect lightweight shoe if you're heavily into running. (If you pronate or supinate, skip to the opposite page.)

It combines maximum cushioning and durability with minimum weight. Sound like a contradiction in terms?

Just lace up a pair, and feel how the Hy-Elvaloy midsole offers both the resilience of polyurethane and the softness and lightness of EVA.

Do a lap or two around the store, and experience the Hexalite system as it helps absorb every shock and cushion every stride.

Keep running (preferably outside the store), and note the durability of the super light-weight outsoles. Tests show virtually no sign of wear even after 300 grueling miles.

Whether you're training or racing, on road or off, the Sole Trainer 5000 is designed to help even the most obsessed runner lighten up.

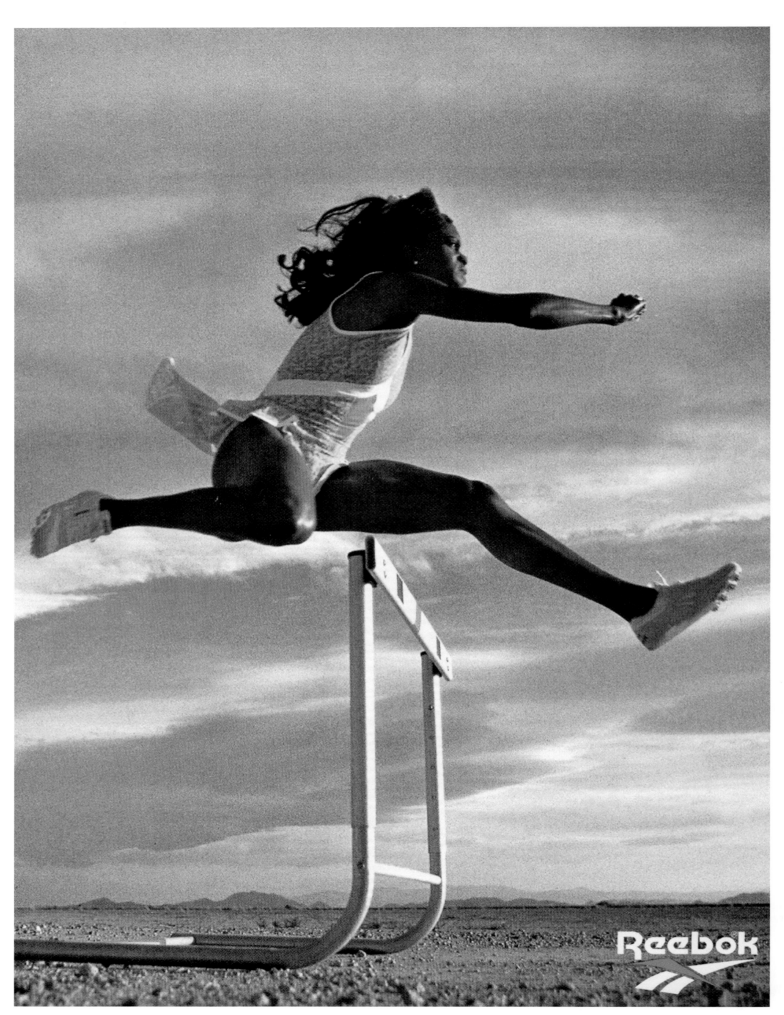

1993: ft. Sandra Farmer-Patrick

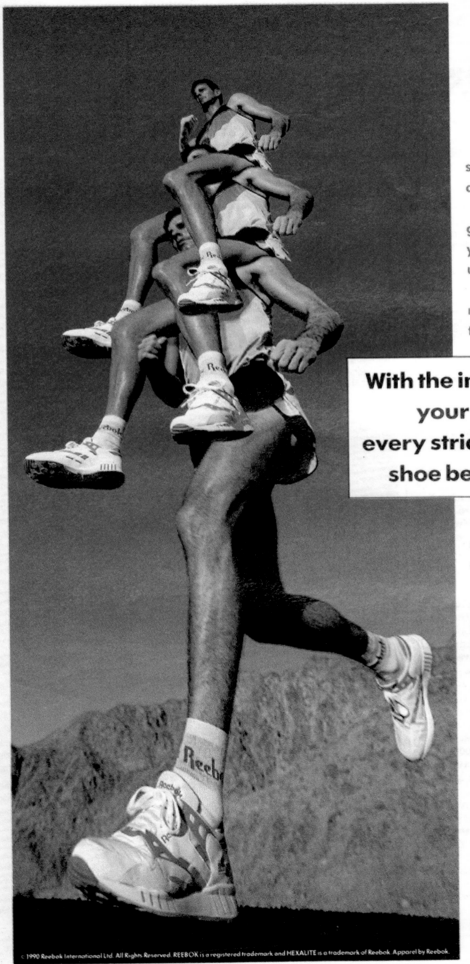

While it may appear that we are stretching the truth, surprisingly it's a fact.

Every time your foot strikes the ground, the impact of three times your bodyweight is sent shuddering up your legs.

Armed with this and years of research, Reebok has developed the Sole Trainer™ 5000.

With the impact of three times your bodyweight in every stride, your lightweight shoe better be cushioned.

At only 10 ounces it's a lightweight shoe, but more importantly, it's exceptionally well-cushioned.

The secret lies in the midsole. It's comprised of Hexalite,™ a unique honeycomb of highly resilient yet light thermo plastic.

(Basically, the honeycomb, one of nature's lightest yet strongest designs, absorbs and spreads shock waves over a much larger area than EVA or polyurethane.)

The bottom line is that the Reebok Sole Trainer 5000 lets you run in a durable, lightweight shoe without sacrificing cushioning or comfort.

Now that should take a load off your mind.

Reebok

1990: Sole Trainer 5000, 'With the Impact of Three Times Your Bodyweight in Every Stride, Your Lightweight Shoe Better Be Cushioned'

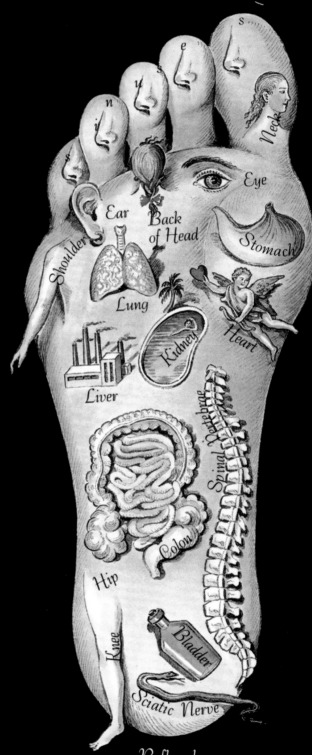

THIS TECHNOLOGY,
YOUR FEET IN MIND.

Leader DMX Walking Shoe.

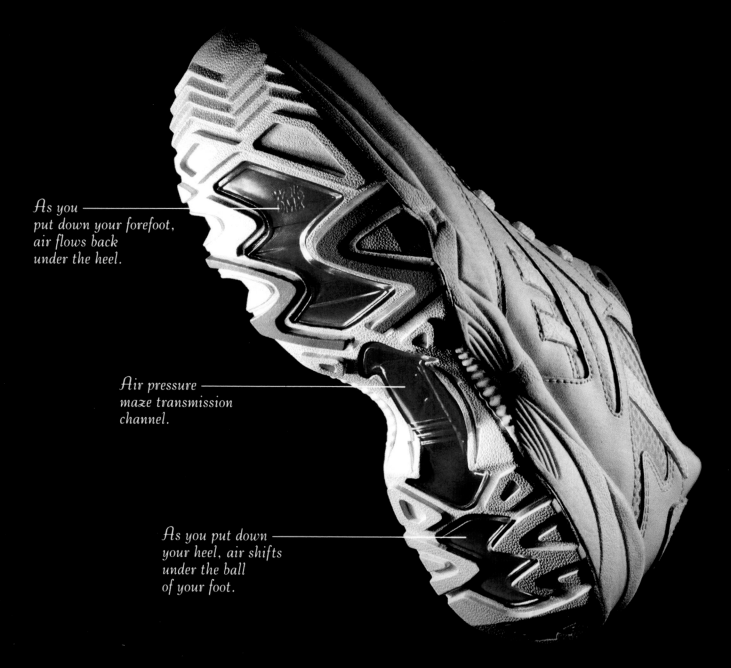

As you put down your forefoot, air flows back under the heel.

Air pressure maze transmission channel.

As you put down your heel, air shifts under the ball of your foot.

DynaMax Technology.

A science operating under the principle that a heel-to-toe cushioning system of air under the part of your foot about to strike the ground will relieve tension, improve circulation and provide peace of mind.

TOGETHER ON PLANET REEBOK.

To receive a free educational walking brochure or to locate a dealer near you, call 1-800-843-4444.

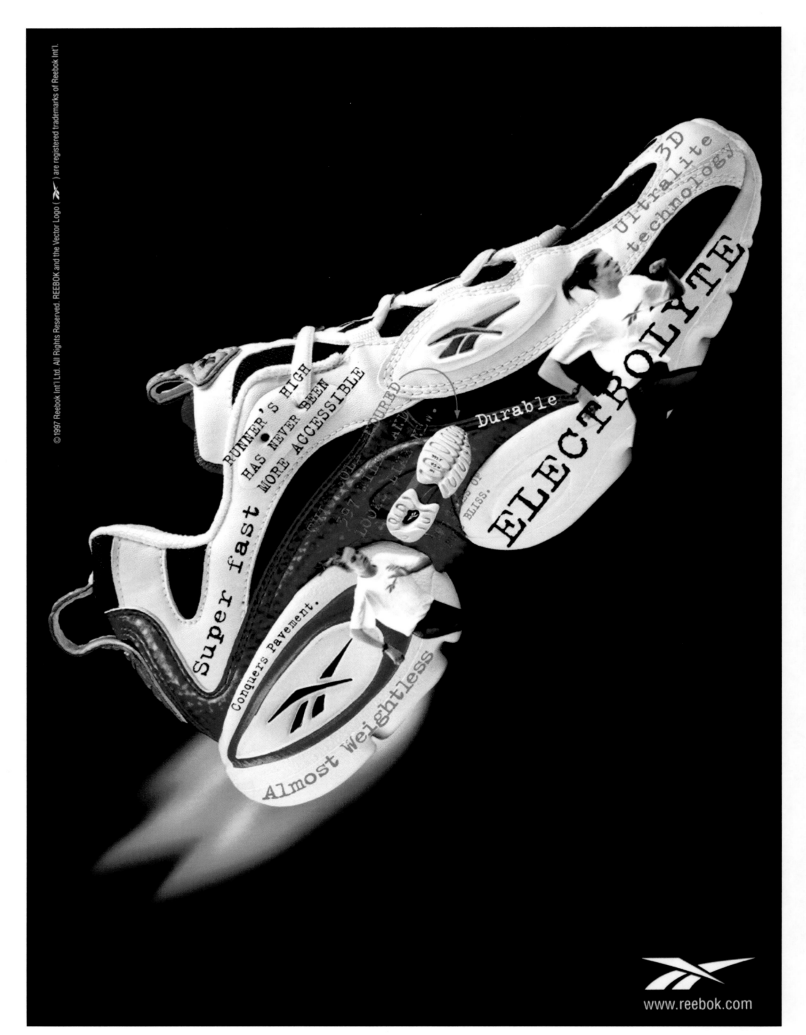

1997: DMX Electrolyte

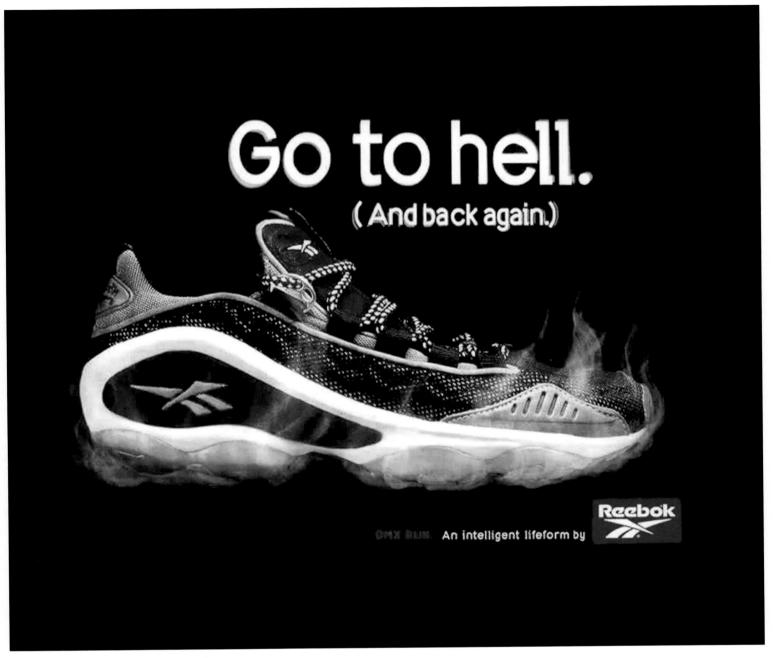

1997: DMX Run 10, 'Go to Hell. (And Back Again)'

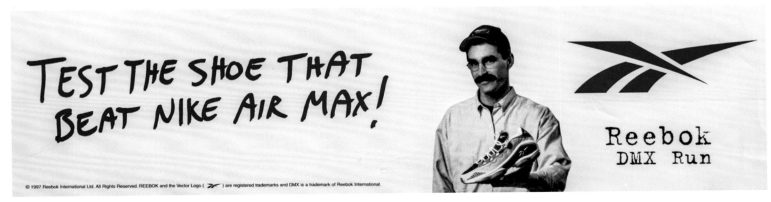

1997: DMX Run, 'Test the Shoe That Beat Nike Air Max!', ft. J Spencer White

Reebok DMX Run
VS.
The Other shoe

1997: DMX Series 2000, 'Reebok DMX Run Vs. the Other Shoe', ft. J Spencer White (1 of 2)

DMX SERIES 2000 TECHNOLOGY

THE TECH:

A) Heel strike drives air flow within the ten chamber system, actively cushioning and stabilizing the foot.

B) Rolling from heel to forefoot, the air adapts to distribute impact forces evenly for a smooth, stable, customized ride.

C) Rolling onto the ball of the foot forces air back under the heel for a lively sensation.

THE TEST:

In development tests, runners loved the DMX RUN shoe. We were so confident we asked an independent firm to test it against our top competitor.

THE RESULTS:

Serious runners preferred the DMX RUN shoe to NIKE AIR MAX and NIKE AIR ZOOM ALPHA!

Runner # 297

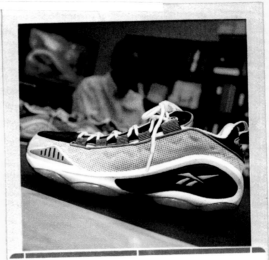

REEBOK DMX RUN SHOE

TEST # 96-93-039

RUNNING SHOE
RFORMANCE TEST

PROJECT A

SE TICK ONE BOX) (10)

Male .. ☒ 1

Female .. ☐ 2

bject run in an average week ? (PLEASE WRITE IN
AVERAGE MILES BELOW)

35 - 40 miles (11,12)

(SUBJECT MUST RUN A MINIMUM OF 20 MILES PER WEEK)

3. Now that the subject has run in these shoes, which shoes do they prefer ?
 (TICK ONE BOX BELOW)

	Cushioning	Overall	
Subject prefers shoe on right foot	☐	☐	1
Subject prefers shoe on left foot	☒	☒	2
No preference	☐	☐	3

(13, 14)

PLEASE PRINT COMMENTS IN SPACE BELOW.

*I never felt a shoe like this before...
cushioning felt better...
balanced fit...
stability.*

EASE HAND BACK TO THE SUPERVISOR.

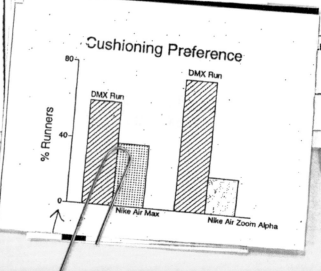

J. Spencer White
Director
Human Performance
Engineering Lab

Reebok International Ltd.
P.O. Box 197
Stoughton, MA 02072 USA
www.reebok.com

You have to test these for yourself!

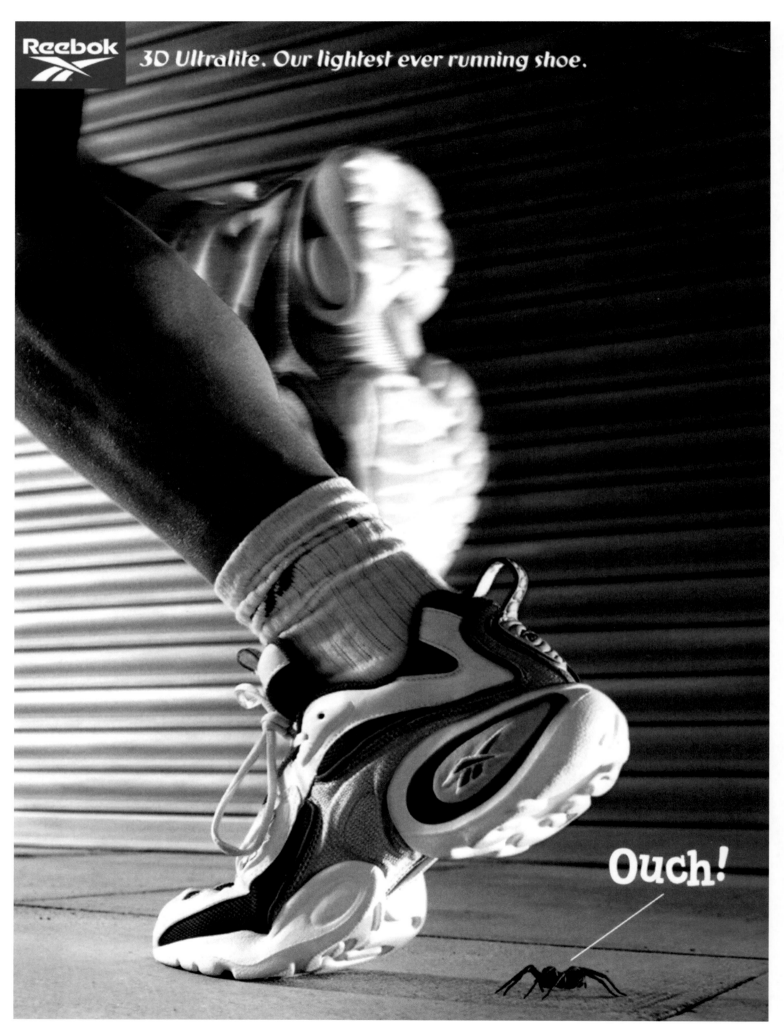

1998: 3D Ultralite Electrolyte, 'Our Lightest Ever Running Shoe'

 Lightweight and also durable.

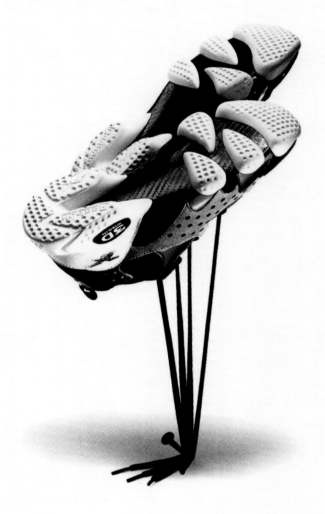

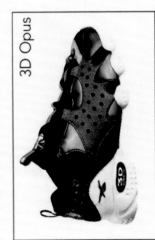
3D Opus

The 3D Opus is minimal, racy and lightweight. The revolutionary 3D Ultralite technology eliminates the need for heavy rubbers and cements used in traditional outsoles. Its design is flexible as well, not to mention durable. Attributes that makes 3D Ultralite technology one of a kind, much like the runners who wear them.

creating possibilities
one runner at a time

1998: 3D Opus, 'Lightweight and Also Durable'

1998: DMX, 'Compatible With All Six Billion Individual Models'

Compatible with all six billion individual models.

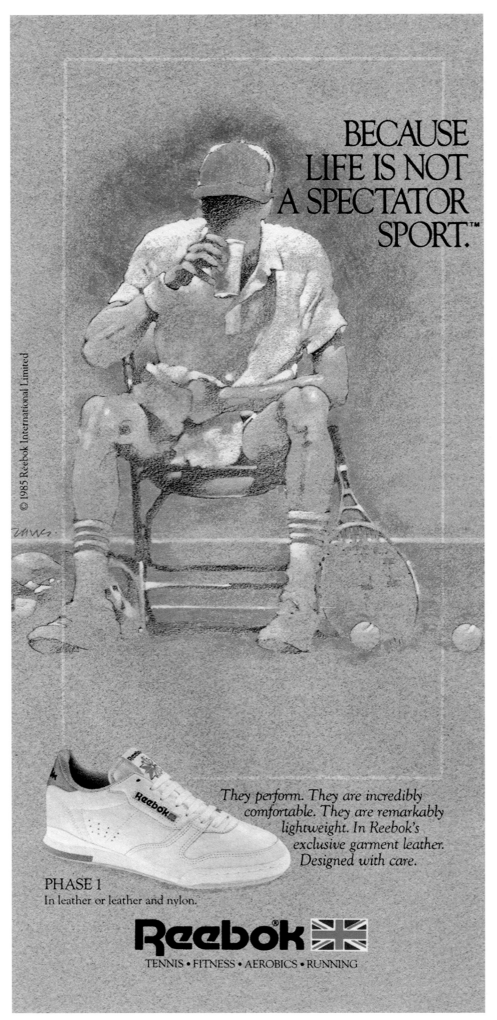

BECAUSE LIFE IS NOT A SPECTATOR SPORT.™

They perform. They are incredibly comfortable. They are remarkably lightweight. In Reebok's exclusive garment leather. Designed with care.

PHASE 1
In leather or leather and nylon.

Reebok®

TENNIS • FITNESS • AEROBICS • RUNNING

1985: Phase 1, 'Because Life is Not a Spectator Sport'

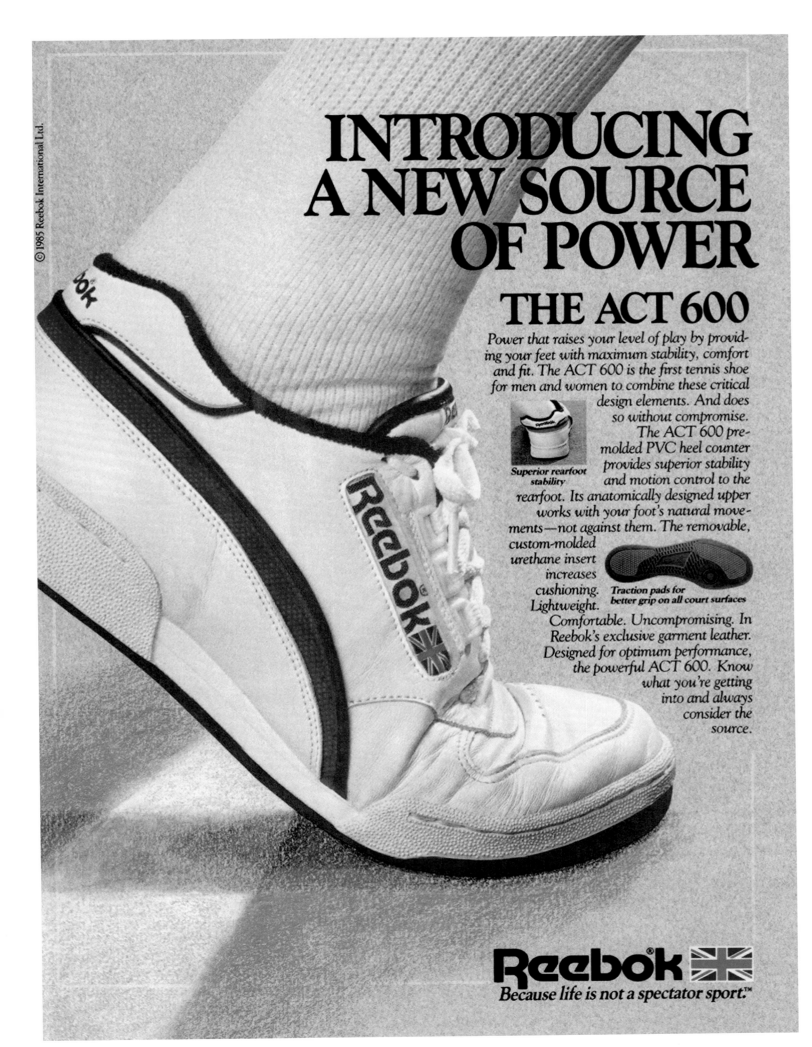

1985: ACT 600, 'Introducing a New Source of Power'

Introducing Axis™ and Victoria.™ An innovative move for men and women.

All serious players need stability and support in a tennis shoe. At no sacrifice in comfort. That's why we developed the men's Axis and women's Victoria tennis shoes.

Both Axis and Victoria feature a unique modified 3/4-wrap outsole, incorporating our exclusive flex-notch system at the forefoot area. This entirely new outsole design both enhances forefoot flexibility and cradles and supports your foot for maximum motion control. It also reduces the shoe's overall weight. The layered midfoot saddle

Exclusive flex-notch enhances forefoot flexibility.

construction adds an extra measure of support and stability where you need it. All this support does not restrict your moves. Distinctive new traction patterns allow the outsole to bend in the right places for added on-court maneuverability.

In addition, Victoria incorporates Reebok's unique polyethylene support straps to stabilize and position your forefoot for quick lateral turns.

Axis and Victoria are durable shoes, built to take a lot of abuse. You won't. Reebok's no-break-in garment leather assures superior comfort, as does the removable, molded insole. Both Axis and Victoria are available in mid-cut versions for added ankle support.

New Axis and Victoria. With all the moves you need for improved performance.

Victoria

Axis

Reebok 🇬🇧

1987: Victoria and Axis, 'Reebok is Performance!'

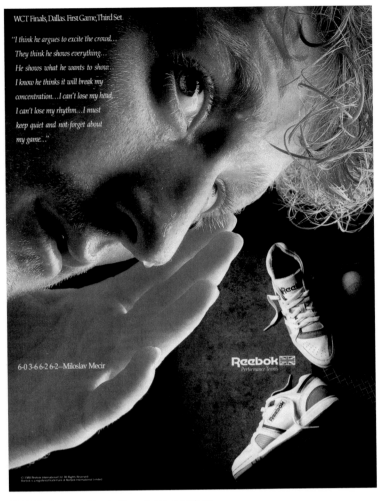

1988: Performance Tennis Shoe, ft. Miloslav Mečíř

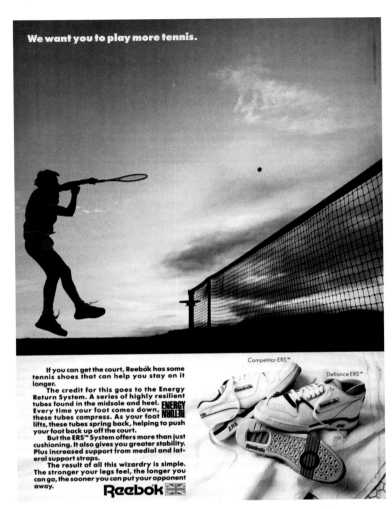

1989: Competitor ERS and Defiance ERS, 'We Want You to Play More Tennis'

1990: Court LWT Series, 'You Can't Hit It if You Can't Get to It'

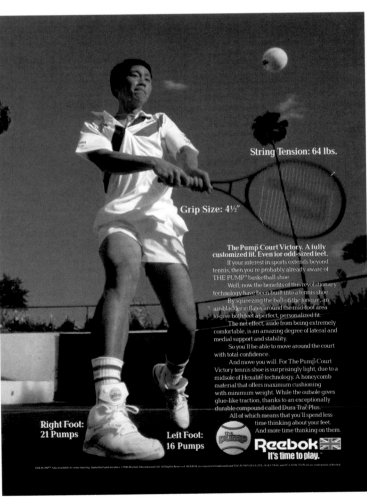

1990: Court Victory, ft. Michael Chang

SAUCONY

Saucony started as a traditional leather shoe manufacturer in the early 1900s. The exotically named company – officially pronounced 'Sock-ah-nee' – was inspired by the Lenni Lenape Native American word 'saconk', meaning 'where two creeks run together'. The S-shaped logo represents a river flowing around a trio of boulders.

Mining a similar advertising vibe to New Balance, the Saucony formula of a bold headline and loads of tech-talk was a persuasive combination, with 'Survival of the Fastest' and 'America the Comfortable' epitomising the approach. The full-page letters written by company president Leonard Fisher were a personal touch that highlighted Saucony's family-first approach.

Encapsulating the spirit of the times, the Jazz runner would go on to become a bestseller. The aerodynamic design featured Maxitrac outsoles with triangle lugs and a 'Butterfly Balance' lacing system. Countless variations were released over the years, including the Jazz 3000, Jazz 4000, Jazz 5000 and GRID Jazz. As Saucony put it in their advertising, 'After much sole-searching, runners always come back to the Jazz!'

●

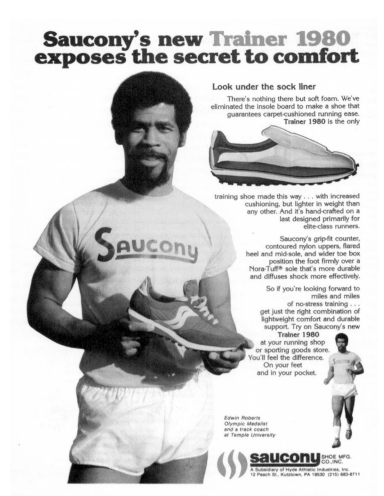

Saucony's new Trainer 1980 exposes the secret to comfort

Look under the sock liner

There's nothing there but soft foam. We've eliminated the insole board to make a shoe that guarantees carpet-cushioned running ease. Trainer 1980 is the only training shoe made this way . . . with increased cushioning, but lighter in weight than any other. And it's hand-crafted on a last designed primarily for elite-class runners.

Saucony's grip-fit counter, contoured nylon uppers, flared heel and mid-sole, and wider toe box position the foot firmly over a Nora-Tuff® sole that's more durable and diffuses shock more effectively.

So if you're looking forward to miles and miles of no-stress training . . . get just the right combination of lightweight comfort and durable support. Try on Saucony's new Trainer 1980 at your running shop or sporting goods store. You'll feel the difference. On your feet and in your pocket.

*Edwin Roberts
Olympic Medalist
and a track coach
at Temple University*

saucony SHOE MFG. CO., INC.
A Subsidiary of Hyde Athletic Industries, Inc.
12 Peach St., Kutztown, PA 19530 (215) 683-8711

1978: Trainer 1980, 'Saucony's New Trainer 1980 Exposes the Secret to Comfort', ft. Edwin Roberts

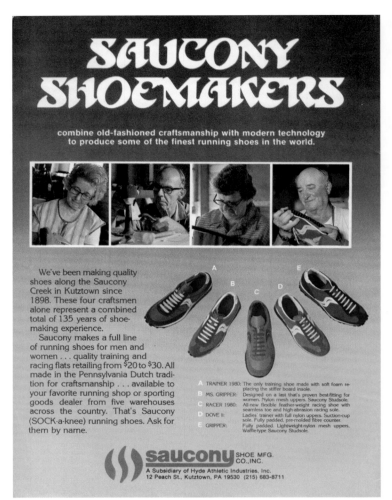

SAUCONY SHOEMAKERS

combine old-fashioned craftsmanship with modern technology to produce some of the finest running shoes in the world.

We've been making quality shoes along the Saucony Creek in Kutztown since 1898. These four craftsmen alone represent a combined total of 135 years of shoe-making experience.

Saucony makes a full line of running shoes for men and women . . . quality training and racing flats retailing from $20 to $30. All made in the Pennsylvania Dutch tradition for craftsmanship . . . available to your favorite running shop or sporting goods dealer from five warehouses across the country. That's Saucony (SOCK-a-knee) running shoes. Ask for them by name.

A TRAINER 1980: The only training shoe made with soft foam replacing the stiffer board insole.
B MS. GRIPPER: Designed on a last that's proven best-fitting for women. Nylon mesh uppers. Saucony Studsole.
C RACER 1980: All-new flexible feather-weight racing shoe with seamless toe and high-abrasion racing sole.
D DOVE II: Ladies' trainer with full nylon uppers. Suction-cup sole. Fully padded, pre-molded fibre counter.
E GRIPPER: Fully padded. Lightweight-nylon mesh uppers. Waffle-type Saucony Studsole.

saucony SHOE MFG. CO., INC.
A Subsidiary of Hyde Athletic Industries, Inc.
12 Peach St., Kutztown, PA 19530 (215) 683-8711

1978: Trainer 1980, Ms. Gripper, Racer 1980, Dove II and Gripper 'Saucony Shoemakers'

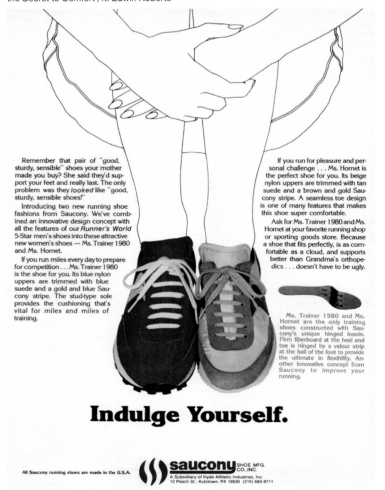

Remember that pair of "good, sturdy, sensible" shoes your mother made you buy? She said they'd support your feet and really last. The only problem was they *looked* like "good, sturdy, sensible shoes!"

Introducing two new running shoe fashions from Saucony. We've combined an innovative design concept with all the features of our *Runner's World* 5-Star men's shoes into these attractive new women's shoes — Ms. Trainer 1980 and Ms. Hornet.

If you run miles every day to prepare for competition . . . Ms. Trainer 1980 is the shoe for you. Its blue nylon uppers are trimmed with blue suede and a gold and blue Saucony stripe. The stud-type sole provides the cushioning that's vital for miles and miles of training.

If you run for pleasure and personal challenge . . . Ms. Hornet is the perfect shoe for you. Its beige nylon uppers are trimmed with tan suede and a brown and gold Saucony stripe. A seamless toe design is one of many features that makes this shoe super comfortable.

Ask for Ms. Trainer 1980 and Ms. Hornet at your favorite running shop or sporting goods store. Because a shoe that fits perfectly, is as comfortable as a cloud, and supports better than Grandma's orthopedics . . . doesn't have to be ugly.

Ms. Trainer 1980 and Ms. Hornet are the only training shoes constructed with Saucony's unique hinged insole. Firm fiberboard at the heel and toe is hinged by a velour strip at the ball of the foot to provide the ultimate in flexibility. Another innovative concept from Saucony to improve your running.

Indulge Yourself.

All Saucony running shoes are made in the U.S.A.

saucony SHOE MFG. CO., INC.
A Subsidiary of Hyde Athletic Industries, Inc.
12 Peach St., Kutztown, PA 19530 (215) 683-8711

1979: Ms. Trainer 1980 and Ms. Hornet, 'Indulge Yourself'

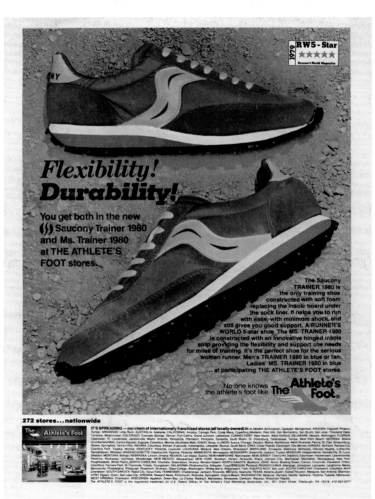

RW5 - Star ★★★★★
1979 Runner's World Magazine

Flexibility! Durability!

You get both in the new **saucony** Trainer 1980 and Ms. Trainer 1980 at THE ATHLETE'S FOOT stores.

The Saucony TRAINER 1980 is the only training shoe constructed with soft foam replacing the insole board under the sock liner. It helps you to run with ease, with minimum shock, and still gives you good support. A RUNNER'S WORLD 5-star shoe. The MS. TRAINER 1980 is constructed with an innovative hinged insole strip providing the flexibility and support she needs for miles of training. It's the perfect shoe for the serious woman runner. Men's TRAINER 1980 in blue or tan. Ladies' MS. TRAINER 1980 in blue . . . at participating THE ATHLETE'S FOOT stores.

No one knows the athlete's foot like The **Athlete's Foot**.

272 stores . . . nationwide

IT'S SPREADING — our chain of internationally franchised stores (all locally-owned) in ALABAMA Birmingham, Gadsden, Montgomery, ARIZONA Flagstaff, Phoenix, Tempe. ARKANSAS Little Rock. AUSTRALIA Adelaide, Canoga Park, Costa Mesa, Cucamonga, Modesto, Palo Alto, San Bernardino, San Bruno, San Jose, Thousand Oaks, Torrance, Westminster. COLORADO Colorado Springs, Denver, Fort Collins, Grand Junction, Lakewood. CONNECTICUT New Haven, West Hartford. DELAWARE Newark, Wilmington. FLORIDA (Cumberland Mall), Jacksonville, Miami, Orlando, Pensacola, Plantation, Pompano, Sarasota, South Miami, St. Petersburg, Tallahassee, Tampa, West Palm Beach. GEORGIA Atlanta (Cumberland Mall), (Lenox Square), Augusta, Columbus, Macon (Southlake Mall). IDAHO Boise. ILLINOIS Aurora, Chicago, Decatur, Moline, Northbrook, North Riverside, Peoria, St. Clair, Schaumburg, Springfield. INDIANA Columbus, Indianapolis, Lafayette, Muncie, South Bend. IOWA Cedar Rapids, Davenport, Des Moines. KANSAS Wichita, Kansas City. Overland Park, Topeka, Wichita. KENTUCKY Florence, Louisville. LOUISIANA Metairie, New Orleans, Shreveport. MARYLAND Annapolis, Baltimore, Bethesda, Hillcrest Heights, Rockville. MASSACHUSETTS Boston, Braintree, Hanover, Springfield, Worcester. MICHIGAN Ann Arbor, Detroit, Flint, Grand Rapids, Lansing, Livonia, Southgate. MINNESOTA Minneapolis. MISSISSIPPI Greenville, Jackson. MISSOURI Independence, Kansas City, St. Louis, Springfield. MONTANA Billings. NEBRASKA Lincoln, Omaha. NEVADA Las Vegas, Sparks. NEW HAMPSHIRE Manchester, NEW JERSEY Cherry Hill, Deptford, Eatontown, Hackensack, Lawrenceville, Newark, Paramus, Woodbridge. NEW MEXICO Albuquerque. NEW YORK Albany, Buffalo, New York City, Poughkeepsie, White Plains. NORTH CAROLINA Charlotte, Greensboro, Hickory, Winston-Salem. NORTH DAKOTA Bismarck. OHIO Akron, Bowling Green, Canton, Cincinnati, Cleveland, Clifton, Columbus, Fairview Park, (Eastwood), Dayton, Kettering, Lima, Toledo, Youngstown. OKLAHOMA Oklahoma City, Stillwater, Tulsa. OREGON Portland. PENNSYLVANIA Allentown, Lancaster, Langhorne, Media, Monroeville, Philadelphia, Pittsburgh, Scranton, State College, Washington, Wilkes-Barre, Williamsport, York. PUERTO RICO San Juan. SOUTH CAROLINA Columbia, North Charleston. SOUTH DAKOTA Rapid City, Sioux Falls. TENNESSEE Chattanooga, Jackson, Knoxville, Memphis, Nashville. TEXAS Abilene, Austin, Dallas, Houston, Mesquite, San Antonio, Sherman. UTAH Ogden, Orem, Salt Lake City. VIRGINIA Newport News, Portsmouth, Roanoke, Springfield, Virginia Beach. WASHINGTON Bellevue, Olympia, Seattle, Spokane, Tacoma, Tukwila, Vancouver. WEST VIRGINIA Charleston. WISCONSIN Appleton, Green Bay, La Crosse, Madison, Manitowoc, Milwaukee, Oshkosh, Waukesha, Wisconsin Rapids. The ATHLETE'S FOOT is the registered trademark of The Athlete's Foot Marketing Associates, Inc., 801 Grant Street, Pittsburgh, PA 15219. 412-263-2077

1979: Trainer 1980, 'Flexibility! Durability!'

Saucony Trainer 1980 Best* of all The 5-Star Shoes

*Leonard R. Fisher
President, Hyde
Athletic Industries*

"We were very pleased to win a 5-Star Rating for the Saucony Trainer 1980,® as well as three other Saucony styles, in *Runner's World* October 1979 rating issue.

"Bob Anderson, publisher of *Runner's World,* recently released data on the numerical weighting system his magazine used to award 5-Star Ratings. This data enabled us to determine that the Trainer 1980 had the highest point score (131.1) of the 85 styles in the very competitive men's training shoe category.

"The Saucony Trainer 1980 ranked first* of all the 5-Stars!

"This singular accomplishment proves the value of the many active runners who are part of our Saucony product development team. It shows that serious runners know what other serious runners want and like in running shoes. That's why the Trainer 1980, Ms. Trainer 1980,® Silver Streak,® and Ms. Silver Streak,® racing flats ran away with 5-Star Ratings.

"I hope you ask to see the Trainer 1980 as well as other fine Saucony shoes at your favorite sporting goods store or running shop. You're the one we keep in mind as we develop ever better Saucony shoes for serious runners."

Help make running safer and more fun. Run in the Saucony 10K...
"Share the Road with a Runner" race series. Ask your favorite running shop for details or write

*For a detailed listing of the numerical rating results, write to us enclosing a stamped, self-addressed envelope.

HYDE ATHLETIC INDUSTRIES, INC., Maker of Spot-bilt,® Saucony,® and Hyde® Athletic Footwear
General Offices: 432 Columbia Street, Cambridge, MA 02141

1979: Trainer 1980, 'Saucony Trainer 1980 Best* of All the 5-Star Shoes', ft. Leonard Fisher

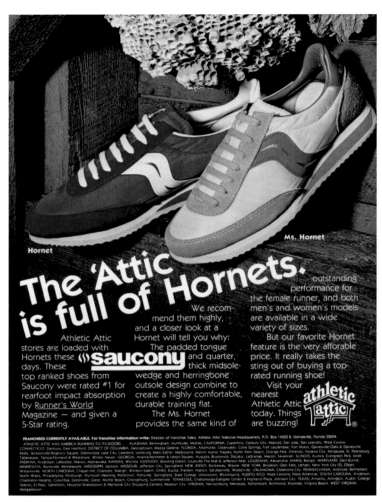

1979: Hornet and Ms. Hornet, 'The 'Attic is Full of Hornets'

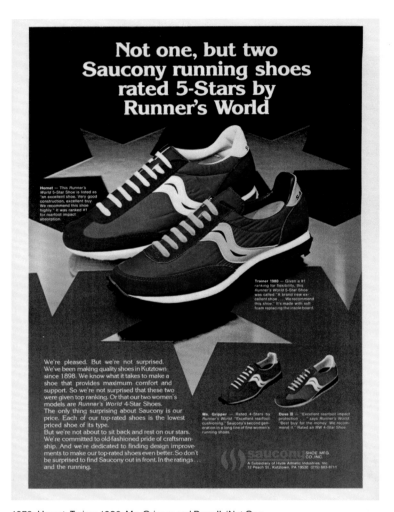

1979: Hornet, Trainer 1980, Ms. Gripper and Dove II, 'Not One, But Two Saucony Running Shoes Rated 5-Stars by Runner's World'

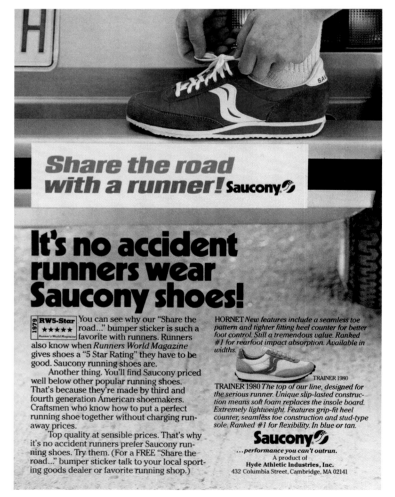

1979: Hornet and Trainer 1980, 'It's No Accident Runners Wear Saucony Shoes!'

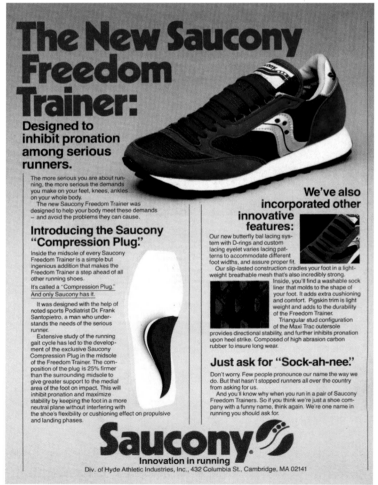

1981: Freedom Trainer

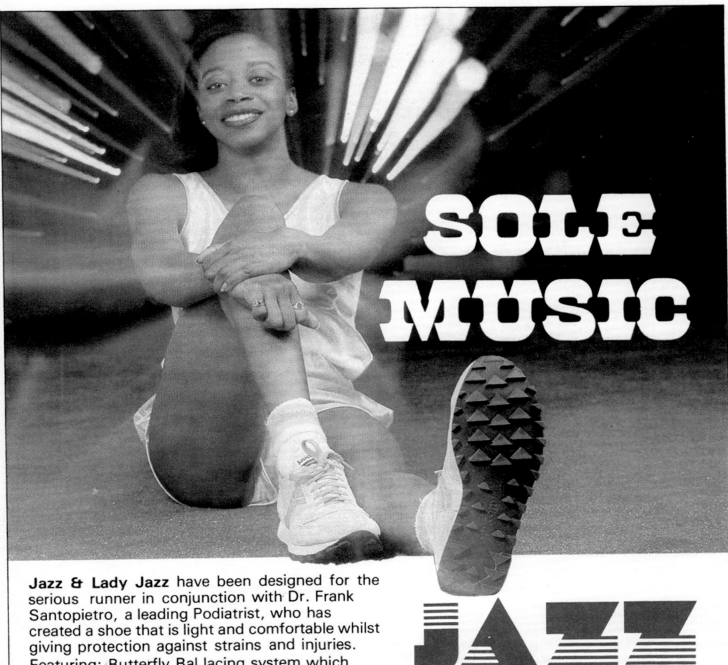

SOLE MUSIC

Jazz & Lady Jazz have been designed for the serious runner in conjunction with Dr. Frank Santopietro, a leading Podiatrist, who has created a shoe that is light and comfortable whilst giving protection against strains and injuries.

Featuring: Butterfly Bal lacing system which adjusts the shoe to the width of the foot. The Maxitrac outer-sole which gives grip and shock absorption where needed. A machine-washable sock insert which moulds to the shape of your foot.

Saucony Jazz shoes won a five-star accolade from the American *Runners World* magazine, a tribute to their lightness, comfort and protection.

If you're serious about running, you'll find that Saucony are serious about shoes. **Step into a pair of Saucony Jazz today. They'll do more than set your feet tapping.**

"Available from all good running shops"
Sole UK Distributors
Runners World Limited, 11-17 Stert Street Abingdon (0235) 31815

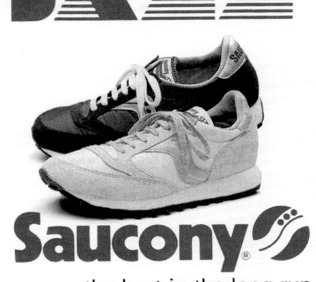

JAZZ

Saucony

. . . the best in the long run

1982: Jazz and Lady Jazz, 'Sole Music'

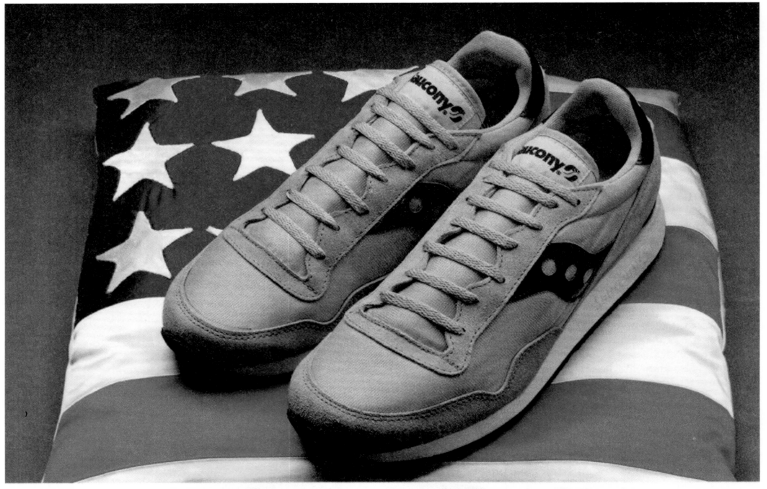

America the Comfortable.

From dawn's early light to the twilight's last gleaming, these are the most comfortable shoes you can run in.

We call them America.

And we build them to be worthy of the name. In a country full of roads that weren't created equal.

To soak up shock on the cobblestones of Boston, we refined a piece of Saucony ingenuity known as the Dutchman.

It's a pad of soft Hytrel plastic which combines with our MEVA midsole to give you a supersoft running system that's exceptionally stable.

For all-terrain traction, from the sands of Santa Barbara to the canyons of Manhattan, we designed a durable, studded outsole of carbon rubber.

And to beat the steamy heat of the muggy Midwest, we let the lightweight uppers breathe, through a tough new mesh.

We, the people who make Saucony shoes, believe we have created a more perfect union of high technology and good old-fashioned comfort.

One more thing.

You don't have to be rich to live in these Americas.

Division of Hyde Athletic Industries, Inc., 432 Columbia Street, Cambridge, MA 02141

Women

Men

Men

1985: America, 'America the Comfortable'

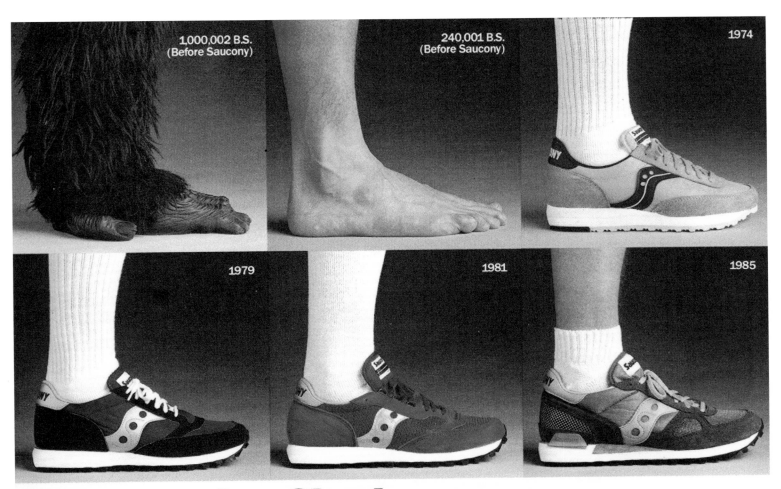

Our Shadow proves the theory of evolution.

Running has come a long way in the last quarter of a million years.

First someone got the bright idea to run on two feet instead of four. About 240,000 years later came the first shoes. Then Saucony developed the Jazz and Freedom Trainer and something called the "Saucony feel" was born.

Now comes the Saucony Shadow.

Its outersole evolved from the Jazz. So it retained the same cushioning ability, while adding reinforced rubber around the edge for longer wear and better support. The midsole grew from the Freedom Trainer, with the addition of a motion controller and shank insert for torsional stability.

And, to insure its survival at night, we've covered the heel counter with 3M Scotchlite® reflective tape and a protective black double screen.

It's a shoe Charles Darwin would have loved. Because it's probably the most comfortable argument anyone's ever made for evolution.

Saucony

Div. of Hyde Athletic Industries, Inc.
Centennial Industrial Park, Centennial Dr., Peabody, MA 01960

Styles for men and women.

1985: Shadow, 'Our Shadow Proves the Theory of Evolution'

Discover the secret of Flite.

As you know, every time you run, your feet come in for thousands of crash landings. So we designed the Flite to turn that tough law of nature to your advantage. Like a pogo stick.

The secret is a molded two-density MEVA midsole wedge. It's constructed of a soft exterior and a firmer inner structure formed into a horizontal platform with vertical pillars.

The wedge is matched to the dynamics of a new Indy 500 outsole, designed with flat stabilizer bars in the rear and canted studs in the forefoot.

This creates a propulsion sys-tem that supports your foot on the medial side through-out the pronation phase. And provides spring on takeoff, which "refuels" your legs.

The result: more bounce in your stride. And a new standard for the words firm, light, and stable. We went the distance on the Flite. And landed a lot closer to what we're all looking for: the perfect run-ning shoe.

Saucony
432 Columbia St, Cambridge, MA 02141
Division of Hyde Athletic Industries, Inc.
For a free copy of our "Construction Blueprints" booklet on our full line of running shoes, write our Promotions Department.

The Flite. For men and women.

1984: Flite, 'Discover the Secret of Flite'

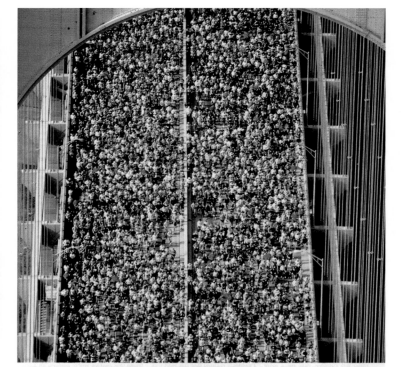

Build a better shoe and the world will beat a path to your door.

When the dust settles, folks want performance, pure and simple. Stripped clean of pointless bells and whistles. This is it. The Jazz Plus. You get breathable, no-nonsense mesh uppers, a rugged outsole that gives you almost unbelievable durability. And an EVA midsole wedge that corrects against over-pronation.

The Jazz Plus. A better running shoe. What it comes down to is this: The real runners of this world never stop improving themselves.

We feel the same way about our shoes.

Saucony
432 Columbia, Cambridge, MASS 02141

Jazz Plus. Also available in Lady Jazz Plus model.

1984: Jazz Plus, 'Build a Better Shoe and the World Will Beat a Path to Your Door'

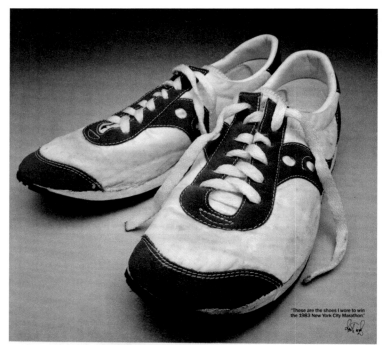

"These are the shoes I wore to win the 1983 New York City Marathon."

Survival of the fastest.

The evolution of running shoes is based on a very simple concept. You live or die based on performance.

And only the survivors go on to help create the next generation.

That's why our new Dixon Trainers were made in the image of the fastest shoes in last year's New York marathon. Rod Dixon's Saucony racing flats.

They inherited features like the "Dixon Mattress," an E.V.A. midsole wedge drilled with holes for extra cushioning.

And a super-soft protective insert under the metatarsal head. The flexible backtab relieves Achilles tension over the long run, and its flatter outsole helps propel you forward.

They may be the best training shoes we've ever made. But then they should be. After all, look whose footsteps they're following in.

Saucony
Division of Hyde Athletic Industries, Inc.
432 Columbia St, Cambridge, Mass 02141
For a free copy of our new "Construction Blue prints" brochure on our full line of athletic shoes, write our Promotion Department D.

1984: Dixon Trainer, 'Survival of the Fastest'

The inside story on the Advance.

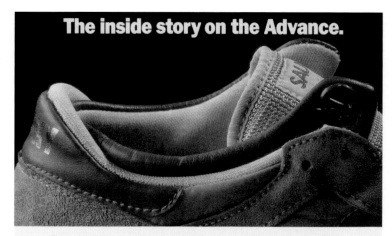

Such attention to detail with the single purpose of performance is some-thing perhaps unexpected from a running shoe. Saucony has artfully merged ingenuity, engineering, and a touch of serendipity in the Advance.

Upon first glance, Saucony ingenuity is apparent in the innovative inner collar which locks your foot precisely in the right position for maximum performance, stability, and protection. Further technical precision was applied in the four-density Advance midsole, designed to react to the foot's varying needs of cushioning, shock attenuation, and support. This system is enhanced by a 2-color, 2-density, longwearing outsole.

However, the uniqueness of the Advance does not end with its superb crafts-manship and great looks.

Each pair of Advance running shoes has a registration number under the tongue affording direct access between the owner and Saucony. Because not everyone will own a pair of Advance. And Saucony wants to assure those who do that it stands firmly behind the quality workmanship of this shoe.

Something perhaps unexpected from a running shoe company.

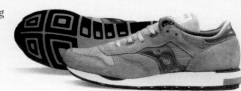

Saucony
Division of Hyde Athletic Industries, Inc.
432 Columbia Street, Cambridge, MA 02141

1985: Advance, 'The Inside Story on the Advance'

It'll never get any easier.

You've been running five years now, or is it ten?

But you still get nervous if you miss three days in a row.

You need your maintenance runs to keep a level of fitness, and your status as a runner.

You wait for those painful runs, when the pain turns into the music of your soul.

And the more you experience it, the more you need it.

Because, for a committed athlete, running is more than a sport.

It's a life.

It's a complicated commitment that never gets any easier.

Not for you. And not for us.

We're Saucony, a group of runners who take a slightly fanatical approach to designing shoes. From the ground up with people, not computers.

Shoes like our Jazz Plus. With features like firm EVA deceleration plugs for better stability. Removable sockliners that form to your feet. Carbon rubber outsoles with biomechanically designed diamond ribbed sole patterns for cushioning, traction, and a firm ride. Flexible, featherweight uppers. And a lacing system that's a cinch for a better fit.

Try a pair. We'll bet you'll come back for more. In fact, we're betting our shoes on it.

432 Columbia, Cambridge, Mass. 02141
For a full color, 22" x 36" poster made from the photo on the left, send $2.00 to cover postage and handling to Saucony Promotions Dept.

Jazz Plus. Also available in Lady Jazz Plus model.

1984: Jazz Plus, 'It'll Never Get Any Easier'

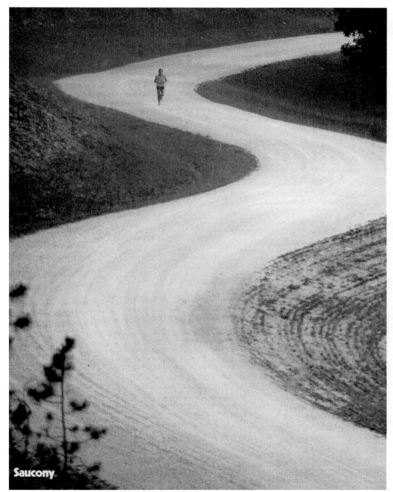

Sometimes it's best to take the long way home.

The smartest distance between two points is not necessarily a straight line.

Easier, maybe.

But after years of running, you've learned a bitter-sweet lesson: Short cuts are dead ends.

So you gut it out through the lows, and hang in there for the highs—those rare, floating moments when the experience is so intensely personal it defies description.

And that's when you know everything you put into running comes back.

Nobody knows that better than the running shoemakers at Saucony. Take our Advance, for example. We put a lot of work into it, but it paid off in a shoe like no one has ever crafted before. In fact, each pair is registered.

The Advance comes close to perfection for protection and control. A unique inner "boot" laces up to position your foot in the optimum location. And holds it there.

A four-density EVA midsole wedge gives you heel stability, a softer forefoot soaks shocks, and a supersoft insert helps protect the metatarsal head against injury.

And down under is a two-color, two-density carbon rubber Bi-Tech outsole, with negative spaces in the pattern that store energy and release it in a propulsion action as you toe off.

The Saucony Advance. Our proud contribution towards the human races.

Division of Hyde Athletic Industries
432 Columbia St.,
Cambridge, MA 02141

1984: Advance, 'Sometimes It's Best to Take the Long Way Home'

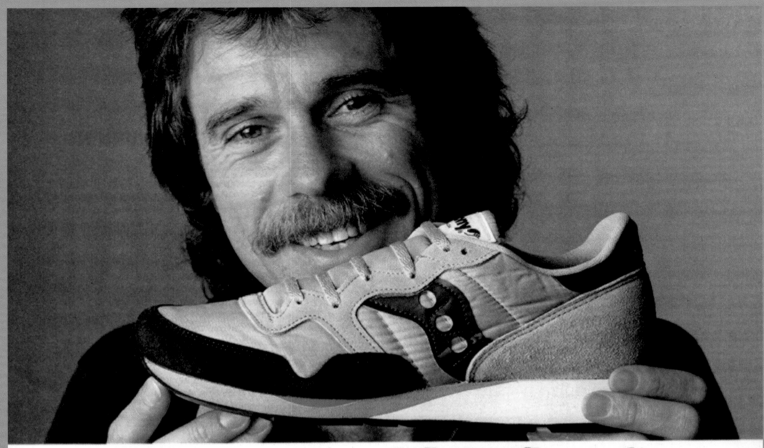

Rod Dixon wasn't satisfied until we put a mattress, a window and a trampoline in these shoes.

Before Rod Dixon let us put his name on these trainers, he took them for a run. And another. And another. And he came back with a few suggestions.

First, he said, how about an EVA midsole wedge with tiny holes drilled in it. For extra cushioning on impact. We suggested the name Dixon Mattress. He said that would be just fine.

Then, Rod said, how about a feature in the backtab that would relieve nagging tension on your Achilles tendon over long runs.

We designed a collapsible backtab, suggested the name Dixon Window, and Rod said that would be just fine.

Then, he said, it sure would be nice to build in a trampoline effect that adds spring during the toeing-off phase. Perhaps, he went on, a supersoft protective insert under the metatarsal head coupled with a flatter outsole.

We agreed that would be just fine.

Now, Rod Dixon is a world class runner. A New York Marathon winner. And a tough customer to satisfy.

So when he said our Dixon Trainers were good enough to wear his name—that was good enough for us.

Just one question remains: Are they good enough for you?

Saucony

Division of Hyde Athletic Industries.
432 Columbia Street, Cambridge, Mass. 02141

1985: Dixon Trainer, 'Rod Dixon Wasn't Satisfied Until We Put a Mattress, a Window and a Trampoline in These Shoes', ft. Rod Dixon

1985: Lady Dixon

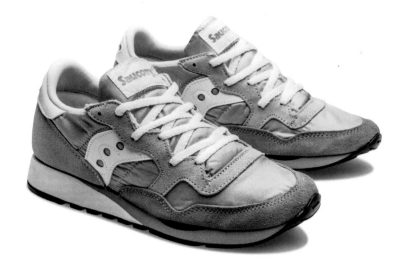

" Rod Dixon is a freak athlete. After winning a Bronze medal against all odds in the 1500 metres at the 1972 Olympics, the 6-foot-2 'Flying Kiwi' proved to be highly competitive on any surface at any distance he put his energetic mind towards. Versatility was the Dixon trademark. In 1983, Rod pulled off one of the greatest road race wins of all time, judging his final few yards of the New York City Marathon to perfection. In only his second 26.2 mile event, Rod's time of 2.08:59 was just one second outside his own prediction. Following his famous victory, Saucony's charismatic 'rock star' runner launched an eponymous DXN line, including the Dixon Trainer and the highly regarded Lady Dixon. Fascinated by how his pro-level shoes were assembled, Rod was frequently found on the factory floor in Kutztown, Pennsylvania, tinkering with experimental tread patterns and cushioning concepts. **"**

Woody
Saucony History Book
Sneaker Freaker (2021)

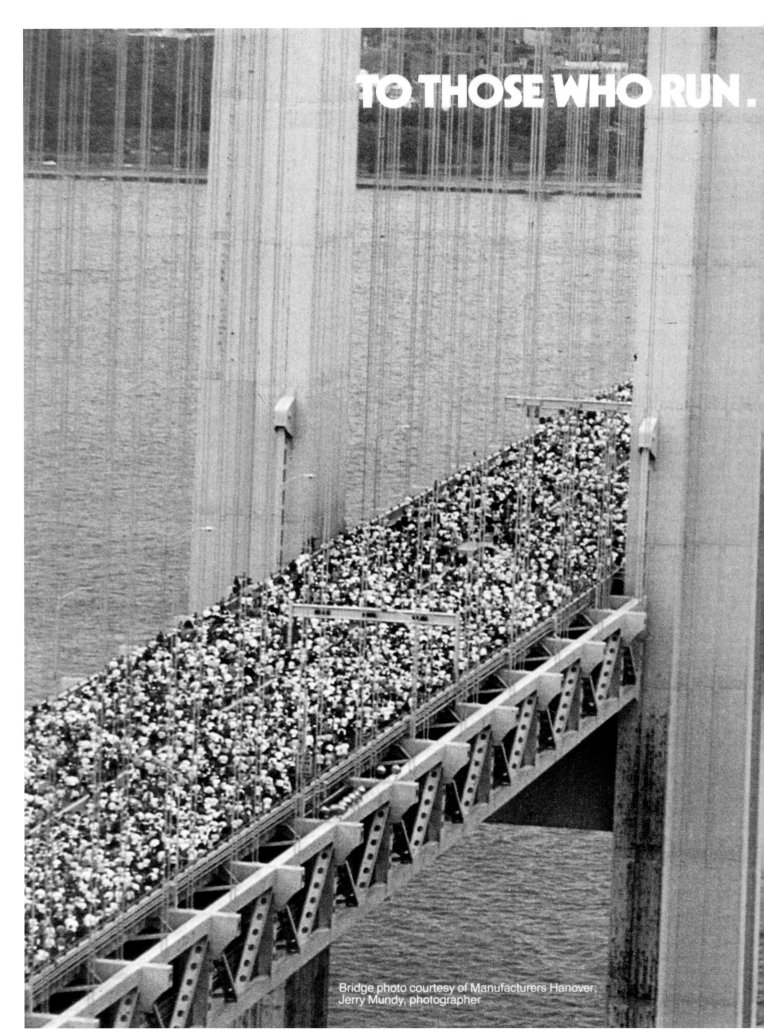

TO THOSE WHO RUN.

Bridge photo courtesy of Manufacturers Hanover;
Jerry Mundy, photographer

1984: 'To Those Who Run…a Salute From the Man Who Won', ft. Rod Dixon

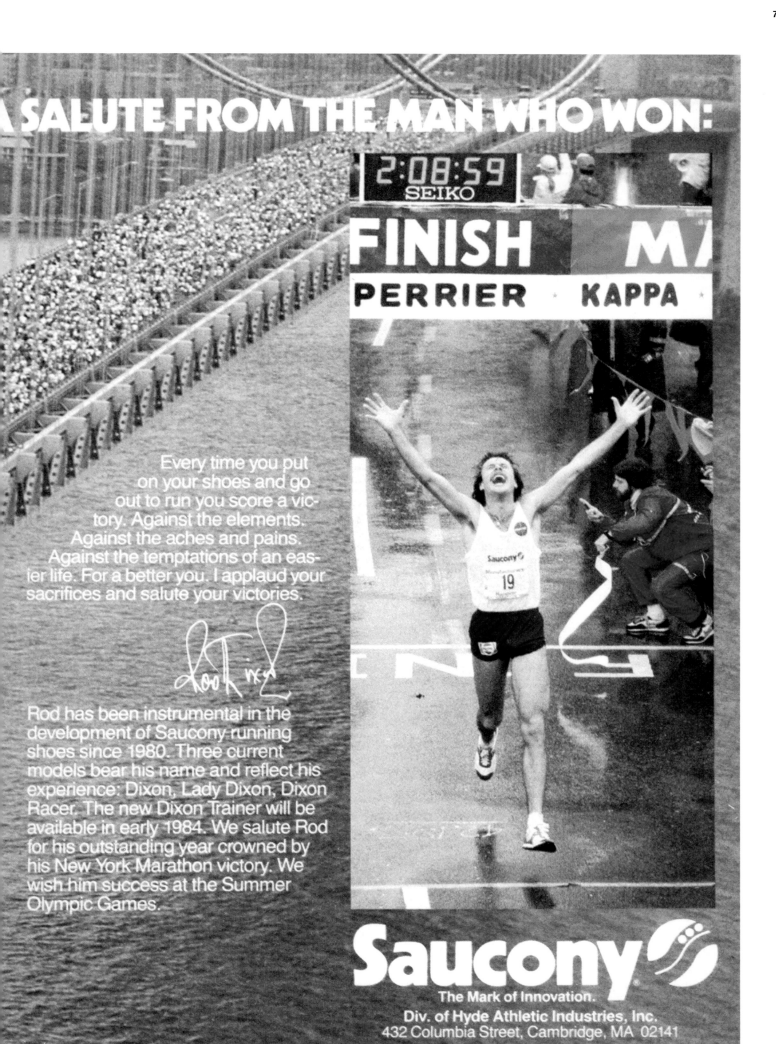

Next month we're going to give you a good swift boot.

The Saucony Advance, worth waiting for.

1984: Advance, 'Next Month We're Going to Give You a Good Swift Boot'

Next month you can throw away your running shoes.

The Flite is coming. Prepare for takeoff.

432 Columbia Street, Cambridge, MA 02141
Div. of Hyde Athletic Industries, Inc.

1984: Flite, 'Next Month You Can Throw Away Your Running Shoes'

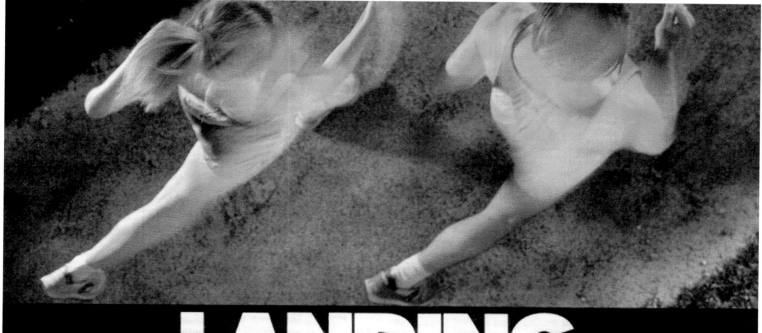

LANDING

One of the first laws of aeronautics says that going up is easy. Coming down safely is the tricky part. Unless, of course, you have the right landing gear. Introducing the Saucony Shadow VS.

The Shadow VS was designed to make getting down to earth as comfortable and safe as possible. The new bi-density, compression molded midsole takes a real pounding. So you don't. There's also a removable polyurethane insole that disperses shock and provides additional protection and comfort. Plus an improved

motion control device and a bias mesh rear quarter insert that work together to give you better mid and rearfoot support. Not to mention exceptional heel fit and stability.

These new features are combined with our classic Indy 500 triangular lug sole that reduces shock and cushions touch downs

on all surfaces. So you get the same fit and feel that have made the Saucony line of running shoes so popular with runners for over 20 years.

Finally, we gave the Shadow VS a lighter, more durable upper. It provides additional midfoot support, and looks great doing it.

The Shadow VS. Available for both men and women.

Happy landings.

Lady Shadow VS

GEAR

Saucony ✺

Shoes for the
Great American Athlete.

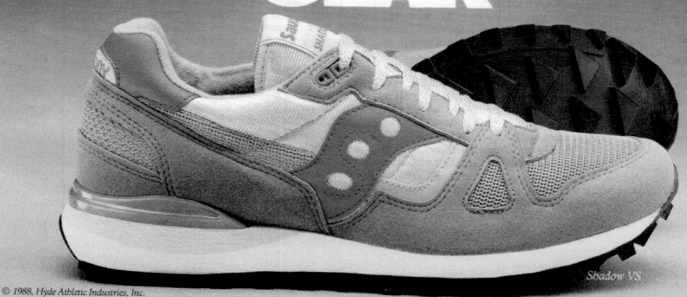

Shadow VS

© 1988, Hyde Athletic Industries, Inc.

1988: Shadow VS, 'Landing Gear'

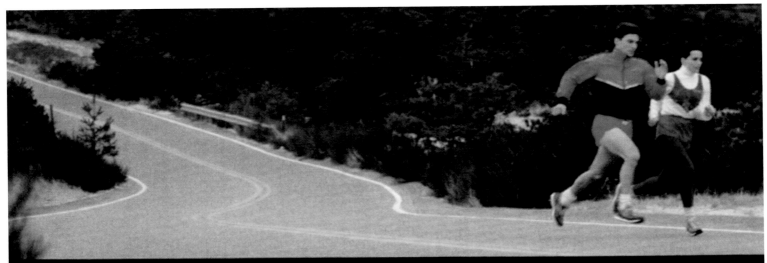

FAST

No pain, no gain was never meant to apply to the feet. And to preserve that very important distinction we've designed an exceptional running shoe.

Courageous by Saucony.

The Courageous, in the tradition of our Freedom Trainer, features a tri-density compression plug midsole, with increasing EVA foam densities across the rearfoot and midfoot region. This effectively reduces the rate and amount of excessive foot pronation—the predominant source of many foot and knee injuries for runners.

Our solid Indy 500 rubber outsole

Tri-density compression plug midsole.

has a modified pyramid forefoot lug pattern for superior durability, pressure dispersion, and cushioning.

And our removable bi-density EVA insole—firmer under the arch for anti-pronation and greater support— conforms to your foot for the most comfortable fit going.

It's an exciting new entry in Saucony's long line of high performance shoes for dedicated runners.

Courageous.

We named it after you.

Saucony ⑨
Shoes for the
Great American Athlete.

RELIEF

© 1987 Hyde Athletic Industries, Inc. Coming in May to your Saucony dealer. *Courageous.*

1987: Courageous, 'Fast Relief'

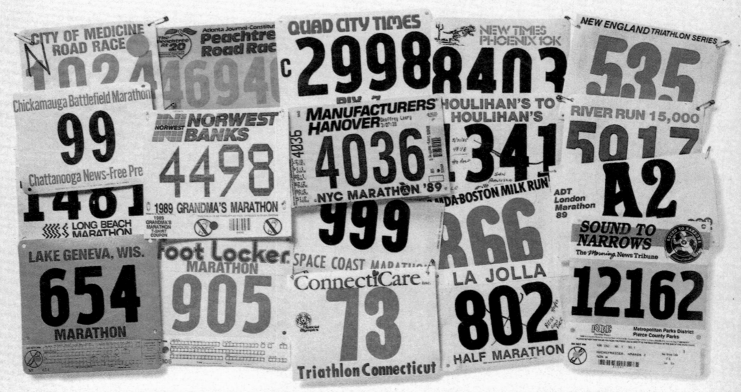

120,000-K AND STILL RIDING HIGH.

We were at Bay-To-Breakers. We were in Boston, Chicago, London, L.A. and New York, at the Marathons. We were at Grandma's, at Bolder-Boulder and at the Peachtree 10-K. Wherever runners run, we were there. Because no other shoes feel quite like ours.

Not just in the toe box. Not just in the midsole. Not just in the rearfoot. But all over. The ride: That elusive combination of cushioning and stability that makes you feel the shoe moving with you as your foot goes through the motions.

Now, if you've never heard anyone else talk about the ride like this, maybe it's because nobody else makes shoes that ride like ours. From Scott Tinley to 10-minute-mile slogger Holly Young, runners get a great ride in Saucony.® Try us. If our shoes didn't perform, they wouldn't have put in over 120,000K last year.

Dodge
176
ALCATRAZ

October, 1989: Saucony Triathlon Team Captain Scott Tinley led an escape from America's most famous prison, winning the Alcatraz Challenge.

Take Us Along For The Ride. **Saucony ⚡ Running**

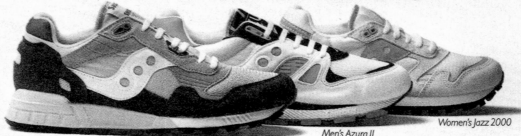

Men's Shadow 5000 Men's Azura II Women's Jazz 2000

Available At Fine Stores Across The Country. © Hyde Athletic Industries, Inc.

1988: Shadow 5000, Azura II and Jazz 2000, '120,000-K and Still Riding High'

" Back in the 1980s, sneaker design wasn't glamorous like it is today. On my first day at Saucony, the development team handed me a book about how shoes are made. On the second day we boarded a little plane and flew to the factory in Bangor, Maine, to watch shoes being made. That was my education! I ended up designing the Jazz 3000, the Shadow 6000 and the Courageous. It's funny looking back on that period now. One of the things I always tried to do was to modernise the panel structure and make the shoes smoother and free-flowing. I had a love/hate relation-ship with the Saucony logo as well. It drove me nuts!' "

Joel Rusnak
Saucony History Book
Sneaker Freaker (2021)

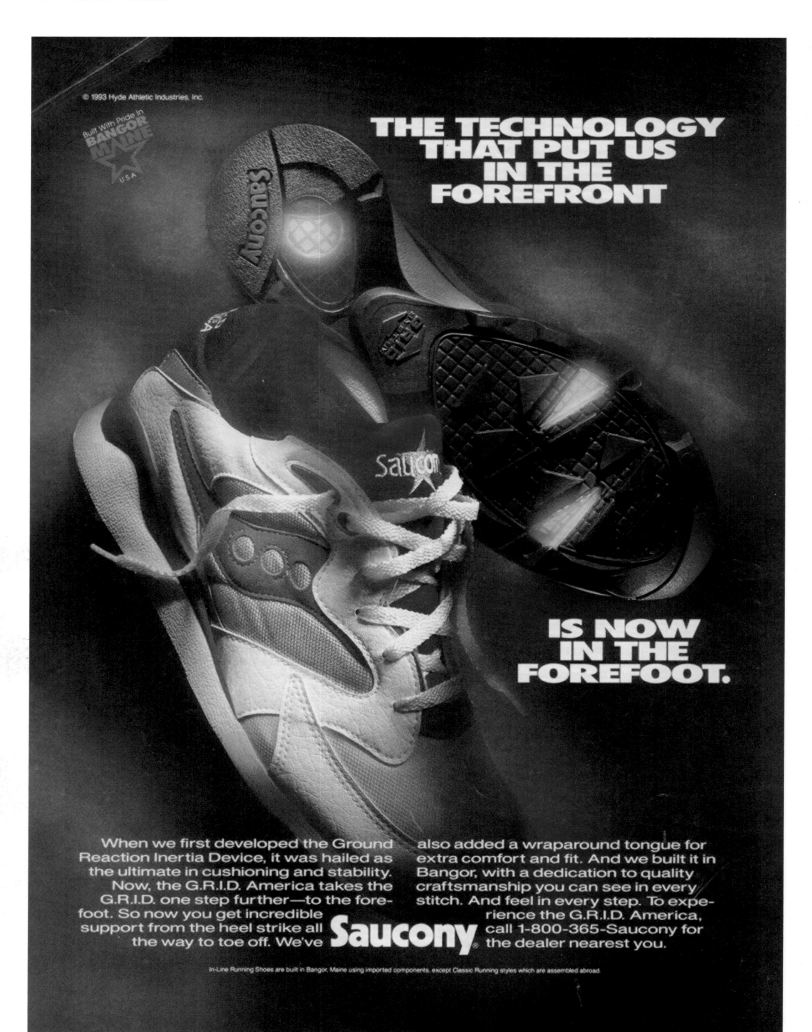

© 1993 Hyde Athletic Industries, Inc.

THE TECHNOLOGY THAT PUT US IN THE FOREFRONT

IS NOW IN THE FOREFOOT.

When we first developed the Ground Reaction Inertia Device, it was hailed as the ultimate in cushioning and stability. Now, the G.R.I.D. America takes the G.R.I.D. one step further—to the forefoot. So now you get incredible support from the heel strike all the way to toe off. We've **Saucony**® also added a wraparound tongue for extra comfort and fit. And we built it in Bangor, with a dedication to quality craftsmanship you can see in every stitch. And feel in every step. To experience the G.R.I.D. America, call 1-800-365-Saucony for the dealer nearest you.

In-Line Running Shoes are built in Bangor, Maine using imported components, except Classic Running styles which are assembled abroad.

1993: GRID America, 'The Technology That Put Us in the Forefront is Now in the Forefoot'

WE TOOK THE GOLD. AND RAN WITH IT.

Recently, the Saucony Jazz 3000 was named the number one running shoe for both men and women by America's leading consumer watchdog magazine. Now, the Jazz 4000 takes the gold to an even higher standard. We've improved the EVA midsole for even better shock absorption and stability. We've added a removable, molded sockliner for additional comfort. And we've updated the design, so its looks match its performance. The Jazz 4000. Go for the gold. Call 1-800-365-Saucony for the dealer nearest you.

Saucony

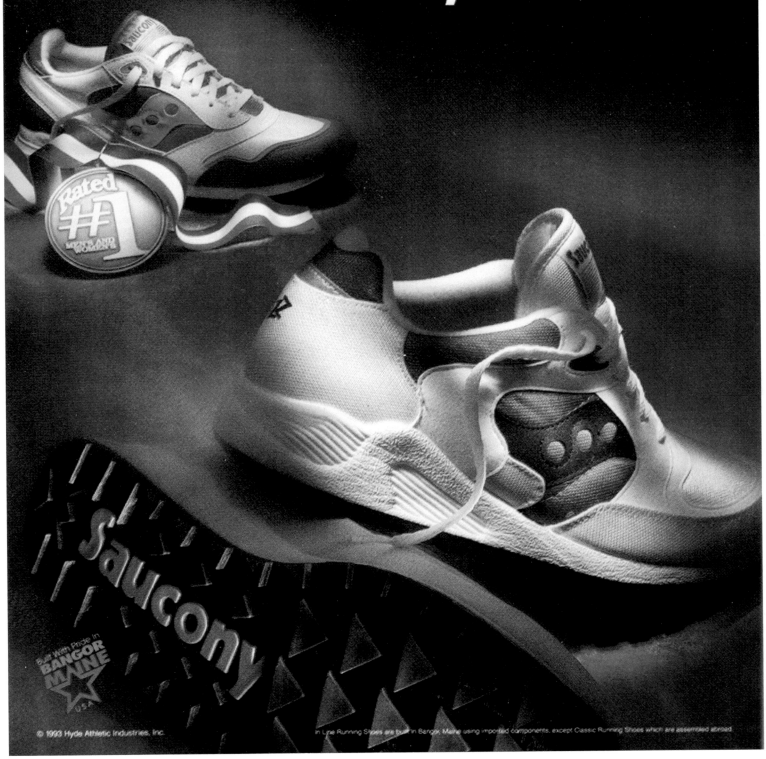

© 1993 Hyde Athletic Industries, Inc. In Line Running Shoes are built in Bangor, Maine using imported components, except Classic Running Shoes which are assembled abroad.

1993: Jazz 4000, 'We Took the Gold. And Ran With It'

RUN.

IT'S A FREE, LIMITED TIME OFFER.

The Saucony Jazz. Time and time again, it's the shoe serious runners choose for unbeatable performance and outstanding American craftsmanship. It even has the critics behind it. Recently, it was rated the number one running shoe by America's leading consumer watchdog publication. And now, there's never been a better

time to run with the Jazz. Because for a limited time only, when you purchase the Jazz or any other pair of Saucony running shoes from Foot Locker, you get a free sportswatch. Just send us your receipt along with the attached coupon, and we'll send you the watch. But hurry. It's a limited time offer. (Now through July 31, 1993.)

Saucony

foot Locker
AMERICA'S MOST COMPLETE ATHLETIC FOOTWEAR STORE™

SAUCONY © 1993 Hyde Athletic Industries, Inc.
In-Line running shoes are built in Bangor, Maine using imported components
except Classic Running Shoes which are assembled abroad.

Built With Pride In BANGOR MAINE ★ USA

1993: Jazz, 'Run. It's a Free, Limited Time Offer'

CAUTION: IT'S LOADED.

There's only one thing more outrageous than the way the G.R.I.D. Sensation looks. The way it performs. It all begins with the patented G.R.I.D. System, which provides superior cushioning and stability. Then there's the new Pontoon Technology™ in the midsole for a wider base of support, improved EVA for a lighter weight, the Radial Decelerator™ in the heel to decrease the rate of pronation and an inner fit system for increased comfort. Finally, it's topped off with a transparent screen mesh upper for breathability. Best of all, it's put together with quality craftsmanship here at home in Bangor, Maine. So call 1-800-365-Saucony for the dealer nearest you. With the G.R.I.D. Sensation, you'll be armed and ready.

Saucony®

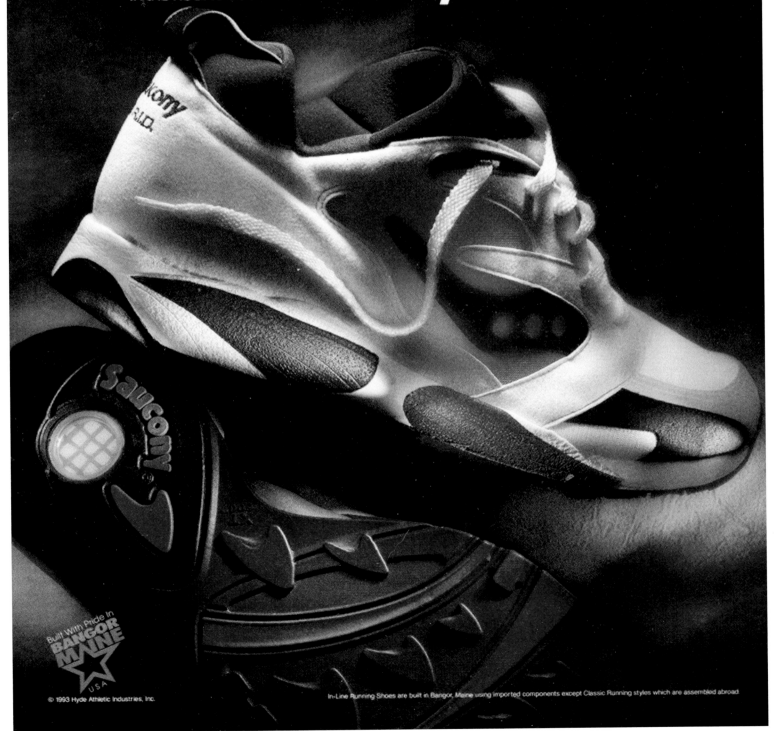

1993: GRID Sensation, 'Caution: It's Loaded'

INDEX

Page numbers in *italics* refer to illustrations

SNEAKER FREAKER

Editor: Woody
Managing Editor: Audrey Bugeja
Designer: Tim Daws
Copy Editors: Ged McMahon and Boon Souphanh
Office Juniors: Sonny Ray, Claude and Marlowe

sneakerfreaker.com
Instagram @sneakerfreakermag
Twitter @snkrfrkrmag

Sneaker Freaker Acknowledgements:
The author would like to thank Deborah Aaronson,
Bill Bowerman, Audrey Bugeja, Adolf Dassler,
Horst Dassler, Rudolf Dassler, Jim Davis,
Solomon Daws, David Carson, Brad 'Yo!' Farrant,
Paul Fireman, Keith Fox, FYM, Tinker Hatfield,
Chuck Kuhn, The Intern, David Kennedy, Phil Knight,
Roberto Muller, Erin Narloch, Kihachiro Onitsuka,
Bob Peterson, Pomo, Pascal Prehn, M Frank Rudy,
Nick Santora, Bill Sumner, Robyn Taylor and
Dan Wieden.

SOLED OUT is dedicated to all the shoe dogs!

DISCLAIMER

This book contains advertisements sourced directly from the pages of vintage magazines and private collectors. Sneaker Freaker acknowledges that various copyrights exist in each of these images and to the extent possible, we have identified the source. This book is intended to provide an independent assessment and historical review of the sneaker industry and the decades of progress these ads chronicle. Thanks to all the athletes, designers, marketing geniuses, copywriters, photographers, agency creatives and magazine proprietors who contributed over the years. Without your energy and expertise, the entire sneaker industry – and this book – would not exist!

PICTURE SOURCES

Listed where available.

Runner's World: 10, 14 (bl), 23 (t), 24 (tr), 54–55, 68–69, 82 (tl), 82 (tr), 82 (br), 83, 84 (tr), 84 (bl), 84 (br), 85 (tr), 86 (b), 89, 97 (tr), 97 (bl), 97 (br), 98–99, 100, 104–5, 128 (tr), 129, 132 (tl), 140, 149, 158 (tl), 158 (tr), 160, 161 (tl), 161 (tr), 163, 204, 205 (tr), 206–7, 208–9, 260 (t), 260 (b), 262–3, 269 (t), 269 (b), 270 (tl), 291 (bl), 322–3, 410, 414–15, 417, 419, 421, 422, 423, 433, 460 (tr), 461, 473 (b), 542 (tl), 542 (tr), 543 (bl), 572, 574 (tl), 574 (tr), 574 (br), 575 (tl), 575 (tr), 575 (br), 576 (t), 595 (b), 662 (t), 662 (br), 668 (b), 672–3, 694 (bl)

The Runner: 13 (br), 25 (b), 30 (tr), 34 (tl), 82 (bl), 84 (tl), 85 (bl), 86 (t), 87 (tl), 87 (tr), 87 (b), 128 (tl), 128 (bl), 128 (br), 132 (tr), 133 (tr), 135, 136 (b), 154–5, 156, 158 (br), 159 (tl), 159 (tr), 159 (br), 162 (t), 162 (b), 164–5, 205 (bl), 210, 210 (bl), 213 (t), 213 (b), 215 (tl), 215 (bl), 261, 264–5, 266, 270 (tr), 270 (bl), 270 (br), 271, 272–3, 274, 275, 276, 277, 278, 280–1, 282 (br), 284–5, 416 (br), 418, 424, 420, 425, 426, 427, 428 (tr), 428 (bl), 428 (br), 429 (b), 432, 434, 435 (tr), 435 (bl), 435 (br), 436 (b), 438 (b), 439 (tl), 439 (tr), 439 (b), 440 (tr), 440 (bl), 440 (br), 441, 542 (tl), 543, 555 (tr), 574 (bl), 575 (bl), 577 (t), 662 (bl), 663 (tl), 663 (tr), 665, 666 (tl), 666 (tr), 694 (br), 696 (tl), 699 (tr), 700 (bl), 707

Running: 664

The Source: 50–51, 76–77, 78–79, 192–3, 502–3

Sports Illustrated: 14 (tr), 28 (b), 31 (t), 39 (t), 93, 118, 120, 130, 131, 133 (l), 134 (l), 178 (l), 178 (r), 180, 214 (l), 214 (r), 221, 363 (tl), 448 (t), 448 (b), 449 (t), 449 (b), 459 (tr), 510 (b), 565, 566, 590, 591, 608–9, 666 (bl), 666 (br), 667, 688, 689, 691 (tr)

Tennis: 30 (t), 30 (b), 216 (l), 219 (t), 219 (b), 512, 514–15, 528–9, 558 (l), 558 (tr)

PHAIDON

Phaidon Press Limited
2 Cooperage Yard
London E15 2QR

Phaidon Press Inc.
65 Bleecker Street
New York, NY 10012

phaidon.com

First published 2021
© 2021 Phaidon Press Limited

ISBN:
978 1 83866 367 4
Limited Edition:
978 1 83866 418 3
Sneaker Freaker Edition:
978 1 83866 382 7

A CIP catalogue record for this book is available from the British Library and the Library of Congress.

Commissioning Editor: Deborah Aaronson
Project Editor: Robyn Taylor
Production Controller: Nerissa Dominguez Vales

Printed in China

Publisher's Acknowledgements:
The publisher would like to extend special thanks to Rebecca Barton, Jane Birch, Nerissa Dominguez Vales, Julia Hasting, Luísa Martelo, João Mota, Anthony Naughton, Holly Pollard and Hans Stofregen for their contributions to the book.